AFRICAN ETHNONYMS
Index to Art-Producing Peoples of Africa

AFRICAN ETHNONYMS

Index to Art-Producing Peoples of Africa

DANIEL P. BIEBUYCK
SUSAN KELLIHER
LINDA MCRAE

G. K. HALL & CO.
An Imprint of Simon & Schuster Macmillan
NEW YORK

PRENTICE HALL INTERNATIONAL
LONDON MEXICO CITY NEW DELHI SINGAPORE SYDNEY TORONTO

G. K. Hall & Co.
An Imprint of Simon & Schuster Macmillan
1633 Broadway
New York, NY 10019

Library of Congress Cataloging-in-Publication Data

Biebuyck, Daniel P., 1925–
 African enthnonyms : index to art-producing peoples of Africa /
 Daniel P. Biebuyck, Susan Kelliher, Linda McRae
 p. cm.
 Includes bibliographical references and index.
 ISBN 0-7838-1532-8 (cloth : alk. paper)
 1. Names, Ethnological—Africa, Sub-Saharan—Dictionaries.
 2. Art, Black—Africa, Sub-Saharan. I. Kelliher, Susan.
 II. McRae, Linda. III. Title
 GN645.B53 1996
 305.8'00967—dc20 96-19439
 CIP

The paper used in this publication meets the minimum requirements of ANSI/NISO Z39.48-1992—(Permanence of Paper).

Nakyo nakyabola
Kiganza kya kuboko ntabola.

A Lega aphorism, sung at the highest levels of the bwami association,
emphasizing the concept of everlasting achievements

To ROBERTA GOLDING

for her enduring contribution
to the study of African art

CONTENTS

Acknowledgments ix
Introduction xiii
Guide to Use xxiii

African Ethnonyms 1

Language Notes 283
Toponyms Index 289
Country Index 297
List of Abbreviations 315
Bibliography 335

ACKNOWLEDGMENTS

The index began three years ago as a simple list of names. We never dreamed that it would take three years to compile or that it would involve so many individuals.

We are especially indebted to Roberta Golding, whose vision and generosity brought us together and made this project possible. In 1990, as a tribute to her husband, the late Stuart Golding, she endowed the University of South Florida with the Stuart Golding Chair in African Art. In 1993, Professor Daniel Biebuyck joined the university as the first Golding scholar.

Enlisted to provide advice and guidance in developing the program, Professor Biebuyck began by reviewing the university's resources. Preparation for the program included building a substantial collection of teaching materials, particularly slides of African art. Under Professor Biebuyck's direction, visual resources librarian Linda McRae and researcher Susan Kelliher began to put together a list of names to be used as an aid in cataloging the newly acquired collection of slides. This list became the focus of our research and the genesis for the index.

We are grateful and honored to have received the Art Library Society of North America's prestigious H. W. Wilson Foundation Research Award for 1995. The award gave us the much-needed impetus to seek a publisher for the index, and we thank G. K. Hall for having the necessary confidence in the project to see us through it.

Along the way, many individuals gave us support and encouragement, including Janet Marquardt-Cherry, chair of the Art Department during the initial planning phases for the Golding Chair; Wallace Wilson, current chair of the department and enthusiastic supporter over the last two years; and John Smith, dean of the College of Fine Arts, who has had a lifelong interest in Africa and its arts.

Without the assistance of librarians, this index would never have come to fruition. We obtained many of our sources through interlibrary loan, and it is

through the patience and goodwill of Maggie Doherty and her dedicated staff at the University of South Florida Tampa Campus Library that we were able to proceed. Thanks also to other library staff, including those in the documents department and the reference department, particularly Ilene Frank, for all their help. We spent many long hours in the University of Florida's Fine Arts and Architecture Library, where Ed Teague, head of the library, graciously gave us assistance. There was never a time when we needed advice or help on some matter that we couldn't count on Janet Stanley, chief librarian of the National Museum of African Art.

Initially, we consulted visual resources librarians and are especially grateful to those who sent us their unpublished authority lists and classification schedules, including Joni Back of the Indianapolis Museum of Art, Eileen Fry of Indiana University, Julie Hausman of the University of Iowa, Helene Roberts of Harvard University, and Carol Van Schaack of Colgate University. We consulted and cited both the *Library of Congress Subject Headings* and the *Art and Architecture Thesaurus*, and we are particularly appreciative of the help we received from Elisa Lanzi and Susanne Warren of the AAT.

Through the newsletter for the African Arts Council of the African Studies Association, we were put in touch with Jeremy Coote of the Pitt Rivers Museum, Oxford, editor of the African section of the forthcoming *Dictionary of Art*. Mr. Coote kindly sent us information on entries in the dictionary so that we have been able to cite the dictionary prior to its publication. We are also grateful to Mr. Coote for reviewing our bibliography and advising us on some of the index entries. We would also like to thank Professor Roy Sieber, who graciously reviewed an early version of the bibliography and made valuable suggestions for additions, and Professor Elizabeth Cameron, who lent us books from her private collection and made many valuable suggestions for the bibliography.

Data for the index was originally organized in tables in Microsoft Word, and somewhere along the way we realized what a colossal task it was going to be to convert it to page format. We consulted Carl Crouch and Harriet Seligsohn, who kindly gave of their time and expertise to consider our needs and advise us on potential software. We are particularly indebted to Kevin and Dawn Boneham, who eventually wrote the macros that did the conversion, saving us endless hours of manual labor, and to Greg Madison for technical support.

Others who contributed to the project include Michael Roy, who put us in touch with the on-line version of the *Ethnologue Database*, and Joseph Lauer, who sent us copies of the *Africana Libraries Newsletter*. Those who lent and gave books from their private collections include Jerelyn and Joel Fyvolent, Fred and Lucille Wallace, and Shirley Martin. Others who helped us in the initial research phases of the project are Kristen Parker, Eileen Riley, and Tracie Timmons, dedicated graduate students assigned to the Golding Chair. A very special thanks goes to Karen Fraser for the countless hours spent in research-

ing and formatting the bibliography. For her perseverance and dedication we are most grateful.

A large measure of gratitude is due friends, colleagues, and staff of the University of South Florida Art Department. To Lowene Moyer, Teresa Infantino, and Joyce Saddler, who were always there to give us advice on university procedures, and to Mary Ann Becker, who maintained order in the slide library despite the chaos brought on by the completion of the project, we are most appreciative.

To Jeremy Gluckman, Sharon and Elliot Greenbaum, and Chris Kiefer, who gave unstintingly of their time to help us proofread the manuscript, and to Jerelyn Fyvolent, who not only helped out with proofreading, but did much of the research for the special sources, we are sincerely grateful. Above all, we thank our families for their patience, support and confidence.

INTRODUCTION

The African continent offers a bewildering array of names: names of distinctive populations and their subdivisions, their languages and dialects; names of countries, geographical places, and archaeological sites; names of empires, kingdoms, chiefdoms, and villages; terms for territorial and administrative divisions; and names of kinship groups, cults, and associations. This terminological profusion permeates all aspects of life, from personal name giving to the as yet insufficiently known artistic and technical taxonomies. Among the Nyanga of Zaire, for example, a full-fledged adult married man with children has at least five to six personal names: a birthname, a "youth name" received at his circumcision rites, a tutelary spirit name, a nickname, a teknonymic name, and eventually a name referring to a status or a skill. Married women with children have an equally large number of personal names. All of these names are kept for life, although each is used only by certain categories of kin and nonkin and only in prescribed types of relationships.

The abundance of African language terms (and their translations or equivalencies in a European language) occurring in studies on African art is no less impressive. An artwork is attributed not merely to a particular ethnic group such as the Bamana (Bambara of Mali) and its numerous territorial, political, social, and ritual divisions, but also to the particular institutional setting within which it is made and functions. Authors on Bamana art typically specify that a certain mask is of the komo, kore, ndomo, kono, namakoroku (tyiwara; flanpeu) or nama association or initiation system.

Artworks linked with hierarchically structured associations or age classes, different grades, and initiation phases, must be placed in their proper socioritual settings and systems of meaning. For example, in order to situate fully a Lega anthropomorphic figurine carved in elephant ivory or bone, the object must be linked with initiations of the "bwami" voluntary association. This association is intricately structured into grades, subgrades and cycles, has male

and female membership, and recognizes among its members certain special statuses (such as most senior by birth or by initiation, master preceptor, or most recent initiate). The figurine must be placed within the framework of initiations into the highest grade of "kindi," because all ivory carvings are associated with that grade. The kindi grade itself comprises three subgrades (kyogo kya kindi, musagi wa kindi and lutumbo lwa kindi), the membership of which uses different types of artworks of diverse shapes and materials, many of them carved in elephant ivory or bone. The male initiations into the three levels of the kindi grade are inseparable from those achieved by a senior wife to the complementary female grade of "bunyamwa." It is therefore necessary to indicate to which subgrade the particular ivory figurine belongs and whether it is associated with the male or the female initiations at the highest grade level. In addition, every ivory figurine has, apart from its generic term, at least one individual name that generally indicates, but in a covert manner, a set of meanings linked with it.

Thus, a Lega anthropomorphic ivory figurine would have to be identified as an object exclusively controlled by members of the "Bwami" association, in individual male ownership by an initiate of the highest lutumbo lwa kindi grade, and used in the bele muno initiatory phase, generally classified as iginga, and specifically known as Sakematwematwe. This profusion of terms associated with a single object illustrates the incredibly rich nomenclature typically found in the study of African art—nomenclature not easily translatable into European languages and consequently the source of numerous difficulties of interpretation and classification.

This work concentrates on an extremely important set of terms—the ethnonyms—terms that include both autoethnonyms (names by which particular ethnic groups identify themselves) and xeno- or heteroethnonyms (names by which others designate them). The work also includes many names representing narrower terms (names by which particular ethnic groups divide themselves internally into smaller units). As the outside world began to transcribe African names into a variety of foreign languages, many different spellings began to appear in the literature. This work also contains many of the name variants resulting from such transcriptions. A correct knowledge of ethnonyms and ethnic nomenclatures is a sine qua non in the study of African art. The primary point of reference in the analysis and comparison of this art is the ethnic group or subgroup, not the time period (which is mostly unknown or just guessed), nor the atelier, the school, or the individual artist (whose name and specific place of work are rarely known).

This index only lists some of the better known and most current ethnonyms; a complete enumeration of autonomous and related groups, and their subethnic divisions, seems impossible to achieve. These limitations are due not merely to the sheer number of ethnonyms (and variant spellings), but also to the fact that Africa remains an understudied continent, whose cultural richness and diversity will never be fully understood. For a vast number of populations and

cultures, reliable data are simply unavailable. Although the scientific study of the continent has progressed enormously since Evans-Pritchard undertook his Zande studies, much basic information is still lacking, and in fact may elude us forever, because of past scholarly neglect and sweeping cultural changes.

Expressing their astonishment about my efforts to study them in 1950 and 1951, the Bembe people of eastern Zaire held up the following proverbial truth: "Byabekyakile milengeci tamulange ngendo, musumona micumbi musulanga ngendo" (At the time of the dry season you did not prepare for the journey, now as you experience the rainy season you make preparations for the journey), referring to the sad reality that efforts to penetrate deep into the mind of the Bembe came too late, for a huge loss had already marked their cultural memory and heritage.

In this brief introduction, I examine some of the many reasons for the emergence and existence of the bewildering number of ethnic terminologies, and present possible explanations for the real and apparent confusions and variations of names.

Outside Intervention and the Transcription of Names

At the time of the earliest contacts with the West, most African ethnic groups (excluding the Arab, Berber, and some Ethiopian societies) had no writing systems of their own. Their cultural traditions were orally based and expressed in a wealth of orally transmitted texts, ranging from epics to tales, legends and historical narratives, from aphorisms to riddles, praises and prayers. The African peoples had, obviously, developed sophisticated systems of communication reflected in the so-called drum-languages, gestural codes, body art and paraphernalia, dance movements and theatrical performances, musical patterns, sculptures, and symbolic designs, but these methods of communication are not relevant for the present discussion. The traditional lack of writing means that the ethnic names recorded in the earliest Western literature lacked written precedent and were transcribed, for better or for worse, by means of alphabetic signs.

Most early and many later observers did not have the language skills needed to decipher the sometimes very difficult sound systems of African languages. Furthermore, a spoken or written symbol (a vowel, a consonant, or a combination of them) currently used in the Western alphabet did not necessarily represent the same sound values for a Dutch, English, French, German, Italian, Portuguese, Scandinavian, Spanish or other commentator reporting on African cultures.

Leaving aside some exceptional early observers, most persons living and working in Africa spoke with Africans in their own European language, mostly with the help of ad hoc "interpreters" sometimes recruited in other ethnic groups who understood the European language imperfectly and frequently experienced great difficulties grasping the Western methods of inquiry and

interview. These untrained "interpreters" often had only a limited knowledge of the tribal language, the culture, and the people they were providing information about, or they might not produce "objective" translations of what they heard, in order to satisfy certain sociopolitical and other interests. Some Westerners conversed with the interested populations in one or another lingua franca and received terminologies adapted to the speech patterns of that particular lingua franca. Thus, someone speaking Kingwana (a Swahili dialect introduced into eastern Zaire during the conquest period) with Lega villagers would get answers that were pertinent to the Kingwana speech patterns and would receive terms such as (Wa)Rega instead of (Ba)Lega, (Wa)Songora instead of (Ba)Songola. The hurried and uncritical approach with which all this name giving and name receiving was done led observers who were primarily explorers or traders, or military, administrative, or missionary personnel, to record incorrect names and even invented ones.

The need for "the unification and simplification of the orthography of African languages" was felt keenly as scholarly interests in Africa began to emerge. Shortly after its creation, the International African Institute (London) prepared a memorandum on the *Practical Orthography of African Languages* (Oxford University Press, 1928, revised 1930). Although the recommendations were successful in some milieus, they were largely ignored by most authors particularly those writing in languages other than English, and had little or no impact on the systematic transcription of ethnic names in administrative and early scholarly documents. Numerous subsequent international conferences notwithstanding, the current nomenclature remains very confused, partly because of the orthographical precedents already in the literature, the unwillingness of some to depart from the established conventions, and the recent flurry of sometimes unverified ethnic denominations.

Among the many examples of the haphazard manner in which ethnic names were codified in past writings, the case of the Chokwe (Cokwe) people of southern Zaire and northern Angola is symptomatic. The Chokwe (Cokwe) are mentioned in the literature before 1879, in various German, English, French, Portuguese, and Flemish articles and books under an incredible number of spellings: A'hioko, Bachoko, Badjok, Ba-Djok, Badjoko, Bajok, Bakioko, Basok, Batchokwe, Batchoque, Batshioko, Batshiokwe, Batshok, Ba-Tshoko, Benatuchoko, Chiboque, Kaschoko, Kibokoe, Kibokwe, Khioko, Kioke, Kiokjo, Kioko, Kioque, Makioko, Matchioko, Quioco, Tschiokwe, Tsokwe, Tutshiokwe, Utshiokwe, Va-Chioko, Watschiwokwe, etc. (The enumeration is based on Maes and Boone, 1935, pp. 190–193, who adopt the spelling Batshioko; for an even longer list see Bastin, 1961, vi, p. 21, n. 1). The example of the Chokwe (Cokwe) shows some of the transcription problems that in the past and present have produced so many variations. Clear influences of the language patterns of the Portuguese, German, French, and English observers are built into the transcriptions. But there is more.

As evidenced in the Chokwe (Cokwe) example, authors have tended to

place a plural prefix of the second class of nominal classifiers before the root, in several permutations such as A-, Ba-, Va-. Other authors have used a singular prefix of different classes, such as Ka-, Ki- and its variants (Qui- or Tshi-) inspired by the observer's European language. They have even introduced other types of plural prefixes, such as Ma- and Tu. Since early authors generally knew little about African language structures, they took the terms they received at face value, the native speaker-interpreter tending to use the prefixes as he heard them. In addition, the name Chokwe (Cokwe) underwent a double manipulation: the ch- or c- of Chokwe (Cokwe) was spelled as tshi-, chi-, tsh-, tschi-, ki-, qui-, j- and dj; kwe, the second syllable in Cho-kwe (Cokwe) was rendered as -ke, -ko or -que.

By 1954, when the Belgian linguist Burssens prepared his introduction to *The Bantu Languages of Zaire*, he gave preference to the spelling Ciokwe (a transcription still favored in Boone, 1973, p. 1, although in 1961, p. 233, she selected the spelling Tshokwe). Burssens added still other variants, such as Tuciokwe and Tutshiokwe. Murdock (1959, p. 293, nr 25) provided even more new variants under the label Chokwe (Aioko, Atsokwe, Bachokwe, Kashioko, Katsokwe, Shioko, Tsiboko, Tsokwe, Tutschokwe, Vichioko, Watschokwe). Fortunately, the term Chokwe is now the preferred one in writings on African art. Linguists, like Mann and Dalby (1987, p. 153) and many other scholars, adopt the spelling Cokwe in accord with the rules already laid out in the 1928 documents of the International African Institute. The Chokwe case thus offers a striking example of the many orthographical confusions that produced useless complications and meaningless variations for persons coping with the organization and classification of ethnic materials.

It must be noted, however, that part of the spelling differences in the Chokwe case, as well as in numerous other instances, are reflections of the existence of diverse dialects, the Chokwe people being a widely dispersed group without central political authority. Moreover, the dispersed segments of the Chokwe population are in contact with numerous distinctive groups of Bantu speakers, such as Lunda, Luba, Pende, Songo, and Lwimbi, so that some observers have adopted the peculiar pronunciation of the contact group.

The significance of regional and dialectal variations in pronunciation and spelling is well illustrated in the case of the Manding (Mandeka, pl. Mandekalu) peoples, a very large group of historically and linguistically related populations dispersed in various countries of West Africa. They are also known in French literature as Mandingue and sometimes in English as Mandingo. According to authorities, such as Dalby, Bird and others (see Hodge, ed., 1971, passim), the designation Manding is derived from the toponym Mande, a historically significant region on the Upper Niger. Because of "fluctuations in nasalization," the term Mande is known in such regional variants as Manden, Mandin, Mani, Mali.

The problems are compounded by other linguistic features inherent in the languages from which particular ethnonyms are derived. In the Mande case,

some variant names, such as Mandi-nka, are the result of the suffixation of the formative elements -ka or -nka, which help in the derivation of adjectival stems from toponyms. Mandinka, a term often used to refer to the Gambian Mande, literally means "belonging/originating in the Mande/Mandin heartland." A term such as Mandingo/Mandinko results from the fusions of the suffix -ka with the suffix -o , to form the noun Mandin-ko, meaning an individual from Mandinka. Still other forms such as Mande-kan, indicate the language. Given these examples, one understands the immense difficulties involved for so many persons not expert in African language systems.

Internal Taxonomies and Subdivisions

Regardless of the numerous transcription errors that have flawed African ethnic nomenclature by creating a large number of meaningless spelling variants, anthropological, archaeological, historical, and linguistic researches have established the irrefutable fact that the African continent is, and has been for a very long time, inhabited by a great many distinctively named human groups, frequently called tribes or clusters of tribes. Over thousands of years these ethnic groups have elaborated their own unique languages and dialects. As the historical processes of migration, scission, and fusion progressed, more and more different sociopolitical entities emerged. Each group invented its own names to demarcate its autonomy and uniqueness versus the outside world and to stress its internal cohesion and solidarity. Since every population is segmented, new subdivisions manifested themselves within more or less homogeneous populations to emphasize an internal system of segmentary oppositions and balances. Subsequent amalgamation or fission of related groups and subgroups further contributed to the emergence and proliferation of new names. For Africa as a whole, the resulting situation is incredibly complex. None of the general ethnic headings familiar to Africanists can do justice to this ethnic puzzle.

For purposes of general classification (as distinct from highly specialized and intensive local and regional studies or small-scale comparisons) it is impossible to take into account the many subdivisions and relationships. An example illustrates the complexities. Anthropologists, historians, and linguists have long recognized the existence of a fairly well delineated cluster of peoples, called Mongo, dispersed over huge distances in the western forest region of Zaire. The peoples included in this cluster exhibit common linguistic and cultural features and participate in a common historical background, but they have no centralized political system and are divided into a large number of distinctive groupings, sometimes for lack of a better descriptive term called "tribes."

Although some of these groups are classified as Mongo because of linguistic and ethnographical comparisons devised by Western scholarship, many of them would consider such classifications to be meaningless. Groups called

Ntomba, Nkundo, Ekonda undoubtedly exhibit a number of specialized patterns, and they recognize this fact. The Ekonda, for example, are also called Baseka Mputela or Banamputela, children of Mputela (their founding ancestor); they owe their name Ekonda (Konda) to the related Nkundo, a neighboring Mongo entity, the term Ekonda probably referring to people inhabiting the hinterland of the Lake Maindombe waters. The Ekonda have come to accept the combined terminology Ekond'Mputela, but prefer the terms Nkund'Mputela (because they consider themselves descendants from the ancestor Mputela, a junior sibling of Bongo, the founder of the prestigious Nkundo group) and Nkund'e nta, "Nkundo of the bow," as they are still called by some of their other neighbors.

Ekonda society incorporates two population strata: the cultivators (the Ekonda, properly speaking, known as Baoto) and the hunters (Batwa or Pygmoids), who live in different hamlets but are subordinate to the Ekonda and somewhat assimilated to them. The Ekonda are politically not integrated, but each village is under the authority of a "nkumu," a consecrated personage who stands in a special ritual relationship to the village spirit (elima). Because of this political fragmentation some authors have gone so far as to refer to the Ekonda as "a collectivity of Bantu tribes" and have listed not less than fourteen so-called subunits (some authors call these subtribes, while others speak of clans). Each of these subunits has a distinctive name, such as Besongo, Djoko, etc., and to complicate matters at least some of these fourteen subunits are grouped under the broader name Ibuyokonda (Van Everbroeck, 1974; Muller, 1957; Tonnoir, 1966; Vangroenweghe, 1977). It is easy to see the difficulties involved in deciding at what level the terms should be recorded, whether from certain points of view the term Ekonda is a "catchword" and whether emphasis should be placed on the fourteen subdivisions of the Ekonda.

Autoethnonyms

The origin and meaning of the autoethnonyms are not easy to determine. They are different from the names for clans and lineages, or those for kingdoms and chiefdoms that are often modeled after the name of an eponymous ancestor (real or putative), a culture hero, a mythical or legendary figure, a king or chief, etc. In some cases an autoethnonym might refer to the uniqueness of the group, combined with a sense of pride and superiority, as occurs when the name selected entails the idea of "we the people," or "the people of . . ." Cardona (1989, p. 351) has pointed out that many of the autoethnonyms are best understood in terms of oppositions, such as "we versus the others, the strangers, the foreigners," "we the free versus the slaves, the captives," "we the believers versus the infidels, the pagans," etc. The well-known Dinka of the southern Sudan call themselves Monyjang (literally Man or Husband of Men) to indicate that "they see themselves as the standard of what is normal for the

dignity of man" and to stress "their superiority to the others or foreigners" (Deng, 1972, p. 2).

A surprisingly small number of autoethnonyms are currently used among the standard ethnic names quoted in the literature. This fact largely reflects the source and manner in which foreign agents registered names, relying more on the "hommes de confiance" that accompanied and served them, than on the people themselves. In cases where the autoethnonym does occur it may have been modified by the already mentioned inadequacy of the transcription (e.g., the Chagga of Tanzania are also known as Chaga, Jagga, Dschagga, Waschagga; see Moore and Pruritt, 1977, p. 1). In other instances, an element of differentiation based on language differences may be lacking. The Acoli who live in Uganda call themselves Log Acoli while those of the Sudan refer to themselves as Dok Acoli. Some variations in the transcription of autoethnonyms may also be due to dialect differences within the group, as was already pointed out for the Chokwe (although it is not clear whether this ethnic denomination, which seems to be related to the name of a river, is an autoethnonym). Thus the name Songhai (Songhay) may be pronounced differently in the vast area they occupy as Sonray or Songhoy (Rouch, 1954, p.3).

Xenoethnonyms and Derogatory Terms

Frequently many of the well-known ethnic names are not autoethnonyms, but xenoethnonyms or heteroethnonyms—that is, terms of reference employed by other ethnic groups, friendly or hostile, who may be closely interacting neighbors or geographically more remote populations. Reading some of the best anthropological and linguistic monographs and comparative studies, or the ethnographic surveys published by the International African Institute, one is struck by the number of classical, commonly mentioned, ethnic denominations that are of "foreign" origin. It is probably not possible, at least at this stage, to eliminate these terms from our studies, because they are so well known and so deeply entrenched in our vocabularies. The real problem, however, is that a significant number of such names seem to have pejorative implications (some milder than others), referring to what "the others" may consider to be physical, behavioral, historical, or cultural traits they do not like or consider to be signs of backwardness and ignorance. Some of these terms are not simply nicknames, but outright insults. The name Songomeno (Songomino, Basongomino), literally, "those who file teeth," for example, already mentioned in 1887 by Wolf and in 1890 by von Wissmann, refers to a portion of the Nkutshu (a Tetela-related group of Zaire) because of their practice of filing teeth, a method apparently disliked by neighboring groups. The Bacwa Pygmies in the rainforest among the Nyanga of East Zaire call populations around them Barimi, or "Ignorant-Ones."

This sense of superiority or drastic difference is obviously expressed not merely in the ethnonyms, but also in numerous other formulas. In his remark-

able *Memoirs, Oui Mon Commandant!* (1994, p. 85), the African scholar-author Hampate Ba notes that for the Mossi a Fulani person (Peul, as he calls them) is not a human but "a red monkey of the yellow savanna," while the Fulani speak about the Mossi as "scar-faced apes, unclean and smelling of alcohol" (terminologies that are often nothing more than expressions of amicable, reciprocal joking relationships among individuals).

These xenoethnonyms seem to have originated under various circumstances and in different situations, and their precise original meaning is not always clear. The term Bambara, until recently preferred over the current Bamana to refer to one of the major art-producing populations of Mali, is a case in point. In 1923, Delafosse made a distinction between the denominations Bambara (which he said was used by West African populations adhering to Islam to refer to non-Islamic populations as the infidels) and Banmana (a term already available in written sources of 1887 by which the people called themselves—a term meaning for some "People of the Crocodile" and for others "Those Rejecting the Master"). The Europeans followed the terminological claims of the Islamicized groups in contact with the Banmana. There was also a third term, Bamana, meaning for some writers "Precipitous Rock" (Paques, 1954, pp. 1–2). The problem seems to be that the Bamana themselves do not frequently use these terms, preferring to identify different sections of the population on the basis of geographical location (e.g., those of Kaarta, those of Segu) or by means of certain nicknames (e.g., the people of Kaarta like to call those of Segu "Tukeleu, Those of the Single Tress").

Xenoethnonyms were obviously in existence before Islamic and European interventions in Africa. Their frequency was the result of contacts between peoples, common migration, scission, neighborliness or hostility, and conquest. But it is also certain that the new concepts, organizations, and administrations that the colonial forces introduced, often arbitrarily without regard for the genuinely traditional structures, had a great influence on the invention and proliferation of heteroethnonyms. Some countries and peoples were subject in the course of time to different Western forms of control, e.g., French, British, or Belgian systems replacing German ones after W W I in parts of West and East Africa, and this also contributed to the development of more heteroethnonyms.

The literature abounds with examples of how some of the so-called ethnic names originated or spread in the early beginnings of colonialism. The term Frafra applied to a people in northern Ghana is a British invention derived from a prevailing form of greeting—fara fara—that is an expression of sympathy in certain circumstances (Smith, 1978, p. 36). Although some segments of the population in the region of Bogatang came to accept the term Frafra, the Frafra call themselves Gurensi and to the outside scholarly world these people are also known as Nankanse. This name was applied to them by Rattray (1932, p. 132) after the terminology used by their northern neighbors, the Kassena.

Western influences and interventions in ethnic affairs have often led to the

emergence and eventually to the reluctant acceptance of a common ethnic name by people who traditionally were not known by such a common name. In Nigeria the term Mbembe is given to several groups who speak related dialects, but had no common name. African traders in the nineteenth century were struck by the frequent use of the term "mbe" (I say) to begin a sentence, and began to apply the "onomatopoetic" term Mbe-mbe to a group of peoples in the middle Cross River area of Nigeria, who spoke related dialects. Disliked at first, the term Mbembe was later accepted as an expression of unity (Wente-Lukas, pp. 262–263).

According to Forde and Jones (1950, p. 9) the Igbo (Ibo) of Nigeria did not use this common name before the advent of the Europeans. The precise meaning of the term is unclear. Various sources furnish such contradictory interpretations as "the people," "forest-dwellers," or "slaves." The term was applied, however, by the Oru or River Igbo to the hinterland dwelling speakers of similar dialects. The Europeans started using the term Heebo or Ibo early in the slave-trade period to refer to anyone of the Ibo-speaking groups, even to the Ibibio. Later the Ibo themselves started using the term to refer to the language and, when talking to Europeans, to refer to Ibo speakers other than themselves.

One of the most extreme examples is offered by the so-called ethnonym Bamileke, a term that refers to a large number of kingdoms in the southern Cameroun grasslands. The much used term originated with the German colonial administration in Cameroun. It is based on a modification of the expression "mbalekeo," which in Bali-Nyonga (one of the Cameroun languages) means "les gens d'en bas" (the people from down below). Traveling in the Bambuto mountain range, a German explorer had asked his Bali-Nyonga guide for the name of the people whose villages he could see below in the savanna, and received the name "mbalekeo" (the people who live down below), which later would become Bamileke and be expanded to include about one hundred political units (large and small kingdoms and chiefdoms) in the Grassland area (Notué, 1993, pp. 35–36).

Similar distinctions between populations living upstream or downstream, in the highlands or lowlands, have led to other ethnonyms. Some early sources referred to the Lega of Zaire as Malinga (those of the lowlands) and Ntata (those of the highlands), dynamic concepts that depend on the speaker's relative geographical position and mean very little in terms of ethnic and cultural classification. A similar distinction was applied to the Zimba of Zaire. There were Zimba wa Mulu (highlands, a relative term) culturally close to the Lega and nowadays called Binja (people of the forest), and Zimba wa Maringa (of the lowlands, a relative term) strongly influenced in the nineteenth century by the Arabicized intruders in eastern Zaire, who called themselves Basole (a term conveying the idea of superiority) and are nowadays referred to as Southern Binja (Van Riel and De Plaen, 1967).

The intensive research on Africa undertaken in recent decades has

improved the ethnonymic situation in that there is more systematization, consistency, and precision and less arbitrariness in the use of terms. However, much work still needs to be done about ethnic nomenclature, particularly in reference to the origin and meaning of terms and the systematization of correct, readable, and acceptable spellings. In the immense amount of descriptive, analytical and comparative studies available on African ethnic cultures, and more particularly on the arts of Africa, it is possible to find adequate solutions for the problems, provided a massive effort is made involving cooperation between various disciplines concerned. To achieve a real solution it is necessary not merely to produce new names and new transcriptions of ethnonyms; but to examine critically the heuristic value of numerous terms, and to clarify the scope of the cultural and artistic realities they cover.

GUIDE TO USE

African Ethnonyms is intended for those who create documentation, for those who do research, and for those who assist them. It is a reference tool for librarians, visual resources catalogers, museum scholars, and researchers in art history, anthropology, linguistics, and African studies.

Research and documentation of traditional African art begins with the accurate identification of the people responsible for its production. The primary access point is through the names not of individuals, but of ethnic groups. One common difficulty in researching ethnic names is the lack of agreement in published sources. A single name can have many variations in spelling, which typically occur when the name has been transcribed from one language to another. In addition, a single ethnic unit may be known by several quite different names, or conversely, several ethnic groups may be known by a single collective term.

Name Identification

The primary purpose of this index is to make name identification easier by clustering all the variant names under a single entry-form name. All names in the cluster are also listed alphabetically in the index and are cross-referenced to the entry-form name. As an aid to identification, the cluster includes the name of the country or countries where the people are located, the language affiliation, the preferred name used in the *Library of Congress Subject Headings* [on-line database, June 1996] and the *Art and Architecture Thesaurus* [version 2.1, 1996], and a coded list of sources to consult for additional information. Many entries have explanatory notes to clarify complex relationships, collective terms, *see also* references, or other information that might help in name identification.

Stylistic Identification

The index may also be used in stylistic or object identification by selective use of the sources cited at the end of each entry. Two types of sources are recommended: catalogues of exhibitions or collections, and monographs or other studies designated as key sources. Asterisks identify key sources, which appear at the end of the coded citations. Entries for peoples with a rich tradition of art production contain numerous art sources and generally include a citation to at least one of the following recent exhibition or collection catalogues: *Africa: The Art of a Continent* [TP]; *Treasures from the African-Museum Tervuren* [TERV]; *Face of the Spirits: Masks from the Zaire Basin* [FHCP]; *African Art from the Barbier-Mueller Collection* [WS]; *African Masterpieces and Selected Works from Munich: The Staatliches Museum für Völkerkunde* [MK]; *African Masterpieces from the Musée de l'Homme* [SVFN]; and *Kings of Africa: Art and Authority in Central Africa Collection Museum für Völkerkunde, Berlin* [EBHK]. Recent general surveys such as *The Dictionary of Art* [DOA] are also helpful for stylistic identification.

Source Identification

Another use of the index is as a bibliographic guide to further study on a particular people. Each entry contains a list of coded sources that provide literary warrent for the name cluster. The sources cover a wide range of disciplines including art, anthropology, and linguistics, and many entries cite key sources by recognized scholars, sources that can lead to specialized studies in art and anthropology, and sources that often provide rich bibliographies for concentrated research on a single people.

Scope and Methodology

African Ethnonyms contains over 4,500 names representing over 2,000 peoples. Geographical emphasis is on sub-Saharan Africa with the concept of art interpreted broadly to include ornamental design, architecture, textiles, body adornment, and material culture, in addition to the more traditional arts of masks and sculpture. The index focuses on classical or traditional African art as the product of a people or ethnic unit and does not list the names of contemporary artists. While the primary emphasis is on the names of ethnic units, the index also includes names of kingdoms and empires, and occasionally the names of styles and early or ancient cultures. A secondary index of toponyms includes some of the better known prehistoric and ancient site names, especially those associated with art production.

The list of ethnonyms and toponyms was compiled using hundreds of sources cited in the bibliography, including major ethnographic, linguistic, and art historical surveys as well as specialized sources with emphasis on particu-

lar time periods, media, geographic regions, and individual peoples. Emphasis was placed on titles generally available in most academic and special libraries. Numerous foreign-language titles are used, but preference was given to English-language titles whenever possible. Every effort was made to include recognized authorities, particularly in the fields of art history and anthropology. Whenever possible, more recent publications, including on-line resources such as the *Ethnologue Database,* were consulted, but older publications considered classic studies, especially in the field of anthropology, are also cited. Publication dates generally range from the 1950s to 1996. Articles were not included but may be discovered by consulting the bibliographies of many of the sources cited.

A selection of 65 art sources was chosen for extensive indexing to aid in stylistic identification. These sources are identified by the symbol ‡ preceding the source code in the list of abbreviations. Criteria for selection included highly illustrated sources, major exhibition and collection catalogues, comprehensive general surveys, and sources with special focus on a particular time period, media, or region. A few specialized bibliographies are also included in this list. For many entries, key sources representing major studies by recognized scholars in art history and anthropology are also included.

The list of names is not intended to be exhaustive. We view the index as a work in progress. We could easily have spent another year adding names, eliminating less relevant source codes, and refining many of the notes. Although we have made every effort to verify names, we recognize the possibility of mistaken attributions, particularly where there may be different people with the same name who reside in the same country. In such cases, the sources are not always sufficiently explicit to indicate with certainty the identity of the people. We trust that the usefulness of the index will more than make up for the flaws that may remain.

Content and Format

The index is arranged alphabetically in dictionary format. All names appear in boldface, flush with the left-hand margin of each column, as either entry form names (in upper case) or variant names (in lower case). Entry-form names contain the cluster of variant names as well as additional data pertaining to the cluster. Variant names are listed alphabetically in the index with a *see* reference to the entry form name.

The device of clustering names under an entry-form name as opposed to indicating a preferred term is modeled on that used in the *Union List of Artist Names,* a name-authority tool produced by the Getty Art History Information Program and generally familiar to those in the United States who document art and architecture. Clustering not only avoids duplication of information since all pertinent information belonging to the cluster as a whole can be recorded in one place, but also places all variant names together, facilitating immediate comparison.

The entry-form name contains some fields that are always present and some that occur only when the information is available. Descriptive data that is always present includes the country or countries where the people are located, AAT- and LCSH-preferred terms for the entry-form name, and a coded list of sources for further research. Language family affiliation is included in most cases. Additional elements of information that are listed when applicable are variant names, subcategories, notes, and *see also* references.

Structure of Main Entry

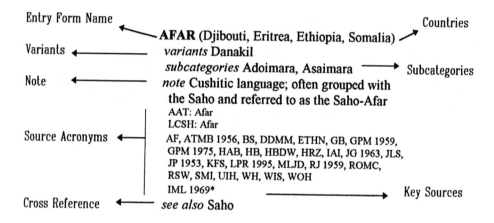

Entry-Form Names
Entry-form names appear in boldface, uppercase letters, flush with the left-hand margin of each column. The choice of name is sometimes based on that which seems to be currently preferred rather than that which may be a more conventional term frequently cited in older literature. Consideration is also given to preference as cited in the *Library of Congress Subject Headings* and the *Art and Architecture Thesaurus*. The entry form name is followed by an alphabetical list of country names enclosed in parentheses.

Variant Names
Variant names appear indented two spaces to the right, directly beneath the entry form name. Labeled *variants*, they appear in unbolded typeface and are listed alphabetically. They include all variant name forms for that entry cross-referenced in the index. The list is not intended to be all-inclusive. For other possible name variations based on typical prefixes or interchangeable letters that produce similar sounds, see the section "Language Notes."

Subcategories

Subcategories appear indented two spaces to the right and follow variant names. Labeled *subcategories*, they appear in unbolded typeface and are listed alphabetically. Subcategory names are reserved for narrower terms and may include subgroups, clans, chiefdoms, or other subdivisions. All subcategory names are cross-listed in the index as entry-form names. Where narrow terms require qualification, they are described within the notes section instead.

Notes

Indented two spaces to the right and labeled "notes," this information contains the language cluster as identified in the "Language Notes" section and may also include broader term information, explanations of *see also* cross-references, and miscellaneous data. When the entry-form name is a subgroup of a larger group, the broader term is listed here. Ambiguous or complex relationships and collective terms are also described in this section.

AAT- and LCSH-Preferred Terms

Indented four spaces to the left in unbolded upper-case typeface appear two-, three-, or four-letter acronyms for the sources from which data were gathered. The *Art and Architecture Thesaurus* and the *Library of Congress Subject Headings* are listed first with their preferred terms. In AAT and LCSH citations, the following cases may occur: the preferred term and the entry-form name match, e.g., *entry-form name*: AMHARA, *AAT-preferred term*: AMHARA; the entry-form name is listed, but the preferred term differs, e.g., *entry-form name*: ADJUKRU, *LCSH-preferred term*: use Adyukru; the entry form name is not listed, but the preferred term is used for one of the variants, e.g., *entry-form name*: ADJUKRU, *AAT-preferred term*: nl (uses Ajukru); no listing is given for either the entry form name or the variant names, e.g. *entry-form name*: ABRI, *AAT-preferred term*: nl. When LCSH lists only the name as a language name rather than the name of a people, this is indicated by the use of the word "language" following the name.

Source Codes

Following the AAT- and LCSH-preferred terms and listed alphabetically are additional source acronyms from which data was taken for the main entry and its variants. Source codes are composed of initials for the author, editor, or sponsoring agency, and are followed by dates when more than one source by an author is used. Key sources are listed last, followed by an asterisk. A source code table with codes (see "List of Abbreviations" section) precedes the bibliography.

Cross-References

Indented two spaces to the right, labeled *see also*, this section lists all other entries that might be useful for further information and identification and that

do not belong in any other field. All names listed here are entry-form names whose relationship to the referent is explained or specified in the notes field. Names listed here are often broader terms or collective terms.

Secondary Indices

African Ethnonyms includes two secondary indices: a toponyms index and a country index. The toponyms index lists important place names that often occur in the study of African art such as archeological sites, geographical place names linked with a style or people, or names of sites relevant to ancient kingdoms and dynasties. The country index lists ethnic units by country.

Orthography, Diacritics, Alphabetical Sequence

Spelling for the entry-form name and its variants reflects the variations in spelling found in the sources cited. Not every possible variation on the name is included. The "Language Notes" section can provide assistance in determining additional spelling variations. Diacritics, which are used sparingly, are restricted to those names where there is a strong tradition for their inclusion such as in Yakö, Añaki, or !Kung. In keeping with standard alphabetizing practices, diacritical marks, hyphens, and apostrophes are ignored. Because of the nature of the material, the word-by-word system of alphaetizing has been used.

Ababda *see* ABABDAH
ABABDAH (Sudan)
 variants Ababda, Ababde
 note Cushitic language; one of the
 groups included in the collective
 term Beja
 AAT: nl
 LCSH: nl
 ATMB 1956, BS, CSBS, GAC, GPM 1959,
 GPM 1975, HAB, HB, HBDW, RJ 1959,
 UIH, WH
 MLV*
 see also Beja
Ababde *see* ABABDAH
Ababua *see* BWA (Zaire)
ABAJA (Nigeria)
 note Kwa language; subcategory of
 Igbo; one of the groups referred to
 as Eastern Igbo
 AAT: nl
 LCSH: nl
 CFGJ, UIH, VCU 1965
 see also Igbo
ABAKWARIGA (Nigeria)
 note Chadic language; subcategory
 of Hausa
 AAT: nl
 LCSH: nl
 ETHN, HB, JLS, JPJM, SV
 see also Hausa
Abaluyia *see* LUYIA
ABAM (Nigeria)
 variants Ohaffia, Ohafya
 note Kwa language; subcategory of
 Igbo; one of the groups referred to
 as Eastern Igbo
 AAT: nl
 LCSH: nl
 DWMB, GIJ, RWL, SV 1986
 CFGJ*
 see also Igbo
ABANDIA (Zaire)
 variants Abandja
 note one of the dynastic groups
 linked in the literature with the
 Zande
 AAT: nl
 LCSH: nl

ESCK, GAH 1950, HBU, JMOB
EEP*
 see also Zande
Abandja *see* ABANDIA
Abangba *see* BANGBA
ABANLIKU (Nigeria)
 note Benue-Congo language;
 subcategory of Hausa
 AAT: nl
 LCSH: nl
 ETHN, GIJ
 see also Hausa
Abanyala *see* LUYIA
Abarambo *see* AGBARAMBO
ABBALA (Sudan)
 subcategories Hamar, Kababish,
 Shukria
 note Semitic language; nomadic
 Arabs of the Sudan region; one of
 the groups included in the
 collective term Sudan Arabs
 AAT: nl
 LCSH: nl
 DDMM, HBDW, WH
 see also Sudan Arabs
Abbe *see* ABE
Abbey *see* ABE
ABE (Côte d'Ivoire)
 variants Abbe, Abbey
 note Kwa language; one of the
 groups included in the collective
 term Lagoon people
 AAT: nl
 LCSH: Abe language
 BS, DDMM, DWMB, EFLH, ENS, ETHN,
 GPM 1959, GPM 1975, HAB, HB, HBDW,
 JEEL, JG 1963, JP 1953, TFG, UIH, WH
 JPB*
 see also Lagoon people
Abelu *see* BEYRU
Abeokuta *see* Toponyms Index
Aberu *see* BEYRU

1

ABIDJI (Côte d'Ivoire)
variants Ari, Abiji
note Kwa language; one of the
groups included in the collective
term Lagoon people
AAT: nl
LCSH: Abidji
BS, DDMM, DWMB, ENS, ETHN, GPM
1959, GPM 1975, HB, HBDW, IAI, JEEL,
JG 1963, JP 1953, RGL, SMI, TFG, UIH,
WH
FL*, JPB*
see also Lagoon people

Abiji *see* ABIDJI

ABIRIBA (Nigeria)
note Kwa language; subcategory of
Igbo
AAT: nl
LCSH: nl
CFGJ, GIJ, HCCA
see also Igbo

Abka *see* Toponyms Index

ABO (Cameroun)
variants Bankon
note Bantu language
AAT: nl
LCSH: nl
CK, DDMM, ETHN, GPM 1959, GPM
1975, HB, HBDW, MGU 1967, MK, PH,
RJ 1958, SV, UIH
MMML*

Abo *see* ABONG

Abõ *see* ABONG

ABOH (Nigeria)
variants Eboh
note Kwa language; subcategory of
Igbo
AAT: nl
LCSH: nl
BS, DDMM, ETHN, PH, RWL, SMI
VCU 1965*
see also Igbo

Abomey *see* Toponyms Index

Abõn *see* ABONG

ABONG (Cameroun, Nigeria)
variants Abo, Abõ, Abõn

note Bantu related language; one of
the groups included in the
collective term Tigong
AAT: nl
LCSH: nl
DDMM, ETHN, GPM 1959, LP 1990, MK,
RWL
see also Tigong

ABONGO (Gabon)
variants Bongo
note one of the groups included in
the collective term Pygmies
AAT: nl
LCSH: nl
BES, HBDW
see also Pygmies

Aboure *see* ABURE

ABRI (Côte d'Ivoire)
variants Abriwi
note Kwa language
AAT: nl
LCSH: nl
DDMM, DWMB, GSGH, HAB, HB, PR,
UIH, WOH

Abriwi *see* ABRI

ABRON (Côte d'Ivoire, Ghana)
variants Bono, Bron, Brong
note Kwa language; known as
Brong in Ghana; one of the
groups included in the collective
term Akan
AAT: use Brong
LCSH: Abron
AF, BDG 1980, BS, DDMM, DFHC,
DWMB, EB, EEWK, EFLH, ELZ, ETHN,
ENS, GBJS, GPM 1959, GPM 1975, HAB,
HB, HBDW, HCDR, IAI, JEEL, JK, JKS,
JLS, JP 1953, JPB, JV 1984, KFS, KFS
1989, LM, LPR 1986, MLB, MM 1950,
NIB, RAB, RGL, RJ 1958, ROMC, RSW,
SMI, TFG, UIH, WG 1984, WH, WMR,
WRB, WS
DMW*
see also Akan

ABUA (Nigeria)
 variants Abuan, Abura
 note Benue-Congo language
 AAT: Abua
 LCSH: Abua language
 DDMM, EEWF, ELZ, ETHN, GIJ, GPM
 1959, HB, JD, JG 1963, JLS, MKW 1978,
 MM 1950, ROMC, RWL, TP, WRB,
 WRNN
Abuan *see* ABUA
Abukaya *see* AVOKAYA
Abulu *see* BEYRU
Abura *see* ABUA
ABURE (Côte d'Ivoire)
 variants Aboure, Akaples
 note Kwa language; one of the
 groups included in the collective
 terms Akan and Lagoon people
 AAT: nl
 LCSH: Abure language
 BS, DDMM, DWMB, ENS, ETHN, GPM
 1959, GPM 1975, HAB, HB, IAI, JEEL, JG
 1963, JLS, MLJD, RJ 1958, TFG, UIH,
 WH
 JPB*
 see also Akan, Lagoon people
Abyssinia *see* Toponyms Index
Acacus *see* Toponyms Index
Accra *see* Toponyms Index
ACHALLA (Nigeria)
 note Kwa language; subcategory of
 Igbo
 AAT: nl
 LCSH: nl
 CFGJ, GIJ
 see also Igbo
Achanti *see* ASANTE
ACHI (Nigeria)
 note Kwa language; subcategory of
 Igbo
 AAT: Achi
 LCSH: nl
 CFGJ, JK, WRB
 see also Igbo
Achira *see* SHIRA
Acholi *see* ACOLI

ACOLI (Sudan, Uganda)
 variants Acholi, Acooli
 note West Nilotic language; one of
 the groups included in the
 collective term Nilotic people;
 sometimes referred to as Southern
 Lwoo. The transcription Acoli
 seems currently preferred to the
 more conventional Acholi.
 AAT: nl (uses Acholi)
 LCSH: Acoli
 ATMB, ATMB 1956, BES, BS, CSBS,
 DDMM, DPB 1987, ECB, ELZ, ETHN,
 EWA, GB, GPM 1959, GPM 1975, HAB,
 HB, HBDW, IAI, JG 1963, JLS, JM, MCA
 1986, MTKW, RGL, RJ 1960, ROMC, RS
 1980, RSW, SD, SMI, TP, UIH, WH, WS
 AJB*
 see also Lwoo, Nilotic people
Acooli *see* ACOLI
ADA (Nigeria)
 variants Edda, Kuturmi
 subcategories Afikpo
 note Kwa language; subcategory of
 Igbo; one of the groups referred to
 as Eastern or Cross River Igbo
 AAT: nl
 LCSH: nl
 DDMM, DWMB, ETHN, GIJ, GPM 1959,
 GPM 1975, HB, MM 1950, NOI, RWL,
 UIH, WFJP
 CFGJ*
 see also Igbo
ADA (Ghana)
 note Kwa language
 AAT: nl
 LCSH: nl
 DWMB, HCDR, MM 1950
Adamaoua *see* ADAMAWA

ADAMAWA (Cameroun, Nigeria)
variants Adamaoua
note a term often used in linguistic
classifications, i.e. Adamawa-
Eastern languages; a geographic
region in Cameroun and Nigeria
populated by many Kirdi people;
also a term used to designate the
Fulani of that region
AAT: <Adamawa-Eastern Branch>
LCSH: Adamawa language; Adamawa
 Fulani; Adamawa Fula use Fula
BS, DDMM, ELZ, ESCK, ETHN, GPM
 1959, HBDW, HRZ, JG 1963, JJM 1972,
 JL, JLS, LP 1993, LPR 1986, MCA, PH,
 RGL, ROMC, RWL, SMI, WEW 1973,
 WG 1984, WOH
see also Fulani, Kirdi, Toponyms
 Index
Adangbe *see* ADANGME
ADANGME (Ghana, Togo)
variants Adangbe, Dangme
subcategories Krobo
note Kwa language; often linked in
the literature to the Ga people and
referred to as Ga-Adangme
AAT: Adangme
LCSH: Adangme
DDMM, DWMB, ETHN, GPM 1959, GPM
 1975, HBDW, HCDR, IAI, JG 1963, JLS,
 JPB, RGL, RJ 1958, ROMC, RS 1980,
 SMI, UIH, WH, WRB
 MM 1950*
see also Ga, Ga-Adangme
ADANSE (Ghana)
variants Adansi
note part of the Asante confederacy;
one of the groups included in the
collective term Akan
AAT: nl
LCSH: nl
BDG 1980, HB, JL, MM 1950, TFG, UIH,
 WG 1984
see also Akan, Asante
Adansi *see* ADANSE
Adara *see* KADARA

ADARAWA (Niger)
note subcategory of Hausa;
inhabitants of the old kingdom of
Adar
AAT: Adarawa
LCSH: nl
GPM 1959, HB, RWL, WH
see also Hausa
Adavida *see* TEITA
Adele *see* ADELI
ADELI (Ghana, Togo)
variants Adele, Bedere
note Kwa language
AAT: nl
LCSH: nl
DDMM, ETHN, GPM 1959, HB, JG 1963,
 JLS, KK 1965, RJ 1958, WH
Adio *see* DIO
Adio Azande *see* DIO
Adioukrou *see* ADJUKRU
Adiukru *see* ADJUKRU
ADIZI (Côte d'Ivoire)
note a pre-colonial and pre-Lagoon
people
AAT: nl
LCSH: nl
JPB
Adja *see* AJA
ADJUKRU (Côte d'Ivoire)
variants Adioukrou, Adiukru,
Adyukru, Ajukru
note Kwa language; one of the
groups included in the collective
term Lagoon people
AAT: nl (uses Ajukru)
LCSH: use Adyukru
BS, DDMM, DWMB, ENS, ETHN, GPM
 1959, HAB, HB, IAI, JEEL, JG 1963, JK,
 JP 1953, MPF 1992, RJ 1958, TFG, WH,
 WRB
JPB*
see also Lagoon people

ADJUMBA (Gabon)
 note Bantu language; one of the
 groups included in the collective
 term Myene
 AAT: nl
 LCSH: nl
 ETHN, GPM 1959, HB, LP 1985
 see also Myene
ADOIMARA (Djibouti, Eritrea,
 Ethiopia, Somalia)
 note Cushitic language; subcategory
 of Afar
 AAT: nl
 LCSH: nl
 HB, IML 1969
 see also Afar
Adouma *see* DUMA
ADRAR (Mali)
 variants Ifoghas, Kel Adrar
 note Berber language; division of
 Tuareg
 AAT: nl
 LCSH: nl
 EDB, EBJN
 see also Tuareg, Toponyms Index
Adrar Bous *see* Toponyms Index
Adrar des Iforas *see* Toponyms
 Index
Adulis *see* Toponyms Index
Aduma *see* DUMA
Adya *see* AJA
Adyukru *see* ADJUKRU
AFAR (Djibouti, Eritrea, Ethiopia,
 Somalia)
 variants Danakil
 subcategories Adoimara, Asaimara
 note Cushitic language; often
 grouped with the Saho and
 referred to as the Saho-Afar
 AAT: Afar
 LCSH: Afar
 AF, ATMB 1956, BS, DDMM, ETHN, GB,
 GPM 1959, GPM 1975, HAB, HB, HBDW,
 HRZ, IAI, JG 1963, JLS, JP 1953, KFS,
 LPR 1995, MLJD, RJ 1959, ROMC, RSW,
 SMI, UIH, WH, WIS, WOH
 IML 1969*

 see also Saho
AFEMA (Ghana)
 note Kwa language; one of the
 groups included in the collective
 term Akan
 AAT: nl
 LCSH: Afema dialect use Sanvi dialect
 DWMB, GPM 1959, GPM 1975, HBDW,
 MM 1950, UIH
 see also Akan
Afenmai *see* ETSAKO
AFIKPO (Nigeria)
 note Kwa language; subcategory of
 Ada Igbo; one of the groups
 referred to as Eastern Igbo. The
 Afikpo are divided into fifteen
 subcategories and spread over
 twenty-two villages.
 AAT: Afikpo
 LCSH: nl
 BS, CFL, CMK, DDMM, DFHC, ELZ,
 ETHN, FW, GPM 1975, HMC, JK, JLS,
 MLB, RSW, SMI, SV, WRB, WRB 1959
 SO, CFGJ
 see also Igbo
Afizere *see* JARAWA
AFO (Nigeria)
 variants Afu
 note Benue-Congo language
 AAT: Afo
 LCSH: nl
 DDMM, EBR, EEWF, ELZ, ETHN, FW,
 GIJ, GPM 1959, GPM 1975, HAB, HB,
 HBDW, IAI, JD, JG 1963, JK, KK 1965,
 LJPG, MKW 1978, MLB, NIB, NOI, RGL,
 RSRW, RSW, RWL, SV, TB, TP, UIH,
 WBF 1964, WFJP, WG 1980, WG 1984,
 WH, WRB, WRNN
 EE*
Afrique Equatoriale Française *see*
 Toponyms Index
Afrique Occidentale Française *see*
 Toponyms Index

AFRO-PORTUGUESE (West
 Africa)
 note Distinctive art forms and styles
 that are the product of
 acculturative movements in West
 Africa, including Bini-Portuguese
 in Nigeria, Sapi-Portuguese in
 Sierra Leone and Kongo-
 Portuguese in Angola and Zaire
 AAT: Afro-Portuguese
 LCSH: nl
 FW, JLS, JV 1984, MLB, MWM, RGL,
 SVFN, WG 1980, WG 1984
 *EBWF

Afu *see* AFO

Afusare *see* JARAWA

Agades *see* AGADEZ

AGADEZ (Algeria, Niger)
 variants Agades
 note Semitic language; name used
 to designate a division of Tuareg
 and a site in Niger
 AAT: nl
 LCSH: nl
 ETHN, JEC 1958, JEG 1958
 see also Tuareg, Toponyms Index

AGALA (Nigeria)
 note Kwa language; subcategory of
 Idoma
 AAT: nl
 LCSH: use Idoma
 GIJ, GPM 1959, RWL
 see also Idoma

AGATU (Nigeria)
 note Kwa language; name of a
 people and the district they
 inhabit
 AAT: nl
 LCSH: nl
 DDMM, DWMB, ETHN, GPM 1959, GPM
 1975, HB, JG 1963, NOI, RWL

Agau *see* AGAW

AGAW (Eritrea, Ethiopia, Somalia)
 variants Agau
 note Cushitic language
 AAT: nl
 LCSH: Agaw language use Agau language

ATMB, ATMB 1956, BS, DDMM, ERC,
ETHN, HB, IAI, JM, RJ 1959, UIH, WIS

AGBA (Côte d'Ivoire)
 note Kwa language; subcategory of
 Baule
 AAT: nl
 LCSH: nl
 JPB, SV
 see also Baule

AGBARAMBO (Zaire)
 variants Abarambo, Barambo,
 Barambu
 note Southern Ubangian language
 AAT: nl
 LCSH: nl (uses Barambu)
 ATMB 1956, BES, CDR 1985, CSBS, DB
 1978, DDMM, DPB 1987, ESCK, ETHN,
 GAH 1950, GPM 1959, GPM 1975, HAB,
 HB, HBDW, IAI, JG 1963, JMOB, NIB,
 OBZ, RS 1980, WH

Agbari *see* GBARI

Age *see* ESIMBI

AGHEM (Cameroun)
 note Bantoid language; an
 independent chiefdom and one of
 the five component migrant
 groups in Bamenda. Wum is
 sometimes used synonymously
 with Aghem to indicate an
 independent chiefdom.
 AAT: use Wum
 LCSH: nl
 DDMM, GPM 1959, GPM 1975, IEZ, PH
 *LP 1993, *PMK, *TN 1973
 see also Bamenda, Wum

Aghwi *see* BATIBO

Agni *see* ANYI

Agona *see* FANTI

AGOTIME (Benin, Ghana, Togo)
 note Kwa language; subcategory of
 Ewe
 AAT: nl
 LCSH: nl
 DDMM, ENS, HB
 see also Ewe

AGUA (Côte d'Ivoire)
variants Agwa, Ogua
subcategories Asebu
note Kwa language; closely linked
with the Baule and possibly a
subcategory; one of the groups
neighboring the Lagoon people
and sometimes included in the
collective term
AAT: nl
LCSH: nl
ENS, GPM 1959, JPB
see also Baule, Lagoon people

Agwa *see* AGUA

Agwaguna *see* AGWAGWUNE

AGWAGWUNE (Nigeria)
variants Agwaguna, Akunakuna,
Akurakura
note Benue-Congo language
AAT: nl
LCSH: nl
DDMM, ETHN, HB, JG 1963, RWL, UIH

AHAFO (Ghana)
note Kwa language; one of the
groups included in the collective
term Akan
AAT: nl
LCSH: nl
ETHN, HCDR, WRB 1959
see also Akan

AHAGGAR (Algeria)
variants Kel Ahaggar
note Berber language; place name
used for a division of Tuareg
AAT: nl
LCSH: Ahaggar Mountains
AF, EWA, GPM 1959, GPM 1975, HB,
KFS, LCB, PG 1990, SMI, WH
EBJN*, EDB*, HLH*
see also Tuareg, Toponyms Index

AHANTA (Ghana)
note Kwa language; one of the
groups included in the collective
term Akan
AAT: nl
LCSH: nl

DDMM, DWMB, ETHN, GPM 1959, GPM
1975, HAB, HB, HBDW, HCDR, HRZ,
IAI, MM 1950, RJ 1958, RSW, TFG, UIH
see also Akan

AHIZI (Côte d'Ivoire)
variants Aizi, Pepehiri
note Kwa language; one of the
groups included in the collective
term Lagoon people
AAT: nl
LCSH: Ahizi language
DDMM, ETHN, HB, TFG, UIH
JPB*
see also Lagoon people

AHORI (Nigeria)
variants Holli, Ohori
note Kwa language; subcategory of
Yoruba
AAT: nl
LCSH: nl
CDF, DDMM, HB, IAI, RJ 1958, RWL
see also Yoruba

Aiere *see* AKOKO

AIR (Niger)
variants Kel Air, Kel Ayr
note Berber language; division of
Tuareg; a mountainous region in
north central Niger, site of ancient
rock paintings, with a long history
as a major trading center and
sultanate
AAT: nl
LCSH: Air
AF, ARW, BS, ETHN, GPM 1959, GPM
1975, HB, JDC, JLS, LPR 1986, MLB,
UGH, WH
ANB*, EBJN*, EDB*, HLH*
see also Tuareg

AIT ATTA (Morocco)
variants Ait Attab, Ayt Atta
note Berber language; one of the
groups included in the collective
term Berber
AAT: nl
LCSH: Ait Atta
AF, BS, GPM 1959, GPM 1975, HAB, JP
1953, JPJM
see also Berber

Ait Attab *see* AIT ATTA

AIT BA AMRAN (Morocco)

note Berber language; one of the groups included in the collective term Berber

AAT: nl

LCSH: nl

DBNV, GPM 1959, HAB, IAI

see also Berber

Ait Jussi *see* AIT YOUSSI

AIT OUGERSIF (Morocco)

note Berber language; one of the groups included in the collective term Berber

AAT: nl

LCSH: nl

ANB

see also Berber

AIT SEGHROUCHEN (Morocco)

variants Serruchen

note one of the groups included in the collective term Berber

AAT: nl

LCSH: nl

DBNV, GPM 1959, GPM 1975

see also Berber

AIT YOUSSI (Morocco)

variants Ait Jussi

note one of the groups included in the collective term Berber

AAT: nl

LCSH: nl

DBNV, GPM 1959, GPM 1975, HAB

see also Berber

AITU (Côte d'Ivoire)

variants Atutu

note Kwa language; subcategory of Baule

AAT: nl

LCSH: nl

FW, JPB, MK, MLJD, RJ 1958

see also Baule

Aizi *see* AHIZI

AIZO (Benin)

variants Ayizo, Whydah

note Kwa language

AAT: Aizo

LCSH: nl

BS, DDMM, ETHN, GPM 1959, GPM 1975, HB, RJ 1958, WG 1984

AJA (Benin, Côte d'Ivoire, Nigeria, Togo)

variants Adja, Adya

note Kwa language; an Ewe subcategory; also a collective term used for Ewe-speaking peoples

AAT: use Adja

LCSH: Aja

BS, DDMM, DWMB, ETHN, GPM 1959, HB, IAI, MM 1952, RJ 1958, RJ 1959, UIH, WG 1984

see also Ewe

AJJER (Algeria, Libya, Niger)

variants Kel Ajjer

note Berber language; division of Tuareg

AAT: nl

LCSH: Ajjer

ETHN, GPM 1959, GPM 1975, HB, HRZ, WH

EBJN*, EDB*, HLH*

see also Tuareg

Ajukru *see* ADJUKRU

AKA (Central African Republic, Congo Republic, Zaire)

variants Akka, Asua

note Central Sudanic language; one of the groups included in the collective terms Mangbetu and Pygmies

AAT: nl

LCSH: Aka

AF, ATMB, ATMB 1956, BS, DDMM, DPB 1987, ETHN, GB, GPM 1959, HAB, HB, HBDW, JEL, JG 1963, JLS, JMOB, JV 1984, NB, OBZ, SMI, UIH, WH

PAS*, RPT*, SB*, SB 1985*

see also Mangbetu, Pygmies

AKAAWAND (Zaire)

note a name used in 19th-century sources for the Ket, Mbala, Ruund, Salampasu, and others.

AAT: nl

LCSH: nl

DPB 1987

AKAJU (Nigeria)
variants Ekajuk, Akajuk
note Bantu language
AAT: nl
LCSH: nl
DDMM, ETHN, GIJ, GPM 1959, GPM 1975, HCCA, RJ 1958, RWL, SV

Akajuk *see* AKAJU

Akamba *see* KAMBA (Kenya)

AKAN (Côte d'Ivoire, Ghana, Togo)
note a collective term for a linguistic division which includes Abron, Abure, Adanse, Afema, Ahafo, Ahanta, Akwamu, Akwapim, Akye, Akyem, Anyi, Aowin, Asante, Assini, Baule, Diabe, Fanti, Gan, Gonja, Kwahu, Metyibo, Nzima, Twi and Wasa
AAT: Akan
LCSH: Akan; Akan language
ACN, AF, ASH, AW, BS, CDR 1985, DDMM, DF, DFHC, DOA, DPB 1987, DWMB, EBR, ELZ, ENS, ETHN, FW, GAC, GBJS, GNB, GPM 1959, HAB, HB, HBDW, HCDR, HRZ, IAI, JEEL, JG 1963, JJM 1972, JK, JL, JLS, JM, JPB, JV 1984, KFS, KFS 1989, LJPG, LM, LP 1993, LPR 1986, LSD, MHN, MLB, MM 1950, MUD 1991, PG 1990, PMPO, RAB, RGL, RJ 1958, ROMC, SMI, SV, SV 1986, SVFN, UIH, WEW 1973, WG 1980, WG 1984, WH, WLA, WOH, WRB, WRB 1959, WRNN, WS
BDG 1980*, DHR 1983*, KEG*, MM 1950*, TFG*

Akaples *see* ABURE

Akare *see* KARE (C.A.R., Sudan, Zaire)

Akasele *see* KASELE

Ake *see* AKYE

Akebu *see* KEBU

Akela *see* KELA

Akele *see* KELE (Gabon)

Akikuyu *see* GIKUYU

Akim *see* AKYEM

Akites *see* Toponyms Index

Akjoujt *see* Toponyms Index

Akka *see* AKA

Akoa *see* AKUA

Akoiyang *see* OKOYONG

AKOKO (Nigeria)
variants Aiere, Akoko-Edo, Eire
note Kwa language; subcategory of Yoruba sometimes referred to as Northern or North West Edo; one of the groups included in the collective term Kukuruku
AAT: nl
LCSH: Akoko
DDMM, DWMB, ETHN, GPM 1959, HJD, JPJM, KK 1960, KK 1965, NIB, NOI, RWL
see also Kukuruku, Yoruba

Akoko-Edo *see* AKOKO

Akokulemu *see* KUMAM

Akota *see* KOTA

Akowa *see* AKUA

Akparabong *see* BALEB

Akposso *see* KPOSSO

AKSUM (Ethiopia)
variants Axum
note ancient Ethiopian city and kingdom flourishing from the first millenium BCE to about 800 CE
AAT: Axum
LCSH: nl
AF, ARW, BD, CMK, GBJM, GG, HB, JDC, JLS, MYH, PG 1990, PR, TP, UGH

AKUA (Gabon)
variants Akoa, Akowa, Babongo
note one of the groups included in the collective term Pygmies
AAT: nl
LCSH: nl
GPM 1959, HB, JMOB, JPB, KK 1965, LP 1985, PH, WBF 1964, WH, WS
SB 1985*
see also Pygmies

Akuapem *see* AKWAPIM

Akue *see* AKWE

Akunakuna *see* AGWAGWUNE

Akurakura *see* AGWAGWUNE

Akure *see* Toponyms Index

AKWA (Congo Republic)
note Bantu language
AAT: nl
LCSH: nl
DDMM, ETHN, HB, MGU 1967, UIH

AKWAMU (Ghana)
note Kwa language; one of the groups included in the collective term Akan; a powerful state expanding in the 17th-18th centuries
AAT: Akwamu
LCSH: nl
BDG 1980, DDMM, DWMB, HB, HCDR, IAI, IAS, JPB, MM 1950, TFG, UIH, WG 1984
see also Akan

Akwapem *see* AKWAPIM

AKWAPIM (Ghana)
variants Akuapem, Akwapem
note Kwa language; one of the groups included in the collective term Akan
AAT: Akwapim
LCSH: Akwapim language use Twi language
DDMM, DWMB, ETHN, GPM 1959, GPM 1975, HAB, HB, HBDW, HCDR, IAI, JLS, MM 1950, MWM, SMI, TFG, UIH
DVB*
see also Akan

AKWE (Côte d'Ivoire)
variants Akue
note Kwa language; subcategory of Baule
AAT: nl
LCSH: nl
SV, JPB
see also Baule

AKWEYA (Nigeria)
note Kwa language
AAT: nl
LCSH: nl
DDMM, ETHN, GPM 1959, HB, RWL, WMR, WRNN, WS

AKYE (Côte d'Ivoire)
variants Ake, Atie, Attie, Atye

note Kwa language; one of the groups included in the collective terms Akan and Lagoon people
AAT: use Attie
LCSH: use Attie
BS, DDMM, DOA, DWMB, ENS, ETHN, GBJS, GPM 1959, GPM 1975, HAB, HB, HBDW, IAI, JEEL, JG 1963, JK, JLS, JP 1953, JTSV, MLB, RGL, RJ 1958, RSW, RWL, SMI, SV, SV 1988, TFG, TP, UIH, WG 1980, WG 1984, WH, WRB, WRNN, WS
JPB*
see also Akan, Lagoon people

AKYEM (Ghana)
variants Akim
note Kwa language; one of the groups included in the collective term Akan
AAT: Akyem
LCSH: nl
DDMM, DWMB, ETHN, GPM 1959, GPM 1975, HB, HCDR, MHN, MM 1950, RJ 1958, ROMC, TFG, WH
see also Akan

Aladian *see* ALADYAN

ALADYAN (Côte d'Ivoire)
variants Aladian, Alagya, Alladian, Alladya, Jack Jack
note Kwa language; one of the groups included in the collective term Lagoon people
AAT: nl (uses Alagya)
LCSH: Aladyan language; (uses Alagya people)
BS, DDMM, DWMB, ELZ, ENS, ETHN, GPM 1959, GPM 1975, HB, HBDW, IAI, JEEL, JG 1963, JP 1953, RJ 1958, TFG, UIH, WH, WRB
JPB*
see also Lagoon people

Alago *see* ARAGO

Alagwa *see* ALAWA

Alagya *see* ALADYAN

Alangoa *see* ALANGWA

Alangoua *see* ALANGWA

Alangua *see* ALANGWA

Alanguira *see* DENKYIRA

ALANGWA (Côte d'Ivoire)
variants Alangoa, Alangoua,
Alangua
note Kwa language; subcategory of
Anyi
AAT: nl
LCSH: nl
CK, ELZ, JPB, WG 1980, WMR
see also Anyi

ALAWA (Tanzania)
variants Alagwa
note Southern Cushitic language;
closely related to or a subcategory
of Iraqw
AAT: nl
LCSH: nl
DDMM, ETHN, GPM 1959, GPM 1975,
GWH 1969, HB, JG 1963, RJ 1960, SD,
UIH, WH
see also Iraqw

ALAWITI (Libya)
note one of the groups included in
the collective term Bedouin
AAT: nl
LCSH: nl
EEP 1949
see also Bedouin

ALAYI (Nigeria)
note Kwa language; subcategory of
Igbo
AAT: nl
LCSH: nl
CFGJ, GIJ

see also Igbo

Albert, Lake *see* Toponyms Index

ALI (Central African Republic)
note Western Ubangian language
AAT: nl
LCSH: nl
DB 1978, DDMM, ETHN, GPM 1959,
GPM 1975, HB, UIH

Alima River *see* Toponyms Index

Allada *see* Toponyms Index

Alladian *see* ALADYAN

Alladya *see* ALADYAN

Alolo *see* LOMWE

Aluena *see* LWENA

Alunda *see* LUNDA

ALUR (Uganda, Zaire)
variants Aluur, Jo Nam, Jonam
note West Nilotic language; one of
the groups included in the
collective term Nilotic people;
sometimes referred to as Southern
Lwoo
AAT: nl
LCSH: Alur
ATMB, ATMB 1956, BES, BS, CSBS,
DDMM, DPB 1987, ECB, ETHN, GAH
1950, GPM 1959, GPM 1975, HAB, HB,
IAI, JG 1963, JMOB, MTKW, OBZ, RJ
1960, RS 1980, SMI, UIH, WH
AJB*, AWS*
see also Lwoo, Nilotic people

Aluund *see* LUNDA

Aluur *see* ALUR

Amadi *see* MA

Amandebele *see* NDEBELE

Amapondo *see* MPONDO

AMARAR (Eritrea)
note Cushitic language; one of the
groups included in the collective
term Beja
AAT: nl
LCSH: nl
ATMB, ATMB 1956, DDMM, GPM 1959,
GPM 1975, HB, HBDW, IAI, RJ 1959, WH
see also Beja

Amashi *see* SHI

Amaswazi *see* SWAZI

Amaxosa *see* XHOSA

Amazulu *see* ZULU

11

AMBA (Uganda, Zaire)
variants Baamba, Bulibuli, Bwamba
subcategories Bwizi
note Bantu language; close cultural
relationship with the Bwizi and
Talinga. Sometimes a distinction
is made between Amba proper (or
Bulibuli) and Bwizi (or Bwezi).
AAT: Amba
LCSH: use Baamba
BES, DDMM, DPB 1987, ECB, ETHN,
GPM 1959, GPM 1975, HAB, HB, HBDW,
IAI, JJM 1972, JLS, MGU 1967, MTKW,
OBZ, RJ 1960, UIH, WH
BKT*, EHW*
see also Bwizi, Talinga
Ambamba *see* MBAAMA
Ambaquista *see* MBAKA
Ambete *see* MBETE
AMBO (Angola, Namibia)
variants Ovambo
note Bantu language
AAT: Ambo
LCSH: use Ovambo
ARW, BS, DDMM, EBR, ETHN, GPM
1959, GPM 1975, HAB, HB, HBDW, HRZ,
IAI, JTSV, JV 1966, MGU 1967, RGL,
ROMC, RS 1980, SD, SMI, TP, UIH, WH,
WOH
MAH*
AMBO (Zaire, Zambia)
variants Kambosenga,
Kambonsenga
note Bantu language
AAT: nl
LCSH: Ambo
DDMM, ETHN, GPM 1959, RJ 1961, UIH,
WVB
BRS*, WWJS*
AMBOIM (Angola)
variants Esele, Mbui
note Bantu language; subcategory of
Kongo
AAT: nl
LCSH: nl
DDMM, GPM 1959, GPM 1975, UIH, WH
see also Kongo
Ambriz *see* Toponyms Index
Ambuella *see* MBWELA (Angola)

Ambundu *see* MBUNDU
Ambundu *see* MBUUN
Ambuun *see* MBUUN
Amekni *see* Toponyms Index
Amer *see* BENI AMER
AMHARA (Ethiopia)
note Semitic language
AAT: Amhara
LCSH: Amhara
AF, BS, DBNV, EBR, ERC, GB, GPM
1959, GPM 1975, HAB, HB, IAI, JG 1963,
JM, KFS, LJPG, MLJD, MYH, RJ 1959,
ROMC, SD, TP, UIH, WH
WIS*
Amwimbe *see* MWIMBE
Ana *see* ATAKPAME
ANAG (Sudan)
note one of the groups included in
the collective term Nubians; a
term applied to almost any group
who previously inhabited the
Nilotic Sudan. see CSBS.
AAT: nl
LCSH: nl
CSBS, ETHN, GPM 1959, GPM 1975, HB,
WH
see also Nubians
ANAGO (Nigeria)
note Kwa language; subcategory of
Yoruba
AAT: nl
LCSH: nl
CDF, CDR 1985, GPM 1959, JK, RWL
see also Yoruba
ANAGUTA (Nigeria)
note Benue-Congo language
AAT: nl
LCSH: nl
DDMM, ETHN, GPM 1959, GPM 1975,
HB, JG 1963, JLS, RWL, UIH
Añaki *see* BIDYOGO

ANAM (Nigeria)
 note Kwa language; subcategory of
 Igbo
 AAT: nl
 LCSH: nl
 IAI, RJ 1958, VCU 1965
 CFGJ*
 see also Igbo
ANANG (Nigeria)
 variants Annang
 note Benue-Congo language;
 subcategory of Ibibio; one of the
 groups referred to as Western
 Ibibio
 AAT: Anang
 LCSH: Anang
 BS, CMK, DDMM, DP, DWMB, ETHN,
 GIJ, GPM 1959, GPM 1975, HB, HBDW,
 IAI, JAF, JG 1963, JK, JLS, JPJM, KFS,
 KMT 1970, MLJD, NOI, RJ 1958, ROMC,
 RWL, SMI, UIH, WLA, WRB 1959, WS
 see also Ibibio
Ande *see* ANYANG
Andembu *see* NDEMBU
Ando *see* ANO
ANDONI (Nigeria)
 variants Obolo
 note Benue-Congo language;
 subcategory of Ibibio; one of the
 groups referred to as Delta Ibibio;
 one of the groups included in the
 collective term Cross River people
 AAT: nl
 LCSH: use Obolo
 DDMM, DWMB, ELZ, ETHN, GIJ, GPM
 1959, GPM 1975, HB, HBDW, JG 1963,
 NOI, RWL, WS
 see also Cross River people, Ibibio
Andumbo *see* NDUMBO
ANGAS (Nigeria)
 variants N'gas
 note Chadic language
 AAT: Angas
 LCSH: Angas
 DDMM, DWMB, ETHN, GPM 1959, GPM
 1975, HB, IAI, JG 1963, JLS, NIB, RJ
 1958, RWL, UIH, WS
 OHDD*
Angba *see* BANGBA

ANGBA (Zaire)
 note Bantu language; closely related
 to the Bwa; one of the groups
 included in the collective term
 Ngelima; not to be confused with
 the Bangba, also in Zaire and
 referred to as Angba, who speak a
 Western Ubangian language
 AAT: nl
 LCSH: nl
 DDMM, ETHN, JMOB
 BJC*
 see also Bwa, Ngelima
Anglo *see* ANLO
Anglo-Egyptian Sudan *see*
 Toponyms Index
Angoni *see* NGONI
Angungwel *see* NGUNGULU
Anguru *see* LOMWE
Ankole *see* NKOLE
Ankutshu *see* NKUTSHU
ANKWE (Nigeria)
 variants Goamai, Goemai
 note Chadic language
 AAT: use Goemai
 LCSH: nl
 CK, DDMM, DWMB, ETHN, GPM 1959,
 HB, HMC, JG 1963, JK, KK 1965, MKW
 1978, RGL, TP, UIH, WFJP, WG 1980,
 WG 1984, WRB, WS
ANLO (Ghana, Togo)
 variants Anglo
 note Kwa language; subcategory of
 Ewe; sometimes referred to as
 Anlo-Ewe
 AAT: nl
 LCSH: Anlo
 DDMM, DWMB, ETHN, GPM 1959, GPM
 1975, HB, MM 1952, RJ 1958
 see also Ewe
Annang *see* ANANG

ANO (Côte d'Ivoire, Ghana, Togo)
variants Ando
note Kwa language; subcategory of
Anyi
AAT: nl
LCSH: nl (uses Ando)
DDMM, ETHN, GPM 1959, HB, JPB, MM
1952
see also Anyi
Anoufom *see* ANUFO
ANTAIFASY (Madagascar)
variants Antefasi, Taifasy
note Malagasi language
(Austronesian)
AAT: nl
LCSH: nl
DDMM, ETHN, GPM 1975, HB, IAI
CKJR*, HDSV*, JMA*
ANTAIMORO (Madagascar)
variants Antaomoro, Antemoro,
Taimoro
note Malagasi language
(Austronesian). The term is also
used by northern Malagasy to
designate all groups of
southeastern Madagascar.
AAT: nl
LCSH: use Taimoro
BS, DDMM, ETHN, GPM 1959, GPM
1975, HB, IAI, KFS, MPF 1992, WH
CKJR*, HDSV*, JMA*
ANTAISAKA (Madagascar)
variants Antesaka, Taisaka
note Malagasi language
(Austronesian)
AAT: nl
LCSH: Antaisaka dialect
DDMM, ETHN, GPM 1959, GPM 1975,
HB, IAI, WH
CKJR*, HDSV*, HUD 1936*, JMA*
Antakarana *see* ANTANKARANA
ANTAMBAHOAKA (Madagascar)
variants Tambahoaka
note Malagasi language
(Austronesian)
AAT: nl
LCSH: nl
DDMM, ETHN, HB, WH
CKJR*, HDSV*, JMA*

ANTANDROY (Madagascar)
variants Tandroy
note Malagasi language
(Austronesian)
AAT: Antandroy
LCSH: Antandroy
BS, DDMM, ELZ, GPM 1959, GPM 1975,
HAB, HB, IAI, JLS, JPJM, LJPG, MPF
1992, WG 1980, WH
CKJR*, GHZ*, JMA*
ANTANKARANA (Madagascar)
variants Antakarana, Tankarana
note Malagasi language
(Austronesian)
AAT: nl
LCSH: nl
DDMM, ETHN, GPM 1959, GPM 1975,
HB, IAI, WH
CKJR*, JMA*
ANTANOSY (Madagascar)
variants Antanusi, Tanosy
note Malagasi language
(Austronesian)
AAT: Antanosy
LCSH: nl
DDMM, ETHN, GPM 1959, GPM 1975,
HAB, HB, IAI, SV, WG 1980, WH
CKJR*, JMA*
Antanusi *see* ANTANOSY
Antaomoro *see* ANTAIMORO
Antefasi *see* ANTAIFASY
Antemoro *see* ANTAIMORO
Antesaka *see* ANTAISAKA
ANTESSAR (Algeria, Mali)
variants Kel Antessar
note Berber language; division of
Tuareg
AAT: nl
LCSH: nl
GPM 1959, GPM 1975, HB, WH
EBJN*, EDB*
see also Tuareg

ANUAK (Ethiopia, Sudan)
variants Anwak, Jo Anywaa, Anyua
note West Nilotic language; one of
the groups included in the
collective term Nilotic people;
sometimes referred to as Northern
Lwoo
AAT: nl
LCSH: Anuak
ATMB 1956, BS, CSBS, DDMM, ERC,
ETHN, GPM 1959, GPM 1975, HAB, HB,
HBDW, IAI, JG 1963, NIB, RJ 1959, UIH,
WEW 1973, WH, WRB 1959
AJB*
see also Lwoo, Nilotic people
ANUFO (Benin, Ghana, Togo)
variants Anoufom, Chakosi,
Chokossi, Tchokossi, Tyokosi
note Kwa language
AAT: nl
LCSH: use Chokossi
DDMM, DWMB, ETHN, GPM 1959, HB,
IAI, MPF 1992, RJ 1958, UIH
JPK*
Anwak *see* ANUAK
ANYANG (Cameroun)
variants Ande, Banyang, Banyangi,
Evambu, Nyang, Nyangi,
Takamanda
subcategories Biteku
note Bantu language. one of the five
component migrant groups in
Bamileke
AAT: Anyang
LCSH: use Nyang
ASH, BS, CFL, CK, CMK, DDMM,
DOWF, DWMB, ELZ, ETHN, GIJ, GPM
1959, GPM 1975, HB, HBDW, IAI, IEZ,
JD, JK, KK 1960, KK 1965, LJPG, MHN,
MK, NOI, PH, RGL, RJ 1958, RSW, RWL,
SMI, TN 1986, UIH, WBF 1964, WG
1984, WOH, WRB, WRNN, WS
LP 1993*
see also Bamileke
Anyanja *see* NYANJA
ANYI (Côte d'Ivoire, Ghana, Togo)
variants Agni

subcategories Alangwa, Ano,
Aowin, Bettye, Binye, Moronu,
Ndenye, Sefwi, Sanwi
note Kwa language; one of the
groups included in the collective
term Akan. The transcription
Anyi seems currently preferred to
the more conventional Agni.
Various small groups within the
Anyi can be distinguished, e.g.
Anyi Ndenye, Anyi Moronu, Anyi
Sanwi, and others. see ENS, JPB*,
SV.
AAT: Anyi
LCSH: Anyi
ASH, BDG 1980, BS, CDR 1985, CK,
CMK, DDMM, DFHC, DFM, DOWF, DP,
DWMB, ETHN, EEWF, EFLH, ELZ, ENS,
EWA, FW, GPM 1959, GPM 1975, HAB,
HB, HBDW, HH, IAI, JD, JEEL, JG 1963,
JK, JL, JLS, JM, JP 1953, KFS, LJPG, LM,
LPR 1986, MLB, MLJD, MM 1950,
PMPO, RGL, RJ 1958, ROMC, RS 1980,
RSAR, RSW, SMI, SV, SV 1986, SVFN,
TFG, TP, UIH, WBF 1964, WG 1980, WG
1984, WH, WMR, WOH, WRB, WRB
1959, WRNN, WS
JPB*, JPE*
see also Akan
Anyua *see* ANUAK
Anzika *see* TEKE
AOWIN (Ghana)
variants Brisa, Brissa, Ebosola
note Kwa language; subcategory of
Anyi; one of the groups included
in the collective term Akan
AAT: Aowin
LCSH: Aowin language use Brissa language
BDG 1980, DDMM, DWMB, ETHN, GPM
1959, HB, HBDW, JK, JLS, JPB,
MM 1950, RJ 1958, TFG, WG 1984
see also Akan, Anyi
Apambia *see* PAMBIA
Apindji *see* TSOGO

APOI (Nigeria)
 note Kwa language; subcategory of
 Ijo
 AAT: nl
 LCSH: nl
 DDMM, ETHN, JLS, RWL
 see also Ijo
Apono *see* PUNU
ARAD (Tunisia)
 note Semitic language; one of the
 groups included in the collective
 term Bedouin
 AAT: nl
 LCSH: nl
 GPM 1959, WH
 see also Bedouin
ARAGO (Nigeria)
 variants Alago
 note Kwa language
 AAT: nl
 LCSH: nl
 BS, DDMM, DWMB, ETHN, GIJ, GPM
 1959, GPM 1975, HB, IAI, RJ 1958, RWL,
 WH
ARAMKA (Chad)
 note Semitic language; related to or
 subcategory of Shuwa; an Arabic
 speaking people of the Chadic
 plains
 AAT: nl
 LCSH: nl
 AML, HB
 see also Shuwa
ARBORE (Ethiopia)
 note Eastern Cushitic language
 AAT: nl
 LCSH: Arbore language
 ATMB 1956, DDMM, ERC, ETHN, GPM
 1959, GPM 1975, HB, IAI, JG 1963, RJ
 1959
ARGOBBA (Ethiopia)
 note Semitic language
 AAT: nl
 LCSH: Argobba language
 ATMB, ATMB 1956, DDMM, ETHN,
 GPM 1975, HB, HBDW, IAI, JG 1963, RJ
 1959, ROMC, UIH
 WIS*
Ari *see* ABIDJI

ARIAAL (Kenya)
 variants Arial
 note Cushitic language; subcategory
 of Rendile but living among
 Samburu
 AAT: nl
 LCSH: Ariaal
 BS, DDMM, ETHN
 see also Rendile, Samburu
Arial *see* ARIAAL
Ariangulu *see* SANYE
Arimi *see* NYATURU
ARO (Nigeria)
 variants Arochuku
 note Kwa language; subcategory of
 Igbo; one of the groups referred to
 as Eastern or Cross River Igbo
 AAT: nl
 LCSH: nl
 GIJ, GPM 1975, HB, JK, RWL, UIH, WRB
 1959
 CFGJ*
 see also Igbo
Arochuku *see* ARO
Arusa *see* ARUSHA
Arush *see* ARUSHA
ARUSHA (Kenya, Tanzania)
 variants Arusa, Arush
 note There are two ethnic groups
 with this name: 1. a subcategory
 of Maasai who speak an Eastern
 Nilotic language and live in both
 Tanzania and Kenya; 2. a Bantu-
 speaking people of Tanzania who
 are also known as Rusha. In some
 sources the information may not
 be sufficiently explicit to
 determine to which group they
 belong. It is also a city in
 Tanzania.
 AAT: Arusha
 LCSH: Arusha
 ATMB 1956, DDMM, ECB, ETHN, GPM
 1959, GPM 1975, HB, IAI, KK 1990, RJ
 1960, UIH, WH, WOH
 PHG*
 see also Maasai

16

ARUSI (Ethiopia, Kenya, Somalia)
variants Arussi
note Cushitic language; subcategory
of Oromo
AAT: Arusi
LCSH: nl
ATMB 1956, DDMM, ECB, ERC, ETHN,
GPM 1959, HB, IAI, IML 1969, RJ 1959,
ROMC, UIH, WH
MOH*
see also Oromo
Arussi *see* ARUSI
Aruwimi River *see* Toponyms Index
ASA (Nigeria)
note Kwa language; subcategory of
Igbo
AAT: nl
LCSH: nl
GIJ, GPM 1959, GPM 1975, WH
CFGJ*
see also Igbo
ASAFO (Ghana)
note Kwa language; subcategory of
Fanti
AAT: nl
LCSH: nl
BDG 1980, HCDR, JLS
PANB 1992*
see also Fanti
ASAIMARA (Ethiopia)
note Cushitic language; subcategory
of Afar
AAT: nl
LCSH: nl
HB, IML 1969
see also Afar
Asalampasu *see* SALAMPASU
Asanfo *see* ASANFWE
ASANFWE (Côte d'Ivoire)
variants Asanfo
note Mande language; subcategory
of Yohure
AAT: nl
LCSH: nl
JPB
see also Yohure
ASANTE (Ghana)
variants Achanti, Ashante, Ashanti

subcategories Adanse
note Kwa language; one of the
groups included in the collective
term Akan; West African
kingdom dating from the 17th
century; The transcription Asante
seems currently preferred to the
more conventional Ashanti.
AAT: Asante
LCSH: use Ashanti
ACN, AF, BDG 1980, BS, CDR 1985, CK,
CMK, DDMM, DFHC, DFM, DOA, DP,
DWMB, EB, EBR, EEWF, EL, ELZ, ENS,
ETHN, EVA, EWA, FW, GAC, GBJM,
GBJS, GPM 1959, GPM 1975, GWS, HAB,
HBDW, HCDR, HH, HMC, HRZ, IAI, JD,
JEEL, JK, JL, JLS, JM, JPB, JPJM, JV
1984, KFS, KK 1960, KK 1965, KMT
1970, KMT 1971, LM, LPR 1986, LSD,
MCA, MHN, MK, MLB, MLJD, MM 1950,
MUD 1991, MWM, NIB, PG 1990, PMPO,
PSG, RAB, RFT 1974, RJ 1958, ROMC,
RS 1980, RSAR, RSRW, RSW, SD, SMI,
SV, SVFN, TB, TFG, TLPM, TP, UGH,
UIH, WBF 1964, WEW 1973, WFJP, WG
1980, WG 1984, WH, WLA, WMR, WOH,
WRB, WRB 1959, WRNN, WS
CFPK*, MDM*, PANB*, RSR*, RSR
1927*
see also Akan
ASEBU (Côte d'Ivoire)
variants Assabu
note Kwa language; subcategory of
Agua
AAT: nl
LCSH: nl
JPB, TFG
see also Agua
Asena *see* SENA
Asenga *see* SENGA
Asen-Twifo *see* ASSINI
Ashango *see* SANGU
Ashante *see* ASANTE
Ashanti *see* ASANTE
Ashira *see* SHIRA
Ashogo *see* TSOGO

ASHUKU (Nigeria)
 note Benue-Congo language; one of
 the groups included in the
 collective term Tigong
 AAT: nl
 LCSH: nl
 DDMM, ETHN, RWL
 see also Tigong
Asin *see* ASSINI
Asolio *see* MORWA
Asolongo *see* SOLONGO
Assabu *see* ASEBU
Assin *see* ASSINI
ASSINI (Côte d'Ivoire, Ghana)
 variants Asen-Twifo, Asin, Assin
 note Kwa language; subcategory of
 Esuma; a Lagoon people who
 have been absorbed by the Anyi
 and Nzima; one of the groups
 included in the collective term
 Akan. see JPB.
 AAT: nl
 LCSH: nl
 ETHN, GPM 1959, GPM 1975, HB,
 HCDR, IAI, JPB, MM 1950, RS 1980, TFG
 see also Akan, Esuma
Assinie *see* Toponyms Index
Assoko *see* NZIMA
Assolongo *see* SOLONGO
Asu *see* PARE
Asua *see* AKA
Asua *see* BASUA
ATAKA (Nigeria)
 variants Atakat, Attakar, Takat
 note Benue-Congo language
 AAT: nl
 LCSH: use Atakat
 DDMM, GPM 1959, HB, JLS, RWL
Atakat *see* ATAKA
ATAKPAME (Togo)
 variants Ana
 note Kwa language; subcategory of
 Yoruba
 AAT: nl
 LCSH: nl
 ETHN, GPM 1959, GPM 1975, HB, KK
 1965, RWL, WH, WOH

 see also Yoruba
ATAM (Nigeria)
 note Bantoid language; share a
 common language with the
 Ofutop
 AAT: nl
 LCSH: nl
 DDMM, ETHN, GIJ, GPM 1959, RWL
 see also Ofutop
Atemne *see* TEMNE
Aten *see* GANAWURI
Ateso *see* TESO
Atetela *see* TETELA
Atie *see* AKYE
Atlas Mountains *see* Toponyms
 Index
Attakar *see* ATAKA
Attie *see* AKYE
ATUOT (Sudan)
 variants Atwot
 note West Nilotic language; one of
 the groups included in the
 collective term Nilotic people
 AAT: nl
 LCSH: Atuot
 ATMB 1956, CSBS, DDMM, ETHN, GPM
 1959, GPM 1975, WH
 AJB*, JWB*
 see also Nilotic people
Atutu *see* AITU
ATWODE (Ghana, Togo)
 variants Atyoti
 note Kwa language
 AAT: nl
 LCSH: nl
 DDMM, ETHN, HB, HCDR
Atwot *see* ATUOT
Atyap *see* KATAB
Atye *see* AKYE
Atyo *see* TIO
Atyoti *see* ATWODE

AUEN (Botswana, Namibia)
note Khoisan language; one of the groups referred to as Southern Kung; one of the groups included in the collective term Bushmen
AAT: nl
LCSH: use !Kung
ATMB 1956, DDMM, ETHN, GPM 1959, GPM 1975, HB, IAI, JG 1963, UIH, WH ALB*
see also Bushmen

Aulimmiden *see* IWLLEMMEDEN

AUNI (Namibia)
note Khoisan language; one of the groups included in the collective term Bushmen
AAT: nl
LCSH: nl
ATMB, ATMB 1956, DDMM, ETHN, GPM 1959, HB, JG 1963, IS, UIH, WH ALB*
see also Bushmen

Aures Mountains *see* Toponyms Index

AUSHI (Zaire, Zambia)
variants Baushi, Mwaushi, Ushi
note Bantu language
AAT: nl
LCSH: use Ushi
BS, CDR 1985, CK, DDMM, DPB 1981, DPB 1987, ELZ, ETHN, GAH 1950, GPM 1959, IAI, JMOB, JV 1966, MHN, OB 1961, OBZ, RJ 1961, UIH, WH, WVB WWJS*

Avalogoli *see* LOGOOLI

AVIKAM (Côte d'Ivoire)
variants Brignan
note Kwa language; one of the groups included in the collective term Lagoon people
AAT: nl
LCSH: Avikam
BS, CK, DDMM, DWMB, ENS, ETHN, GPM 1959, GPM 1975, HAB, HB, IAI, JEEL, JG 1963, JP 1953, RJ 1958, TFG, UIH, WH JPB*
see also Lagoon people

AVOKAYA (Zaire)
variants Abukaya, Avukaija
note Central Sudanic language; often linked with the Logo and referred to as Logo-Avokaya. see DPB 1987, IAI.
AAT: nl
LCSH: nl
ATMB 1956, DDMM, DPB 1987, GAH 1950, HAB, HB, HBDW, IAI, JG 1963, JMOB, OBZ, WS
see also Logo

Avongara *see* AVUNGARA

Avukaija *see* AVOKAYA

AVUNGARA (Zaire)
variants Avongara
note one of the dynastic groups linked in the literature with the Zande
AAT: nl
LCSH: nl
CDR 1985, CSBS, ELZ, ESCK, ETHN, GAH 1950, IAI, JMOB, RJ 1959, ROMC
see also Zande

Awadaghust *see* Toponyms Index

Awemba *see* BEMBA

AWING (Cameroun)
note Bantoid language; one of the groups included in the collective term Bamenda
AAT: nl
LCSH: nl
DDMM, ETHN, LP 1993
see also Bamenda

AWKA (Nigeria)
note subcategory of Igbo; as Nri-Awka a division of the Northern or Onitsha Igbo
AAT: nl
LCSH: nl
BS, CFL, DDMM, FW, GIJ, HMC, JLS, JM, SMI, SV, VCU 1965, WG 1984, WFJP CFGJ*
see also Igbo

AWORI (Benin, Nigeria)
variants Aworri
note Kwa language; subcategory of
Yoruba
AAT: nl
LCSH: nl
CDF, DDMM, ETHN, GPM 1959, HB,
JAF, RWL, SV
HJD*
see also Yoruba
Aworri *see* AWORI
AWUTU (Ghana)
note Kwa language
AAT: nl
LCSH: nl
DDMM, DWMB, ETHN, GPM 1959,
HCDR
Axum *see* AKSUM
Ayahou *see* AYAHU
AYAHU (Côte d'Ivoire)
variants Ayaou, Ayahou
note Kwa language; subcategory of
Baule
AAT: nl
LCSH: nl
GPM 1959, JPB, SV, WS
see also Baule
Ayaou *see* AYAHU
Ayizo *see* AIZO
Ayt Atta *see* AIT ATTA
AYT HADIDDU (Morocco)
note Berber language; one of the
groups included in the collective
term Berber
AAT: nl
LCSH: nl
JPJM
see also Berber
AZA (Chad, Libya, Niger)
variants Azza
note Nilo-Saharan language; the
Azza are a separate people living
among the Teda
AAT: nl
LCSH: nl
BS, ETHN, HB, IAI, JEC 1958, LCB, LPR
1995, UIH
see also Teda

Azande *see* ZANDE
Azania *see* Toponyms Index
Azza *see* AZA

Baakpe *see* KWIRI
Baamba *see* AMBA
Baati *see* BATI (Zaire)
BABA (Cameroun)
variants Bamessi, Papiakum
note Bantoid language; one of the
groups included in the collective
term Bamenda
AAT: nl
LCSH: nl
DDMM, ETHN, GPM 1959, RFT 1974
LP 1993*, MMML*, PH*, PMK*
see also Bamenda
Babadjou *see* BABADJU
BABADJU (Cameroun)
variants Babadjou
note Bantoid language; one of the
groups included in the collective
term Bamileke
AAT: nl
LCSH: nl
ETHN, GPM 1959, KK 1965, MMML, PH,
UIH
LP 1993*
see also Bamileke
Babale *see* BALE
Babali *see* BALI (Zaire)
Babangi *see* BANGI

BABANKI (Cameroun)
variants Banki
subcategories Daso, Kijem, Tungo
note Bantoid language; one of the
groups included in the collective
terms Bamenda and Grasslands
AAT: use Banki
LCSH: nl
ASH, CDR 1985, CMK, DDMM, DP,
EBHK, EBR, ETHN, GPM 1959, HAB,
HB, HBDW, HMC, JD, TN 1984, TN
1986, WG 1980, WOH, WRB, WRNN
GDR*, LP 1993*, MKW*, MMML*
see also Bamenda, Grasslands
Babanki-Daso *see* DASO
Babanki-Kijem *see* KIJEM
Babanki-Tungaw *see* TUNGO
Babanki-Tungo *see* TUNGO
Babelu *see* BEYRU
Babemba *see* BEMBA
Babembe *see* BEMBE (Zaire)
BABEMO (Zaire)
note small group living near the
Lega
AAT: nl
LCSH: nl
CDR 1985, DPB 1986
Babenga *see* BABINGA
Babeo *see* BEO
BABESSI (Cameroun)
variants Wushi
note Bantoid language
AAT: nl
LCSH: nl
CK, DDMM, EBHK, ELZ, ETHN, GPM
1959, PH
TN 1984*, TN 1986*
BABETE (Cameroun)
note Bantoid language
AAT: nl
LCSH: nl
DDMM, ETHN, KK 1965
MMML*, PH*
Babeyru *see* BEYRU
Babila *see* BIRA
Babindja *see* BINJA
Babindji *see* BINJI

BABINGA (Cameroun, Central
African Republic, Congo Republic,
Equatorial Guinea, Gabon)
variants Babenga, Bakoa,
Bambenga, Benga, Binga
note Ubangian language; a
collective term used to refer to the
Aka, Bagyele, Baka, and others;
one of the groups included in the
collective term Pygmies see SB*
AAT: nl
LCSH: Babinga
ATMB, ATMB 1956, BES, BS, DPB 1987,
FN 1994, GPM 1959, GPM 1975, HAB,
HB, IAI, IEZ, JG 1963, JMOB, LJPG,
MGU 1967, SMI, UIH, WH
RPT*, SB*
see also Pygmies
Babinji *see* BINJI
Babira *see* BIRA
Babisa *see* BISA (Zaire, Zambia)
Baboa *see* BWA (Zaire)
BABOANTU (Cameroun)
variants Babouantou
note Bantoid language; one of the
groups included in the collective
term Bamileke
AAT: nl
LCSH: nl
MMML, PH, TN 1984, TN 1986
see also Bamileke
Baboma *see* BUMA
Baboma *see* MBOMA
Babongo *see* AKUA
Baboshi *see* MBOSHI
Babouantou *see* BABOANTU
Baboute *see* WUTE
Babua *see* BWA (Zaire)
Babuende *see* BWENDE
Babujwe *see* BUJWE
Babukusu *see* BUKUSU
Babunda *see* MBUUN
Babundu *see* MBUUN

BABUNGO (Cameroun)

variants Ngo

note Bantoid language; one of the groups included in the collective terms Bamenda and Grasslands

AAT: nl

LCSH: Babungo language use Ngo language

ASH, CK, DDMM, EBHK, ELZ, ETHN, GPM 1959, HAB, HB, HMC, KK 1960, KK 1965, LM, PH, RSW, SMI, TN 1984, TN 1986, WH, WRNN

GDR*, PAG*, LP 1993*, MMML*

see also Bamenda, Grasslands

Babur *see* PABIR

Babute *see* WUTE

Babuto Mountains *see* Toponyms Index

Babuye *see* BOYO

Babuyu *see* BOYO

Babwa *see* BWA (Zaire)

Babwari *see* BWARI

Babwende *see* BWENDE

Babwendi *see* BWENDE

Bacam *see* BATCHAM

Bacham *see* BATCHAM

BACHAMA (Cameroun, Nigeria)

note Chadic language

AAT: Bachama

LCSH: Bachama

BEL, BS, DDMM, DWMB, ELZ, ETHN, GPM 1959, GPM 1975, HAB, IAI, IEZ, JG 1963, MBBH, MCA, NOI, RJ 1958, ROMC, RS 1980, RWL, UIH, WH

EPHE 9*

Bachokwe *see* CHOKWE

Bachopi *see* CHOPI

Bachua *see* CWA

Bacouba *see* KUBA

Bacwa *see* CWA

Badia *see* DIA

Badiaranke *see* BADYARANKE

Badinga *see* DINGA

Badjok *see* CHOKWE

Badjokwe *see* CHOKWE

Badogo *see* GBADOGO

Badoko *see* DOKO

Badondo *see* DONDO

Badouma *see* DUMA (Gabon)

Badyara *see* BADYARANKE

BADYARANKE (Guinea, Guinea-Bissau, Senegal)

variants Badiaranke, Badyara, Gola, Pajade, Pajadinca

note West Atlantic language; one of the groups included in the collective term Tenda

AAT: nl

LCSH: use Badyara

BS, DDMM, DWMB, ETHN, GPM 1959, GPM 1975, HB, IAI, JG 1963, MDL, MPF 1992, RJ 1958, SMI, SV, UIH

WSS*

see also Tenda

BAFANDJI (Cameroun)

variants Bafanji

note Bantoid language; one of the groups included in the collective terms Bamenda and Grasslands

AAT: nl

LCSH: nl

DDMM, ETHN, JLS, MMML, PH

LP 1993*

see also Bamenda, Grasslands

BAFANG (Cameroun)

variants Fe'fe'

note Bantoid language; one of the four administrative divisions of Bamileke

AAT: nl

LCSH: use Fe'Fe'

DDMM, DWMB, ETHN, GPM 1959, HB, PH

GDR*, LP 1993*, MMML*, PAG*

see also Bamileke

Bafanji *see* BAFANDJI

BAFIA (Cameroun)
variants Bekpak, Fia, Kpa
note Bantu language; one of the five
 component migrant groups in
 Bamileke
 AAT: use Fia
 LCSH: Bafia
 CK, DDMM, ETHN, GPM 1959, GPM
 1975, HAB, HB, HBDW, HMC, IAI, IEZ,
 KK 1965, MG, MGU 1967, MPF 1992, PH,
 RGL, RJ 1958, SMI, TN 1984, UIH, WH,
 WOH, WRB
 GT 1934*, MMML*
see also Bamileke

Bafing River *see* Toponyms Index

BAFO (Cameroun)
variants Fo
note Bantu language
 AAT: Bafo
 LCSH: nl
 ASH, CK, DDMM, ELZ, ETHN, GPM
 1959, GPM 1975, HAB, HB, JK, KFS
 1989, KK 1960, KK 1965, MK, MLB, PH,
 RGL, RSW, SV 1986, TLPM, TN 1984,
 UIH, WBF 1964, WH, WMR, WOH, WRB,
 WRNN
 LP 1993*

BAFOCHU (Cameroun)
variants Baforchu
note Bantoid language
 AAT: nl
 LCSH: nl
 DDMM, PH

Baforchu *see* BAFOCHU

Bafou *see* BAFU

BAFOU-FONDONG (Cameroun)
note one of the groups included in
 the collective term Bamileke
 AAT: nl
 LCSH: nl
 LP 1993, PH
see also Bamileke

Bafounda *see* BAFUNDA

Bafoussam *see* BAFUSSAM

BAFRENG (Cameroun)
variants Nkwem, Nkwen
note Bantoid language; one of the
 groups included in the collective
 term Bamenda
 AAT: nl
 LCSH: nl
 CK, DDMM, ETHN, GPM 1959, HBDW,
 HMC, KK 1965, LP 1993
 MMML*, PH*
see also Bamenda

BAFU (Cameroun)
variants Bafou
note Bantoid language; one of the
 groups included in the collective
 term Bamileke
 AAT: nl
 LCSH: nl
 DDMM, ETHN, HB, LP 1993, MMML,
 WMR
see also Bamileke

BAFUM (Cameroun)
variants Fum
note Bantoid language; one of the
 groups included in the collective
 term Bamileke
 AAT: use Fum
 LCSH: nl
 CK, DDMM, EBHK, ELZ, HAB, JD, JK,
 KK 1960, KK 1965, PH, RSW, TN 1984,
 TN 1986, WBF 1964, WMR, WRB,
 WRNN
 LP 1993*
see also Bamileke

Bafum-Katse *see* ISU

Bafumu *see* MFUNU

Bafumungu *see* MFINU

BAFUNDA (Cameroun)
variants Bafounda
note Bantoid language; one of the
 groups included in the collective
 term Bamileke
 AAT: nl
 LCSH: nl
 DDMM, KK 1965, LP 1993, MMML, PH
 TN 1986*
see also Bamileke

Bafusam *see* BAFUSSAM

BAFUSSAM (Cameroun)
variants Bafoussam, Bafusam, Fusam
note Bantoid language; one of the four administrative divisions of Bamileke
AAT: nl
LCSH: nl
DDMM, DWMB , GPM 1959, HB, JPN, KK 1960, PH, SMI, TN 1984, TN 1986, UIH
GDR*, PAG*, LP 1993*, MMML*
see also Bamileke

BAFUT (Cameroun)
variants Fut
note Bantoid language; one of the groups included in the collective terms Bamenda and Tikar
AAT: nl (uses Fut)
LCSH: Bafut
ASH, CK, DDMM, DFHC, DWMB, EBHK, EBR, ETHN, FW, GPM 1959, GPM 1975, HAB, HB, HMC, IAI, IEZ, JLS, JV 1984, KK 1965, MK, PH, SMI, TN 1984, TN 1986, UIH, WOH
LP 1993*, MMML*, PAG*, PMK*, RRPR*
see also Bamenda, Tikar

BAGA (Guinea, Sierra Leone)
variants Bagga
note West Atlantic language; often linked with the Landuma, Nalu and Temne
AAT: Baga
LCSH: nl
ASH, AW, BS, CDR 1985, CFL, CK, CMK, DDMM, DFHC, DFM, DOA, DOWF, DP, DWMB, EBR, EEWF, ELZ, ETHN, EVA, EWA, FW, GBJM, GBJS, GPM 1959, GPM 1975, GWS, HAB, HB, HBDW, HH, HMC, IAI, JD, JG 1963, JJM 1972, JK, JL, JLS, JP 1953, JTSV, KFS, KFS 1989, KK 1960, KMT 1970, LJPG, LM, MH, MHN, MLB, MLJD, RFT 1974, RJ 1958, RGL, RS 1980, RSAR, RSRW, RSW, SV, SV 1988, SVFN, TB, TLPM, TP, UIH, WBF 1964, WEW 1973, WG 1980, WG 1984, WH, WMR, WOH, WRB, WRB 1959, WRNN, WS
see also Landuma, Nalu, Temne
Baga Fore *see* MBULUNGISH

BAGAM (Cameroun)
variants Gam, Gham
note Bantoid language; subcategory of Bali; one of the groups included in the collective term Bamileke
AAT: Bagam
LCSH: nl
DDMM, DWMB, ELZ, ETHN, GPM 1959, GPM 1975, HAB, HB, HBDW, IAI, KK 1965, KMT 1971, PH, RJ 1958, TN 1984, TN 1986, UIH, WH, WRB
GDR*, LP 1993*, MMML*, PMK*
see also Bali, Bamileke

Baganda *see* GANDA
Bagangala *see* GANGALA
Bagengele *see* NGENGELE
Bagenia *see* ENYA
Bageshu *see* GISU
Bagesu *see* GISU
Bagga *see* BAGA

BAGGARA (Chad, Sudan)
variants Baqqara, Fellata-Baggare
note Semitic language; semi-nomadic Arabs who range from Lake Chad to the White Nile, including the Hamar, Hawazma, Messeria and Rizeygat
AAT: Baggara
LCSH: Baggara
BS, CSBS, GB, GPM 1959, GPM 1975, HBDW, IAI, JLS, KK 1990, LPR 1995, RJ 1959, ROMC, SMI, WH
IGC*, ICWJ*
see also Sudan Arabs
Baghirmi *see* BAGIRMI
Bagieli *see* BAGYELE

BAGIRMI (Central African
Republic, Chad, Sudan)
variants Baghirmi, Baguirmi
note Central Sudanic language;
ancient Chadic kingdom lasting
from circa 16th century to 1915
AAT: Bagirmi
LCSH: Bagirmi
ATMB, ATMB 1956, BEL, DDMM,
ETHN, GB, GPM 1959, HB,
HBDW, HRZ, JG 1963, JJM 1972, JL, JLS,
JM, JPAL, MPF 1992, NIB, NOI, ROMC,
RSW, SMI, UIH, WG 1980, WH, WRNN
AML*, VP 1977*

Bagishu *see* GISU

Bagoma *see* GOMA

Baguha *see* GUHA

Baguirmi *see* BAGIRMI

Bagunda *see* GUNDI

BAGYELE (Cameroun, Equatorial
Guinea)
variants Bagieli, Bako, Bakong
note Bantu language; one of the
groups included in the collective
terms Babinga and Pygmies.
AAT: nl
LCSH: Bagyele
ETHN, HB, JMOB, JPN, LP 1993, PH, WH
SB*
see also Babinga, Pygmies

Baham *see* BAHUAN

BAHARIYA (Egypt)
note Semitic language; one of the
groups included in the collective
term Bedouin
AAT: nl
LCSH: Bahariya Oasis (Egypt)
AHF, GPM 1959, GPM 1975
see also Bedouin

Bahemba *see* HEMBA

Bahemba *see* LUBA-HEMBA

Bahera *see* HERA (Uganda, Zaire)

Bahima *see* HIMA

Baholo *see* HOLO

Baholoholo *see* HOLOHOLO

Bahoma *see* GOMA

Bahouang *see* BAHUAN

Bahoyo *see* WOYO

Bahr-al-Ghazal *see* Toponyms Index

BAHUAN (Cameroun)
variants Baham, Bahouang
note Bantoid language; one of the
groups included in the collective
term Bamileke
AAT: nl
LCSH: nl
DDMM, EBHK, KK 1965, PH
JPN*, LP 1993*
see also Bamileke

Bahuana *see* WAAN

Bahuku *see* HUKU

Bahumbe *see* HUMBE

Bahumbu *see* WUUM

BAHUMONO (Nigeria)
variants Ekumuru, Humono
note Benue-Congo language
AAT: nl
LCSH: Bahumono language use Kohumono
language
DDMM, ETHN, GPM 1959, HCCA, RWL

Bahunde *see* HUNDE

Bahungana *see* WAAN

Bahutu *see* HUTU

Bai *see* BARI

BAI (Chad, Sudan)
variants Mbai
note Western Ubangian language
AAT: nl
LCSH: nl
ATMB, ATMB 1956, DDMM, ETHN,
GPM 1959, RJ 1959
STS*

BAI (Zaire)
variants Bay, Baye, Bobai, Bobaie
note Bantu language
AAT: nl
LCSH: nl
DDMM, DPB 1985, DPB 1987, ETHN,
GAH 1950, GPM 1959, GPM 1975, HAB,
HB, HBDW, IAI, JG 1963, JMOB, OBZ,
RGL, UIH, WH

Baila *see* ILA

BAILUNDO (Angola)
variants Bailundu
note Bantu language. Portuguese
 sources used the term to refer to
 various groups now known as
 Ovimbundu (Quimbundo and
 Kimbanda).
AAT: nl
LCSH: Bailundo War, Angola, 1902; BT
 Mbundu (African people)
DDMM, GPM 1959, GPM 1975, HAB,
HB, HRZ, WOH, WS
MEM*
see also Ovimbundu
Bailundu *see* BAILUNDO
Bainuk *see* BANYUN
Baja *see* GBAYA (Cameroun,
 C.A.R., Congo Republic, Zaire)
Bajokwe *see* CHOKWE
BAJUN (Kenya, Somalia)
note Bantu language; subcategory of
 Swahili
AAT: Bajun
LCSH: Bajun
DDMM, ECB, ETHN, GPM 1959, GPM
1975, MCA 1986
see also Swahili
BAKA (Cameroun, Gabon)
variants Mbaka
note Ubangian language; sometimes
 referred to as Babinga; one of the
 groups included in the collective
 term Pygmies
AAT: nl
LCSH: Baka (Pygmies)
DDMM, ETHN, HB, IAI, JLS, JMOB,
PAS, SB 1985, WH
HVV*, NB*, SB*
see also Babinga, Pygmies
BAKA (Sudan, Zaire)
note Central Sudanic language
AAT: nl
LCSH: Baka language (Sudan, Zaire)
ATMB, ATMB 1956, BS, CSBS, DDMM,
DPB 1987, ETHN, GAH 1950, GPM 1959,
GPM 1975, HAB, HB, HBDW, JG 1963,
KFS, OB 1973, OBZ, RJ 1959, UIH, WH
Bakaka *see* MFUMTE

Bakango *see* KANGO
Bakanu *see* NKANU
Bakasai *see* LUBA-KASAI
Bakasayi *see* LUBA-KASAI
BAKASSA (Cameroun)
variants Bankassa
note one of the groups included in
 the collective term Bamileke
AAT: nl
LCSH: nl
JPN, LP 1993, MMML, PH
see also Bamileke
Bakatla *see* KHATLA
Bakel *see* KEL
Bakele *see* KELE (Gabon)
BAKEMBAT (Cameroun)
AAT: nl
LCSH: nl
KK 1965, PH
Baket *see* KET
Bakete *see* KET
Bakira *see* KIRA
Bakitara *see* KITARA
Bako *see* BAGYELE
BAKO (Ethiopia)
note Cushitic language; subcategory
 of Sidamo
AAT: nl
LCSH: nl
ATMB, ATMB 1956, DDMM, ERC,
ETHN, GPM 1959, GPM 1975, HAB,
HBDW, JG 1963, UIH, WH
see also Sidamo
Bakoa *see* BABINGA
Bakoko *see* BASA (Cameroun)
Bakola *see* PYGMIES
Bakomo *see* KOMO
Bakong *see* BAGYELE
Bakongo *see* KONGO
Bakonjo *see* KONJO
Bakono *see* TEKE
Bakosi *see* NKOSI
Bakossi *see* NKOSI
Bakota *see* KOTA (Congo Republic,
 Gabon)

Bakouba *see* KUBA

Bakuba *see* KUBA

Bakucu *see* KUTU (Zaire)

Bakulya *see* KURIA

Bakumbu *see* KOMO

Bakumu *see* KOMO

Bakunda *see* KUNDA (Zaire)

Bakundu *see* KUNDU

Bakusu *see* KUSU

Bakutu *see* KUTU (Zaire)

BAKWA KATAWA (Zaire)

 note Bantu language; subcategory of
 Luluwa
 AAT: nl
 LCSH: nl
 JC 1971, OB 1973
 see also Luluwa

Bakwa Mputu *see* MPUT

Bakwa Ndolo *see* NDOLO

Bakwakaonde *see* KAONDE

Bakwame *see* KWAME

BAKWANZALA (Zaire)

 note Bantu language; subcategory of
 Songye
 AAT: nl
 LCSH: nl
 LES
 see also Songye

BAKWE (Côte d'Ivoire)

 note Kwa language
 AAT: nl
 LCSH: nl
 BS, DDMM, DWMB, EFLH, ETHN, GPM
 1959, GPM 1975, GSGH, HB, JEEL, JG
 1963, JP 1953, JPB, ROMC, RSW, UIH

Bakwele *see* KWELE

Bakwere *see* KWERE

Bakweri *see* KWIRI

Bakwese *see* KWESE

Bakwiri *see* KWIRI

BALA (Angola)

 variants Kibala, Kipala
 note Bantu language
 AAT: nl
 LCSH: nl
 DDMM, DPB 1987, GPM 1959, GPM
 1975, HB, HJK, JK, MLB 1994

Baladi *see* LAADI

Baladougou *see* BELEDUGU

Balala *see* LALA

Balali *see* LAADI

Balamba *see* LAMBA

BALANG (Cameroun)

 note one of the groups included in
 the collective term Bamileke
 AAT: nl
 LCSH: nl
 LP 1993
 see also Bamileke

Balanta *see* BALANTE

BALANTE (Guinea-Bissau, Senegal)

 variants Balanta
 note West Atlantic language
 AAT: nl
 LCSH: use Balanta
 DDMM, BS, DWMB, ETHN, GPM 1959,
 GPM 1975, HAB, HB, HBDW, JG 1963,
 KFS, MPF 1992, RJ 1958, UIH, WH

BALE (Zaire)

 variants Babale
 note Bantu language; a riparian
 population in the Ngiri area of
 Zaire not to be confused with the
 Bali of eastern Zaire. In some
 sources the information may not
 be sufficiently explicit to
 determine to which group they
 belong.
 AAT: nl
 LCSH: nl
 DDMM, ETHN, GAH 1950, GPM 1959,
 GPM 1975, HB, HBU, JMOB, WH

Bale *see* LENDU

Bäle *see* BIDEYAT

BALEB (Nigeria)
variants Akparabong, Balep
note Bantoid language; one of the
groups included in the Ekoi
language cluster.
AAT: nl
LCSH: nl
DDMM, ETHN, GIJ, HB, JAF, MGU 1967,
RWL, SV
see also Ejagham
Balega *see* LEGA
Balegga *see* LEGA
Balei *see* BALENG
Baleka *see* LEKA
Balemfu *see* LEMFU
Balendu *see* LENDU
BALENG (Cameroun)
variants Balei
note Bantoid language; one of the
groups included in the collective
term Bamileke
AAT: nl
LCSH: nl
DDMM, HB, JPN, PH
LP 1993*, MMML*
see also Bamileke
Balengdjou *see* BANJUN
Balengola *see* LENGOLA
Balep *see* BALEB
Balesa *see* LESE
Balese *see* LESE
BALESSING (Cameroun)
note Bantoid language; one of the
groups included in the collective
term Bamileke
AAT: nl
LCSH: Balessing language use Bamougoun-
Bamenjou language
DDMM, PH, TN 1984
MMML*, TN 1986*
see also Bamileke
BALI (Cameroun)
variants Bani, Li
note Bantoid language; independent
chiefdom; one of the five
component migrant groups in

Bamenda. Bali "chefferies"
include Bagam, Balikumbat,
Gangsin, Gaso, Muti, and
Nyonga.
AAT: use Li
LCSH: Bali
ACN, CK, DDMM, DOWF, DP, DWMB,
EBHK, ELZ, ETHN, GPM 1959, GPM
1975, HB, HH, IEZ, KK 1960, KK 1965,
KMT 1970, KMT 1971, LJPG, MK, PH,
RGL, RJ 1958, RSW, SMI, SV 1988,
TLPM, TN 1984, TN 1986, WOH, WRB
WRNN
GDR*, HK*, LP 1993*, MKW*, PMK*
see also Bamenda, Grasslands
BALI (Zaire)
variants Babali, Mabali, Mobali
note Bantu language; a group living
in Eastern Zaire not to be
confused with the Bale in the
Ngiri region of Zaire. In some
sources the information may not
be sufficiently explicit to
determine to which group they
belong.
AAT: nl
LCSH: nl
BES, DDMM, DOWF, DPB 1987, DWMB,
ESCK, ETHN, FHCP, GAH 1950, GPM
1959, GPM 1975, HAB, HB, HBDW,
HVGA, IAI, JMOB, KMT 1971, LJPG,
MGU 1967, OB 1973, OBZ, RGL, SMI,
SV, TLPM, WH, WOH
HVG 1960*
Bali-Gasho *see* GASO
Bali-Nyonga *see* NYONGA
Balika *see* LIKA
Balikumbad *see* BALIKUMBAT
BALIKUMBAT (Cameroun)
variants Balikumbad, Kumbat
note Bantoid language; subcategory
of Bali; one of the groups included
in the collective term Bamenda
AAT: nl
LCSH: nl
EBHK, KK 1965, LP 1993, PH, TN 1973
PMK*
see also Bali, Bamenda

Balimba *see* LIMBA
Balinga *see* LINGA
Baloi *see* LOI
Balolo *see* LOLO
BALOM (Cameroun)
variants Fak
note Bantu language; subcategory of
Banen
AAT: nl
LCSH: nl
DDMM, ETHN, GPM 1959, GPM 1975,
HAB, HB, HBDW, IAI, IEZ, MGU 1967,
RGL, RJ 1958
MMML*
see also Banen
Balomotwa *see* LOMOTWA
BALONG (Cameroun)
variants Balun, Balung
note Bantu language
AAT: nl
LCSH: nl
CK, DDMM, ETHN, GPM 1975, HB,
HBDW, KFS 1989, KK 1965, MGU 1967,
MK, PH, RJ 1958
MMML*
Baloum *see* BALUM
Balovale *see* LUVALE
Balovedu *see* LOVEDU
Balozi *see* LOZI
Balualua *see* LWALU
Baluba *see* LUBA
Baluba *see* LUBA-HEMBA
BALUM (Cameroun)
variants Baloum
note Bantoid language; one of the
groups included in the collective
term Bamileke
AAT: nl
LCSH: nl
DDMM, ETHN, LP 1993, MMML, PH
see also Bamileke
Balumbi *see* RUMBI
Balumbo *see* LUMBO
Balumbu *see* LUMBU (Zaire)
Balun *see* BALONG
Balunda *see* LUNDA
Balundu *see* LONDO

Balung *see* BALONG
Baluyia *see* LUYIA
Balwalwa *see* LWALU
Bamako *see* Toponyms Index
BAMALA (Zaire)
note Bantu language; subcategory of
Songye
AAT: nl
LCSH: nl
LES
see also Songye
Bamalang *see* BAMBALANG
BAMALE (Cameroun)
variants Bamali
note Bantoid language
AAT: nl
LCSH: nl
ASH, DDMM, ETHN, KK 1960, KK 1965,
PH, TN 1984, TN 1986
GDR*, LP 1993*, MMML*
Bamali *see* BAMALE
BAMANA (Burkina Faso, Gambia,
Guinea, Mali, Senegal)
variants Bambara, Banmana
subcategories Beledugu, Somono
note Mande language; often
referred to by geographical and/or
regional divisions such as Bamana
of Bandiagara, Bougouni,
Bafoulabe, Dioila, Kolokani,
Koulikoro, Kutiala, Macina,
Niafunke, Mopti, San, Segou,
Sikasso, Somono. Some of these
denominations have political
implications, such as Beledugu-
ka-u, Kaarta-n-ka-u, Segu-n-ka-u.
see VP*
AAT: Bamana
LCSH: use Bambara
ACN, ASH, AW, BH 1966, BS, CDR 1985,
CFL, CK, CMK, DDMM, DF, DFHC,
DFM, DOA, DOWF, DWMB, EB, EBR,
EEWF, EFLH, ELZ, ETHN, EVA, EWA,
FW, GAC, GBJM, GBJS, GPM 1959, GPM
1975, GWS, HAB, HB, HBDW, HH, HMC,
HRZ, IAI,

JAF, JB, JD, JG 1963, JJM 1972, JK, JL,
JLS, JM, JP 1953, JPB, JPJM, JTSV, JV
1984, KE, KFS, KFS 1989, KK 1960, KK
1965, KMT 1970, KMT 1971, LJPG, LM,
LPR 1986, MH, MHN, MK, MLB, MLJD,
MPF 1992, NIB, PH, PMPO, PRM, PSG,
RFT 1974, RGL, RJ 1958, ROMC, RS
1980, RSAR, RSRW, RSW, SMI, SV, SV
1988, SVFN, TB, TFG, TLPM, TP, UIH,
WBF 1964, WEW 1973, WG 1980, WG
1984, WH, WMR, WOH, WRB, WRB
1959, WRNN, WS
DZ 1960*, DZ 1974*, DZ 1980*, GD
1972*, GD 1988*,MJA*, PJI*, PRM*,
RJG*, SBS*, VP*

see also Mande

Bamanga *see* MBA

BAMANYAN (Cameroun)
note one of the groups included in
 the collective term Bamileke
 AAT: nl
 LCSH: nl
 MMML
see also Bamileke

Bamarung *see* LUNGU

Bamassing *see* BAMESSING

Bamate *see* MATE

Bamaziba *see* MAZIBA

Bambagani *see* MBAGANI

Bambala *see* MBALA

BAMBALANG (Cameroun)
variants Bamalang, Bambolang
note Bantoid language
 AAT: nl
 LCSH: nl
 DDMM, ETHN, KK 1965, PH
 MMML*, GDR*

Bambara *see* BAMANA

Bambata *see* MBATA

Bambenga *see* BABINGA

Bambili *see* MBILI

Bambo *see* LUBA-BAMBO

Bambochi *see* MBOSHI

Bamboko *see* MBOKO (Cameroun)

Bambolang *see* BAMBALANG

Bambole *see* MBOLE (Zaire)

Bambote *see* MBUTI

Bambuba *see* MBUBA

BAMBUI (Cameroun)
variants Mbui, Bui
note Bantoid language
 AAT: nl
 LCSH: nl
 DDMM, ETHN, PH
 LP 1993*, MMML*, TN 1984*, TN 1986*

Bambulewe *see* BAMBULUE

BAMBULUE (Cameroun)
variants Bambulewe, Bambuluwe
note Bantoid language
 AAT: nl
 LCSH: nl
 DDMM, ETHN, KK 1965, PH
 LP 1993*

Bambuluwe *see* BAMBULUE

Bambunda *see* MBUUN

Bambuti *see* MBUTI

Bambuto Mountains *see* Toponyms
 Index

BAMEKA (Cameroun)
variants Meka
note Bantoid language; one of the
 groups included in the collective
 term Bamileke
 AAT: nl
 LCSH: Bameka language use Bamougoun-
 Bamenjou language
 DDMM, DWMB, ETHN, JK, KK 1960, KK
 1965, PH
 JPN*, LP 1993*, MMML*
see also Bamileke

Bamekom *see* KOM

BAMENA (Cameroun)
variants Mena
note Bantoid language; one of the
 groups included in the collective
 term Bamileke
 AAT: nl
 LCSH: nl
 DDMM, LP 1993
see also Bamileke

BAMENDA (Cameroun)

note A collective term for the larger and smaller kingdoms/chiefdoms of the Cameroun Grasslands, some incorporated into others, which resulted from the confluence of five major group migrations: Aghem, Bali, Mbembe, Tikar, Widekum. The former province of British Cameroons which was divided into twenty-three "native authority areas" grouped into four geographically based sets: the northwestern, northeastern, southwestern and southeastern. Includes the following: Aghem, Awing, Baba, Babanki, Babungo, Bafandji, Bafreng, Bafut, Bali, Balikumbat, Bamessing, Bamumkumbit, Bamunka, Batibo, Beba Befang, Esimbi, Esu, Fungom, Kom, Laabum, Laikom, Mankon, Mbaw, Mbem, Mbembe, Mbiami, Mbum, Meta, Mfumte, Misaje, Mogamaw, Ndop, Ndu, Ngemba, Ngie, Ngwo, Nkambe, Nsaw, Nsungli, Ntem, Oku, Tang, Tikar, Tungo, Widekum, Wiya, Wum.
AAT: nl
LCSH: nl
BS, CK, EBHK, ELZ, GPM 1959, HAB, HBDW, HMC, JK, JLS, JM, KFS, KK 1960, KK 1965, KMT 1971, LJPG, LPR 1986, PH, RFT 1974, RGL, RS 1980, RSW, SMI, TN 1986, WG 1980, WOH, WRNN, WS
GDR*, LP 1993*, MKW*, MMML*, PAG*, PMK*, TN 1973*, TN 1984*
see also Grasslands

BAMENDJINDA (Cameroun)
AAT: nl
LCSH: nl
ETHN, MMML, PH

BAMENDJING (Cameroun)

note Bantoid language; one of the groups included in the collective term Bamileke
AAT: nl
LCSH: nl
DDMM, ETHN, PH
MMML*
see also Bamileke

BAMENDJO (Cameroun)

variants Bamenjo, Bamendzo, Menjo

note Bantoid language; one of the groups included in the collective term Bamileke
AAT: nl (uses Bamenjo)
LCSH: nl
CK, DDMM, GPM 1975, JPN, PH, TN 1984, TN 1986, WRB
LP 1993*, MMML*
see also Bamileke

Bamendjou *see* BAMENJU

Bamendou *see* BAMENDU

BAMENDU (Cameroun)

variants Bamendou

note one of the groups included in the collective term Bamileke
AAT: nl
LCSH: nl
HB, LP 1993, MMML, PH
see also Bamileke

Bamendzo *see* BAMENDJO

Bamenjo *see* BAMENDJO

BAMENJU (Cameroun)

variants Bamendjou

note Bantoid language; one of the groups included in the collective term Bamileke
AAT: nl
LCSH: nl
GPM 1959, MMML, PH, WMR
JPN*, LP 1993*
see also Bamileke

BAMENKOMBO (Cameroun)
note Bantoid language; one of the
groups included in the collective
term Bamileke
AAT: nl
LCSH: nl
DDMM, LP 1993, MMML, PH
see also Bamileke

BAMENOM (Cameroun)
variants Bamenon
AAT: nl
LCSH: nl
EBHK, KK 1960, KK 1965, PH

Bamenon *see* BAMENOM

BAMENYAM (Cameroun)
note Bantoid language
AAT: nl
LCSH: nl
DDMM, PH, UIH
LP 1993*, MMML*

Bamessi *see* BABA

BAMESSING (Cameroun)
variants Bamassing, Nsei
note Bantoid language; one of the
groups included in the collective
term Bamenda
AAT: nl
LCSH: nl
CK, CMK, DDMM, EBHK, ELZ, ETHN,
GPM 1959, HAB, HB, HMC, JV 1984, KK
1960, KK 1965, KMT 1970, LM, PH, RJ
1958, RSW, TN 1973, TN 1984, TN 1986,
WOH
GDR*, LP 1993*, MMML*
see also Bamenda

BAMESSO (Cameroun)
note Bantoid language; one of the
groups included in the collective
term Bamileke
AAT: nl
LCSH: nl
DDMM, ETHN, KK 1965, LP 1993, PH
MMML*
see also Bamileke

Bameta *see* META

BAMETO (Cameroun)
AAT: nl
LCSH: nl
KK 1960

Bametta *see* META
Bamfinu *see* MFINU
Bamfumu *see* MFINU
Bamfumungu *see* MFINU
Bamfunu *see* MFUNU

BAMILEKE (Cameroun)
variants Mbalekeo, Mileke
note A collective term for the larger
and smaller chiefdoms/kingdoms
of the Cameroun Grasslands,
some incorporated into others,
which resulted from the
confluence of five major group
migrations: Anyang, Bafia, Mbo,
Tikar and Widekum. They have
been commonly grouped into four
major administrative divisions:
Bafang, Bafussam, Bangangte and
Dschang. Bamileke includes
Anyang, Babadju, Baboantu,
Bafou-Fondong, Bafu, Bafum,
Bafunda, Bagam, Bahuan,
Bakassa, Balang, Baleng,
Balessing, Balum, Bamanyan,
Bameka, Bamena, Bamendjing,
Bamendjo, Bamendu, Bamenju,
Bamenkombo, Bamesso,
Bamugong, Bamugum, Bana,
Bandenkop, Bandeng, Bandrefam,
Bangang, Bangangte, Bangulap,
Banjun, Banka, Bansoa, Bapa,
Bapi, Batam, Batcham,
Batchingu, Bati, Batie, Batufam,
Bayangam, Bazu, Dibum, Eastern
Bangwa, Elelem, Fegwa,
Fomopea, Fonchatula, Fongo-
Ndeng, Fongo-Tongo,
Fonjomekwet, Fontem, Foreke,
Fossong, Fotetsa, Fotomena,

Fotuni, Kekem, Mbo, Nkapa,
Pamben, and Tonga.
AAT: Bamileke
LCSH: Bamileke
ASH, BEL, BS, CFL, CK, DDMM, DFHC,
DOA, DP, DWMB, EBHK, EBR, ELZ, FW,
GBJM, GPM 1959, GPM 1975, HAB,
HBDW, HH, HMC, HRZ, IAI, IEZ, JAF,
JD, JJM 1972, JK, JLS, JP 1953, JPN,
JTSV, JV 1984, KFS, KFS 1989, KK 1965,
LJPG, LM, MCA, MH, MK, MLB, MLJD,
MPF 1992, NIB, PH, RFT 1974, RGL, RJ
1958, ROMC, RS 1980, RSAR, RSRW,
RSW, SD, SMI, SV, SVFN, TB, TLPM, TP,
UIH, WEW 1973, WFJP, WG 1980, WG
1984, WH, WOH, WRB, WRNN, WS
CT 1960*, GDR*, LP 1993*, MKW*,
MMML*, PAG*, RAL*, TN 1984*
see also Grasslands
Bamilembwe *see* MILEMBWE
Bamitaba *see* MBOMOTABA
Bamougong *see* BAMUGONG
Bamougoum *see* BAMUGUM
Bamoum *see* BAMUM
Bamoumkoumbit *see*
BAMUMKUMBIT
Bamoun *see* BAMUM
Bampanza *see* MPANZA
Bampeen *see* MBAL
BAMUGONG (Cameroun)
variants Bamougong
note Bantoid language; one of the
groups included in the collective
term Bamileke
AAT: nl
LCSH: nl
DDMM, EBHK, MMML
LP 1993*
see also Bamileke
BAMUGUM (Cameroun)
variants Bamougoum, Bamungom,
Bamungum, Bamungun
note Bantoid language; one of the
groups included in the collective
term Bamileke
AAT: nl
LCSH: nl
DDMM, HB, KK 1960, KK 1965, MMML
LP 1993*, PH*

see also Bamileke
Bamuku *see* OKU
BAMUM (Cameroun)
variants Bamoum, Bamoun,
Bamun, Banun, Mom, Mum, Mun
subcategories Mbot
note Bantoid language; term used
for both the people and the
kingdom. Fumban is the capital.
Unlike the Bamileke there are few
Bamum outside the kingdom
itself.
AAT: Bamum
LCSH: use Bamun
AF, ASH, BEL, BES, BS, CFL, CK, CMK,
DDMM, DFHC, DOA, DP, DWMB,
EBHK, EBR, ELZ, ESCK, ETHN, GAC,
GBJM, GPM 1959, GPM 1975, HAB, HB,
HBDW, HH, HMC, IAI, IEZ, JD, JJM
1972, JK, JL, JLS, JP 1953, JV 1984, KFS,
KFS 1989, KK 1965, KMT 1970, KMT
1971, LJPG, LM, LPR 1986, MG, MH,
MHN, MK, MLB, MLJD, MPF 1992, PH,
RFT 1974, RGL, RJ 1958, RS 1980,
RSAR, RSW, SMI, SV, TLPM, TN 1984,
UIH, WBF 1964, WG 1980, WH, WMR,
WOH, WRB, WRNN, WS
CMG*, CMG 1983*, CMG 1994*, CT
1980*, EPHE 4*, GDR*, LP 1993*,
MKW*, MMML*, PAG*
see also Grasslands
BAMUMKUMBIT (Cameroun)
variants Bamoumkoumbit
note one of the groups included in
the collective term Bamenda
AAT: nl
LCSH: nl
LP 1993, MMML, PH
see also Bamenda
Bamun *see* BAMUM
Bamungom *see* BAMUGUM
Bamungum *see* BAMUGUM
Bamungun *see* BAMUGUM

BAMUNKA (Cameroun)
 note Bantoid language; one of the
 groups included in the collective
 term Bamenda
 AAT: nl
 LCSH: nl
 DDMM, EBHK, ETHN, PH
 GDR*, LP 1993*, MMML*
 see also Bamenda

BAMWE (Zaire)
 note Bantu language; one of the
 groups included in the collective
 term Ngiri
 AAT: nl
 LCSH: nl
 DDMM, ETHN, HBU
 see also Ngiri

BANA (Cameroun)
 subcategories Djimi
 note Bantoid language; one of the
 groups included in the collective
 term Bamileke
 AAT: nl
 LCSH: Bana
 ASH, BEL, DDMM, ETHN, GPM 1959,
 GPM 1975, HB, IEZ, JPN, LJPG, PH, RJ
 1958, TN 1984
 LP 1993*, MMML*, TN 1986*
 see also Bamileke

Banande *see* KONJO

BANDA (Cameroun, Central African
 Republic, Sudan, Zaire)
 note Central Ubangian language
 AAT: nl
 LCSH: Banda
 ATMB, ATMB 1956, BES, BS, CSBS,
 DDMM, DFHC, DP, DPB 1987, DWMB,
 ELZ, ENS, ETHN, FE 1933, GAH 1950,
 GB, GPM 1959, GPM 1975, HAB, HB,
 HBU, HBDW, HCDR, IAI, JG 1963, JD,
 JLS, JMOB, JP 1953, LJPG, MH, MLJD,
 MPF 1992, OBZ, RAB, RSW, SMI, SVFN,
 TFG, UIH, WH

Bandaka *see* NDAKA

Bandama River *see* Toponyms Index

Bandassa *see* NDASA

BANDENG (Cameroun)
 note Bantoid language; one of the
 groups included in the collective
 term Bamileke
 AAT: nl
 LCSH: nl
 CK, DDMM, ETHN, GPM 1959, PH
 MMML*, TN 1986*, TN 1984*
 see also Bamileke

BANDENKOP (Cameroun)
 note one of the groups included in
 the collective term Bamileke
 AAT: nl
 LCSH: nl
 MMML
 see also Bamileke

Bandi *see* GBANDI

Bandiagara *see* Toponyms Index

Bandibu *see* NDIBU

Bandja *see* BANJA

Bandjabi *see* NJABI

Bandjoun *see* BANJUN

BANDREFAM (Cameroun)
 note Bantoid language; one of the
 groups included in the collective
 term Bamileke
 AAT: nl
 LCSH: nl
 DDMM, LP 1993, MMML, PH
 see also Bamileke

Bandzabi *see* NJABI

BANE (Cameroun)
 variants Bene
 note Bantu language; sometimes
 referred to as Northern Fang
 AAT: nl
 LCSH: nl
 BS, DDMM, ETHN, GPM 1959, GPM
 1975, HB, IEZ, KK 1965, LP 1979, LP
 1985, LP 1990, MGU 1967, MK, RJ 1958,
 WH, WMR, WS
 see also Beti

BANEN (Cameroun)
subcategories Balom, Banen proper, Bape, Ndiki, Yambasa
note Bantu language
AAT: nl
LCSH: Banen
BS, DDMM, ETHN, GPM 1959, GPM 1975, HB, IAI, IEZ, MGU 1967, RGL, RJ 1958, SMI, UIH, WH
ID*, MMML*

Banfora *see* Toponyms Index

Bangala *see* NGALA (Zaire)

Bangala *see* MBANGALA (Angola)

BANGAM (Cameroun)
AAT: nl
LCSH: nl
DDMM, MMML, PH

Bangandu *see* NGANDU

BANGANG (Cameroun)
note Bantoid language; one of the groups included in the collective term Bamileke
AAT: nl
LCSH: nl
DDMM, EBHK, ETHN, PH
LP 1993*
see also Bamileke

BANGANGTE (Cameroun)
variants Ngangte
note Bantoid language; one of the four administrative divisions of Bamileke
AAT: nl
LCSH: use Ngangte
DDMM, DWMB, ETHN, GDR, GPM 1959, GPM 1975, HAB, HB, HBDW, IAI, KFS, KK 1965, PH, RJ 1958, SMI, TN 1984, TN 1986, UIH
JPN*, LP 1993*, MMML*, PAG*
see also Bamileke

BANGANTU (Cameroun)
note Some sources divide into two groups: 1. Northern Bangantu, who speak a Bantu language; 2. Southern Bangantu, who speak a Western Ubangian language. see DDMM
AAT: nl
LCSH: nl

DB 1978, DDMM, ETHN, HB, WH

BANGBA (Zaire)
variants Abangba, Angba
note Western Ubangian language; closely related to the Mayogo; not to be confused with the Bantu-speaking Angba who are also in Zaire; There are two separate groups, both in Zaire called "Angba": 1. the Bangba who speak a Western Ubangian language and are closely related to the Mayogo, and 2. the Angba who speak a Bantu language and are closely related to the Bwa.
AAT: nl
LCSH: nl
ATMB, ATMB 1956, BES, CSBS, DB 1978, DDMM, DPB 1987, EB, ELZ, ESCK, GAH 1950, GPM 1959, GPM 1975, HB, HBDW, IAI, JG 1963, JMOB, KMT 1971, MGU 1967, OBZ, SMI, SV, UIH, WH
BJC*
see also Mayogo

Bangelima *see* NGELIMA

Bangende *see* NGEENDE

Bangengele *see* NGENGELE

BANGI (Congo Republic, Zaire)
variants Babangi, Bobangi
note Bantu language
AAT: Bangi
LCSH: nl
AF, DDMM, DPB 1985, DPB 1987, DWMB, ETHN, GAH 1950, GPM 1959, GPM 1975, HAB, HB, HBU, IAI, JC 1971, JMOB, OB 1973, OBZ, RGL, SD, SMI, UIH, WH, WMR, WRNN

Bangobango *see* BANGUBANGU

Bangomo *see* NGOM

Bangongo *see* NGONGO

35

BANGONGO (Zaire)
note Bantu language; subcategory of Songye
AAT: nl
LCSH: nl
ETHN, GAH 1950, GPM 1959, GPM 1975
LES*
see also Songye

Bangoombe *see* NGOOMBE

Bangou *see* BANGU

Bangoua *see* BANGWA

Bangoulap *see* BANGULAP

BANGU (Cameroun)
variants Bangou
note Bantoid langauge
AAT: nl
LCSH: nl
BES, CK, DDMM, EBHK, GPM 1959,
GPM 1975, KK 1965, TN 1984, TN 1986
MMML*, PH*

Bangua *see* BANGWA

BANGUBANGU (Zaire)
variants Bangobango
subcategories Kasenga, Mamba, Nonda, Zula
note Bantu language. The Bangubangu and the Zimba are known in recent literature as the Southern Binja, in contrast to the Songola or Northern Binja. Some Hemba are also known as Bangubangu.
AAT: nl
LCSH: Bangubangu language
CDR 1985, DDMM, DPB 1981, DPB 1986, DPB 1987, EB, ELZ, ETHN, FHCP, FN 1994, GPM 1959, GPM 1975, IAI, JAF, JC 1971, JC 1978, JK, JMOB, MGU 1967, MLF, OB 1961, OBZ, SMI, UIH, WMR, WS
AEM*
see also Binja

Bangui *see* BEBA BEFANG

BANGULAP (Cameroun)
variants Bangoulap
note Bantoid language; one of the groups included in the collective term Bamileke

AAT: nl
LCSH: nl
DDMM, KK 1965, LP 1993, MMML, PH
see also Bamileke

BANGWA (Cameroun)
variants Bangoua, Bangua, Ngwa, Nwe
note Bantoid languages; nine independent chiefdoms including Fontem, Fozimogndi, Fozomombin, Fossungo, Fonjumetor, Foto Dungatet, Foreke Chacha, and two chiefdoms called Fotabong; one of the groups included in the collective term Bamileke, sometimes divided into Eastern Bangwa (or Bamileke) and Western Bangwa (or Fontem)
AAT: use Ngwa
LCSH: Bangwa
BS, CDR 1985, CK, CMK, DDMM, DF, DFHC, DOA, DP, DWMB, EBHK, EBR, ELZ, ETHN, GIJ, GPM 1959, GPM 1975, HAB, HB, HBDW, IAI, JAF, JD, JK, JLS, JPN, JTSV, JV 1984, KK 1960, KK 1965, LM, MHN, MK, MLB, PH, RGL, RJ 1958, RSAR, SMI, SV, TN 1984, TN 1986, TP, WBF 1964, WG 1980, WRB, WRNN, WS
GDR*, LP 1993*, MMML*, PAG*, ROB*
see also Bamileke

Bangweemy *see* NGOOMBE

Bangweulu, Lake *see* Toponyms Index

Bangwoong *see* NGONGO

Bangyeen *see* NGEENDE

Bani *see* BALI (Cameroun)

BANJA (Cameroun)
variants Bandja
note Bantoid language
 AAT: nl
 LCSH: nl (uses Bandja)
 BS, DDMM, ETHN, SMI, WH
 PH*
Banjabi *see* NJABI
Banjoun *see* BANJUN
BANJUN (Cameroun)
variants Balengdjou, Bandjoun,
 Banjoun
note Bantoid language; one of the
 groups included in the collective
 term Bamileke
 AAT: nl
 LCSH: use Bandjoun
 DDMM, EBHK, ETHN, IAI, JLS, JPN, KK
 1965, RJ 1958, TN 1984, UIH, WRNN
 LP 1993*, MMML*, PH*, RME*, TN
 1986*
see also Bamileke
BANKA (Cameroun)
note Bantoid language; one of the
 groups included in the collective
 term Bamileke
 AAT: nl
 LCSH: nl
 DDMM, EBHK, ETHN, HB, JPN, KK
 1965, MM 1950, PH, TN 1984, TN 1986
 LP 1993*, MMML*
see also Bamileke
BANKAAN (Zaire)
note Bantu language; chiefdom of
 mixed ethnic composition
 AAT: nl
 LCSH: nl
 DPB 1985
Bankanu *see* NKANU
Bankassa *see* BAKASSA
Banki *see* BABANKI
BANKIM (Cameroun)
variants Kimi, Nkimi, Rifum
note Bantoid language; one of the
 Tikar chiefdoms in former French
 Cameroun
 AAT: nl
 LCSH: nl

 DDMM, ETHN, PH
 LP 1993*, PMK*, TN 1984*
see also Tikar
Bankon *see* ABO
Bankoni *see* Toponyms Index
Bankutshu *see* NKUTSHU
Banmana *see* BAMANA
Banoo *see* NOO
Bansapo *see* NSAPO
Banso *see* NSAW
BANSOA (Cameroun)
note Bantoid language; one of the
 groups included in the collective
 term Bamileke
 AAT: nl
 LCSH: Bansoa language use Bamougoun-
 Bamenjou language
 DDMM, EBHK, ETHN, HB, PH, TN 1984
 LP 1993*, MMML*, TN 1986*
see also Bamileke
Bansso *see* NSAW
Bantandu *see* NTANDU
Bantu Kavirondo *see* LUYIA
BANU (Central African Republic)
variants Gbanu
note Western Ubangian language
 AAT: nl
 LCSH: nl
 DB 1978, DDMM, ETHN, HB
Banun *see* BAMUM
Banyabungu *see* SHI
Banyakyusa *see* NYAKYUSA
Banyamituku *see* METOKO
Banyamwezi *see* NYAMWEZI
Banyang *see* ANYANG
Banyanga *see* NYANGA
Banyangi *see* ANYANG
Banyankole *see* NKOLE
Banyarwanda *see* RWANDA
Banyindu *see* NYINDU
BANYO (Cameroun)
 AAT: nl
 LCSH: nl
 ETHN, HB, KK 1965, PH, WOH
Banyoro *see* NYORO

BANYUN (Guinea, Senegal)
variants Bainuk, Baynuk, Baynunk
note West Atlantic language
AAT: Banyun
LCSH: nl
DDMM, DWMB, ELZ, ETHN, GPM 1959,
GPM 1975, HB, IAI, JG 1963, KFS, MPF
1992, RJ 1958, UIH, WH, WRB

Banza *see* MBANJA

Banziri *see* GBANZIRI

Baombo *see* OMBO

Baoule *see* BAULE

BAPA (Cameroun)
note Bantoid language; one of the
groups included in the collective
term Bamileke
AAT: nl
LCSH: nl
DDMM, ETHN, LP 1993, PH
see also Bamileke

BAPE (Cameroun)
note Bantu language; subcategory of
Banen
AAT: nl
LCSH: nl
DDMM, ETHN, GPM 1959, MMML
see also Banen

Bapedi *see* PEDI

Bapende *see* PENDE

Bapere *see* PERE

BAPI (Cameroun)
note Bantoid langauge; one of the
groups included in the collective
term Bamileke
AAT: nl
LCSH: nl
DDMM, GPM 1959
LP 1993*, MMML*, PH*
see also Bamileke

Bapili *see* PERE

Bapindi *see* PINDI

Bapindji *see* PINDI

Bapiri *see* PERE

Bapopoie *see* POPOI

Bapubi *see* BUBI

Bapunu *see* PUNU

Bapyaang *see* PYAANG

Baqqara *see* BAGGARA

BARA (Madagascar)
note Malagasi language
(Austronesian)
AAT: Bara
LCSH: Bara
BS, DDMM, DWMB, ETHN, GBJS, GPM
1959, GPM 1975, HAB, HB, HBDW, HRZ,
IAI, JK, JP 1953, KFS, SMI, SV, WH
CKJR*, JMA*

BARABAIG (Kenya, Tanzania)
variants Tatonga
note Southern Nilotic language;
subcategory of Tatog; one of the
groups included in the collective
term Nilo-Hamitic people
AAT: nl
LCSH: Barabaig
ATMB 1956, BS, DDMM, EBR, ECB,
ETHN, GPM 1959, GPM 1975, HB, IAI,
RJ 1960, SMI, UIH
GJK*, GWH 1969*
see also Nilo-Hamitic people, Tatog

BARABRA (Sudan)
note Eastern Sudanic language; one
of the groups included in the
collective term Nubians
AAT: nl
LCSH: nl
ATMB 1956, CSBS, GPM 1959, GPM
1975, HBDW, IAI, RJ 1959, WH
see also Nubians

Baraguyu *see* KWAFI

BARAMA (Gabon)
variants Bavarama
note Bantu language
AAT: nl
LCSH: nl
CK, DDMM, GPM 1959, GPM 1975,
ETHN, LP 1985, WH

Barambo *see* AGBARAMBO

Barambu *see* AGBARAMBO

BARAWA (Nigeria)
note Chadic language
AAT: Barawa
LCSH: nl
GPM 1959, GPM 1975, ETHN, JG 1963,
RS 1980, RWL, UIH

BARAYTUMA (Ethiopia, Kenya, Somalia)
variants Barentu
note Cushitic language; name for the eastern division of the Oromo; sometimes called Eastern Galla
AAT: nl
LCSH: nl
HB, WH, UIH
GWH 1955*, MOH*
see also Oromo

Barba *see* BARGU

Bardai *see* Toponyms Index

BAREA (Eritrea, Ethiopia)
variants Baria, Barya, Nara, Nera
note Eastern Sudanic language. Barea appears to be a derogatory term. Nara is preferred. see ETHN.
AAT: nl
LCSH: Baria
ATMB, ATMB 1956, DDMM, ETHN, GPM 1959, GPM 1975, HAB, HB, HBDW, IAI, JG 1963, KK 1990, RJ 1959, UIH, WH

Barentu *see* BARAYTUMA

BARGU (Benin, Nigeria)
variants Barba, Bariba, Borgawa
note Kwa language
AAT: Bargu
LCSH: use Bariba
BS, DDMM, DWMB, ETHN, GB, GPM 1959, GPM 1975, HAB, HB, HBDW, IAI, JD, JG 1963, JLS, JP 1953, KFS, KMT 1971, MLJD, NOI, RJ 1958, SD, SMI, UIH, WEW 1973, WFJP, WH, WOH
RP*

BARI (Sudan, Zaire)
variants Bai
subcategories Ligo, Marshia
note Eastern Nilotic language, one of the groups included in the collective term Nilo-Hamitic people
AAT: Bari
LCSH: Bari language
ASH, ATMB, ATMB 1956, BES, CFL, CK, CSBS, DDMM, DFHC, DOWF, DPB 1987, EBR, ELZ, ESCK, ETHN, GAH 1950, GPM 1959, GPM 1975, HAB, HB, HBDW,

IAI, JD, JG 1963, JLS, JMOB, KK 1960, KK 1990, LJPG, MLB, MLJD, MTKW, RJ 1959, RS 1980, RSW, SD, UIH, WBF 1964, WG 1980, WH, WOH, WRB, WRB 1959, WS
GWH*
see also Nilo-Hamitic people

Baria *see* BAREA

Bariba *see* BARGU

Baronga *see* TSONGA

Barotse *see* ROTSE

Barozwi *see* ROZWI

Barumbi *see* RUMBI

Barundi *see* RUNDI

BARWE (Malawi, Mozambique, Zimbabwe)
variants Rue
note Bantu language
AAT: nl
LCSH: Barwe
DDMM, ETHN, GPM 1959, GPM 1975, HB, MGU 1967, RJ 1961

Barya *see* BAREA

Basa *see* BASSA (Liberia)

BASA (Cameroun, Nigeria)
variants Bakoko, Basawa, Bassa, Koko
note Bantu language
AAT: use Bassa
LCSH: Basa
BS, CK, DDMM, ETHN, GPM 1959, GPM 1975, HAB, HB, HBDW, IAI, IEZ, JG 1963, JLS, KK 1965, LJPG, LP 1990, LP 1993, MGU 1967, MK, NIB, PH, RJ 1958, ROMC, RS 1980, SMI, TN 1984, UIH, WDH, WFJP, WH, WS
CHB*, HGFC*, JMEW*, NDB*

Basakata *see* SAKATA

Basalampasu *see* SALAMPASU

BASANGA (Zaire)
note Bantu language; subcategory of Songye
AAT: nl
LCSH: use Sanga
GAH 1950, GPM 1959, GPM 1975, JLS
LES*
see also Songye

Basange *see* BASSA NGE

Basa-Nge *see* BASSA NGE
Basango *see* SANGO
Basanze *see* SANZE
Basari *see* BASSARI (Guinea, Senegal)
Basari *see* BASSAR (Ghana, Togo)
Basawa *see* BASA (Cameroun, Nigeria)
Baseke *see* SHAKE
Basengele *see* SENGELE
Bashi *see* SHI
Bashibiyeeng *see* BIYEENG
Bashibukil *see* BUKIL
Bashibulaang *see* BULAANG
Bashi-Bushongo *see* BUSHOONG
Bashibushoong *see* BUSHOONG
Bashiidiing *see* IDIING
Bashikongo *see* KONGO
Bashilange *see* LULUWA
Bashileele *see* LEELE
Bashilele *see* LEELE
BASHILEP (Zaire)
 variants Ilebo, Ilibo
 note Bantu language; subcategory of Kuba
 AAT: nl
 LCSH: nl
 JC 1971, JC 1982, JMOB, JV 1978
 see also Kuba
Bashilyeel *see* LEELE
Bashobwa *see* SHOOWA
Bashoobo *see* SHOOWA
Bashu *see* SHU
Basikasingo *see* KASINGO
Basoko *see* SO (Zaire)
Basolongo *see* SOLONGO
Basonde *see* SOONDE
Basonge *see* SONGYE
Basongo *see* SONGO
Basongo Meno *see* SONGOMENO
Basongola *see* SONGOLA
Basongomeno *see* SONGOMENO
Basongora *see* SONGOLA
Basongye *see* SONGYE

BASSA (Liberia)
 variants Basa
 note Kwa language
 AAT: nl
 LCSH: Bassa
 BES, CMK, DDMM, DWMB, ETHN,
 GPM 1959, GPM 1975, GSGH, HAB, HB,
 HBDW, IAI, JG 1963, JK, JLS, MLB,
 RGL, RJ 1958, SMI, SV, TB, UIH, WEW
 1973, WG 1980, WMR, WOH, WRB,
 WRNN, WS
 GSDS*
Bassa *see* BASA (Cameroun, Nigeria)
BASSA KADUNA (Nigeria)
 note Benue-Congo language
 AAT: nl
 LCSH: nl
 DDMM, ETHN, GPM 1959
BASSA KOMO (Nigeria)
 note Benue-Congo language
 AAT: nl
 LCSH: nl
 DDMM, GPM 1959, GPM 1975, MKW
 1978, SV
BASSA NGE (Nigeria)
 variants Basa-Nge, Basange, Nge
 note Kwa language; subcategory of Nupe
 AAT: nl
 LCSH: use Nupe
 DDMM, ETHN, FW, GPM 1959, GPM
 1975, KK 1965, RWL, WBF 1964, WH
 YHH*
 see also Nupe
BASSAM (Côte d'Ivoire)
 AAT: nl
 LCSH: nl
 JPB, MG

BASSAR (Ghana, Togo)
variants Basari, Bassari
note Gur language;often linked with Kasele and Tobote; related to the Chamba
AAT: nl (uses Basari)
LCSH: nl (uses Bassari)
BS, DDMM, DWMB, ETHN, GPM 1959, HAB, HBDW, IAI, JCF, JG 1963, JLS, LJPG, MLJD, MPF 1992, RGL, RJ 1958, SMI, TFG, UIH, WH, WOH
HPH*, JJP*
see also Chamba, Kasele, Tobote

Bassari *see* BASSAR

BASSARI (Guinea, Senegal)
variants Basari, Belian
note West Atlantic language; one of the groups included in the collective term Tenda. They call themselves Belian.
AAT: nl
LCSH: Bassari
BS, DDMM, DWMB, ETHN, EWA, GPM 1959, GPM 1975, HB, HBDW, IAI, JCF, JG 1963, JJM 1972, LJPG, MCA, MH, MLJD, MPF 1992, RJ 1958, SMI, UIH
MDL*, MOG*
see also Tenda

BASUA (Zaire)
variants Asua, Sua
note Bantu language; one of the groups included in the collective term Pygmies
AAT: nl
LCSH: nl (uses Asua)
ESCK, HB, JG 1963, JMOB, UIH, WH
SB*
see also Pygmies

Basuku *see* SUKU

Basukuma *see* SUKUMA

Basundi *see* SUNDI

Basuto *see* SOTHO

Basutoland *see* Toponyms Index

Baswaga *see* SWAGA

BATA (Cameroun, Nigeria)
note Chadic language; one of the groups included in the collective term Kirdi
AAT: nl
LCSH: nl
DDMM, DWMB, ELZ, ETHN, GPM 1959, GPM 1975, HB, HBDW, IEZ, JG 1963, KK 1965, LP 1990, MBBH, NOI, RGL, RJ 1958, ROMC, RWL, UIH, WH, WOH
BEL*
see also Kirdi

BATABI (Cameroun)
AAT: nl
LCSH: nl
KK 1960, PH

Batabwa *see* TABWA

BATAM (Cameroun)
note Bantoid language; one of the groups included in the collective term Bamileke
AAT: nl
LCSH: nl
ETHN
see also Bamileke

BATAMMALIBA (Benin, Togo)
variants Betammaribe, Ditammari, Somba, Tamari, Tamberma
note Gur language
AAT: nl (uses Tamberma)
LCSH: use Somba
BS, DDMM, DWMB, ETHN, GPM 1959, GPM 1975, HAB, HB, HBDW, IAI, JLS, MLJD, RGL, RJ 1958, SMI, UIH, WH, WOH, WS
SPB 1987*

Batanga *see* TANGA

Batangi *see* TANGI

41

BATCHAM (Cameroun)
 variants Bacam, Bacham, Batsham, Cham
 note Bantoid language; one of the groups included in the collective term Bamileke
 AAT: nl (uses Cham)
 LCSH: nl
 DDMM, EBR, ELZ, ETHN, JD, JK, KK 1965, PH, TN 1984, WBF 1964, WG 1980, WRB, WRNN
 JPN*, LP 1993*, MMML*, PAG*, TN 1986*
 see also Bamileke
Batchingou *see* BATCHINGU
BATCHINGU (Cameroun)
 variants Batchingou, Batchoungou
 note Bantoid language; one of the groups included in the collective term Bamileke
 AAT: nl
 LCSH: nl
 DDMM, LP 1993, MMML, PH
 see also Bamileke
Batchopi *see* CHOPI
Batchoungou *see* BATCHINGU
Bateke *see* TEKE
Batembo *see* TEMBO
BATEMPA (Zaire)
 note Bantu language; subcategory of Songye
 AAT: nl
 LCSH: nl
 CDR 1985, CK, JMOB
 LES*
 see also Songye
Batende *see* YANZ
Batetela *see* TETELA
Bathonga *see* TSONGA
BATI (Cameroun)
 note Bantu language; one of the groups included in the collective term Bamileke
 AAT: use Beti
 LCSH: Bati language
 DDMM, ETHN, GPM 1959, GPM 1975, HBDW, JAF, KFS, KK 1965, MGU 1967
 LP 1993*, MMML*, PH*

 see also Bamileke
BATI (Zaire)
 variants Baati, Mobadi, Mobati, Benge
 note Bantu language
 AAT: nl
 LCSH: nl
 DDMM, ESCK, ETHN, GAH 1950, GPM 1959, GPM 1975, HB, JMOB, MGU 1967
BATIBO (Cameroun)
 variants Aghwi
 note Bantoid language; one of the groups included in the collective term Bamenda
 AAT: nl
 LCSH: nl
 DDMM, EBHK, ETHN, LP 1993
 MMML*, PH*
 see also Bamenda
BATIE (Cameroun)
 note Bantoid language; one of the groups included in the collective term Bamileke
 AAT: Batie
 LCSH: nl
 DDMM, ELZ, ETHN, JPN, MLB, WG 1980
 LP 1993*, PH*
 see also Bamileke
Batoa *see* TWA
Batoufam *see* BATUFAM
Batouffam *see* BATUFAM
Batouni *see* FOTUNI
Batsangi *see* TSANGI
Batsangui *see* TSANGI
Batsham *see* BATCHAM
Batshioko *see* CHOKWE
Batsilele *see* LEELE

BATU (Cameroun, Nigeria)
 note Bantoid language; one of the
 groups included in the collective
 term Tigong
 AAT: nl
 LCSH: nl
 DDMM, ETHN, GPM 1959, GPM 1975,
 JG 1963, RWL, WH
 see also Tigong
Batua *see* CWA
BATUFAM (Cameroun)
 variants Batoufam, Batouffam
 note Bantoid language; one of the
 groups included in the collective
 term Bamileke
 AAT: nl
 LCSH: nl
 DDMM, JAF, JPN, KK 1965, MMML, TN
 1984
 LP 1993*, PH*, TN 1986*
 see also Bamileke
Batumbwe *see* TUMBWE
Batutsi *see* TUTSI
Batwa *see* TWA
Bauchi *see* Toponyms Index
Bauchi *see* BAUSHI (Nigeria)
BAULE (Côte d'Ivoire)
 variants Baoule, Bawule
 subcategories Agba, Aitu, Akwe,
 Ayahu, Denkyira, Faafue, Gode,
 Nanafue, Ngban, Nzikpri, Saafwe,
 Satikran, Warebo
 note Kwa language; one of the
 groups included in the collective
 term Akan
 AAT: Baule
 LCSH: use Baoulé
 ACN, AF, ASH, AW, BES, BS, CDR 1985,
 CFL, CK, CMK, DDMM, DFM, DOA, DP,
 DWMB, EB, EBR, EEWF, EFLH, ELZ,
 ENS, ETHN, EVA, EWA, FW, GAC,
 GBJM, GBJS, GPM 1959, GPM 1975,
 GWS, HAB, HB, HBDW, HH, HMC, HRZ,
 IAI, JC 1971, JD, JEEL, JG 1963, JJM
 1972, JK, JL, JLS, JM, JP 1953, JPJM,
 JTSV, JV 1984, KFS, KFS 1989, KK 1960,
 KK 1965 , KMT 1970, KMT 1971, LJPG,
 LM, LP 1993, LSD, MG, MH, MK, MLB,
 MLJD, MPF 1992, MUD 1991, MWSV,

PMPO, RFT 1974, RGL, RJ 1958, ROMC,
RS 1980, RSAR, RSRW, RSW, SMI, SV,
SV 1986, SV 1988, SVFN, TB, TFG,
TLPM, TP, UIH, WBF 1964, WEW 1973,
WG 1980, WG 1984, WH, WMR, WOH,
WRB, WRB 1959, WRNN, WS
JPB*, PLR*, PLR 1980*
 see also Akan
Baunga *see* UNGA
Baushi *see* AUSHI (Zaire, Zambia)
BAUSHI (Nigeria)
 variants Bauchi
 note Benue-Congo language
 AAT: nl
 LCSH: nl
 DDMM, DWMB, ETHN, GPM 1959, HB,
 LJPG, LPR 1986, MPF 1992, NIB, NOI,
 RWL
Bavarama *see* BARAMA
Bavenda *see* VENDA
Bavili *see* VILI
Bavira *see* VIRA
Bavuma *see* VUMA
Bavuvi *see* BUBI
Bawenda *see* VENDA
Bawongo *see* WONGO
Bawoyo *see* WOYO
Bawule *see* BAULE
Bawumbu *see* WUMVU
Bawumbu *see* WUUM
Bay *see* BAI
Baya *see* GBAYA (Cameroun,
 Central African Republic)
Bayaka *see* YAKA
BAYANGAM (Cameroun)
 note Bantoid language; one of the
 groups included in the collective
 term Bamileke
 AAT: nl
 LCSH: nl
 DDMM, KK 1965, LP 1993, MMML, PH
 see also Bamileke
Bayansi *see* YANZ
Bayanzi *see* YANZ
Baye *see* BAI (Zaire)
Bayei *see* YEEI

Bayeke *see* YEKE
Bayembe *see* SONGYE
Bayew *see* YEW
Baynuk *see* BANYUN
Baynunk *see* BANYUN
Bayombe *see* YOMBE
BAYOT (Senegal)
note West Atlantic language
AAT: nl
LCSH: nl
DDMM, ETHN, GPM 1959, GPM 1979,
HB, RJ 1958, UIH
Bazela *see* ZELA
Bazimba *see* ZIMBA
Bazombo *see* ZOMBO
Bazou *see* BAZU
BAZU (Cameroun)
variants Bazou
note Bantoid language; one of the
groups included in the collective
term Bamileke
AAT: nl
LCSH: nl
DDMM, LP 1993, MMML, PH
see also Bamileke
Beafada *see* BIAFADA
BEBA BEFANG (Cameroun)
variants Bangui, Befang
note Bantoid language; one of the
groups included in the collective
term Bamenda
AAT: nl
LCSH: nl
DDMM, DWMB, ETHN, GPM 1959, GPM
1975, IEZ, LP 1993
PMK*
see also Bamenda
Bechuana *see* TSWANA
Bedawiye *see* BEJA
Bedere *see* ADELI
BEDIK (Guinea-Bissau, Senegal)
note West Atlantic language; one of
the groups included in the
collective term Tenda
AAT: nl
LCSH: Bedik

BS, DDMM, ETHN, GPM 1975, IAI, MPF
1992
see also Tenda
Bedja *see* BEJA
BEDOUIN (Algeria, Egypt, Libya,
Mali, Mauritania, Morocco, Niger,
Tunisia)
note Semitic language, Arabic;
collective term used to refer to
Alawiti, Arad, Bahariya,
Berabish, Brakna, Chaamba,
Cyrenaicans, Hamama, Hamyan,
Imraguen, Jebala, Jerid, Kunta,
Oulad Delim, Regeibat, Riyah,
Sanusi, Trarza, Ulad 'Ali, Uled
Nail, Uled Said, Zenaga *see* GPM
1959 for a more exhaustive listing
AAT: Bedouin
LCSH: Bedouins
BS, GPM 1959, GPM 1975, HBDW, JLS,
JM, LSD, SMI
FK*, PC*
BEELANDE (Zaire)
variants Builande, Ilande
note Bantu language; group situated
between the Songye and Luba-
Katanga
AAT: nl
LCSH: nl
DDMM, DPB 1987, FN 1994
LES*
Beembe *see* BEMBE (Congo
Republic)
Befang *see* BEBA BEFANG
Begho *see* Toponyms Index

BEJA (Egypt, Eritrea, Ethiopia, Sudan)
variants Bedawiye, Bedja
note Northern Cushitic language; a collective term used to refer to the Ababdah, Amarar, Beni Amer, Bilen, Bisharin, Hadendowa, Tigre
AAT: Beja
LCSH: Beja
AF, ARW, ATMB, ATMB 1956, BS, DDMM, ELZ, ETHN, GPM 1959, GPM 1975, HAB, HB, HBDW, HRZ, IAI, JG 1963, JLS, JM, LPR 1995, RJ 1959, ROMC, SMI, UIH, WH, WIS

Bekalebwe *see* KALEBWE
Bekom *see* KOM
Bekpak *see* BAFIA

BEKWARRA (Nigeria)
note Benue-Congo language
AAT: nl
LCSH: Bekwarra language
ETHN, RWL

Bekwil *see* KWELE

BELANDA (Sudan)
variants Bor Belanda
subcategories Bor, Bviri
note The term Belanda (or Bor Belanda) includes both the Bor (or JoBor), who speak a Western Nilotic langauge, and the Bviri (or Bor Bviri) who speak an Eastern Sudanic language.
AAT: nl
LCSH: Belanda language use Bor language
ATMB, CSBS, DDMM, ESCK, ETHN, HB, RJ 1959, UIH
AJB*

BELEDUGU (Mali)
variants Baladougou
note Mande language; subcategory of Bamana
AAT: nl
LCSH: nl
KK 1960, MLB, VP
see also Bamana

Belian *see* BASSARI

BELLA (Algeria, Mali, Niger)
note Berber language; one of the groups included in the collective term Berber
AAT: nl
LCSH: nl
AF, GPM 1959, HB, IAI, JP 1953, KFS, MPF 1992, RJ 1958
see also Berber

BELO (Cameroun)
AAT: nl
LCSH: nl
GDR, PH

BEMBA (Angola, Zaire, Zambia)
variants Awemba, Babemba, Wabemba, Wemba
note Bantu language
AAT: Bemba
LCSH: Bemba
ARW, ASH, BS, CDR 1985, CK, DDMM, DPB 1981, DPB 1986, DPB 1987, DWMB, EB, ELZ, ETHN, FN 1994, GAH 1950, GPM 1959, GPM 1975, HAB, HB, HBDW, HJK, HMC, IAI, JJM 1972, JK, JLS, JM, JMOB, JTSV, JV 1966, KK 1965, KK 1990, LJPG, MCA 1986, MGU 1967, MPF 1992, NIB, OB 1961, PMPO, RGL, RJ 1961, ROMC, RSW, SD, SMI, UIH, WDH, WG 1980, WH, WOH, WRB, WRB 1959, WS, WVB
ACPG*, AIR*, ECMG*, WWJS*

BEMBE (Congo Republic, Zaire)
variants Beembe
note Bantu language; subcategory of Kongo
AAT: Bembe (Lower Zaire)
LCSH: Bembe (West Africa)
ASH, CDR 1985, CMK, DDMM, DPB 1985, DPB 1987, EB, EEWF, ELZ, ETHN, EWA, GBJS, GPM 1959, GPM 1975, HH, HMC, JC 1971, JC 1978, JD, JK, JLS, JTSV, LM, MGU 1967, MK, MLB, MLJD, MPF 1992, MUD 1986, MUD 1991, OB 1961, RFT 1974, RGL, RLD 1974, RSAR, SG, SMI, SV, TERV, TLPM, TP, WBF 1964, WG 1980, WG 1984, WH, WMR, WRB, WS
see also Kongo

BEMBE (Zaire)

variants Babembe, Wabembe

note Bantu language. This group living in the Fizi and Mwanga zones of eastern Zaire is not to be confused with the Bembe who are a subcategory of Kongo or with the Bemba of Zambia. There are many groups living among the Bembe who are sometimes referred to by the collective term Pre-Bembe. see DPB 1981.

AAT: Bembe (North-eastern Zaire)
LCSH: Bembe (East Africa)
ALM, BES, CDR 1985, CFL, CK, DDMM, DP, DPB 1985, DPB 1987, ELZ, ETHN, FHCP, FN 1994, FW, GAH 1950, GPM 1959, GPM 1975, HAB, IAI, JC 1971, JC 1978, JD, JMOB, JTSV, LP 1985, MGU 1967, MHN, MLB, MLJD, MUD 1986, RGL, RS 1980, RSAR, RSW, SMI, SV, TERV, TLPM, TP, UIH, WG 1980, WG 1984, WH, WMR, WRB, WRNN, WS DPB 1986*, GED*

see also Pre-Bembe

Ben *see* GAN (Côte d'Ivoire)

Ben Eki *see* EKIIYE

BENA (Tanzania, Zambia)

variants Ubena, Wabena

note Bantu language

AAT: Bena
LCSH: Bena
DDMM, ECB, ETHN, GPM 1959, GPM 1975, HAB, HB, IAI, JLS, KK 1990, MGU 1967, MFMK, RJ 1960, SD, UIH, WH
ATC*

Bena Biombo *see* BIOMBO

Bena Kalebwe *see* KALEBWE

Bena Kanioka *see* KANYOK

BENA KAZEMBE (Zambia)

variants Kazembe, Lunda Kazembe

note Bantu language; a distinctive Lunda group called Lunda Kazembe after Chief Kazembe

AAT: nl
LCSH: nl
DPB 1987, GPM 1959, GPM 1975, EBHK, HB, RJ 1961, WH, WWJS

see also Lunda

Bena Lulua *see* LULUWA

Bena Luluwa *see* LULUWA

Bena Mai *see* KET

Bena Malungu *see* LUNGU

Bena Moyo *see* LULUWA

Bena Mpassa *see* MPASSA

Bena Mukuni *see* LENJE

Bena Niembo *see* NIEMBO

Bena Nsapo *see* NSAPO

BENDE (Kenya, Tanzania)

variants Wabende

note Bantu language

AAT: Bende (Kenya)
LCSH: nl
BES, DDMM, ECB, ETHN, FW, GPM 1959, GPM 1975, HB, IAI, JK, MFMK, RJ 1960, UIH, WBF 1964, WH, WRB

BENDE (Nigeria)

note Benue-Congo language; originally of Enyong origin but now considered a subcategory of Igbo; sometimes referred to as Southern Igbo

AAT: Bende (Igbo)
LCSH: nl
RWL
CFGJ*

see also Igbo

BENDE-BETE (Nigeria)

note Benue-Congo language; subcategory of Bete

AAT: nl
LCSH: nl
DDMM, ETHN, GPM 1975, RWL

see also Bete

Bene *see* BANE

Beneki *see* EKIIYE

Benekiiye *see* EKIIYE

Benembaho *see* GOMA

Benga *see* BABINGA

BENGA (Cameroun, Equatorial Guinea, Gabon)

note Bantu language; one of the groups included in the Bo-Mbongo cluster.

AAT: nl
LCSH: Benga language
DDMM, ETHN, GPM 1959, GPM 1975, LP 1979, LP 1985, LP 1990, WS

see also Bo-Mbongo

Benge *see* BATI (Zaire)

Benguela *see* Toponyms Index

BENI AMER (Ethiopia, Sudan)

variants Amer

note Northern Cushitic language; one of the groups included in the collective term Beja

AAT: use Amer
LCSH: Beni Amer
AF, ATMB 1956, CSBS, DDMM, DPB 1986, ETHN, GPM 1959, GPM 1975, HAB, HB, IAI, LPR 1995, RJ 1959, SMI, WH
WIS*

see also Beja

BENI MENASSER (Algeria)

note one of the groups included in the collective term Berber

AAT: nl
LCSH: nl
DDMM, GPM 1959, WH

see also Berber

BENI M'TIR (Morocco)

variants Ndhir

note Berber language; one of the groups included in the collective term Berber

AAT: nl
LCSH: Beni Mtir use Ndhir
GPM 1959, JLS

see also Berber

Beni Mukuni *see* LENJE

BENI MZAB (Algeria)

variants Mzab, Mozabites

note Berber language; one of the groups included in the collective term Berber

AAT: nl
LCSH: nl (uses Mzab language)
DDMM, ETHN, GPM 1959, GPM 1975, HAB, IAI, JLS, JPJM, LCB, WH

see also Berber

BENI SHANGUL (Ethiopia)

note Chari-Nile language; subcategory of Berta

AAT: nl
LCSH: nl
ATMB 1956, ETHN, GPM 1959, HB
ERC*

see also Berta

BENI YENNI (Algeria)

note Berber language; one of the groups included in the collective term Berber

AAT: nl
LCSH: nl
DBNV, HCF

see also Berber

BENIN (Nigeria)

note Kwa language. This term is used for a people, for an ancient kingdom circa 1100-1900's CE , and for the country formerly called Dahomey.

AAT: Benin
LCSH: Benin people use Bini; also Benin, art
AF, BDG 1980, BES, CDR 1985, CMK, DDMM, DF, DFHC, DFM, DOA, DOWF, DP, EB, EBR, EEWF, EL, ELZ, ETHN, EVA, FW, GAC, GBJM, GBJS, GIJ, GPM 1975, HAB, HB, HH, HJD, HRZ, IAI, JDC, JJM 1972, JK, JL, JLS, JM, JV 1984, KFS, KFS 1989, KK 1960, KK 1965, KMT 1970, KMT 1971, LM, LP 1993, LPR 1986, LPR 1995, LSD, MCA, MK, MLB, MUD 1991, PG 1990, PMPO, PR, RFT 1974, RGL, RJ 1958, ROMC, RS 1980, RSW, SG, SMI, SV, SV 1988, TFG, TLPM, UGH, WBF 1964, WG 1980, WG 1984, WH, WMR, WOH, WRB, WRB 1959, WRNN, WS
AD* , BF*, BWB*, CFPK*, EBWF*, KE 1992*, PBA*, PJD*, REB*, WBF 1982*

see also Bini

Benin River *see* Toponyms Index

BENUE (Cameroun, Nigeria)
note stylistic designation; also used as Benue-Congo to indicate a subdivision of the Niger-Congo language family
AAT: <Benue-Congo branch>
LCSH: Benue River
EBHK, EBR, ELZ, HRZ, JLS, JM, JV 1984, KFS, KK 1965, LM, MKW 1978,PH, RGL, ROMC, SMI, SV, SV 1986, WG 1980, WH
FN 1985*
see also Toponyms Index

Benzabi *see* NJABI

BEO (Zaire)
variants Babeo
note Bantu language
AAT: nl
LCSH: nl
DDMM, ETHN, GAH 1950, HB, JMOB, MGU 1967, OBZ, RS 1980

Berabich *see* BERABISH

BERABISH (Algeria)
variants Berabich
note Semitic language; one of the groups included in the collective term Bedouin
AAT: nl
LCSH: nl
GB, GPM 1959, GPM 1975, LPR 1995, WH
see also Bedouin

BERBER (Algeria, Egypt, Libya, Mauritania, Morocco, Tunisia)
note Berber language; a collective term for a number of peoples who are heavily dispersed from Mauritania to Egypt; includes the Ait Atta, Ait Ba Amran, Ait Ougersif, Ait Seghrouchen, Ait Youssi, Ayt Hadiddu, Bella, Beni Menasser, Beni M'tir, Beni Mzab, Beni Yenni, City Berber, Jebala, Ghadames, Hamama, Ida ou Nadif, Jerba, Kabyle, Nefusa, Rif, Senhaja, Shawia, Shluh, Siwa, Sous, Tamazight, Tekna, Tuareg.

see ANB* and GPM 1959 pp. 112-114 for a more exhaustive listing.
AAT: Berber
LCSH: Berbers
AF, ATMB, ATMB 1956, DDMM, DOA, EBR, ELZ, ETHN, EWA, GPM 1959, GPM 1975, HAB, HB, HRZ, IAI, JG 1963, JJM 1972, JLS, JPJM, JV 1984, KFS, LPR 1995, LSD, MPF 1992, NIB, PG 1990, PMPO, ROMC, SMI, TFG, TO, WEW 1973, WG 1984, WOH, WH, WRB
ANB*

BERGDAMA (Namibia, South Africa)
variants Bergdamara, Dama, Damara
note Khoisan language
AAT: Bergdama
LCSH: use Damara
ARW, ATMB 1956, DDMM, ETHN, GPM 1959, GPM 1975, HAB, HB, HRZ, IAI, UIH, WH, WOH
ALB*, IS*

Bergdamara *see* BERGDAMA

BERI (Chad, Sudan)
note Nilo-Saharan language; a collective name used for the Bideyat and Zaghawa who may also be in Libya and Niger. see ETHN.
AAT: nl
LCSH: use Zaghawa
AML, ATMB 1956, CSBS, DDMM, ETHN, GPM 1959, GPM 1975, HB, IAI, JLS, MPF 1992, RJ 1959, UIH, WH
MTJT*

Berom *see* BIROM

BERTA (Ethiopia, Sudan)
subcategories Beni Shangul
note Chari-Nile language
AAT: nl
LCSH: Berta
ATMB, ATMB 1956, CSBS, DDMM, ETHN, GPM 1959, GPM 1975, HAB, HB, IAI, ICWJ, JG 1963, JLS, RJ 1959, ROMC, SMI, UIH, WH
ERC*

BERTI (Sudan)

note Nilo-Saharan language

AAT: nl
LCSH: Berti
ATMB 1956, CSBS, DDMM, ETHN, GPM
1959, GPM 1975, HAB, HB, IAI, ICWJ, JG
1963, JLS, NIB, SMI
LAH 1991*

Beta Israel *see* FALASHA

Betammaribe *see* BATAMMALIBA

BETANIMENA (Madagascar)

note Malagasi language
(Austronesian)

AAT: nl
LCSH: nl
GPM 1959, HAB

BETE (Côte d'Ivoire, Nigeria)

note Kwa language; sometimes
divided into four groups: Daloa
(northern Bete), Gagnoa (eastern
Bete), Gbadi and Guiberoua
(central or western Bete), and the
Bende-Bete (Bete of Nigeria)

AAT: Bete
LCSH: Bété
AF, CDR 1985, CFL, CMK, DDMM,
DWMB, ETHN, EBR, EFLH, GBJS, GPM
1959, GPM 1975, HAB, HB, HMC, IAI,
JD, JEEL, JG 1963, JK, JLS, JP 1953,
JTSV, KFS, LM, MLB, MLJD, MPF 1992,
NOI, RGL, RJ 1958, RSW, SMI, TLPM,
TP, UIH, WBF 1964, WG 1980, WRB,
WRNN, WS
DP 1962*, JPB*

BETI (Cameroun)

variants Betsi

note Bantu language; a collective
term for the northern Fang,
sometimes including Fang,
Ewondo, Bane, Bulu, and others;
a Fang style/culture division. see
LP 1979, 1985, 1990*.

AAT: Beti
LCSH: Beti
DDMM, ETHN, GAC, GPM 1975, HAB,
HB, IAI, IEZ, JAF, JK, JLS, JV 1984, LM,
MK, MLB, MPF 1992, MUD 1986, NIB,
RGL, SG, SMI, UIH, WH, WRB, WS
LP 1979*, LP 1985*, LP 1990*, LP 1993*,
MAB 1993*, PAJB*, PLT*

see also Fang

Betibe *see* METYIBO

Betsi *see* BETI

BETSILEO (Madagascar)

note Malagasi language
(Austronesian)

AAT: nl
LCSH: Betsileos
DDMM, ELZ, ETHN, GPM 1959, GPM
1975, HAB, HB, IAI, JK, JLS, JP 1953,
JPJM, KFS, KK 1990, ROMC, SMI, SV,
WH, WOH
CKJR*, HMD*, JMA*

BETSIMISARAKA (Madagascar)

note Malagasi language
(Austronesian)

AAT: nl
LCSH: Betsimisaraka
DDMM, ETHN, GPM 1959, GPM 1975,
HB, JPJM
CKJR*, JMA*, PVC*

Bettie *see* BETTYE

BETTYE (Côte d'Ivoire, Ghana,
Togo)

variants Bettie

note Kwa language; subcategory of
Anyi

AAT: nl
LCSH: nl
GPM 1959, JPB

see also Anyi

BEYRU (Zaire)

variants Abelu, Aberu, Abulu,
Babelu, Babeyru

note Central Sudanic language; one
of the groups included in the
collective term Mangbetu

AAT: nl
LCSH: nl
DDMM, ESCK, ETHN, GAH 1950, GPM
1959, HAB, HB, JMOB, UIH, WH
JEL*

see also Mangbetu

BEZANOZANO (Madagascar)
 note Malagasi language
 (Austronesian)
 AAT: nl
 LCSH: Bezanozano
 DDMM, ETHN, GPM 1959, GPM 1975,
 HB, IAI
 CKJR*, JMA*
Bhaca *see* BHAKA
BHAKA (South Africa)
 variants Bhaca
 note Bantu language; subcategory of
 Nguni
 AAT: nl (uses Bhaca)
 LCSH: nl (uses Bhaca)
 DDMM, GPM 1959, GPM 1975, HAB,
 HB, JLS, UIH, WDH
 WDH 1962*
 see also Nguni
BIAFADA (Guinea-Bissau)
 variants Beafada, Yola
 note West Atlantic language
 AAT: nl
 LCSH: nl
 DDMM, DWMB, EB, ETHN, GPM 1959,
 GPM 1975, HB, HBDW, IAI, JG 1963 ,
 KFS, MPF 1992, RJ 1958, SV, UIH, WG
 1984, WH
Bida *see* Toponyms Index
BIDEYAT (Chad, Sudan)
 variants Bäle
 note Nilo-Saharan language; one of
 the groups included in the
 collective term Beri
 AAT: nl
 LCSH: nl
 AML, ATMB, ATMB 1956, DDMM,
 ETHN, GPM 1959, GPM 1975, HB, IAI,
 MPF 1992, UIH, WH
 MTJT*
 see also Beri
Bidjogo *see* BIDYOGO
BIDYOGO (Guinea-Bissau)
 variants Añaki, Bidjogo, Bijago,
 Bijogo, Bijugo, Bissago
 note West Atlantic language
 AAT: use Bijogo
 LCSH: use Bijago
 ASH, CFL, CMK, DDMM, DOA, DWMB,
 EBR, ETHN, GBJS, GPM 1959, GPM

1975, HAB, HB, HH, IAI, JD, JG 1963, JK,
JLS, JTSV, KFS 1989, KK 1960, KK 1965,
LJPG, MLB, MLJD, MPF 1992, MUD
1991, NIB, RFT 1974, RGL, RJ 1958, RS
1980, SMI, SV, SV 1988, TP, UIH, WBF
1964, WG 1980, WH, WMR, WOH, WRB,
WRNN, WS
DGD*
Bié *see* VIYE
Bieeng *see* BIYEENG
Bigo *see* Toponyms Index
Bijago *see* BIDYOGO
Bijogo *see* BIDYOGO
Bijugo *see* BIDYOGO
Bikom *see* KOM
Bila *see* BIRA
Bilala *see* BULALA
BILEN (Eritrea, Ethiopia)
 variants Bilin, Bogos
 note Central Cushitic language; one
 of the groups included in the
 collective term Beja. The Tigre
 are sometimes erroneously
 referred to as Bogos.
 AAT: nl
 LCSH: Bilen language use Bilin language
 ATMB 1956, DDMM, DWMB, ETHN,
 GPM 1959, GPM 1975, HB, JG 1963, RJ
 1959, UIH, WH
 WIS*
 see also Beja
Bili *see* PERE
Bilin *see* BILEN
BIM (Ghana)
 note Gur language; subcategory of
 Bimoba
 AAT: nl
 LCSH: nl
 ETHN
 MM 1951
 see also Bimoba

BIMAL (Somalia)
note one of the groups included in the collective term Sab
AAT: Bimal
LCSH: nl
GPM 1959, HB, IML 1969
see also Sab

Bimbia *see* ISUWU

BIMOBA (Ghana, Togo)
variants B'moba
subcategories Bim, Moba
note Gur language
AAT: nl
LCSH: Bimoba language use Moba language
DDMM, DWMB, ETHN, LPR 1969, LPR 1986, WH
MM 1951*

Bindi *see* BINJI

Bindji *see* BINJI

Binga *see* BABINGA

BINGA (Sudan)
note Central Sudanic language
AAT: nl
LCSH: nl
ATMB, DDMM, ETHN, HB, IAI, RJ 1959, UIH, WH

Bini *see* BINYE

BINI (Benin, Nigeria)
note Kwa language; the name used for the people of the Benin Kingdom whose language is Edo
AAT: Bini
LCSH: Bini
AW, CK, CMK, DDMM, DFHC, DWMB, ELZ, ETHN, FW, GPM 1959, GPM 1975, HB, HMC, IAI, JD, JG 1963, JJM 1972, JK, JL, JLS, KFS, KFS 1989, KK 1960, KMT 1970, KMT 1971, LM, MLJD, MKW 1978, NOI, RFT 1974, RGL, RJ 1958, ROMC, RSW, RWL, SMI, SV, UIH, WBF 1964, WG 1980, WG 1984, WH, WMR, WRB, WRB 1959
EBWF*, JB*, JB 1983*, PBA*
see also Benin, Edo

BINI-PORTUGUESE (Nigeria)
note One of the distinctive art forms and styles that are the product of acculturative movements in West Africa, sometimes referred to collectively as Afro-Portuguese
AAT: Bini-Portuguese
LCSH: nl
JLS, JPB, SV, SVFN
EBWF*
see also Afro-Portuguese

BINJA (Zaire)
variants Babindja, Mobindja
note Bantu language. Some groups within the Binja are designated by the terms Northern Binja (or Songola), and Southern Binja (Bangubangu and Zimba).
AAT: nl
LCSH: use Songola
CDR 1985, DDMM, DPB 1981, DPB 1986, DPB 1987, ETHN, FN 1994, IAI, JC 1978, OB 1961, SV

Binji *see* MBAGANI

BINJI (Zaire)
variants Babindji, Babinji, Bindi, Bindji
note Bantu language; sometimes confused with the Mbagani who are also called Binji
AAT: nl
LCSH: nl
CDR 1985, DDMM, DPB 1987, EBHK, ELZ, ETHN, GAH 1950, GPM 1959, GPM 1975, HB, JC 1971, JC 1978, JK, JMOB, JV 1984, MGU 1967, MLF, OB 1961, OB 1973, TERV, WRNN, WS
see also Mbagani

Binna *see* YUNGUR

BINYE (Côte d'Ivoire)
variants Bini
note Kwa language; subcategory of Anyi
AAT: nl
LCSH: nl
DDMM, DWMB, ETHN, JPB
see also Anyi

BINZA (Zaire)
variants Mabinza
note Bantu language; one of the
 groups included in the collective
 term Ngiri
 AAT: nl
 LCSH: nl
 DDMM, DPB 1987, ETHN, GPM 1959,
 GPM 1975, HB, JMOB, OB 1973
see also Ngiri
BIOMBO (Zaire)
variants Bena Biombo
note Bantu language
 AAT: Biombo
 LCSH: nl
 ALM, CDR 1985, DFHC, DPB 1987,
 FHCP, JC 1971, JC 1978, JD, MLF, OB
 1973, TERV, WG 1980, WRNN, WS
BIRA (Zaire)
variants Babila, Babira, Bila,
 Wabira
note Bantu language. There are
 considerable cultural diffferences
 between Bira living in the forest
 (Forest Bira)and those living in
 the savannah (Plains Bira).
 AAT: nl
 LCSH: Bira
 CDR 1985, DDMM, DPB 1986, DPB
 1987, DWMB, ESCK, ETHN, GAH 1950,
 GPM 1959, GPM 1975, HAB, HB, IAI,
 JJM 1972, JMOB, RGL, RS 1980, SD,
 SMI, WH
 HVGA*
Biri *see* BVIRI
BIRIFOR (Burkina Faso, Ghana)
variants Lober
note Gur language; one of the
 groups included in the collective
 term Dagara. There is some
 question as to whether the Lober
 are a subcategory or synonyous
 with the Birifor. see MM 1951.
 AAT: nl
 LCSH: Birifor
 CDR 1987, DDMM, DWMB, EFLH,
 ETHN, EWA, GPM 1959, GPM 1975,
 HAB, HB, IAI, JG 1963, JK, JLS, JPB,

LPR 1969, MLJD, MM 1952, RAB, SMI,
 UIH, WH
 GS*, MM 1951*
see also Dagara
BIRKED (Sudan)
note Eastern Sudanic language; one
 of the groups included in the
 collective term Nubians
 AAT: nl
 LCSH: nl
 AML, ATMB, ATMB 1956, CSBS,
 DDMM, ETHN, GPM 1959, GPM 1975,
 HB, JG 1963, UIH, WH
see also Nubians
BIROM (Nigeria)
variants Berom, Burum
note Benue-Congo language
 AAT: nl
 LCSH: Birom
 DDMM, DWMB, EBR, ETHN, GPM 1959,
 GPM 1975, HB, HDG, IAI, JG 1963, JLS,
 MPF 1992, NOI, RGL, RJ 1958, RSW,
 RWL, SD, UIH, WH
BISA (Burkina Faso, Ghana)
variants Bissa
note Mande language
 AAT: nl
 LCSH: Bisa
 CDR 1987, DDMM, DWMB, ETHN, GPM
 1959, GPM 1975, HAB, IAI, JG 1963, JLS,
 MPF 1992, RJ 1958, SMI, UIH, WH
 ACPG*
see also Mande
BISA (Zaire, Zambia)
variants Babisa, Wisa
note Bantu language
 AAT: nl
 LCSH: Bisa
 DDMM, DPB 1987, ETHN, GPM 1959,
 GPM 1975, HB, HJK, IAI, MGU 1967, RJ
 1961, UIH, WH, WVB
 WWJS*, SAM*

BISHARIN (Ethiopia, Sudan)
note Northern Cushitic language;
one of the groups included in the
collective term Beja
AAT: nl
LCSH: nl
ATMB 1956, DDMM, ELZ, ETHN, GPM
1959, GPM 1975, HAB, IAI, JJM 1972,
MCA 1986, RJ 1959, SMI, UIH, WOH
MLV*
see also Beja
Bisio *see* MABEA
Bissa *see* BISA (Burkina Faso,
Ghana)
Bissago *see* BIDYOGO
Bitare *see* YUKUTARE
BITEKU (Cameroun)
variants Bitieku
note Bantoid language; subcategory
of Anyang
AAT: nl
LCSH: nl
DDMM, KK 1965, RWL
see also Anyang
Bitieku *see* BITEKU
BIYEENG (Zaire)
variants Bashibiyeeng, Bieeng
note Bantu language; subcategory of
Kuba
AAT: nl
LCSH: nl
HB, JC 1982, JV 1978
see also Kuba
B'moba *see* BIMOBA
Boa *see* BWA (Zaire)
Bobai *see* BAI (Zaire)
Bobaie *see* BAI (Zaire)
Bobangi *see* BANGI
Bobe *see* BUBI
BOBO (Burkina Faso, Mali)
subcategories Bobo-Fing
note Mande language. The term
Bobo should not be applied to or
be confused with the Bwa, as has
been done previously. In earlier
literature, some distinctions were

made between these peoples using
terms such as Bobo-Fing and
Bobo-Oule. The Bobo-Fing speak
a Mande language while the
Bobo-Oule (see Bwa) speak a Gur
language.
AAT: Bobo
LCSH: Bobo
AF, ASH, CDR 1987, CFL, CK, CMK,
DDMM, DFM, DOA, DP, DWMB, EBR,
EEWF, ELZ, ETHN, EVA, EWA, FW,
GBJM, GPM 1959, GPM 1975, GWS,
HAB, HB, HH, HMC, IAI, JD, JJM 1972,
JK, JLS, JP 1953, JPB, KE, KFS, KFS
1989, KK 1965, KK 1960, KMT 1970, LM,
LPR 1986, MH, MLB, MLJD, MPF 1992,
PRM, RAB, RFT 1974, RGL, RJ 1958,
ROMC, RSAR, RSW, SD, SMI, TLPM,
UIH, WBF 1964, WH, WMR, WOH, WRB,
WRNN, WS
GLM*
Bobo-Dioulasso *see* Toponyms Index
BOBO-FING (Burkina Faso, Mali)
variants Sia
note Mande language; subcategory
of Bobo; sometimes known as Sia
(but see separate entry)
AAT: Bobo-Fing
LCSH: Bobo-Fing
CDR 1985, CMK, DDMM, DWMB,
ETHN, GPM 1959, GPM 1975, HB, IAI,
JD, MCA, RAB, RJ 1958, RSW, WG 1980
see also Bobo, Sia
Bobo-Oule *see* BWA (Burkina Faso)
Bobo-Ule *see* BWA (Burkina Faso)
Bocheba *see* MAKE
Bochi *see* MBOSHI
Bodiman *see* DWALA
BOGONGO (Central African
Republic)
note Bantu language
AAT: nl
LCSH: nl
DDMM, ETHN, MGU 1967
Bogos *see* BILEN

53

BOGOTO (Cameroun)
note Western Ubangian language
AAT: nl
LCSH: nl
DDMM, GPM 1959, GPM 1975, HB, MK

BOIN (Senegal)
variants Tenda Boeni
note West Atlantic language; one of
the groups included in the
collective term Tenda
AAT: nl
LCSH: nl
DDMM, HB, MDL, MPF 1992, UIH
see also Tenda

Bokala *see* KALA

BOKI (Nigeria)
variants Bokyi
note Benue-Congo language; one of
the groups included in the
collective term Cross River people
AAT: Boki
LCSH: nl
CFL, CK, DDMM, DWMB, ELZ, ETHN,
GIJ, GPM 1959, GPM 1975, HAB, HB,
JAF, JG 1963, JK, JLS, KFS, KK 1965, KK
1960, LP 1993, MKW 1978, NOI, PH,
RGL, RJ 1958, ROMC, RSW, RWL, SV,
TN 1986, UIH, WBF 1964, WEW 1973,
WG 1984, WH, WRB, WRNN, WS
see also Cross River people

Bokila *see* BUKIL

Bokkos *see* RON

Boko *see* BUSA (Nigeria)

Boko *see* WOKO (Cameroun)

BOKO (Zaire)
variants Iboko
note Bantu language
AAT: nl
LCSH: nl
DPB 1987, ETHN, GAH 1950, HB, JMOB,
OBZ

BOKONGO (Zaire)
note Bantu language; subcategory of
Mongo
AAT: nl
LCSH: nl
DPB 1985, DPB 1987, GAH 1950, GPM
1959, JMOB
see also Mongo

BOKOTE (Zaire)
note Bantu language; subcategory of
Mongo
AAT: nl
LCSH: nl
DPB 1987, GAH 1950, GPM 1959, HB,
JMOB
see also Mongo

Bokyi *see* BOKI

Bole *see* BOLEWA (Nigeria)

Bole *see* MBOLE (Zaire)

Bolem *see* BULOM

BOLEMBA (Zaire)
note Bantu language; subcategory of
Mongo
AAT: nl
LCSH: nl
ETHN, GPM 1959, UIH
see also Mongo

BOLENDO (Zaire)
note Bantu language
AAT: nl
LCSH: nl
DDMM, DPB 1985, GAH 1950, HB,
JMOB

BOLEWA (Nigeria)
variants Bole, Fika
note Chadic language
AAT: nl
LCSH: Bolewa language
DDMM, ETHN, GPM 1959, GPM 1975,
HB, JG 1963, NIB, NOI, RAB, RJ 1958,
RWL, UIH, WH

BOLIA (Zaire)
variants Lia
note Bantu language
AAT: Bolia
LCSH: Bolia language
DDMM, DPB 1985, DPB 1986, DPB 1987,
ETHN, GAH 1950, GPM 1959, GPM
1975, HAB, HB, IAI, JPB, JMOB, JV 1966,
MGU 1967, UIH, WH, WRB

Bolo *see* LIBOLO (Angola)

BOLO (Liberia)
note Kwa language
AAT: nl
LCSH: nl
DDMM

Bolô *see* BOLON

Boloki *see* LOKI

Bolom *see* BULOM

BOLON (Burkina Faso, Mali)
variants Bolô, Boron
note Mande language; subcategory
of Marka
AAT: nl
LCSH: nl
CDR 1987, DDMM, ETHN, HB, IAI, JK,
JLS, MPF 1992, SG
see also Marka

Boma *see* BUMA (Zaire)

Boma *see* MBOMA (Zaire)

Bomboko *see* MBOKO (Cameroun)

BOMBOLI (Congo Republic, Zaire)
note Bantu language
AAT: nl
LCSH: nl
DDMM, DPB 1987, ETHN, GAH 1950,
HB, HBU

BO-MBONGO (Cameroun)
note a collective term for an
ensemble of forest dwelling
coastal populations of Cameroun,
including the Benga, Dwala,
Limba, Noo, and Tanga
AAT: nl
LCSH: nl
MAB

BOMBWANJA (Zaire)
note Bantu language; subcategory of
Mongo
AAT: nl
LCSH: nl
GAH, HB, JMOB
see also Mongo

Bomitaba *see* MBOMOTABA

Bomu River *see* Toponyms Index

BOMVANA (South Africa)
variants Bomwana
note Bantu language
AAT: nl
LCSH: Bomvana
DDMM, ETHN, GPM 1959, GPM 1975,
HB, JLS, UIH, WDH

Bomwana *see* BOMVANA

Bon *see* BONI

BONDEI (Tanzania)
variants Wabondei
note Bantu language
AAT: Bondei
LCSH: Bondei language
DDMM, ECB, ELZ, ETHN, GPM 1959,
GPM 1975, HB, IAI, KK 1990, MFMK,
MGU 1967, UIH, RJ 1960, WH, WOH

Bondo *see* MBONDO

Bondoukou *see* Toponyms Index

BONGILI (Congo Republic)
variants Bongiri
note Bantu language
AAT: nl
LCSH: nl
DDMM, ETHN, JMOB, MGU 1967, UIH

Bongiri *see* BONGILI

Bongo *see* ABONGO (Gabon)

Bongo *see* PONGO (Cameroun)

BONGO (Sudan)
note Central Sudanic language
AAT: Bongo
LCSH: Bongo
ATMB, ATMB 1956, BES, CSBS, DDMM,
DOWF, DPB 1987, EBR, ELZ, ESCK,
ETHN, GB, GPM 1959, GPM 1975, HAB,
HB, JD, JG 1963, JK, JLS, KK 1990,
MLJD, NIB, RJ 1959, SMI, TP, UIH, WG
1980, WG 1984, WH, WRNN, WS

BONGOMO (Gabon)
note Bantu language; subcategory of
Kele
AAT: nl
LCSH: nl
LP 1985
see also Kele

BONGOR (Cameroun, Chad)
note Chadic language; subcategory
of Massa
AAT: nl
LCSH: nl
DDMM, ETHN, HB, IDG
see also Massa

BONI (Kenya, Somalia)
variants Bon
note Eastern Cushitic language
AAT: nl
LCSH: Boni language
ATMB 1956, DDMM, ECB, ETHN, GPM
1959, GPM 1975 HAB, HB, IAI, MUD
1991, RJ 1959, RS 1980, SV, UIH, WH
BONKENG (Cameroun)
note Bantu language
AAT: nl
LCSH: nl
DDMM, HB, MGU 1967, MMML
Bonkese *see* NDENGESE
Bono *see* ABRON
Bono-Mansu *see* Toponyms Index
BOO (Congo Republic)
note Bantu language; subcategory of
Teke
AAT: nl
LCSH: nl
DDMM, DPB 1985, ETHN, JV 1973,
MGU 1967
see also Teke
Booli *see* OLI (Zaire)
BOONDE (Zaire)
note Bantu language; subcategory of
Mongo
AAT: nl
LCSH: nl
GAH 1950, HB
see also Mongo
BOR (Sudan)
variants JoBor
note Western Nilotic language; one
of the groups included in the
collective terms Belanda and
Nilotic people; sometimes referred
to as Northern Lwoo
AAT: nl
LCSH: Bor language and dialect (Lwo)
ATMB, ATMB 1956, CSBS, DDMM,
ETHN, GPM 1959, GPM 1975, HAB, HB,
IAI, JG 1963, RJ 1959, UIH, WH
AJB*
see also Belanda, Lwoo, Nilotic
people
Bor Belanda *see* BELANDA

Bor Bviri *see* BVIRI
BORAN (Ethiopia, Kenya, Somalia)
variants Borana
note Eastern Cushitic language; a
western subdivision of the Oromo;
sometimes called Western Galla
AAT: nl (uses Borana)
LCSH: Boran
AF, ATMB 1956, DBNV, DDMM, ECB,
ELZ, ETHN, GPM 1959, GPM 1975, HAB,
HB, IAI, IML 1969, JLS, MCA 1986, RJ
1959, ROMC, RS 1980, SMI, TP, UIH,
WH, WRB
see also Oromo
Borana *see* BORAN
Borgawa *see* BARGU
Borkou *see* BORKU
BORKU (Chad)
variants Borkou
note ancient kingdom and region in
northern Chad
AAT: nl
LCSH: nl
GPM 1975, UGH
BORNU (Nigeria)
variants Bournou
note ancient kingdom later allied
with the Kanem kingdom; often
referred to as Kanem-Bornu
AAT: nl
LCSH: use Kanuri
BD, DFHC, ELZ, ETHN, GBJM, GPM
1959, HB, HRZ, JDC, JJM 1972, JM, KFS,
LPR 1986, NOI, RAB, RGL, RJ 1958,
ROMC, SMI, WOH
ABJ*
see also Kanem
Boro *see* BURU
Boron *see* BOLON

BORORO (Chad, Mali, Niger,
Senegal, Sudan)
variants Bororo'en
note West Atlantic language; may
be used as a variant name for the
Fulani or more specifically used
for nomadic pastoralist groups of
Fulani
AAT: Bororo
LCSH: Bororo
AF, CEH, DDMM, EBR, ETHN, GPM
1959, GPM 1975, HAB, HB, HMC, HRZ,
IAI, IEZ, JJM 1972, JL, JLS, MH, RJ 1958,
RSW, SMI, WH
AG*
see also Fulani
Bororo'en *see* BORORO
Bosaka *see* SAKA
Boskop *see* Toponyms Index
Bouaka *see* NGBAKA
Boudouma *see* BUDUMA
Boulala *see* BULALA
Boulou *see* BULU
Boum *see* MBUM
Bournou *see* BORNU
Boyela *see* YELA
BOYO (Zaire)
variants Babuye, Babuyu, Buye,
Buyi, Buyu, Wabuye
note Bantu language; a complex
ethnic group composed of small
chiefdoms, such as Hucwe and
Sumba; frequently confused with
Hemba and Luba-Hemba
AAT: Boyo
LCSH: nl (uses Hemba)
CDR 1985, CFL, DDMM, DPB 1986, DPB
1987, EB, ELZ, ETHN, FN 1994, GAH
1950, GPM 1959, GPM 1975, HB, IAI,
JAF, JC 1971, JC 1978, JD, JK, JMOB,
LM, MGU 1967, MK, MLB, MLF, MLJD,
OB 1961, RGL, RSRW, RSW, TERV, TP,
WG 1980, WG 1984, WH, WOH, WRNN,
WS
DPB 1981*
BOZO (Mali)
variants Sorko, Sorogo
note Mande language

AAT: Bozo
LCSH: Bozo
BS, CFL, DDMM, DP, DWMB, EB,
ETHN, GPM 1959, GPM 1975, HAB, HB,
HBDW, HRZ, IAI, JAF, JD, JK, JLS, JM,
JP 1953, KFS, KFS 1989, LM, LPR 1986,
MLB, MLJD, MPF 1992, PRM, RGL, RJ
1958, ROMC, RSW, SMI, SV, SVFN, UIH,
WG 1980, WG 1984, WH, WOH, WRNN,
WS
ZL*
BRAKNA (Mauritania)
note Semitic language; one of the
groups included in the collective
term Bedouin
AAT: nl
LCSH: Brakna
GPM 1959, GPM 1975, IAI, LPR 1995, RJ
1958, WH
see also Bedouin
Brandberg *see* Toponyms Index
Brass *see* NEMBE
Brignan *see* AVIKAM
Brisa *see* AOWIN
Brissa *see* AOWIN
British Camerouns *see* Toponyms
Index
British East Africa *see* Toponyms
Index
British Somaliland *see* Toponyms
Index
Bron *see* ABRON
Brong *see* ABRON
Bua *see* BWA (Zaire)
Bube *see* BUBI
BUBI (Equatorial Guinea)
variants Bapubi, Bavuvi, Bobe,
Bube, Ediya, Pouvi, Povi, Pubi,
Puvi, Vouvi, Vuvi
note Bantu language
AAT: Bubi
LCSH: Bubi
BES, CDR 1985, CK, DDMM, ETHN,
GPM 1975, HB, IAI, JLS, JM, LP 1979, LP
1985, MGU 1967, MLB, MLJD, RGL, SG,
SMI, SV, UIH, WH, WRNN, WS
SC*

Budama *see* JO PADHOLA
Buddu *see* GANDA
BUDIA (Zaire)
note Bantu language
AAT: nl
LCSH: nl
DDMM, DPB 1987
BUDIGRI (Central African
Republic)
note Western Ubangian language
AAT: nl
LCSH: nl
DB 1978, DDMM, ETHN, HB
Budja *see* MBUJA
BUDU (Zaire)
variants Mabodu, Mabudu
note Bantu language
AAT: Budu
LCSH: nl
DDMM, DPB 1987, ESCK, ETHN, GAH
1950, GPM 1959, GPM 1975, HAB, HB,
JMOB, KMT 1971, NIB, UIH, WH, WRB
HVG 1960*
BUDUMA (Cameroun, Chad, Niger,
Nigeria)
variants Boudouma, Yedina,
Yidena
note Chadic language
AAT: nl
LCSH: Buduma
AML, DB, DDMM, DWMB, ETHN, GPM
1959, GPM 1975, HB, IAI, IEZ, JG 1963,
JP 1953, JPAL, MLJD, NOI, ROMC, RWL,
SMI, UIH, WH, WOH
BUGANDA (Uganda)
note ancient kingdom
AAT: nl
LCSH: nl
AIR 1959, BD, DPB 1986, ECB, HB, PG
1990, WG 1984
BUGUDUM (Chad)
note Chadic language; subcategory
of Massa; one of the groups
included in the collective term
Kirdi
AAT: nl
LCSH: nl
ETHN, HB, JP 1953, IDG
see also Kirdi, Massa

Buha *see* HA
Buhaya *see* HAYA
BUHWEJU (Uganda)
note a subcategory of Nkole; one of
the kingdoms included in the
Nyankore kingdom
AAT: nl
LCSH: nl
BKT
see also Nkole
Bui *see* BAMBUI
Builande *see* BEELANDE
BUILSA (Burkina Faso, Ghana)
variants Buli, Bulsa
note Gur language
AAT: nl
LCSH: Builsa
AF, DDMM, DF, ELZ, ETHN, GPM 1959,
GPM 1975, HB, HCDR, IAI, JLS, LPR
1969, RGL, SMI, UIH, WH
Buja *see* MBUJA
BUJWE (Zaire)
variants Babujwe
note Bantu language; also
sometimes used as a variant of
Boyo
AAT: nl
LCSH: nl
DDMM, DPB 1981, DPB 1986, DPB 1987,
ETHN
see also Boyo
BUKIL (Zaire)
variants Bashibukil, Bokila
note Bantu language; subcategory of
Kuba
AAT: nl
LCSH: nl
JC 1982, JV 1978
see also Kuba

BUKUSU (Kenya)
variants Babukusu, Kitosh, Vugusu
note Bantu language; subcategory of
Luyia
AAT: nl
LCSH: use Kusu
DDMM, ECB, ETHN, GPM 1959, GPM
1975, HB, JLS, UIH, WRB 1959
FEM*
see also Luyia

Bukwaya *see* JITA

BUL (Sudan)
note West Nilotic language;
subcategory of Nuer
AAT: nl
LCSH: nl
DDMM, ETHN, WH
see also Nuer

BULAANG (Zaire)
variants Bashibulaang
note Bantu language; subcategory of
Kuba
AAT: nl
LCSH: nl
CDR 1985, HB, JC 1982, JV 1978
see also Kuba

BULAHAY (Cameroun)
note Chadic language; subcategory
of Matakam
AAT: nl
LCSH: nl (Bulahai use Matakam)
HB, JLS, RWL
see also Matakam

BULALA (Chad)
variants Bilala, Boulala
note Central Sudanic language;also
ancient 14th-15th century
kingdom with various small
freeholdings; a composite
population, the result of a scission
with Kanembu
AAT: nl
LCSH: nl
AML, ATMB, DDMM, ETHN, GPM 1959,
GPM 1975, HB, UIH, WOH
see also Kanembu

Bulawayo *see* Toponyms Index

Buli *see* BUILSA

Bulibuli *see* AMBA

Bullom *see* BULOM

BULOM (Guinea, Sierra Leone)
variants Bolem, Bolom, Bullom
note West Atlantic language;
sometimes referred to as Sherbro
or Sapi-Portuguese. The Bulom,
Sherbro and Krim are closely
connected to and often confused
with each other.
AAT: use Sapi-Portugese; Sherbro
LCSH: Bulom language use Bullom
language
CK, DDMM, DWMB, ETHN, FW, GB,
GPM 1959, GPM 1975, HAB, HB, IAI, JG
1963, JK, JLS, JV 1984, RJ 1958, RS 1980,
RSW, SG, SMI, SV, UIH, WG 1984, WH,
WRB, WRNN, WS
MEM 1950*
see also Sapi-Portuguese, Sherbro

Bulsa *see* BUILSA

BULU (Cameroun, Gabon)
variants Boulou
note Bantu language; subcategory of
Fang
AAT: Bulu
LCSH: Bulu
AW, DDMM, ELZ, ETHN, GPM 1959,
GPM 1975, GSGH, HAB, HB, IAI, IEZ,
JAF, JJM 1972, JK, JLS, KK 1960 , KK
1965, LP 1979, LP 1985, LP 1990, LP
1993, MGU 1967, MK, MLB, MLJD, MPF
1992, RGL, RJ 1958, SMI, UIH, WEW
1973, WH, WMR, WOH, WRB, WS
PAJB*
see also Fang

Bum *see* MBUM (Cameroun)

BUM (Cameroun)
note Bantoid language; not the
same as the Mbum of Cameroun
and Central African Republic,
who speak an Adamawa language
AAT: nl
LCSH: nl
DDMM, DWMB, ETHN, GPM 1959, GPM
1975, RFT 1974

BUMA (Zaire)

variants Baboma, Boma

note Bantu language; situated in southwestern Zaire on the Kwa River; not to be confused with the Mboma, who are also in Zaire and referred to as Baboma. Some sources may not be sufficiently explicit to make a critical judgment to which group they belong.

AAT: nl (uses Boma)
LCSH: use Boma
ASH, DDMM, DPB 1985, ETHN, GAH 1950, GPM 1959, HB, IAI, JMOB, JV 1966, MGU 1967, OB 1973 HEH*, RT*

Bunda *see* MBUUN (Zaire)

Bunda *see* MBUNDA (Angola)

Bundali *see* NDALI

BUNGU (Tanzania)

note Bantu language

AAT: nl
LCSH: nl
DDMM, ETHN, GPM 1975, HB, IAI, JV 1966, KK 1990, MFMK, MGU 1967, WVB

BUNU (Nigeria)

note Kwa language; subcategory of Yoruba

AAT: nl
LCSH: nl
DDMM, ETHN, GPM 1959, GPM 1975, KK 1965, JLS, RWL, WH

see also Yoruba

Bunyoro *see* NYORO

BURA (Nigeria)

note Chadic language. Bura may be closely related to or synonymous with Pabir.

AAT: Bura
LCSH: nl
DDMM, DWMB, ELZ, ETHN, GPM 1959, GPM 1975, HAB, HB, IAI, JG 1963, JK, JLS, NOI, RJ 1958, RWL, UIH, WH, WRB, WS

see also Pabir

BURAKA (Central African Republic, Zaire)

note Western Ubangian language

AAT: nl
LCSH: nl
ATMB, ATMB 1956, DB 1978, DDMM, DPB 1987, ETHN, FE 1933, GPM 1959, GPM 1975, HAB, HBU, JMOB

BURU (Zaire)

variants Boro

note Bantu language; one of the groups included in the collective term Ngelima

AAT: nl
LCSH: nl
DDMM, ETHN, HB, MGU 1967, SV, UIH

see also Ngelima

Burum *see* BIROM

BURUN (Ethiopia, Sudan)

note West Nilotic language; one of the groups included in the collective term Nilotic people; sometimes distinguished as Northern and Southern Burun; one of the groups referred to as Northern Lwoo

AAT: nl
LCSH: nl
ATMB 1956, CSBS, DDMM, EBR, ELZ, ETHN, GPM 1959, GPM 1975, HAB, HB, IAI, ICWJ, JG 1963, RJ 1959, UIH, WH AJB*

see also Lwoo, Nilotic people

BURUNGI (Tanzania)

note Southern Cushitic language; closely related to or subcategory of Iraqw

AAT: nl
LCSH: nl
ATMB 1956, DDMM, ECB, ETHN, GPM 1959, GPM 1975, GWH 1969, HB, IAI, JG 1963, KK 1990, MFMK, RJ 1960, UIH, WH, WOH

see also Iraqw

BUSA (Benin, Nigeria)
variants Boko, Busawa
note Mande language; known as
Busa in Nigeria and Boko in
Benin
AAT: nl
LCSH: Busa language
DDMM, DWMB, ETHN, GPM 1959, GPM
1975, HB, IAI, JG 1963, NOI, RJ 1958,
RWL, SMI, UIH, WH
see also Mande

Busawa *see* BUSA

Bushamaye *see* SHAMAYE

Bushmaye *see* SHAMAYE

BUSHMEN (Angola, Botswana,
Namibia, South Africa)
variants San
note Khoisan language; a collective
term for various Khoisan speaking
peoples of southern Africa
including Auen, Auni, Heikum,
Hiechware, Hoa, Hukwe, Koroca,
Kung, Namib, Naron, Okung,
San, Xam. The term 'San' is
sometimes considered a general or
collective term for all Bushmen
people.
AAT: use San
LCSH: use San
ATMB, ATMB 1956, DDMM, DFHC,
DOWF, EBR, ELZ, ETHN, EWA, FW, GB,
GBJM, GPM 1959, GPM 1975, HMC,
HRZ, IAI, JD, JG 1963, JJM 1972, JLS,
JM, JV 1966, MCA 1986, MLJD, PMPO,
RGL, ROMC, RSW, SD, SMI, SV, UIH,
WDH, WEW 1973, WG 1980, WG 1984,
WH, WMR, WRB, WRB 1959, WVB
ALB*, CVN*, IS*

Bushong *see* KUBA

Bushongo *see* KUBA

BUSHOONG (Zaire)
variants Bashi-Bushongo,
Bashibushoong
note Bantu language; subcategory of
Kuba. The same name is also
used to refer to the Kuba people as
a whole.
AAT: nl (uses Kuba kingdom)
LCSH: Bushoong language
CDR 1985, CFL, DDMM, DFHC, EBHK,
ELZ, ETHN, FHCP, HB, HRZ, JC 1971, JC
1978, JC 1982, JLS, JV 1966, LM, MGU
1967, OB 1973, TERV, TP, WEW 1973,
WG 1984, WS
ETTJ*

BUSSA (Ethiopia)
note Cushitic language
AAT: nl
LCSH: nl
DDMM, ETHN, GPM 1975, HB, SD, WH

Bute *see* WUTE

Buye *see* BOYO

Buyi *see* BOYO

Buyu *see* BOYO

BUZIMBA (Uganda)
note one of the Nyankore kingdoms
of Nkole
AAT: nl
LCSH: nl
BKT, HB
see also Nkole

BVANUMA (Zaire)
variants Vanuma
note Bantu language
AAT: nl
LCSH: nl
DDMM, ETHN, MGU 1967

BVIRI (Sudan, Uganda, Zaire)
variants Biri, Bor Bviri, Gumba,
Viri
note Western Ubangian language;
one of the groups included in the
collective term Belanda
AAT: nl
LCSH: nl (Viri language use Birri)
ATMB, ATMB 1956, DDMM, ECB,
ETHN, GPM 1959, GPM 1975, HB, IAI,
JG 1963, JMOB, RJ 1959, UIH
STS*

see also Belanda

BWA (Burkina Faso, Mali)
variants Bobo-Oule, Bobo-Ule,
Bwaba, Bwamu
subcategories Zara
note Gur language; sometimes
confused with the Bobo
AAT: Bwa
LCSH: use Bobo
CDR 1987, CFL, DDMM, DOA, ETHN,
EPHE 8, GPM 1959, HAB, HB, IAI, JD, JG
1963, JK, JLS, KFS 1989, LJPG, LM,
MHN, MLB, MLJD, RSW, SMI, SV, UIH,
WG 1980, WH, WRNN, WS

BWA (Zaire)
variants Ababua, Baboa, Babua,
Babwa, Boa, Bua
note Bantu language. The Yew are
a Bwa-related group.
AAT: nl (uses Babwa)
LCSH: nl (uses Ababua)
ALM, CK, DDMM, DPB 1987, EB, ELZ,
ESCK, ETHN, FHCP, GBJS, GPM 1959,
GPM 1975, HB, JC 1971, JK, JLS, JMOB,
JTSV, MGU 1967, MLB, MLJD, MUD
1991, OBZ, RSRW, SV, TERV, UIH, WG
1980, WH, WOH, WRB, WRNN
JC 1978*, SC*
see also Yew

Bwaba *see* BWA (Burkina Faso)
Bwaka *see* NGBAKA
Bwamba *see* AMBA
Bwamu *see* BWA (Burkina Faso)
Bwandaka *see* NDAKA
BWARI (Zaire)
variants Babwari
note Bantu language; one of many
groups living among the Bembe
and Boyo who are sometimes
referred to as Pre-Bembe
AAT: nl
LCSH: nl
DPB 1987, GPM 1959, GPM 1975, HB,
JLS, JV 1984, WG 1984, MGU 1967
DPB 1981*
see also Pre-Bembe

BWENDE (Zaire)
variants Babuende, Babwende,
Babwendi
note Bantu language; subcategory of
Kongo
AAT: Bwende
LCSH: Bwende
BES, CFL, CK, DDMM, DPB 1985, DPB
1987, ELZ, ETHN, GBJS, GPM 1959,
GPM 1975, HAB, IAI, JK, JLS, JMOB,
MGU 1967, MLB, OB 1973, RGL, RLD
1974, RSW, SG, SMI, SV, WG 1980, WG
1984, WH, WRNN, WS
RW*
see also Kongo
Bwene Mukuni *see* LENJE
Bwezi *see* BWIZI
BWILE (Zaire, Zambia)
variants Bwilile
note Bantu language
AAT: nl
LCSH: nl
DDMM, DPB 1987, ETHN, FHCP, FN
1994, GPM 1959, GPM 1975, HAB, HB,
JV 1966, OB 1961, RJ 1961, UIH, WVB
WWJS*
Bwilile *see* BWILE
BWIZI (Zaire)
variants Bwezi
note Bantu language; subcategory of
Amba; close cultural relationship
between Amba, Bwizi and
Talinga
AAT: nl
LCSH: nl
BKT, DPB 1987, GPM 1959
see also Amba, Talinga

CABINDA (Congo Republic)
note region/enclave in the Congo
Republic, but the term is
sometimes used to refer to the art
of the Vili people
AAT: nl
LCSH: use Kongo
BES, BS, CDR 1985, DDMM, DP, EBHK,
ELZ, ETHN, FW, GPM 1975, IAI, JC
1978, JMOB, JTSV, JV 1966, JV 1984,
KFS, KK 1965, MGU 1967, OB 1973,
RGL, SG, SMI, WG 1980, WG 1984, WH,
WOH
see also Vili

Caffre *see* XHOSA

Caga *see* CHAGGA

Calabar *see* EFIK

Calabari *see* KALABARI

Camba *see* CHAMBA

CANGBORONG (Ghana)
variants Nchumbulu, Nchumuru
note Kwa language
AAT: nl
LCSH: nl (Cangborong language use
Nchumburu language)
DDMM, DWMB, ETHN, GPM 1959, JLS

Cape Province *see* Toponyms Index

Carthage *see* Toponyms Index

Casamance River *see* Toponyms
Index

Cassanga *see* KASANGA

Cerma *see* GOUIN

CEWA (Malawi, Mozambique,
Zambia, Zimbabwe)
variants Chewa
note Bantu language; one of the
groups included in the collective
term Maravi
AAT: nl (uses Chewa)
LCSH: use Chewa
ARW, BS, DDMM, ETHN, GPM 1959,
GPM 1975, IAI, JLS, JM, JV 1966, KFS,
MGU 1967, NIB, RJ 1961, ROMC, SD,
SMI, TP, UIH, WH, WVB
ACPG*, MGM*, SYN*, TEW*
see also Maravi

CHAAMBA (Algeria)
note Semitic language; Arab
nomads of the northwest central
desert; one of the groups included
in the collective term Bedouin
AAT: nl
LCSH: Chaamba
GPM 1959, LCB, WH
ACL*, YR*
see also Bedouin

CHAD civilization (Cameroun,
Chad, Nigeria)
note ancient civilizations in the
region of Lake Chad including
Bornu, Kanem, Sao and others
AAT: use Sao Empire
LCSH: Chad, Lake
AF, EBR, FW, GPM 1975, HRZ, JJM
1972, JL, JLS, JV 1984, KFS, LJPG, MCA,
RGL, ROMC, SMI, TFG, WG 1980, WG
1984
AML*, DB*, GJJG*, JPAL*

Chad, Lake *see* Toponyms Index

Chaga *see* CHAGGA

CHAGGA (Kenya, Tanzania)
variants Caga, Chaga, Djaga,
Dschaga, Dschagga, Jagga,
Wachagga
note Bantu language; a collective
term for various people living on
Mount Kilimanjaro, who
organized into small autonomous
chiefdoms in the 19th century
AAT: Chagga
LCSH: use Chaga
ARW, BS, DDMM, ECB, ELZ, ETHN,
GPM 1959, GPM 1975, HAB, HB, IAI, JM,
JMOB, KK 1990, MFMK, MGU 1967,
PMPO, RJ 1960, ROMC, RSW, SD, SMI,
UIH, WH, WOH, WRB 1959
BUG*, SMPP*

Chakosi *see* ANUFO

Cham *see* BATCHAM

CHAM (Nigeria)
variants Dijim, Mwana, Mwona
note Adamawa language
AAT: nl
LCSH: nl
DDMM, ETHN, GPM 1959, JG 1963, JLS,
MBBH, NIB, RGL, RWL, WFJP

CHAMBA (Ghana, Togo)
note Gur language; often grouped
with the Bassar and others
AAT: nl
LCSH: use Bassari
DDMM, DWMB, ETHN, GPM 1959, GPM
1975, JG 1963, KK 1965, ROMC, SMI,
UIH
see also Bassar

CHAMBA (Cameroun, Nigeria)
variants Camba, Tchamba,
Waschamba
subcategories Daka, Leko
note Adamawa language
AAT: Chamba
LCSH: Chamba
BEL, BS, CMK, DDMM, DOA, DWMB,
ELZ, ETHN, FW, GBJS, GPM 1959, GPM
1975, HMC, JAF, JD, JG 1963, JK, JL,
JLS, KK 1960, LP 1993, MKW 1978,
MLB, MPF 1992, NIB, NOI, PH, PMK,
RSW, RWL, SD, SMI, SV, TP, UIH, WBF
1964, WG 1980, WG 1984, WH, WRB,
WRNN, WS
RF*

Chamba Daka *see* DAKA
Chamba Leko *see* LEKO
CHAMBULI (Benin, Togo)
variants Tchumbuli
note Kwa language
AAT: nl
LCSH: nl
DDMM, GPM 1959

Chaouia *see* SHAWIA
Chari River *see* Toponyms Index
CHEMBA (Mozambique)
note in southeast Africa between
Lake Malawi and the coast
AAT: nl
LCSH: nl
CDR 1985, WRNN

CHEREPONG (Ghana)
note Kwa language; sometimes
referred to with Larteh as
Cherepong-Larteh
AAT: nl
LCSH: nl
DDMM, ETHN, HCDR
see also Larteh

Chewa *see* CEWA
CHIADMA (Morocco)
AAT: Chiadma
LCSH: nl
GPM 1959, TP

CHICHAOUA (Morocco)
AAT: Chichaoua
LCSH: nl
TP

Chiga *see* KIGA
Chigga *see* KIGA
Chikunda *see* KUNDA
CHIP (Nigeria)
note Chadic language
AAT: nl
LCSH: nl
DDMM, ETHN, GPM 1959, JG 1963, NIB,
RWL, WS

Chipeta *see* PETA
Chleuh *see* SHLUH
Choa *see* SHUWA
Chokossi *see* ANUFO

CHOKWE (Angola, Zaire, Zambia)
variants Bachokwe, Badjok, Badjokwe, Bajokwe, Batshioko, Ciokwe, Cokwe, Djok, Djokwe, Jokwe, Kioko, Kiokue, Quioco, Shioko, Tchokwe, Tschokwe, Tshioko, Tshokwe, Tuchokwe, Watschiwokwe
note Bantu language; one of the groups included in the Lunda-Lovale peoples. Chokwe is the current form in most art sources while linguists seem to prefer the form Cokwe.
AAT: Chokwe
LCSH: Chokwe
ALM, ASH, BS, CDR 1985, CFL, CK, DDMM, DFHC, DOA, DP, DPB 1985, DPB 1987, EB, EBHK, EBR, EEWF, ELZ, ETHN, FHCP, FW, GBJM, GBJS, GPM 1959, GPM 1975, HJK, HMC, IAI, JC 1971, JD, JK, JLS, JM, JMOB, JTSV, JV 1966, JV 1984, KFS 1989, KK 1960, KK 1965, KMT 1971, MCA, MGU 1967, MHN, MK, MLB, MLJD, NIB, OB 1973, OBZ, PH, RFT 1974, RGL, RJ 1961, ROMC, RS 1980, RSAR, RSRW, RSW, SG, SMI, SV, SV 1988, SVFN, TB, TERV, TLPM, TP, UIH, WBF 1964, WG 1980, WG 1984, WH, WLA, WMR, WOH, WRB, WRNN, WS, WVB
AGL*, CWMN*, HB 1935*, HH 1993*, MLB 1961*, MLB 1978*, MLB 1982*, MLB 1994*, MLDA*, MUD*
see also Lunda-Lovale people

Chondwe *see* Toponyms Index

CHONYI (Kenya)
note Bantu language; one of the groups included in the collective term Nyika
AAT: Chonyi
LCSH: nl
AHP 1952, DDMM, ECB, ETHN, GPM 1959, SV 1988, UIH, WS
see also Nyika

CHOPI (Mozambique)
variants Bachopi, Batchopi, Copi, Lenge, Tschopi
note Bantu language
AAT: Chopi
LCSH: Chopi
ACN, DDMM, EBR, ETHN, GPM 1959, GPM 1975, HAB, HB, HMC, IAI, JLS, MGU 1967, MTKW, RJ 1961, RSW, SMI, TP, UIH, WDH, WH, WRB, WRB 1959
EDE*, HUT*

CHUKA (Kenya)
note Bantu language; one of the groups included in the collective term Meru
AAT: nl
LCSH: nl
DDMM, ECB, ETHN, GPM 1959, GPM 1975, RJ 1960, UIH, WH
JMGK*, WWJS*
see also Meru

Chwabo *see* CUABO

Chwana *see* TSWANA

CHWEZI (Uganda)
note alleged ancestors and founders of Ugandan kingdoms. Their empire was Kitara.
AAT: nl
LCSH: nl
PG 1990
see also Bigo culture, Kitara

CIAKA (Angola)
variants Ciyaka, Quiaca, Tshiaka
note Bantu language; one of the groups included among the Ovimbundu
AAT: nl
LCSH: nl
GPM 1959, HB, MEM, MLB 1994, WS
see also Ovimbundu

Ciga *see* KIGA

Ciina Mukuni *see* LENJE

CILE (Tanzania)
note Bantu language
AAT: nl
LCSH: nl
ETHN, HB, RGW

CILENGE (Angola)
 variants Kilenge, Lenge, Quilenge,
 Tshilenge
 note Bantu language; Ovimbundu
 related or influenced; one of the
 groups included in the collective
 term Mbangala
 AAT: nl
 LCSH: nl
 DDMM, GPM 1959, GPM 1975, HB, MLB
 1994
 see also Mbangala
Cimba *see* HIMBA
Ciokwe *see* CHOKWE
CIPUNGU (Angola)
 variants Pungu, Quipungo,
 Tchipungu, Tshipungu
 note Bantu language; Ovimbundu
 related or influenced; one of the
 groups included in the collective
 term Mbangala
 AAT: nl
 LCSH: nl
 DDMM, GPM 1959, GPM 1975, HB, MLB
 1994
 see also Mbangala
Ciyaka *see* CIAKA
Cobiana *see* KOBIANA
Cokwe *see* CHOKWE
Colo *see* SHILLUK
Coman *see* KOMA (Ethiopia)
Comorian *see* KOMORO
Coniagui *see* KONYAGI
COOFA (Zaire)
 note Bantu language
 AAT: nl
 LCSH: nl
 HB, JV 1978, OB 1973
Copi *see* CHOPI
COPTS (Egypt, Ethiopia)
 note sometimes referred to as
 Coptic Christians
 AAT: nl (uses Coptic)
 LCSH: Copts
 AF, BD, GPM 1975
 MYH*

CROSS RIVER people (Cameroun,
 Nigeria)
 note collective term which includes
 Andoni, Boki, Efik, Gayi, Ibibio,
 Korop, Kpan, Ododop, Ogoni,
 Okoyong, Yakö, Yakoro. The
 term is also used by linguists for a
 group of related languages.
 AAT: <Cross River Region>
 LCSH: Cross River (Cameroon and Nigeria)
 CFL, ELZ, FW, GIJ, GPM 1975, HBDW,
 JAF, JLS, JM, JPJM, JV 1984, KFS, KFS
 1989, KK 1960, KK 1965, KMT 1970,
 LJPG, LP 1993, MKW 1978, PH, ROMC,
 SG, SMI, SV, SV 1986, TP, WEW 1973,
 WG 1980, WG 1984, WOH
 see also Toponyms Index
CUABO (Mozambique)
 variants Chwabo, Cuambo
 note Bantu language; one of the
 groups included in the collective
 term Maravi
 AAT: nl
 LCSH: nl
 DDMM, ETHN, IAI, MGU 1967, RJ 1961,
 WH
 TEW*
 see also Maravi
Cuambo *see* CUABO
CUANDO (Angola)
 note Bantu language; Ovimbundu
 related or influenced
 AAT: nl
 LCSH: nl
 MLB 1994
Cunama *see* KUNAMA
Cunene River *see* Toponyms Index
Curoca *see* KOROCA
Cush *see* KUSH

CWA (Zaire)
variants Bachua, Bacwa, Batua, Tshwa
note one of the groups included in the collective term Pygmies. Some sources consider the Cwa and Twa to be the same.
AAT: nl
LCSH: nl (uses Batwa)
ATMB 1956, DPB 1981, DPB 1987, HAB, HB, JK, JMOB, JV 1978, OB 1973, SB, SMI, WH
see also Pygmies, Twa

Cyrenaica *see* Toponyms Index

CYRENAICANS (Libya)
note Semitic language; one of the groups included in the collective term Bedouin
AAT: Cyrenaican
LCSH: nl (uses Cyrene, Libya)
EWA, GPM 1959, GPM 1975, JLS, JM, PG 1990, ROMC, SMI
see also Bedouin

DAAROOD (Ethiopia, Kenya, Somalia)
note Cushitic language; clan-family of the Somali
AAT: nl
LCSH: nl
ATMB 1956, GPM 1975, UIH, WH
IML*
see also Somali

DABA (Cameroun)
subcategories Musgoy
note Chadic language; one of the groups included in the collective term Kirdi
AAT: nl
LCSH: Daba
ATMB 1956, DB, DDMM, ETHN, GPM 1959, GPM 1975, HB, IEZ, JG 1963, UIH
BEL*
see also Kirdi

Dabida *see* TEITA

Dabosa *see* TOPOTHA

Daboya *see* Toponyms Index

Dadjo *see* DAJU

DAFING (Burkina Faso, Mali)
variants Marka Dafing
note Mande language; a specialized group within the Marka
AAT: nl
LCSH: use Soninke
CDR 1985, CDR 1987, DDMM, DWMB, ETHN, GPM 1959, HB, HBDW, JK, JLS, RAB, UIH, WH
see also Marka

Dagaba *see* LODAGABA

Dagara *see* KANURI

DAGARA (Burkina Faso, Côte d'Ivoire, Ghana)
note a collective term which includes the Birifor, Lobi, Lodagaa, Lowiili, and others
AAT: nl
LCSH: use Dagari
DDMM, ETHN, JK, JLS, JPB

Dagari *see* LODAGAA

DAGARTI (Ghana)
variants Dagati
note Gur language
AAT: nl
LCSH: nl (uses Dagari)
DWMB, ETHN, HB, HCDR, WH, WRNN

Dagati *see* DAGARTI

Dagbamba *see* DAGOMBA

Dagbani *see* DAGOMBA

DAGOMBA (Ghana)
variants Dagbamba, Dagbani
note Gur language; one of the groups included In the collective term Wala
AAT: nl
LCSH: use Dagbani
BS, DDMM, DFHC, ELZ, ENS, ETHN, GPM 1959, GPM 1975, HAB, HB, HBDW, HCDR, HRZ, IAI, JEEL, JG 1963, JM, KFS, LPR 1986, MM 1950, PMPO, RAB, RJ 1958, ROMC, RS 1980, RSW, SD, SMI, SV, UIH, WH, WRB 1959
see also Wala

Dagu *see* DAJU

DAHO (Côte d'Ivoire)
note Mande language; sometimes referred to with the Doo as Daho Doo
AAT: nl
LCSH: nl
DDMM, JPB
see also Doo

DAHOMEY kingdom (Benin)
note Fon kingdom whose capital was Abomey, circa 1650-1900 CE; former name of the country Benin
AAT: nl
LCSH: Dahomey use Fon
FW, GPM 1975, JDC, JL, JLS, JPJM, KMT 1971, LPR 1986, PG 1990, RJ 1958, SV, TFG, UGH, WG 1984, WRB 1959
CFPK*, EL*, MJH 1938*
see also Fon

DAÏ (Central African Republic, Chad)
variants Day
note Adamawa language
AAT: nl
LCSH: use Day
ATMB, ATMB 1956, DDMM, ETHN, GPM 1959, HB, IAI, MPF 1992

Daima *see* Toponyms Index

Daiso *see* SEGEJU

Daisu *see* SEGEJU

DAJU (Chad, Sudan)
variants Dadjo, Dagu
note Eastern Sudanic language
AAT: nl
LCSH: nl
AML, ATMB, ATMB 1956, DDMM, ETHN, GPM 1959, GPM 1975, HB, HBDW, IAI, ICWJ, JG 1963, MPF 1992, RJ 1959, WH

DAKA (Nigeria)
variants Chamba Daka, Dakka, Dako, Samba Daka
note Bantoid language; subcategory of Chamba
AAT: nl
LCSH: nl

DDMM, DWMB, ETHN, GPM 1959, GPM 1975, HB, HBDW, JG 1963, JLS, MPF 1992, RWL, SV, WH
see also Chamba

Dakabori *see* Toponyms Index

DAKAKARI (Nigeria)
variants Dakarkari, Dakkakarri, Lela
note Benue-Congo language; a collective term used for non-Islamic groups of people in northern Nigeria, such as the Bangawa, Fakawa, Lilawa and Kelawa
AAT: nl
LCSH: nl
DDMM, DWMB, ETHN, FW, GPM 1959, GPM 1975, HAB, HB, HBDW, IAI, JG 1963, JK, JLS, NIB, NOI, RGL, RJ 1958, RWL, TP, UIH, WG 1980, WG 1984, WH
EE*

Dakarkari *see* DAKAKARI

Dakka *see* DAKA

Dakkakarri *see* DAKAKARI

Dako *see* DAKA

DAKPA (Central African Republic)
note Central Ubangian language
AAT: nl
LCSH: nl
DDMM, ETHN, GPM 1959, HB, MLJD, UIH

DALOA (Côte d'Ivoire)
note Kwa language; subcategory of Bete; sometimes referred to as Northern Bete
AAT: nl
LCSH: nl
ETHN, JEEL, JPB
see also Bete

Dama *see* BERGDAMA (Namibia)

Dama *see* DASENECH (Ethiopia)

Damara *see* BERGDAMA

Dambwa *see* Toponyms Index

DAN (Côte d'Ivoire, Guinea, Liberia)
variants Dan-Gioh, Gio, Gioh, Gyo, Yacouba, Yacuba, Yakuba
subcategories Gulome, Kulime
note Mande language. Dan are officially called Yakuba in Côte d'Ivoire and Gio in Liberia. They call themselves "people who speak the Dan language," hence the name Dan.
AAT: Dan
LCSH: Dan
ACN, AF, AM, ASH, AW, BS, CDR 1985, CFL, CK, CMK, DDMM, DFM, DOA, DP, DWMB, EB, EBR, EEWF, ELZ, ETHN, EVA, EWA, FW, GBJM, GBJS, GPM 1959, GPM 1975, GSGH, GWS, HAB, HBDW, HH, HMC, HUZ, IAI, JD, JEEL, JG 1963, JK, JL, JLS, JP 1953, JTSV, JV1984, KFS, KFS 1989, LJPG, LM, LPR 1986, MH, MHN, MLB, MLJD, MUD 1991, NIB, RFT 1974, RGL, RJ 1958, RS 1980, RSAR, RSRW, RSW, SG, SMI, SV, SV 1988, SVFN, TB, TP, UIH, WBF 1964, WEW 1973, WG 1980, WG 1984, WH, WMR, WOH, WRB, WRNN, WS
EFHH*, HUZ*, JPB*, MKK*, PJLV*
see also Mande

Danakil *see* AFAR

DANGALEAT (Chad)
note Chadic language
AAT: nl
LCSH: Dangaleat
AML, DDMM, ETHN, HB, IAI, MH, UIH

DAN-NGERE (Côte d'Ivoire)
note an older term for separate styles of the Dan and Ngere
AAT: nl
LCSH: nl
EBR, KMT 1970, TLPM
PJLV*

Dan-Gioh *see* DAN

Dangme *see* ADANGME

DARFUR (Sudan)
note site of ancient kingdoms, also a province and mountainous region of western Sudan
AAT: Darfur
LCSH: nl

BD 1959, CSBS, ELZ, GPM 1959, HB, HBU, HRZ, ICWJ, JDC, JJM 1972, JL, JLS, JM, KFS, LJPG, NIB, PR, ROMC, SMI, UGH, WG 1984, WH

DASENECH (Ethiopia, Kenya)
variants Dama, Daseneck, Dathanaic, Geleba, Marille, Marle, Merile
note Cushitic language
AAT: nl
LCSH: nl (uses Dasanetch)
ATMB, DDMM, ETHN, GPM 1959, GPM 1975, HB, IAI, JG 1963, JLS, RJ 1959, UIH, WH
ERC*

Daseneck *see* DASENECH

DASO (Cameroun)
variants Babanki-Daso
note Bantoid language; subcategory of Babanki
AAT: nl
LCSH: nl
PH
LP 1993*
see also Babanki

DASSA (Nigeria)
note Kwa language; subcategory of Yoruba
AAT: nl
LCSH: nl
DDMM, GPM 1959, RWL
see also Yoruba

Dathanaic *see* DASENECH

Datoga *see* TATOG

Daura *see* Toponyms Index

Dawida *see* TEITA

Day *see* DAÏ

DAZA (Chad, Niger)
variants Dazaga, Dazawa, Gorane
note Nilo-Saharan language; one of
the groups included in the
collective term Tubu
AAT: nl
LCSH: Daza
AML, ATMB, ATMB 1956, BS, DDMM,
ETHN, GPM 1959, GPM 1975, HB,
HBDW, IAI, JEC 1958, JG 1963, JJM
1972, JLS, JPAL, LPR 1995, MLJD, MPF
1992, ROMC, RWL, SMI, UIH
JEC 1982*
see also Tubu

Dazaga *see* DAZA

Dazawa *see* DAZA

Dchang *see* DSCHANG

DE (Liberia)
variants Dei, Dey
note Kwa language
AAT: De
LCSH: nl
CK, DDMM, DWMB, EBR, ETHN, GPM
1959, GPM 1975, GSDS, GSGH, HAB,
HB, HBDW, JG 1963, JK, JLS, KK 1960,
ROMC, TB, UIH, WBF 1964, WH, WRB,
WS

Deg *see* DEGHA

DEGEMA (Nigeria)
note Kwa language
AAT: nl
LCSH: Degema language
DDMM, ETHN, RWL, WEW 1973
OGI*

DEGHA (Côte d'Ivoire, Ghana)
variants Deg, Janela, Mo, Mo
Dyamu
note Gur language
AAT: nl
LCSH: Degha language use Mo language
DDMM, DWMB, ETHN, GPM 1959, GPM
1975, HB, HBDW, HCDR, HMC, JG 1963,
JK, JM, JPB, MM 1952, RAB, RS 1980

Dei *see* DE

DEK (Cameroun, Nigeria)
note Adamawa language; related to
the Lakka
AAT: nl
LCSH: nl

DDMM, ETHN, GPM 1959, HB, JG 1963,
WH
see also Lakka

Dekese *see* NDENGESE

DELO (Ghana, Togo)
variants Ntribu
note Gur language
AAT: nl
LCSH: nl
DDMM, DWMB, ETHN, GPM 1959, HB,
HBDW, JG 1963, UIH

Dengese *see* NDENGESE

Denkyera *see* DENKYIRA

DENKYIRA (Côte d'Ivoire)
variants Alanguira, Dyenkera
note Kwa language; subcategory of
Baule
AAT: nl
LCSH: Denkyira kingdom
HCDR, JL, JPB, RJ 1958, TFG, WG 1984,
WRB
see also Baule

Dera *see* KANAKURU

Dey *see* DE

Dhe bang *see* HEIBAN

Dhlo Dhlo *see* Toponyms Index

DHO LUO (Kenya)
variants Luo
note Western Nilotic language; one
of the groups included in the
collective term Nilotic people;
sometimes referred to as Southern
Lwoo
AAT: nl
LCSH: use Luo
ATMB 1956, DDMM, ETHN, HB, IAI, RJ
1960, WEW 1973
see also Lwoo, Nilotic people

Dhopadhola *see* JO PADHOLA

Dhopalwo *see* JO PALUO

Di *see* DZING

DIA (Zaire)
variants Badia, Dya, Jia
note Bantu language
AAT: nl
LCSH: nl
DDMM, DPB 1985, DPB 1987, ETHN,
GAH 1950, GPM 1959, GPM 1975, HRZ,
IAI, JMOB, JV 1966, KFS, OBZ, UIH,
WH, WMR

DIABE (Côte d'Ivoire)
note Kwa language; one of the
groups included in the collective
term Akan
AAT: nl
LCSH: nl
ETHN, GPM 1959, JPB
see also Akan

Dialonke *see* DYALONKE

Diamande *see* DIOMANDE

DIAMARE (Cameroun)
note Chadic language; subcategory
of Mofu
AAT: nl
LCSH: nl
MPF 1992, SMI
see also Mofu

Dian *see* DYAN

DIARA (Mali)
note an early town and independent
Sudanic kingdom, circa 1200-
1500 CE
AAT: nl
LCSH: nl
ROJF

DIBUM (Cameroun)
note Bantu language; one of the
groups included in the collective
term Bamileke
AAT: nl
LCSH: nl
DDMM, GPM 1959, GPM 1975, WH
see also Bamileke

DIDA (Côte d'Ivoire)
note Kwa language
AAT: nl
LCSH: Dida
BS, DDMM, DFHC, DWMB, EFLH, ENS,
ETHN, GPM 1959, HAB, HB, HBDW, IAI,
JEEL, JLS, KFS, MLJD, MPF 1992, RJ
1958, WH
ET*, JPB*

DIDINGA (Sudan)
note Eastern Sudanic language
AAT: nl
LCSH: Didinga
ATMB, ATMB 1956, BS, CSBS, DDMM,
ECB, ERC, ETHN, GPM 1959, GPM 1975,
HAB, HB, HBDW, IAI, ICWJ, JG 1963,
PMPO, RJ 1959, UIH, WEW 1973, WH
ANK 1972*

DIELI (Burkina Faso, Côte d'Ivoire,
Mali)
note Mande language; a caste of
leather workers among the
Senufo; sometimes considered a
subcategory of Senufo or Dyula.
see AJG* and BH 1966*
AAT: nl
LCSH: nl
IAI, JD, RSW
AJG*, BH 1966*

DIFALE (Togo)
note Gur language
AAT: nl
LCSH: nl
GPM 1959, GPM 1975, HBDW, KK 1965

DIGIL (Somalia)
note Cushitic language; clan-family
of the Somali; one of the groups
included in the collective term
Sab
AAT: nl
LCSH: nl
ATMB 1956, GPM 1959, GPM 1975,
HAB, HB, RJ 1959, UIH, WH
IML 1969*
see also Sab, Somali

DIGO (Kenya, Tanzania)
variants Wadigo
note Bantu language; one of the
groups included in the ethnic
cluster Nyika
AAT: Digo
LCSH: Digo
AHP 1952, BS, ECB, ETHN, GPM 1959,
GPM 1975, HAB, HB, HBDW, IAI, JLS,
KK 1990, MGU 1967, RJ 1960, UIH, WG
1980, WH, WOH
see also Nyika

Diing *see* IDIING

Dijim *see* CHAM

DIKIDIKI (Congo Republic)
note Bantu language; subcategory of
Kongo
AAT: nl
LCSH: nl
BES, DDMM, DPB 1985, DPB 1987,
ETHN, HB, JC 1978, OB 1973, OBZ
see also Kongo

DILLING (Sudan)
note Eastern Sudanic language;
subcategory of Nuba; one of the
groups included in the collective
term Nubians
AAT: nl
LCSH: nl
ATMB, ATMB 1956, DDMM, ETHN,
GPM 1959, GPM 1975, HB, HBDW, IAI,
JG 1963, RJ 1959, WH
SFN*
see also Nuba, Nubians

Dimba *see* HERERO

DIMMUK (Nigeria)
note Chadic language; subcategory
of Kofyar
AAT: nl
LCSH: nl
DDMM, ETHN, HB, JG 1963, RJ 1958,
RWL, WS
see also Kofyar

Ding *see* DZING

Ding Mukeen *see* DINGA

DINGA (Zaire)
variants Badinga, Ding Mukeen,
Kongo-Dinga

note Bantu language. The Dinga
and Dzing share a common
origin. see JV 1966
AAT: nl
LCSH: nl
EBHK, HB, HJK, JC 1978, JK, JMOB,
JV 1966*
see also Dzing

Dinga *see* IDIING

DINKA (Sudan)
variants Jieng
note West Nilotic language;
sometimes distinguished as
northern (Abialang), eastern
(Bor), central (Agar), and western
(Rek) Dinka; one of the groups
included in the collective term
Nilotic people
AAT: Dinka
LCSH: Dinka
AF, AJB, ATMB, ATMB 1956, BS, CSBS,
DDMM, EBR, ESCK, ETHN, GB, GPM
1959, GPM 1975, HAB, HB, HBDW, HRZ,
IAI, JD, JG 1963, JJM 1972, JLS, JM, KK
1990, LJPG, LSD, MCA 1986, RJ 1959,
ROMC, RS 1980, RSW, SD, SMI, TP, UIH,
WEW 1973, WG 1980, WH, WOH
FMD*, GOL*
see also Nilotic people

DIO (Sudan, Zaire)
variants Adio, Adio Azande,
Makaraka
note Southern Ubangian language;
one of the groups incorporated
among the Zande
AAT: nl
LCSH: nl
ATMB 1956, CSBS, DB 1978, DDMM,
ESCK, ETHN, GPM 1959, HAB, HB,
JMOB, UIH, WH
see also Zande

Diola *see* JOOLA

DIOMANDE (Côte d'Ivoire)
variants Diamande
note Mande language
AAT: nl
LCSH: nl
CDR 1985, GPM 1959, JPB, RSW

Dioula *see* DYULA
DIR (Ethiopia, Somalia)
subcategories Issa
note Cushitic language; clan-family
of the Somali
AAT: nl
LCSH: nl
ATMB 1956, DDMM, GPM 1959, GPM
1975, HAB, HB, UIH, WH
IML 1969*
see also Somali
DITAM (Cameroun)
variants Nditam
note one of the Tikar chiefdoms in
former French Cameroun
AAT: nl
LCSH: nl
ETHN, LP 1993, PH
PAG*, PMK*
see also Tikar
Ditammari *see* BATAMMALIBA
Diula *see* DYULA
Diwala *see* DWALA
Dizi *see* MAJI
Djado *see* Toponyms Index
Djaga *see* CHAGA
Djalonke *see* DYALONKE
Djandjero *see* JANJERO
Djebala *see* JEBALA
Djebalia *see* JEBALA
Djem *see* NYEM
DJENNE (Mali)
variants Jenne
note ancient site and civilization;
former capital of Songhai
AAT: use Jenne
LCSH: nl
AF, BDG 1980, DDMM, EBR, ETHN, EW,
FW, GAC, GBJS, GPM 1975, HBDW, JAF,
JJM 1972, JK, JL, JLS, JPB, JTSV, JV
1984, KFS, LPR 1986, MLB, MUD 1991,
PG 1990, PH, PR, PRM, SMI, TFG, TP,
UGH, WG 1980, WG 1984, WRNN, WS
SKM*
Djerba *see* JERBA
Djerma *see* ZARMA

DJIBETE (Cameroun, Nigeria)
AAT: nl
LCSH: nl
JK, MLB
DJIKINI (Congo Republic, Gabon)
variants Ndjinini
note Bantu language; subcategory of
Mbaama or Teke. see LP 1985*
AAT: nl
LCSH: nl
DDMM, ETHN, RLD 1974
LP 1985*
see also Mbaama, Teke
DJIMI (Cameroun, Chad)
note Chadic language; subcategory
of Bana; one of the groups
included in the collective term
Kirdi
AAT: nl
LCSH: nl
BEL, DDMM, ETHN, GPM 1959
see also Bana, Kirdi
Djimini *see* JIMINI
Djok *see* CHOKWE
Djokwe *see* CHOKWE
Djola *see* JOOLA
Djonga *see* JONGA
Djula *see* DYULA
Djumperi *see* KUTEP
Djumperri *see* KUTEP
Do *see* NDO
Do Ayo *see* DOYAYO
Doayo *see* DOYAYO
Dodos *see* DODOTH
Dodoso *see* DODOTH

DODOTH (Uganda)
variants Dodos, Dodoso
note Eastern Nilotic language; one of the groups included in the collective terms Karimojong and Nilo-Hamitic people
AAT: nl
LCSH: Dodoth
ATMB 1956, CSBS, DDMM, ECB, ETHN, GPM 1959, GPM 1975, GWH, HAB, HB, HBDW, JG 1963, MTKW, PGPG, PMPO, RJ 1960, SMI, UIH, WH
EMT*, PGPG*
see also Karimojong, Nilo-Hamitic people

DOE (Tanzania)
variants Doei, Wadoe
note Bantu language
AAT: Doe
LCSH: nl
ASH, CDR 1985, DDMM, ECB, ELZ, ETHN, GPM 1959, GPM 1975, HB, HBDW, JLS, KK 1990, MFMK, RJ 1960, UIH, WG 1980

Doei *see* DOE
Dogo *see* DOGON
Dogom *see* DOGON
DOGON (Burkina Faso, Mali)
variants Dogo, Dogom, Habbé, Habe, Kado, Kaddo, Kibisi, Tombo
note Gur language
AAT: Dogon
LCSH: Dogon
ACN, AF, ARW, ASH, AW, BS, CDR 1985, CFL, CK, CMK, DDMM, DF, DFHC, DFM, DOA, DOWF, DP, DWMB, EB, EBR, EEWF, ELZ, ETHN, EVA, EWA, FW, GAC, GBJM, GBJS, GPM 1959, GPM 1975, GWS, HAB, HB, HBDW, HH, HMC, IAI, JAF, JD, JG 1963, JK, JL, JLS, JM, JP 1953, JPB, JPJM, JTSV, JV 1984, KFS, KFS 1989, KK 1960, KK 1965, KMT 1970, LJPG, LM, LPR 1986, LSD, MH, MHN, MK, MLB, MLJD, NIB, PMPO, PRM, PSG, RFT 1974, RGL, RJ 1958, ROMC, RS 1980, RSAR, RSRW, RSW, SD, SG, SMI, SV, SV 1988, SVFN, TB, TLPM, TP, UIH, WBF 1964, WEW 1973, WG 1980, WG 1984, WH, WMR, WOH, WRB, WRNN, WS

DP 1940*, GCG 1968*, HLP*, JL 1973*, KE*, MG 1963*, MG 1965*
DOK (Sudan)
note Western Nilotic language; subcategory of Nuer
AAT: nl
LCSH: nl
ATMB 1956, DDMM, WH
see also Nuer

Dokhosie *see* DOROSIE
Dokise *see* DOROSIE
DOKO (Zaire)
variants Badoko
note Bantu language; Some sources consider the Doko a subcategory of Ngombe. see HBU.
AAT: nl
LCSH: Doko language
DDMM, DPB 1987, ETHN, GAH 1950, GPM 1959, GPM 1975, HAB, HB, HBDW, IAI, JG 1963, JMOB, KFS, OBZ, WH
HBU*
see also Ngombe

DOMPAGO (Benin, Togo)
note Gur language
AAT: nl
LCSH: Dompago dialect
DDMM, ETHN, GPM 1959, GPM 1975, HB, IAI, RJ 1958, UIH

DONDO (Congo Republic)
variants Badondo
note Bantu language; subcategory of Kongo
AAT: Dondo
LCSH: nl
BES, DDMM, DPB 1987, ETHN, GPM 1959, GPM 1975, HB, HBU, IAI, JK, OB 1973, RJ 1961, SG, UIH, WBF 1964, WG 1980
JODO*
see also Kongo

DONG (Nigeria)
variants Donga, Dongo
note Adamawa language
AAT: nl
LCSH: nl
DDMM, ETHN, GPM 1959, GPM 1975,
HB, JG 1963, RWL
Donga *see* DONG
Dongo *see* DONG
DONGO (Zaire)
note Southeast Ubangian language
AAT: nl
LCSH: nl
ATMB 1956, DB 1978, DDMM, ETHN,
HB
DONGOTONO (Sudan)
note Eastern Nilotic language;
subcategory of Lango
AAT: nl
LCSH: nl
ATMB 1956, DDMM, ETHN, HB, IAI, RJ
1959, UIH
GWH*
see also Lango
DONYIRO (Ethiopia, Sudan)
variants Nyangatom
note Eastern Nilotic language; one
of the groups included in the
collective terms Karimojong and
Nilo-Hamitic people
AAT: nl
LCSH: use Nyangatom
ATMB 1956, DDMM, ETHN, GPM 1959,
GPM 1975, HB, RJ 1959
ERC*, PGPG*
see also Karimojong, Nilo-Hamitic
people
DOO (Côte d'Ivoire)
note Mande language; sometimes
referred to with the Daho as Daho
Doo. see JPB
AAT: nl
LCSH: nl
DDMM, GPM 1959, JPB
see also Daho
DOR (Sudan)
note Western Nilotic language;
subcategory of Nuer

AAT: nl
LCSH: nl
ATMB 1956, DDMM, ETHN, GPM 1959,
GPM 1975, HB, WH
see also Nuer
DOROBO (Kenya, Tanzania)
variants Nderobo, Ndorobo, Okiek,
Wanderobo
note Southern Nilotic language; one
of the groups included in the
collective terms Kalenjin and
Nilo-Hamitic people. The term
Okiek is preferred by some
authorities.
AAT: Dorobo
LCSH: Dorobo
ATMB 1956, BS, CSBS, DDMM, ECB,
ETHN, GPM 1959, GPM 1975, GWH, HB,
IAI, JLS, RJ 1960, ROMC, UIH, WH,
WOH
GWH 1969*, CAK*
see also Kalenjin, Nilo-Hamitic
people
DOROSIE (Burkina Faso)
variants Dokhosie, Dokise,
Dorossie
note Gur language; one of the
groups included in the collective
term Lobi
AAT: nl
LCSH: nl
CDR 1987, DDMM, ETHN, GFS, GPM
1959, GPM 1975, HB, MPF 1992, WH
see also Lobi
Dorossie *see* DOROSIE
DORZE (Ethiopia)
note Cushitic language
AAT: nl
LCSH: Dorze
DDMM, ETHN, GPM 1959, GPM 1975,
HB, KFS, SD
Douala *see* DWALA
Dourou *see* DURU
Dourrou *see* DURU
Dowayo *see* DOYAYO

DOYAYO (Cameroun)
variants Doayo, Do Ayo, Dowayo,
Namchi, Namji, Namshi
note Adamawa language; one of the
groups included in the collective
term Kirdi. Namchi is considered
by some a derogatory name.
AAT: nl
LCSH: Doyayo
DDMM, DWMB, ETHN, GPM 1959, GPM
1975, HB, HBDW, IAI, JG 1963, JLS,
KFS, MLB, NIB, RJ 1958, SMI, WH,
WRNN
BEL*, NIB 1983*
see also Kirdi

Drakensberg *see* Toponyms Index

DRANU (Côte d'Ivoire)
note Mande language; subcategory
of Guro
AAT: nl
LCSH: nl
JPB
see also Guro

Dschaga *see* CHAGGA

Dschagga *see* CHAGGA

DSCHANG (Cameroun)
variants Dchang, Foreke Djang,
Foreke Dschang
subcategories Fongo
note Bantu language; subcategory of
Foreke; one of the four
administrative divisions of
Bamileke
AAT: nl
LCSH: nl
DDMM, ETHN, JPN, KK 1965, TN 1984
LP 1993*, MMML*, PAG*, PH*, TN
1986*
see also Bamileke, Foreke

Duala *see* DWALA

DUALA-LIMBA (Cameroun)
note A collective term which
includes the Pongo, Dwala,
Limba, Mungo, Oli, and others.
see EDA.
AAT: nl
LCSH: nl
EDA*

Dualla *see* DWALA

Dugatet *see* FOTO DUNGATET

DUKAWA (Nigeria)
variants Dukkawa
note Benue-Congo language
AAT: nl
LCSH: Dukawa
DDMM, ETHN, GPM 1959, GPM 1975,
HB, JG 1963, RWL

Dukkawa *see* DUKAWA

DUMA (Mozambique, Zimbabwe)
note Bantu language; a Shona-
speaking group not to be confused
with the Duma of Gabon
AAT: nl
LCSH: nl
DDMM, GPM 1959, GPM 1975, HB, IAI,
JLS, RJ 1961

DUMA (Gabon)
variants Adouma, Aduma,
Badouma
note Bantu language; not to be
confused with the Duma of
Mozambique and Zimbabwe who
are Shona-speaking people
AAT: Duma
LCSH: Duma language use Aduma
language
BES, DDMM, DP, ETHN, GPM 1959,
GPM 1975, HB, IAI, JD, KK 1965, LP
1979, LP 1985, MGU 1967, MLB, SV,
SVFN, TP, UIH, WH, WRB, WS

DUMBO (Uganda)
variants Wadumbo
note Bantu language
AAT: Dumbo
LCSH: nl
JMOB, WBF 1964, WRB

DUMBO (Cameroun)
variants Dzumbo
note Bantoid language
AAT: nl
LCSH: nl
DDMM, ETHN, GPM 1959, GPM 1975
Durru *see* DURU
DURU (Cameroun)
variants Dourou, Dourrou, Durru
note Adamawa language; one of the groups included in the collective term Kirdi
AAT: nl
LCSH: nl
BEL, DDMM, ETHN, GPM 1959, GPM 1975, HB, JG 1963, JLS, SD, UIH, WH
see also Kirdi
DURUMA (Kenya, Tanzania)
variants Wanduruma
note Bantu language; one of the groups included in the ethnic cluster Nyika
AAT: Duruma
LCSH: Duruma language
AHP 1952, ECB, ETHN, GPM 1959, GPM 1975, HB, JLS, MGU 1967, RJ 1960, UIH, WG 1984, WH, WS
see also Nyika
DWALA (Cameroun)
variants Bodiman, Diwala, Douala, Duala, Dualla, Dwela, Kole
note Bantu language: one of the groups included in the collective terms Bo-Mbongo cluster and Dwala-Limba group. The transcription Dwala seems currently preferred over the more conventional Duala.
AAT: nl (uses Duala)
LCSH: use Duala
ASH, BES, BS, CFL, CK, DDMM, DOWF, DP, EBHK, EBR, EDA, ELZ, ETHN, FW, GB, GPM 1959, GPM 1975, HB, HBDW, HH, IAI, IEZ, JK, JLS, JV 1984, KFS, KK 1960, KK 1965, KMT 1970, LP 1990, LP 1993, MGU 1967, MK, MKW, MLB, MLJD, MMML, MPF 1992, PH, RGL, RJ 1958, ROMC, RS 1980, SG, SMI, SV,
TLPM, TN 1984, TP, UIH, WEW 1973, WG 1980, WH, WOH, WRB, WRNN, WS MAB*, MAB 1993*
see also Bo-Mbongo, Duala-Limba
Dwela *see* DWALA
Dya *see* DIA
DYALONKE (Côte d'Ivoire, Guinea, Mali, Senegal, Sierra Leone)
variants Dialonke, Djalonke, Jallonke, Jalonka
note Mande language. The term Yalunka is an anglicized version for a detached branch of the Dyalonke in Sierra Leone. see GPM 1959
AAT: nl
LCSH: use Yalunka
BS, DDMM, DWMB, ETHN, GPM 1959, GPM 1975, HAB, HB, HBDW, IAI, JD, JG 1963, JK, JPB, KFS, LPR 1986, MLJD, PRM, RJ 1958, UIH, VP, WH MEM 1950*
see also Mande, Yalunka
DYAN (Burkina Faso)
variants Dian
note Gur language; one of the groups included in the collective term Lobi
AAT: nl
LCSH: Dyan dialect
DDMM, DP, ETHN, GPM 1959, GPM 1975, HB, JG 1963, JPB, RJ 1958, WH
see also Lobi
Dye *see* JIYE (Kenya)
DYE (Benin, Ghana, Togo)
note Gur language
AAT: nl
LCSH: nl
DDMM, DWMB, ETHN, GPM 1959, JCF, RS 1980, UIH
Dyenkera *see* DENKYIRA
Dyimini *see* JIMINI
Dyola *see* JOOLA

DYULA (Burkina Faso, Côte d'Ivoire, Mali)
variants Dioula, Diula, Djula, Jula, Juula
subcategories Dieli
note Mande language
AAT: nl
LCSH: Dyula
BS, CDR 1985, DDMM, DWMB, EFLH, ENS, ETHN, GPM 1959, GPM 1975, HAB, HB, HMC, HRZ, IAI, JG 1963, JEEL, JLS, JP 1953, JPB, KFS, LM, MLJD, PG 1990, PRM, PSG, RAB, RJ 1958, ROMC, RSW, SMI, TFG, UIH, WG 1984, WH, WRNN, WS
see also Mande

Dza *see* JEN

Dzalamo *see* ZARAMO

Dzamba *see* JAMBA

Dzem *see* NYEM

DZIHANA (Kenya)
variants Jibana
note Bantu language; one of the groups included in the ethnic cluster Nyika
AAT: nl (uses Jibana)
LCSH: nl
AHP 1952, DDMM, ECB, ETHN, GPM 1959, GPM 1975, UIH
see also Nyika

Dzindza *see* ZINZA

DZING (Zaire)
variants Di, Ding
note Bantu language. The Dinga and Dzing share a common origin. see JV 1966
AAT: nl
LCSH: nl
CDR 1985, DDMM, ETHN, GPM 1959, GPM 1975, HBDW, IAI, JLS, JMOB, MGU 1967, OB 1973, OBZ, UIH, WH
DPB 1985*, JV 1966*
see also Dinga

Dzumbo *see* DUMBO (Cameroun)

Ebaa *see* KWELE

Ebira *see* IGBIRA

Eboh *see* ABOH

Ebosola *see* AOWIN

EBRIE (Côte d'Ivoire)
variants Gyaman, Kyama, Kyaman, Tshaman, Tyama
note Kwa language; one of the groups included in the collective term Lagoon people
AAT: Ebrie
LCSH: nl
BS, DDMM, DWMB, ELZ, ENS, ETHN, GPM 1959, GPM 1975, HAB, HB, HBDW, HCDR, IAI, JEEL, JG 1963, JLS, JP 1953, MLB, MLJD, RGL, RJ 1958, SMI, SV, TFG, TLPM, TP, UIH, WG 1980, WH, WRB, WRNN, WS
JPB*
see also Lagoon people

Edda *see* ADA (Nigeria)

Ediya *see* BUBI

EDO (Benin, Nigeria)
note a linguistic division within the Kwa languages which includes the Bini, Degema, Etsako, Ineme, Ishan, Isoko, Ivbiosakon, Urhobo, and others; name for Benin City in the Edo language. see RWL
AAT: Edo
LCSH: use Bini
BS, CDR 1985, CMK, DDMM, DWMB, EBR, ELZ, ETHN, FW, GAC, GB, GBJM, GIJ, GPM 1959, GPM 1975, HAB, HB, HBDW, HRZ, IAI, JK, JLS, JM, JPJM, KFS 1989, KMT 1970, LJPG, LM, MHN, MK, NIB, NOI, PRM, RJ 1958, ROMC, RS 1980, RSRW, RSW, RWL, SD, SMI, SV, TB, UIH, WEW 1973, WG 1980, WG 1984, WH, WOH, WRB, WRNN, WS
EE*, REB*
see also Benin

Edward, Lake *see* Toponyms Index

EFE (Zaire)
variants Eve
note Central Sudanic language; one
of the groups included in the
collective term Pygmies
AAT: nl
LCSH: Efe
ATMB, ATMB 1956, BS, DDMM, DPB
1987, ESCK, ETHN, GAH 1950, GPM
1959, HAB, HB, HBDW, IAI, JG 1963,
JLS, JMOB, OBZ, SMI, WH
CMT 1961*, PAS*, RRG*, SB*
see also Pygmies

EFIK (Nigeria)
variants Calabar, Riverain Ibibio
subcategories Efut
note Benue-Congo language;
subcategory of Ibibio; sometimes
referred to as Riverain Ibibio; one
of the groups included in the
collective term Cross River people
AAT: Efik
LCSH: Efik
BS, DDMM, DFHC, DP, DWMB, ETHN,
FW, GB, GIJ, GPM 1959, GPM 1975,
HAB, HB, HBDW, HMC, IAI, JG 1963,
JJM 1972, JK, JLS, JPJM, KFS, KK 1960,
KMT 1970, LJPG, MKW 1978, MLJD,
NOI, PH, RJ 1958, ROMC, RWL, RSAR,
SMI, SV, UIH, WEW 1973, WG 1980,
WRB 1959
see also Ibibio, Cross River people

Efon Alaye *see* Toponyms Index

EFUT (Nigeria)
note Benue-Congo language;
subcategory of Efik
AAT: nl
LCSH: nl
JLS, RWL, SV
see also Efik

Efutop *see* OFUTOP

EFUTU (Ghana)
note Kwa language
AAT: nl
LCSH: nl
DDMM, ETHN, HCDR, IAI, WEW 1973

EGA (Côte d'Ivoire)
note Kwa language; neighboring
group sometimes included among
the Lagoon people
AAT: nl
LCSH: nl
DDMM, ENS, ETHN, GPM 1959, JPB,
TFG
ADS*
see also Lagoon people

EGBA (Nigeria)
note Kwa language; subcategory of
Yoruba
AAT: Egba
LCSH: Egba
BS, CDF, CDR 1985, DDMM, DWMB,
ETHN, GPM 1959, GPM 1975, HB,
HBDW, HJD, HMC, IAI, LJPG, RJ 1958,
RWL, SMI, SV, UIH, WH, WRB
see also Yoruba

EGBADO (Nigeria)
note Kwa language; subcategory of
Yoruba
AAT: nl
LCSH: nl
CDF, CDR 1985, DDMM, JLS, RWL, WH,
WRB
see also Yoruba

EGBEMA (Nigeria)
note Kwa language; subcategory of
Igbo; sometimes referred to as
Western or Riverain Igbo
AAT: nl
LCSH: nl
DDMM, ETHN, GIJ, RWL
see also Igbo

EGEDE (Nigeria)
variants Igede, Igedde
note Kwa language
AAT: nl
LCSH: nl
AW, DDMM, ETHN, GIJ, GPM 1959, HB,
RWL, UIH

Egun *see* GUN

EGUN (Benin, Nigeria)
note Kwa language; subcategory of
Yoruba
AAT: nl
LCSH: nl
DDMM, RWL
see also Yoruba
Eire *see* AKOKO
EJAGHAM (Cameroun, Nigeria)
variants Ekoi
subcategories Ekwe, Keaka, Nta,
Obang, Qua
note Bantoid language. The term
Ekoi is used for a language cluster
which encompasses not just the
Ejagham but also the Baleb,
Etung, Nde, Nta, Nkim, Qua, and
others.
AAT: Ejagham
LCSH: Ejagham
ASH, AW, BES, BS, CFL, CK, CMK,
DDMM, DFHC, DOA, DOWF, DP,
DWMB, EB, EBR, EEWF, ELZ, ETHN,
EVA, FW, GB, GBJM, GBJS, GIJ, GPM
1959, GPM 1975, HAB, HB, HBDW, HH,
HMC, HRZ, IAI, JAF, JD, JK, JL, JLS, JM,
JPJM, JTSV, JV 1984, KFS, KK 1960, KK
1965, KMT 1970, LJPG, LM, LP 1993,
MGU 1967, MHN, MK, MKW 1978, MLB,
MLJD, NIB, NOI, PH, RFT 1974, RGL, RJ
1958, RSAR, RSW, RWL, SD, SMI, SV,
SV 1988, TB, TLPM, TN 1986, TP, UIH,
WBF 1964, WFJP, WG 1980, WG 1984,
WH, WMR, WOH, WRB, WRNN, WS
EE*
Ekajuk *see* AKAJU
EKET (Nigeria)
note Benue-Congo language;
subcategory of Ibibio; one of the
groups referred to as Southern
Ibibio
AAT: Eket
LCSH: nl
CDR 1985, CFGJ, DDMM, DWMB,
ETHN, GBJS, GPM 1959, GPM 1975, HB,
HBDW, JK, JTSV, JV 1984, KFS 1989, KK
1960, LP 1993, MLB, NOI, RWL, SV, TP,
WG 1980, WG 1984, WRNN
FN 1979*
see also Ibibio

EKIIYE (Zaire)
variants Ben Eki, Beneki,
Benekiiye, Ekiye
note Bantu language; subcategory of
Songye
AAT: nl
LCSH: nl
CDR 1985, DDMM, DPB 1987, JMOB,
OB 1961
LES*, LS*
see also Songye
EKITI (Nigeria)
note Kwa language; subcategory of
Yoruba
AAT: Ekiti
LCSH: nl
AW, CDR 1985, DDMM, DWMB, EBR,
ELZ, ETHN, FW, GAC, GPM 1959, GPM
1975, HB, HBDW, JAF, JLS, KFS, MK,
MWM, NOI, RWL, SMI, SV, TP, UIH, WG
1980, WG 1984, WH, WRB
CDF*, HJD*
see also Yoruba
Ekiye *see* EKIIYE
Ekoi *see* EJAGHAM
EKOLOMBE (Zaire)
note Bantu language
AAT: nl
LCSH: nl
DPB 1987, JC 1978, JC 1982, WS
EKONDA (Zaire)
note Bantu language; subcategory of
Mongo
AAT: nl
LCSH: Ekonda
BES, BS, DDMM, DPB 1985, DPB 1987,
ETHN, GAH 1950, GPM 1959, GPM
1975, HAB, HB, HBDW, IAI, JLS, JMOB,
JV 1966, RGL, RSW, SMI, TP, UIH, WH
DV*, PE*
see also Mongo
Ekota *see* KOTA (Zaire)
Ekpahia *see* EKPEYE
Ekpeya *see* EKPEYE

EKPEYE (Nigeria)
variants Ekpahia, Ekpeya
note Kwa language; subcategory of
Igbo
AAT: nl
LCSH: Ekpeye language
DDMM, ETHN, GIJ, JLS, RWL, VCU
1965
see also Igbo

Ekuk *see* KUK

Ekumuru *see* BAHUMONO

EKWE (Nigeria)
note Bantoid language; subcategory
of Ejagham
AAT: nl
LCSH: Ekwe language use Ejagham
language
DDMM, ETHN, GIJ, RWL
see also Ejagham

El Gony *see* KONY

El Kony *see* KONY

El Molo *see* ELMOLO

ELEGU (Nigeria)
note Kwa language; subcategory of
Igbo; sometimes referred to as
Northern Igbo
AAT: nl
LCSH: nl
CFGJ
see also Igbo

ELEKU (Zaire)
note Bantu language; subcategory of
Mongo
AAT: nl
LCSH: Eleku dialect use Leko dialect
ALM, CFL, DPB 1987, ETHN, GAH 1950,
GPM 1959, HB, HBU, JD, MLJD
GAH*
see also Mongo

ELELEM (Cameroun)
note one of the groups included in
the collective term Bamileke
AAT: nl
LCSH: nl
LP 1993, PH
see also Bamileke

ELEME (Nigeria)
note Benue-Congo language;
subcategory of Ogoni
AAT: nl
LCSH: nl
DDMM, ETHN, RWL
see also Ogoni

Elgeyo *see* KEYYO

Elgon *see* KONY

Elgon Maasai *see* SAPAUT

Elgon, Mount *see* Toponyms Index

Elila River *see* Toponyms Index

ELMOLO (Kenya)
variants El Molo
note Cushitic language
AAT: nl
LCSH: Elmolo
DDMM, ECB, ETHN, GPM 1959, GPM
1975, IAI, JLS, RJ 1960

Embo *see* EMBU

EMBU (Kenya)
variants Embo, Waembu
note Bantu language; closely related
to Mbere
AAT: nl
LCSH: Embu
DDMM, ECB, ETHN, GPM 1959, GPM
1975, HB, JLS, MGU 1967, RJ 1960, UIH,
WH
JMGK*, SS*
see also Mbere

Ena *see* ENYA

ENDO (Kenya)
variants To
note Southern Nilotic language;
sometimes referred to by the cover
term Marakwet; one of the groups
included in the collective term
Nilo-Hamitic people
AAT: nl
LCSH: Endo River, Kenya
DDMM, ETHN, GPM 1959, GPM 1975,
HB, JLS, RJ 1960, UIH, WH
GWH 1969*
see also Marakwet, Nilo-Hamitic
people

81

ENENGA (Gabon)
 note Bantu language; one of the
 groups included in the collective
 term Myene
 AAT: nl
 LCSH: nl
 DDMM, ETHN, GPM 1959, GPM 1975,
 HB, LP 1985, WS
 see also Myene
Engaruka *see* Toponyms Index
ENGENNI (Nigeria)
 variants Ngene
 note Kwa language
 AAT: nl
 LCSH: Engenni language
 ETHN, RWL, WEW 1973
ENHLA (South Africa, Zimbabwe)
 note Bantu language; subcategory of
 Ndebele
 AAT: nl
 LCSH: nl
 HKVV, MCC
 see also Ndebele
Ennedi *see* Toponyms Index
ENYA (Zaire)
 variants Bagenia, Ena, Enye,
 Genya, Tsheenya, Wagenia
 note Bantu language
 AAT: nl
 LCSH: use Genya
 BES, BS, DDMM, DPB 1986, DPB 1987,
 ETHN, FN 1994, GPM 1959, GPM 1975,
 HAB, IAI, JM, JMOB, MGU 1967, OB
 1961, OBZ, RS 1980, SD, SMI, WH
 AFD*
Enye *see* ENYA
ENYONG (Nigeria)
 note Benue-Congo language;
 subcategory of Ibibio; one of the
 groups referrred to as Northen
 Ibibio
 AAT: nl
 LCSH: nl
 DWMB, ETHN, FW, GPM 1959, GPM
 1975, IAI, NOI, RWL
 see also Ibibio
Eotile *see* METYIBO
Erokh *see* IRAQW

Esa *see* ISSA
Esan *see* ISHAN
Esele *see* AMBOIM
Eshira *see* SHIRA
Esie *see* Toponyms Index
ESIMBI (Cameroun)
 variants Age, Simpi
 note Bantoid language; subcategory
 of Widekum in Bamenda
 AAT: nl
 LCSH: nl
 DDMM, ETHN, GPM 1959, GPM 1975,
 IEZ, LP 1993, UIH, WRNN
 PMK*
 see also Widekum, Bamenda
Eso *see* SO (Zaire)
Esoko *see* SO (Zaire)
Essouma *see* ESUMA
ESU (Cameroun)
 note Bantu language; one of the
 groups included in the collective
 term Bamenda
 AAT: nl
 LCSH: nl
 HAB, PH, SV, TN 1984, TN 1986
 GDR*
 see also Bamenda
ESUMA (Côte d'Ivoire)
 variants Essouma
 subcategories Assini
 note Kwa language; neighboring
 group sometimes included among
 the Lagoon people
 AAT: nl
 LCSH: nl
 DDMM, ENS, ETHN, GPM 1959, HB,
 JPB, TFG, WH
 see also Lagoon people
ETCHE (Nigeria)
 note Kwa language; subcategory of
 Igbo
 AAT: nl
 LCSH: nl
 DDMM, GIJ, HMC, RWL
 CFGJ*
 see also Igbo

ETON (Cameroun)
note Bantu language
AAT: nl
LCSH: Eton
DDMM, ELZ, ETHN, GPM 1959, GPM
1975, HB, IEZ, JLS, KK 1965, LP 1979,
LP 1985, LP 1990, RJ 1958, MGU 1967,
UIH, WH, WS
JPO*, SHD*

ETSAKO (Nigeria)
variants Afenmai
note Kwa language; a collective
term used to describe a number of
Edo-speaking peoples; one of the
groups included in the collective
term Kukuruku
AAT: Etsako
LCSH: Etsako language
DDMM, ETHN, FW, GPM 1959, GPM
1975, HB, JPJM, NOI, RWL, WEW 1973
see also Kukuruku

ETULO (Nigeria)
note Kwa language
AAT: nl
LCSH: nl
DDMM, ETHN, GPM 1959, RWL, UIH

ETUNG (Nigeria)
note Bantoid language; one of the
groups included in the Ekoi
language cluster
AAT: nl
LCSH: nl
DDMM, ETHN, GIF, JAF, JK, RWL
see also Ejagham

Evambu *see* ANYANG

Eve *see* EFE (Zaire)

Eve *see* EWE

Evhe *see* EWE

EWE (Ghana, Togo)
variants Eve, Evhe, Krepi
subcategories Agotime, Aja, Anlo
note Kwa language. Recent authors
give preference to the spelling
Evhe. see de Surgy in EPHE 9.
AAT: Ewe
LCSH: Ewe
BS, CK, DDMM, DFHC, DP, DWMB,
EBR, ELZ, ENS, ETHN, EVA, EWA, GPM
1959, GPM 1975, HAB, HB, HBDW,
HCDR, HH, IAI, JG 1963, JJM 1972, JK,
JLS, JM, JP1953, JPB, JPJM, KFS, KK
1965, MH, MHN, MLJD, MPF 1992,
PMPO, PSG, RGL, RJ 1958, ROMC, RSW,
SMI, TFG, TP, UIH, WEW 1973, WFJP,
WG 1980, WG 1984, WH, WOH, WRB
1959
JKS*, MM 1952*, PANB*

Ewodi *see* OLI

EWONDO (Cameroun)
variants Jaunde, Yaounde, Yaunde
note Bantu language; sometimes
referred to as Northern Fang
AAT: nl
LCSH: Ewondo
BES, CK, DDMM, EBHK, ELZ, ETHN,
GPM 1959, GPM 1975, HB, HBDW, HH,
IAI, IEZ, JM, JPB, KK 1965, LP 1979, LP
1985, LP 1990, LP 1993, MGU 1967, MK,
MPF 1992, MUD 1991, RJ 1958, SV, TB,
TLPM, UIH, WBF 1964, WDH, WEW
1973, WH, WOH
MKW*, SNEK*
see also Fang

Eyajima *see* YAELIMA

Eza *see* EZZA

Ezaa *see* EZZA

Ezekwe *see* UZEKWE

EZIAMA (Nigeria)
AAT: nl
LCSH: nl
GIJ

EZZA (Nigeria)
variants Eza, Ezaa
note Kwa language; sometimes
included with Igbo
AAT: nl
LCSH: Ezza use Ezaa language
DDMM, ETHN, NOI, RWL, VCU 1965,
WS
see also Igbo

FAAFUE (Côte d'Ivoire)
note Kwa language; subcategory of
Baule
AAT: nl
LCSH: nl
JPB
see also Baule
Fadjelu *see* PÖJULU
Fajulu *see* PÖJULU
Fak *see* BALOM
FALAFALA (Burkina Faso, Côte
d'Ivoire)
note Gur language
AAT: nl
LCSH: nl
DDMM, GPM 1959, JPB
FALASHA (Ethiopia)
variants Beta Israel, Fellascha
note Cushitic language
AAT: Falasha
LCSH: use Jews, Ethiopian
AF, ATMB 1956, BS, DDMM, GPM 1959,
GPM 1975, HAB, HRZ, IAI, JLS, RJ 1959,
SMI, UIH, WH
WIS*, WLL*, WLL 1957*
FALI (Cameroun, Nigeria)
note Adamawa language although
some groups speak Chadic
languages; a Fulani collective
term for various groups living in
the Cameroun mountains and
Nigeria; sometimes described by
their location, e.g. Fali of Mubi, of
Kiria, of Jilbu; one of the groups
included in the collective term
Kirdi
AAT: Fali
LCSH: Fali
AF, BEL, BS, DDMM, DWMB, EBR,
ETHN, FW, GPM 1959, GPM 1975, HB,
HBDW, IAI, IEZ, JAF, JG 1963, JJM 1972,
JL, JPAL, JLS, KFS, LJPG, MH, MPF
1992, NOI, RGL, RJ 1958, ROMC, RWL,
SMI, WG 1980, WG 1984, WH
JPL*
see also Kirdi
Falupes *see* FELUP

FAMOSI (Côte d'Ivoire)
AAT: nl
LCSH: nl
JPB
Fan *see* FANG
FANG (Cameroun, Gabon,
Equatorial Guinea)
variants Fan, Mpangwe, Pahouin,
Pamue, Pangwe
subcategories Beti, Bulu, Make,
Mekeny, Mvae, Ntumu, Okak,
Southern Fang
note Bantu language; Fang are
sometimes subdivided by region
with the Beti (Northern Fang) in
the north, the Bulu in the central
area and the Southern Fang (or
Fang 'proper,' further subdivided
into the Ntumu and Okak) in the
south. Fang cultural and stylistic
divisions include Betsi, Mabea,
Mekeny, Mvai, Ngumba, Ntumu,
Nzaman, Okak, Okano. see LP
1979, 1985, 1990.
AAT: Fang
LCSH: Fang
AF, ASH, AW, BES, BS, CDR 1985, CMK,
DDMM, DF, DOA, DOWF, DP, DPB
1986, EB, EBHK, EBR, EEWF, ELZ,
ETHN, EWA, FW, GAC, GB, GBJM,
GBJS, GPM 1959, GPM 1975, HAB, HB,
HH, HMC, HRZ, IAI, IEZ, JAF, JD, , JK,
JL, JLS, JM, JP 1953, JTSV, JV 1984, KFS,
KFS 1989, KK 1960, KK 1965, KMT 1970,
LJPG, LM, LP 1993, MCA, MGU 1967,
MHN, MK, MLB, MLJD, MPF 1992, MUD
1986, MUD 1991, NIB, PH, RFT 1974,
RGL, ROMC, RS 1980, RSAR, RSRW,
RSW, SMI, SV, SV 1988, SVFN, TB,
TLPM, TP, UIH, WBF 1964, WG 1980,
WH, WLA, WMR, WOH, WRB, WRB
1959, WRNN, WS
GT*, JWF*, LP 1979*, LP 1985*, LP
1990*, PAJB*

FANG, SOUTHERN (Gabon)
subcategories Make
note Bantu language. Make is
 sometimes considered a
 subcategory of Southern Fang.
 AAT: nl
 LCSH: nl
 LP 1985
see also Fang
Fante *see* FANTI
FANTI (Ghana)
variants Agona, Fante
subcategories Asafo
note Kwa language; one of the
 groups included in the collective
 term Akan
 AAT: Fanti
 LCSH: Fanti
 ACN, BDG 1980, BS, CDR 1985, CK,
 CMK, DDMM, DFHC, DWMB, ENS,
 ETHN, EVA, FW, GAC, GB, GPM 1975,
 HAB, HB, HBDW, HCDR, HRZ, IAI,
 JEEL, JK, JLS, JM, JPB, JPJM, KFS, KK
 1965, MLB, MM 1950, PMPO, RFT 1974,
 RGL, RJ 1958, ROMC, RS 1980, RSAR,
 RSW, SMI, TFG, TP, UIH, WEW 1973,
 WFJP, WG 1980, WG 1984, WH, WMR,
 WOH, WRB, WRB 1959, WRNN, WS
 DHR*, KH*, PANB 1992*
see also Akan
Fayum *see* Toponyms Index
Fe'fe' *see* BAFANG
FEGWA (Cameroun)
note one of the groups included in
 the collective term Bamileke
 AAT: nl
 LCSH: nl
 LP 1993, PH
see also Bamileke
FELLAHIN (Egypt, Sudan)
note agricultural peoples along the
 Nile
 AAT: nl
 LCSH: nl
 GPM 1975, SMI
Fellascha *see* FALASHA
Fellata *see* FULANI
Fellata-Baggare *see* BAGGARA

FELUP (Guinea, Guinea-Bissau,
 Senegal)
variants Falupes, Fulup
note West Atlantic language
 AAT: Felup
 LCSH: Felup
 DDMM, ETHN, HB, KFS, MPF 1992, RJ
 1958, UIH
 EPHE 4*, EPHE 9*
Feri *see* PÄRI
FESIRA (Madagascar)
note Malagasi language
 (Austronesian)
 AAT: nl
 LCSH: nl
 JMA
Fezzan *see* Toponyms Index
Fia *see* BAFIA
FIJEMBELE (Burkina Faso, Côte
 d'Ivoire, Mali)
note Gur language; subcategory of
 Senufo; a collective term used for
 Senufo ethnic groups not
 associated with farming
 AAT: nl
 LCSH: nl
 DR
see also Senufo
Fika *see* BOLEWA
Filani *see* FULANI
Fingo *see* MFENGU
Fiome *see* GOROWA
Fiot *see* FIOTE
FIOTE (Congo Republic)
variants Fiot, Fjort
note Bantu language; term used for
 Kongo groups living along the
 Atlantic coast, e.g. Woyo and Vili
 AAT: nl
 LCSH: Fiote language use Kituba language
 DDMM, ETHN, GAH 1950, GPM 1959,
 GPM 1975, HAB, HBDW, JL, JMOB,
 LJPG, OB 1973, WH
see also Kongo, Vili, Woyo

FIPA (Tanzania, Zambia)
note Bantu language
AAT: Fipa
LCSH: Fipa
BS, DDMM, ECB, ETHN, FN 1994, GPM
1959, GPM 1975, HAB, HB, HBDW, IAI,
JM, JV 1966, KFS, KK 1990, MFMK,
MGU 1967, NIB, RJ 1960, SD, SMI, UIH,
WH, WOH, WVB
JMR*

Fizere *see* JARAWA

Fjort *see* FIOTE

Fo *see* BAFO

Fododon *see* FODONON

Fodombele *see* FODONON

FODONON (Côte d'Ivoire)
variants Fododon, Fodombele
note Gur language; subcategory of
Senufo
AAT: nl
LCSH: nl
HB, JPB, SV, WS
AJG*
see also Senufo

FOMA (Zaire)
variants Fuma
note Bantu language
AAT: nl
LCSH: Foma
BS, DDMM, DPB 1987, ETHN, IAI

FOMOPEA (Cameroun)
note Bantu language; one of the
groups included in the collective
term Bamileke
AAT: nl
LCSH: nl
DDMM, ETHN, LP 1993, PH
MMML*
see also Bamileke

FON (Benin, Ghana, Nigeria, Togo)
note Kwa language; ruled the
kingdom of Dahomey in the 17th
-19th centuries
AAT: Fon
LCSH: Fon
ACN, ASH, BS, CDR 1985, CFL, CK,
CMK, DDMM, DFHC, DOA, DP, DWMB,
EB, EBR, EEWF, EL, ELZ, ETHN, EWA,
FW, GBJM, GPM 1975, HAB, HB,
HBDW, HH, IAI, JD, JK, JLS, JM, JP

1953, JPJM, KFS, KK 1965, KMT 1971,
LJPG, LM, MH, MHN, MLB, MLJD, MPF
1992, MWM, NIB, RFT 1974, RGL, RJ
1958, ROMC, RSAR, RSW, SMI, SV,
SVFN, TLPM, TP, UIH, WBF 1964, WG
1980, WG 1984, WH, WMR, WOH, WRB,
WRNN, WS
see also Dahomey

FONCANDA (Cameroun)
AAT: nl
LCSH: nl
EBHK, KK 1965

FONDONERA (Cameroun)
variants Fonjonera, Fongdonera
note Bantoid language
AAT: nl
LCSH: nl
DDMM, KK 1960, LP 1993
MMML*, PH*

Fongdonera *see* FONDONERA

FONGO (Cameroun)
note subcategory of Dschang;
includes Fongo Ndeng and Fongo
Tongo; one of the groups included
in the collective term Bamileke
AAT: nl
LCSH: nl
LP 1993, MMML, PH, ROB
see also Bamileke, Dschang

FONJOMEKWET (Cameroun)
note one of the groups included in
the collective term Bamileke
AAT: nl
LCSH: nl
DDMM, MMML, PH
see also Bamileke

Fonjonera *see* FONDONERA

FONJUMETOR (Cameroun)
note Bangwa chiefdom
AAT: nl
LCSH: nl
PH, ROB
see also Bangwa

FONO (Côte d'Ivoire)
variants Fononbele
note Gur language; subcategory of
Senufo
AAT: nl
LCSH: nl
AJG, SV
see also Senufo
Fononbele *see* FONO
FONTCHATULA (Cameroun)
variants Fontsa Tuala
note Bantoid language; one of the
groups included in the collective
term Bamileke
AAT: nl
LCSH: nl
DDMM, LP 1993, PH
see also Bamileke
FONTEM (Cameroun)
variants Lebang
note Bantoid language; Bangwa
chiefdom; sometimes referred to
as Western Bangwa; one of the
groups included in the collective
term Bamileke
AAT: nl
LCSH: nl
DDMM, ETHN, JPN, NIB, ROB, TN 1984
TN 1986*, LP 1993*, PH*
see also Bamileke, Bangwa
Fontsa Tuala *see* FONTCHATULA
FOREKE (Cameroun)
note Bantoid language; divided into
Foreke Chacha and Foreke
Dschang
AAT: nl
LCSH: nl
DDMM, ETHN
LP 1993*
FOREKE CHACHA (Cameroun)
note Bangwa chiefdom; subcategory
of Foreke
AAT: nl
LCSH: nl
LP 1993, PH, ROB
see also Bangwa
Foreke Djang *see* DSCHANG

Foreke Dschang, *see* DSCHANG
FORO (Côte d'Ivoire)
note Gur language; subcategory of
Senufo
AAT: nl
LCSH: nl
BH 1966, DDMM, DWMB, JG 1963, UIH
see also Senufo
FOSSONG (Cameroun)
note Bantoid language; one of the
groups included in the collective
term Bamileke
AAT: nl
LCSH: nl
DDMM, LP 1993, MMML
see also Bamileke
FOSSUNGO (Cameroun)
note Bangwa chiefdom
AAT: nl
LCSH: nl
LP 1993, ROB
see also Bangwa
FOTABONG (Cameroun)
note Bangwa chiefdom, includes
two villages
AAT: nl
LCSH: nl
KK 1965, LP 1993, PH, ROB, SV
see also Bangwa
Fotessa *see* FOTETSA
FOTETSA (Cameroun)
variants Fotessa
note one of the groups included in
the collective term Bamileke
AAT: nl
LCSH: nl
DDMM, LP 1993, MMML, PH
see also Bamileke

FOTO (Cameroun)

note Bantoid language
AAT: nl
LCSH: nl
DDMM, ETHN, HAB, HB, KK 1960, KK 1965, PH
LP 1993*, MMML*

FOTO DUNGATET (Cameroun)

variants Dugatet

note Bangwa chiefdom
AAT: nl
LCSH: nl
PH, ROB

see also Bangwa

FOTOMENA (Cameroun)

note Bantoid language; one of the groups included in the collective term Bamileke
AAT: nl
LCSH: nl
DDMM, MMML

see also Bamileke

Fotouni *see* FOTUNI

FOTUNI (Cameroun)

variants Batouni, Fotouni

note Bantoid language; one of the groups included in the collective term Bamileke
AAT: nl
LCSH: nl
DDMM, HB, LP 1993, MMML, PH

see also Bamileke

Foula *see* FULANI

Foulanke *see* FULANI

Foulbe *see* FULANI

Fouta Djallon *see* Toponyms Index

Fouta Toro *see* Toponyms Index

FOZIMOGNDI (Cameroun)

variants Fozimonde

note Bangwa chiefdom
AAT: nl
LCSH: nl
PH, ROB

see also Bangwa

FOZIMOMBIN (Cameroun)

note Bangwa chiefdom
AAT: nl
LCSH: nl

LP 1993, PH, ROB

see also Bangwa

Fozimonde *see* FOZIMOGNDI

FRAFRA (Burkina Faso, Ghana)

note Gur language. The term is also used to refer to a cluster of people in northern Ghana including the Gurensi, Kusasi, Namnam, and Tallensi.
AAT: nl
LCSH: Frafra language use Nankanse language
BS, DDMM, DWMB, ENS, ETHN, GPM 1959, HB, HBDW, HCDR, JLS, JPB, KFS, RAB, UIH
FTS*

French Cameroun *see* Toponyms Index

French Equatorial Africa *see* Toponyms Index

French Somaliland *see* Toponyms Index

French West Africa *see* Toponyms Index

Fula *see* FULANI

FULANI (Benin, Burkina Faso,
Cameroun, Chad, Central African
Republic, Côte d'Ivoire, Gambia,
Ghana, Guinea, Guinea-Bissau,
Mali, Mauritania, Niger, Nigeria,
Senegal, Sierra Leone, Sudan,
Togo)
variants Fellata, Filani, Foula,
Foulanke, Foulbe, Fula, Fulata,
Fulbe, Fulfulde, Peuhl, Peul,
Pullo, Pulo
subcategories Bororo, Toorobbe,
Tukulor, Wodaabe
note West Atlantic language; often
divided into two groups:
sedentary and nomadic Fulani,
and Islamicized and non-
Islamicized Fulani; often referred
to according to regions and
administrative centers in which
they are found, e.g. Adamawa,
Bauchi, Fouta Djalon, Kita, etc.
Consult RWL and other special
sources for an exhaustive
overview of Fulani groups.
AAT: Fulani
LCSH: use Fula
AF, AML, ARW, BEL, BS, CDR 1987,
CFL, DDMM, DFHC, DOA, DWMB, EBR,
EFLH, ELZ, ETHN, FN 1994, FW, GBJM,
GPM 1959, GPM 1975, HAB, HB, HBDW,
HBU, HMC, HRZ, IAI, ICWJ, IEZ, JAF,
JD, JEG 1958, JG 1963, JJM 1972, JK, JL,
JLS, JM, JP 1953, JPAL, JPB, JPJM, JV
1966, JV 1984, KE, KFS, KMT 1970, KMT
1971, LJPG, LM, LP 1993, LPR 1986, LPR
1995, LSD, MBBH, MCA, MG, MH,
MHN, MLB, MLJD, MPF 1992, NIB, NOI,
PG 1990, PH, PMK, PMPO, PR, PRM,
PSG, RAB, RGL, RJ 1958, ROMC, RS
1980, RSW, SG, SMI, SV, TFG, TN 1984,
UIH, VP, WEW 1973, WG 1980, WG
1984, WH, WOH, WRB, WRB 1959,
WRNN, WS
BBH*, CEH*, COA*, HBR*, RWL*
Fulata *see* FULANI
Fulbe *see* FULANI
Fulero *see* FURIIRU

Fulfulde *see* FULANI
Fuliiro *see* FURIIRU
Fuliru *see* FURIIRU
Fulse *see* KURUMBA
Fulup *see* FELUP
Fum *see* BAFUM
Fuma *see* FOMA
Fumban *see* Toponyms Index
Fumu *see* MFINU
Fung *see* FUNJ-HAMAJ
FUNGOM (Cameroun)
note Bantoid language; one of the
groups included in the collective
terms Bamenda and Tikar
AAT: nl
LCSH: nl
DDMM, DWMB, ETHN, GPM 1975, HB,
IEZ, KK 1960, PH, RJ 1958, TN 1984, TN
1986
GDR*, LP 1993*, MMML*, PMK*
see also Bamenda, Tikar
Funika *see* MFINU
Funj *see* Toponyms Index
FUNJ-HAMAJ (Sudan)
variants Fung, Hamej
note Nilo-Saharan language
AAT: nl
LCSH: nl
CSBS, ETHN, GPM 1975, HB, ICWJ,
LJPG, LPR 1986, MPF 1992, RJ 1959, WH
ERC*
FUR (Chad, Sudan)
variants Furr
note Nilo-Saharan language; Darfur
province
AAT: nl
LCSH: Fur
ATMB, BS, CSBS, DDMM, ETHN, GPM
1959, GPM 1975, HB, ICWJ, JG 1963,
JLS, RJ 1959, SMI, WH
Furero *see* FURIIRU

FURIIRU (Zaire)

variants Fulero, Fuliiro, Fuliru, Furero

note Bantu language
AAT: nl
LCSH: nl (Fuliru language)
DDMM, DPB 1981, DPB 1987, ETHN, GPM 1959, GPM 1975, HB, MGU 1967, UIH

Furr *see* FUR

FURU (Zaire)

variants Gbaya

note Central Sudanic language; subcategory of Kreish
AAT: nl
LCSH: nl
ATMB 1956, DDMM, ETHN, GAH 1950, GPM 1959, GPM 1975, HAB, HB, HBU, IAI, JMOB, OBZ, WH

see also Kreish

Fusam *see* BAFUSSAM

Fut *see* BAFUT

Fyam *see* PYEM

GA (Ghana)

variants Gã, Gan

note Kwa language; often linked in the literature with Adangme or referred to as Ga-Adangme
AAT: Ga
LCSH: Ga
BS, DDMM, DWMB, EBR, ETHN, GPM 1959, GPM 1975, HAB, HB, HBDW, HCDR, HRZ, IAI, JG 1963, JLS, KK 1965, MM 1950, RJ 1958, RS 1980, SMI, UIH, WEW 1973, WH, WRB

see also Adangme, Ga-Adangme

Gã *see* GA

Ga-Adangbe *see* GA-ADANGME

GA-ADANGME (Ghana)

variants Ga-Adangbe

note Kwa language which is sometimes divided into two groups: Adangme speakers and Ga speakers
AAT: nl
LCSH: nl
DDMM, DWMB, ETHN, GPM 1959, HCDR, JG 1963
MM 1950*

see also Adangme, Ga

GAANDA (Nigeria)

note Chadic language
AAT: Ga'anda
LCSH: Gaanda
BS, DDMM, ETHN, JLS, NIB, RWL

GABBRA (Ethiopia, Kenya)

variants Gabra

note Cushitic language; subcategory of Oromo
AAT: Gabbra
LCSH: Gabbra
AF, DDMM, ECB, ETHN, HB, JLS, LPR 1995, WH
MOH*

see also Oromo

Gabra *see* GABBRA

GADABURSI (Djibouti, Ethiopia, Somalia)

note Cushitic language
AAT: nl
LCSH: nl
GPM 1959, HB, KFS, RJ 1959, UIH
IML 1969*

GADE (Nigeria)

note Kwa language
AAT: nl
LCSH: Gade
DDMM, ETHN, GPM 1959, GPM 1975, HB, HBDW, JG 1963, IAI, NOI, RWL, SMI
SN*

GADI (Côte d'Ivoire)

note Kwa language; single large ethnic group which split into the Magwe and We. see JPB
AAT: nl
LCSH: Gadi
JPB

see also Magwe

GAFAT (Ethiopia)
note Semitic language
AAT: nl
LCSH: Gafat language
ATMB, ATMB 1956, DDMM, ETHN, HB,
IAI, RJ 1959, UIH
WIS*

GAGNOA (Côte d'Ivoire)
note Kwa language; subcategory of
Bete; sometimes referred to as
Eastern Bete; also the name for a
Mesolithic site
AAT: nl
LCSH: nl
ETHN, JPB
see also Bete

Gagou see GAGU

GAGU (Côte d'Ivoire)
variants Gagou, Gban
note Mande language
AAT: nl
LCSH: Gagu language
DDMM, DWMB, EFLH, ETHN, GPM
1959, GPM 1975, HAB, HB, HBDW, IAI,
JK, JLS, JP 1953, KFS, MLJD, MPF 1992,
RGL, RJ 1958, SD, SMI, WH, WS
BH 1975*, JPB*

Gala see OROMO

GALIM (Cameroun)
note Bantoid language
AAT: nl
LCSH: nl
DDMM, ETHN, GPM 1959, HB, LP 1993,
PH, WH

Galla see OROMO

Gallinas see VAI

Gallinyas see OROMO

Galoa see GALWA

GALWA (Gabon)
variants Galoa
note Bantu language; one of the
groups included in the Myene
cluster
AAT: Galwa
LCSH: Galwa
CDR 1985, DDMM, DP, ELZ, ETHN,
EWA, GPM 1959, GPM 1975, HAB, HB,
HBDW, LP 1979, LP 1985, TB, WH,
WRB, WS

see also Myene

Gam see BAGAM

Gambia River see Toponyms Index

GAMERGU (Cameroun, Nigeria)
note Chadic language
AAT: nl
LCSH: nl
DDMM, ETHN, GPM 1959, HB, JG 1963,
RWL, SD

Gan see GA

GAN (Côte d'Ivoire)
variants Ben, Ngan
note Mande language; one of the
groups included in the collective
term Akan
AAT: nl
LCSH: use Beng
DDMM, ETHN, GPM 1959, GPM 1975,
HBDW, KFS, WH
JPB*
see also Akan

GAN (Burkina Faso)
variants Kaanse
subcategories Gbadogo
note Gur language; one of the
groups included in the collective
term Lobi
AAT: nl
LCSH: nl
DDMM, DP, DWMB, EFLH, ETHN, GPM
1959, GPM 1975, HBDW, IAI, JG 1963,
UIH, WH
see also Lobi

Gana see GHANA empire

GANAWURI (Nigeria)
variants Aten
note Benue-Congo language
AAT: nl
LCSH: nl
BS, DDMM, DWMB, ETHN, GPM 1959,
GPM 1975, HB, HDG, HRZ, IAI, JG 1963,
NOI, RWL, UIH, WH

GANDA (Uganda)
variants Baganda, Buddu
note Bantu language
AAT: Ganda
LCSH: Ganda
BES, BS, DWMB, EBR, ECB, ELZ,
ETHN, EWA, GB, GPM 1959, GPM 1975,
HAB, HB, HBDW, HMC, IAI, JD, JLS,
JPJM, KMT 1971, LJPG, MCA 1986,
MGU 1967, MLB, MLJD, MTKW, RGL,
RJ 1960, ROMC, RS 1980, RSW, SD, SMI,
UIH, WFJP, WH, WOH, WRB 1959
AYL*, BCR*, MCF*

GANGALA (Congo Republic)
variants Bagangala
note Bantu language; subcategory of
Sundi
AAT: nl
LCSH: nl
DDMM, DPB 1985, JMOB
see also Sundi

Gangara *see* GHANA empire

GANGSIN (Cameroun)
note subcategory of Bali
AAT: nl
LCSH: nl
PMK
see also Bali

Ganguella *see* NGANGELA

GANZI (Central African Republic)
note Western Ubangian language;
one of the groups included in the
collective term Pygmies
AAT: nl
LCSH: nl
DB 1978, DDMM, ETHN, UIH
see also Pygmies

GAO (Mali)
note Nilo-Saharan language; an
ancient city and capital of the
Songhay empire; also a modern
dialect of the Songhai language
spoken in the Gao region of Mali
AAT: Gao
LCSH: Gao empire use Songhai Empire
DDMM, ETHN, EWA, FW, GPM 1975,
HB, HBDW, HRZ, JDC, JG 1963, JJM
1972, JL, JPB, JPJM, JV 1984, KFS, LPR
1986, PG 1990, PR, RAB, ROMC, TFG,
UGH, WG 1984, WOH

see also Songhai, Toponyms Index

GARAMANTES (Algeria, Libya,
Mauritania)
note described by Herodotus, circa
450 BCE; a term used for
sedentary mixed populations of
the North African oases, known as
such before the Islamicization of
these areas
AAT: nl
LCSH: nl
ARW, HB, JLS, JV 1984, PG 1990, VP
1964

GARBO (Côte d'Ivoire, Liberia)
note Kwa language: subcategory of
Kran
AAT: nl
LCSH: nl
GSDS
see also Kran

GASO (Cameroun)
variants Bali-Gasho
note subcategory of Bali
AAT: nl
LCSH: nl
PMK
see also Bali

GATO (Ethiopia)
note Cushitic language; subcategory
of Konso
AAT: Gato
LCSH: use Konso
DDMM, ELZ, ERC, ETHN, HB, JD, JK,
JLS, MLB, MLJD, WG 1984, WRB,
WRNN, WS
see also Konso

Gawaar *see* GAWEIR

GAWEIR (Sudan)
variants Gawaar
note Western Nilotic language;
subcategory of Nuer
AAT: nl
LCSH: nl
ATMB 1956, DDMM, ETHN, HB, UIH
see also Nuer

GAYA (Tanzania)
note Western Nilotic language;
 subcategory of Lwoo
 AAT: nl
 LCSH: Gaya language use Luo language
 ATMB 1956, GPM 1959, GPM 1975,
 HBDW, KK 1990, WOH
see also Lwoo

GAYI (Cameroun, Nigeria)
variants Uge
note Benue-Congo language; one of
 the groups included in the
 collective term Cross River people
 AAT: nl
 LCSH: nl
 DDMM, DWMB, ETHN, GPM 1959, HB,
 JG 1963, NOI, RWL, UIH
see also Cross River people

GBADI (Côte d'Ivoire)
note Kwa language; subcategory of
 Bete; sometimes referred to as
 Central or Western Bete
 AAT: nl
 LCSH: nl
 DDMM, ETHN
see also Bete

GBADOGO (Burkina Faso)
variants Badogo, Padorho
note Gur language; subcategory of
 Gan
 AAT: nl
 LCSH: nl
 DDMM, ETHN, HB, MPF 1992
see also Gan

Gbaja *see* GBAYA (Cameroun)
Gbaka *see* NGBAKA
Gban *see* GAGU
Gbande *see* GBANDI
Gbandi *see* NGBANDI (Zaire)
GBANDI (Liberia, Sierra Leone)
variants Bandi, Gbande
note Mande language
 AAT: nl (uses Gbande)
 LCSH: Gbandi
 CDR 1985, DDMM, DWMB, ETHN, GPM
 1959, GPM 1975, GSGH, HAB, HB,
 HBDW, IAI, JG 1963, KFS, RJ 1958, RS

1980, SMI, UIH, WEW 1973, WH, WOH,
WRB, WS
BGD*, MEM 1950*
see also Mande

Gbanu *see* BANU
Gbanzili *see* GBANZIRI
GBANZIRI (Central African
 Republic, Zaire)
variants Banziri, Gbanzili
note Western Ubangian language
 AAT: nl
 LCSH: use Banziri
 ATMB 1956, DB 1978, DDMM, DPB
 1987, ETHN, FE 1933, GPM 1959, GPM
 1975, HAB, HB, HBDW, HBU, IAI, JG
 1963, JMOB, OBZ, WH

GBARI (Nigeria)
variants Agbari, Gwari
subcategories Ngenge
note Kwa language
 AAT: use Gwari
 LCSH: Gbari
 DDMM, DWMB, ELZ, ETHN, GPM 1959,
 GPM 1975, HB, HBDW, HMC, IAI, JG
 1963, JLS, KFS, LJPG, NIB, NOI, RJ 1958,
 ROMC, RWL, UIH, WFJP, WG 1984, WH
 HGFC*, SN*

GBARZON (Côte d'Ivoire, Liberia)
note Kwa language: subcategory of
 Kran
 AAT: nl
 LCSH: nl
 ETHN, GSDS
see also Kran

GBATO (Côte d'Ivoire)
variants Gbatobele
note Gur language; subcategory of
 Senufo
 AAT: nl
 LCSH: nl
 BH 1966, DDMM, JPB, SV
see also Senufo

Gbatobele *see* GBATO
Gbaya *see* FURU

GBAYA (Central African Republic, Sudan)
variants Gbaya Ndogo
subcategories Kara
note Central Sudanic language; subcategory of Kreish; not to be confused with the Gbaya of the Congo and Central African Republic, who speak a Western Ubangian language. In some sources the information may not be sufficiently explicit to determine to which group they belong.
AAT: nl
LCSH: nl
ATMB 1956, CSBS, DDMM, ETHN, GPM 1959, GPM 1975, HAB, HB, IAI, RJ 1959, WH
see also Kreish

GBAYA (Cameroun, Central African Republic, Congo Republic, Zaire)
variants Baja, Baya, Gbaja, Gbeya
note Western Ubangian language; includes many small groups in this region; not to be confused with the Gbaya of the Sudan who speak a Central Sudanic language. In some sources the information may not be sufficiently explicit to determine to which group they belong. see ATMB 1956 and DDMM for a more complete list of groups
AAT: use Ngbaka
LCSH: Gbaya
ATMB, ATMB 1956, BES, BS, CDR 1985, DB 1978, DDMM, DPB 1987, EBR, ETHN, GAH 1950, GPM 1959, GPM 1975, HB, HBDW, HBU, IAI, IEZ, JG 1963, JLS, JM, JMOB, JP 1953, KK 1960, KK 1965, LJPG, LP 1990, MH, MK, MLJD, MPF 1992, NIB, OBZ, RGL, RSW, RWL, SMI, UIH, WEW 1973, WOH, WRB, WS
JH*

Gbaya Ndogo *see* GBAYA (Sudan)

GBEON (Côte d'Ivoire)
note Kwa language; subcategory of Wobe
AAT: nl
LCSH: nl
DDMM, JPB
see also Wobe

Gberese *see* KPELLE

Gbeya *see* GBAYA (Congo Republic, Zaire)

GBI (Liberia)
variants Gibi
note Kwa language
AAT: nl
LCSH: nl
DDMM
GSDS*

Gbinna *see* YUNGUR

GBOFI (Central African Republic)
note Western Ubangian language
AAT: nl
LCSH: nl
DB 1978, DDMM, ETHN, HB

GBONZORO (Côte d'Ivoire)
note Gur language; subcategory of Senufo
AAT: nl
LCSH: nl
DDMM, JPB, SV
AJG*
see also Senufo

Gbou *see* GBU

GBU (Côte d'Ivoire, Liberia)
variants Gbou
note Kwa language; subcategory of Kran
AAT: nl
LCSH: nl
GSDS
see also Kran

Gbugu *see* MBUGU (C.A.R.)

Gbunde *see* GBUNDI

GBUNDI (Guinea, Liberia)
 variants Gbunde
 note Mande language; considered a
 dialect of Loma. see DDMM.
 AAT: Gbundi
 LCSH: nl
 DDMM, ETHN, GPM 1959, GSGS, HB,
 JG 1963, UIH, WRB
 see also Loma, Mande

GE (Benin, Togo)
 variants Geh, Gen, Mina
 note Kwa language
 AAT: nl
 LCSH: use Mina
 CK, DDMM, ELZ, ETHN, GPM 1959,
 GPM 1975, HB, JD, JLS, RJ 1958, UIH,
 MLJD

Gedi *see* Toponyms Index

Geh *see* GE

Geia *see* LWOO

Gekoyo *see* GIKUYU

Geleba *see* DASENECH

Gen *see* GE

Gengele *see* NGENGELE

Gens d'Eau *see* NGALA

Genya *see* ENYA

Gerawege *see* GURAGE

Gere *see* NGERE

Gere Wobe *see* NGERE

GERES (Mali, Nigeria)
 variants Kel Gress
 note Berber language; division of
 Tuareg
 AAT: nl
 LCSH: nl
 GPM 1959
 EDB, EBJN
 see also Tuareg

German East Africa *see* Toponyms
Index

German Southwest Africa *see*
Toponyms Index

Gerze *see* KPELLE

GESERA (Burundi, Rwanda)
 note one of the groups included in
 the collective term Pygmies
 AAT: nl

 LCSH: nl
 ETHN, GPM 1959, UIH
 see also Pygmies

Gesu *see* GISU

GHADAMES (Libya)
 note Berber language; one of the
 groups included in the collective
 term Berber
 AAT: nl
 LCSH: nl
 ETHN, GPM 1959, KFS, WH
 see also Berber

Gham *see* BAGAM

GHANA Empire
 variants Gana, Gangara
 note ancient and medieval
 kingdom, circa 700-1100 CE.
 People of the Ghana empire were
 sometimes called Gangara.
 AAT: Ghana kingdom
 LCSH: Ghana empire
 BD, CDR 1985, DP, EL, GPM 1975, HB,
 JL, LPR 1986, PG 1990, PR, TP, UGH

Ghimirra *see* GIMIRA

GIBE (Ethiopia)
 note Eastern Cushitic language;
 subcategory of Sidamo
 AAT: nl
 LCSH: Gibe River use Gibbe River,
 Ethiopia
 GPM 1959, GPM 1975, WH
 see also Sidamo

Gibi *see* GBI

Gidar *see* GUIDAR

GIKUYU (Kenya)
 variants Akikuyu, Gekoyo, Kikuyu,
 Wakikuyu
 note Bantu language
 AAT: nl (uses Kikuyu)
 LCSH: use Kikuyu
 AF, BS, CFL, DDMM, EBR, ECB, ELZ,
 ETHN, EWA, GBJM, GBJS, GPM 1959,
 GPM 1975, HAB, HMC, HRZ, IAI, JJM
 1972, JLS, JM, LJPG, LSD, MCA 1986,
 MGU 1967, MLJD, PG 1990, PMPO, PR,
 RGL, RJ 1960, ROMC, RSW, SD, SMI, SV
 1988, TP, UIH, WEW 1973, WH, WOH,
 WRB, WRB 1959
 JMGK*, JOK*, PIB*

Gili *see* MIGILI

GIMIRA (Ethiopia)

variants Ghimirra

note Cushitic language; subcategory of Sidamo
AAT: nl
LCSH: Gimira
ATMB, ATMB 1956, DDMM, ETHN, GPM 1959, GPM 1975, IAI, JG 1963, KFS, RJ 1959, SMI, WH
ERC*, WJL*

see also Sidamo

GIMR (Chad, Sudan)

variants Kimr, Qimr

note Eastern Sudanic language
AAT: nl
LCSH: nl
ATMB 1956, DDMM, ETHN, GPM 1959, HB, WH

Gio *see* DAN

Gioh *see* DAN

Giriama *see* GIRYAMA

GIRYAMA (Kenya, Tanzania)

variants Giriama, Gyriama, Wagiryama

note Bantu language; one of the groups included in the ethnic cluster Nyika
AAT: nl (uses Giriama)
LCSH: Giryama
AHP 1952, BS, DDMM, EBR, ECB, ELZ, ETHN, GPM 1959, GPM 1975, HAB, HB, HBDW, IAI, JK, MGU 1967, MK, MLB, RGL, RJ 1960, RS 1980, SMI, SV 1988, TP, UIH, WG 1980, WH, WOH, WRNN, WS
AMC*, DJP*, EW*

see also Nyika

Gisai *see* GISEI

GISEI (Cameroun)

variants Gisai, Guisey

note Chadic language; subcategory of Massa; one of the groups included in the collective term Kirdi
AAT: nl
LCSH: nl
ETHN, GPM 1959, HB, JP 1953
IDG*

see also Kirdi, Massa

Gishu *see* GISU

GISIGA (Cameroun)

variants Giziga, Guisiga

note Chadic language; subcategory of Matakam; one of the groups included in the collective term Kirdi
AAT: nl
LCSH: Gisiga language
BEL, DB, DDMM, DWMB, ETHN, GPM 1959, GPM 1975, HB, IAI, JG 1963, JLS, JP 1953, KFS, RJ 1958, UIH, WH

see also Kirdi, Matakam

Gisira *see* SHIRA

GISU (Kenya, Uganda)

variants Bageshu, Bagesu, Bagishu, Gesu, Gishu, Malaba, Masaba

note Bantu language
AAT: Gisu
LCSH: Gisu
BS, DDMM, ECB, ETHN, GPM 1959, GPM 1975, HB, IAI, KK 1990, MGU 1967, MTKW, NIB, PMPO, RGL, RJ 1960, SMI, UIH, WH
JOR 1924*, JSL*

Giziga *see* GISIGA

Goamai *see* ANKWE

Goba *see* MBUKUSHU

Gobir *see* Toponyms Index

GOBU (Central African Republic, Zaire)

variants Ngobu

note Central Ubangian language
AAT: Gobu
LCSH: nl
ATMB 1956, DB 1978, DDMM, DPB 1987, ETHN, GAH 1950, GPM 1959, GPM 1975, HBU, HB, JC 1978, JMOB, OBZ, WH, WRB

GODE (Côte d'Ivoire)

note Kwa language; subcategory of Baule
AAT: nl
LCSH: nl
JPB

see also Baule

GODIE (Côte d'Ivoire)
variants Godye, Kodie
note Kwa language
AAT: nl
LCSH: Godie dialect use Godye dialect
DDMM, ETHN, GPM 1959, HB, JEEL,
JPB, KFS, RJ 1958, UIH

Godye *see* GODIE
Goemai *see* ANKWE
GOGO (Tanzania)
note Bantu language
AAT: Gogo
LCSH: Gogo
BS, DDMM, EBR, ECB, ETHN, GPM
1959, GPM 1975, HAB, HB, HBDW, HRZ,
IAI, JLS, JM, KK 1990, MFMK, MGU
1967, RJ 1960, SD, UIH, WG 1980, WH,
WOH
MTM*

Goin *see* GOUIN
GOKANA (Nigeria)
note Benue-Congo language; one of
the groups included in the
collective term Ogoni
AAT: nl
LCSH: nl
DDMM, ETHN, JG 1963, HB, RWL
see also Ogoni

Gokomere *see* Toponyms Index
Gola *see* BADYARANKE (Guinea)
GOLA (Liberia, Sierra Leone)
note West Atlantic language
AAT: Gola
LCSH: Gola language
DDMM, DWMB, ETHN, FW, GPM 1959,
GPM 1975, GSGH, HAB, HB, HBDW,
HH, IAI, JG 1963, JK, JLS, JV 1984, KFS,
MHN, RGL, RJ 1958, RSRW, SG, SMI,
TB, UIH, WG 1980, WH, WLA, WRB,
WRNN, WS
MEM 1950*, WLA 1965*, WLA 1972*,

Golo *see* SHILLUK
GOLO (Sudan, Zaire)
note Central Ubangian language
AAT: nl
LCSH: Golo language
ATMB 1956, DB 1978, DDMM, ETHN,
GPM 1959, GPM 1975, HB, HBDW, JG
1963, RJ 1959
STS*

GOMA (Zaire)
variants Bagoma, Bahoma,
Benembaho, Homa, Ngoma
note Bantu language; one of many
groups living among the Bembe
and Boyo who are sometimes
referred to as Pre-Bembe
AAT: nl
LCSH: nl
DDMM, DPB 1986, DPB 1987, ETHN,
GPM 1959, GPM 1975, HB, IAI, JMOB,
OBZ, SV
DPB 1981*
see also Pre-Bembe

Gombe *see* NGOMBE
Gonga *see* KAFA
GONJA (Benin, Ghana, Togo)
variants Guan, Guang, Ngbanya
note Kwa language; includes
several incorporated units, some
of them overlapping into Togo;
also an ancient kingdom; one of
the groups included in the
collective term Akan
AAT: Gonja
LCSH: Gonja
BS, CFPK, DDMM, DWMB, ENS, ETHN,
GPM 1959, GPM 1975, HAB, HB, HCDR,
IAI, JG 1963, JLS, KFS, MM 1950, MM
1952, PR, RJ 1958, SMI, UIH, WH, WRB
ESG*, JBJG*, MM 1951*
see also Akan

Gonji *see* NGONJE
Gorane *see* DAZA
Goroa *see* GOROWA
GORORI (Cameroun)
AAT: nl
LCSH: nl
LP 1993, PH

GOROWA (Tanzania)
variants Fiome, Goroa, Gorowe
note Southern Cushitic language;
 closely related to or a subcategory
 of Iraqw
 AAT: nl
 LCSH: nl
 DDMM, ECB, ETHN, GPM 1959, GPM
 1975, GWH 1969, HB, JG 1963, MFMK,
 RJ 1960, RS 1980, SD, UIH, WH
 see also Iraqw
Gorowe *see* GOROWA
Goude *see* GUDE
GOUIN (Burkina Faso, Côte
 d'Ivoire)
variants Cerma, Goin, Guin
note Gur language
 AAT: nl
 LCSH: Gouin
 BH 1966, BS, CDR 1987, DDMM,
 DWMB, ETHN, GPM 1959, HB, JD, JG
 1963, JLS, JPB, MPF 1992, RJ 1958, UIH,
 WH
 EHA*
Goumaye *see* GUMMAI
Goummai *see* GUMMAI
Gourma *see* GURMA
Gourmantche *see* GURMA
Gouro *see* GURO
Gourounsi *see* GRUNSHI
Gova *see* MBUKUSHU
Grassfields *see* GRASSLANDS
GRASSLANDS (Cameroun)
variants Grassfields
note One of three very large so-
 called stylistic regions in the
 Cameroun; the others being:
 Northern and Central Cameroun
 together, ranging from southern
 Lake Chad to Adamawa; and the
 Forest Zone ranging from
 southwestern Cameroun along the
 Atlantic Coast to the extreme
 south of Cameroun bordering on
 Gabon. It includes hundreds of
 kingdoms and chiefdoms and

many rich cultural and artistic
traditions. Perrois and Notue
distinguish three stylistic regions:
1. Tikar and Bamum country 2.
Bamileke country 3. North
Western Grasslands, including
Babanki, Babungo, Bafandji, Bali,
Kom, and Oku. In addition there
are numerous transitional zones.
see LP 1994.
 AAT: nl
 LCSH: Grasslands Bantu languages
 CFL, DDMM, EBHK, EEWF, GDR, HMC,
 JLS, KK 1960, KK 1965, LM, LPR 1995,
 PMPO, RJ 1958, TP, WOH, WS
 CMG*, CT 1981*, CT 1960*, JPN*, LP
 1993*, PAG*, PMK*, TN 1984*
 see also Bamenda, Bamileke
Great Lakes *see* Toponyms Index
GREAT ZIMBABWE (Zimbabwe)
note ancient culture
 AAT: use Karanga
 LCSH: Great Zimbabwe
 AF, ARW, CDR 1985, DOA, EBR, GBJM,
 GPM 1959, GPM 1975, HBDW, HRZ, JK,
 JLS, JM, KFS, LJPG, LSD, MLB, PMPO,
 PR, RGL, RSAR, SMI, WG 1980, WG
 1984, WMR, WRB
 HLL*, JOV*, KNM*, PG 1973*, PG 1990*,
 PG 1995*, RGS*
 see also Toponyms Index, Karanga,
 Monomotapa
GREBO (Côte d'Ivoire, Liberia)
note Kwa language
 AAT: Grebo
 LCSH: Grebo
 CDR 1985, CFL, CMK, DDMM, DWMB,
 EBR, ETHN, GPM 1959, GSGH, HAB,
 HB, HBDW, IAI, JD, JG 1963, JJM 1972,
 JK, JLS, JTSV, LM, MLB, MLJD, RGL, RJ
 1958, RS 1980, SD, SMI, TP, UIH, WG
 1980, WH, WMR, WRB, WRNN, WS
 EFHH*, GSDS*, JPB*

GRUNSHI (Burkina Faso, Ghana)
variants Gourounsi, Grusi, Gurunsi, Jaman
note collective term which includes Gurensi, Kasena, Lyele, Nuna, Sisala, and Winiama
AAT: Grunshi
LCSH: use Grusi
AF, BS, CDR 1985, CMK, DDMM, DFM, DOA, DWMB, ELZ, ETHN, GPM 1959, GPM 1975, HAB, HB, HCDR, IAI, JD, JG 1963, JK, JL, JLS, JP 1953, JPB, JTSV, KFS, LM, LPR 1986, MLB, MLJD, MPF 1992, MUD 1991, RAB, RFT 1974, RGL, RJ 1958, RS 1980, RSW, SMI, SV, TP, UIH, WG 1980, WG 1984, WH, WOH, WS
AMD*, CDR 1987*

Grusi *see* GRUNSHI

Guan *see* GONJA

Guang *see* GONJA

GUBU (Central African Republic)
note Central Ubangian language
AAT: nl
LCSH: nl
DB 1978, DDMM, ETHN

GUDE (Cameroun, Nigeria)
variants Goude
note Chadic language; one of the groups included in the collective term Kirdi
AAT: nl
LCSH: Gude language
BEL, DDMM, ETHN, GPM 1959, GPM 1975, HB, JG 1963, KFS, WH
see also Kirdi

GUDUR (Cameroun)
note Chadic language; subcategory of Mofu
AAT: nl
LCSH: nl
DWMB, MPF 1992
see also Mofu

Guere *see* NGERE

Guere Wobe *see* NGERE

Guerze *see* KPELLE

GUHA (Tanzania, Zaire)
variants Baguha, Kuha
note Bantu language; one of the groups included in the collective term Holoholo
AAT: nl
LCSH: use Holoholo
DDMM, DPB 1981, DPB 1987, ELZ, ETHN, GPM 1959, GPM 1975, HB, MGU 1967, WH
AC*
see also Holoholo

GUIBEROUA (Côte d'Ivoire)
note Kwa language; subcategory of Bete; sometimes referred to as Central or Western Bete
AAT: nl
LCSH: nl
ETHN
see also Bete

GUIDAR (Cameroun, Chad)
variants Gidar
note Chadic language; one of the groups included in the collective term Kirdi
AAT: nl
LCSH: nl
DDMM, DWMB, ETHN, GPM 1959, HB, UIH
IEZ*, BEL*
see also Kirdi

Guin *see* GOUIN

Guinea, Gulf of *see* Toponyms Index

Guisey *see* GISEI

Guisiga *see* GISIGA

GUJI (Ethiopia)
note Cushitic language; subcategory of Oromo
AAT: nl
LCSH: nl
DDMM, ERC, ETHN, HB, UIH
see also Oromo

GULOME (Côte d'Ivoire)
note Mande language; subcategory of Dan
AAT: nl
LCSH: nl
FW
see also Dan

Gumba *see* BVIRI

GUMMAI (Cameroun)
variants Goumaye, Goummai
note Chadic language; subcategory
of Massa
AAT: nl
LCSH: nl
HB
IDG
see also Massa

GUN (Benin, Nigeria)
variants Egun
note Kwa language
AAT: Gun
LCSH: Gun
DDMM, ETHN, GPM 1959, GPM 1975,
IAI, JLS, MPF 1992, NIB, RJ 1958, UIH,
WG 1984, WH, WRB

GUNDI (Central African Republic)
variants Bagunda
note Western Ubangian language
AAT: nl
LCSH: nl
DPB 1986, ETHN, GPM 1959, GPM 1975,
JMOB, UIH, WH

GURAGE (Ethiopia)
variants Gerawege
note Semitic language. There are
fourteen divisions in the Gurage
cluster, divided into eastern and
western groups
AAT: Gurage
LCSH: Gurage
ATMB, ATMB 1956, BS, DDMM, ETHN,
GB, GPM 1959, GPM 1975, HAB, HB,
IAI, JG 1963, JLS, KFS, RJ 1959, SD, SMI,
TP, UIH, WH, WRNN
HG*, WIS*, WIS 1966*

GURE (Nigeria)
note Benue-Congo language
AAT: nl
LCSH: nl
DDMM, DWMB, ETHN, GPM 1959, GPM
1975, HB, JG 1963, NOI, RWL

Gurenne *see* GURENSI

GURENSI (Burkina Faso, Ghana)
variants Gurenne, Nankani,
Nankanse

note Gur language; one of the
groups included in the collective
terms Frafra and Grunshi
AAT: nl
LCSH: use Grusi
BS, DDMM, EBR, ETHN, FTS, GPM
1959, GPM 1975, HB, HBDW, HCDR, JG
1963, JLS, JP 1953, LPR 1969, LPR 1986,
MM 1952, SMI, UIH, WH
MM 1951*, RSR 1932*
see also Frafra, Grunshi

GURMA (Benin, Burkina Faso,
Niger, Togo)
variants Gourma, Gourmantche,
Gurmantche
note Gur language; referred to with
the Moba (Mwaba) as Mwaba-
Gurma
AAT: nl
LCSH: Gurma
AML, BS, CDR 1987, DDMM, DWMB,
EPHE 4, EPHE 5, ETHN, GB, GPM 1959,
HAB, HB, HBDW, HMC, IAI, JG 1963,
JK, JLS, JM, JP 1953, KFS, PRM, RJ 1958,
ROMC, RSW, UIH, WEW 1973, WH,
WOH
see also Mwaba-Gurma
Gurmantche *see* GURMA

GURO (Côte d'Ivoire)
variants Gouro, Gwio, Kweni, Lo,
Lorube
subcategories Dranu, Ngoï,
Nianangon
note Mande language
AAT: Guro
LCSH: Guro
ACN, AW, BS, CDR 1985, CK, CMK,
DDMM, DFHC, DFM, DOA, DP, DWMB,
EB, EBR, EEWF, EFLH, ELZ, ETHN,
EVA, EWA, FW, GAC, GBJM, GBJS,
GPM 1959, GPM 1975, GWS, HAB, HB,
HBDW, HH, IAI, JD, JEEL, JG 1963, JK,
JLS, JP 1953, JTSV, JV 1984, KFS, KFS
1989, KMT 1970, LM, MG, MH, MK,
MLB, MLJD, MPF 1992, MUD 1991, PH,
PSG, RFT 1974, RGL, RJ 1958, RSAR,
RSRW, RSW, SD, SMI, SV, SVFN, TB,
TLPM, TP, UIH, WBF 1964, WG 1980,
WG 1984, WH, WMR, WOH, WRB, WRB
1959, WRNN, WS
EFLH*, EFLH 1986*, JPB*
see also Mande

Guruguru *see* MANGBETU

Gurunsi *see* GRUNSHI

GUSII (Kenya)
variants Guzii, Kisii
note Bantu language
AAT: Gusii
LCSH: Gusii
BS, DDMM, ECB, ETHN, GPM 1959,
GPM 1975, HB, IAI, JLS, MGU 1967, RJ
1960, SMI, UIH, WOH
WRO*

Guzii *see* GUSII

GWA (Nigeria)
note Benue-Congo language
AAT: nl
LCSH: nl
DDMM, ETHN, RWL

GWA (Côte d'Ivoire)
variants Mbato, Mbatto
note Kwa language; one of the
groups included in the collective
term Lagoon people
AAT: nl
LCSH: Gwa dialect
DDMM, DWMB, ENS, ETHN, GPM 1959,
GPM 1975, HAB, HB, HBDW, JG 1963,
JP 1953, TFG, UIH

JPB*
see also Lagoon people

GWANDARA (Nigeria)
note Chadic language
AAT: Gwandara
LCSH: Gwandara language
DDMM, ETHN, GPM 1959, HB, JG 1963,
RWL, WH

Gwari *see* GBARI

GWE (Tanzania)
note Bantu language; subcategory of
Luyia
AAT: nl
LCSH: nl
ECB, ETHN, GPM 1975, GW, HB,
MTKW, RJ 1960, WH
see also Luyia

GWENO (Tanzania)
note Bantu language; merged into
the Pare
AAT: nl
LCSH: nl
DDMM, ETHN, HB, MFMK, SD, UIH
see also Pare

Gwere *see* NGERE

GWERE (Uganda)
note Bantu language
AAT: nl
LCSH: nl
ECB, ETHN, GPM 1959, GPM 1975, HB,
UIH

Gwio *see* GURO

GWORAM (Nigeria)
note Chadic language; one of the
groups included in the collective
term Kofyar
AAT: nl
LCSH: nl
DDMM, ETHN, GPM 1959, RWL, WS
see also Kofyar

Gyaman *see* EBRIE

Gye *see* JIYE

Gyo *see* DAN

Gyriama *see* GIRYAMA

HA (Burundi, Tanzania)
variants Buha
note Bantu language. Buha more
properly designates the kingdom
or region of the Ha.
AAT: Ha
LCSH: nl
AIR 1959, ECB, GPM 1959, GPM 1975,
HAB, HB, IAI, KK 1990, JLS, MFMK,
MGU 1967, RJ 1960, UIH, WH, WOH
MDAT*

Haavu *see* HAVU

HABAB (Eritrea)
note Semitic language; subcategory
of Tigre
AAT: nl
LCSH: nl
GPM 1959, GPM 1975, HB, JLS, RJ 1959
see also Tigre

Habbe *see* DOGON

Habe *see* DOGON

HADENDOWA (Ethiopia)
note Cushitic language; one of the
groups included in the collective
term Beja
AAT: nl
LCSH: nl
AF, DDMM, ETHN, GPM 1959, GPM
1975, HB, JG 1963, LPR 1995, RJ 1959,
UIH
see also Beja

HADIMU (Tanzania)
note Bantu language; subcategory of
Swahili
AAT: nl
LCSH: nl
DDMM, ECB, ETHN, GPM 1959, GPM
1975, HB, IAI, MGU 1967, RJ 1960, WH
see also Swahili

HADIYA (Ethiopia)
variants Hadya
note Cushitic language
AAT: nl
LCSH: Hadiya
DDMM, ERC, ETHN, GPM 1959, IAI, JG
1963, KFS, UIH

HADJERAI (Chad)
variants Hadjeray

AAT: nl
LCSH: Hadjerai
AML, HB, MPF 1992, WOH

Hadjeray *see* HADJERAI

Hadsa *see* HADZAPI

Hadya *see* HADIYA

Hadza *see* HADZAPI

HADZAPI (Tanzania)
variants Hadsa, Hadza, Hatsa,
Kangeju, Kindiga, Ndiga,
Tindega, Tindiga, Watindega
note Khoisan language; one of the
groups included in the collective
term Nilo-Hamitic people
AAT: nl
LCSH: use Tindiga
ARW, ATMB, ATMB 1956, BS, DDMM,
EBR, ECB, ELZ, ETHN, GPM 1959, GPM
1975, GWH 1969, HAB, HB, HBDW,
HRZ, IAI, JG 1963, MFMK, RJ 1960,
ROMC, SD, SMI, UIH, WEW 1973, WH,
WRB
JW*, LKL*
see also Nilo-Hamitic people

Ham *see* JABA

HAMAMA (Tunisia)
note Semitic language; one of the
groups included in the collective
terms Bedouin and Berber
AAT: nl
LCSH: nl
GPM 1959, GPM 1975, HB, JP 1953, WH
see also Bedouin, Berber

HAMAR (Sudan, Ethiopia)
variants Humr
note Cushitic language; subcategory
of Abbala; one of the groups
included in the collective terms
Baggara and Sudan Arabs
AAT: nl
LCSH: Hamar
ATMB 1956, DDMM, DWMB, ETHN,
GPM 1959, GPM 1975, HB, IGC, ICWJ,
RJ 1959, WH, WOH
IVS*, JNL*
see also Abbala, Baggara, Sudan
Arabs

HAMBA (Zaire)
note Bantu language; closely identified and often grouped with the Tetela; one of the groups included in the collective term Nkutshu
AAT: nl
LCSH: nl
DDMM, DPB 1987, ETHN, GPM 1959, GPM 1975, HAB, HB, HBDW, IAI, JJM 1972, MGU 1967, OBZ, WH
JOJ*, LDH*
see also Nkutshu, Tetela

Hambukushu *see* MBUKUSHU

Hamej *see* FUNJ-HAMAJ

HAMYAN (Algeria)
note Semitic language; one of the groups included in the collective term Bedouin
AAT: nl
LCSH: nl
GPM 1959, GPM 1975
see also Bedouin

HANANWA (South Africa)
note Bantu language
AAT: nl
LCSH: nl
DDMM, ETHN

Hanga *see* WANGA

HANGAZA (Tanzania)
note Bantu language
AAT: nl
LCSH: nl
DDMM, ETHN, MFMK, MGU 1967, RJ 1960

HANYA (Angola)
note Bantu language; one of the groups included in the collective term Mbangala
AAT: nl
LCSH: Hanya
DDMM, GPM 1959, GPM 1975, HB, UIH
AH*
see also Mbangala

Haoussa *see* HAUSA

Harage *see* HARARI

HARARI (Ethiopia)
variants Harage

note Semitic language; a unique urban complex in eastern Ethiopia
AAT: nl
LCSH: Harari
ATMB, ATMB 1956, DDMM, ETHN, GPM 1959, GPM 1975, HB, IAI, JG 1963, RJ 1959, ROMC, SMI, UIH, WH
EDH*, WIS*

Hassaniya *see* MAURES

Hatsa *see* HADZAPI

HAUSA (Benin, Cameroun, Chad, Ghana, Niger, Nigeria, Sudan, Togo)
variants Haoussa, Haussa
subcategories Abakwariga, Abanliku, Adarawa, Kebbi, Mawri
note Chadic language. Members of this group, widespread in west Africa, are often referred to by major regions or centers, such as Hausa of Bauchi, Kaduna, Kano, Katsina, Maradi, Sokoto, Zaria, and Zinder. The term is also used for the Hausa States, circa 1200-1900 CE. see RWL for an extensive list of subcategories and divisions.
AAT: Hausa
LCSH: Hausa
AF, AML, BEL, BES, BS, CK, DB, DDMM, DFHC, DOA, DOWF, DP, DWMB, EBR, EL, ELZ, ENS, ETHN, EWA, FW, GBJM, GPM 1959, GPM 1975, HAB, HB, HCDR, HRZ, IAI, JD, JG 1963, JJM 1972, JK, JL, JLS, JM, JPAL, JPB, JPJM, JV 1984, JK, KFS, KK 1960, KK 1965, KMT 1970, KMT 1971, LJPG, LPR 1986, LPR 1995, LSD, MBBH, MCA, MLB, MLJD, MPF 1992, MWM, NIB, NOI, PG 1990, PH, PMPO, PRM, PSG, RAB, RJ 1958, RGL, ROMC, RS 1980, RSW, RWL, SD, SMI, SV, TB, TFG, TP, UIH, WEW 1973, WFJP, WG 1984, WH, WLA, WOH, WRB, WRB 1959, WRNN, WS
CFPK*, MGS*, RWL*

Haussa *see* HAUSA

HAVU (Zaire)
variants Haavu
note Bantu language
AAT: nl
LCSH: Havu
DDMM, DPB 1986, DPB 1987, ETHN,
GPM 1959, GPM 1975, HB, MGU 1967,
OBZ, UIH

HAWAZMA (Chad, Sudan)
note Semitic language; one of the
groups included in the collective
term Baggara
AAT: nl
LCSH: nl
GPM 1959, HB, IGC
see also Baggara, Sudan Arabs

HAWIYE (Kenya, Somalia)
note Cushitic language; clan-family
of Somali
AAT: nl
LCSH: nl
GPM 1975, IML 1969, UIH, WH
see also Somali

HAYA (Tanzania)
variants Buhaya, Muhaya, Wasiba,
Ziba
note Bantu language; divided into
eight chiefdoms including
Bugabo, Ihangiro, Karagwe,
Kiamtwara, Kianja, Maraku,
Kiziba and Missenyi
AAT: Haya
LCSH: Haya
BS, DDMM, ECB, ETHN, GPM 1959,
GPM 1975, HAB, HB, HBDW, IAI, JLS,
JV 1984, KK 1990, LJPG, MFMK, MGU
1967, MK, PMPO, PR, RGL, RJ 1960, SD,
SMI, SVFN, UIH, WDH, WG 1980, WH,
WOH
AGMI*, BKT*

HEHE (Tanzania)
variants Wahehe
note Bantu language
AAT: Hehe
LCSH: Hehe
BS, CDR 1985, DDMM, ECB, ETHN,
GPM 1959, GPM 1975, HAB, HB, HBDW,
IAI, JLS, JM, KK 1990, MFMK, MGU
1967, PMPO, RJ 1960, ROMC, RSRW,

SD, UIH, WG 1980, WG 1984, WH, WOH,
WS

HEIBAN (Sudan)
variants Dhe bang
note Congo-Kordofanian language;
subcategory of Nuba
AAT: nl
LCSH: nl
ATMB, ATMB 1956, DDMM, ETHN,
GPM 1959, GPM 1975, HB, IAI, ICWJ, JG
1963, RJ 1959
SFN*
see also Nuba

HEIKUM (Namibia)
variants Heiom, San
note Khoisan language; one of the
groups included in the collective
term Bushmen
AAT: nl (uses San)
LCSH: Heikum
ATMB 1956, DDMM, ETHN, GB, GPM
1959, GPM 1975, HAB, HB, IAI, JG 1963,
IS, WH
ALB*
see also Bushmen

Heiom *see* HEIKUM

Hema *see* HIMA

HEMBA (Zaire)

variants Bahemba

subcategories Sayi

note Bantu language. They are divided as follows: 1. Hemba north of the Luika river: chefferies Hombo, Kagulu, Katego, Mogasa, northern Muhiya, northern Muhona; 2. Hemba south of the Luika river: chefferies Honga, Kahela, Kayungu, Mambwe, Muhona, Niembo, Nkuvu, Yambula. They must not be confused with the Eastern Luba (Luba Hemba), who are located east of the Lualaba River and south of the Lukuga-Lufuluka rivers that mark their boundaries with the Hemba. see FN 1977*.

AAT: Hemba
LCSH: Hemba
AW, BS, CDR 1985, CMK, DDMM, DOA, DPB 1981, DPB 1985, DPB 1986, DPB 1987, EBHK, ELZ, ETHN, FHCP, FN 1994, GAH 1950, GBJS, HAB, HBDW, HJK, IAI, JAF, JC 1971, JC 1978, JK, JLS, JMOB, JPB, JTSV, JV 1966, JV 1984, KFS, KFS 1989, LM, MGU 1967, MLB, OB 1961, OB 1973, OBZ, RSRW, SMI, SV, TB, TP, UIH, WG 1980, WG 1984, WRB, WRNN, WS
EV*, FN 1977*, TERV*

see also Luba-Hemba

HENGA (Zambia)

note Bantu language; subcategory of Tumbuka

AAT: nl
LCSH: nl
DDMM, ETHN, GPM 1959, GPM 1975, HB, RJ 1961
TEW*

see also Tumbuka

HERA (Uganda, Zaire)

variants Bahera

note Bantu language; subcategory of Konjo

AAT: nl
LCSH: nl
CSBS, ELZ, ETHN
RMP*

see also Konjo

HERA (Zimbabwe)

subcategories Zezuru

note Bantu language; subcategory of Shona

AAT: nl
LCSH: Hera
DDMM, GPM 1959, GPM 1975, HB, RJ 1961

see also Shona

HERERO (Angola, Botswana, Namibia)

variants Dimba

note Bantu language; close to Himba

AAT: Herero
LCSH: Herero
ARW, BES, BS, DDMM, DPB 1985, ELZ, ETHN, GPM 1959, GPM 1975, HAB, HB, HBDW, HRZ, IAI, JLS, JM, MCA 1986, MGU 1967, MLB, MLB 1994, OBZ, ROMC, RS 1980, RSW, SD, SG, SMI, TB, TP, UIH, WEW 1973, WDH, WH, WOH, WRNN
FRV*, JML*

see also Himba

HIDE (Cameroun, Nigeria)

note Chadic language; one of the groups included in the collective term Kirdi

AAT: nl
LCSH: nl
ETHN, GPM 1959, IAI, JP 1953, RWL
BEL*

see also Kirdi

HIECHWARE (Botswana, Zimbabwe)

note Khoisan language; one of the groups included in the collective term Bushmen

AAT: nl
LCSH: nl
ATMB 1956, DDMM, ETHN, GPM 1959, GPM 1975, HB, IS, JG 1963, WH, WOH
ALB*, IS*

see also Bushmen

Higi *see* KAPSIKI

Hiji *see* KAPSIKI

HIMA (Burundi, Rwanda, Uganda, Zaire)

variants Bahima, Hema, Huma

note Bantu language

AAT: nl
LCSH: Hima
CSBS, DDMM, DPB 1987, DWMB, ECB,
ELZ, ETHN, GPM 1959, HAB, HB,
HBDW, IAI, JD, JJM 1972, JM, JMOB,
KMT 1971, LJPG, MCA 1986, MGU 1967,
MLJD, MTKW, OBZ, RJ 1960, RSW, SMI,
UIH, WH, WMR, WOH, WRB 1959
CMS*, PP*

HIMBA (Angola, Botswana, Namibia)

variants Cimba, Shimba, Simba

note Bantu language; close to Herero

AAT: nl
LCSH: Himba
BS, DDMM, ETHN, GPM 1959, GPM
1975, HB, JLS, SMI, WDH, WH

see also Herero

HINA (Cameroun, Nigeria)

note Chadic language; one of the groups included in the collective term Kirdi

AAT: nl
LCSH: nl
DDMM, ETHN, GPM 1959, GPM 1975,
HB, JG 1963, RWL, UIH
BEL*

see also Kirdi

HOA (Botswana)

note Khoisan language; one of the groups included in the collective term Bushmen

AAT: nl
LCSH: nl
ALB, DDMM

see also Bushmen

HOLI (South Africa, Zimbabwe)

note Bantu language; subcategory of Ndebele, who are of Shona and Kalanga origins

AAT: nl
LCSH: nl

HKVV, JK
see also Ndebele

Holli *see* AHORI

HOLO (Angola, Zaire)

variants Baholo, Holu

note Bantu language

AAT: Holo
LCSH: nl
ALM, AW, CDR 1985, DDMM, DPB
1985, DPB 1987, EBHK, ELZ, ETHN,
FHCP, GAH 1950, GPM 1959, GPM 1975,
HAB, HB, HBDW, HJK, IAI, JC 1971, JC
1978, JD, JK, JMOB, JV 1966, JV 1984,
LJPG, MGU 1967, MLB, MLB 1994,
MLJD, OB 1973, OBZ, RSW, SD, SMI,
TERV, TP, UIH, WG 1980, WG 1984, WH
FN 1982*

HOLOHOLO (Tanzania, Zaire)

variants Baholoholo, Horohoro, Waholoholo

note Bantu language. The name Holoholo is claimed by the Guha, Kalanga, Kunda, Mamba, Tumbwe and Twagi.

AAT: Holoholo
LCSH: Holoholo
BES, CDR 1985, DDMM, DPB 1981, DPB
1987, ETHN, FN 1994, GPM 1959, GPM
1975, HB, IAI, JK, KK 1965, LJPG,
MFMK, MGU 1967, MK, OB 1961, OBZ,
RGL, RS 1980, SMI, TP, UIH, WBF 1964,
WG 1980, WG 1984, WH, WMR, WRB,
WRNN
AC*, ROS*

Holu *see* HOLO

Homa *see* GOMA

Hombo *see* OMBO

Hombori *see* SONGHAI

HONA (Nigeria)

note Chadic language

AAT: nl
LCSH: nl
DDMM, ETHN, GPM 1959, GPM 1975,
HB, JG 1963, JLS, NOI, RWL

HONGO (Zaire)

AAT: nl
LCSH: nl
DPB 1985, WS

Hongwe *see* MAHONGWE

Horohoro *see* HOLOHOLO
Hororo *see* MPORORO
Hottentot *see* KHOIKHOI
Hova *see* MERINA
HUAMBO (Angola)
 variants Wambu
 note Bantu language; one of the
 groups included among the
 Ovimbundu
 AAT: nl
 LCSH: nl
 DDMM, GPM 1959, GPM 1975, HAB,
 HB, HRZ, MEM, ROMC, SMI, UIH, WS
 see also Ovimbundu
Huana *see* WAAN
Huela *see* HWELA
HUKU (Uganda, Zaire)
 variants Bahuku
 note Central Sudanic language
 AAT: nl
 LCSH: nl
 DDMM, GPM 1959, GPM 1975, JMOB
HUKWE (Angola, Botswana)
 variants Kwengo, Makwengo,
 Xunkhwe
 note Khoisan language; one of the
 groups included in the collective
 term Bushmen
 AAT: nl
 LCSH: nl
 ATMB 1956, DDMM, ELZ, ETHN, GPM
 1959, GPM 1975, HAB, HB, IAI, IS, WH,
 WVB
 see also Bushmen
Hum *see* WUUM
Huma *see* HIMA
Humba *see* KWANYAMA
HUMBE (Angola)
 variants Bahumbe, Ngumbi
 note Bantu language
 AAT: nl
 LCSH: nl
 DDMM, DPB 1986, ETHN, GPM 1959,
 GPM 1975, HAB, HB, HRZ, IAI, MGU
 1967, RS 1980, UIH, WH
Humbu *see* WUUM
Humono *see* BAHUMONO

Humr *see* HAMAR
HUNDE (Zaire)
 variants Bahunde
 note Bantu language
 AAT: nl
 LCSH: nl
 BS, CDR 1985, DDMM, DPB 1986, DPB
 1987, ETHN, GAH 1950, GPM 1959,
 GPM 1975, HB, IAI, JMOB, MGU 1967,
 OBZ, UIH, WH
Hungaan *see* WAAN
Hungana *see* WAAN
Hunganna *see* WAAN
Hungwe *see* MAHONGWE
HURUTSHE (Botswana)
 note Bantu language; subcategory of
 Tswana
 AAT: nl
 LCSH: nl
 DDMM, ETHN, GPM 1959, GPM 1975,
 HB, UIH, WDH
 see also Tswana
HUTU (Burundi, Rwanda, Tanzania)
 variants Bahutu, Ndogo
 note Bantu language
 AAT: nl
 LCSH: Hutu
 BS, DPB 1987, ECB, ELZ, ETHN, GBJM,
 GPM 1959, GPM 1975, HAB, HB, IAI,
 JLS, JM, JMOB, MTKW, NIB, OBZ,
 PMPO, RJ 1960, ROMC, RSW, SD, SMI,
 UIH, WMR, WOH, WRB 1959
 JJM 1961*, MDAT*
Huum *see* WUUM
HWELA (Côte d'Ivoire, Ghana)
 variants Huela
 note Mande language
 AAT: nl
 LCSH: nl
 DDMM, DWMB, ETHN, HB, HMC, JG
 1963, RAB, UIH, WS
 JPB*

IBARAPA (Nigeria)
note Kwa language; subcategory of
Yoruba
AAT: nl
LCSH: nl
HJD, RWL
see also Yoruba

IBEKE (Zaire)
note Bantu language; one of the
groups included in the collective
term Mongo
AAT: nl
LCSH: nl
DDMM, DPB 1987, JMOB
see also Mongo

IBEKU (Nigeria)
note Kwa language; subcategory of
Igbo
AAT: nl
LCSH: nl
VCU 1965, WS
see also Igbo

IBENO (Nigeria)
variants Ibino
note Benue-Congo language;
subcategory of Ibibio; sometimes
referred to as Delta Ibibio
AAT: nl
LCSH: nl
DDMM, ETHN, GPM 1959, HBDW, KK
1960, NOI, RWL
see also Ibibio

IBIBIO (Nigeria)
note Benue-Congo language; one of
the groups included in the
collective term Cross River
people. Sources distinguish six
major divisions: 1. Eastern or
Ibibio proper including the Nsit
and Uruan; 2. Western or Anang
including the Opobo; 3. Northern
or Enyong; 4. Delta or Andoni-
Ibeno; 5. Riverain or Efik Ibibio;
and 6. Southern or Eket including
the Oron. see CFGJ and RWL for a
more complete listing of the
numerous Ibibio subcategories.

AAT: Ibibio
LCSH: Ibibio
ACN, AF, BS, CDR 1985, CK, CMK,
DDMM, DFHC, DOA, DP, DWMB, EB,
EBR, EEWF, ELZ, ETHN, EVA, FW,
GBJM, GBJS, GIJ, GPM 1959, GPM 1975,
HAB, HB, HBDW, HH, HMC, IAI, JD, JG
1963, JJM 1972, JK, JL, JLS, JM, JPJM, JV
1984, KFS, KK 1960, KK 1965, KMT
1970, KMT 1971, LJPG, LM, LP 1993,
MCA, MK, MKW 1978, MLB, MLJD ,
NOI, PH, RFT 1974, RJ 1958, RGL,
ROMC, RSAR, RSRW, RSW, RWL, SD,
SMI, SV, TB, TLPM, TP, UIH, WBF 1964,
WG 1980, WG 1984, WH, WMR, WOH,
WRB, WRB 1959, WRNN, WS
CFGJ*, EE*
see also Cross River people

Ibino *see* IBENO
Ibo *see* IGBO
Iboko *see* BOKO

IDANRE (Nigeria)
note Kwa language; subcategory of
Yoruba
AAT: nl
LCSH: nl
CDF, RWL
see also Yoruba

IDA OU NADIF (Morocco)
note Berber language; one of the
groups included in the collective
term Berber
AAT: nl
LCSH: nl
DBNV
see also Berber

Iddingishyaam *see* IDIING

IDIING (Zaire)
variants Bashiidiing, Diing, Dinga,
Iddingishyaam
note Bantu language; subcategory of
Kuba
AAT: nl
LCSH: nl
JC 1982, JV 1978
see also Kuba

IDOMA (Nigeria)
 subcategories Agala, Oturkpo
 note Kwa language; one of the
 groups included in the collective
 term Okpoto
 AAT: Idoma
 LCSH: Idoma
 BS, CDR 1985, CFL, CMK, DDMM,
 DFHC, DOA, DWMB, EBR, ETHN, EVA,
 FW, GBJS, GIJ, GPM 1959, GPM 1975,
 HB, HBDW, HMC, IAI, JD, JG 1963, JK,
 JLS, KFS, KFS 1989, KK 1965, KMT
 1970, LM, MKW 1978, MLB, NOI, RGL,
 RJ 1958, ROMC, RWL, SMI, SV, TP, UIH,
 WG 1980, WG 1984, WH, WRB, WRNN,
 WS
 EE*, CFPB*
 see also Okpoto
IFE (Nigeria)
 variants Ile-Ife
 note ancient kingdom, circa 850-
 1700; site and culture of Yoruba
 origin; ancient civilization; site of
 terracottas and castings dating to
 circa 600-800 CE; also a
 subcategory of Yoruba
 AAT: Ife
 LCSH: nl
 AF, BDG 1980, BS, CDF, CDR 1985,
 DDMM, DFHC, DOA, DWMB, ELZ,
 ETHN, EWA, FW, GAC, GBJM, GPM
 1959, GPM 1975, HB, HBDW, HH, HRZ,
 IAI , JJM 1972, JK, JL, JLS, JM, JV 1984,
 KFS, KK 1965, KMT 1970, KMT 1971,
 LJPG, LM, MCA, MHN, MK, MLB,
 MWM, NOI, PG 1990, PH, PMPO, PR,
 RAHD, RGL, RJ 1958, ROMC, RS 1980,
 RSW, RWL, SMI, SV, TB, TP, UIH, WBF
 1964, WG 1980, WG 1984, WH, WMR,
 WRB, WRB 1959, WS
 EE*, EEFW*, EEWF*, FW 1967*, HJD*,
 MAF*, WBF 1982*
 see also Yoruba
Ife-Ilesha *see* ILESHA
Ifoghas *see* ADRAR
IGALA (Nigeria)
 variants Igara
 note Kwa language; one of the
 groups included in the collective
 term Okpoto
 AAT: Igala
 LCSH: Igala
 BS, CFL, DDMM, DFHC, DOA, DWMB,
 EBR, ELZ, ETHN, FW, GBJS, GIJ, GPM
 1959, GPM 1975, HB, IAI, JD, JG 1963,
 JK, JLS, JTSV, JV 1984, KFS, KFS 1989,
 KK 1965, MHN, MKW 1978, NOI, RGL,
 RJ 1958, ROMC, RS 1980, RWL, SD, SMI,
 SV, TB, UIH, WEW 1973, WG 1980, WG
 1984, WH, WRB, WRNN, WS
 EE*, CFPB*, JSB*
 see also Okpoto
Igara *see* IGALA
IGARA (Uganda)
 note subcategory of Nkole; one of
 the Nyankore kingdoms
 AAT: nl
 LCSH: nl
 BKT, HB
 see also Nkole
IGBERE (Nigeria)
 note subcategory of Igbo; sometimes
 referred to as Southern Igbo
 AAT: nl
 LCSH: nl
 CFGJ
 see also Igbo
IGBIRA (Nigeria)
 variants Ebira, Igbirra, Okene,
 Tchaman
 note Kwa language; one of the
 groups included in the collective
 term Okpoto
 AAT: use Ebira
 LCSH: Igbira language
 DDMM, DWMB, EB, ELZ, ETHN, FW,
 GIJ, GPM 1959, GPM 1975, HAB, HB,
 HBDW, IAI, JG 1963, JK, JLS, JPJM, KFS,
 KK 1960, NOI, RGL, RJ 1958, RWL, UIH,
 WG 1980, WG 1984, WH, WRB
 CFPB*, HAS*
 see also Okpoto
Igbirra *see* IGBIRA

IGBO (Nigeria)

variants Ibo

note Kwa language. The Igbo people have been divided into the following: 1. Onitsha or Northern Igbo including the Nri-Awka, Elegu, and Onitsha properly speaking; 2. Owerri or Southern Igbo including the Asa, Bende, Etche, Igbere, Ika, Isu-Ama, Isu-Item, Ohuhu, Oratta, Oratta-Ikwerri, Orlu, Owerri, and Ngwa; 3. Western Igbo including the Aboh, Achalla, Anam, Egbema, Ekpeye, Ika, Kwale, Ndoni, Umunri and Riverain Igbo; 4. Eastern or Cross River Igbo including the Abaja, Abam, Abiriba, Achi, Ada, Afikpo, Aro, Ezza, Nkporo, Nsukka, Oboro, and Udi; 5. Northeastern Igbo or Ogu Uku including the Ikwo. See CFGJ, VCU and RWL for more complete listings of the numerous Igbo subcategories, e.g. Alayi, Ibeku, Mbaise, Nzam.

AAT: Igbo

LCSH: Igbo

ACN, AF, ASH, AW, BS, CFL, CK, CMK, DDMM, DF, DFHC, DFM, DOA, DP, DWMB, EBR, EEWF, ELZ, EVA, FW, GAC, GBJM, GBJS, GIJ, GPM 1959, GPM 1975, HAB, HB, HBDW, HH, HMC, HRZ, IAI, JD, JG 1963, JK, JLS, JM, JPJM, KFS, KFS 1989, KK 1965, KMT 1970, KMT 1971, LJPG, LM, MCA, MHN, MK, MKW 1978, MLB, MLJD, MUD 1991, NIB, NOI, PMPO, PRM, RFT 1974, RGL, RJ 1958, ROMC, RS 1980, RSAR, RSRW, RSW, RWL, SD, SMI, SV, TB, TLPM, TP, UIH, WBF 1964, WEW 1973, WFJP, WG 1980, WG 1984, WH, WMR, WOH, WRB, WRB 1959, WRNN, WS

CFGJ*, HCCA*, JCA*, JSB*, OOE*, SO 1989*, VCU 1965*

IGBOLO (Nigeria)

note Kwa language; subcategory of Yoruba

AAT: nl

LCSH: nl

DDMM, GPM 1959, NOI, WH

see also Yoruba

IGBOMINA (Nigeria)

variants Igbona

note Kwa language; subcategory of Yoruba

AAT: Igbomina

LCSH: use Igbona

DDMM, GAC, GPM 1959, JLS, NOI, SMI, SV, UIH, WH

HJD*, POD*

see also Yoruba

Igbona *see* IGBOMINA

IGBO-UKWU (Nigeria)

variants Ukwu

note ancient site and kingdom circa 800-1150 CE

AAT: Igbo-Ukwu

LCSH: nl

BDG 1980, DFHC, DOA, EBR, EL, FW, GAC, HRZ, JK, JLS, JM, JPJM, JV 1984, KFS, LJPG, MCA, MLB, NIB, PG 1990, PMPO, PR, RGL, ROMC, RS 1980, SMI, SV, UGH, WG 1980, WG 1984, WRB

EE*, TS*

Igedde *see* EGEDE

Igede *see* EGEDE

IGEMBE (Kenya)

note Bantu language; one of the groups included in the collective term Meru

AAT: nl

LCSH: nl

ECB, ETHN, GPM 1975, JLS

see also Meru

IGOJI (Kenya)

note Bantu language; one of the groups included in the collective term Meru

AAT: nl
LCSH: nl
DDMM, ETHN, HB, JMGK

see also Meru

Ijaw *see* IJO

IJEBU (Nigeria)

note Kwa language; subcategory of Yoruba

AAT: Ijebu
LCSH: Ijebu
CDR 1985, DDMM, DWMB, ETHN, FW, GBJS, GPM 1959, GPM 1975, HB, HJD 1990, IAI, JLS, JM, JPJM, MK, NOI, PG 1990, PMPO, RJ 1958, ROMC, RWL, SV, TP, UIH, WG 1984, WH, WRB 1959, WS HJD*, KE 1992*

see also Yoruba

Ijesha *see* ILESHA

IJO (Nigeria)

variants Ijaw

subcategories Apoi, Nembe

note Kwa language; often linked in the literature with Kalabari

AAT: Ijo
LCSH: Ijo
AW, BS, CDR 1985, CK, DDMM, DFHC, DOA, DP, DWMB, EBR, EEWF, ELZ, ETHN, EVA, FW, GBJM, GBJS, GIJ, GPM 1959, GPM 1975, HB, HJD, HMC, IAI, JD, JG 1963, JK, JLS, JM, JTSV, KFS 1989, KK 1960, KK 1965, KMT 1970, LM, MKW 1978, MLB, MLJD, NIB, NOI, RFT 1974, RGL, RJ 1958, ROMC, RSRW, RSW, RWL, SD, SMI, SV, TB, TLPM, TP, UIH, WBF 1964, WEW 1973, WFJP, WG 1980, WG 1984, WH, WMR, WRB, WRB 1959, WRNN, WS EE*, NIB 1988*, RH*

see also Kalabari

IK (Kenya, Uganda)

variants Teuso

note Eastern Sudanic language; along with Nyangeya and Tepes close to the Nilotic languages; one of the groups included in the collective term Nilo-Hamitic people. see PGPG

AAT: nl
LCSH: Ik
ATMB, ATMB 1956, DDMM, ECB, ETHN, GPM 1959, GPM 1975, HB, IAI, JG 1963, PGPG, SMI, UIH, WH CMT*

see also Nilo-Hamitic people

IKA (Nigeria)

note Kwa language; subcategory of Igbo; has been further subdivided into Northern and Southern Ika; sometimes referred to as Western Igbo

AAT: nl
LCSH: nl
DDMM, DWMB, EBR, ETHN, GPM 1959, GPM 1975, JB, NOI, RWL, RJ 1958 CFGJ*

see also Igbo

IKALE (Nigeria)

note Kwa language; subcategory of Yoruba

AAT: nl
LCSH: nl
CDF, DDMM, ETHN, RWL

see also Yoruba

Ikalebwe *see* KALEBWE

IKIZU (Tanzania)

note Bantu language

AAT: nl
LCSH: nl
DDMM, ETHN, GPM 1975, HB, MFMK, RJ 1960

IKOM (Nigeria)

note Benue-Congo language; an ancient culture of the Cross River region represented by huge monoliths dating from the 16th century to the early 20th century

AAT: nl
LCSH: nl
DDMM, JLS, WG 1984
EEFW*

IKOMA (Tanzania)
note Bantu language
AAT: nl
LCSH: nl
ETHN, GPM 1959, GPM 1975, HB,
MFMK, UIH, WH

IKULU (Nigeria)
note Benue-Congo language
AAT: nl
LCSH: nl
ETHN, GPM 1959, GPM 1975, HB, RWL,
SD

IKWERRE (Nigeria)
variants Ikwerri
note Kwa language; formerly
considered a subcategory of Igbo
but now considered a separate
group. see RWL.
AAT: nl
LCSH: use Ikwere
CFGJ, DDMM, ETHN, GIJ, RWL, VCU
1965
ON*
see also Igbo

Ikwerri *see* IKWERRE

IKWO (Nigeria)
note Kwa language; subcategory of
Igbo
AAT: nl
LCSH: Ikwo language
DDMM, ETHN, HBDW, RJ 1961, RWL,
UIH, VCU 1965
CFGJ*
see also Igbo

Il Chamus *see* NJEMPS
Il Loikop *see* SAMBURU

ILA (Zambia)
variants Baila
note Bantu language. The Tonga
and Ila are often grouped together
and referred to as Ila Tonga.
AAT: nl
LCSH: Ila
CK, DDMM, DWMB, ETHN, FW, GPM
1959, GPM 1975, HAB, HB, HBDW, IAI,
JD, MGU 1967, MLJD, RJ 1961, SD, SMI,
SV, TP, UIH, WDH, WH, WVB
MAJ*
see also Tonga

Ilaje *see* MAHIN
Ilande *see* BEELANDE
Ilebo *see* BASHILEP
Ile-Ife *see* IFE

ILESHA
variants Ife-Ilesha, Ijesha
note Kwa language; subcategory of
Yoruba
AAT: nl
LCSH: nl
CDF, DDMM, ETHN, FW, GPM 1959,
RWL, SV 1986, UIH
HJD*, JDYP*
see also Yoruba

Ilibo *see* BASHILEP

ILLABAKAN (Niger)
note Berber language; division of
the Tuareg; range across the
Saharan regions of North Africa
to Mali
AAT: nl
LCSH: nl
EDB, EDB 1974, MPF 1992
see also Tuareg

Ilma Orma *see* OROMO
Ilogooli *see* LOGOOLI

ILORIN (Nigeria)
note Kwa language; subcategory of
Yoruba
AAT: nl
LCSH: nl
CDR 1985, DDMM, ELZ, ETHN, FW,
GPM 1959, HBDW, HB, HRZ, JLS, KK
1965, LJPG, MCA, NOI, ROMC, RWL,
SMI, SV, WG 1984, WH
HJD*
see also Yoruba, Toponyms Index

Imbangala *see* MBANGALA

IMENTI (Kenya)
note Bantu language; one of the
groups included in the collective
term Meru
AAT: nl
LCSH: nl
DDMM, ECB, ETHN, HB, JLS
see also Meru

Imerina *see* MERINA

IMOMA (Zaire)
note Bantu language; subcategory of
Mongo
AAT: nl
LCSH: nl (uses Imona)
GAH 1950, GPM 1959, GPM 1975, HB,
JMOB, WH
see also Mongo
Imragen *see* IMRAGUEN
IMRAGUEN (Mauritania)
variants Imragen
note Semitic language; one of the
groups included in the collective
term Bedouin; fishing people who
live along the Atlantic coast of the
Sahara
AAT: nl
LCSH: nl (uses Imragen)
ETHN, GPM 1959, GPM 1975, IAI, LCB,
RJ 1958, WH
see also Bedouin
Indenie *see* NDENYE
INEME (Nigeria)
note Kwa language; one of the
groups included in the collective
term Kukuruku
AAT: nl
LCSH: nl
DDMM, ETHN, GPM 1959, GPM 1975,
HB, NOI, OB 1973, RWL
see also Kukuruku
INGASSANA (Sudan, Ethiopia)
variants Ingessana, Tabi
note Eastern Sudanic language
AAT: nl
LCSH: Ingassana
ATMB, ATMB 1956, CSBS, DDMM,
ETHN, GPM 1959, GPM 1975, HAB, HB,
HBDW, IAI, ICWJ, JG 1963, RJ 1959,
UIH, WH
ERC*, MCJ*
Ingessana *see* INGASSANA
Ingombe Ilede *see* Toponyms Index
Inyanga *see* Toponyms Index
IPANGA (Zaire)
variants Panga
note Bantu language

AAT: nl
LCSH: nl
DDMM, DPB 1987, ETHN, GAH 1950,
GPM 1959, GPM 1975, HAB, HBDW,
JMOB, OB 1973, OBZ, SD, WH
Iraku *see* IRAQW
Irakw *see* IRAQW
IRAMBA (Kenya, Tanzania)
variants Nyilamba
note Bantu language
AAT: nl
LCSH: Iramba language use Nilamba
language
DDMM, ETHN, GPM 1959, HB, MFMK,
RJ 1960, UIH, WOH
IRAMBI (Tanzania)
variants Nyirambi
AAT: nl
LCSH: nl
ECB, GPM 1959
Irangi *see* RANGI
IRAQW (Tanzania)
variants Erokh, Iraku, Irakw,
Mbulu
note Cushitic language; sometimes
includes the Alawa, Burungi and
Gorowa; one of the groups
included in the collective term
Nilo-Hamitic people
AAT: nl
LCSH: Iraqw
ATMB 1956, BS, DDMM, EBR, ECB,
ETHN, GPM 1959, GPM 1975, GWH
1969, HB, HRZ, IAI, JG 1963, JLS, JM,
JPJM, MCA 1986, MFMK, RJ 1960,
ROMC , SD, SMI, TP, UIH, WEW 1973,
WH, WOH, WRNN
see also Nilo-Hamitic people
IRIGWE (Nigeria)
variants Rgwe, Rigwe
note Benue-Congo language
AAT: nl
LCSH: nl
DDMM, ETHN, GPM 1959, GPM 1975,
HB, JG 1963, JLS, RWL, UIH, WH, WS
IRU (Uganda)
note Bantu language
AAT: nl
LCSH: nl
ECB, ECMG, HB, MTKW

ISAAQ (Somalia)
variants Issaq
note Cushitic language; clan-family
of the Somali
AAT: nl
LCSH: nl
ATMB 1956, BS, GPM 1975, IML
see also Somali

Isala *see* SISALA

ISANZU (Tanzania)
variants Izanzu, Nyisanzu
note Bantu language
AAT: nl
LCSH: nl
ECB, ETHN, GPM 1959, HB, KK 1990, RJ
1960, WOH

ISAWAGHEN (Mali, Niger)
note Berber language
AAT: nl
LCSH: nl
BS, EDB, MPF 1992

Isekiri *see* ITSEKIRI

ISHA (Nigeria)
variants Itsha
note Kwa language; subcategory of
Yoruba
AAT: nl
LCSH: nl
CDF, GPM 1959, RWL
see also Yoruba

ISHAN (Nigeria)
variants Esan
note Kwa language
AAT: Ishan
LCSH: nl
DDMM, DWMB, ETHN, FW, GPM 1959,
GPM 1975, HB, IAI, JD, JG 1963, JK, JLS,
KFS, MKW 1978, NOI, RFT 1974, RWL,
SV, WG 1980, WG 1984, WRB, WRNN
REB*

Ishango *see* Toponyms Index

ISOKO (Nigeria)
note Kwa language; one of the
groups included in the collective
term Sobo
AAT: Isoko
LCSH: Isoko
DDMM, DWMB, ETHN, GPM 1959, GPM
1975, HB, HBDW, IAI, JLS, JTSV, KK

1965, MKW 1978, NOI, RGL, RJ 1958,
RWL, SMI, SV, WG 1980, WG 1984, WH,
WRB, WRNN
OI*
see also Sobo

Isongo *see* MBATI

ISSA (Djibouti, Ethiopia, Kenya,
Somalia)
variants Esa
note Cushitic language; subcategory
of Dir
AAT: nl
LCSH: nl
ATMB 1956, ETHN, GPM 1975, HAB,
HB, JP 1953, KFS, RJ 1959, UIH
IML 1969*
see also Dir

Issaq *see* ISAAQ

Isu *see* ISUWU

ISU (Cameroun)
variants Bafum-Katse
note Bantoid language
AAT: nl
LCSH: nl
DDMM, ETHN, PH

ISU-AMA (Nigeria)
note Kwa language; subcategory of
Igbo; sometimes referred to as
Southern Igbo
AAT: nl
LCSH: nl
DWMB, GIJ, VCU 1965
CFGJ*
see also Igbo

Isubu *see* ISUWU

ISU-ITEM (Nigeria)
note Kwa language; subcategory of
Igbo; sometimes referred to as
Southern Igbo or Cross River Igbo
AAT: nl
LCSH: nl
DWMB, GIJ, VCU 1965
CFGJ*
see also Igbo

ISUKHA (Kenya, Uganda)
variants Kakamega, Kakameka
note Bantu language; subcategory of
Luyia
AAT: nl
LCSH: nl
DDMM, ECB, ETHN, GPM 1975, HB, KK
1990
see also Luyia

ISUWU (Cameroun)
variants Bimbia, Isu, Isubu, Su
note Bantu language; one of the
groups included in the collective
term Kpe-Mboko
AAT: nl
LCSH: nl
DDMM, ETHN, GPM 1959, GPM 1975,
HB, IAI, MGU 1967, PH, RJ 1958, UIH
EDA*
see also Kpe-Mboko

ITAKETE (Nigeria)
note Kwa language; subcategory of
Yoruba
AAT: nl
LCSH: nl
MPF 1992
see also Yoruba

Iteso *see* TESO

ITSEKIRI (Nigeria)
variants Isekiri, Iwere, Jekri, Warri
note Kwa language
AAT: Itsekiri
LCSH: Itsekiri
BS, DDMM, DWMB, ETHN, GIJ, GPM
1959, GPM 1975, HB, IAI, JLS, KFS, NOI,
RJ 1958, RWL, SMI, UIH, WH, WOH, WS
BA*,REB*

Itsha *see* ISHA

Ittu *see* ITU

ITU (Ethiopia)
variants Ittu, Qottu
note Cushitic language; subcategory
of Oromo
AAT: nl
LCSH: Ittu dialect use Qottu
DDMM, ETHN, GPM 1959, GPM 1975,
HB, KK 1960, UIH, WH
see also Oromo

Itumba *see* SAGARA

Ituri River *see* Toponyms Index

Iullemmiden *see* IWLLEMMEDEN

IVBIOSAKON (Nigeria)
note Kwa language; one of the
groups included in the collective
term Kukuruku
AAT: nl
LCSH: nl
ETHN, GPM 1959, GPM 1975, HB, NOI,
REB, RWL
see also Kukuruku

Ivili *see* VILI

IWA (Zambia)
note Bantu language
AAT: nl
LCSH: nl
DDMM, ETHN, GPM 1959, RGW, RJ
1960, UIH, WH, WWJS

Iwere *see* ITSEKIRI

IWLLEMMEDEN (Mali, Niger)
variants Aulimmiden, Iullemmiden,
Uliminden Tuareg
note Berber language; division of
the Tuareg; includes the Kel
Ataram and the Kel Dinnik. see
EDB*.
AAT: nl
LCSH: nl
GPM 1959, HAB, LPR 1995, UIH, WH
EDB*
see also Tuareg

IYALA (Nigeria)
variants Yala
note Kwa language
AAT: nl
LCSH: nl
DDMM, DWMB, ETHN, GIJ, GPM 1959,
GPM 1975, HB, JG 1963, NOI, RWL, UIH,
WEW 1973, WH

IYEMBE (Zaire)
note Bantu language
AAT: nl
LCSH: nl
DDMM, GAH 1950, GPM 1959, HB, JV
1966, OBZ, UIH

Izanzu *see* ISANZU

Izere *see* JARAWA

IZI (Nigeria)
variants Izzi
note Kwa language; formerly
considered a subcategory of Igbo
but now considered a separate
group. see ETHN.
AAT: nl
LCSH: Izi language
DDMM, ETHN, HMC, IAI, JK, NOI,
RWL, SMI, VCU 1965, WS
see also Igbo
Izzi *see* IZI

JA'ALIYYIN (Sudan)
note Semitic language
AAT: nl
LCSH: Ja'aliyyin
BS, DDMM, GPM 1959, ICWJ, SMI
JABA (Nigeria)
variants Ham
note Benue-Congo language; one of
the groups included in the Katab
cluster
AAT: Jaba
LCSH: nl
DDMM, ELZ, ETHN, FW, GPM 1959,
GPM 1975, HB, JD, JG 1963, JK, JLS,
RWL, UIH, WRB, WS
see also Katab
Jabal-Nafusah *see* NEFUSA
JABO (Liberia)
note Kru language
AAT: nl
LCSH: Jabo
DDMM, ETHN, GPM 1959, RJ 1958
Jack Jack *see* ALADYAN
JAGA (Angola, Zaire)
note ancient people who invaded
the central African Kongo
kingdom circa 16th century and
then moved to Angola and the
coast
AAT: nl
LCSH: nl

DPB 1987, HAB, HB, HBDW, HRZ, IAI,
JC 1971, JK, JLS, LJPG, OB 1973, UIH,
WG 1984, WH
JV 1966*
JAGEI (Sudan)
note West Nilotic language;
subcategory of Nuer
AAT: nl
LCSH: nl
ATMB 1956, CSBS, DDMM, HB, UIH
see also Nuer
Jagga *see* CHAGGA
JAKONG (Cameroun)
AAT: nl
LCSH: nl
PAG
Jallonke *see* DYALONKE
Jalonka *see* DYALONKE
Jaluo *see* LWOO
JAMALA (Côte d'Ivoire)
note Gur language; subcategory of
Senufo
AAT: nl
LCSH: nl
JPB
see also Senufo
Jaman *see* GRUNSHI
JAMBA (Zaire)
variants Dzamba
note Bantu language
AAT: nl
LCSH: nl
DDMM, ETHN, GAH 1950
Jambassa *see* YAMBASA
JANDO (Zaire)
note one of the groups included in
the collective term Ngiri
AAT: nl
LCSH: nl
HB
see also Ngiri
Janela *see* DEGHA

JANJERO (Ethiopia)
variants Djandjero, Yemma
note Cushitic language; subcategory of Sidamo. The name is now considered derogatory.
AAT: nl
LCSH: nl
ATMB, ATMB 1956, DDMM, ETHN, GPM 1959, GPM 1975, HB, IAI, JG 1963, KFS, RJ 1959, ROMC, SMI, UIH, WH, WIS
GWH 1955*
see also Sidamo

Janjo *see* JEN

JARAWA (Nigeria)
variants Afizere, Afusare, Fizere, Izere
note Bantoid language
AAT: Jarawa
LCSH: use Izere
DDMM, ETHN, GPM 1959, GPM 1975, HB, HDG, JG 1963, JLS, NOI, RJ 1958, RWL, UIH, WH

Jarbah *see* JERBA

Jaunde *see* EWONDO

JEBALA (Morocco, Tunisia)
variants Djebala, Djebalia
note Semitic language; Arabized Berbers; one of the groups included in the collective terms Bedouin and Berber
AAT: nl
LCSH: nl
GPM 1959, GPM 1975, JP 1953, WH
see also Bedouin, Berber

Jebba *see* Toponyms Index

Jebel Barkal *see* Toponyms Index

Jebel Uwinat *see* Toponyms Index

Jekaing *see* JIKANY

Jekri *see* ITSEKIRI

JEN (Nigeria)
variants Dza, Janjo
note Adamawa language
AAT: nl
LCSH: nl
DDMM, ETHN, GPM 1959, GPM 1975, HB, JG 1963, JLS, KK 1965, RWL

Jenne *see* DJENNE

Jenne-Jeno *see* Toponyms Index

JERBA (Tunisia)
variants Djerba, Jarbah
note Berber language; one of the groups included in the collective term Berber
AAT: nl
LCSH: nl (uses Jarbah Island)
AF, DDMM, DFHC, ETHN, GPM 1959, GPM 1975, JLS, LJPG, SMI, WH
see also Berber

JERID (Tunisia)
note Semitic language; one of the groups included in the collective term Bedouin
AAT: nl
LCSH: nl
GPM 1959
see also Bedouin

Jerma *see* ZARMA

Jia *see* DIA

Jibana *see* DZIHANA

JIBU (Nigeria)
note Benue-Congo language
AAT: Jibu
LCSH: nl
DDMM, ETHN, GPM 1959, GPM 1975, RWL

Jie *see* JIYE

Jieng *see* DINKA

JIJI (Burundi, Tanzania)
variants Ujiji
note Bantu language
AAT: Jiji
LCSH: nl
CDR 1985, ECB, ETHN, GPM 1959, JLS, KK 1990, MFMK, UIH, WG 1980, WG 1984, WRNN

Jiju *see* JINJU

JIKANY (Sudan)
variants Jekaing
note West Nilotic language; subcategory of Nuer
AAT: nl
LCSH: nl
ATMB, ATMB 1956, CSBS, DDMM, ETHN, WH
see also Nuer

JIMINI (Côte d'Ivoire)
variants Djimini, Dyimini
note Gur language; subcategory of
Senufo
AAT: nl
LCSH: use Djimini
DDMM, DFHC, DWMB, ETHN, HB,
JEEL, JG 1963, JK, JPB, KFS, MLB, RAB,
UIH, WEW 1973, WS
see also Senufo

Jinja *see* ZINZA

JINJU (Congo Republic)
variants Jiju
note Bantu language; subcategory of
Teke
AAT: nl
LCSH: nl
DDMM, DPB 1985, JV 1973
see also Teke

JITA (Tanzania)
variants Bukwaya, Kwaya
note Bantu language
AAT: nl
LCSH: Jita language
DDMM, ECB, ETHN, GPM 1959, GPM
1975, HB, MFMK, MGU 1967, RJ 1960,
UIH

JIYE (Kenya, Uganda, Sudan)
variants Dye, Gye, Jie
note Eastern Nilotic language;
sometimes referred to as
Karimojong; one of the groups
included in the collective term
Nilo-Hamitic people. The Jie and
Jiye are viewed as two separate
groups in some sources. The
transcription Jiye seems currently
preferred to the more conventional
Jie.
AAT: nl (uses Jie)
LCSH: nl (uses Jie)
ATMB 1956, BS, DDMM, ECB, ETHN,
GPM 1959, GPM 1975, HAB, HB, IAI, JG
1963, MTKW, RGL, RJ 1960, SMI, UIH,
WH
GWH*, PGPG*
see also Karimojong, Nilo-Hamitic
people

Jo Anywaa *see* ANUAK

Jo Lwo *see* JUR

Jo Nam *see* ALUR

JO PADHOLA (Kenya, Uganda)
variants Budama, Dhopadhola,
Jopadhola, Padhola
note Eastern Nilotic language; one
of the groups included in the
collective term Nilotic people;
sometimes referred to as Southern
Lwoo
AAT: nl
LCSH: nl
ATMB 1956, DDMM, ECB, ETHN, GPM
1959, GPM 1975, HB, IAI, MTKW, RJ
1960, UIH
AJB*
see also Lwoo, Nilotic people

JO PALUO (Uganda)
variants Dhopalwo, Jopaluo
note Eastern Nilotic language;
southern group of the Lwo; one of
the groups included in the
collective term Nilotic people
AAT: nl
LCSH: nl (uses Luo)
ATMB 1956, DDMM, HB, MTKW
AJB*
see also Lwoo, Nilotic people

JoBor *see* BOR

Jokwe *see* CHOKWE

Jola *see* JOOLA

Jolof *see* WOLOF

Jompre *see* KUTEP

Jonam *see* ALUR

JONGA (Zaire)
variants Djonga, Onga
note Bantu language; one of the
groups included in the collective
term Nkutshu
AAT: nl
LCSH: nl
DDMM, DPB 1987, ETHN, GAH 1950,
HAB, HB, JD, KMT 1971, MLJD, OBZ,
UIH, WDH
JOJ*
see also Nkutshu

JOOLA (Gambia, Guinea, Senegal)
variants Diola, Djola, Dyola, Jola
note West Atlantic language. The
transcription Joola seems to be
currently preferred to the more
conventional Diola/Dyola.
AAT: nl (uses Jola)
LCSH: nl (uses Diola)
BS, DDMM, DFHC, DWMB, ETHN, GPM
1959, GPM 1975, HAB, HB, HBDW, IAI,
JG 1963, JJM 1972, JLS, JM, JP 1953, KK
1960, LJPG, MH, MLJD, MPF 1992, RJ
1958, ROMC, RSW, SMI, UIH, WH, WRB
EPHE 4*, EPHE 9*, LVT*, OJAJ*

Jopadhola *see* JO PADHOLA
Jopaluo *see* JO PALUO
JORTO (Nigeria)
note Chadic language; one of the
groups included in the collective
term Kofyar
AAT: nl
LCSH: nl
DDMM, ETHN, GPM 1959, JG 1963,
RWL, WS
see also Kofyar

Jos Plateau *see* Toponyms Index
Juba *see* Toponyms Index
Juba River *see* Toponyms Index
JUKUN (Nigeria)
subcategories Kororofa, Takum,
Wukari, Wurbo
note Benue-Congo language. Some
sources differentiate Jukun by
region, e.g. Jukun of Kona, Abins,
etc. The term is also used for

Jukunoid-speaking peoples
collectively.
AAT: Jukun
LCSH: Jukun
DDMM, DFHC, DOA, DWMB, EBR, ELZ,
ETHN, FW, GBJS, GPM 1959, GPM 1975,
HMC, HRZ, IAI, JAF, JD, JG 1963, JK,
JLS, JM, JTSV, JV 1984, KFS, KK 1960,
KK 1965, MHN, MKW 1978, MLB,
MLJD, NIB, NOI, PH, RGL, RJ 1958,
ROMC, RS 1980, RSW, RWL, SD, SMI,
SV, TB, TP, UIH, WBF 1964, WEW 1973,
WG 1980, WG 1984, WH, WRB, WRNN,
WS
ARU 1969*, CKM*, EE*

Jula *see* DYULA
JUR (Sudan)
variants Jo Lwo
note West Nilotic language;
northern group of the Lwoo; one
of the groups included in the
collective term Nilotic people
AAT: nl
LCSH: Jur language use Lwo language
ATMB 1956, BS, DDMM, ETHN, GPM
1959, GPM 1975, HAB, HB, IAI, JG 1963,
RJ 1959, UIH
AJB*
see also Lwoo, Nilotic people
Juula *see* DYULA

KAAM (Zaire)
note Bantu language; subcategory of
Kuba
AAT: nl
LCSH: nl
CDR 1985, JC 1971, JV 1978, JC 1982
see also Kuba

Kaanse *see* GAN (Burkina Faso)

KABABISH (Sudan)
note Semitic language; subcategory
of Abbala
AAT: nl
LCSH: Kababish
DDMM, EBR, GB, GPM 1959, GPM 1975,
HBDW, IAI, ICWJ, JLS, LPR 1995, RJ
1959, SMI, WH
see also Abbala, Sudan Arabs

KABBA (Nigeria)
note Kwa language; subcategory of
Yoruba
AAT: nl
LCSH: nl
DDMM, GPM 1959, GPM 1975, RWL
see also Yoruba

Kabende *see* KAWENDE

KABILA (Nigeria)
note Benue-Congo language
AAT: nl
LCSH: nl
DDMM, ETHN, GPM 1975, RWL

Kabiye *see* KABRE

KABONGO (Zaire)
note one of the Luba kingdoms
AAT: nl
LCSH: nl
DDMM, DPB 1987, EBHK
see also Luba

KABRE (Benin, Ghana, Togo)
variants Kabiye, Kabremba, Kabye,
Kabyemba, Katiba
note Gur language; also the name of
the region inhabited by the Kabre
people
AAT: Kabre
LCSH: Kabre
BS, DDMM, DWMB, ETHN, GPM 1959,
GPM 1975, HAB, HB, HBDW, HRZ, IAI,
JG 1963, JP 1953, MLJD, MPF 1992,

RAB, RGL, RJ 1958, SMI, UIH, WEW
1973, WH, WOH
EPHE 5*, JCF*

Kabremba *see* KABRE

Kabye *see* KABRE

Kabyemba *see* KABRE

Kabyl *see* KABYLE

KABYLE (Algeria, Mauritania)
variants Kabyl
note Berber language; one of the
groups included in the collective
term Berber
AAT: Kabyle
LCSH: Kabyle language
AF, BS, ETHN, GPM 1959, GPM 1975,
HBDW, IAI, JFS, JLS, LJPG, ROMC, SMI,
WG 1984, WH, WOH
see also Berber

Kabylie *see* Toponyms Index

KADA (Cameroun, Chad)
note Chadic language
AAT: nl
LCSH: nl
DB, DDMM, ETHN

KADAM (Kenya, Uganda)
note Western Nilotic language
AAT: nl
LCSH: nl
DDMM, ECB, ETHN, GPM 1959, HB

KADARA (Niger, Nigeria)
variants Adara
note Benue-Congo language
AAT: nl
LCSH: Kadara
DDMM, ETHN, GPM 1959, GPM 1975,
HB, JG 1963, NOI, RJ 1958, RWL, WH
HDG 1956*

Kaddo *see* DOGON

KADLE (Côte d'Ivoire)
note Gur language; subcategory of
Senufo
AAT: nl
LCSH: nl
DDMM, JPB, UIH
see also Senufo

Kado *see* DOGON

KAFA (Ethiopia)
variants Gonga, Kaffa
note Cushitic language; subcategory
of Sidamo
AAT: nl
LCSH: use Kaffa
ATMB, ATMB 1956, BS, DDMM, ELZ,
ETHN, GPM 1959, GPM 1975, HB, IAI,
JG 1963, KFS, RJ 1959, SMI, TP, UIH,
WH, WIS
see also Sidamo
Kaffa *see* KAFA
Kaffirs *see* XHOSA
Kafibele *see* KAFIRE
KAFIRE (Côte d'Ivoire)
variants Kafibele, Kafiri
note Gur language; subcategory of
Senufo
AAT: nl
LCSH: nl
DDMM, DWMB, JPB, SV
AJG*
see also Senufo
Kafiri *see* KAFIRE
Kafue *see* Toponyms Index
Kagera *see* Toponyms Index
KAGORO (Nigeria)
note Benue-Congo language; one of
the groups included in the Katab
cluster
AAT: nl
LCSH: Kagoro
BS, DDMM, DWMB, ETHN, GPM 1959,
GPM 1975, HAB, HBDW, IAI, JG 1963,
JLS, NOI, RGL, RJ 1958, UIH
RWL*
see also Katab
KAGORO (Mali)
note Mande language
AAT: nl
LCSH: nl
BS, DDMM, DWMB, ETHN, GPM 1959,
GPM 1975, HB, HBDW, JLS, PRM, UIH,
VP, WH
Kagulu *see* KAGURU
KAGURU (Tanzania)
variants Kagulu, Northern Sangala
note Bantu language

AAT: nl
LCSH: Kaguru
BES, BS, DDMM, ECB, ETHN, GPM
1959, GPM 1975, HAB, HB, IAI, JLS,
MFMK, MHN, MGU 1967, RJ 1960, SMI,
TP, UIH, WH
TOB*, TOB 1967*
KAHE (Tanzania)
note Bantu language
AAT: nl
LCSH: nl
DDMM, ECB, ETHN, GPM 1959, HB,
MFMK, RS 1980
KAHELA (Zaire)
note Bantu language; subcategory of
Hemba
AAT: nl
LCSH: nl
JAF, JLS
see also Hemba
KAJE (Nigeria)
note Benue-Congo language
AAT: nl
LCSH: Kaje language
DDMM, ETHN, GPM 1959, GPM 1975,
JG 1963, JLS, RWL
Kaka *see* MFUMTE
Kakamega *see* ISUKHA
Kakameka *see* ISUKHA
Kaka-Ntem *see* NTEM
KAKONDA (Angola)
note Bantu language; one of the
groups included among the
Ovimbundu
AAT: nl
LCSH: nl
GMC, GPM 1959, HB, UIH, WS
see also Ovimbundu
Kakongo *see* KONGO

KAKWA (Sudan, Uganda, Zaire)
note Eastern Nilotic language; one of the groups included in the collective term Nilo-Hamitic people
AAT: nl
LCSH: Kakwa dialect
ATMB, ATMB 1956, CSBS, DDMM, DPB 1987, ECB, ETHN, GAH 1950, GPM 1959, GPM 1975, HAB, HB, HBDW, IAI, JG 1963, JMOB, MTKW, OBZ, RJ 1959, UIH, WH
GWH*
see also Nilo-Hamitic people

KALA (Zaire)
variants Bokala
note Bantu language
AAT: nl
LCSH: nl
DDMM, DPB 1985, ETHN, GAH 1950, GPM 1959, GPM 1975, HAB, HB, JMOB, OBZ, RSW, WH

KALABARI (Nigeria)
variants Calabari, Kalabari Ijo
note Kwa language. Kalabari is sometimes used synonymously with Ijo, is the capital of Ijo, and also an eastern subcategory of Ijo. see RWL for a more extensive list of subcategories.
AAT: Kalabari
LCSH: use Ijo
DDMM, DFHC, DWMB, EBR, ETHN, FW, GIJ, GPM 1959, GPM 1975, HB, HCCA, HMC, IAI, JLS, KFS 1970, KMT 1971, LJPG, MCA, NIB, NOI, RJ 1958, SD, SG, SMI, SV, UIH, WG 1980, WG 1984, WRB, WS
NIB 1988*, RH*, RWL*
see also Ijo

Kalabari Ijo *see* KALABARI
Kalai *see* KELE (Gabon)
Kalambo Falls *see* Toponyms Index

KALANGA (Botswana, Zimbabwe)
variants Makalanga
note Bantu language; subcategory of Shona
AAT: nl
LCSH: Kalanga
DDMM, ETHN, GPM 1959, GPM 1975, HAB, HB, IAI, JRE, MGU 1967, RJ 1961, UIH, WDH
see also Shona

KALANGA (Tanzania, Zaire)
note Bantu language; one of the groups included in the collective term Holoholo
AAT: nl
LCSH: nl
BS, DDMM, DPB 1981, DPB 1987, ETHN, FN 1994, GBJS, GPM 1959, GPM 1975, JV 1966, MGU 1967, OB 1961, UIH, WVB
AC*
see also Holoholo

Kale *see* KELE (Gabon)

KALEBWE (Zaire)
variants Bekalebwe, Bena Kalebwe, Ikalebwe
note Bantu language; subcategory of Songye
AAT: nl
LCSH: use Lulua
CDR 1985, DDMM, ETHN, FN 1994, HJK, OB 1961, OBZ, WRB, WS
see also Songye

KALENJIN (Kenya, Uganda)
note Nilotic language; a collective term which includes the Dorobo, Kipsikis, Suk and many others; preceded in the region by the Sirikwa. see DDMM
AAT: nl
LCSH: Kalenjin
ATMB, DDMM, ECB, ETHN, HB, JLS, UIH
see also Sirikwa

Kaleri *see* KULERE

KALIKO (Sudan, Zaire)
variants Keliko
note Central Sudanic language;
 subcategory of Madi; sometimes
 referred to as Western Madi
AAT: nl
LCSH: nl
ATMB, ATMB 1956, CSBS, DDMM, DPB
1987, ETHN, GAH 1950, GPM 1959,
GPM 1975, HB, HBDW, JG 1963, JMOB,
OBZ, UIH, WH
see also Madi

KALOMO (Zambia)
note ancient people and
 archeological site of Iron Age
 pottery and other items of material
 culture
AAT: nl
LCSH: nl
HB, JLS, PG 1973, ROJF

Kaluba *see* LUBA
Kaluena *see* LWENA
Kaluimbi *see* LWIMBI
Kalundu *see* Toponyms Index

KALUNDWE (Zaire)
note Bantu language
AAT: nl
LCSH: nl
DDMM, EBHK, HB, HJK, JC 1971, OB
1961, TERV, UIH
JC 1978*

KAMANGA (Malawi)
note Bantu language; subcategory of
 Tumbuka
AAT: nl
LCSH: nl
DDMM, ETHN, GPM 1959, HB, MGU
1967, RJ 1961, WVB
see also Tumbuka

Kamasia *see* TUKEN
Kamasya *see* TUKEN

KAMBA (Kenya)
variants Akamba, Wakamba
note Bantu language
AAT: Kamba
LCSH: Kamba
BS, DDMM, ECB, ETHN, FW, GBJS,
GPM 1959, GPM 1975, HAB, HB, HBDW,
IAI, JLS, KMT 1971, LJPG, MFMK, MGU

1967, MLJD, NIB, RGL, RJ 1960, ROMC,
RS 1980, SD, SMI, SV 1988, TP, UIH, WG
1980, WH, WRB 1959, WRNN
GL*, JMGK*

KAMBA (Zaire)
note Bantu language; subcategory of
 Kongo
AAT: nl
LCSH: nl
BES, DDMM, GPM 1959, IAI, SV, UIH
see also Kongo

KAMBARI (Nigeria)
variants Kamberi
note Benue-Congo language
AAT: nl
LCSH: nl
DDMM, DWMB, ETHN, GPM 1959, HB,
IAI, JG 1963, NOI, ROMC, RWL, UIH,
WH
HGFC*

KAMBE (Kenya)
note Bantu language; one of the
 groups included in the ethnic
 cluster Nyika
AAT: Kambe
LCSH: nl
ECB, ETHN, GPM 1959, HB, UIH, WG
1984
see also Nyika

Kamberi *see* KAMBARI
Kambonsenga *see* AMBO (Zaire,
 Zambia)
Kambosenga *see* AMBO (Zaire,
 Zambia)

KAMI (Tanzania)
note Bantu language
AAT: Kami
LCSH: nl
DDMM, ECB, ETHN, GPM 1959, GPM
1975, HAB, HBDW, IAI, KK 1990,
MFMK, MGU 1967, MLB, RJ 1960, RS
1980, UIH, WG 1980

Kamwe *see* KAPSIKI

KANA (Nigeria)

note Benue Congo language; one of
the groups included in the
collective term Ogoni
AAT: nl
LCSH: Kana language
DDMM, DWMB, ETHN, JG 1963, RWL

see also Ogoni

KANAKURU (Nigeria)

variants Dera

note Chadic language
AAT: nl
LCSH: Kanakuru language
BS, DDMM, ETHN, GPM 1959, HB, JG
1963, JLS, NOI, RWL, UIH, WH

Kanam *see* KOENOEM

KANAM (Nigeria)

note Bantoid language; not to be
confused with the Koenoem, who
speak a Chadic language and are
also sometimes known as Kanam.
see RWL.
AAT: nl
LCSH: nl
DDMM, ETHN, RWL

Kande *see* OKANDE

KANEM (Chad)

note ancient kingdom with various
small freeholdings from circa 9th
century; later evolved into the
Bornu empire, often jointly
referred to as Kanem-Bornu
AAT: Kanem-Bornu
LCSH: nl
AF, AML, BD, GPJM, GPM 1975, HB,
HBDW, HRZ, JJM 1972, JL, JPAL, KFS,
LPR 1995, NOI, PG 1990, ROMC, SMI,
UGH, WG 1984, WH
ABJ*

see also Bornu

KANEMBU (Chad, Niger, Nigeria)

note Nilo-Saharan language;
kingdom founded by the Kanuri;
closely related to the Bulala,
Daza, Kanuri, Kotoko, Teda,
Yedina and others
AAT: nl
LCSH: Kanembu

ATMB 1956, BS, DDMM, ETHN, GB,
GPM 1959, GPM 1975, HAB, HB, HRZ,
IAI, JG 1963, MPF 1992, NOI, RAB,
ROMC, RSW, RWL, UIH, WH

Kangeju *see* HADZAPI

KANGO (Zaire)

variants Bakango, Makango

note Bantu language; one of groups
included in the collective term
Riverain people
AAT: nl
LCSH: nl
BS, DPB 1987, ESCK, ETHN, GAH 1950,
GPM 1959, GPM 1975, HAB, HB, IAI,
JMOB, LP 1990, OBZ, RGL, SMI, UIH

see also Riverain people

Kaniana *see* Toponyms Index

Kaniok *see* KANYOK

Kanioka *see* KANYOK

Kankan *see* Toponyms Index

Kano *see* Toponyms Index

Kano *see* NKANU

Kanouri *see* KANURI

Kantana *see* MAMA

Kanu *see* NKANU

KANURI (Chad, Niger, Nigeria,
Sudan)

variants Dagara, Kanouri

note Nilo-Saharan language
AAT: Kanuri
LCSH: Kanuri
AF, AML, ATMB, ATMB 1956, BS,
DDMM, EBR, ETHN, GB, GPM 1975,
HAB, HB, HRZ, IAI, JG 1963, JLS, JM,
JPAL, KFS, KK 1965, LPR 1995, MBBH,
MLJD, NOI, PMPO, RJ 1958, ROMC, RS
1980, RSW, RWL, SD, SMI, TP, UIH,
WFJP, WH, WOH
RC*

Kanyiki *see* KANYOK

KANYOK (Zaire)

variants Bena Kanioka, Kaniok, Kanioka, Kanyiki, Kanyoka

note Bantu language
AAT: nl (uses Kanioka)
LCSH: Kanyok
BES, BS, DDMM, DFHC, DPB 1987,
EBHK, ELZ, ETHN, FN 1994, GPM 1959,
GPM 1975, HAB, HB, HBDW, HJK, IAI,
JC 1971, JK, JLS, JMOB, MGU 1967,
MLB, MLF, MLJD, OB 1961, OBZ, RGL,
RSAR, RSW, SMI, TERV, UIH, WBF
1964, WG 1980, WG 1984, WRB, WRNN,
WS
JCY*

Kanyoka *see* KANYOK

KAONDE (Zaire, Zambia)

variants Bakwakaonde, Kawonde

note Bantu language
AAT: nl
LCSH: Kaonde
BS, DDMM, DPB 1987, ETHN, FN 1944,
GPM 1959, GPM 1975, HAB, HB, HBDW,
IAI, JMOB, JV 1966, MGU 1967, OB
1961, OBZ, RJ 1961, SD, SMI, UIH,
WFJP, WVB
FHM*, HNB*, WWJS*

KAPSIKI (Cameroun, Nigeria)

variants Higi, Hiji, Kamwe, Psikye

note Chadic language; one of the
groups included in the collective
term Kirdi. The people are called
Higi in Nigeria and Kapsiki in
Cameroun.
AAT: nl
LCSH: use Kamwe
AF, BEL, BS, DDMM, DWMB, ETHN,
GPM 1959, GPM 1975, HAB, HB, HBDW,
IAI, IEZ, JG 1963, JLS, JP 1953, JPAL, RJ
1958, RWL, UIH, WEW 1973, WH
WEVB*

see also Kirdi

Kapwirimbwe *see* Toponyms Index

KARA (Cameroun, Central African
Republic, Congo Republic, Nigeria)

note Ubangian language;
subcategory of Gbaya living in
western C.A.R.; not to be
confused with the Kara (Yamegi)
living in the eastern C.A.R.

AAT: nl
LCSH: Kara (Gbayan people)
ATMB 1956, ETHN, HB

see also Gbaya

KARA (Central African Republic,
Sudan)

note Central Sudanic language; not
to be confused with the Kara
(Gbaya) of western Central
African Republic
AAT: nl
LCSH: nl
ATMB 1956, DDMM, ETHN, GPM 1959,
GPM 1975, HAB, HB, HBDW, IAI, JG
1963, WH

KARA (Tanzania)

note Bantu language
AAT: nl
LCSH: nl
ETHN, GPM 1959, HB, IAI, MFMK, RJ
1960, UIH

KARABORO (Burkina Faso)

note Gur language
AAT: nl
LCSH: Karaboro language
DDMM, DWMB, ETHN, GPM 1959, JPB,
UIH, WS

Karagwa *see* KARAGWE

KARAGWE (Tanzania)

variants Karagwa, Nyambo

note Bantu language
AAT: Karagwe
LCSH: use Nyambo
CDR 1985, DDMM, ECB, ETHN, HB, JK,
JLS, MFMK, MGU 1967, MLB, SMI, TP,
UIH, WG 1984
IKK*

Karamajong *see* KARIMOJONG
Karamoja *see* KARIMOJONG
Karamojo *see* KARIMOJONG
Karamojong *see* KARIMOJONG

KARANGA (Chad)

note Nilo-Saharan language
AAT: nl
LCSH: nl
ATMB 1956, DDMM, ETHN, GPM 1959,
GPM 1975, HB, UIH

KARANGA (Mozambique, Zimbabwe)

variants Makaranga

note Bantu language; subcategory of Shona

AAT: Karanga
LCSH: Karanga
DDMM, ETHN, FW, GPM 1959, GPM 1975, HAB, HB, HBDW, IAI, JJM 1972, JRE, MGU 1967, NIB, RJ 1961, ROMC, SMI, UIH, WDH, WH, WRB 1959
HEA*, MIG*

see also Great Zimbabwe, Monomotapa, Shona

KARE (Cameroun, Central African Republic, Chad)

variants Kari, Kere

note Adamawa language

AAT: nl
LCSH: use Mbum
DDMM, ETHN, JMOB, UIH

KARE (Central African Republic, Sudan, Zaire)

variants Akare

note Bantu language

AAT: nl
LCSH: nl
DDMM, DPB 1987, DWMB, ETHN, FE 1933, GPM 1959, GPM 1975, HB, HBDW, IAI, JMOB, OBZ, UIH, WEW 1973, WH

Kari *see* KARE (Cameroun, C.A.R., Chad)

Kariba, Lake *see* Toponyms Index

KARIM (Nigeria)

variants Kiyu

note Benue-Congo language

AAT: nl
LCSH: nl
DDMM, ETHN, MLB, RWL, WG 1980, WG 1984

KARIMOJONG (Kenya, Uganda)

variants Karamajong, Karamoja, Karamojo, Karamojong

note Eastern Nilotic language; one of the groups included in the collective term Nilo-Hamitic people. The term is also used to refer to a cluster of ethnic groups living on the boundaries of Sudan, Uganda and Kenya including the Karimojong proper, Dodoth, Donyiro, Jiye, Topotha, and Turkana. see EMT*.

AAT: nl
LCSH: use Karamojong
AF, ARW, ATMB, ATMB 1956, BS, CSBS, DDMM, ECB, ELZ, ETHN, GPM 1959, GPM 1975, HB, IAI, JG 1963, JLS, MCA 1986, MTKW, NIB, PG 1990, RJ 1960, ROMC, RS 1980, RSW, SMI, TP, UIH, WH, WRB 1959
EMT*, PGPG*

see also Nilo-Hamitic people

KARON (Senegal)

note West Atlantic language

AAT: nl
LCSH: use Felup
DDMM, ETHN, GPM 1959

Kasai Pende *see* PENDE

Kasai River *see* Toponyms Index

KASANGA (Guinea-Bissau, Senegal)

variants Cassanga

note West Atlantic language

AAT: nl
LCSH: Kasanga
DDMM, DWMB, ETHN, HB, JG 1963, MPF 1992, UIH

Kasāra *see* KASEMBELE

Kasayi *see* LUBA KASAI

KASELE (Togo)

variants Akasele

note Gur language; sometimes included among the Bassar

AAT: nl
LCSH: nl (uses Bassari)
DDMM, DWMB, ETHN, HB, IAI, JG 1963, RJ 1958, UIH

see also Bassar

Kasem *see* KASENA

KASEMBELE (Côte d'Ivoire)

variants Kasãra, Kassembele

note Gur language; subcategory of
Senufo
AAT: nl
LCSH: nl
AJG, DDMM, DR, DWMB, ETHN, HB
JPB*

see also Senufo

KASENA (Burkina Faso, Ghana)

variants Kasem, Kasim, Kassena,
Qasim

note Gur language; one of the
groups included in the collective
term Grunshi
AAT: nl (uses Qasim)
LCSH: use Kasem
AF, BS, CDR 1987, DDMM, DWMB,
ETHN, GPM 1959, GPM 1975, HAB, HB,
HBDW, HCDR, IAI, JG 1963, JK, JLS,
JPB, LPR 1969, LPR 1986, MM 1952,
MPF 1992, RJ 1958, RSW, SMI, UIH,
WDH, WH, WS

see also Grunshi

KASENGA (Zaire)

note Bantu language; subcategory of
Bangubangu
AAT: nl
LCSH: use Kasanga
AEM, OB 1961

see also Bangubangu

Kasim *see* KASENA

KASINGO (Zaire)

variants Basikasingo, Sikasingo

note Bantu language; one of many
groups living among the Bembe
and Boyo who are sometimes
referred to as Pre-Bembe.
AAT: Kasingo
LCSH: use Basikasingo
CDR 1985, DPB 1981, DPB 1986, DPB
1987, HB, JC 1971, JC 1978, JK, MLB,
TERV, WBF 1964, WG 1980, WMR,
WRB, WRNN

see also Pre-Bembe

KASONKE (Gambia, Mali, Senegal)

variants Khasonke, Khassonke,
Xasonke

note Mande language
AAT: nl
LCSH: nl
DDMM, DWMB, ELZ, ETHN, GPM 1959,
HB, HRZ, IAI, JG 1963, JM, LJPG, PRM,
RJ 1958, RSW, SMI, TGF, UIH, VP, WH

see also Mande

Kassembele *see* KASEMBELE

Kassena *see* KASENA

KATAB (Nigeria)

variants Atyap

note Benue-Congo language; a
collective term for a cluster of
small groups including the Jaba,
Kagoro, and others. see RWL.
AAT: nl
LCSH: Katab language
DDMM, DWMB, ETHN, GPM 1959, GPM
1975, HB, HBDW, IAI, JG 1963, JLS,
NOI, RJ 1958, RWL, UIH, WH
HDG 1956*

Katiba *see* KABRE

KATLA (Sudan)

note Kordofanian language
AAT: nl
LCSH: nl
ATMB, ATMB 1956, DDMM, ETHN,
GPM 1959, GPM 1975, HAB, HB, HBDW,
JG 1963, ROMC, UIH, WH

Katsina *see* Toponyms Index

KAUMA (Kenya)

note Bantu language; one of the
groups included in the ethnic
cluster Nyika
AAT: Kauma
LCSH: nl
AHP 1952, ECB, ETHN, UIH, WS

see also Nyika

KAVIRONDO (Kenya, Tanzania, Uganda)
note a collective term used for peoples of this region, applied to both the Luyia as Bantu Kavirondo and the Lwoo as Nilotic Kavirondo
AAT: Bantu Kavirondo
LCSH: Kavirondo
CSBS, ECB, ETHN, GB, GPM 1959, HAB, HB, HBDW, IAI, RJ 1960, ROMC, RSW, SMI
see also Luyia, Lwoo

Kawalib *see* KOALIB

KAWENDE (Tanzania, Zambia)
variants Kabende, Kawendi
note Bantu language
AAT: nl

LCSH: nl
DDMM, ETHN, GPM 1959, GPM 1975, HB, KK 1990, UIH, WOH, WVB, WWJS

Kawendi *see* KAWENDE

Kawonde *see* KAONDE

Kayongo *see* KAYUWEENG

KAYUWEENG (Zaire)
variants Kayongo, Kayweeng
note Bantu language; subcategory of Kuba
AAT: nl
LCSH: nl
JC 1971, JV 1978, JC 1982
see also Kuba

Kayweeng *see* KAYUWEENG

Kazembe *see* BENA KAZEMBE

KAZIBATI (Zaire)
note Westen Ubangian language
AAT: nl
LCSH: nl
DB 1978, DDMM, GAH 1950, OBZ

KEAKA (Nigeria, Cameroun)
note Bantoid language; subcategory of Ejagham
AAT: Keaka
LCSH: nl
DDMM, DOWF, DWMB, ELZ, ETHN, GIJ, GPM 1959, GPM 1975, HAB, HB, HBDW, JK, JL, JLS, KFS, KK 1960, KK 1965, MLB, NOI, PH, RWL, TN 1986, TP, WBF 1964, WG 1980, WG 1984, WH, WRB, WRNN, WS
see also Ejagham

Kebbawa *see* KEBBI

KEBBI (Nigeria)
variants Kebbawa
note Chadic language; subcategory of Hausa; old Hausa kingdom whose inhabitants are known as Kebbawa
AAT: nl
LCSH: nl
ETHN, GPM 1959, HB, RJ, 1958, RWL, UIH
see also Hausa

KEBU (Togo)
variants Akebu
note Kwa language
AAT: nl
LCSH: nl
DDMM, ETHN, GPM 1959, HB, IAI, JG 1963, RJ 1958, UIH, WEW 1973, WH
JCF*

Kedjom *see* KIJEM

KEKEM (Cameroun)
note one of the groups included in the collective term Bamileke
AAT: nl
LCSH: nl
ETHN, LP 1993, PH
see also Bamileke

KEL (Zaire)
variants Bakel
note Bantu language; subcategory of Kuba
AAT: nl
LCSH: nl
EBJK, JC 1971, JV 1978, OB 1973
JC 1982*
see also Kuba

Kel Adrar *see* ADRAR

Kel Ahaggar *see* AHAGGAR

Kel Air *see* AIR

Kel Ajjer *see* AJJER

Kel Antessar *see* ANTESSAR

Kel Ayr *see* AIR

Kel Gress *see* GERES
KELA (Zaire)
variants Akela, Lemba
note Bantu language
> AAT: nl
> LCSH: Kela
> BES, BS, DDMM, DPB 1985, DPB 1987,
> ETHN, GPM 1959, GPM 1975, HAB,
> HBDW, IAI, JMOB, MGU 1967, OB 1961,
> OBZ, RSW, UIH, WH, WOH

KELE (Zaire)
variants Lokele
note Bantu language
> AAT: Kele
> LCSH: use Lokele
> BES, BS, DDMM, DPB 1987, ETHN,
> GAH 1950, GPM 1959, GPM 1975, HAB,
> HB, HBDW, IAI, JC 1978, JMOB, MGU
> 1967, OBZ, UIH

KELE (Gabon)
variants Akele, Bakele Kalai, Kale
subcategories Bongomo, Mbissisiou
note Bantu language
> AAT: nl
> LCSH: nl
> DDMM, ELZ, ETHN, GPM 1959, GPM
> 1975, HB, IAI, JMOB, KK 1965, MH, OB
> 1961, OB 1973, UIH, WH, WOH, WS
> LP 1979*, LP 1985*

Keliko *see* KALIKO
KEMANT (Ethiopia)
variants Qemant
note Cushitic language
> AAT: Kemant
> LCSH: Kemant language
> ATMB 1956, DDMM, ETHN, GPM 1959,
> GPM 1975, HBDW, IAI, JG 1963, RJ
> 1959, ROMC, SMI, UIH, WH, WIS
> FCG*

Kembara *see* TYEBARA
KENGA (Chad)
note Central Sudanic language
> AAT: nl
> LCSH: Kenga language
> AF, ATMB, DDMM, ETHN, GPM 1959,
> GPM 1975, HB, JG 1963, WMR

KENUZI (Egypt)
note Eastern Sudanic language
> AAT: nl
> LCSH: Kenuzi dialect use Dongola-Kenuz
> dialect
> DDMM, ETHN, GPM 1959, GPM 1975,
> HB, JG 1963, WH

Kenya, Mount *see* Toponyms Index
KENYI (Uganda)
note Bantu language
> AAT: nl
> LCSH: nl
> ECB, ETHN, GPM 1975, HB, RJ 1960

KERA (Cameroun, Chad)
note Chadic language
> AAT: nl
> LCSH: Kera
> ATMB 1956, DDMM, DWMB, ETHN,
> HB, MPF 1992
> KHE*

Kere *see* KARE (Cameroun, C.A.R.,
Chad)
Kerebe *see* KEREWE
KEREWE (Tanzania)
variants Kerebe, Wakerewe
note Bantu language
> AAT: Kerewe
> LCSH: use Kerebe
> BS, DDMM, EBR, ECB, ELZ, ETHN,
> GPM 1959, GPM 1975, HB, HBDW, IAI,
> JLS, KK 1990, MFMK, MGU 1967, RJ
> 1960, TP, UIH, WBF 1964, WG 1980, WG
> 1984, WH, WRB, WS
> GDH*

KERMA (Sudan)
note ancient Nubian culture and
kingdom in the Nile valley, circa
1500 BCE; known to the
Egyptians as Kush
> AAT: Kerma
> LCSH: nl
> BMS, GC, JLS, PR, WG 1984
see also Kush

KET (Zaire)
variants Baket, BaKete, Bena Mai, Kete
note Bantu language; subcategory of Kuba; divided into northern and southern groups; one of the groups referred to as Akaawand. The transcription Ket seems currently preferred to the more conventional Kete.
AAT: nl
LCSH: nl
AW, BES, BS, CDR 1985, CFL, CK, CMK, DDMM, DFHC, DFM, DPB 1987, DWMB, EB, EBHK, ELZ, ETHN, FHCP, FN 1994, FW, GAH 1950, GPM 1959, GPM 1975, HAB, HB, HBDW, HH, IAI, JC 1971, JD, JK, JLS, JMOB, JTSV, JV 1966, KK 1965, KMT 1970, MLJD, OB 1961, OB 1973, OBZ, RGL, RSW, SV, SV 1988, TERV, TLPM, TP, UIH, WG 1980, WG 1984, WH, WRB, WRNN, WS
JC 1982*, JV 1978*
see also Akaawand, Kuba

Kete *see* KET

Ketou *see* KETU

KETU (Nigeria)
variants Ketou
note Kwa language; subcategory of Yoruba
AAT: Ketu
LCSH: nl
DDMM, FW, GPM 1959, HB, IAI, JAF, JLS, MPF 1992, RJ 1958, RWL, SV, UIH, WRB
HJD*
see also Yoruba

Keyo *see* KEYYO

KEYYO (Kenya)
variants Elgeyo, Keyo
note Southern Nilotic language; one of the groups included in the collective term Nilo-Hamitic people
AAT: nl
LCSH: nl (uses Elgeyo)
ATMB 1956, DDMM, ECB, ETHN, GPM 1959, GPM 1975, HB, IAI, RJ 1960, WH, WRB 1959

GWH 1969*
see also Nilo-Hamitic people

KGALAGADI (Botswana)
note Bantu language
AAT: nl
LCSH: Kgalagadi
DDMM, GPM 1959, GPM 1975, HB, IAI, UIH, WH

Kgatla *see* KHATLA

Khami *see* Toponyms Index

Khasonke *see* KASONKE

Khassonke *see* KASONKE

KHATLA (Botswana)
variants Bakatla, Kgatla
note Bantu language; subcategory of Tswana
AAT: nl
LCSH: nl (uses Kgatla)
DDMM, ETHN, GPM 1959, GPM 1975, HB, JLS, MGU 1967, NIB, SMI, UIH, WDH
see also Tswana

Khoekhoe *see* KHOIKHOI

Khoi *see* KHOIKHOI

KHOIKHOI (Namibia, South Africa)
variants Hottentot, Khoekhoe, Khoi
subcategories Korana, Nama
note Khoisan langugage. The terms Nama and Hottentot are both sometimes used for the Khoikhoi in general.
AAT: Khoikhoi
LCSH: Khoikhoi
ARW, ATMB 1956, BES, BS, DDMM, EBR, ETHN, FW, GB, GBJM, GPM 1959, GPM 1975, HB, HBDW, HRZ, IAI, JG 1963, JJM 1972, JK, JLS, JM, JMOB, JV 1984, MCA 1986, MK, MLJD, PMPO, PR, ROMC, RS 1980, RSW, SD, SG, SMI, UIH, WDH, WEW 1973, WG 1984, WH, WOH, WRB, WRB 1959, WVB
ALB*, IS*

Khosa *see* XHOSA

KHUMBI (Angola)
variants Nkhumbi, Nkumbi
note Bantu language; one of the
groups included in the collective
term Mbangala
AAT: nl
LCSH: nl
DDMM, ETHN, GPM 1959, GPM 1975,
HB, MGU 1967, MLB 1994
see also Mbangala
Khutu *see* KUTU (Tanzania)
Kiantapo *see* Toponyms Index
Kibala *see* BALA
Kibisi *see* DOGON
Kiembara *see* TYEBARA
KIGA (Rwanda, Uganda)
variants Chiga, Chigga, Ciga,
Kyiga
note Bantu language
AAT: nl
LCSH: use Chiga
BES, DDMM, ECB, ETHN, GPM 1959,
GPM 1975, HAB, HB, IAI, KMT 1971,
MGU 1967, MTKW, RJ 1960, SMI, UIH,
WH
BKT*, MME*
KIJEM (Cameroun)
variants Babanki-Kijem, Kedjom
note Bantoid language; subcategory
of Babanki
AAT: nl
LCSH: nl
DDMM, ETHN, LP 1993, MMML, PAG
see also Babanki
Kikuyu *see* GIKUYU
Kilenge *see* CILENGE
Kilimanjaro, Mount *see* Toponyms
Index
KILWA (Tanzania)
note ancient culture situated in
Zanzibar, circa 13th century; a
pre-colonial coastal town; site of
East African sultanate
AAT: Kilwa
LCSH: nl
BD, FW, GPM 1975, JDC, KK 1990, PG
1973, PG 1990, PR, WG 1984
Kim *see* KRIM

Kimbanda *see* OVIMBUNDU
Kimbaw *see* MBAW
KIMBU (Tanzania)
note Bantu language; one of the
groups included in the collective
term Greater Unyamwezi
AAT: nl
LCSH: Kimbu
BS, CDR 1985, DDMM, ECB, ETHN,
GPM 1959, GPM 1975, HAB, HB, IAI, KK
1990, MFMK, MGU 1967, SMI, UIH, WH
BEBG*, RGA*, RGA 1967*
see also Unyamwezi
Kimbundu *see* MBUNDU
Kimi *see* KRIM (Sierra Leone)
Kimi *see* BANKIM (Cameroun)
Kimr *see* GIMR
KINANGOP (Kenya)
note Eastern Nilotic language;
subcategory of Maasai
AAT: nl
LCSH: nl
ATMB 1956, GWH 1969
see also Maasai
Kindiga *see* HADZAPI
KINGA (Tanzania)
note Bantu language
AAT: nl
LCSH: Kinga
DDMM, ETHN, GPM 1959, GPM 1975,
HB, HBDW, IAI, KK 1990, MFMK, MGU
1967, RJ 1960, UIH, WH, WOH
KINGA (Chad)
AAT: nl
LCSH: nl
AML, UIH
Kinshasa *see* Toponyms Index
KINTAMPO (Ghana)
note stylistic designation and site of
ancient pottery culture
AAT: Kintampo
LCSH: nl
GC, HCDR, JPB, PG 1990, PR, UGH
Kioko *see* CHOKWE
Kiokue *see* CHOKWE
Kipala *see* BALA

Kipsigi *see* KIPSIKIS

Kipsikiek *see* KIPSIKIS

KIPSIKIS (Kenya)

 variants Kipsigi, Kipsikiek,
 Lumbwa

 note Southern Nilotic language; one
 of the groups included in the
 collective terms Kalenjin and
 Nilo-Hamitic people
 AAT: nl (uses Kipsigis)
 LCSH: use Kipsigis
 ATMB, BS, DDMM, ECB, ETHN, GPM
 1959, GWH 1969, HB, HMC, IAI, ICWJ,
 RGL, RJ 1960, ROMC, RSW, SD, SMI,
 UIH, WH, WRB, WRB 1959

 see also Kalenjin, Nilo-Hamitic
 people

KIRA (Uganda, Zaire)

 variants Bakira, Yira

 note Bantu language; subcategory of
 Konjo
 AAT: nl
 LCSH: nl
 BKT, DWMB, ETHN, HB, JMOB
 RMP*

 see also Konjo

KIRDI (Cameroun, Chad, Nigeria)

 note a collective name given to
 various non-Islamicized peoples
 in northern Cameroun and Chad,
 including the Bugudum, Daba,
 Djimi, Doyayo, Fali, Gisei,
 Gisiga, Gude, Guidar, Hide, Hina,
 Kapsiki, Kwang, Marba, Margi,
 Massa, Matakam, Mofu,
 Mundang, Musgun, Nzangi and
 Tupuri. Other non-Islamic groups
 of Adamawa are sometimes
 added, such as the Bata, Duru,
 Kotoko, Mandara, and Mbum.
 AAT: nl
 LCSH: nl
 AF, BS, ELZ, GPM 1959, GPM 1975, HB,
 JD, JP 1953, LJPG, LSD, MCA, MLJD,
 RGL, RSW, RWL, SMI, TN 1984, WH
 GBJM*

KIROBA (Kenya, Tanzania)

 note Bantu language
 AAT: nl
 LCSH: nl
 DDMM, MFMK

KISALIAN culture (Zaire)

 note an ancient culture and its
 distinctive pottery style found in
 sites around Lake Kisale in Zaire,
 e.g. Sanga
 AAT: nl
 LCSH: nl
 GC, ROJF

 see also Sanga (Toponyms Index)

KISAMA (Angola)

 variants Quissama

 note Bantu language
 AAT: nl
 LCSH: nl
 DDMM, EBHK, ETHN, GPM 1959, HB,
 MLB 1994, UIH, WH

Kisi *see* KISSI

KISI (Tanzania)

 variants Wakissi

 note Bantu language
 AAT: nl
 LCSH: nl
 DDMM, ETHN, GPM 1959, GPM 1975,
 HBDW, IAI, KK 1990, MFMK, MGU
 1967, RGL, RJ 1960, UIH, WH, WOH
 SACW*

Kisii *see* GUSII

KISSI (Guinea, Liberia, Sierra
Leone)

 variants Kisi

 note West Atlantic language
 AAT: Kissi
 LCSH: Kissi
 ASH, BES, BS, CDR 1985, CMK, DDMM,
 DOA, DP, DWMB, ECB, EEWF, ELZ,
 EVA, EWA, FW, GBJM, GPM 1959, GPM
 1975, GSGH, HAB, HBDW, HH, JD, JG
 1963, JJM 1972, JK, JL, JLS, JM, JP 1953,
 JPB, JV 1984, KFS, KFS 1989, KK 1965,
 KMT 1970, LJPG, MH, MLB, MLJD, MPF
 1992, PR, RGL, RJ 1958, ROMC, RSRW,
 RSW, SMI, SV, SVFN, TB, TP, UIH, WBF
 1964, WG 1980, WG 1984, WH, WMR,
 WOH, WRB, WRNN, WS
 DP 1954*

Kita *see* Toponyms Index

KITARA (Uganda)

variants Bakitara

note ancient kingdom, circa 13th-15th centuries, ruled over by the Chwezi dynasty and supplanted by the Bito dynasty of the Nyoro kingdom; at one time extended over most of Uganda and even into some parts of Zaire, Sudan and Tanzania; resulting in the Ganda, Nkore, Nyoro, Soga, and Toro kingdoms; archeological sites include Bigo and Mutende Hill (see Toponyms Index)

AAT: use Nyoro
LCSH: use Nyoro
ECB, GBJM, GPM 1959, GPM 1975, PG 1990, RJ 1960, SMI, WH
JOB*, JOR*

see also Chwezi, Nyoro

Kitosh *see* BUKUSU

Kivu, Lake *see* Toponyms Index

Kiyu *see* KARIM

KIZIMKAZI (Tanzania)

note ancient civilisation, circa 9th century and later

AAT: nl
LCSH: nl
ROJF

Ko *see* WINIAMA

KO MENDE (Sierra Leone)

note Mande language; subcategory of Mende

AAT: nl
LCSH: nl
DDMM, ETHN, GPM 1959, MEM 1950

see also Mande

KOALIB (Sudan)

variants Kawalib

note Kordofanian language; subcategory of Nuba

AAT: nl
LCSH: nl
ATMB, ATMB 1956, DDMM, ETHN, GPM 1959, GPM 1975, HB, HBDW, IAI, JG 1963, RJ 1959, ROMC, SD, UIH, WH

see also Nuba

Koba *see* YEEI

KOBIANA (Guinea-Bissau, Senegal)

variants Cobiana

note West Atlantic language

AAT: nl
LCSH: nl
DDMM, ETHN, GPM 1959, GPM 1975, HB, JG 1963, MPF 1992, RJ 1958

Kodie *see* GODIE

KOENOEM (Nigeria)

variants Kanam

note Chadic language

AAT: nl
LCSH: nl
DDMM, ETHN, RWL, WS

KOFYAR (Nigeria)

variants Kwolla

note Chadic language; toponym and collective term that includes the Dimmuck, Gworam, Jorto, Lardang, Miriam and other small groups. see RWL.

AAT: nl
LCSH: Kofyar
DDMM, ETHN, GPM 1959, HB, HMC, JG 1963, JLS, SD, RWL

Koko *see* BASA

Kole *see* DWALA

KOLOLO (Zambia, Zimbabwe)

note Bantu language; subcategory of Lozi

AAT: nl
LCSH: Kololo language use Lozi language
ETHN, GPM 1959, GPM 1975, HB, PG 1990, RJ 1961, UIH, WDH, WRB, WVB

see also Lozi

KOM (Cameroun)
variants Bamekom, Bekom, Bikom, Kom-Tikar, Nkom
subcategories Nyos
note Bantoid language; division of the Grasslands; subcategory of Tikar, one of the groups included in the collective term Bamenda
AAT: Kom
LCSH: Kom
CDR 1985, CMK, DDMM, DFHC, DP, DWMB, EBHK, EBR, ELZ, ETHN, GDR, GPM 1959, GPM 1975, HAB, HB, HBDW, HJK 1977, IAI, IEZ, JK, JLS, KK 1960, KK 1965, MLB, RFT 1974, RGL, RJ 1958, RSAR, RSW, SMI, SV, TN 1984, TN 1986, UIH, WBF 1964, WG 1980 , WOH, WRB, WRNN
CFPK*, FRF*, LP 1993*, MKW*, MMML*, PH*, PMK*
see also Bamenda, Tikar, Grasslands

KOMA (Ghana)
note Gur language
AAT: nl
LCSH: nl
BS, DDMM, ETHN, TP, WS

KOMA (Cameroun, Nigeria)
note Adamawa language
AAT: nl
LCSH: nl
BEL, BS, DDMM, DWMB, ETHN, JG 1963, JLS, LP 1993, MPF 1992, NOI, RWL, UIH

KOMA (Ethiopia, Sudan)
variants Coman
note Nilo-Saharan language; one of the groups included in the collective term Nilotic people
AAT: nl
LCSH: Koma
ATMB, ATMB 1956, DDMM, ETHN, GPM 1959, GPM 1975, HAB, HB, IAI, JG 1963, JLS, KFS, LM, RJ 1959, UIH, WH, WS
ERC*
see also Nilotic people

KOMO (Zaire)
variants Bakomo, Bakumbu, Bakumu, Kumu

note Bantu language
AAT: Komo
LCSH: Komo
ARW, BES, BS, CDR 1985, DDMM, DPB 1986, DPB 1987, ETHN, EWA, FHCP, GAH 1950, GB, GPM 1959, GPM 1975, HAB, HB, HBDW, JC 1971, JC 1978, JD, JK, JMOB, MGU 1967, MH, MLJD, OBZ, RAB, RGL, SV, UIH, WG 1980, WH, WRB
PRM 1979*, WDM*

KOMONO (Burkina Faso, Côte d'Ivoire)
note Gur language; subcategory of Senufo
AAT: nl
LCSH: nl
DDMM, DWMB, ETHN, GPM 1959, GPM 1975, HB, JPB, UIH
see also Senufo

KOMORO (Comoros, Madagascar)
variants Comorian
note Bantu language; subcategory of Swahili
AAT: nl
LCSH: Komoro language use Comorian language
DDMM, ETHN, GPM 1959, MGU 1967
see also Swahili

Komso *see* KONSO

Kom-Tikar *see* KOM

KONA (Nigeria)
note Benue-Congo language; subcategory of Jukun
AAT: nl
LCSH: nl
DDMM, EPHE 9, ETHN, GPM 1959, GPM 1975, HB, RWL
see also Jukun

Konde *see* NGONDE

Kondoa *see* Toponyms Index

Kong *see* Toponyms Index

KONGO (Angola, Congo Republic, Zaire)
variants Bakongo, Bashikongo, Kakongo
subcategories Amboim, Asolongo, Bembe, Bwende, Dikidiki, Dondo, Kamba, Kunyi, Lemfu, Loango, Manyanga, Mbaka, Mbata, Mbeko, Mbinsa, Mboka, Mboma, Mpangu, Mpempa, Ndibu, Nkanu, Ntandu, Solongo, Sundi, Tukongo, Vili, Woyo, Yombe, Zombo
note Bantu language. Divisions among the Kongo peoples include regional designations such as Eastern, Northern, Southern Kongo. The Lula and Tsotso are sometimes considered as Kongo related. The Kongo kingdom was founded circa 1350 and declined from 1665 on into the 18th century.
AAT: Kongo; Kongo Kingdom
LCSH: Kongo
ACN, ASH, AW, BD, BES, BS, CDR 1985, CFL, CK, CMK, DDMM, DFHC, DOA, DOWF, DP, DPB 1985, DPB 1987, EB, EBHK, EBR, EEWF, ELZ, ETHN, FN 1994, FW, GB, GBJM, GBJS, GPM 1959, GPM 1975, GWS, HAB, HH, HJK, HRZ, IAI, JAF, JC 1971, JC 1978, JD, JJM 1972, JK, JL, JLS, JM, JMOB, JPJM, JTSV, KFS, KFS 1989, KK 1960, KK 1965, KMT 1971, LJPG, LM, LP 1985, MGU 1967, MHN, MLB, MLB 1994, MLJD, MPF 1992, MUD 1991, NIB, OB 1973, OBZ, PG 1990, PMPO, PR, RFT 1974, RGL, ROMC, RS 1980, RSRW, RSW, SD, SG, SMI, SV, SV 1988, SVFN, TB, TERV, TLPM, TP, UIH, WBF 1964, WEW 1973, WG 1980, WG 1984, WH, WMR, WRB, WRB 1959, WRNN, WS
JV 1966*, JVW*, KL*, RLD 1977*, RLD 1980*, RLD 1989*, WM*

Kongo do Kasai *see* TUKONGO
Kongo-Dinga *see* DINGA

KONGO-PORTUGUESE (Angola, Zaire)
note One of the distinctive art forms and styles that are the product of acculturative movements in West Africa, sometimes referred to collectively as Afro-Portuguese
AAT: nl
LCSH: nl
EBWF
see also Afro-Portuguese

Koniagi *see* KONYAGI
Koniagui *see* KONYAGI
Konianke *see* KONYANKE

KONJO (Uganda, Zaire)
variants Bakonjo, Banande, Konzo, Nande, Ndande, Wanande
subcategories Hera, Kira, Mate, Shu, Swaga, Tangi
note Bantu language; known as Konjo in Uganda and Nande in Zaire; not to be confused with the Nandi of Kenya who speak a Nilotic language
AAT: nl
LCSH: use Nande
DDMM, DPB 1986, DPB 1987, ECB, ETHN, GAH 1950, GPM 1959, GPM 1975, HAB, HB, HBDW, IAI, JMOB, MGU 1967, MTKW, OBZ, RJ 1960, SD, SMI, WH, WOH
BKT*, RMP*

KONKOMBA (Ghana, Togo)
note Gur language
AAT: Konkomba
LCSH: Konkomba
BS, DDMM, DWMB, ETHN, GPM 1959, GPM 1975, HAB, HB, HBDW, HCDR, HMC, IAI, KFS, LJPG, LPR 1986, MM 1952, RGL, RJ 1958, RSW, SD, SMI, UIH, WH, WOH
DAT*, JCF*, JCF 1954*

Konno *see* KONO

KONO (Sierra Leone)

variants Konno

note Mande language
AAT: Kono
LCSH: Kono
DDMM, DWMB, EBR, ELZ, ETHN, GPM
1959, GPM 1975, GSGH, HB, HBDW, IAI,
JD, JG 1963, JL, JLS, JPB, KFS, LJPG,
MH, MLJD, NOI, PRM, RGL, RJ 1958,
RSW, SMI, TB, UIH, WG 1980, WH,
WRB, WS
BH 1952*, EFHH*

see also Mande

KONONGO (Tanzania)

note Bantu language; one of the
groups included in the collective
term Greater Unyamwezi
AAT: nl
LCSH: nl
ECB, ETHN, GPM 1959, GPM 1975,
HAB, HB, HBDW, IAI, MFMK, UIH, WH
BEBG*, RGA*

see also Unyamwezi

KONSO (Ethiopia)

variants Komso

subcategories Gato

note Cushitic language
AAT: Konso
LCSH: Konso
AF, ATMB 1956, BS, CK, DDMM, EB,
EBR, ELZ, ETHN, GPM 1959, GPM 1975,
HAB, HB, HBDW, IAI, JD, JG 1963, JK,
JLS, KFS, MLB, MLJD, NIB, RJ 1959,
ROMC, SMI, TP, UIH, WG 1980, WG
1984, WH, WRB, WRNN, WS
CRC*, CRH*, ERC*

KONY (Kenya, Uganda)

variants El Gony, El Kony, Elgon,
Mount Elgon Masai, Sebei

note Southern Nilotic language; one
of the groups included in the
collective terms Nilo-Hamitic
people and Sapaut
AAT: nl
LCSH: nl
ATMB, DDMM, ETHN, ECB, GPM 1959,
GPM 1975, HB, RJ 1960, UIH, WRB 1959
GWH 1969*

see also Nilo-Hamitic people,
Sapaut

KONYAGI (Guinea, Senegal)

variants Coniagui, Koniagi,
Koniagui

note West Atlantic language; one of
the groups included in the
collective term Tenda
AAT: nl (uses Koniagui)
LCSH: nl (uses Koniagui)
BS, DDMM, DWMB, ETHN, GPM 1959,
GPM 1975, HB, IAI, JG 1963, JL, JLS,
LJPG, MH, MLJD, MPF 1992, SMI, UIH,
WDH, WRB
MDL*

see also Tenda

KONYANKE (Guinea, Senegal)

variants Konianke
AAT: nl
LCSH: nl
GPM 1959, WH

Konzo *see* KONJO

KORANA (South Africa)

note Khoisan language; one of the
groups included in the term
Khoikhoi
AAT: nl
LCSH: Korana
ARW, ATMB 1956, ETHN, GB, GPM
1959, GPM 1975, HAB, HB, HBDW, IAI,
IS, JG 1963, WH
ALB*, JAE*

see also Khoikhoi

Koranko *see* KURANKO

Kordofan *see* Toponyms Index

KOREKORE (Zambia, Zimbabwe)

note Bantu language; subcategory of
Shona
AAT: nl
LCSH: use Shona
DDMM, ETHN, GPM 1959, HB, MGU
1967, RJ 1961, UIH, WVB

see also Shona

Korhogo *see* Toponyms Index

Koria *see* KURIA

KORO (Nigeria)

variants Kwaro

note Kwa, Chadic and Benue-
Congo languages; includes a
number of linguistically
heterogeneous groups in Nigeria
including the Lafia, Migili and
others. see RWL.

AAT: Koro
LCSH: Koro
DDMM, ELZ, ETHN, EVA, GB, GBJS,
GPM 1959, GPM 1975, HB, HBDW, JG
1963, JK, JPB, JTSV, KFS, KFS 1989,
MLB, NOI, RWL, SMI, WG 1980, WG
1984, WH, WRB, WRN
HGFC*, SN*

see also Migili

KOROCA (Angola)

variants Curoca, Kwadi

note Khoisan language; one of the
groups included in the collective
term Bushmen

AAT: nl
LCSH: nl
ALB, DDMM, ETHN, GPM 1975, GPM
1959, WH

see also Bushmen

Korofora *see* KOROROFA

KORONGO (Sudan)

variants Krongo

note Kordofanian language;
subcategory of Nuba

AAT: nl
LCSH: use Krongo
DDMM, ETHN, GPM 1959, HB, SD
SFN*

see also Nuba

KOROP (Nigeria)

note Benue-Congo language;
subcategory of Ododop; one of the
groups included in the collective
term Cross River people

AAT: nl
LCSH: nl
DDMM, ETHN, GPM 1959, GPM 1975,
HB, HBDW, JG 1963, NOI, RWL

see also Cross River people,
Ododop

KOROROFA (Nigeria)

variants Korofora

note Kororofa is used both as the
name of an ethnic group and as
the name of the kingdom, country,
and capital of the Jukun.

AAT: nl
LCSH: nl
EPHE 9, HB, JK, RWL

see also Jukun

Kossi *see* NKOSI

KOTA (Congo Republic, Gabon)

variants Akota, Bakota, Kuta

subcategories Mahongwe, Mbaama,
Ndambomo, Ndasa, Ndumbo,
Shamaye, Wumvu

note Bantu language. The
transcription Kuta seem currently
preferred to the more conventional
Kota.

AAT: Kota
LCSH: Kota
ASH, AW, BES, BS, CDR 1985, CFL, CK,
CMK, DDMM, DFHC, DOA, DP, DPB
1987, EB, EBHK, EBR, EEWF, ELZ,
ETHN, EWA, FW, GAC, GBJM, GBJS,
GPM 1959, GPM 1975, HAB, HB, HBDW,
HH, HMC, IAI, IEZ, JAF, JD, JK, JL, JLS,
JTSV, JV 1984, KFS 1989, KK 1965, KMT
1970, LJPG, LM, LP 1979, LP 1985, LP
1990, MGU 1967, MHN, MLB, MLJD,
MPF 1992, MUD 1986, OBZ, RFT 1974,
RGL, RS 1980, RSAR, RSW, SMI, SV, SV
1988, SVFN, TB, TLPM, TP, UIH, WBF
1964, WG 1980, WH, WMR, WOH, WRB,
WRB 1959, WRNN, WS
ACFC*, EA*, EA 1987*

KOTA (Zaire)

variants Ekota

note Bantu language; subcategory of
Mongo

AAT: nl
LCSH: nl
GAH 1950, GPM 1959, HB, OBZ

see also Mongo

KOTO (Zaire)

note Bantu language; one of the groups included in the collective term Ngiri

AAT: nl
LCSH: nl
DDMM, HB

see also Ngiri

KOTOKO (Cameroun, Chad, Nigeria)

subcategories Logone, Mandage, Mida'a

note Chadic language; an ancient kingdom including various small freeholdings, dating from about the 10th century, with origins in Sao; a collective name for peoples of Cameroun, Chad, and Nigeria who live in fortified cities; one of the groups included in the collective term Kirdi

AAT: Kotoko
LCSH: Kotoko
BS, DB, DDMM, DWMB, EWA, GPM 1959, GPM 1975, HAB, HB, HBDW, IAI, IEZ, JG 1963, JJM 1972, JK, JL, JP 1953, KFS, MLB, MLJD, MPF 1992, NOI, RGL, RJ 1958, RWL, SMI, SVFN , UIH, WG 1980, WG 1984, WH
AML*, BEL*, JPAL*

see also Kirdi, Sao

KOTOKOLI (Benin, Togo)

note Gur language; collective term used to refer to various peoples, usually Tem-speakers with similar lifestyles, many of them under the single authority of the chief of Tchaondjo

AAT: use Tem
LCSH: use Tem
BS, DDMM, DWMB, ETHN, GPM 1959, GPM 1975, HB, IAI, KK 1965, MPF 1992, UIH, WG 1980, WH
JCF*

see also Tem

KOTOPO (Cameroun, Nigeria)

variants Potopo

note Adamawa language

AAT: nl
LCSH: nl
BEL, DDMM, DWMB, ETHN, GPM 1959, GPM 1975, HB, JG 1963, RWL, WH

Kouele *see* KWELE

Koulango *see* KULANGO

Kouroumba *see* KURUMBA

Koyo *see* KUYU

Kpa *see* BAFIA

KPA MENDE (Sierra Leone)

note Mande language; subcategory of Mende

AAT: nl
LCSH: nl
DDMM, ETHN, GPM 1959, MEM 1950

see also Mende

KPALA (Central African Republic, Zaire)

note Western Ubangian language

AAT: nl
LCSH: nl
DB 1978, DDMM, ETHN, HB

Kpalagha *see* PALARA

KPAN (Nigeria)

subcategories Takum

note Benue-Congo language; one of the groups included in the collective term Cross River people

AAT: nl
LCSH: nl
DDMM, DWMB, ETHN, RWL, UIH, WS

see also Cross River people

Kpatili *see* PATRI

Kpe *see* KWIRI

Kpeembele *see* KPEENE

Kpeenbele *see* KPEENE

KPEENE (Burkina Faso, Côte d'Ivoire, Mali)

variants Kpeembele Kpeenbele

note Gur language; subcategory of Senufo

AAT: nl
LCSH: nl
AJG, DR, NIB

see also Senufo

KPELLE (Guinea, Liberia)
variants Gberese, Gerze, Guerze,
Kpelli, Kpwesi, Pessi
note Mande language. Guerze is
the French name often used in
Guinea.
AAT: Kpelle
LCSH: Kpelle
ASH, BS, CDR 1985, DDMM, DOWF, DP,
DWMB, EBR, ELZ, ETHN, GB, GPM
1959, GPM 1975, GSGH, HAB, HB,
HBDW, HH, IAI, JD, JG 1963, JK, JLS,
JM, JP 1953, JPB, KFS, KK 1960, LJPG,
MG, MHN, MLJD, PMPO, RGL, RJ 1958,
RMS, ROMC, RS 1980, RSW, SMI, TB,
UIH, WEW 1973, WH, WOH, WRB,
WRNN, WS
BLB*, EFHH*, RMS*
see also Mande
Kpelli *see* KPELLE
KPE-MBOKO (Cameroun)
note Bantu language; a collective
term which includes the Kwiri
(Kpe), Mboko, Isuwu and Wovea
AAT: nl
LCSH: nl
EDA
KPERE (Cameroun)
note Adamawa language;
subcategory of Mbum
AAT: nl
LCSH: nl
DDMM, ETHN, JG 1963
see also Mbum
KPONE (Ghana)
note Kwa language
AAT: nl
LCSH: nl
GPM 1959, MM 1950
Kporo *see* NAMA (Cameroun)
Kposo *see* KPOSSO
KPOSSO (Ghana, Togo)
variants Akposso, Kposo
note Kwa language
AAT: nl
LCSH: nl (uses Kposo)
DDMM, DWMB, ETHN, GPM 1959,
HBDW, IAI, JG 1963, KK 1965, RJ 1958,
UIH, WH
Kpwesi *see* KPELLE

Kra *see* KRAN
KRACHI (Ghana)
note Kwa language
AAT: nl
LCSH: Krachi
DDMM, GPM 1959, HCDR, UIH, WH
Krah *see* KRAN
Krahn *see* KRAN
KRAN (Côte d'Ivoire, Liberia)
variants Kra, Krah, Krahn
note Kwa language; known as Kran
in Liberia and as Ngere or Guere
in Côte d'Ivoire; a collective term
for various ethnic groups,
including the Garbo, Gbarzon,
Gbu and Ubi
AAT: use Wee
LCSH: nl (uses Gere)
ASH, DDMM, DFHC, DP, DWMB, EBR,
ELZ, ETHN, FW, GPM 1959, GPM 1975,
GS, HB, HBDW, HH, IAI, JD, JLS, KFS,
KFS 1989, KK 1960, MLJD, RJ 1958,
RSW, SMI, TB, UIH, WEW 1973, WG
1980, WMR, WOH, WRB, WS
EFHH*, GSDS*
see also Ngere
Krawi *see* KRU
KREISH (Central African Republic,
Sudan)
variants Krej, Kresh
subcategories Furu, Gbaya
note Central Sudanic language
AAT: nl
LCSH: nl Kreish language use Kresh language
ATMB, DDMM, ELZ, ETHN, GPM 1959,
GPM 1975, HAB, HB, JG 1963, RJ 1959,
UIH, WH
Krej *see* KREISH
Krepi *see* EWE
Kresh *see* KREISH

KRIM (Sierra Leone)
variants Kim, Kimi
note West Atlantic language. The Bulom, Sherbro and Krim are closely connected to and often confused with each other.
AAT: nl
LCSH: nl
DDMM, DWMB, ETHN, GPM 1959, GPM 1975, HB, HBDW, IAI, KFS, LP 1993, TB, UIH, WH
MEM 1950*

KRINJABO (Ghana)
note name for a people, a Neolithic site, and a town
AAT: nl
LCSH: nl
BDG 1980, CDR 1985, ELZ, ENS, JPB, MLB

KRIO (Sierra Leone)
note Creole-speaking people of Sierra Leone
AAT: nl
LCSH: use Creoles
DDMM, ETHN, IAI, RJ 1958, SMI, WEW 1973

KROBO (Benin, Ghana, Togo)
note Kwa language; subcategory of Adangme
AAT: Krobo
LCSH: Krobo
AF, DDMM, DWMB, ETHN, GPM 1959, HB, HBDW, HCDR, IAI, JPB, LSD, MCA, MHN, MM 1950, RJ 1958, SMI, WH
HGH*
see also Adangme

Krobou *see* KROBU

KROBU (Côte d'Ivoire)
variants Krobou
note Kwa language; one of the groups included in the collective term Lagoon people
AAT: nl
·LCSH: nl
DDMM, DWMB, ENS, ETHN, GPM 1959, TFG
see also Lagoon people

Krongo *see* KORONGO

Krou *see* KRU

KRU (Côte d'Ivoire, Liberia)
variants Krawi, Krou
note Kwa language; a collective term used in Côte d'Ivoire and Liberia for various coastal populations. The term Kru is also used by linguists for the Kru-speaking peoples within the Kwa language group in Liberia and Côte d'Ivoire.
AAT: Kru
LCSH: Kru
AF, BS, CDR 1985, DDMM, DFHC, DWMB, EBR, EFLH, ELZ, ETHN, GB, GPM 1959, GPM 1975, GSGH, HAB, HB, HH, IAI, JEEL, JG 1963, JK, JM, JPB, KFS, KFS 1989, KK 1960, KK 1965, LP 1993, MLJD, MPF 1992, PMPO, RGL, RJ 1958, ROMC, RSW, SD, SMI, TFG, TP, UIH, WBF 1964, WEW 1973, WG 1980, WH, WOH, WRB, WS
EFHH*, GSDS*

Kuafi *see* KWAFI

Kuanyama *see* KWANYAMA

KUBA (Congo Republic, Zaire)
variants Bacouba, Bakouba,
Bakuba, Bushong, Bushongo
subcategories Bashilep, Bukil,
Bulaang, Bushoong, Biyeeng,
Idiing, Kaam, Kayuweeng, Kel,
Ket, Maluk, Mbal, Mbeengy,
Ngeende, Ngoombe, Ngongo,
Pyaang, Shoowa
note Bantu language; a kingdom,
confederation and ensemble of
ethnic groups known as Kuba
AAT: Kuba; Kuba Kingdom
LCSH: Kuba
ACN, ALM, ASH, AW, BES, BS, CDR
1985, CFL, CK, CMK, DDMM, DF,
DFHC, DOA, DOWF, DP, DPB 1985, DPB
1987, EB, EBHK, EBR, EEWF, ELZ,
FHCP, FW, GAC, GAH 1950, GB, GBJM,
GBJS, GPM 1959, GPM 1975, GWS, HAB,
HH, HJK, HMC, HRZ, IAI, JC 1971, JD,
JJM 1972, JK, JL, JLS, JM, JMOB, JPB,
JPJM, JV 1966, JV 1984, KFS, KFS 1989,
KK 1960, KK 1965, KMT 1970, LJPG,
LM, MCA, MG, MGU 1967, MH, MK,
MLB, MLJD, NIB, OB 1961, OB 1973,
OBZ, RFT 1974, RGL, ROMC, RS 1980,
RSAR, RSW, SMI, SV 1988, SVFN, TB,
TERV, TLPM, TP, UIH, WBF 1964,
WFJP, WG 1980, WG 1984, WH, WMR,
WOH, WRB, WRB 1959, WRNN, WS
ETTJ*, GSM*, HH 1993*, JC 1982*, JV
1954*, JV 1978*, MEJM*, MUD 1988*

Kubaï *see* Toponyms Index

Kucu *see* KUTU (Zaire)

KUFOLO (Côte d'Ivoire)
variants Kufuru
note Kwa language; subcategory of
Senufo
AAT: nl
LCSH: nl
AJG, SG, SV
see also Senufo

Kufuru *see* KUFOLO

Kuha *see* GUHA

KUK (Cameroun)
variants Ekuk
note Bantoid language
AAT: nl
LCSH: nl

CDR 1985, ETHN, KK 1960, KK 1965, LP
1993, MMML, PH

KUKU (Sudan, Uganda, Zaire)
note Eastern Nilotic language; one
of the groups included in the
collective term Nilo-Hamitic
people
AAT: nl
LCSH: Kuku
ATMB 1956, CSBS, DDMM, DPB 1987,
ECB, ETHN, GAH 1950, GPM 1959, GPM
1975, HAB, HB, IAI, JMOB, LJPG,
MTKW, RJ 1959, WH
GWH*
see also Nilo-Hamitic people

KUKURUKU (Nigeria)
note Kwa language; considered by
most authors a derogatory or
pejorative term applied to the
Northwest Edo (Akoko), Etsako,
Ineme, Ivbiosakon, Okpella and
others. see RWL.
AAT: use Etsako
LCSH: Kukuruku language use Etsako
language
DDMM, DWMB, ETHN, GPM 1959, GPM
1975, HB, IAI, JD, JG 1963, NOI, RJ 1958,
RWL, UIH, WH

KUKUYA (Congo Republic, Zaire)
variants Kukwa
note Bantu language; subcategory of
Teke
AAT: nl
LCSH: use Kukwa
DDMM, DPB 1985, ETHN, HB, RLD
1974, UIH
EPHE 8*, JV 1973*
see also Teke

Kukwa *see* KUKUYA

KUKWE (Malawi, Tanzania)
note Bantu language; subcategory of
Nyakyusa.
AAT: nl
LCSH: nl
DDMM, ETHN, GPM 1959, GPM 1975,
HB, MHW, UIH
TEW*
see also Nyakyusa

KULANGO (Côte d'Ivoire)
variants Koulango, Pakala
note Gur language
AAT: Kulango
LCSH: Kulango language
DDMM, DFHC, DP, DWMB, EFLH,
ETHN, GBJS, GPM 1959, GPM 1975,
HAB, HB, HMC, IAI, JEEL, JG 1963, JK,
JP 1953, JPB, KFS, KFS 1989, LPR 1986,
MUD 1991, RAB, RFT 1974, RGL, RJ
1958, TFG, UIH, WG 1980, WH, WRNN,
WS

Kule *see* KULEBELE

KULEBELE (Côte d'Ivoire, Mali)
variants Kule
note Gur language; subcategory of
Senufo
AAT: nl
LCSH: Kulebele
AJG, DR, SMI, SV
see also Senufo

KULERE (Nigeria)
variants Kaleri, Kuleri
note Chadic language
AAT: nl (uses Kaleri)
LCSH: nl
DDMM, ETHN, GPM 1959, HB, JG 1963,
JLS, RJ 1958, WS
RWL*

Kuleri *see* KULERE

KULIME (Côte d'Ivoire, Liberia)
note Mande language; subcategory
of Dan
AAT: nl
LCSH: nl
ELZ, RSW
see also Dan

KUMAM (Uganda)
variants Akokulemu
note Western Nilotic language; one
of the groups included in the
collective term Nilo-Hamitic
people; sometimes referred to as
Southern Lwoo.
AAT: nl
LCSH: nl
DDMM, ETHN, GPM 1959, GPM 1975,
HB, RJ 1960, UIH, WRB 1959
PGPG*
see also Lwoo, Nilo-Hamitic people

Kumasi *see* Toponyms Index

KUMBA (Nigeria)
note Adamawa language; one of the
groups included in the collective
term Mumuye
AAT: nl
LCSH: nl
DDMM, DWMB, ETHN, GPM 1959, GPM
1975, JG 1963, KK 1960, KK 1965, LP
1993, NOI, ROMC, RWL, SMI, UIH
see also Mumuye

Kumbat *see* BALIKUMBAT

Kumbi Saleh *see* Toponyms Index

KUMBO (Cameroun)
note kingdom in Tikar
AAT: nl
LCSH: nl
EBHK, KK 1965
PH
see also Tikar

Kumu *see* KOMO

Kunaama *see* KUNAMA

Kunam *see* KUNAMA

KUNAMA (Eritrea, Ethiopia)
variants Cunama, Kunaama,
Kunam
note Nilo-Saharan language; one of
the groups included in the
collective term Nilotic people
AAT: nl
LCSH: Kunama
ATMB, ATMB 1956, BS, DDMM, ETHN,
GB, GPM 1959, GPM 1975, HAB, HB,
IAI, JG 1963, RJ 1959, ROMC, UIH, WH,
WIS
see also Nilotic people

KUNDA (Mozambique, Zambia, Zimbabwe)

variants Chikunda

note Bantu language

AAT: nl
LCSH: nl
DDMM, ETHN, GPM 1959, HB, MGU 1967, PG 1990, RJ 1961, WH, WVB

KUNDA (Zaire)

variants Bakunda

note Bantu language; close affiliations with the Boyo, Kalanga, Lumbu and some other groups; scattered by the Lunda and Luba; one of the groups included in the collective term Holoholo

AAT: nl
LCSH: nl
DDMM, DPB 1981, DPB 1987, ETHN, FN 1994, GPM 1959, GPM 1975, HAB, HB, HBU, IAI, JC 1971, JK, JV 1966, MLF, OB 1961, OBZ, WS
AC*

see also Holoholo

Kundu *see* NKUNDO

KUNDU (Cameroun)

variants Bakundu

note Bantu language

AAT: Kundu
LCSH: nl
ASH, BES, DDMM, EBHK, ETHN, GPM 1959, GPM 1975, HAB, HB, IAI, KK 1960, KK 1965, LP 1993, MK, PH, RJ 1958, TN 1984, TP, UIH, WBF 1964, WH, WOH, WRB

!Kung *see* KUNG

KUNG (Angola, Namibia)

variants !Kung

note Khoisan language; one of the groups included in the collective term Bushmen

AAT: nl
LCSH: !Kung
ARW, ATMB 1956, BS, DDMM, EBR, ETHN, GB, GPM 1959, GPM 1975, HAB, HB, HRZ, IAI, JG 1963, JM, KK 1960, PMPO, ROMC, SMI, SV 1988, TP, UIH, WH
ALB*, IS*

see also Bushmen

KUNTA (Burkina Faso, Mali, Mauritania, Niger)

note Semitic language; an Arabized Berber group who inhabit the Sahara north of Timbuktu; one of the groups included in the collective term Bedouin

AAT: nl
LCSH: nl
GPM 1959, GPM 1975, LPR 1995, RJ 1958, WH

see also Bedouin

Kunye *see* KUNYI

KUNYI (Congo Republic, Zaire)

variants Kunye

note Bantu language; subcategory of Kongo

AAT: nl
LCSH: nl
ASH, BS, DDMM, DPB 1985, DPB 1987, ETHN, GPM 1959, GPM 1975, HAB, HB, MGU 1967, SV, UIH

see also Kongo

KUPA (Nigeria)

note Kwa language; subcategory of Nupe

AAT: nl
LCSH: nl
DDMM, ETHN, GPM 1959, RWL, UIH

see also Nupe

KURAMA (Nigeria)

note Benue-Congo language

AAT: nl
LCSH: nl
BS, DDMM, DWMB, ETHN, GPM 1959, GPM 1975, HB, JG 1963, NOI, ROMC, RWL, UIH, WH
HDG 1956*

KURANKO (Guinea, Sierra Leone)
variants Koranko
note Mande language
AAT: nl
LCSH: Kuranko
BS, DDMM, DWMB, ETHN, GPM 1959,
GPM 1975, GSGH, HAB, HB, HBDW,
IAI, JG 1963, JLS, JPJM, KFS, LPR 1986,
PRM, RJ 1958, RJ 1960, SMI, UIH, WH,
WS
MEM 1950*, MJ*
see also Mande

KURIA (Kenya, Tanzania)
variants Bakulya, Koria, Kurya,
Watende
subcategories Simbiti
note Bantu language
AAT: nl
LCSH: Kuria
BS, DDMM, ECB, ETHN, GPM 1959, HB,
JLS, MFMK, MGU 1967, RJ 1960, UIH,
WH

KURUMBA (Burkina Faso, Mali)
variants Fulse, Kouroumba
subcategories Nyonyosi, Sikomse
note Gur language. The Kurumba
have also been referred to as
Tellem. The terms Nyonyosi and
Sikomse may be used for Mossi-
influenced Kurumba.
AAT: Kurumba
LCSH: Kurumba
ASH, BS, CDR 1987, CMK, DDMM,
DWMB, EEWF, ELZ, ETHN, FW, GPM
1959, GPM 1975, GWS, HB, HMC, IAI,
JD, JG 1963, JK, JL, JLS, LJPG, LM, MG,
MH, MLB, MLJD, MPF 1992, NIB, RGL,
RJ 1958, RSAR, RSW, SMI, SV, UIH,
WBF 1964, WG 1980, WG 1984, WMR,
WRB, WRNN, WS
ASH 1973*
see also Tellem

Kurya *see* KURIA

KUSASI (Burkina Faso, Ghana,
Togo)
note Gur language; one of the
groups included in the collective
term Frafra
AAT: nl
LCSH: Kusasi language use Kussassi
language
BS, DDMM, DWMB, ETHN, FTS, GPM
1959, GPM 1975, HAB, HB, HCDR, IAI,
JG 1963, LPR 1969, RJ 1958, UIH
see also Frafra

KUSH (Sudan)
variants Cush
note ancient Nubian kingdom also
known as Napata and centered in
that city; a successor to Kerma
and later succeeded by Meroë
AAT: nl (uses Kushite)
LCSH: nl
BD, GC, PG 1990, UGH, WH 1984, WS
1984

KUSU (Zaire)
variants Bakusu
note Bantu language; one of the
groups included in the collective
term Nkutshu. In earlier
literature the term was sometimes
used to refer to Kusu proper,
Malela, Ngengele, Songola, and
Tetela..
AAT: Kusu
LCSH: Kusu
CDR 1985, DDMM, DPB 1981, DPB
1985, DPB 1986, DPB 1987, EB, ETHN,
FN 1994, GAH 1950, GPM 1959, GPM
1975, HJK, JAF, JC 1971, JC 1978, JK,
JMOB, JPJM, JTSV, JV 1966, JV 1984,
KFS 1989, MGU 1967, OB 1961, OBZ,
UIH, WG 1980, WG 1984, WH, WOH,
WRB, WRNN, WS
JOJ*
see also Nkutshu

Kuta *see* KOTA

Kuteb *see* KUTEP

KUTEP (Nigeria)
variants Djumperi, Djumperri,
Jompre, Kuteb, Kutev, Zumper
note Benue-Congo language
AAT: nl (uses Zumper)
LCSH: nl
DDMM, DWMB, ETHN, GPM 1959, GPM
1975, HB, HMC, IAI, JAF, JG 1963, JK,
KK 1960, RJ 1958, RWL, WBF 1964,
WEW 1973, WH, WRB, WS

Kutev *see* KUTEP
KUTIN (Cameroun, Nigeria)
note Adamawa language
 AAT: nl
 LCSH: nl
 DDMM, ETHN, GPM 1959, GPM 1975,
 HB, JD, JG 1963, JK, RJ 1958, RWL
KUTU (Tanzania)
variants Khutu
note Bantu language
 AAT: nl
 LCSH: nl
 DDMM, ETHN, GPM 1959, GPM 1975,
 HAB, HB, IAI, KK 1990, MFMK, MGU
 1967, RJ 1960, UIH
KUTU (Zaire)
variants Bakucu, Bakutu, Kucu
note Bantu language; subcategory of
 Mongo
 AAT: nl
 LCSH: nl
 DDMM, DPB 1985, DPB 1987, ETHN,
 GAH 1950, GPM 1959, GPM 1975, HAB,
 HB, HBU, JMOB, MGU 1967, OB 1973,
 OBZ, UIH, WH
 GAH*, JOJ*
see also Mongo
Kuturmi *see* ADA (Nigeria)
KUYA (Côte d'Ivoire)
note Kwa language
 AAT: nl
 LCSH: nl
 DDMM, ETHN, GPM 1959, JPB
KUYU (Congo Republic)
variants Koyo
note Bantu language
 AAT: Kuyu
 LCSH: nl
 BS, CFL, CK, CMK, DDMM, DP, EEWF,
 ELZ, ETHN, EWA, GBJS, GPM 1975, HB,
 IAI, JD, JK, JLS, KFS 1989, KK 1965, LM,
 MGU 1967, MH, MLB, MLJD, MPF 1992,
 MUD 1986, RFT 1974, RSAR, RSW, SV,
 SV 1988, WBF 1964, WG 1980, WMR,
 WRB, WRNN, WS
KUZIE (Côte d'Ivoire)
variants Kuzye
note Kwa language
 AAT: nl
 LCSH: nl
 DDMM, JPB

Kuzye *see* KUZIE
Kwa *see* QUA
Kwa River *see* Toponyms Index
Kwadi *see* KOROCA
KWADYA (Côte d'Ivoire)
note Kwa language
 AAT: nl
 LCSH: nl
 DDMM, ETHN, GPM 1959, HB, JPB
KWAFI (Tanzania)
variants Baraguyu, Kuafi, Kwavi
note Eastern Nilotic language;
 subcategory of Maasai
 AAT: nl
 LCSH: Kwafi language
 ATMB 1956, ECB, ETHN, GPM 1959,
 GPM 1975, HB, HBDW, IAI, KK 1990, RJ
 1960, UIH, WH
 GWH 1969*
see also Maasai
KWAHU (Ghana)
note Kwa language; one of the
 groups included in the collective
 term Akan
 AAT: nl
 LCSH: Kwahu
 BDG 1980, DDMM, DFHC, GPM 1959,
 GPM 1975, HAB, HB, HCDR, IAI, MM
 1950, RJ 1958, TFG, WFJP
 WOB*
see also Akan
KWALA (Congo Republic)
note Bantu language
 AAT: nl
 LCSH: nl
 DDMM, ETHN, HB, IAI, MGU 1967
Kwale *see* Toponyms Index
KWALE (Nigeria)
note Kwa language; subcategory of
 Igbo
 AAT: nl
 LCSH: nl
 DDMM, ELZ, ETHN, JLS, RWL, SV 1986,
 WRB
see also Igbo

KWAMBI (Angola, Namibia)
note Bantu language
AAT: nl
LCSH: nl
DDMM, ETHN, HB, IAI, MGU 1967

KWAME (Zaire)
variants Bakwame
note Bantu language
AAT: nl
LCSH: nl
DPB 1986, ETHN

KWANDI (Zambia)
note Bantu language
AAT: nl
LCSH: nl
DDMM, ETHN, GPM 1959, HB, WH,
WVB

Kwando River *see* Toponyms Index

KWANDU (Angola, Zambia)
note Bantu language
AAT: nl
LCSH: nl
DDMM, ETHN, HB, JLS

KWANG (Chad)
note Chadic language; one of the
groups included in the collective
term Kirdi
AAT: nl
LCSH: nl
DB, DDMM, ETHN
see also Kirdi

Kwango River *see* Toponyms Index

KWANGWA (Zambia)
note Bantu language
AAT: nl
LCSH: Kwangwa
DDMM, ELZ, HB, MLB, UIH, WVB

KWANYAMA (Angola, Namibia)
variants Humba, Kuanyama
note Bantu language
AAT: nl
LCSH: use Kuanyama
DDMM, ETHN, GPM 1959, GPM 1975,
HB, MCA, MGU 1967, MLB 1994, RS
1980, SMI, UIH, WDH

Kwanza River *see* Toponyms Index

Kwaro *see* KORO

Kwavi *see* KWAFI

Kwaya *see* JITA

KWEI (Congo Republic)
note Bantu language; subcategory of
Teke
AAT: nl
LCSH: nl
DDMM, DPB 1985, DPB 1987, JV 1973
see also Teke

Kwele *see* KWERE

KWELE (Congo Republic,
Cameroun, Gabon)
variants Bakwele, Bekwil, Ebaa,
Kouele
note Bantu language
AAT: Kwele
LCSH: nl
CDR 1985, CFL, DDMM, DFM, EB,
EEWF, ELZ, ETHN, FW, GBJS, GPM
1959, GPM 1975, HB, HMC, HRZ, JC
1971, JD, JK, JL, JTSV, KFS 1989, LM, LP
1979, LP 1985, LP 1990, MGU 1967,
MHN, MLB, MLJD, MUD 1986, RGL,
RSAR, RSRW, RSW, SV, TP, UIH, WBF
1964, WG 1980, WH, WMR, WRB,
WRNN, WS
LS*

KWENA (Botswana)
note Bantu language; subcategory of
Tswana
AAT: nl
LCSH: nl
DDMM, ETHN, GPM 1959, HB, RSW,
UIH, WDH
see also Tswana

Kwengo *see* HUKWE

Kweni *see* GURO

KWERE (Tanzania)
variants Bakwere, Kwele, Wakwere
note Bantu language
AAT: nl
LCSH: nl
CDR 1985, DDMM, ECB, ETHN, GPM
1959, GPM 1975, HAB, HB, HBDW, IAI,
JK, JLS, KK 1990, TP, UIH, WH
MFMK*, TOB 1967*

KWESE (Zaire)

variants Bakwese

note Bantu language
AAT: Kwese
LCSH: Kwese
CDR 1985, DDMM, DPB 1985, DPB
1987, ETHN, FHCP, GAH 1950, GPM
1959, GPM 1975, HAB, HB, HBDW, JC
1978, JMOB, JV 1966, MGU 1967, OB
1973, OBZ, SMI, UIH, WH, WRB, WRNN,
WS

Kwilu River *see* Toponyms Index

KWIRI (Cameroun)

variants Baakpe, Bakweri, Bakwiri,
Kpe

note Bantu language; one of the
groups included in the collective
term Kpe-Mboko.
AAT: use Kpe
LCSH: Kwiri
BES, DDMM, ETHN, GPM 1959, GPM
1975, HB, HBDW, IAI, IEZ, KK 1965,
MGU 1967, RJ 1958, SMI, UIH, WH,
WOH, WRB
EDA*, EDA 1962*

see also Kpe-Mboko

Kwolla *see* KOFYAR

Kwotto *see* OKPOTO

Kyama *see* EBRIE

Kyaman *see* EBRIE

Kyiga *see* KIGA

LAABUM (Cameroun)

note one of the groups included in
the collective term Bamenda
AAT: nl
LCSH: nl
LP 1993, MMML, PMK

see also Bamenda

LAADI (Congo Republic)

variants Baladi, Balali, Laali, Ladi,
Lali, Lari

note Bantu language; Kongo and
Teke related group
AAT: nl (uses Lali)
LCSH: Laadi
BES, BS, DDMM, DPB 1985, DPB 1987,
ELZ, ETHN, GPM 1959, HB, HBDW, IAI,
JK, JV 1966, JV 1973, LP 1985, MGU
1967, OB 1973, RLD 1974, SG, UIH, WG
1980, WRB

Laak *see* LAK

Laali *see* LAADI

LABWOR (Sudan, Uganda)

variants Tobur

note West Nilotic language; one of
the groups included in the
collective term Nilotic people;
sometimes referred to as Southern
Lwoo.
AAT: nl
LCSH: Labwor
ATMB 1956, DDMM, ECB, ETHN, GPM
1959, GPM 1975, HB, MTKW, WH

see also Lwoo, Nilotic people

Ladi *see* LAADI

LAFIA (Nigeria)

note one of the groups included in
the collective term Koro
AAT: nl
LCSH: nl
ETHN, KK 1960, RWL

see also Koro

LAFOFA (Sudan)

note Kordofanian language
AAT: nl
LCSH: nl
CSBS, DDMM, ETHN, SD

LAGOON people (Côte d'Ivoire)

variants Lagunaires

note Kwa language; a collective
term which includes the Abe,
Abidji, Abure, Adjukru, Ahizi,
Akye, Aladyan, Avikam, Ebrie,
Gwa, Krobu, and Metyibo. Some
also include the Agua, Ega,
Esuma, and Nzima.
AAT: nl
LCSH: Lagoon languages
BS, DDMM, ENS, GPM 1959, GPM 1975,
HBDW, JEEL, JLS, JPB, LM, MPF 1992,
TFG, WH, WS
JPB*

Lagunaires *see* LAGOON people

LAIKIPIAK (Kenya)

note Eastern Nilotic language;
subcategory of Maasai
AAT: nl
LCSH: nl
ATMB 1956, GWH 1969, JLS, WH

see also Maasai

LAIKOM (Cameroun)

variants Lakom

note subcategory of Tikar; one of
the chiefdoms included in the
collective term Bamenda
AAT: nl
LCSH: nl
EBHK, GDR, KK 1965, LM, PH, TN 1984
LP 1993*, PAG*, PMK*

see also Bamenda, Tikar

LAK (Sudan)

variants Laak

note Western Nilotic language;
subcategory of Nuer
AAT: nl
LCSH: nl
ATMB 1956, CSBS, DDMM, ETHN, HB,
WH

see also Nuer

LAKA (Cameroun, Chad)

note Central Sudanic language
AAT: nl
LCSH: nl
ATMB 1956, DDMM, DWMB, ETHN,
GPM 1959, GPM 1975, HAB, HB, HBDW,
IAI, IEZ, JG 1963, JLS, JP 1953, UIH

LAKKA (Central African Republic,
Nigeria)

note Adamawa language; related to
the Dek
AAT: nl
LCSH: nl
DDMM, ETHN, GPM 1959, GPM 1975,
JG 1963, RWL, WOH

see also Dek

Lako *see* POK

Lakom *see* LAIKOM

LALA (Zaire, Zambia)

variants Balala

note Bantu language

AAT: nl
LCSH: Lala
BS, DDMM, DPB 1981, DPB 1986, DPB
1987, DWMB, ETHN, EBR, FN 1994,
GAH 1950, GPM 1959, GPM 1975, HAB,
HB, HBDW, IAI, JK, JMOB, JV 1966,
MGU 1967, NOI, OB 1961, OBZ, PR, RJ
1961, SMI, UIH, WDH, WH, WVB
WWJS*

Lali *see* LAADI

LALIA (Zaire)

note Bantu language
AAT: nl
LCSH: nl
DDMM, ETHN, GPM 1959, GPM 1975,
JMOB, UIH, WH

Lalibela *see* Toponyms Index

Lama *see* LAMBA (Benin, Togo)

LAMBA (Zaire, Zambia)

variants Balamba

note Bantu language
AAT: nl
LCSH: Lamba
DDMM, DPB 1987, ETHN, GAH 1950,
GPM 1959, GPM 1975, HAB, HB, JMOB,
JV 1966, MHN, OB 1961, RGL, RJ 1961,
UIH, WH, WVB
CMD*, WWJS*

LAMBA (Benin, Togo)

variants Lama, Namba

note Gur language
AAT: use Namba
LCSH: nl
DDMM, DWMB, ETHN, GPM 1959, HB,
JCF, KK 1965, MHN, UIH, WG 1980

LAMBYA (Malawi, Tanzania)

note Bantu language
AAT: nl
LCSH: nl
ETHN, GPM 1959, GPM 1975, HB,
MFMK, WVB

Lamu *see* Toponyms Index

Landouman *see* LANDUMAN

LANDUMA (Guinea, Guinea-Bissau, Sierra Leone)

variants Landuman, Landouman

note West Atlantic language

AAT: Landuma
LCSH: nl
ASH, DDMM, DP, DWMB, ELZ, ETHN, GPM 1959, GPM 1975, HH, HMC, JD, JG 1963, JK, KFS 1989, MLJD, RSAR, RSW, TB, UIH, WBF 1964, WEW 1973, WG 1980, WH, WMR, WRB, WRNN, WS

Landuman *see* LANDUMA

LANGA (Zaire)

note Bantu language

AAT: nl
LCSH: nl
DDMM, DPB 1987

LANGBA (Central African Republic, Zaire)

note Central Ubangian language

AAT: nl
LCSH: nl
DB 1978, DDMM, ETHN, HB

Langbase *see* LANGBWASE

Langbasse *see* LANGBWASE

Langbassi *see* LANGBWASE

LANGBWASE (Central African Republic, Zaire)

variants Langbase, Langbasse, Langbassi, Langbwasse, Langwassi

note Central Ubangian language

AAT: nl
LCSH: Langbwase use Langbas
DB 1978, DDMM, DPB 1987, ETHN, FE 1933, GAH 1950, GPM 1959, HAB, HB, UIH

Langbwasse *see* LANGBWASE

Langi *see* RANGI

LANGO (Sudan)

subcategories Dongotono, Logir, Logiri

note Eastern Nilotic language; sometimes referred to as Southern Lwoo; not to be confused with the Lango of Kenya and Uganda; one of the groups included in the Nilo-Hamitic people. The Lango of Sudan have a Nilo-Hamitic base (the Logir subcategory) with Nilotic and other additions.

AAT: nl
LCSH: nl
ATMB, ATMB 1956, CSBS, DDMM, ELZ, ETHN, GPM 1959, GPM 1975, HAB, HB, HBDW, IAI, RJ 1959, UIH, WH
GWH*

see also Lwoo, Nilo-Hamitic people

LANGO (Kenya, Uganda)

note Western Nilotic language; not to be confused with the Lango of the Sudan. The Lango of Uganda are one of the groups referred to by the collective term Nilotic people.

AAT: Lango
LCSH: Lango
ATMB 1956, BES, BS, CSBS, DDMM, ECB, ETHN, EWA, GPM 1959, GPM 1975, HAB, HBDW, JD, JG 1963, LJPG, MCA 1986, MTKW, RJ 1960, SMI, UIH, WH
AJB*, GWH*, JHD*

see also Nilotic people

Langulu *see* SANYE

Langwassi *see* LANGBWASE

Laobe *see* LEBU

LARDANG (Nigeria)

note Chadic language; one of the groups included in the collective term Kofyar

AAT: nl
LCSH: nl
RWL, WS

see also Kofyar

Lari *see* LAADI

LARO (Sudan)

note Kordofanian language

AAT: nl
LCSH: nl
DDMM, ETHN, GPM 1959, GPM 1975, HB, SD

LARTEH (Ghana)

note Kwa language; sometimes referred to with Cherepong as Cherepong-Larteh

AAT: nl

LCSH: nl

DDMM, ETHN, HCDR, IAI

see also Cherepong

Latuka *see* LOTUKO

Latuko *see* LOTUKO

Lebang *see* FONTEM

Lebou *see* LEBU

LEBU (Cape Verde, Senegal)

variants Laobe, Lebou

note West Atlantic language

AAT: nl

LCSH: nl (uses Lebou)

BS, DDMM, ETHN, GPM 1959, GPM 1975, HB, HRZ, JLS, JP 1953, MPF 1992, PMPO, RGL, RJ 1958, SMI, UIH

DPG*

Leek *see* LEK

LEELE (Zaire)

variants Bashileele, Bashilele, Bashilyeel, Batsilele, Lele, Schilele, Shilele

note Bantu language. The transcription Leele seems currently preferred to the more conventional Lele.

AAT: nl (uses Lele)

LCSH: nl (uses Lele)

CDR 1985, DDMM, DPB 1985, DPB 1987, DWMB, EBHK, ELZ, ETHN, FHCP, GAH 1950, GPM 1959, GPM 1975, HAB, HB, HBDW, HH, HJK, IAI, JC 1971, JLS, JMOB, JV 1978, JV 1966, JV 1984, MGU 1967, MLB, OB 1973, OBZ, RFT 1974, RGL, RSW, SD, SMI, SV, TB, TERV, TLPM, UIH, WG 1980, WH, WRB, WRNN

JC 1978*, TEW 1963*

LEGA (Zaire)

variants Balega, Balegga, Rega, Walega, Warega

note Bantu language. Some other remnant groups in northeastern

Zaire are collectively referred to as Balega or Balegga.

AAT: Lega

LCSH: use Rega

ACN, AF, ALM, BES, BS, CDR 1985, CFL, CK, CMK, DDMM, DFHC, DOA, DOWF, DP, DPB 1981, DPB 1985, DPB 1986, EB, EBHK, EBR, EEWF, ELZ, ETHN, FHCP, FN 1994, FW, GAH 1950, GBJM, GBJS, GPM 1959, GPM 1975, HAB, HB, HBDW, HH, HJK, HMC, IAI, JAF, JC 1971, JC 1978, JD, JJM 1972, JK, JL, JLS, JMOB, JPB, JTSV, JV, JV 1984, KFS 1989, KK 1960, KK 1965, KMT 1970, LJPG, LM, MGU 1967, MHN, MLB, MLJD, MUD 1991, OBZ, RFT 1974, RGL, ROMC, RS 1980, RSAR, RSRW, RSW, SMI, SV, SV 1988, TB, TERV, TLPM, TP, UIH, WBF 1964, WG 1980, WH, WMR, WRB, WRB 1959, WRNN, WS

DPB 1973*, DPB 1994*

LEK (Sudan)

variants Leek

note West Nilotic language; subcategory of Nuer

AAT: nl

LCSH: nl

ATMB 1956, CSBS, DDMM, EEP 1940, HB, WH

see also Nuer

LEKA (Zaire)

variants Baleka

note Bantu language

AAT: nl

LCSH: nl

DPB 1986, DPB 1987, GAH 1950, HB, JMOB, MLF

LEKO (Cameroun, Nigeria)

variants Chamba Leko, Lekon, Samba Leko

note Adamawa language; subcategory of Chamba

AAT: nl

LCSH: nl

DDMM, ETHN, GPM 1959, HB, RWL

see also Chamba

Lekon *see* LEKO

Lela *see* LYELE (Burkina Faso)

Lela *see* DAKAKARI

Lele *see* LEELE (Zaire)

Lele *see* LYELE (Burkina Faso)

Lelesu *see* Toponyms Index

Lemba *see* KELA

LEMBA (South Africa, Zimbabwe)

note Bantu language
AAT: nl
LCSH: Lemba
DDMM, GPM 1959, GPM 1975, HAB,
HB, HBDW, JRE, RJ 1961, UIH, WH
WDH*

LEMBWE (Zaire)

note Bantu language
AAT: nl
LCSH: nl
DDMM, DPB 1987, HB, UIH

LEMFU (Zaire)

variants Balemfu

note Bantu language; subcategory of
Kongo
AAT: nl
LCSH: nl
DPB 1985, OB 1973, WM

see also Kongo

LENDU (Zaire, Uganda)

variants Bale, Balendu

note Central Sudanic language
AAT: nl
LCSH: Lendu
ATMB, ATMB 1956, CSBS, DDMM, DPB
1985, DPB 1987, ECB, ETHN, EWA,
GAH 1950, GPM 1959, GPM 1975, HAB,
HB, HBDW, HVGA, IAI, JG 1963, JMOB,
MTKW, OBZ, SMI, UIH, WH
MMT*

Lenge *see* CILENGE (Angola)

Lenge *see* CHOPI (Mozambique)

Lengi *see* LENJE

LENGOLA (Zaire)

variants Balengola

note Bantu language; encompasses
three groups: Balega fishermen,
Babila hunters, and a transitional
group called Bavalongo
AAT: Lengola
LCSH: nl
ALM, CDR 1985, CMK, DDMM, DPB
1986, ETHN, FHCP, GAH 1950, GPM
1959, GPM 1975, HB, IAI, JK, JC 1971, JC
1978, JD, MLB, MLJD, OBZ, UIH, WG
1980, WRB, WRNN

DPB 1987*

LENJE (Zaire, Zambia)

variants Ciina Mukuni, Bena
Mukuni, Beni Mukuni, Bwene
Mukuni, Lengi, Mukuni

note Bantu language
AAT: nl
LCSH: Lenje
DDMM, DPB 1987, ETHN, FN 1994,
GPM 1959, GPM 1975, HAB, HB, HBDW,
IAI, JMOB, MGU 1967, RJ 1961, UIH,
WDH, WH, WVB

Lesa *see* SAKATA

LESE (Zaire, Uganda)

variants Balesa, Balese, Walese

note Central Sudanic language
AAT: Lese
LCSH: Lese
ATMB, ATMB 1956, BS, DDMM, DPB
1987, ESCK, ETHN, GPM 1959, GPM
1975, HAB, HB, HBDW, IAI, JG 1963,
JMOB, OBZ, UIH, WH
HVGB*

Lesotho *see* Toponyms Index

LEYA (Zambia)

note Bantu language
AAT: nl
LCSH: nl
DDMM, ETHN, GPM 1959, GPM 1975,
JLS, UIH

Li *see* BALI

Lia *see* BOLIA

LIBINZA (Zaire)

note Bantu language; one of the
groups included in the collective
term Ngiri
AAT: nl
LCSH: nl
BS, DDMM, ETHN, DPB 1987, HBU,
JMOB

see also Ngiri

LIBOLO (Angola)

variants Bolo

note Bantu language
AAT: nl
LCSH: nl
DDMM, ETHN, GPM 1959, GPM 1975,
HB, UIH, WH

LIFUMBA (Zaire)
 note Bantu language; subcategory of
 Mongo
 AAT: nl
 LCSH: nl
 DPB 1987, GPM 1959

LIGBA (Benin, Togo)
 note Gur language; not to be
 confused with the Ligbi of Ghana
 and Côte d'Ivoire, who speak a
 Mande language
 AAT: nl
 LCSH: nl
 DDMM

LIGBI (Côte d'Ivoire, Ghana)
 note Mande language; not to be
 confused with the Ligbi, who
 speak a Gur language, in Togo
 and Benin
 AAT: Ligbi
 LCSH: nl
 DDMM, DFHC, DWMB, ETHN, GPM
 1959, GPM 1975, HB, HBDW, JG 1963,
 JK, JPB, KFS, PRM, RAB, UIH, WG 1980,
 WH, WS
 see also Mande

LIGO (Sudan)
 note Nilotic language; subcategory
 of Bari; one of the groups
 included in the collective term
 Nilo-Hamitic people
 AAT: nl
 LCSH: nl
 ETHN, GWH, HB
 see also Bari, Nilo-Hamitic people

LIKA (Zaire)
 variants Balika
 note Bantu language
 AAT: nl
 LCSH: nl
 DDMM, DPB 1987, ETHN, GAH 1950,
 GPM 1959, GPM 1975, HAB, HB, HBDW,
 JMOB, OBZ, WH
 HVG 1960*

Likouala River *see* Toponyms Index
Likouba *see* LIKUBA
LIKUBA (Congo Republic)
 variants Likouba

 note Bantu language
 AAT: nl
 LCSH: nl
 DDMM, ETHN, JLS, JPL 1978, MPF 1992
Lilse *see* LYELE
LIMA (Tanzania, Zambia)
 note Bantu language; sometimes
 included in the Nyaturu cluster
 AAT: nl
 LCSH: use Nyaturu
 DDMM, ETHN, GPM 1959, GPM 1975,
 HB, SV, UIH, WH, WVB
 WWJS*
 see also Nyaturu
LIMBA (Sierra Leone)
 note West Atlantic language
 AAT: Limba
 LCSH: Limba
 BS, DDMM, DWMB, ETHN, GPM 1959,
 GPM 1975, GSGH, HB, HBDW, JG 1963,
 JLS, KFS, RJ 1958, ROMC, SD, SMI, UIH,
 WH, WOH
 MEM 1950*, RHF*
LIMBA (Cameroun)
 variants Balimba
 note Bantu language; one of the
 groups included in the collective
 terms Bo-Mbongo cluster, Duala-
 Limba group
 AAT: nl
 LCSH: nl
 DDMM, EDA, ETHN, GPM 1959, HB
 MAB*
 see also Bo-Mbongo, Duala-Limba
Limbum *see* NSUNGLI
Limi *see* NYATURU
Limpopo River *see* Toponyms Index
LINGA (Zaire)
 variants Balinga
 note Bantu language
 AAT: nl
 LCSH: nl
 DPB 1986, DPB 1987, GPM 1959, GPM
 1975, JMOB, OBZ
Liptako *see* Toponyms Index
Lo *see* GURO
Loanda *see* LUANDA
Loange *see* Toponyms Index

LOANGO (Zaire)

note Bantu language; subcategory of Kongo

AAT: nl

LCSH: use Vili

ASH, BES, DFHC, DPB 1987, EBHK, ELZ, EWA, GPM 1959, GPM 1975, HB, HBDW, HRZ, IAI, JJM 1972, JK, JL, JLS, JV 1966, JV 1984, KFS, KK 1960, KK 1965, KMT 1970, KMT 1971, LJPG, MG, MGU 1967, NIB, OB 1973, PMPO, RFT 1974, ROMC, SG, SMI, TB, UIH, WG 1980, WG 1984, WH, WM, WMR, WOH

see also Kongo

LOBALA (Congo Republic, Zaire)

note Bantu language; one of the groups included in the collective term Ngiri

AAT: nl

LCSH: nl

CDR 1985, DDMM, DPB 1987, ETHN, GAH 1950, GPM 1959, GPM 1975, HAB, HB, HBU, HBDW, JMOB, KFS 1989, MGU 1967, OBZ, WH

see also Ngiri

Lobedu *see* LOVEDU

Lober *see* BIRIFOR

LOBI (Burkina Faso, Côte d'Ivoire)

note Gur language; collective term for various groups living in Burkina Faso, Côte d'Ivoire and Ghana, including the Dorosie, Dyan, Gan, Lowilisi, and sometimes the Birifor; one of the groups included in the collective terms Dagara and Wala

AAT: Lobi

LCSH: Lobi

AF, ASH, BS, CDR 1985, CDR 1987, CK, CMK, DDMM, DFM, DOA, DP, DWMB, EB, EBR, EFLH, ELZ, ETHN, EVA, EWA, FW, GBJS, GPM 1959, GPM 1975, GWS, HAB, HB, HBDW, HCDR, HH, IAI, JD, JEEL, JG 1963, JJM 1972, JK, JLS, JP 1953, JTSV, KFS, KFS 1989, LJPG, LM, LPR 1986, MH, MLB, MLJD, MPF 1992, NIB, RAB, RFT 1974, RGL, RJ 1958, RS 1980, RSAR, RSRW, RSW, SD, SG, SMI, SV, TFG, TLPM, TP, UIH, WBF 1964, WG 1980, WG 1984, WH, WMR, WRB, WRNN, WS

GFS*, HEL*, JCH*, JPB*, MM 1951*, PTM*

see also Dagara, Wala

Lobi Lorhon *see* LORHON

LOBO (Zaire)

note Bantu language; one of the groups included in the collective term Ngiri

AAT: nl

LCSH: nl

DDMM, DPB 1987, ETHN, OBZ

see also Ngiri

LODAGAA (Burkina Faso, Côte d'Ivoire, Ghana)

variants Dagari

subcategories Lodagaba, Lowiili

note Gur language; a collective term for the Lodagaba and the Lowiili; one of the groups included in the collective term Dagara. Some sources refer to them as Lobi. see JAG 1962.

AAT: nl

LCSH: use Dagari

BS, CDR 1987, DDMM, DWMB, EPHE 5, ESG, ETHN, GPM 1959, GPM 1975, HAB, HB, IAI, JG 1963, MHN, RJ 1958, RSW, SMI, UIH, WH

JAG 1962*, JAG 1967*

see also Dagara, Lobi

LODAGABA (Burkina Faso, Ghana)

variants Dagaba

note Gur language; subcategory of Lodagaa; one of the groups included in the collective terms Lodagaa and Wala

AAT: nl

LCSH: nl

BS, DDMM, GPM 1959, GPM 1975, HB, HBDW, RGL, UIH, WH

JAG 1962*

see also Lodagaa, Wala

Logbara *see* LUGBARA

LOGIR (Sudan)
note Eastern Nilotic language;
subcategory of Lango
AAT: nl
LCSH: nl
DDMM, GWH, HB
see also Lango

LOGIRI (Sudan)
note Eastern Nilotic language;
subcategory of Lango
AAT: nl
LCSH: nl
DDMM, GWH, HB
see also Lango

LOGO (Zaire)
note Central Sudanic language;
often referred to with Avokaya as
Logo-Avokaya. see DPB 1987 and
IAI.
AAT: nl
LCSH: Logo language
ATMB, ATMB 1956, DDMM, DPB 1987,
ESCK, ETHN, GAH 1950, GPM 1959,
GPM 1975, HAB, HB, HBDW, JG 1963,
JJM 1972, JMOB, MPF 1992, OBZ, WDH,
WH

Logoli *see* LOGOOLI

LOGONE (Cameroun, Chad,
Nigeria)
note Chadic language; subcategory
of Kotoko
AAT: nl
LCSH: nl
DDMM, DWMB, ELZ, ETHN, GPM 1959,
HBDW, HB, IAI, JG 1963, JPAL, RJ 1958,
ROMC, SMI, UIH, WH
see also Kotoko

LOGOOLI (Kenya)
variants Avalogoli, Ilogooli, Logoli,
Maragoli, Ragoli
note Bantu language; subcategory of
Luyia
AAT: nl
LCSH: Logooli
DDMM, ECB, ETHN, GPM 1959, GPM
1975, HB, JLS, LPR 1995, MGU 1967, RJ
1960
see also Luyia

LOI (Zaire)
variants Baloi
note Bantu language; one of the
groups included in the collective
term Ngiri
AAT: Loi
LCSH: nl
DDMM, DPB 1987, ETHN, GAH 1950,
GPM 1959, GPM 1975, HAB, HB, HBDW,
JMOB, MGU 1967, OBZ, TERV, WH,
WRB
see also Ngiri

Loikop *see* SAMBURU

Loikpo *see* SAMBURU

Lokele *see* KELE (Zaire)

LOKI (Zaire)
variants Boloki
note Bantu language; one of the
groups included in the collective
term Ngiri
AAT: nl
LCSH: nl
DDMM, DPB 1987, ETHN, GAH 1950,
GPM 1959, GPM 1975, HAB, HB, HBU,
IAI, JMOB, OBZ, SMI, WH
see also Ngiri

LOKO (Sierra Leone)
note Mande language
AAT: nl
LCSH: Loko language
DDMM, DWMB, ETHN, GPM 1959,
GPM 1975, HB, HBDW, IAI, JG 1963,
JPB, KK 1960, RJ 1958, UIH, WH
MEM 1950*
see also Mande

Lokö *see* YAKÖ

Lokoiya *see* LOKOYA

Lokoro *see* PÄRI

LOKOYA (Sudan)

variants Lokoiya

note Eastern Nilotic language; one of the groups included in the collective term Nilo-Hamitic people
AAT: nl
LCSH: nl
ATMB 1956, CSBS, DDMM, ETHN, HB
GWH*

see also Nilo-Hamitic people

LOLO (Congo Republic)

variants Balolo

note Bantu language
AAT: nl
LCSH: nl
ELZ, GPM 1959, GPM 1975, HB, JMOB,
RJ 1961, WH

LOMA (Liberia)

variants Lorma

subcategories Gbundi

note Mande language; known as Toma in Guinea and as Loma in Liberia
AAT: Loma
LCSH: Loma language
BS, CMK, DDMM, DWMB, ETHN, GPM
1959, GPM 1975, GSGH, HAB, HB,
HBDW, IAI, JG 1963, JLS, JM, KFS, KFS
1989, RJ 1958, RSRW, TP, UIH, WEW
1973, WH, WOH, WRB, WRNN, WS

see also Mande, Toma

Lomami River *see* Toponyms Index

LOMAPO (Côte d'Ivoire)

note Gur language; subcategory of Lorhon
AAT: nl
LCSH: nl
ETHN, JPB

see also Lorhon

Lombi *see* RUMBI

LOMBO (Zaire)

variants Olombo, Turumbu

note Bantu language
AAT: nl
LCSH: nl
BES, DDMM, DPB 1987, ETHN, GAH
1950, GPM 1959, HAB, IAI, JMOB, MGU
1967, OB 1973, OBZ, UIH

LOMOTWA (Zaire, Zambia)

variants Balomotwa

note Bantu language
AAT: nl
LCSH: nl
DDMM, DPB 1987, ETHN, FN 1994,
GAH 1950, HAB, HB, IAI, JC 1971, JC
1978, JV 1966, MHN, OB 1961, OBZ, SD,
UIH, WVB

Lomues *see* LOMWE

LOMWE (Malawi, Mozambique)

variants Alolo, Anguru, Lomues, Nguru

note Bantu language
AAT: Lomwe
LCSH: Lomwe
CDR 1985, DDMM, ETHN, GPM 1959,
GPM 1975, HAB, HB, HBDW, IAI, JD,
KK 1990, MGU 1967, MLJD, RJ 1961, TP,
UIH, WBF 1964, WG 1980, WH, WOH,
WRB, WS
TEW*

LONDO (Cameroun)

variants Balundu, Lundu

note Bantu language
AAT: nl (uses Lundu)
LCSH: nl
DDMM, ETHN, GPM 1959, GPM 1975,
HB, IAI, MGU 1967, RJ 1958, WRB

LONGARIM (Ethiopia, Sudan)

note Eastern Sudanic language
AAT: nl
LCSH: Longarim
ATMB, ATMB 1956, DDMM, ERC, GPM
1959, HB, JG 1963, RJ 1959, WH
ANK 1972*

LONGUDA (Nigeria)

note Adamawa language
AAT: nl
LCSH: Longuda language
DDMM, ETHN, GPM 1959, HB, JG 1963,
JLS, NIB, NOI, RWL, UIH

LORHON (Côte d'Ivoire)

variants Lobi Lorhon

subcategories Lomapo, Tegessie

note Gur language
AAT: nl
LCSH: Lorhon language
DDMM, ETHN, HB, JPB, TFG

LORI (Zaire)
variants Lwer
note Bantu language
AAT: nl
LCSH: nl
DDMM, DPB 1985, DPB 1987, GPM
1959, HB, JV 1966, OBZ, UIH
Lorma *see* LOMA
Lorube *see* GURO
LOSENGO (Zaire)
variants Lusengo, Sengo
note Bantu language; a cluster of
people including the Mbuja,
Mpesa, Ndolo, and Poto; one of
the groups included in the
collective term Ngiri
AAT: nl
LCSH: Losengo language
DDMM, ETHN, MGU 1967
see also Ngiri
Losso *see* NAUDEM
Lotuho *see* LOTUKO
LOTUKO (Sudan, Uganda)
variants Latuka, Latuko, Lotuho,
Lotuxo, Lutoko
note Eastern Nilotic language; one
of the groups included in the
collective term Nilo-Hamitic
people
AAT: nl
LCSH: Lutuko
ATMB, ATMB 1956, CSBS, DDMM,
ETHN, GPM 1959, GPM 1975, HAB, HB,
IAI, JG 1963, RJ 1959, RSW, SD, UIH,
WH, WRB 1959, WS
ADG*, GWH*
see also Nilo-Hamitic people
Lotuxo *see* LOTUKO
Loumbou *see* LUMBO
Lovale *see* LUVALE
LOVEDU (South Africa)
variants Balovedu, Lobedu
note Bantu language; subcategory of
Sotho
AAT: Lovedu
LCSH: use Lobedu
DDMM, ETHN, GPM 1959, GPM 1975,
HB, IAI, JLS, JRE, JTSV, MCA 1986,

MGU 1967, NIB, TP, UIH, WDH, WH,
WRB, WRB 1959
EJK*
see also Sotho
LOWIILI (Burkina Faso, Côte
d'Ivoire, Ghana)
variants Oulé, Wiili, Wile
note Gur language; subcategory of
Lodagaa; one of the groups
included in the collective term
Dagara
AAT: nl
LCSH: LoWiili
BS, DDMM, ETHN, GPM 1959, GPM
1975, HB, IAI, RAB, RJ 1958, SMI, UIH,
WH
JAG 1962*, JAG 1967*
see also Dagara, Lodagaa
LOZI (Zambia, Zimbabwe)
variants Balozi
subcategories Kololo
note Bantu language. The Rotse
kingdom, or Barotseland, includes
the Lozi and other peoples as
well.
AAT: Lozi
LCSH: Lozi
BS, DDMM, DFHC, EBHK, ETHN, FW,
GPM 1959, GPM 1975, HB, HBDW, HRZ,
IAI, JD, JJM 1972, JLS, JM, JV 1966, NIB,
PG 1990, PMPO, RJ 1961, ROMC, RS
1980, SMI, SV 1988, TP, UIH, WG 1980,
WG 1984, WH, WMR, WRB, WRB 1959,
WRNN, WVB
ECMG*, MUM*
see also Rotse
Lualaba River *see* Toponyms Index
LUANDA (Angola)
variants Loanda
note Bantu language; subcategory of
Mbundu
AAT: nl
LCSH: use Loanda
EBHK, GPM 1959, GPM 1975, HB, JLS,
JV 1984, RS 1980, SG
see also Mbundu

LUANO (Zambia)

note Bantu language

AAT: nl

LCSH: nl

DDMM, ETHN, GPM 1959, HB, WVB
WWJS*

Luapula River *see* Toponyms Index

LUBA (Zaire, Zambia)

variants BaLuba, Kaluba, Warua

subcategories Luba-Bambo, Luba-
Bamema, Luba-Hemba, Luba-
Kasai, Luba-Lolo, Luba-
Lubengule, Luba-Shankadi

note Bantu language. The Luba
Kingdom originated in Shaba
(Katanga) Province, southeastern
Zaire at the end of the 17th
century. Neyt's (FN 1994) main
divisions are Eastern Luba,
Central Luba, and Western Luba.
The term has been used to include
related languages and styles, such
as Songye, Luluwa and others.
see EBHK for further information
on Luba kingdoms, Kabongo, etc.

AAT: Luba; also Luba Empire, Luba-Lunda
Kingdoms, Luba-Northern

LCSH: Luba

ACN, AF, ALM, ASH, AW, BES, BS, CDR
1985, CFL, CK, CMK, DDMM, DFHC,
DOA, DOWF, DP, DPB 1981, DPB 1985,
DPB 1986, DPB 1987, EB, EBHK, EBR,
EEWF, ELZ, ESCK, FHCP, FW, GB,
GBJM, GBJS, GPM 1959, GPM 1975,
GWS, HAB, HB, HH, HJK, HMC, HRZ,
IAI, JAF, JC 1971, JC 1978, JD, JJM 1972,
JK, JL, JLS, JM, JMOB, JTSV, JV 1984,
KFS, KFS 1989, KK 1960, KK 1965, KMT
1970, LM, MCA, MHN, MK, MLB, MLJD,
MUD 1991, NIB, OB 1961, OB 1973, PG
1990, PMPO, RFT 1974, RGL, ROMC, RS
1980, RSAR, RSRW, RSW, SD, SG, SMI,
SV, SV 1988, TB, TERV, TLPM, TP, UIH,
WBF 1964, WG 1980, WG 1984, WH,
WMR, WOH, WRB, WRB 1959, WRNN,
WS, WVB

EV*, FN 1994*, JV 1966*, MRAR*, WFB*

LUBA-BAMBO (Zaire)

variants Bambo

note Bantu language; subcategory of
Luba

AAT: nl

LCSH: nl

GAH 1950, JC 1971, JMOB, OB 1961

see also Luba

LUBA-BAMEMA (Zaire)

variants Luba-Bamena

note Bantu language; subcategory of
Luba

AAT: nl

LCSH: nl

FN 1994

see also Luba

Luba-Bamena *see* LUBA-BAMEMA

LUBA-HEMBA (Zaire)

variants Bahemba, Baluba

subcategories Niembo

note Bantu language; has been
referred to as Baluba and
Bahemba in the literature. The
name is still valid if not confused
with Hemba who are also referred
to as Bahemba.

AAT: nl

LCSH: use Hemba

DDMM, DPB 1981, DPB 1987, ELZ,
ETHN, GAH 1950, GPM 1959, GPM
1975, HAB, HJK, IAI, JK, JMOB, JV 1966,
JV 1984, LM, MHN, MK, SG, SMI, UIH,
WH, WS

EV*, FN 1994*

see also Luba

LUBA-KASAI (Zaire)

variants Bakasai, Bakasayi, Kasayi

note Bantu language; subcategory of
Luba; The term Bakasai may
include the Luba-Kasa, the
Luluwa and others in the Kasai
region.

AAT: nl

LCSH: Luba-Kasai language

BS, DDMM, DFHC, DPB 1987, ETHN,
HB, HJK, JV 1966, MGU 1967, OB 1961,
OB 1973

FN 1994*

see also Luba

LUBA-LOLO (Zaire)
note Bantu language; subcategory of
Luba
AAT: nl
LCSH: nl
FN 1994
see also Luba

LUBA-LUBENGULE (Zaire)
note Bantu language; subcategory of
Luba
AAT: nl
LCSH: nl
FN 1994*
see also Luba

Luba-Samba *see* LUBA-
SHANKADI

LUBA-SHANKADI (Zaire)
variants Luba-Samba, Shankadi
note Bantu language; subcategory of
Luba. Luba Samba is sometimes
used synonymously with Luba
Shankadi.
AAT: nl (uses Shankadi)
LCSH: use Luba
CDR 1985, DPB 1987, ELZ, ETHN, GAH
1950, HB, HJK, JAF, JC 1971, JK, JM,
JTSV, MLB, OB 1961, SG, SMI, WG
1980, WG 1984, WS
FN 1994*, JC 1978*
see also Luba

Lucazi *see* LUCHAZI

LUCHAZI (Angola, Zambia, Zaire)
variants Lucazi, Lujazi, Lutchase,
Lutshaxe, Lutshazi, Ponda
note Bantu language; one of the
groups included in the collective
term Ngangela
AAT: Luchazi
LCSH: Luchazi
BS, DDMM, DFHC, DPB 1987, EBHK,
ETHN, GPM 1959, GPM 1975, HAB, IAI,
JLS, JM , JV 1966, MGU 1967, MLB 1994,
RJ 1961, ROMC, UIH, WH, WVB
CWMN*, GRK*
see also Ngangela

Luena *see* LWENA

LUGBARA (Uganda, Zaire)
variants Logbara, Lugware,
Lugwaret
note Central Sudanic language
AAT: nl
LCSH: Lugbara
ATMB, ATMB 1956, BES, BS, DDMM,
DPB 1987, ECB, ETHN, GAH 1950, GPM
1959, GPM 1975, HAB, HB, IAI, JG 1963,
JM, JMOB, MCA 1986, MHN, MTKW,
OBZ, PMPO, RGL, RJ 1960, ROMC,
RSW, SMI, UIH, WH
JOM 1960*

Lugulu *see* LUGURU

LUGURU (Tanzania)
variants Lugulu
note Bantu language
AAT: Luguru
LCSH: Luguru
BS, CDR 1985, DDMM, ECB, ETHN,
GPM 1959, GPM 1975, HAB, HB, IAI,
JLS, MFMK, RGL, RJ 1960, SD, UIH,
WH, WOH
TOB 1967*

Lugware *see* LUGBARA

Lugwaret *see* LUGBARA

Luhya *see* LUYIA

Luimbe *see* LWIMBI

Luimbi *see* LWIMBI

Lujazi *see* LUCHAZI

Lukenye River *see* Toponyms Index

Lukolwe *see* MBWELA (Zambia)

LULA (Zaire)
note Bantu language; sometimes
considered as Kongo-related.
AAT: nl
LCSH: nl
CDR 1985, DPB 1985, DPB 1987, GPM
1959, JC 1978, OB 1973, OBZ, WS
see also Kongo

Lulua *see* LULUWA

LULUBA (Sudan, Uganda)
note Central Sudanic language; one
of the groups included in the
collective term Nilo-Hamitic
people
AAT: nl
LCSH: nl
ATMB 1956, DDMM, ETHN, GPM 1959,
GPM 1975, HB, UIH
GWH*
see also Nilo-Hamitic people

LULUWA (Zaire)
variants Bashilange, Bena Lulua,
Bena Luluwa, Bena Moyo, Lulua,
Shilange
subcategories Bakwa Katawa
note Bantu language
AAT: nl (uses Lulua)
LCSH: use Lulua
ALM, ASH, AW, CDR 1985, CFL, CK,
CMK, DDMM, DFHC, DOWF, DP, DPB
1981, DPB 1985, DPB 1987, EB, EBHK,
EEWF, ELZ, FHCP, FN 1994, FW, GAH
1950, GB, GBJM, GBJS, GPM 1959, GPM
1975, HAB, HH, HJK, IAI, JAF, JC 1971,
JC 1978, JD, JK, JL, JLS, JM, JMOB,
JTSV, JV 1966, KK 1965, KMT 1970, LM,
MGU 1967, MHN, MK, MLB, MLF,
MLJD, OB 1961, OB 1973, OBZ, PMPO,
RFT 1974, RGL, RS 1980, RSRW, RSW,
SMI, SV 1988, SVFN, TERV, TLPM, TP,
UIH, WBF 1964, WG 1980, WG 1984,
WH, WMR, WRB, WRB 1959, WRNN,
WS

LUMBO (Congo Republic, Gabon)
variants Balumbo, Loumbou,
Lumbu
note Bantu language
AAT: nl (uses Lumbu)
LCSH: nl (uses Lumbu)
AW, CDR 1985, CMK, DDMM, DP,
EEWF, ELZ, ETHN, FW, GBJS, GPM
1959, HAB, HB, HMC, JD, JK, JL, KFS
1989, LP 1979, LP 1985, MGU 1967,
MLB, MUD 1991, RSRW, RSW, SG, SV,
SV 1988, TB, UIH, WBF 1964, WH,
WMR, WRB, WRNN, WS

Lumbu *see* LUMBO

LUMBU (Zaire)
variants Balumbu
note Bantu language

AAT: nl
LCSH: nl
DDMM, DPB 1986, GPM 1959, OB 1961,
UIH, WOH

Lumbwa *see* KIPSIKIS

LUNDA (Angola, Zaire, Zambia)
variants Alunda, Aluund, Balunda,
Luunda, Ruund
note Bantu language; one of the
groups included in the Lunda-
Lovale peoples. From the 16th
century on, they formed a
powerful empire under the
paramount Mwaantayaav
(Mwatayamvo). The
Benakazembe are a separate
Lunda group.
AAT: Lunda
LCSH: use Northern Lunda, Southern
Lunda
ALM, AW, BES, BS, CDR 1985, CK,
DDMM, DFHC, DP, DPB 1981, DPB
1985, DPB 1987, EB, EBHK, EBR, ELZ,
ESCK, ETHN, FN 1994, GAH 1950, GB,
GBJM, GPM 1959, GPM 1975, HAB, HB,
HH, HJK, HRZ, IAI, JAF, JC 1971, JC
1978, JD, JJM 1972, JK, JL, JLS, JM,
JMOB, JV 1966, JV 1984, KFS, KK 1965,
KMT 1970, LJPG, LM, MCA, MGU 1967,
MLB, MLJD, OB 1961, OB 1973, OBZ,
PG 1990, PMPO, PR, RFT 1974, RGL, RJ
1961, ROMC, RS 1980, RSW, SD, SG,
SMI, SV, TB, TERV, UIH, WG 1980, WG
1984, WH, WOH, WRB, WRNN, WS,
WVB
ACPG*, CWMN*, HB 1935*, IGC 1959*,
MEM 1951*, MRF*, VWTU*, WWJS*
see also Benakazembe, Lunda-
Lovale

Lunda Kazembe *see* BENA
KAZEMBE

LUNDA-LOVALE (Angola, Zaire, Zambia)

variants Lunda-Luwale

note collective term for a number of peoples in northwestern Zambia including the Lunda, Luvale, Lwena, Chokwe and Ovimbundu

AAT: nl

LCSH: nl

JL, RJ 1961

CWMN*

Lunda-Luwale *see* LUNDA-LOVALE

Lundu *see* LONDO

LUNDWE (Zambia)

note Bantu language

AAT: nl

LCSH: nl

DDMM, ETHN, GPM 1959, GPM 1975, HB, UIH, WVB

LUNGU (Tanzania, Zambia)

variants Bamarung, Bena Malungu, Malungu, Marungu

note Bantu language

AAT: Lungu

LCSH: nl

AF, CDR 1985, DDMM, ETHN, FN 1994, GPM 1959, GPM 1975, HB, JMOB, JV 1966, KFS, KK 1965, KK 1990, MFMK, NIB, NOI, SV, TP, UIH, WG 1980, WH, WVB

LUNTU (Zaire)

note Bantu language

AAT: Luntu

LCSH: nl

DPB 1987, ETHN, FN 1994, HB, IAI, MLB, OB 1961, OB 1973, OBZ, WG 1980

Luo *see* DHO LUO

Luo *see* LWOO

LURUM (Burkina Faso)

note used for both a region and people

AAT: nl

LCSH: nl

ASH, JLS

Lusengo *see* LOSENGO

LUSO-AFRICANS (Gambia, Senegal)

AAT: nl

LCSH: nl

BS, MPF 1992, SMI

Lutchase *see* LUCHAZI

Lutoko *see* LOTUKO

Lutshaxe *see* LUCHAZI

Lutshazi *see* LUCHAZI

Luunda *see* LUNDA

LUVALE (Angola, Zaire, Zambia)

variants Balovale, Lovale

note Bantu language; one of the groups included in the Lunda-Lovale peoples.

AAT: use Lwena

LCSH: Luvale

DDMM, DFHC, DPB 1987, EBR, ETHN, GPM 1959, GPM 1975, HB, IAI, JM, KFS, LJPG, MGU 1967, RJ 1961, ROMC, SMI, UIH, WG 1980, WH, WMR, WRB, WVB

CWMN*, JC 1978*

see also Lunda-Lovale, Lwena

LUWA (Zaire)

note Bantu language; of Lunda origin

AAT: nl

LCSH: nl

DPB 1985, DPB 1987, GPM 1959, GPM 1975, HB, JV 1966, OB 1973, OBZ, UIH, WH, WS

LUYANA (Angola, Zambia)

variants Luyi

note Bantu language; a collective term which includes the Lozi and other small incorporated groups

AAT: nl

LCSH: Luyana language

DDMM, ETHN, GPM 1959, GPM 1975, HB, MGU 1967, RJ 1961, TEW, UIH, WVB

MUM*

Luyi *see* LUYANA

LUYIA (Kenya, Uganda)
variants Abaluyia, Abanyala, Baluyia, Bantu Kavirondo, Luhya
note Bantu language; a collective term which includes the Bukusu, Gwe, Isukha, Logooli, Samia, Tadjoni, Tiriki, and Wanga; sometimes referred to as Bantu Kavirondo
AAT: nl
LCSH: Luyia
BS, DDMM, EBR, ECB, ETHN, EWA, GPM 1959, GPM 1975, HB, HRZ, IAI, JLS, MGU 1967, RGL, RJ 1960, SMI, UIH, WH
CDF 1954*, GW*, JNBO*

LWALU (Zaire)
variants Balualua, Balwalwa, Lwalwa
note Bantu language. The transciption Lwalu seems currently preferred to the more conventional Lwalwa.
AAT: nl (uses Lwalwa)
LCSH: nl (uses Lwalwa)
CDR 1985, DDMM, DFM, DPB 1987, ETHN, FHCP, GBJS, HB, HRZ, IAI, JAF, JC 1971, JD, JK, JV 1966, LM, MGU 1967, MLB, MLF, MLJD, OB 1961, OB 1973, OBZ, RSAR, SG, SV, TERV, WBF 1964, WG 1980, WRB, WRNN
JC 1978*

Lwalwa *see* LWALU

LWENA (Angola, Zaire, Zambia)
variants Aluena, Kaluena, Luena
note Bantu language; also often referred to as Luvale; one of the groups included in the Lunda-Lovale peoples
AAT: Lwena
LCSH: use Luena(s)
BS, DDMM, DFHC, DPB 1985, DPB 1987, EB, EBHK, ELZ, FHCP, GBJS, GPM 1959, GPM 1975, HAB, HB, HBDW, IAI, JC 1971, JC 1978, JD, JK, JLS, JV 1966, KFS, KK 1965, MGU 1967, MK, MLB, MLB 1994, MLJD, OB 1961, OB 1973, OBZ, RGL, RJ 1961, RSW, TERV, UIH, WG 1980, WG 1984, WH, WMR, WOH, WRB, WRNN, WS, WVB

CWMN*
see also Lunda-Lovale, Luvale

Lwer *see* LORI

LWIMBI (Angola, Zaire, Zambia)
variants Kaluimbi, Luimbi, Luimbe
note Bantu language; sometimes included in the collective term Ngangela
AAT: nl
LCSH: nl
CK, DDMM, DPB 1987, ETHN, GPM 1959, GPM 1975, HAB, HB, IAI, JLS, JM, KK 1965, MGU 1967, MLB 1994, UIH, WH
see also Ngangela

Lwo *see* LWOO

LWOO (Ethiopia, Kenya, Sudan, Tanzania, Uganda)
variants Geia, Jaluo, Luo, Lwo, Nilotic Kavirondo, Wageia
note West Nilotic language; sometimes referred to as Kavirondo or Nilotic Kavirondo; one of the groups included in the collective term Nilotic people. The Lwoo peoples collectively are divided into the Northern Lwoo including the Anuak, Bor, Burun, Jur, Maban; and the Southern Lwoo including the Acoli, Alur, Dho Luo, Gaya, Jo Padhola, Jo Paluo, Kumam, Labwor, and Lango. The transciption Lwoo seems currently preferred to the more conventional Luo.
AAT: nl
LCSH: nl (uses Luo)
ATMB 1956, BS, CSBS, DDMM, EBR, ECB, ETHN, EWA, GPM 1959, GPM 1975, HAB, HB, HRZ, IAI, JG 1963, JJM 1972, JLS, JM, KMT 1971, MCA 1986, MTKW, NIB, PG 1990, PMPO, RJ 1959, RJ 1960, ROMC, SD, SMI, UIH, WEW 1973, WH, WOH
AJB*, ATMB*
see also Nilotic people

Lyela *see* LYELE

LYELE (Burkina Faso, Côte
d'Ivoire)
variants Lela, Lele, Lilse, Lyela
note Gur language; one of the
groups included in the collective
term Grunshi
AAT: nl
LCSH: nl
CDR 1987, DDMM, DWMB, ETHN, GPM
1959, GPM 1975, HB, IAI, JG 1963, JLS,
RJ 1958, WS
see also Grunshi

MA (Zaire)
variants Amadi, Madi, Madyo
note Southeastern Ubangian
language; not to be confused with
the Madi of Sudan, Zaire and
Uganda, who speak a Central
Sudanic language
AAT: nl
LCSH: Ma language
ATMB, ATMB 1956, CSBS, DB 1978,
DDMM, ETHN, FW, GAH 1950, GPM
1959, GPM 1975, HB, HBDW, JG 1963,
JMOB, JPB, OBZ, UIH, WS

MAASAI (Kenya, Tanzania)
variants Masai, Massai
subcategories Arusha, Kinangop,
Kwafi, Laikipiak
note Eastern Nilotic language;
grouped as Northern Maasai,
Central or Rift Valley Maasai, and
Southern Maasai; one of the
groups included in the collective
term Nilo-Hamitic people. see
GWH 1969* for numerous
additional subcategories.
AAT: Maasai
LCSH: use Masai
AF, ARW, ATMB, ATMB 1956, BES, BS,
CDR 1985, CSBS, DDMM, DOA, EBR,
ECB, ELZ, ESCK, ETHN, FW, GB, GPM
1959, GPM 1975, HAB, HB, HMC, HRZ,
IAI, JG 1963, JJM 1972, JK, JLS, JM,

JPJM, JV 1966, JV 1984, KFS, KMT 1971,
LJPG, LSD, MCA 1986, MFMK, MLB,
MLJD, MPF 1992, PG 1990, PMPO, PR,
RJ 1960, ROMC, RS 1980, RSW, SD, SMI,
TP, UIH, WEW 1973, WG 1980, WG
1984, WH, WOH, WRB, WRB 1959,
WRNN, WS
GIT*, GWH 1969*, PHG*, TOS*
see also Nilo-Hamitic people

MABA (Chad)
note Nilo-Saharan language
AAT: nl
LCSH: Maba language
AML, ATMB, ATMB 1956, DDMM,
ETHN, GB, GPM 1959, GPM 1975, HAB,
HB, HBDW, IAI, JG 1963, JLS, MPF 1992,
NOI, UIH, WH

Mabali *see* BALI (Zaire)

MABAN (Ethiopia, Sudan)
variants Meban
note West Nilotic language; one of
the groups included in the
collective term Nilotic people;
sometimes referred to as Northern
Lwoo
AAT: nl
LCSH: Maban
ATMB 1956, CSBS, DDMM, ETHN, GPM
1959, GPM 1975, HAB, HB, HBDW, IAI,
ICWJ, JG 1963, JM, RJ 1959, ROMC,
UIH, WH
see also Lwoo, Nilotic people

MABEA (Cameroun)
variants Bisio
note Bantu language; Fang
style/culture division. see LP 1979.
AAT: nl
LCSH: use Bisio
DDMM, ETHN, GAC, GPM 1959, GPM
1975, HAB, HB, HBDW, IEZ, JAF, JK, KK
1965, LM, SG, WH, WS
LP 1979*, LP 1985*, LP 1990*
see also Fang

MABENDI (Zaire)
note Central Sudanic language
AAT: nl
LCSH: nl
ATMB 1956, DDMM, DPB 1987, ETHN,
GPM 1959, HB, IAI, OBZ

Mabiha *see* MAWIA

Mabinza *see* BINZA

MABISANGA (Zaire)
 note Central Sudanic language; one
 of the groups included in the
 collective term Mangbetu
 AAT: nl
 LCSH: nl
 ESCK, ETHN, GPM 1959, HB, JMOB
 JEL*
 see also Mangbetu

MABITI (Zaire)
 note Bantu language
 AAT: nl
 LCSH: nl
 ESCK, ETHN

Mabo *see* MABO-BARKUL
 (Nigeria)

Mabo *see* NGBAKA MABO (Central
 African Republic)

Ma'bo *see* NGBAKA MABO

MABO-BARKUL (Nigeria)
 variants Mabo, Maboh
 note Benue-Congo language
 AAT: nl
 LCSH: Mabo-Barkul
 DDMM, ETHN, RWL

Mabodu *see* BUDU

Maboh *see* MABO-BARKUL

Mabudu *see* BUDU

MACHA (Ethiopia)
 variants Matcha, Mecha
 note Cushitic language; subcategory
 of Oromo
 AAT: nl
 LCSH: nl
 ATMB 1956, DDMM, ETHN, GPM 1959
 MOH*
 see also Oromo

Machango *see* SANGU

MADA (Nigeria)
 note Benue-Congo language
 AAT: nl
 LCSH: use Mabo-Barkul
 DDMM, ETHN, GPM 1959, GPM 1975,
 HB, JG 1963, RJ 1958, RWL, WS

Madi *see* MA (Zaire)

MADI (Sudan, Uganda, Zaire)
 subcategories Kaliko, Okollo
 note Central Sudanic language.
 Sources distinguish between
 Western Madi (Kaliko) in Zaire
 and Sudan, and Southern Madi
 (Okollo)in Uganda. not to be
 confused with the Ma (Madi) of
 Zaire, who speak a Ubangian
 language; often referred to with
 the Moru as Moru-Madi
 AAT: nl
 LCSH: Ma'di use Lugbara
 ATMB, ATMB 1956, BES, BS, CSBS,
 DDMM, DPB 1987, ECB, ELZ, ESCK,
 ETHN, EWA, GAH 1950, GPM 1959,
 GPM 1975, HAB, HB, HBDW, IAI, JG
 1963, JMOB, MTKW, RJ 1959, UIH, WH
 see also Moru

MADJUU (Zaire)
 note Eastern Sudanic language; one
 of the groups included in the
 collective term Mangbetu
 AAT: nl
 LCSH: nl
 JEL*
 see also Mangbetu

Madyo *see* MA

Maele *see* MALELE

Mafa *see* MATAKAM

MAFIA (Tanzania)
 note Bantu language
 AAT: nl
 LCSH: nl
 DDMM, MFMK
 see also Toponyms Index

MAGBA (Cameroun)
 note Tikar chiefdom
 AAT: nl
 LCSH: nl
 LP 1993, PH
 see also Tikar

Maghrib *see* Toponyms Index

MAGU (Nigeria)
note Benue-Congo language; one of
the groups included in the
collective term Tigong
AAT: nl
LCSH: nl
DDMM, ETHN, GPM 1959, GPM 1975,
RWL
see also Tigong

MAGWE (Côte d'Ivoire)
note scission of the Gadi
AAT: nl
LCSH: use Gadi
JPB
see also Gadi

MAHAFALY (Madagascar)
note Malagasi language
(Austronesian)
AAT: Mahafaly
LCSH: Mahafaly
AW, BS, DDMM, ELZ, GPM 1959, GPM
1975, HAB, HB, IAI, JK, JLS, JPJM, KFS,
KK 1990, MPF 1992, SMI, SV, TP, WH,
WOH, WRNN
CKJR*, JMA*, LSG*

MAHAS (Egypt, Sudan)
note Eastern Sudanic language;
undisplaced survivors of Pre-
Islamic Nubians
AAT: nl
LCSH: nl
ATMB 1956, DDMM, ETHN, GPM 1959,
JG 1963, MPF 1992, RJ 1959

MAHIN (Nigeria)
variants Ilaje
note Kwa language; subcategory of
Yoruba
AAT: nl
LCSH: nl
DDMM, FW, RWL
HJD*
see also Yoruba

Mahongoue *see* MAHONGWE
MAHONGWE (Congo Republic,
Gabon)
variants Hongwe, Hungwe,
Mahongoue, Mahoungoue
note Bantu language; subcategory of
Kota

AAT: nl (uses Hongwe)
LCSH: use Kota
BS, CDR 1985, CFL, DDMM, ETHN,
GBJS, GPM 1959, GPM 1975, HB, IAI,
JAF, JK, JTSV, KFS 1989, LM, LP 1979,
LP 1985, MGU 1967, MLB, MUD 1986,
PH, RSRW, SV, SVFN, TP, WG 1980,
WRB, WRNN, WS
see also Kota

Mahoungoue *see* MAHONGWE
MAHRIA (Sudan)
note Semitic language; part of a
tribal federation in northern
Darfur called Rizeygat
AAT: nl
LCSH: nl
GPM 1959, GPM 1975, LPR 1995
see also Rizeygat

Mai Ndomde, Lake *see* Toponyms
Index

Majang *see* MAJANGIR
MAJANGIR (Ethiopia)
variants Majang, Masongo, Tama
note Eastern Sudanic language
AAT: nl
LCSH: Majangir
ATMB 1956, DDMM, ETHN, GPM 1959,
HB, IAI, JG 1963, RJ 1959, SMI, WH
ERC*, JS*

MAJI (Ethiopia)
variants Dizi
note Cushitic language; subcategory
of Sidamo
AAT: nl
LCSH: use Dizi
ATMB 1956, DDMM, ETHN, GPM 1959,
GPM 1975, HB, IAI, JG 1963, RJ 1959,
UIH, WH
ERC*
see also Sidamo

Majombe *see* YOMBE
Majugu *see* MAYOGO
MAKA (Nigeria)
note Chadic language
AAT: nl
LCSH: nl
ETHN, HB, RWL

Maka *see* MAKAA

MAKAA (Cameroun)

variants Maka

note Bantu language
AAT: nl
LCSH: nl (uses Maka)
BS, DDMM, ETHN, GPM 1959, GPM
1975, HAB, HB, HBDW, IEZ, KK 1965,
LP 1985, LP 1990, MGU 1967, MK, RJ
1958, UIH, WH, WS
PEG*

Makalanga *see* KALANGA

Makango *see* KANGO

Makaraka *see* DIO

Makaranga *see* KARANGA

MAKE (Cameroun, Equatorial
Guinea, Gabon)

variants Bocheba, Mekina,
Oscheba, Oseyba, Oshiba,
Ossyeba, Osyeba

note Bantu language; subcategory of
Fang; sometimes included with
the Southern Fang. The better
known name for this group is
Osyeba.
AAT: nl
LCSH: nl
DDMM, DP, EBHK, ETHN, HB, HH, KK
1960, LP 1979, SMI
LP 1985*, LP 1990*, PAJB*

see also Fang

MAKERE (Zaire)

note Central Sudanic language; one
of the groups included in the
collective term Mangbetu
AAT: nl
LCSH: nl
ATMB, ATMB 1956, CFL, DDMM, DPB
1987, ESCK, ETHN, GAH 1950, GPM
1959, GPM 1975, HAB, HB, HBDW, JG
1963, JMOB, OBZ, RSW, UIH, WH
JEL*

see also Mangbetu

Makoa *see* MAKUA

Makoane *see* MAKUA

Makoko *see* TIO

MAKONDE (Mozambique,
Tanzania)

variants Wamakonde

note Bantu language
AAT: Makonde
LCSH: Makonde
ACN, BS, CDR 1985, CK, DDMM, DFM,
DOA, EBR, ECB, EEWF, ELZ, ETHN,
EWA, FW, GB, GBJS, GPM 1959, GPM
1975, HAB, HB, HBDW, HH, HMC, IAI,
JD, JK, JLS, JM, JTSV, KFS 1989, KK
1990, LJPG, LM, MFMK, MGU 1967, MK,
MLB, MLJD, MWM, RFT 1974, RGL, RJ
1960, ROMC, RSRW, RSW, SMI, SV
1988, TLPM, TP, UIH, WBF 1964, WG
1980, WG 1984, WH, WMR, WOH, WRB,
WRB 1959, WRNN, WS
CH*, HKG*, LH*, ROF*, TEW*

MAKUA (Malawi, Mozambique,
Tanzania)

variants Makoa, Makoane, Makwa,
Wamakua

note Bantu language
AAT: Makua
LCSH: Makua
BS, CK, DDMM, EBR, ECB, ELZ, ETHN,
GB, GPM 1959, GPM 1975, HAB, HB,
IAI, JLS, JM, KK 1990, MFMK, MGU
1967, RJ 1961, ROMC, RSW, SMI, UIH,
WH, WOH, WRB, WS
HC*, TEW*

Makua, Western *see* NGULU

MAKUTU (Zaire)

note Bantu language; one of the
groups included in the collective
term Ngiri
AAT: nl
LCSH: nl
DDMM, DPB 1987, ETHN, HBU, SMI

see also Ngiri

Makwa *see* MAKUA

Makwengo *see* HUKWE

Malaba *see* GISU

Malawi *see* MARAVI

Malawi, Lake *see* Toponyms Index

Malela *see* MALELE

MALELE (Uganda, Zaire)
variants Maele, Malela
note Central Sudanic language; one
of the groups included in the
collective term Mangbetu
AAT: nl
LCSH: nl
ATMB 1956, DDMM, DPB 1987, ESCK,
ETHN, GAH 1950, GPM 1959, GPM
1975, HB, HJK, JMOB, OBZ, UIH, WH
JEL*
see also Mangbetu

MALI empire (Mali)
note ancient kingdom; founded by
Son-jara (Sundiata Keita);
developped in the 13th century
and declined in the 15th century;
partly absorbed by the Songhay
empire
AAT: Mali Kingdom
LCSH: Mali Empire
AF, ARW, DFHC, DWMB, EB, EBR, EL,
ENS, FW, GAC, GBJS, GPM 1959, GPM
1975, HAB, HBDW, HRZ, JJM 1972, JLS,
JV 1984, KFS, KMT 1970, LM, LPR 1986,
LSD, MCA, PG 1990, PMPO, PR, RAB,
ROMC, SG, SMI, TFG, TP, WG 1980, WG
1984, WS
GE*, JJ*, NL*
see also Songhai

MALILA (Tanzania)
note Bantu language
AAT: nl
LCSH: nl
DDMM, ETHN, GPM 1975, HB, MFMK

MALINKE (Côte d'Ivoire, Guinea,
Mali, Senegal)
variants Wangara, Wasulunka
note Mande language
AAT: Malinke
LCSH: use Mandingo
ACN, BES, BS, CK, DDMM, DFHC,
DOWF, DP, DWMB, EEWF, EFLH, ELZ,
ETHN, EWA, GB, GPM 1959, GPM 1975,
GSGH, GWS, HAB, HB, HBDW, IAI, JAF,
JEEL, JG 1963, JK, JLS, JM, JPB, KFS,
LM, MH, MLB, MPF 1992, PMPO, PSG,
RAB, RJ 1958, ROMC, RSW, SG, SMI,
SV, TFG, TLPM, UIH, WG 1980, WG
1984, WH, WOH, WRB, WS
NK*

see also Mande

MALUK (Congo Republic, Zaire)
note Bantu language; subcategory of
Kuba
AAT: nl
LCSH: nl
HB, JV 1978, OB 1973
see also Kuba

Malungu *see* LUNGU

MAMA (Nigeria)
variants Kantana
note Bantoid language
AAT: Mama
LCSH: nl
CMK, DDMM, ELZ, ETHN, FW, GPM
1959, GPM 1975, HB, HBDW, HMC, JD,
JK, MKW 1978, MLB, NOI, PH, RWL, TP,
WBF 1964, WG 1980, WH, WRB, WRNN,
WS
EE*

MAMBA (Tanzania, Zaire)
note Bantu language; subcategory of
Bangubangu; one of the groups
included in the collective term
Holoholo
AAT: nl
LCSH: nl
AEM, DDMM
AC*
see also Bangubangu, Holoholo

Mambai *see* MANGBEI

MAMBILA (Cameroun, Nigeria)
variants Mambilla
note Bantoid language
AAT: Mambila
LCSH: Mambila
BEL, CMK, DDMM, DWMB, ELZ, ETHN,
GDR, GPM 1959, GPM 1975, HB, HBDW,
HMC, IAI, IEZ, JAF, JD, JG 1963, JK, JLS,
JTSV, KFS 1989, KK 1965, LM, LP 1993,
MKW 1978, MLB, NOI, PH, RFT 1974, RJ
1958, RS 1980, RWL, SD, SMI, TN 1984,
TN 1986, TP, UIH, WG 1980, WG 1984,
WH, WRB, WRNN, WS
DVZ*, EE*, NBS*

Mambilla *see* MAMBILA
Mambunda *see* MBUNDA

MAMBWE (Tanzania, Zambia)

note Bantu language
AAT: nl
LCSH: Mambwe
BS, DDMM, DPB 1987, ECB, ETHN, FN
1994, GPM 1975, HAB, HB, HBDW, IAI,
JAF, JC 1978, JV 1966, KK 1990, MGU
1967, MK, NIB, RJ 1961, SV, TP, UIH,
WVB
RGW*, WW*, WWJS*

MAMPOKO (Zaire)

note Bantu language; one of the
groups included in the collective
term Ngiri
AAT: nl
LCSH: nl
DDMM, DPB 1987, ETHN, GAH 1950,
GPM 1975, HB, HBU
see also Ngiri

MAMPRUSI (Burkina Faso, Ghana,
Togo)

variants Mamprussi

note Gur language; one of the
groups included in the collective
term Wala
AAT: nl
LCSH: Mamprusi
BS, DDMM, DWMB, GPM 1959, GPM
1975, HB, HCDR, HRZ, JG 1963, JLS,
KFS, LPR 1986, RGL, ROMC, RSW, SMI,
UIH, WH, WOH, WRB 1959, WS
SDB*
see also Wala

Mamprussi *see* MAMPRUSI

MAMVU (Zaire)

variants Momfu, Momvo, Momvu

note Central Sudanic language
AAT: nl
LCSH: Mamvu
ATMB, ATMB 1956, BES, DDMM,
DFHC, DPB 1986, ESCK, ETHN, GAH
1950, GPM 1959, GPM 1975, HAB, HB,
JG 1963, JMOB, OBZ, RS 1980, SMI,
UIH, WH, WS

Man *see* MANO

Manbele *see* MANDE

Mancagne *see* MANKANYA

MANDA (Tanzania)

note Bantu language
AAT: nl
LCSH: nl
DDMM, ETHN, KK 1990, MFMK

MANDAGE (Cameroun, Chad)

note Chadic language; subcategory
of Kotoko; sometimes referred to
as Northern Kotoko
AAT: nl
LCSH: nl
AML, DB, DDMM, ETHN, HB
see also Kotoko

Mandang *see* MANDING

MANDARA (Cameroun, Nigeria)

variants Wandala

note Chadic language; one of the
groups included in the collective
term Kirdi
AAT: Mandara
LCSH: Mandara language
BEL, BS, DDMM, DWMB, ENS, ETHN,
GPM 1959, GPM 1975, HB, HBDW, IAI,
IEZ, JG 1963, JLS, KFS, LJPG, NOI, RJ
1958, RSW, RWL, SMI, UIH, WH
see also Kirdi

MANDARI (Kenya, Sudan)

variants Mondari, Mundari, Shir

note two divisions of Mandari:
Eastern Nilotic language in
Sudan, and Southern Nilotic
language in Kenya; one of the
groups included in the collective
term Nilo-Hamitic people
AAT: nl
LCSH: Mandari
ATMB 1956, CSBS, DDMM, ELZ, ETHN,
GAH 1950, GPM 1959, GPM 1975, HAB,
HB, HBDW, IAI, JG 1963, RJ 1959, SMI,
WH
GWH*, JBX*
see also Nilo-Hamitic people

MANDE (Burkina Faso, Côte d'Ivoire, Gambia, Ghana, Guinea, Guinee-Bissau, Liberia, Mali, Senegal, Sierra Leone)
variants Manbele
note Mande language. The region which is the heartland of the Malinke, Bamana, Dyula, Manding, and others, was part of the Ghana empire and the center of the Mali empire (13th-15th centuries). Mande is also a linguistic division which includes the following groups : 1. Western Mande (Mande-tan): Bamana, Dyalonke, Dyula, Gbandi, Gbundi, Hwela, Kasonke, Kono, Kuranko, Kpelle, Ligbi, Loko, Loma, Malinke, Mende, Numu, Soninke, Susu, Sia, Vai; and 2. Eastern Mande (Mande-fu): Bisa, Busa, Dan, Guro, Mano, Mwan, Samo, and Wan.
AAT: <Mande Region>
LCSH: use Mandingo
BES, BS, CDR 1985, DDMM, DFM, DWMB, ELZ, ENS, ETHN, GAC, GPM 1959, HB, HBDW, HRZ, IAI, JD, JEEL, JG 1963, JK, JL, JLS, JPB, KFS, LM, LPR 1986, MHN, PG 1990, RAB, RJ 1958, ROMC, RWL, SAB, SMI, TB, TFG, WEW 1973, WG 1980, WG 1984, WH, WS
GPM 1959*, JJ*, PRM*

Mandebele *see* NDEBELE

MANDING (Gambia, Guinea-Bissau, Senegal)
variants Mandang, Mandinga, Mandingo, Mandingue, Mandinka, Soninka
note Mande language. The heartland of the Manding is on the upper Niger River and is call Mandin.
AAT: Manding
LCSH: use Mandingo
BS, DDMM, DWMB, ELZ, ETHN, GPM 1959, GPM 1975, GSGH, HAB, HB,

HBDW, HRZ, IAI, JAF, JEEL, JL, JLS, JM, JP 1953, JPB, JPJM, KFS, KMT 1970, LJPG, LM, LPR 1986, MG, MLJD, MPF 1992, PMPO, PRM, RGL, RJ 1958, ROMC, RSW, SMI, SV, SVFN, UIH, VP, WEW 1973, WG 1984, WH, WOH, WRB 1959, WS
DCBF*, DTN*, EFHH*, GA*
see also Mande

Mandinga *see* MANDING
Mandingo *see* MANDING
Mandingue *see* MANDING
Mandinka *see* MANDING
Mandja *see* MANZA
Mandjak *see* MANDYAK
Mandjia *see* MANZA

MANDYAK (Guinea, Guinea-Bissau, Senegal)
variants Mandjak, Manjaco, Manjak, Manjaka, Manjako, Mandyako
note West Atlantic language
AAT: nl
LCSH: use Mandjak
DDMM, DWMB, ETHN, GPM 1959, GPM 1975, HB, IAI, JG 1963, JLS, JPJM, MLJD, NIB, RJ 1958, SD, UIH, WH

Mandyako *see* MANDYAK
Manga *see* MBA

MANGANJA (Malawi)
variants Waganga
note Bantu language; one of the groups included in the collective term Nyanja
AAT: nl
LCSH: Mang'anja language use Nyanja language
DDMM, ETHN, GPM 1959, GPM 1975, HB, KK 1990, MGU 1967, UIH, WOH
TEW*
see also Nyanja

Mangati *see* TATOG
Mangbai *see* MANGBEI

MANGBEI (Cameroun, Central African Republic, Chad)
variants Mambai, Mangbai
note Adamawa language
AAT: nl
LCSH: nl
DDMM, DWMB, ETHN, GPM 1959, GPM 1975, HB, JG 1963, UIH

Mangbele *see* NGBELE

Mangbetou *see* MANGBETU

MANGBETU (Congo Republic, Uganda, Zaire)
variants Guruguru, Mangbetou, Mombouttous, Monbuttoo, Ngbetu
note Central Sudanic language; a conquering group that influenced numerous ethnic entities. Hence the term Mangbetu sometimes refers to the Mangbetu cluster or language group, consisting of the Beyru, Mabisanga, Madjuu, Makere, Malele, Meegye, Ngbele, Popoi, Rumbi and a Mangbetu dialect-speaking Pygmy group called Aka or Asua.
AAT: Mangbetu
LCSH: Mangbetu
AF, ALM, ASH, ATMB, ATMB 1956, BS, CDR 1985, CFL, CK, CMK, DDMM, DOA, DP, DPB 1987, EB, EBHK, EBR, EEWF, ELZ, ETHN, FW, GAH 1950, GB, GBJS, GPM 1959, GPM 1975, HAB, HB, HBDW, HH, HJK, IAI, JC 1971, JD, JG 1963, JK, JL, JLS, JMOB, JTSV, JV 1984, KK 1965, KMT 1971, LJPG, LM, MG, MH, MLB, MLJD, MUD 1991, NIB, OBZ, RGL, RS 1980, RSAR, RSRW, SD, SMI, SV, SV 1986, SV 1988, TB, TERV, TLPM, TP, UIH, WBF 1964, WFJP, WG 1980, WH, WMR, WOH, WRB, WRB 1959, WRNN, WS
ESCK*, ESCK 1990*, HBAG*, JEL*

MANGBUTU (Zaire)
variants Mangutu
note Central Sudanic language
AAT: nl
LCSH: nl
ATMB, ATMB 1956, DDMM, DPB 1987, ETHN, GPM 1959, JG 1963, JL, UIH, WH

MANGORO (Côte d'Ivoire)
note Mande language
AAT: nl
LCSH: nl
GPM 1959, JLS

Mangutu *see* MANGBUTU

Mangwato *see* NGWATO

MANI (Central African Republic, Sudan, Zaire)
note subcategory of Zande
AAT: nl
LCSH: nl
CDR 1985, HB, JK, SG, WS
see also Zande

Manianga *see* MANYANGA

Maniema *see* Toponyms Index

MANIGRI (Nigeria)
note Kwa language; subcategory of Yoruba
AAT: nl
LCSH: nl
DDMM, GPM 1959, RWL
see also Yoruba

MANINKA (Côte d'Ivoire, Guinea, Mali, Senegal)
note Mande language
AAT: nl
LCSH: Maninka language use Mandingo language
DDMM, ETHN, JK, SV, WEW 1973

Manja *see* MANZA

Manjaco *see* MANDYAK

Manjak *see* MANDYAK

Manjaka *see* MANDYAK

Manjako *see* MANDYAK

MANKANYA (Gambia, Senegal)
variants Mancagne
note West Atlantic language
AAT: nl
LCSH: Mankanya language
DDMM, ETHN, GPM 1959, HB

MANKON (Cameroun)
note Bantoid language; subcategory
of Bamenda
AAT: nl
LCSH: Mankon language
DDMM, ETHN, LP 1993, PH
see also Bamenda

MANO (Guinea, Liberia)
variants Man, Manon
note Mande language
AAT: Mano
LCSH: Mano
ASH, BS, CDR 1985, CK, DDMM, DFHC,
DFM, DWMB, ELZ, ETHN, GPM 1959,
GSDS, GSGH, HAB, HB, HBDW, HH,
IAI, JD, JG 1963, JK, JLS, JP 1953, JPB,
KFS, LPR 1986, MLJD, RGL, RJ 1958, RS
1980, SMI, SV, TB, TP, UIH, WEW 1973,
WG 1980, WOH, WRB, WRNN
EFHH*
see also Mande

Manon *see* MANO

MANYANGA (Zaire)
variants Manianga
note Bantu language; subcategory of
Kongo
AAT: nl
LCSH: use Sundi
BES, DDMM, DPB 1985, DPB 1987, GAH
1950, GPM 1975, JMOB, MGU 1967, OB
1973, PR, SG, WM
see also Kongo

MANYIKA (Mozambique,
Zimbabwe)
note Bantu language; subcategory of
Shona
AAT: nl
LCSH: Manyika
BS, DDMM, ETHN, GPM 1959, HB, MGU
1967, UIH, WRB 1959
see also Shona

Manyikeni *see* Toponyms Index

MANZA (Chad, Central African
Republic, Zaire)
variants Mandja Mandjia, Manja
note Western Ubangian language
AAT: nl
LCSH: use Manja
ATMB, ATMB 1956, CDR 1985, DB
1978, DDMM, DPB 1987, ETHN, FE

1933, GPM 1959, HB, IAI, JG 1963, KK
1965, LJPG, MLJD, MPF 1992, UIH,
WOH
AMV*

Mao *see* MAU (Côte d'Ivoire)

MAO (Ethiopia)
note Nilo-Saharan language
(northern group) and Southern
Cushitic language (southern
group)
AAT: nl
LCSH: nl
ATMB 1956, DDMM, ETHN, GPM 1959,
HB, JG 1963, RJ 1959

Mapungubwe *see* Toponyms Index

Maragoli *see* LOGOOLI

MARAKWET (Kenya)
note Southern Nilotic language; one
of the groups included in the
collective term Nilo-Hamitic
people. The name is used as a
cover term for the Talai and Endo.
AAT: nl
LCSH: Marakwet
ATMB 1956, DDMM, ECB, ETHN, GPM
1959, GPM 1975, HB, SMI, UIH
GUB*, GWH 1969*
see also Nilo-Hamitic people

Maraui *see* MARAVI

MARAVI (Malawi, Mozambique,
Tanzania, Zambia, Zimbabwe)
variants Malawi, Maraui
note Bantu languages; a collective
term that includes the Cewa,
Cuabo, Nsenga, Nyanja, Sena,
Tumbuka and others
AAT: Maravi
LCSH: use Chewa
ARW, CDR 1985, DDMM, EBHK, ETHN,
GPM 1959, GPM 1975, HB, IAI, JV 1966,
KK 1990, PG 1990, PR, RJ 1961, ROMC,
SG, SMI, UIH, WDH, WEH, WG 1980,
WRNN, WS, WVB
ACPG*, TEW*

MARBA (Chad)
 note Chadic language; one of the
 groups included in the collective
 term Kirdi
 AAT: nl
 LCSH: nl
 DDMM, ETHN, GPM 1959, GPM 1975,
 HB, UIH
 see also Kirdi
Marghi *see* MARGI
MARGI (Cameroun, Nigeria)
 variants Marghi, Margui
 note Chadic language; one of the
 groups included in the collective
 term Kirdi
 AAT: nl
 LCSH: Margi language
 ARW, DB, DDMM, DWMB, ETHN, GB,
 GPM 1959, GPM 1975, HAB, HB, HBDW,
 IAI, IEZ, JG 1963, LJPG, MBBH, NIB,
 NOI, PMPO, PRM, RGL, RJ 1958, ROMC,
 RS 1980, RWL, UIH, WH, WLA
 BEL*
 see also Kirdi
Margui *see* MARGI
Marille *see* DASENECH
MARKA (Burkina Faso, Mali)
 subcategories Bolon, Dafing
 note Mande language. Some
 Soninke living in Mali are
 referred to as Marka (or Marka
 Soninke) in contrast to the Marka
 (or Marka Dafing) of Burkina
 Faso. see CDR 1987 and DDMM.
 AAT: Marka
 LCSH: use Soninke
 BS, CDR 1987, CMK, DDMM, DWMB,
 ELZ, ETHN, GPM 1959, GPM 1975,
 HBDW, HMC, IAI, JAF, JD, JK, JLS, JPB,
 KFS, LPR 1986, MLB, PRM, RJ 1958,
 RSW, TFG, UIH, VP, WG 1980, WG 1984,
 WOH, WRB, WRNN
 see also Soninke
Marka Dafing *see* DAFING
Marka Soninke *see* SONINKE
Marle *see* DASENECH
Marongo *see* RONGO

MARSHIA (Sudan)
 note subcategory of Bari; one of the
 groups included in the collective
 term Nilo-Hamitic people
 AAT: nl
 LCSH: nl
 HB
 CSBS, GWH
 see also Bari, Nilo-Hamitic people
Marungu *see* LUNGU
Masa *see* MASSA
Masaba *see* GISU
Masai *see* MAASAI
Masango *see* SANGU
MASASI (Tanzania)
 note Bantu language
 AAT: nl
 LCSH: nl
 ARW, KK 1990, TEW
Mashango *see* SANGU
MASHI (Angola, Zambia)
 note Bantu language; not to be
 confused with the Shi of Zaire,
 who are also sometimes referred
 to as Mashi
 AAT: nl
 LCSH: nl
 DDMM, ETHN, GPM 1959, HB, RS 1980,
 WVB
Mashona *see* SHONA
Masina *see* Toponyms Index
Masongo *see* MAJANGIR

MASSA (Cameroun, Chad)
 variants Masa
 note Chadic language; a collective
 term that includes Bongor,
 Bugudum, Gisei, Gummai,
 Mussey and others. see BEL and
 IDG; one of the groups included in
 the collective term Kirdi
 AAT: nl
 LCSH: use Masa
 AML, BS, DB, DDMM, DWMB, ELZ,
 ETHN, GBJM, GPM 1959, GPM 1975,
 HAB, HB, HBDW, IAI, IEZ, JJM 1972, JP
 1953, JPAL, JPB, MH, MLJD, MPF 1992,
 RGL, SD, SMI, UIH, WH
 BEL*, EPHE 4*, IDG*
 see also Kirdi
Massai *see* MAASAI
Massango *see* SANGU
Masubiya *see* SUBIYA
Masupia *see* SUBIYA
MATABELE (Zimbabwe)
 note Bantu language; historically
 related to the Ndebele
 AAT: nl
 LCSH: use Ndebele
 GPM 1959, HB, IAI, RJ 1961, SMI, UIH,
 WRB, WVB
Matabeleland *see* Toponyms Index
Matadi *see* NDIBU
MATAKAM (Cameroun, Nigeria)
 variants Mafa, Mofa
 subcategories Bulahay, Gisiga
 note Chadic language; considered a
 derogatory term in Cameroun;
 one of the groups included in the
 collective term Kirdi
 AAT: nl
 LCSH: Matakam
 AF, BEL, BS, DB, DDMM, DWMB, EBR,
 ELZ, ETHN, GPM 1959, GPM 1975, HAB,
 HB, HBDW, IAI, IEZ, JG 1963, JLS, JP
 1953, MFMK, MH, NIB, PMPO, RJ 1958,
 RSW, RWL, SD, SMI, TN 1984, UIH, WH
 AMP*, JYM*
 see also Kirdi
Matal *see* MOUKTELE

MATAMBA (Angola)
 note Bantu language
 AAT: nl
 LCSH: nl
 GPM 1959, GPM 1975, HB, JV 1984
MATAMBWE (Tanzania)
 variants Tambwe
 note Bantu language
 AAT: Matambwe
 LCSH: nl
 ECB, ETHN, GPM 1975, HB, TEW, UIH
MATAPA (Angola)
 note Kasai region
 AAT: nl
 LCSH: nl
 JMOB, MLB 1994
Matcha *see* MACHA
MATE (Uganda, Zaire)
 variants Bamate
 note Bantu language; subcategory of
 Konjo
 AAT: nl
 LCSH: nl
 DPB 1986, ETHN, HB
 see also Konjo
MATENGO (Tanzania)
 note Bantu language
 AAT: Matengo
 LCSH: Matengo
 ECB, ETHN, GPM 1959, HB, JLS, MFMK,
 RJ 1960, UIH
 TEW*
MATUMBI (Tanzania)
 variants Tumbi, Wamatumbi
 note Bantu language
 AAT: nl
 LCSH: Matumbi language
 DDMM, ECB, ETHN, GPM 1959, GPM
 1975, HB, MFMK, RJ 1960

MAU (Côte d'Ivoire)
variants Mao
note Mande language
AAT: nl
LCSH: Mau dialect
CDR 1985, DWMB, ETHN, GPM 1959,
GPM 1975, GSGH, HB, JK, MWSV, UIH,
WS
EFHH*, JPB*

MAURES (Algeria, Mali,
Mauritania, Morocco, Niger,
Senegal)
variants Hassaniya, Moors
note Berber language
AAT: nl
LCSH: nl (uses Hassaniyeh)
BS, EDB, ETHN, HBDW, ICWJ, JEG
1958, JLS, LCB, LPR 1995, MPF 1992, RJ
1958, TFG, TP

Mauri *see* MAWRI

Mavia *see* MAWIA

Maviha *see* MAWIA

Mavul *see* SURA

MAWIA (Tanzania, Mozambique)
variants Mabiha, Mavia, Maviha,
Wamawia
note Bantu language
AAT: Mawia
LCSH: nl
CK, DDMM, ECB, ELZ, ETHN, EWA,
GPM 1959, GPM 1975, HAB, HB, KK
1990, MGU 1967, UIH, WH, WRB, WS

MAWRI (Niger)
variants Mauri
note Chadic language; subcategory
of Hausa
AAT: nl
LCSH: Mawri
BS, GPM 1959, HB, IAI, MPF 1992, RWL,
SMI, UIH, WH
MHP*
see also Hausa

MAYOGO (Zaire)
variants Majugu, Mayugu
note Western Ubangian language;
closely related to Bangba
AAT: nl
LCSH: nl

ATMB, ATMB 1956, CFL, DB 1978,
DDMM, DPB 1987, ESCK, ETHN, GAH
1950, GPM 1959, IAI, JG 1963, JMOB,
OBZ, UIH, WDH, WH
see also Bangba

Mayombe *see* YOMBE

Mayugu *see* MAYOGO

Mayumba *see* YOMBE

Mayumbe *see* YOMBE

MAZIBA (Zaire)
variants Bamaziba
note Bantu language; subcategory of
Songye
AAT: nl
LCSH: nl
DDMM
LES*
see also Songye

MBA (Zaire)
variants Bamanga, Manga, Mbae
note South-Central Ubangian
language
AAT: nl
LCSH: nl
ATMB 1956, DB 1978, DDMM, DPB
1987, ETHN, GAH 1950, GPM 1959,
GPM 1975, HB, JG 1963, JMOB, UIH,
WH

MBAAMA (Congo Republic, Gabon)
variants Ambamba, Mbamba,
Obamba, Ombaamba
subcategories Djikini, Ngutu
note Bantu language; subcategory of
Kota. The transcription Mbaamba
seems currently preferred to the
more conventional Obamba.
AAT: nl
LCSH: nl (uses Mbete)
AW, CDR 1985, CFL, DDMM, DP, ETHN,
GPM 1959, GPM 1975, HB, JAF, JK, LM,
LP 1979, LP 1985, MGU 1967, MLB, MPF
1992, MUD 1986, SV, UIH, WH, WRB,
WS
see also Kota

Mbae *see* MBA

Mbafu Cave *see* Toponyms Index

MBAGANI (Zaire)
variants Bambagani
note Bantu language; sometimes confused with the Binji people
AAT: Mbagani
LCSH: nl
CDR 1985, CFL, DDMM, DPB 1987, ETHN, FHCP, GAH 1950, GPM 1959, GPM 1975, HB, IAI, JC 1971, JC 1978, JD, JK, JV 1966, LM, MLF, MLJD, OB 1961, OB 1973, OBZ, WG 1980, WG 1984, WRNN
see also Binji

Mbahouin *see* MBANGWE

Mbai *see* BAI (Chad, Sudan)

MBAI (Central African Republic, Chad)
note Central Sudanic language
AAT: nl
LCSH: Mbai
ATMB, ATMB 1956, DDMM, ETHN, GPM 1959, HB, IAI, JG 1963, MPF 1992, WH

MBAISE (Nigeria)
note Kwa language; subcategory of Igbo
AAT: nl
LCSH: nl
HMC 1982, SV, VCU 1965
see also Igbo

Mbaka *see* BAKA (Cameroun, Gabon)

Mbaka *see* NGBAKA (Zaire)

MBAKA (Angola)
variants Ambaquista
note Bantu language; subcategory of Kongo
AAT: nl
LCSH: nl
DDMM, ETHN, GPM 1959, GPM 1975, HB, IAI, MLB 1994
see also Kongo

MBAL (Zaire)
variants Bampeen, Mbala
note Bantu language; subcategory of Kuba
AAT: nl (uses Mbala, Kuba folk style)
LCSH: nl

DDMM, DPB 1985, ELZ, FW, GPM 1959, HB, HBDW, IAI, MGU 1967, OB 1961, OB 1973, OBZ, UIH, WH, WRB JV 1966*
see also Kuba

Mbala *see* MBAL

MBALA (Zaire)
variants Bambala
note Bantu language; one of the groups referred to as Akaawand
AAT: Mbala (Western Zaire)
LCSH: Mbala
ALM, BES, BS, CDR 1985, CK, DDMM, DP, DPB 1985, DPB 1987, EBHK, EBR, ELZ, ETHN, FHCP, GAH 1950, GPM 1959, GPM 1975, HAB, HB, HBDW, HJK, JC 1971, JC 1978, JD, JK, JLS, JMOB, JV 1966, KK 1965, KMT 1970, KMT 1971, LJPG, LM, MGU 1967, MLB, MLF, MLJD, OB 1973, OBZ, RGL, RSAR, RSW, SD, SG, SMI, SV, TERV, TP, UIH, WBF 1964, WG 1980, WH, WMR, WRB, WRNN, WS, WVB
LUM*
see also Akaawand

Mbalekeo *see* BAMILEKE

MBALI (Angola)
variants Quimbares
note Bantu language
AAT: nl
LCSH: use Benguella
DDMM, ETHN, GPM 1959, GPM 1975, HB, JLS, JMOB, MLB 1994

Mbamba *see* MBAAMA (Gabon)

MBAMBA (Angola)
variants Njinga
note Bantu language
AAT: Mbamba
LCSH: nl
DDMM, EBHK, ETHN, HB, MGU 1967, UIH, WRB

Mbandja *see* MBANJA

MBANGALA (Angola)
variants Bangala, Imbangala
note Bantu languages; a collective
 term that includes such groups as
 Cilenge, Cipungu, Hanya,
 Khumbi, Mulondo, Mwila,
 Ndombe, Nganda, and Nyaneka;
 not to be confused with the Ngala
 of Zaire
 AAT: nl
 LCSH: nl (uses Bangala)
 BS, CDR 1985, DDMM, DPB 1985,
 EBHK, ETHN, GB, GPM 1959, GPM
 1975, HAB, HB, HBDW, HBU, HJK, IAI,
 JC 1971, JMOB, JV 1966, KK 1965, LM,
 MGU 1967, MLB 1994, OB 1973, ROMC,
 RSW, UIH, WDH, WH, WS
 HAEF*

MBANGWE (Congo Republic,
Gabon)
variants Mbahouin
note Bantu language
 AAT: nl
 LCSH: nl
 DDMM, ETHN, HB, LP 1985, MUD 1986

MBANJA (Central African Republic,
Zaire)
variants Banza, Mbandja, Mbanza
note Central Ubangian language.
 Some consider Mbanza and
 Mbanja as separate but related
 groups.
 AAT: nl (uses Mbanza)
 LCSH: nl
 ATMB, ATMB 1956, BES, CFL, CK, DB
 1978, DDMM, DPB 1985, DPB 1987,
 ELZ, ETHN, FHCP, GAH 1950, GPM
 1959, GPM 1975, HAB, HB, HBDW, IAI,
 JMOB, KK 1965, MLB, OBZ, TERV, UIH,
 WH, WM, WRB
 HBU*

Mbanza *see* MBANJA

Mbanza Kongo *see* Toponyms Index

MBARA (Chad)
note Chadic language
 AAT: nl
 LCSH: use Bagirmi
 ETHN, HMC, MPF 1992, SMI

MBATA (Zaire)
variants Bambata
note Bantu language; subcategory of
 Kongo
 AAT: Mbata
 LCSH: Mbata
 BES, CK, DDMM, DPB 1985, ELZ, GAH
 1950, GPM 1959, GPM 1975, HAB,
 HBDW, JLS, JMOB, OB 1973, OBZ, PR,
 UIH, WH, WRB, WH
see also Kongo

MBATI (Central African Republic,
Congo Republic)
variants Isongo
note Bantu language
 AAT: nl
 LCSH: Mbati
 BS, DDMM, ETHN, HBU, IAI, MGU
 1967, MPF 1992, UIH

Mbato *see* GWA

Mbatto *see* GWA

MBAW (Cameroun)
variants Kimbaw
note Bantoid language; subcategory
 of Tikar; one of the groups
 included in the collective terms
 Ntem and Bamenda
 AAT: nl
 LCSH: nl
 DDMM, ETHN, GPM 1959, IEZ, PAG
 MMML*, PMK*
see also Bamenda, Ntem, Tikar

MBE (Nigeria)
note Bantoid language; subcategory
 of Mbube; sometimes referred to
 as Western Mbube
 AAT: nl
 LCSH: nl
 DDMM, ETHN, RJ 1958, RWL
see also Mbube

MBE (Congo Republic)
note Bantu language; subcategory of
 Teke
 AAT: nl
 LCSH: nl
 DDMM, JV 1973
see also Teke

Mbede *see* MBETE

Mbeeko *see* MBEKO
Mbeengi *see* MBEENGY
MBEENGY (Congo Republic, Zaire)
 variants Mbeengi
 note Bantu language; subcategory of
 Kuba
 AAT: nl
 LCSH: nl
 EBHK, HB, JV 1978
 JC 1982*
 see also Kuba
Mbeere *see* MBERE
MBEKO (Zaire)
 variants Mbeeko, Mbeku
 note Bantu language; Kongo related
 group who are both Kongo and
 Yaka influenced
 AAT: nl
 LCSH: nl
 DDMM, DPB 1985, DPB 1987, JC 1978,
 OB 1973, OBZ
 FHCP*
 see also Kongo
Mbeku *see* MBEKO
MBELO (Zaire)
 note Bantu language; subcategory of
 Mongo
 AAT: nl
 LCSH: nl
 DPB 1985, DPB 1987, GAH 1950, JV
 1966, JV 1973
 see also Mongo
MBEM (Cameroun)
 note Bantoid language; subcategory
 of Tikar; one of the groups
 included in the collective terms
 Ntem and Bamenda
 AAT: nl
 LCSH: use Yamba
 DDMM, ETHN, GDR, GPM 1959, HB,
 HMC, IEZ, IAI, LP 1993, PH, RJ 1958, SV
 MMML*, PMK*
 see also Bamenda, Ntem, Tikar
MBEMBE (Cameroun)
 variants Mbembe-Njari
 subcategories Mfumte, Misaje
 note Benue-Congo language; an
 independent chiefdom and one of
the five component migrant
groups in Bamenda; sometimes
called Eastern Mbembe to
distinguish them from the
Mbembe of Nigeria who are a
separate group; one of the groups
included in the collective term
Tigong. The Mbembe inhabit the
lowlying forest areas of the north
and northeast of Bamenda.
AAT: nl
LCSH: nl
DDMM, DWMB, ETHN, GBJS, GPM
1959, HB, IEZ, LP 1993, RWL, SV, WEW
1973, WG 1980
GDR*, MMML*, PAG*, PH, PMK*
 see also Bamenda, Tigong
MBEMBE (Nigeria)
 variants Mbembe-Obubra
 note Benue-Congo language; a
 collective term used to describe
 various small populations in the
 Cross River region; sometimes
 called Western Mbembe to
 distinguish them from the
 Mbembe of Cameroun, who are a
 separate group. see RWL.
 AAT: Mbembe
 LCSH: Mbembe
 DDMM, DWMB, EE, ETHN, GPM 1959,
 GPM 1975, HBDW, IAI, JG 1963, JK,
 MLB, NOI, RGL, RJ 1958, RWL, SMI, SV,
 TP, UIH, WG 1984, WH
Mbembe-Njari *see* MBEMBE
 (Cameroun)
Mbembe-Obubra *see* MBEMBE
 (Nigeria)
MBERE (Kenya)
 variants Mbeere
 note Bantu language; closely related
 to Embu
 AAT: nl
 LCSH: Mbere
 DDMM, ECB, ETHN, GPM 1959, GPM
 1975, HB, JG 1963, JLS
 JMGK*
 see also Embu

MBESA (Zaire)
variants Mombesa
note Bantu language
AAT: nl
LCSH: nl
DDMM, DPB 1987, ETHN, GPM 1959,
GPM 1975, IAI, JMOB, OBZ

MBETE (Congo Republic, Gabon)
variants Ambete, Mbede, Mbeti
note Bantu language
AAT: Mbete
LCSH: Mbete
BS, CK, DDMM, DP, DWMB, EEWF,
ELZ, ETHN, GBJS, GPM 1959, GPM
1975, HAB, HB, HBDW, JK, JLS, JV
1984, LM, LP 1979, MGU 1967, MLB,
MLJD, MUD 1986, SMI, UIH, WBF 1964,
WG 1980, WH, WRB, WRNN, WS
LP 1985*

Mbeti *see* MBETE

Mbiame *see* MBIAMI

MBIAMI (Cameroun)
variants Mbiame
note subcategory of Nsaw; one of
the groups included in the
collective term Bamenda
AAT: nl
LCSH: nl
EBHK, PH, LP 1993
MMML*
see also Bamenda, Nsaw

Mbiem *see* YANZ

MBILI (Cameroun)
variants Bambili
note Bantoid language
AAT: nl
LCSH: nl
DDMM, ETHN, MMML, PH

MBILIANKAMBA (Zaire)
note Bantu language
AAT: nl
LCSH: nl
DDMM, DPB 1985

MBIMU (Cameroun, Central African
Republic)
variants Mpiemo, Mpyemo
note Bantu language
AAT: nl
LCSH: nl

DDMM, ETHN, GPM 1959, HB, MGU
1967

MBINSA (Zaire)
variants Mbinza
note Bantu language; subcategory of
Kongo in southwestern Zaire
AAT: nl
LCSH: Mbinsa language
DDMM, DPB 1985, MGU 1967, OB 1973
see also Kongo

Mbinza *see* MBINSA

MBISSISIOU (Gabon)
note Bantu language; subcategory of
Kele
AAT: nl
LCSH: nl
LP 1985
see also Kele

Mbitse *see* TIV

MBO (Cameroun)
note Bantu language; one of the five
component migrant groups in
Bamileke
AAT: nl
LCSH: Mbo language
DDMM, ETHN, GPM 1959, GPM 1975,
HB, HBDW, LP 1993, MGU 1967, PH, TN
1984, WEW 1973, WS
TN 1986*
see also Bamileke

Mbochi *see* MBOSHI

MBOI (Nigeria)
variants Mboyi
note Adamawa language;
subcategory of Yungur
AAT: nl
LCSH: nl
DDMM, ETHN, GBJS, GPM 1959, GPM
1975, HB, JG 1963, RWL
see also Yungur

MBOKA (Angola, Zaire)
note Bantu language; subcategory of
Kongo
AAT: nl
LCSH: nl
DDMM, ETHN, MGU 1967
see also Kongo

MBOKO (Congo Republic)

note Bantu language

AAT: nl

LCSH: nl

DDMM, ETHN, HB, HBDW, MGU 1967, WOH, WS

MBOKO (Cameroun)

variants Bamboko, Bomboko, Wumboko

note Bantu language; one of the groups included in the collective term Kpe-Mboko

AAT: nl

LCSH: nl

DDMM, ETHN, GPM 1959, GPM 1975, HAB, HB, HBDW, IEZ, MGU 1967, WOH

see also Kpe-Mboko

MBOLE (Zaire)

variants Bambole, Bole

note Bantu language; in eastern Zaire, not to be confused with Mbole, who are a subcategory of Mongo, also in Zaire

AAT: Mbole

LCSH: nl

ALM, AW, CDR 1985, CMK, DPB 1986, DPB 1987, EEWF, ELZ, ETHN, FHCP, FW, GAH 1950, GBJS, HB, HBDW, IAI, JC 1971, JC 1978, JD, JK, JLS, JMOB, JTSV, MGU 1967, MHN, MLB, MLJD, OBZ, RS 1980, RSRW, RSW, SMI, SV 1988, TERV, TP, WBF 1964, WG 1980, WH, WMR, WOH, WRB, WRNN

MBOLE (Zaire)

note Bantu language; subcategory of Mongo

AAT: nl

LCSH: Mbole

DDMM, ETHN, GAH 1950, GPM 1959, GPM 1975, HAB, JC 1978, OBZ, UIH DPB 1987*

see also Mongo

MBOMA (Zaire)

variants Baboma, Boma

note Bantu language; subcategory of Kongo in southwestern Zaire; not to be confused with the Buma, who are also referred to in some sources as Baboma.

AAT: nl

LCSH: nl

ALM, BES, DDMM, DPB 1987, ETHN, GPM 1959, GPM 1975, HAB, HB, HBDW, JC 1971, JC 1978, KFS, KK 1965, OB 1973, UIH, WG 1984 WM*

see also Kongo

MBOMOTABA (Central African Republic, Congo Republic, Zaire)

variants Bamitaba, Bomitaba

note Bantu language

AAT: nl

LCSH: Mbomotaba language

DDMM, ETHN, GPM 1959, GPM 1975, HAB, HB, IAI, JP 1953, MGU 1967, WH

MBONDO (Angola, Zaire)

variants Bondo

note Bantu language

AAT: nl

LCSH: nl

DDMM, EBHK, GPM 1959, GPM 1975, HB, HJK, UIH

Mboschi *see* MBOSHI

MBOSHI (Congo Republic)

variants Baboshi, Bambochi, Bochi, Mbochi, Mboschi, Mbosi

note Bantu language

AAT: nl

LCSH: use Mbosi

BS, DDMM, DP, ELZ, ETHN, GPM 1975, HB, HBDW, JD, JLS, JV 1966, LP 1985, MGU 1967, MLJD, MPF 1992, UIH, WS TO 1976*

Mbosi *see* MBOSHI

MBOT (Cameroun)

note chiefdom of Bamum

AAT: nl

LCSH: nl

LP 1993, PH

see also Bamum

Mbote *see* MBUTI

Mboum *see* MBUM (Cameroun)

Mboyi *see* MBOI

MBUBA (Zaire)
variants Bambuba, Mvuba
note Central Sudanic language
AAT: nl
LCSH: nl
ATMB, ATMB 1956, BES, DDMM, DPB
1986, DPB 1987, ESCK, ETHN, GAH
1950, GPM 1959, GPM 1975, HAB, HB,
JG 1963, JMOB, MGU 1967, OBZ, SMI
HVGB*

MBUBE (Nigeria)
subcategories Mbe, Utugwang
note sometimes divided into
 Western Mbube or Mbe, who
 speak a Bantoid language, and
 Eastern Mbube or Utugwang, who
 speak a Benue-Congo language.
 see RWL.
AAT: nl
LCSH: nl
DDMM, ETHN, JK, MK, RWL

Mbudikem *see* WIDEKUM

Mbudza *see* MBUJA

MBUGU (Tanzania)
note Cushitic language
AAT: nl
LCSH: nl
ATMB, ATMB 1956, DDMM, ECB,
ETHN, GPM 1959, GPM 1975, IAI, JG
1963, MFMK, RJ 1960, UIH, WEW 1973,
WH, WOH

MBUGU (Central African Republic,
Zaire)
variants Gbugu, Ngbugu
note Central Ubangian language
AAT: nl
LCSH: nl
ATMB 1956, DB 1978, DDMM, ETHN,
HBU, UIH

Mbugue *see* MBUGWE

MBUGWE (Tanzania)
variants Mbugue
note Bantu language
AAT: nl
LCSH: nl
DDMM, ECB, ETHN, GPM 1959, GPM
1975, HB, IAI, KK 1990, MGU 1967,
MFMK, RJ 1960, SV 1988, UIH, WH,
WOH

Mbui *see* AMBOIM

Mbui *see* BAMBUI

MBUJA (Zaire)
variants Budja, Buja, Mbudza
note Bantu language; one of the
 groups included in the collective
 term Losengo
AAT: nl
LCSH: nl (uses Budja)
BES, DDMM, DPB 1987, ETHN, GAH
1950, GPM 1959, GPM 1975, HB, IAI,
JMOB, OBZ, RJ 1961, UIH
see also Losengo

MBUKUSHU (Angola, Botswana,
Namibia)
variants Goba, Gova, Hambukushu
note Bantu language; sometimes
 divided into northern and
 southern Mbukushu
AAT: nl
LCSH: Mbukushu
ARW, DDMM, ETHN, GPM 1959, GPM
1975, HB, JLS, RS 1980, WDH, WVB

MBULA (Nigeria)
note Benue-Congo language
AAT: nl
LCSH: Mbula language use Mangap
 language
DDMM, ETHN, GPM 1959, HB, RWL,
WH

MBULI (Zaire)
note Bantu language; subcategory of
 Mongo
AAT: nl
LCSH: nl
ETHN, IAI, UIH
see also Mongo

Mbulu *see* IRAQW

MBULUNGISH (Guinea)
variants Baga Fore
note West Atlantic language
AAT: nl
LCSH: nl
DDMM, DWMB, ETHN, HB

MBUM (Cameroun, Central African Republic)
variants Boum, Bum, Mboum
subcategories Kpere
note Adamawa language; one of the groups included in the collective terms Bamenda and Tikar. The Bum may actually be a separate group in Cameroun speaking a Bantoid language. see DDMM.
AAT: nl
LCSH: Mbum
DDMM, DWMB, EPHE 9, ETHN, GPM 1959, GPM 1975, HAB, HB, HMC, IAI, JG 1963, KK 1965, PH, RJ 1958, RSW, SMI, UIH, WH, WOH
GDR*, LP 1993*, MMML*, PH*, PAG*, PMK*
see also Bamenda, Tikar

MBUM (Chad)
note Adamawa language; one of the groups included in the collective term Kirdi
AAT: nl
LCSH: Mbum
BEL, ETHN, GB, GPM 1959, HB, IEZ, JLS, JPAL, UIH, WH
see also Kirdi

Mbun *see* MBUUN

MBUNDA (Zambia, Angola)
variants Bunda, Mambunda
note Bantu language; one of the groups included in the collective term Ngangela
AAT: nl
LCSH: Mbunda
CK, DDMM, DPB 1987, EBR, EEWF, ELZ, ETHN, FN 1994, GBJS, GPM 1959, GPM 1975, HAB, HB, HMC, IAI, JD, JM, JV 1966, MGU 1967, MLB, MLB 1994, MLJD, RSW, TP, WG 1980, WH, WRB, WVB
see also Ngangela

Mbundo *see* OVIMBUNDU

Mbundu *see* OVIMBUNDU

MBUNDU (Angola)
variants Ambundu, Kimbundu, Ndongo, Ngola

note Bantu language known as Kimbundu; somewhat related to the Kongo; not to be confused with the Ovimbundu, who also live in Angola
AAT: nl
LCSH: Mbundu
BES, BS, DDMM, DPB 1985, DPB 1987, ETHN, GPM 1959, GPM 1975, HAB, HB, HRZ, IAI, JLS, JM, KK 1965, MGU 1967, MLB 1994, RGL, ROMC, RS 1980, RSW, SMI, UIH, WG 1984, WH, WMR, WOH
EDA*, MEM*

MBUNGA (Tanzania)
note Bantu language
AAT: Mbunga
LCSH: use Ndendeule
DDMM, ECB, ETHN, GPM 1959, HB, MFMK

MBUNJO (Congo Republic)
note Western Ubangian language
AAT: nl
LCSH: nl
DB 1978, DDMM

Mbute *see* WUTE

MBUTI (Zaire)
variants Bambote, Bambuti, Mbote
note Bantu language, see SB 1985; one of the groups included in the collective term Pygmies
AAT: nl
LCSH: Mbuti
ATMB 1956, BES, BS, DPB 1981, DPB 1987, ELZ, ESCK, ETHN, GAH 1950, GPM 1959, GPM 1975, HAB, HB, HRZ, IAI, JJM 1972, JLS, JM, JMOB, MH, MTKW, OBZ, RSW, SMI, UIH, WG 1980, WOH
PAS*, RFTH*, SB*, SB 1985*
see also Pygmies

MBUUN (Zaire)
variants Ambunu, Ambuun,
Babunda, Babundu, Bambunda,
Bunda, Mbun
note Bantu language
AAT: nl (uses Mbun)
LCSH: use Bunda
CK, DDMM, DFHC, DPB 1985, DPB
1986, DPB 1987, ETHN, GAH 1950, GPM
1959, GPM 1975, HB, IAI, JK, JMOB,
JPJM, JV 1966, KMT 1971, LJPG, MGU
1967, MK, OB 1973, OBZ, SMI, TERV,
UIH, WH, WRB

MBWELA (Zambia)
variants Lukolwe
note Bantu language. There are
two Mbwela groups, one in
Angola and the other in Zambia,
who are historically related but
separate peoples.
AAT: nl
LCSH: nl
DDMM, DPB 1987, ETHN, GPM 1959,
GPM 1975, HB, RJ 1961, WVB
MEM 1951*

MBWELA (Angola)
variants Ambuella, Mbwera
note Bantu language; one of the
groups included in the collective
term Ngangela. There are two
Mbwela groups, one in Angola
and the other in Zambia, who are
historically related but separate
peoples.
AAT: nl
LCSH: nl
DDMM, DPB 1987, ETHN, GPM 1959,
GPM 1975, HB, IAI, JM, JV 1966, MGU
1967, MLB 1994, UIH, WH
MEM 1951*
see also Ngangela

Mbwera *see* MBWELA (Angola)
Meban *see* MABAN
Mecha *see* MACHA
Medge *see* MEEGYE
Medje *see* MEEGYE
MEEGYE (Zaire)
variants Medge, Medje, Meje

note Central Sudanic language; one
of the groups included in the
collective term Mangbetu
AAT: nl
LCSH: nl
ATMB, ATMB 1956, CFL, DDMM, DPB
1987, ESCK, ETHN, GAH 1950, GPM
1959, GPM 1975, HAB, HB, HBDW, IAI,
JC 1971, JG 1963, JMOB, RSW, TERV,
UIH, WH
JEL*
see also Mangbetu

Me'en *see* MEKAN
Meidob *see* MIDOBI
Meje *see* MEEGYE
Meka *see* BAMEKA
MEKAN (Ethiopia)
variants Me'en
note Eastern Sudanic language.
The Mekan are sometimes called
Surma by the Gimira. see ATMB
1956 and ERC.
AAT: nl
LCSH: Mekan
ATMB 1956, DDMM, ERC, ETHN, GPM
1959, GPM 1975, HB, JG 1963, RJ 1959,
UIH, WH
see also Surma

MEKENY (Gabon)
note Bantu language; subcategory of
Fang; a style/culture division. see
LP*.
AAT: nl
LCSH: nl
JV 1984, UIH, WS
LP 1979*, LP 1985*, LP 1990*
see also Fang

Mekibo *see* METYIBO
Mekina *see* MAKE
Mekyibo *see* METYIBO
Mena *see* BAMENA

MENDE (Liberia, Sierra Leone)
variants Mendi
note Mande language; The Mende
are divided into three main
groups: Kpa Mende, Sewa Mende
and Ko Mende
AAT: Mende
LCSH: Mende
ACN, ASH, BES, BS, CDR 1985, CK,
CMK, DDMM, DOA, DOWF, DP, DWMB,
EB, EBR, EEWF, ELZ, ETHN, EVA, FW,
GPM 1959, GPM 1975, GSGH, HAB, HB,
HBDW, HH, HMC, IAI, JD, JG 1963, JK,
JL, JLS, JM, JPB, JPJM, JTSV, KFS, KK
1960, KK 1965, KMT 1970, LJPG, LM,
MEM 1950, MHN, MLB, MLJD, MUD
1991, PMPO, PSG, RFT 1974, RGL, RJ
1958, ROMC, RSAR, RSRW, RSW, SD,
SG, SMI, SV, SVFN, TB, TP, UIH, WBF
1964, WEW 1973, WG 1980, WG 1984,
WH, WMR, WOH, WRB, WRB 1959,
WRNN, WS
CFPK*, KLT*, MEM 1950*, SAB*
see also Mande
Mendi *see* MENDE
Menemo *see* META
Menjo *see* BAMENDJO
Merile *see* DASENECH
MERINA (Madagascar)
variants Hova, Imerina
note Malagasi language
(Austronesian)
AAT: Merina
LCSH: Merina
BS, DDMM, ELZ, ETHN, GPM 1959,
GPM 1975, HAB, HB, IAI, JLS, JM, JP
1953, JPJM, JV 1984, KFS, MCA 1986,
ROMC, SMI, WH
ADM*, CKJR*, JFLB*, JMA*, MB*
Mero *see* MERU
MEROË (Sudan)
note ancient kingdom on the Nile;
Kushite capital
AAT: nl
LCSH: Meroe (extinct city)
ARW, BD, CSBS, GBJM, HB, JL, JLS, PG
1990, PR, TP, UGH
see also Kush
MERU (Kenya)
variants Mero

note Bantu language; a collective
term for several groups in the
Meru district of Kenya, including
the Chuka, Igembe, Igoji, Imenti,
Miutini, Muthambi, Mwimbi, and
others
AAT: Meru
LCSH: Meru
DDMM, ECB, ETHN, GPM 1959, GPM
1975, HAB, HB, IAI, MGU 1967, RJ 1960,
SMI, UIH, WH
JMGK*, SMPP*
MERU (Tanzania)
note Bantu language; sometimes
referred to as southern Meru; not
to be confused with the Meru of
Kenya who are a separate group
AAT: nl
LCSH: Meru
DDMM, ECB, ETHN, GPM 1959, HB,
MFMK, UIH, WH
SMPP*
Meru, Mount *see* Toponyms Index
MESAKIN (Sudan)
note Kordofanian language; one of
the groups included in the
collective term Nuba
AAT: nl
LCSH: nl
ATMB, DDMM, ETHN, GPM 1959, GPM
1975, HB, ICWJ, SD
SFN*
see also Nuba
MESSERIA (Chad, Sudan)
variants Messiriya
note one of the groups included in
the collective terms Baggara and
Sudan Arabs
AAT: nl
LCSH: nl
DBNV, GPM 1959, HB, IGC, RJ 1959,
WH
see also Baggara, Sudan Arabs
Messiriya *see* MESSERIA

META (Cameroun)

variants Bameta, Bametta, Menemo

note Bantoid language; subcategory
of Widekum, one of the groups
included in the collective term
Bamenda
AAT: nl
LCSH: Meta
CK, DDMM, DWMB, EBHK, ETHN,
GPM 1959, GPM 1975, HB, HMC, IEZ,
KK 1965, PH, TN 1973, UIH
GDR*, LP 1993*, PMK*

see also Bamenda, Widekum

Metcho *see* MISAJE

METOKO (Zaire)

variants Banyamituku, Mitoko,
Mituku

note Bantu language
AAT: Metoko
LCSH: Mituku language
DDMM, DPB 1986, DPB 1987, ETHN,
FHCP, GAH 1950, GPM 1959, GPM 1975,
JC 1971, JD, JK, JMOB, MLJD, TERV,
WRB, WRNN
JC 1978*

Metscho *see* MISAJE

METYIBO (Côte d'Ivoire)

variants Betibe, Eotile, Mekibo,
Mekyibo, Vetre

note Kwa language; one of the
groups included in the collective
terms Akan and Lagoon people
AAT: nl (uses Eotile)
LCSH: nl
DDMM, DWMB, ENS, ETHN, GPM 1959,
HB, JG 1963, JLS, TFG, UIH
JPB*

see also Akan, Lagoon people

MFENGU (South Africa)

variants Fingo

note Bantu language
AAT: nl
LCSH: use Fingo
GPM 1959, HB, IAI, MCA 1986, UIH,
WDH, WH

MFINU (Zaire)

variants Bafumungu, Bamfinu,
Bamfumu, Bamfumungu, Fumu,

Funika, Mfumu, Mfumungu,
Mfunu, Mfunuka, Mfununga

note Bantu language
AAT: use Fumu
LCSH: nl
BS, CK, DDMM, DP, DPB 1987, ETHN,
GPM 1959, GPM 1975, HB, IAI, JMOB,
JV 1966, KK 1965, MGU 1967, MLF, OB
1973, OBZ, RLD 1974, RSW, WH, WRB
DPB 1985*, JV 1966*

MFUMTE (Cameroun)

variants Bakaka, Kaka

note Bantu language; subcategory of
Mbembe; one of the groups
included in the collective term
Bamenda
AAT: nl
LCSH: Mfumte
BS, DDMM, ETHN, GDR, GPM 1959,
GPM 1975, HAB, HB, HMC, IAI, IEZ, JK,
JP 1953, JTSV, KFS 1989, MGU 1967,
MMML, PH, RFT 1974, RJ 1958, RWL,
SV, TN 1986, UIH, WEW 1973, WH,
WRNN
GDR*, LP 1993*, PAG*, PMK*

see also Bamenda, Mbembe

Mfumu *see* MFINU

Mfumungu *see* MFINU

MFUNU (Congo Republic)

variants Bafumu, Bamfunu

note Bantu language; subcategory of
Teke
AAT: nl
LCSH: nl
FW, HB, JMOB, JV 1973

see also Teke

Mfunu *see* MFINU

Mfunuka *see* MFINU

Mfununga *see* MFINU

MIANGBA (Zaire)

note Southern Ubangian language
AAT: nl
LCSH: nl
DB 1978, DDMM

Mida *see* MIDA'A

MIDA'A (Chad)
variants Mida
note Chadic language; subcategory
of Kotoko sometimes referred to
as Southern Kotoko
AAT: nl
LCSH: nl
AML, DB, DWMB
see also Kotoko
Midob *see* MIDOBI
MIDOBI (Sudan)
variants Meidob, Midob
note Eastern Sudanic language; one
of the groups included in the
collective term Nubians
AAT: nl
LCSH: nl
ATMB, ATMB 1956, DDMM, ETHN,
GPM 1959 , GPM 1975, HB, ICWJ, JG
1963, RJ 1959, UIH, WH
CSBS*
see also Nubians
MIGILI (Nigeria)
variants Gili
note Benue-Congo language;
subcategory of Koro, sometimes
referred to as Koro of Lafia
AAT: nl
LCSH: Migili language
DDMM, ETHN, GPM 1959, RWL, WH
see also Koro
Mijikenda *see* NYIKA
Mileke *see* BAMILEKE
MILEMBWE (Zaire)
variants Bamilembwe
note Bantu language; subcategory of
Songye
AAT: nl
LCSH: nl
DDMM, DPB 1987, JMOB, OB 1961
LES*
see also Songye
Mime *see* MIMI
MIMI (Chad)
variants Mime
note Nilo-Saharan language. Most
now speak Arabic.

AAT: nl
LCSH: nl
AML, ATMB, ATMB 1956, DWMB,
DDMM, ETHN, GPM 1959, GPM 1975,
HB, HBDW, JG 1963, IAI, JD, UIH, WG
1980, WH
Mina *see* GE
Mindassa *see* NDASA
Mindumu *see* NDUMBO
MINIANKA (Mali)
variants Minyanka
note Gur language; sometimes
considered a Senufo subcategory
AAT: Minianka
LCSH: Minianka
CDR 1987, CK, DDMM, DWMB, ETHN,
ELZ, GPM 1959, GPM 1975, HB, HBDW,
HH, IAI, JD, JG 1963, JK, JLS, JPB, KFS,
LPR 1986, RGL, RJ 1958, SMI, WG 1980,
WH, WS
BH 1966*
see also Senufo
Minungo *see* MINUNGU
MINUNGU (Angola, Zaire, Zambia)
variants Minungo
note Bantu language
AAT: nl
LCSH: nl
DDMM, DPB 1985, DPB 1987, ETHN,
GPM 1959, GPM 1975, HB, JV 1966, KK
1965, OB 1961, OB 1973, TERV, UIH,
WVB
Minyanka *see* MINIANKA
MIRIAM (Nigeria)
note Chadic language; one of the
groups included in the collective
term Kofyar
AAT: nl
LCSH: nl
DDMM, ETHN, GPM 1959, GPM 1975,
HB, JG 1963, RWL, WS
see also Kofyar

MISAJE (Cameroun)
variants Metcho, Metscho, Missaje
note subcategory of Mbembe; one of
the groups included in the
collective term Bamenda
AAT: nl
LCSH: nl
DDMM, GPM 1959, GPM 1975, IEZ, KK
1960, LP 1993, PH
PMK*
see also Bamenda, Mbembe

Missaje *see* MISAJE
Mitoko *see* METOKO
Mitshi *see* TIV
Mitshogho *see* TSOGO
Mitsogho *see* TSOGO
Mitsogo *see* TSOGO

MITTU (Sudan)
note Central Sudanic language;
subcategory of Zande
AAT: nl
LCSH: nl
ESCK, ETHN, GPM 1959, GPM 1975, JG
1963, WS
see also Zande

Mituku *see* METOKO

MIUTINI (Kenya)
note Bantu language; one of the
groups included in the collective
term Meru
AAT: nl
LCSH: nl
ETHN, JMGK
see also Meru

MME (Cameroun)
note Bantoid language
AAT: nl
LCSH: nl
DDMM, ETHN, MMML
LP 1993*, PH*

Mo *see* DEGHA
Mo Dyamu *see* DEGHA
Moa *see* MOBA

MOBA (Burkina Faso, Ghana, Togo)
variants Moa, Mowa, Mwaba
note Gur language; subcategory of
Bimoba; one of the groups

inlcuded in the collective term
Mwaba-Gurma
AAT: Moba
LCSH: Moba
BS, DDMM, DWMB, EPHE 4, ETHN,
GPM 1959, GPM 1975, HAB, HB, HBDW,
HCDR, IAI, JG 1963, JLS, KK 1965, MPF
1992, RJ 1958, SMI, TP, UIH, WG 1980,
WH, WRNN
JCF*, MM 1951*, MM 1952*
see also Bimoba, Mwaba-Gurma

Mobadi *see* BATI (Zaire)
Mobali *see* BALI (Zaire)
Mobati *see* BATI (Zaire)
Mobindja *see* BINJA
Mobutu Sese Seko, Lake *see*
Toponyms Index
Mofa *see* MATAKAM
Mofou *see* MOFU

MOFU (Cameroun)
variants Mofou
subcategories Diamare, Gudur
note Chadic language; one of the
groups included in the collective
term Kirdi. Some distinguish
between Mofu and Gudur.
AAT: nl
LCSH: use Mofu, Northern; Mofu, Southern
AML, BEL, BS, DB, DDMM, DWMB,
ETHN, GPM 1959, HB, IAI, IEZ, JG 1963,
JLS, JP 1953, MPF 1992, RJ 1958
EPHE 10*
see also Kirdi

MOGAMAW (Cameroun)
variants Mogamo
note Bantoid language; subcategory
of Widekum; one of the groups
included in the collective term
Bamenda
AAT: nl
LCSH: nl
DDMM, GPM 1959, IEZ, LP 1993, PH
PMK*
see also Bamenda, Widekum

Mogamo *see* MOGAMAW
Mogwandi *see* NGBANDI

MOKULU (Chad)
 note Chadic language
 AAT: nl
 LCSH: Mokulu language
 DDMM, ETHN
Mole *see* MOSSI
Mom *see* BAMUM
Mombesa *see* MBESA
Mombouttous *see* MANGBETU
Momfu *see* MAMVU
Momvo *see* MAMVU
Momvu *see* MAMVU
Monbuttoo *see* MANGBETU
Mondari *see* MANDARI
Mondunga *see* NDUNGA
Mongelima *see* NGELIMA
MONGO (Zaire)
 note Bantu language, a collective
 term that includes Bokongo,
 Bokote, Bolemba, Bombwanja,
 Boonde, Ekonda, Eleku, Ibeke,
 Imoma, Kota, Kutu, Lifumba,
 Mbelo, Mbole, Mbuli, Mpama,
 Ngandu, Nkundo, Ntomba,
 Ohendo, Saka, Tswa, and
 numerous other groups, more or
 less Mongo-related or Mongo-
 influenced. (Many of them are
 listed under separate entries).
 AAT: nl
 LCSH: Mongo
 BES, BS, CFL, CK, DDMM, DPB 1985,
 DPB 1986, DPB 1987, DWMB, ETHN,
 GAH 1950, GPM 1959, GPM 1975, HAB,
 HB, HBU, HBDW, IAI, JC 1971, JC 1978,
 JJM 1972, JK, JLS, JMOB, JV 1966, JV
 1984, LJPG, MUD 1991, OB 1973, OBZ,
 ROMC, RSW, SMI, UIH, WEW 1973, WG
 1980, WG 1984, WH, WS
 GAH*, GAH 1938*, GHDV*, JOJ*
MONGOBA (Zaire)
 note Western Ubangian language
 AAT: nl
 LCSH: nl
 DB 1978, DDMM
Mongwandi *see* NGBANDI

MONJOMBO (Congo Republic,
 Zaire)
 variants Monzombo
 note Western Ubangian language
 AAT: nl
 LCSH: Monjombo
 ATMB, ATMB 1956, DB 1978, DDMM,
 DPB 1987, ETHN, HB, HBDW, IAI, JG
 1963, MPF 1992, OBZ, UIH
MONO (Zaire)
 note Central Ubangian language
 AAT: nl
 LCSH: nl
 ATMB 1956, DDMM, DPB 1987, DWMB,
 ETHN, GAH 1950, HB, HBU, JMOB, OBZ
MONOMOTAPA (Zimbabwe)
 note the name of both the founder
 and 15th century empire of the
 Karanga, who were descendents
 of the builders of Great
 Zimbabwe. They were supplanted
 and driven north by the Rozvi
 empire in the 17th century.
 AAT: Monomotapa
 LCSH: Monomotapa Empire
 CDR 1985, ELZ, FW, GBJM, HB, JL,
 JMOB, WH, WRB 1959
 see also Great Zimbabwe, Karanga
MONTOL (Nigeria)
 note Chadic language
 AAT: Montol
 LCSH: nl
 DDMM, EB, EE, ETHN, FW, GPM 1959,
 HB, JG 1963, JK, MKW 1978, NOI, RFT
 1974, RGL, RSRW, RWL, TP, WBF 1964,
 WG 1980, WRB, WRNN, WS
MONYA (Zaire)
 note Bantu language
 AAT: nl
 LCSH: nl
 DPB 1987, HBU
Monzombo *see* MONJOMBO
Moors *see* MAURES
Moose *see* MOSSI

MOPTI (Mali)

note ancient culture; town on the Niger River; French colonial administrative district.

AAT: Mopti
LCSH: nl
AF, EBR, ELZ, EWA, FW, HBDW, JAF, JL, JM, JV 1984, KFS, LPR 1986, MG, PMPO, PRM, ROMC, SMI, SV, TFG, WG 1980, WG 1985, WOH, WRB
BEG 1985*

MORO (Sudan)

note Kordofanian language; one of the groups included in the collective term Nuba

AAT: nl
LCSH: nl
ATMB, ATMB 1956, BS, CSBS, DDMM, ETHN, GPM 1959, GPM 1975, HBDW, JG 1963, MPF 1992
SFN*

see also Nuba

Moroa *see* MORWA

Moronou *see* MORONU

MORONU (Côte d'Ivoire)

variants Moronou

note Kwa language; subcategory of Anyi

AAT: nl
LCSH: nl
DDMM, SV, ENS

see also Anyi

MORU (Sudan, Uganda, Zaire)

note Central Sudanic language; referred to with the Madi as Moru-Madi

AAT: nl
LCSH: Moru language
ATMB, ATMB 1956, DPB 1987, DWMB, ETHN, GPM 1959, GPM 1975, HAB, HB, JG 1963, JMOB, RJ 1959, UIH, WH

see also Madi

MORWA (Nigeria)

variants Asolio, Moroa, Sholio

note Benue-Congo language

AAT: nl
LCSH: nl
DDMM, ETHN, HB, DDMM, GPM 1959, JG 1963, RWL, SD, UIH

Mosi *see* MOSSI

MOSSI (Guinea, Burkina Faso, Togo)

variants Mole, Moose, Mosi

note Gur language. The term Moose seems currrently prefererd to the more conventional Mossi. The Mossi kingdom or Mossi states, circa 1500-1900, were formed in the 16th century by Dagomba horsemen from Ghana called Nakomse, and established rule over various local populations, such as the Dogon, Gurmantche, Gurunsi, and Kurumba. The subjugated groups were collectively called Tengabisi, 'children of the earth,' and fall into three categories: Nyonyosi, who are the descendants of farmers, the Saya, who are blacksmiths, and Sikomse. see CDR 1987*

AAT: Mossi
LCSH: Mossi
AF, AW, BES, BS, CDR 1985, CFL, CK, CMK, DDMM, DFM, DOA, DP, DWMB, EBR, EEWF, ELZ, ENS, ETHN, EWA, GB, GBJM, GBJS, GPM 1959, GPM 1975, HAB, HB, HBDW, HH, HMC, HRZ, IAI, JAF, JD, JG 1963, JJM 1972, JK, JL, JLS, JM, JP 1953, JPB, JV 1984, KE, KFS, KFS 1989, KK 1960, KK 1965, KMT 1970, LJPG, LM, LPR 1986, MH, MLB, MLJD, MPF 1992, MUD 1991, NIB, PMPO, PSG, RAB, RFT 1974, RGL, RJ 1958, ROMC, RSW, SG, SMI, SV, TB, TFG, TLPM, TP, UIH, WBF 1964, WG 1980, WG 1984, WH, WMR, WOH, WRB, WRB 1959, WRNN, WS
CDR 1987*, CFPK*, EL*, EPS*, MI*

Moswea *see* MOWEA

Motembo *see* TEMBO

MOUKTELE (Cameroun)
 variants Matal
 note Chadic language
 AAT: nl
 LCSH: nl
 BS, DDMM, ETHN, IEZ
Moundang *see* MUNDANG
Mount Elgon Masai *see* KONY
Mousey *see* MUSSEY
Mousgoum *see* MUSGUN
Mousgoun *see* MUSGUN
Moussai *see* MUSSEY
Moussey *see* MUSSEY
Mowa *see* MOBA
MOWEA (Zaire)
 variants Moswea
 note Bantu language; subcategory of
 Ngombe
 AAT: nl
 LCSH: nl
 AWW, HB, HBU, JMOB
 see also Ngombe
Mozabites *see* BENI MZAB
MPAMA (Zaire)
 note Bantu language; subcategory of
 Mongo
 AAT: nl
 LCSH: nl
 DDMM, DPB 1987, ETHN, GAH 1950,
 GPM 1959, HB, HBDW, IAI, JMOB, OBZ
 see also Mongo
MPANGU (Zaire)
 note Bantu language; subcategory of
 Kongo
 AAT: Mpangu
 LCSH: nl
 DDMM, DPB 1985, GPM 1959, GPM
 1975, MGU 1967, OB 1973, OB 1974,
 UIH, WM, WRB
 see also Kongo
Mpangwe *see* FANG
MPANZA (Zaire)
 variants Bampanza
 note Bantu language; subcategory of
 Songye
 AAT: nl
 LCSH: nl
 DDMM

LES*
 see also Songye
MPASSA (Zaire)
 variants Bena Mpassa
 note Bantu language; subcategory of
 Songye
 AAT: nl
 LCSH: nl
 ELZ, FHCP, JK, KK 1960
 LES*
 see also Songye
Mpasu *see* SALAMPASU
MPE (Zaire)
 variants Mpey
 note Bantu language
 AAT: nl
 LCSH: nl
 DPB 1985, DPB 1987
MPEMBA (Zaire)
 note Bantu language; subcategory of
 Kongo
 AAT: Mpemba
 LCSH: nl
 HB, HBDW, WH, WRB
 see also Kongo
MPESA (Zaire)
 note Bantu language; one of the
 groups included in the collective
 term Losengo
 AAT: nl
 LCSH: nl
 DDMM, MGU 1967
 see also Losengo
Mpey *see* MPE
Mpiemo *see* MBIMU
Mpiin *see* PINDI
MPONDO (South Africa)
 variants Amapondo, Pondo
 note Bantu language; one of the
 groups referred to as Southern
 Nguni
 AAT: use Pondo
 LCSH: use Pondo
 DDMM, ETHN, GPM 1959, GPM 1975,
 HAB, HB, HBDW, HRZ, IAI, JLS, RSW,
 SD, UIH, WDH, WH

MPONGWE (Gabon)

variants Pongwe

note Bantu language; one of the
groups included in the collective
term Myene
AAT: Mpongwe
LCSH: Mpongwe
ASH, BS, CK, DDMM, DOWF, DP, EBR,
ELZ, ETHN, EWA, FW, GB, GBJM, GPM
1959, GPM 1975, HAB, HB, HBDW, IAI,
JD, JL, JP 1953, KFS 1989, KMT 1970, LP
1979, LP 1985, MCA, MGU 1967, RSW,
SMI, TB, UIH, WH, WMR, WRB, WRB
1959, WS
JMG*

see also Myene

MPORORO (Tanzania)

variants Hororo

note Bantu language
AAT: nl
LCSH: nl
ECB, ETHN, HB, IAI, RJ 1960, WOH

MPOTO (Tanzania)

note Bantu language
AAT: nl
LCSH: nl
DDMM, ETHN, GPM 1959, MFMK

Mpuono *see* MPUUN

MPUT (Zaire)

variants Bakwa Mputu, Mputu

note Bantu language
AAT: nl
LCSH: nl
DDMM, DPB 1985, DPB 1987, FHCP,
GAH 1950, GPM 1975, HB, JMOB, OB
1961, OBZ, SMI, UIH

Mputu *see* MPUT

MPUUN (Zaire)

variants Mpuono

note Bantu language
AAT: nl
LCSH: nl
DDMM, ETHN, MGU 1967

Mpyemo *see* MBIMU

MRIMA (Tanzania)

note Bantu language; subcategory of
Swahili
AAT: nl
LCSH: nl
DDMM, ETHN, HB, IAI, MGU 1967

see also Swahili

Muan *see* MWAN

MUBI (Chad)

note Chadic language
AAT: nl
LCSH: nl
DDMM, DWMB, ETHN, GPM 1959, GPM
1975, HB, IAI, JG 1963, MBBH, UIH, WH

Mucubal *see* MUKUBAL

Muera *see* MWERA

Muhaya *see* HAYA

MUKUBAL (Angola)

variants Mucubal

note Bantu language; Ovimbundu
related or influenced.
AAT: nl
LCSH: nl
MLB 1994

MUKULU (Zaire, Zambia)

note Bantu language
AAT: nl
LCSH: nl
DDMM, ETHN, GPM 1959, HB

Mukuni *see* LENJE

MULONDO (Angola)

note Bantu language; one of the
groups included in the collective
term Mbangala
AAT: nl
LCSH: nl
DDMM, GPM 1959

see also Mbangala

MULWI (Cameroun, Chad)

note Chadic language; used as a
collective term to include the
Musgun, Munjuk and Mulwi
AAT: nl
LCSH: Mulwi dialect use Vulum dialect
DDMM, DWMB, ETHN, MPF 1992, UIH

see also Munjuk, Musgun

Mum *see* BAMUM

Mumoye *see* MUMUYE

MUMUYE (Cameroun, Nigeria)
variants Mumoye
note Adamawa language; a
 collective term for various groups
 in Adamawa province including
 the Kumba, Yakoko and others.
 see RWL.
 AAT: Mumuye
 LCSH: Mumuye
 BS, CMK, DDMM, DOA, DWMB, EB,
 ETHN, FW, GPM 1959, GPM 1975, HB,
 JAF, JG 1963, JK, JLS, JTSV, KFS, MKW
 1978, MLB, NOI, PH, RFT 1974, RSRW,
 RWL, SD, SMI, SV, TP, UIH, WG 1980,
 WG 1984, WH, WRB, WRNN, WS
 EE*
see also Kumba, Yakoko
Mun *see* BAMUM
Munchi *see* TIV
MUNDANG (Cameroun, Chad)
variants Moundang
note Adamawa language; one of the
 groups included in the collective
 term Kirdi
 AAT: nl
 LCSH: Mundang
 BEL, BS, DDMM, DWMB, ETHN, GPM
 1959, GPM 1975, HAB, HB, HBDW, IEZ,
 JG 1963, JLS, JP 1953, MPF 1992, RJ
 1958, SMI
 EPHE 7*
see also Kirdi
Mundari *see* MANDARI
MUNDU (Sudan, Zaire)
note Western Ubangian language
 AAT: nl
 LCSH: Mundu
 ATMB, ATMB 1956, DB 1978, DDMM,
 ESCK, ETHN, GAH 1950, GPM 1959,
 GPM 1975, HB, JG 1963, JMOB, UIH,
 WH
MUNGO (Cameroun)
note Bantu language; one of the
 groups included in the Duala-
 Limba group
 AAT: nl
 LCSH: nl
 DDMM, DP, EDA, ETHN, GPM 1959,
 GPM 1975, HB, JLS, RJ 1958
see also Duala-Limba

MUNJUK (Cameroun, Chad)
note Chadic language; one of the
 groups included in the collective
 term Mulwi
 AAT: nl
 LCSH: nl
 DB, DDMM, ETHN
see also Mulwi
Munshi *see* TIV
MURLE (Ethiopia, Sudan)
note Eastern Sudanic language
 AAT: nl
 LCSH: Murle
 AF, ATMB, ATMB 1956, BS, CSBS,
 DDMM, DBNV, ETHN, GPM 1959, GPM
 1975, HAB, HB, IAI, JG 1963, LP 1993,
 RJ 1959, UIH, WEW 1973, WH
 BAL*, ERC*
MURSI (Ethiopia)
variants Murzu
note Eastern Sudanic language
 AAT: nl
 LCSH: use Murzu
 DDMM, ERC, ETHN, GPM 1959, HB, JG
 1963
Murzu *see* MURSI
Musei *see* MUSSEY
Muserongo *see* SOLONGO
Musgoi *see* MUSGOY
MUSGOY (Cameroun)
variants Musgoi
note Chadic language; subcategory
 of Daba
 AAT: nl
 LCSH: Musgoy language use Daba
 language
 DDMM, ETHN, GPM 1959
see also Daba
Musgu *see* MUSGUN
Musgum *see* MUSGUN

MUSGUN (Cameroun, Chad)
variants Mousgoum, Mousgoun,
 Musgu, Musgum, Muzuk
note Chadic language; one of the
 groups included in the collective
 terms Kirdi and Mulwi
 AAT: nl
 LCSH: nl
 AF, BEL, DDMM, DWMB, ELZ, ETHN,
 GPM 1959, HB, IAI, IEZ, JG 1963, JP
 1953, JPAL, LJPG, MPF 1992, RJ 1958,
 RS 1980, SD, UIH, WH, WOH
see also Kirdi, Mulwi
Mussai *see* MUSSEY
MUSSEY (Chad, Cameroun)
variants Mousey, Moussai,
 Moussey, Musei, Mussai, Mussoi
note Chadic language; one of the
 groups included in the collective
 term Massa
 AAT: nl
 LCSH: nl
 DDMM, ETHN, GBJM, GPM 1959, HB,
 HMC, MH, MPF 1992
 IDG*
see also Massa
Mussoi *see* MUSSEY
MUTHAMBI (Kenya)
note Bantu language; one of the
 groups included in the collective
 term Meru
 AAT: nl
 LCSH: nl
 DDMM, ECB, ETHN, HB, JMGK
see also Meru
MUTI (Cameroun)
note Bantoid language; subcategory
 of Bali
 AAT: nl
 LCSH: nl
 PMK
see also Bali
MUTURUA (Cameroun)
note Chadic language
 AAT: nl
 LCSH: nl
 ETHN, GPM 1959
Muzuk *see* MUSGUN

MVAE (Cameroun, Gabon)
variants Mvai
note Bantu language; subcategory of
 Fang; Fang style/culture division.
 see LP*.
 AAT: nl
 LCSH: nl
 BS, DDMM, ELZ, ETHN, GAC, GPM
 1959, JAF, JK, HB, IEZ, JV 1984, MPF
 1992, MUD 1986, WH, WS
 LP 1979*, LP 1985*, LP 1990*
see also Fang
Mvai *see* MVAE
MVELE (Cameroun)
note Bantu language
 AAT: nl
 LCSH: use Basa
 DDMM, ETHN, GPM 1959, GPM 1979,
 HB, LP 1990
Mvuba *see* MBUBA
Mvumbo *see* NGUMBA
Mwaba *see* MOBA
MWABA-GURMA (Togo)
note a collective term for various
 populations in Togo showing
 either Moba (Mwaba) or Gurma
 influences
 AAT: nl
 LCSH: nl
 JLS
 EPHE 4*
Mwaghavul *see* SURA
MWAMBA (Malawi, Tanzania)
note Bantu language
 AAT: nl
 LCSH: Mwamba language
 DDMM, ETHN, GPM 1959, UIH
MWAN (Côte d'Ivoire)
variants Muan
note Mande language
 AAT: nl
 LCSH: nl
 ETHN, WH
 JPB*
see also Mande
Mwana *see* CHAM
Mwanga *see* NYAMWANGA
Mwaushi *see* AUSHI

Mwela *see* MWERA
MWERA (Tanzania)
 variants Muera, Mwela, Wamuera,
 Wamwera
 note Bantu language
 AAT: Mwera
 LCSH: Mwera
 ARW, DDMM, EBHK, ECB, ELZ, ETHN,
 GPM 1959, GPM 1975, HAB, HB, HBDW,
 IAI, JLS, KK 1990, MFMK, MGU 1967,
 OB 1973, RJ 1960, UIH, WEW 1973, WG
 1980, WH
 TEW*
Mweru, Lake *see* Toponyms Index
MWILA (Angola)
 note Bantu language; one of the
 groups included in the collective
 term Mbangala
 AAT: nl
 LCSH: Mwila
 DDMM, ETHN, HB, MLB 1994, UIH
 see also Mbangala
Mwimbe *see* MWIMBI (Kenya)
MWIMBE (Angola)
 variants Amwimbe
 note Bantu language
 AAT: nl
 LCSH: nl
 ECB, ETHN, GPM 1959, GPM 1975,
 HAB, WH
MWIMBI (Kenya)
 variants Mwimbe
 note Bantu language; one of the
 groups included in the collective
 term Meru
 AAT: nl
 LCSH: nl
 DDMM, ECB, ETHN, HB, IAI, RJ 1960,
 UIH
 JMGK*
 see also Meru
Mwona *see* CHAM
MYENE (Gabon)
 note Bantu language; a collective
 term that includes the Adjumba,
 Enenga, Galwa, Mpongwe,
 Nkomi, Rongo, and others
 AAT: nl
 LCSH: Myene

 DDMM, ETHN, HB, IAI, LP 1979, LP
 1985, LP 1990, MPF 1992, SMI, WS
 ERB*
Mzab *see* BENI MZAB

Naath *see* NUER
Nabdam *see* NAMNAM
Nabt *see* NAMNAM
Nafambele *see* NAFANA
NAFANA (Côte d'Ivoire, Ghana)
 variants Nafambele, Nafanra,
 Nafara, Nafarha, Naffara
 note Gur language; subcategory of
 Senufo
 AAT: Nafana
 LCSH: nl
 BH 1966, DDMM, DF, DFHC, DWMB,
 ETHN, GPM 1959, GPM 1975, HB,
 HBDW, HMC, IAI, JD, JG 1963, JPB, KFS
 1989, MLB, RAB, RJ 1958, SV, TP, WH,
 WRB, WRNN, WS
 AJG*, DR*
 see also Senufo
Nafanra *see* NAFANA
Nafara *see* NAFANA
Nafarha *see* NAFANA
Naffara *see* NAFANA
NAGO (Benin)
 note Kwa language; subcategory of
 Yoruba
 AAT: nl
 LCSH: Nago language use Yoruba language
 DDMM, DP, ELZ, ETHN, GPM 1959, HB,
 JD, RJ 1958, RWL
 see also Yoruba
Nakomce *see* NAKOMSE
NAKOMSE (Burkina Faso)
 variants Nakomce
 note Gur language
 AAT: nl
 LCSH: nl
 EPS, JK, MLB, SV
 EPS*
 see also Mossi

Naletale *see* Toponyms Index

NALU (Guinea Bissau)

note West Atlantic language; often linked with the Baga and Landuma
AAT: Nalu
LCSH: Nalu
BS, CMK, DDMM, DP, DWMB, ELZ, ETHN, GPM 1959, GPM 1975, HAB, HB, HH, HMC, IAI, JD, JG 1963, JK, KFS, KFS 1989, LJPG, MH, MLB, MLJD, RFT 1974, RJ 1958, RSRW, RSW, SMI, SV, TB, UIH, WBF 1964, WG 1980, WH, WOH, WRB, WRNN, WS

see also Baga, Landuma

NAMA (Cameroun, Nigeria)

variants Kporo

note Benue-Congo language; one of the groups included in the collective term Tigong
AAT: nl
LCSH: nl
DDMM, ETHN, GPM 1959, GPM 1975, RWL

see also Tigong

NAMA (Namibia, South Africa)

note Khoisan language; subcategory of Khoikhoi. The name 'Nama' is also used for the Khoikhoi in general.
AAT: nl
LCSH: Nama
ATMB 1956, DDMM, ETHN, GPM 1959, GPM 1975, HAB, HB, HBDW, IAI, JG 1963, JM, RGL, TP, UIH, WH
ALB*, WHGH*

see also Khoikhoi

NAMANLE (Côte d'Ivoire)

variants Nanpanle

note Mande language; one of the divisions of Yohure
AAT: nl
LCSH: nl
JPB

see also Yohure

Namba *see* LAMBA

Namchi *see* DOYAYO

NAMIB (Namibia)

note Khoisan language; one of the groups included in the collective term Bushmen
AAT: nl
LCSH: Namib Desert
ALB, ARW, GPM 1959, HBDW, JJM 1972, JM

see also Bushmen

Namji *see* DOYAYO

NAMNAM (Ghana)

variants Nabdam, Nabt

note Gur language; one of the groups included in the collective term Frafra
AAT: nl
LCSH: Namnam
DDMM, DWMB, ETHN, FTS, GPM 1959, GPM 1975, HB, HCDR, JG 1963, UIH, WFJP

see also Frafra

Namshi *see* DOYAYO

NANAFUE (Côte d'Ivoire)

note Kwa language; subcategory of Baule
AAT: nl
LCSH: nl
JPB

see also Baule

Nande *see* KONJO

NANDI (Kenya)

note Southern Nilotic language; not to be confused with the Nande of Zaire, who speak a Bantu language; one of the groups included in the collective term Nilo-Hamitic people
AAT: nl
LCSH: Nandi
ATMB, ATMB 1956, CSBS, DDMM, ECB, ETHN, GPM 1959, GPM 1975, GWH, HAB, HBDW, IAI, JG 1963, LJPG, MCA 1986, RJ 1960, RSW, SD, SMI, UIH, WEW 1973, WH
GWH 1953*, GWH 1969*, MTL*

see also Nilo-Hamitic people

Nankani *see* GURENSI

Nankanse *see* GURENSI
Nanpanle *see* NAMANLE
Nantaka *see* Toponyms Index
NANUMBA (Ghana)
 note Gur language
 AAT: nl
 LCSH: nl
 DDMM, DWMB, ENS, ETHN, GPM 1959,
 GPM 1975, HB, HCDR, LPR 1986, MM
 1950
Naoudemba *see* NAUDEM
NAPATA (Sudan)
 note ancient city and civilization on
 the Nile River; capital of the
 kingdom of Nubia
 AAT: nl (uses Napatan)
 LCSH: Napata (extinct city)
 BD, HB, MLB, TP, UGH, WH
NAPORE (Uganda)
 note Eastern Nilotic language; one
 of the groups included in the
 collective term Nilo-Hamitic
 people
 AAT: nl
 LCSH: nl
 DDMM, GPM 1959, HB, WH
 PGPG*
 see also Nilo-Hamitic people
Naqa *see* Toponyms Index
Nara *see* BAREA
NARON (Botswana)
 variants Nharo San, Nharon
 note Khoisan language; one of the
 groups included in the collective
 term Bushmen
 AAT: nl
 LCSH: Naron
 ARW, ATMB 1956, DDMM, ETHN, GPM
 1959, GPM 1975, HB, HBDW, HRZ, IAI,
 JG 1963, JJM 1972, RS 1980, RSRW, SMI,
 UIH, WH
 ALB*, IS*
 see also Bushmen
NATA (Tanzania)
 note Bantu language
 AAT: nl
 LCSH: nl
 ETHN, GPM 1975, HB, MFMK
Natal *see* Toponyms Index

NATIORO (Burkina Faso)
 note Gur language
 AAT: nl
 LCSH: nl
 DDMM, ETHN, GPM 1959, GPM 1975,
 JG 1963, RJ 1958
Naudeba *see* NAUDEM
NAUDEM (Togo)
 variants Losso, Naoudemba,
 Naudeba, Naudemba, Nawdam,
 Nawdba
 note Gur language
 AAT: nl
 LCSH: nl
 BS, DDMM, DWMB, ETHN, GPM 1959,
 HB, HBDW, IAI, JCF, JLS, KK 1965, MPF
 1992, RJ 1958, UIH, WH
Naudemba *see* NAUDEM
Nawdam *see* NAUDEM
Nawdba *see* NAUDEM
Nbaka *see* NGBAKA
Nchumbulu *see* CANGBORONG
Nchumuru *see* CANGBORONG
Ndaaka *see* NDAKA
NDAKA (Zaire)
 variants Bandaka, Bwandaka,
 Ndaaka
 note Bantu language
 AAT: nl
 LCSH: nl
 DDMM, DPB 1987, ESCK, ETHN, FHCP,
 GAH 1950, GPM 1959, GPM 1975, HAB,
 HB, HBDW, IAI, JMOB, OBZ, UIH, WH
 HVG 1960*
NDALI (Tanzania)
 variants Bundali
 note Bantu language
 AAT: nl
 LCSH: nl
 DDMM, ECB, ETHN, GPM 1959, GPM
 1975, HB, MFMK, RJ 1960, UIH
NDAMBA (Tanzania)
 variants Wandamba
 note Bantu language
 AAT: nl
 LCSH: nl
 DDMM, ECB, ETHN, GPM 1959, HB,
 MFMK, RJ 1960, UIH

NDAMBOMO (Gabon)
 note Bantu language; subcategory of
 Kota
 AAT: nl
 LCSH: nl
 JAF
 LP 1979*, LP 1985*
 see also Kota
Ndande *see* NANDE
NDASA (Congo Republic, Gabon)
 variants Bandassa, Mindassa,
 Ndassa
 note Bantu language; subcategory of
 Kota
 AAT: nl
 LCSH: nl
 AW, CDR 1985, DDMM, GPM 1959, HB,
 LP 1979, MLJD, MUD 1986, SV, WH, WS
 LP 1985*
 see also Kota
Ndassa *see* NDASA
NDAU (Mozambique, Zimbabwe)
 variants Sofala, Vandau
 subcategories Shanga
 note Bantu language; subcategory of
 Shona
 AAT: nl
 LCSH: Ndau language
 BS, DDMM, ETHN, GPM 1959, HB, JLS,
 MGU 1967, PG 1990, RJ 1961, UIH, WH,
 WOH
 see also Shona
NDE (Nigeria)
 note Bantoid language; subcategory
 of Ejagham; one of the groups
 included in the Ekoid language
 cluster
 AAT: nl
 LCSH: nl
 DDMM, GIJ, GPM 1959, HB, RWL, UIH
 see also Ejagham
NDEBELE (South Africa,
 Zimbabwe)
 variants Amandebele, Mandebele
 subcategories Ndzundza
 note Bantu language. Having
 absorbed many different groups,
 they are divided into three
 categories: Zansi, people from
 down countries; Enhla, people
 from up countries; Holi, people of
 Shona-Kalanga origins.
 AAT: Ndebele
 LCSH: Ndebele
 ACN, AF, BS, DDMM, DOA, EBR, ELZ,
 ETHN, GPM 1959, GPM 1975, HAB, HB,
 HRZ, IAI, JLS, JM, JV 1966, LJPG, LSD,
 MCA 1986, MGU 1967, MHN, MLJD, PG
 1990, PMPO, RGL, RJ 1961, ROMC,
 RSW, SMI, TP, UIH, WDH, WH, WRB,
 WRNN, WVB
 HKVV*, MCC*
Ndem *see* NNAM
Ndembo *see* NDEMBU
NDEMBU (Angola, Zaire, Zambia)
 variants Andembu, Ndembo
 note Bantu language
 AAT: Ndembu
 LCSH: Ndembu
 BS, CFL, DDMM, DFHC, DPB 1987,
 ETHN, FN 1994, GAH 1950, GPM 1959,
 GPM 1975, HB, IAI, JC 1971, JK, JLS,
 JMOB, JV 1966, MHN, MLB 1994, NIB,
 OB 1961, RGL, RJ 1961, ROMC, SMI,
 UIH, WRB, WVB
 ELBT*, VWT*
Ndendeule *see* NDENDEULI
NDENDEULI (Tanzania)
 variants Ndendeule, Ndeneuli
 Wandendehule
 note Bantu language; includes
 several important groups of Ngoni
 rulers
 AAT: nl
 LCSH: use Ndendeule
 DDMM, ECB, HB, IAI, MFMK, RJ 1960,
 UIH
 PHG 1971*
 see also Ngoni
Ndeneuli *see* NDENDEULI
NDENGEREKO (Tanzania)
 variants Ndereko
 note Bantu language
 AAT: nl
 LCSH: nl
 DDMM, GPM 1959, UIH

NDENGESE (Zaire)
variants Bonkese, Dekese, Dengese, Ndenkese
note Bantu language
AAT: Ndengese
LCSH: use Dengese
ALM, ASH, CDR 1985, CK, DP, DPB 1987, EBHK, EEWF, ELZ, ETHN, FN 1994, FW, GAH 1950, GPM 1959, GPM 1975, HAB, HB, HBDW, HH, JC 1971, JC 1978, JD, JK, JMOB, JTSV, JV 1984, KFS, KMT 1970, LM, MFMK, MHN, MLB, MLJD, OB 1973, OBZ, RSW, SMI, TB, TERV, TP, UIH, WBF 1964, WG 1980, WG 1984, WH, WRB, WRNN, WS ALG*

Ndenkese *see* NDENGESE

NDENYE (Côte d'Ivoire)
variants Indenie
note Kwa language; subcategory of Anyi
AAT: nl
LCSH: nl (uses Anyi)
DDMM, DWMB, ENS, GPM 1959, SV, WRB 1959
see also Anyi

Ndereko *see* NDENGEREKO

Nderobo *see* DOROBO

Ndhir *see* BENI M'TIR

NDIBU (Zaire)
variants Bandibu, Matadi
note Bantu language; subcategory of Kongo
AAT: nl
LCSH: nl
DDMM, DPB 1985, HB, JC 1971, JMOB, MGU 1967, OB 1973, OBZ, SG, WM
see also Kongo

Ndiga *see* HADZAPI

NDIKI (Cameroun)
note Bantu language; subcategory of Banen
AAT: nl
LCSH: Ndiki
GPM 1959, MMML, RJ 1958, RS 1980
see also Banen

NDIMBA (Angola)
AAT: nl
LCSH: nl
MLB 1994

Nditam *see* DITAM

Ndjaal *see* NZADI

Ndjabi *see* NJABI

Ndjinini *see* DJIKINI

NDO (Uganda, Zaire)
variants Do, Oke'bu, Okebo, Okebu
note Central Sudanic language
AAT: nl
LCSH: nl
ATMB, ATMB 1956, DDMM, DPB 1987, DWMB, ECB, ELZ, ESCK, ETHN, GAH 1950, GPM 1959, GPM 1975, HAB, HB, IAI, OBZ, RAB, SMI, WH

Ndob *see* NDOP

NDOBO (Cameroun)
note Bantu language; peoples related to or predecessors of the Tikar
AAT: nl
LCSH: nl
DDMM, PH
LP 1993*

NDOGO (Central African Republic, Sudan)
note Western Ubangian language
AAT: nl
LCSH: nl
ATMB, ATMB 1956, BS, DDMM, ETHN, GPM 1959, GPM 1975, HB, HBDW, IAI, JG 1963, RJ 1959, UIH, WH
STS*

Ndogo *see* HUTU

NDOLO (Zaire)
variants Bakwa Ndolo
note Bantu language; one of the groups included in the Losengo cluster
AAT: nl
LCSH: nl
DDMM, DPB 1987, ETHN, GAH 1950, GBJS, HB, HBU, MGU 1967, TERV
see also Losengo

NDOMBE (Angola)

note Bantu language; one of the
groups included in the collective
term Mbangala
AAT: nl
LCSH: nl
DDMM, ETHN, GPM 1959, HB, MGU
1967, UIH, WH, WS
see also Mbangala

NDONDE (Tanzania)

variants Wandonde

note Bantu language
AAT: nl
LCSH: nl
DDMM, ECB, ETHN, GPM 1959, GPM
1975, HB, HBDW, KK 1990, MGU 1967,
UIH

NDONGA (Angola, Namibia)

note Bantu language
AAT: nl
LCSH: Ndonga
DDMM, ETHN, GPM 1959, HB, IAI,
MGU 1967, UIH

Ndongo *see* MBUNDU

NDONI (Nigeria)

note Kwa language; sometimes
considered a subcategory of Igbo
AAT: nl
LCSH: nl
RWL
CFGJ*, VCU 1965*
see also Igbo

NDOP (Cameroun)

variants Ndob

note Bantoid language; congeries of
small chiefdoms; independent
chiefdom of Tikar; one of the
groups included in the collective
terms Bamenda and Tikar
AAT: nl
LCSH: nl
DDMM, ETHN, GPM 1959, HB, IEZ, PH,
RFT 1974
LP 1993*, MMML*, PMK*
see also Bamenda, Tikar

NDORO (Cameroun, Nigeria)

note Bantoid language
AAT: nl
LCSH: nl
DDMM, ETHN, GPM 1959, GPM 1975,
HB, HBDW, JG 1963, RWL, WEW 1973,
WH

Ndorobo *see* DOROBO

Ndoumou *see* NDUMBO

NDU (Cameroun)

note one of the groups included in
the collective term Bamenda
AAT: nl
LCSH: nl
EBHK, GPM 1959, HB, LP 1993, PH
see also Bamenda

NDULU (Angola)

note Bantu language; one of the
groups included among the
Ovimbundu
AAT: nl
LCSH: nl
GPM 1959, UIH, WS
see also Ovimbundu

NDUMBO (Congo Republic, Gabon)

variants Andumbo, Mindumu,
Ndoumou, Ndumbu, Ndumu,
Ondoumbo, Ondumbo

note Bantu language, subcategory of
Kota
AAT: Ndumbo
LCSH: Ndumbo language use Ndumu
language
CDR 1985, CK, DDMM, DP, ELZ, ETHN,
GPM 1959, GPM 1975, HAB, HB, JAF,
JK, JV 1984, KK 1965, LP 1979, LP 1985,
MUD 1986, SV, WH, WRB, WS
see also Kota

Ndumbu *see* NDUMBO

Ndumu *see* NDUMBO

Ndunda *see* VIDUNDA

NDUNGA (Zaire)

variants Mondunga

note South-Central Ubangian
language
AAT: nl
LCSH: nl
ATMB 1956, DB 1978, DDMM, ETHN,
HB, IAI, JG 1963, JMOB, WEW 1973

Ndzabi *see* NJABI

Ndzem *see* NYEM

Ndzimu *see* NZIMU

NDZUNDZA (South Africa)
 note Bantu language; subcategory of
 Ndebele
 AAT: nl
 LCSH: Ndzundza language use Ndebele
 language
 DDMM, ETHN, GPM 1959, HB, JLS,
 WDH
 see also Ndebele

Nefousa *see* NEFUSA

NEFUSA (Libya)
 variants Jabal-Nafusah, Nefousa
 note Berber language; one of the
 groups included in the collective
 term Berber
 AAT: nl
 LCSH: nl
 DDMM, ETHN, GPM 1959, WH
 see also Berber

NEMADI (Mali, Mauritania)
 note unclassified language,
 probably a mixture of Azer,
 Berber and Hassaniya
 AAT: nl
 LCSH: Nemadi dialect use Nimadi dialect
 ETHN, RJ 1958, WH
 LCB*

NEMBE (Nigeria)
 variants Brass
 note Kwa language; subcategory of
 Ijo
 AAT: nl
 LCSH: Nembe language
 DDMM, ETHN, GPM 1959, HB, RJ 1958,
 RWL, WRB, WS
 see also Ijo

Nera *see* BAREA

NEYO (Côte d'Ivoire)
 note Kwa language
 AAT: nl
 LCSH: nl
 CK, DDMM, ETHN, GPM 1959, HB, RJ
 1958, UIH
 JPB*

NGALA (Zaire)
 variants Bangala, Gens d'Eau
 note Bantu language; frequently
 used as a collective term for
populations in northwestern Zaire
also called the Gens d'Eau; one of
the groups included in the
collective term Ngiri; not to be
confused with the Bangala in
Angola
 AAT: nl
 LCSH: use Bangala
 ASH, AW, BES, CDR 1985, CK, DDMM,
 DP, DPB 1985, DPB 1987, ETHN, EWA,
 GB, GPM 1959, GPM 1975, HAB, HB,
 HBDW, IAI, JG 1963, JMOB, KK 1965,
 LJPG, MLJD, MPF 1992, RGL, RJ 1959,
 RS 1980, RSW, SD, SMI, SV 1988, TLPM,
 UIH, WEW 1973, WH, WOH, WS
 HBU*
 see also Ngiri

NGALANGI (Angola)
 note Bantu language; one of the
 groups included among the
 Ovimbundu
 AAT: nl
 LCSH: nl
 GPM 1959, HB, UIH, WS
 see also Ovimbundu

NGAMA (Chad, Central African
 Republic)
 note Central Sudanic language
 AAT: nl
 LCSH: Ngama
 DDMM, ETHN, GPM 1959, HB

NGAMBAI (Chad)
 note Central Sudanic language
 AAT: nl
 LCSH: Ngambai dialect use Gambai dialect
 DDMM, ETHN, HB

NGAMBE (Cameroun)
 note Bantoid language; one of the
 Tikar chiefdoms
 AAT: nl
 LCSH: nl
 DDMM, ETHN, KK 1960, PH
 LP 1993*, PAG*, PMK*
 see also Tikar

Ngami, Lake *see* Toponyms Index

Ngan *see* GAN (Côte d'Ivoire)

NGANDA (Angola)

note Bantu language; one of the groups included in the collective term Mbangala

AAT: nl

LCSH: nl

GPM 1959, HB, MLB 1994, UIH

see also Mbangala

Ngando *see* NGANDU (Zaire)

NGANDO (Central African Republic)

note Bantu language

AAT: nl

LCSH: use Ngandu

DDMM, ETHN

NGANDU (Zaire)

variants Bangandu, Ngando

note Bantu language; one of the groups included in the collective term Mongo; not related to the Ngando of the Central African Republic

AAT: nl

LCSH: nl

DDMM, ETHN, GPM 1959, GPM 1975, HB, JMOB, RS 1980, SMI, UIH, WH, WOH

see also Mongo

NGANDYERA (Angola)

note Bantu language

AAT: nl

LCSH: nl

DDMM, ETHN, MGU 1967

NGANGELA (Angola, Zambia)

variants Ganguella

note Bantu language; a collective term used by the Ovimbundu to refer to such ethnic groups as the Lwimbi, Luchazi, Mbunda, Mbwela, Nyemba and Tschitunda

AAT: nl

LCSH: Ngangela

BES, BS, DDMM, DPB 1987, EBR, ETHN, FHCP, GPM 1975, HAB, HB, IAI, JK, JLS, JM, KK 1960, KK 1965, MGU 1967, MLB 1994, RGL, RSW, SMI, UIH, WH

MEM*

Ngangte *see* BANGANGTE

NGARE (Congo Republic)

note Bantu language

AAT: nl

LCSH: nl

DDMM, HB, IAI, MGU 1967, WS

N'gas *see* ANGAS

NGATA (Zaire)

variants Wangata

note Bantu language

AAT: nl

LCSH: nl

BES, CFL, CK, DDMM, DPB 1987, ELZ, ETHN, GPM 1959, GPM 1975, HBDW, IAI, JMOB, LJPG, RSW

NGBAKA (Central African Republic, Zaire)

variants Bouaka, Bwaka, Gbaka, Mbaka, Nbaka

note Western Ubangian language

AAT: Ngbaka

LCSH: Ngbaka

AF, ALM, ASH, ATMB, ATMB 1956, BES, BS, CDR 1985, CFL, CK, CMK, DDMM, DFHC, DPB 1986, DPB 1987, EB, EBHK, EBR, ELZ, ESCK, ETHN, FHCP, GAH 1950, GBJS, GPM 1959, GPM 1975, HAB, HB, HJK, IAI, JC 1971, JC 1978, JD, JG 1963, JK, JLS, JMOB, LM, MCA, MH, MLB, MLJD, MPF 1992, OBZ, RGL, RS 1980, RSW, SMI, SV, TERV, TP, UIH, WBF 1964, WG 1980, WH, WMR, WOH, WRB, WRNN, WS

HBU*

NGBAKA MABO (Central African Republic)

variants Ma'bo, Mabo

note Western Ubangian language

AAT: nl

LCSH: Ngbaka-Ma'bo

ATMB, ATMB 1956, BS, DB 1978, DDMM, DPB 1987, ETHN, GAH 1950, HB, HBU, JMOB, OBZ, SMI

NGBAN (Côte d'Ivoire)

note Kwa language; subcategory of Baule

AAT: nl

LCSH: nl

JPB

see also Baule

NGBANDI (Central African Republic, Zaire)
variants Gbandi, Mogwandi, Mongwandi
note Western Ubangian language
AAT: Ngbandi
LCSH: Ngbandi language
AF, ATMB, ATMB 1956, BES, BS, CDR 1985, CFL, CMK, DDMM, DPB 1987, DWMB, EBR, ELZ, ETHN, GAH 1950, GPM 1959, GPM 1975, HAB, HBDW, HBU, IAI, JC 1971, JC 1978, JD, JG 1963, JK, JMOB, MLB, MLJD, MUD 1991, OBZ, RSW, TERV, UIH, WG 1980, WH, WOH, WRB, WS
HBU*

Ngbanya *see* GONJA

Ngbe *see* NGBEE

NGBEE (Zaire)
variants Ngbe
note Bantu language
AAT: nl
LCSH: nl
DPB 1987, ETHN, KFS

NGBELE (Zaire)
variants Mangbele
note Central Sudanic language; one of the groups included in the collective term Mangbetu
AAT: nl
LCSH: nl
ATMB 1956, DDMM, DPB 1987, ESCK, ETHN, GAH 1950, GPM 1959, HAB, HB, HBDW, JMOB, OBZ, UIH, WH
JEL*
see also Mangbetu

Ngbetu *see* MANGBETU

Ngbugu *see* MBUGU (Central African Republic)

NGBUNDU (Zaire)
note Ubangian language
AAT: nl
LCSH: nl
ATMB 1956, DDMM, DPB 1987, ETHN, GAH 1950, HB, HBU, OBZ

Nge *see* BASSA-NGE

Ngeend *see* NGEENDE

NGEENDE (Congo Republic, Zaire)
variants Bangyeen, Ngeend, Ngende, Ngendi
note Bantu language; subcategory of Kuba
AAT: nl
LCSH: nl
CDR 1985, DDMM, EBHK, ELZ, ETHN, FHCP, HB, JC 1978, JC 1982, JK, JLS, JV 1978, MLF, TERV, WRB
see also Kuba

NGELIMA (Zaire)
variants Bangelima, Mongelima
note Bantu language; a collective term, sometimes used synonymously with Beo, to refer to the Angba, Buru, Salia and others
AAT: nl
LCSH: nl
DDMM, DPB 1987, ESCK, ETHN, GPM 1959, GPM 1975, HB, IAI, JMOB, MGU 1967, SV
see also Beo

NGEMBA (Cameroun)
note Bantoid language; subcategory of Widekum; one of the groups included in the collective term Bamenda
AAT: nl
LCSH: Ngemba
DDMM, DWMB, ETHN, GPM 1959, GPM 1975, HMC, IAI, IEZ, LP 1993, UIH
GDR*, PMK*
see also Bamenda, Widekum

Ngende *see* NGEENDE

Ngendi *see* NGEENDE

Ngene *see* ENGENNI

NGENGE (Congo Republic, Gabon)
note Bantu language; subcategory of Teke
AAT: nl
LCSH: nl
DDMM, DPB 1985, HB, JV 1973
see also Teke

NGENGE (Nigeria)
note Kwa language; subcategory of
Gbari
AAT: nl
LCSH: nl
DDMM, ETHN, RWL
see also Gbari

NGENGELE (Zaire)
variants Bagengele, Bangengele,
Gengele
note Bantu language
AAT: nl
LCSH: nl
DPB 1985, DPB 1986, DPB 1987, GAH
1950, GPM 1959, GPM 1975, HB, IAI,
JMOB, UIH

NGERE (Côte d'Ivoire, Liberia)
variants Gere, Gere Wobe, Guere,
Guere Wobe, Gwere, We, Wee
note Kwa language; called Kran in
Liberia and Ngere in Côte
d'Ivoire. Numerous sources often
link them with the Dan.
AAT: use Wee
LCSH: use Gere
AF, ASH, BS, CDR 1985, CFL, DDMM,
DP, DWMB, EBR, EEWF, EFLH, ETHN,
EVA, EWA, FW, GBJM, GBJS, GPM
1959, GPM 1975, GSGH, HAB, HB, HH,
HMC, IAI, JD, JEEL, JK, JL, JLS, JP 1953,
JPB, JV 1984, KK 1960, LM, MH, MLB,
MLJD, MUD 1991, RJ 1958, RSAR,
RSRW, RSW, SMI, SV, SV 1986, TB, TP,
UIH, WBF 1964, WH, WRB, WS
GSDS*, PJLV*
see also Kran, Dan-Ngere

Ngi *see* NGIE

NGIE (Cameroun)
variants Ngi
note Bantoid language; subcategory
of Widekum; one of the groups
included in the collective term
Bamenda
AAT: nl
LCSH: nl
DDMM, DWMB, ELZ, ETHN, GPM 1959,
HB, IEZ, WH
LP 1993*, PMK*
see also Bamenda, Widekum

NGINDO (Tanzania)
variants Wagindo, Wangindo
note Bantu language
AAT: Ngindo
LCSH: nl
CDR 1985, DDMM, ECB, ETHN, GPM
1959, GPM 1975, HB, IAI, KK 1990, MGU
1967, RJ 1960, UIH, WG 1980, WH

NGIRI (Zaire)
note Bantu language; a collective
term which includes small
populations in northwestern Zaire,
often referred to collectively as
Ngala or Gens d'Eau. These
groups include the Bamwe, Binza,
Jando, Koto, Lobala, Libinza,
Lobo, Loi, Loki, Losengo cluster,
Makutu, Mampoko, Ngala, Poto
and others.
AAT: nl
LCSH: nl
BES, DDMM, ETHN, GPM 1959, GPM
1975, HB, HBU, MGU 1967, UIH, WH
see also Ngala

NGIZIM (Nigeria)
note Chadic language
AAT: nl
LCSH: Ngizim language
DDMM, GPM 1959, HB, JG 1963, KFS,
UIH, WH

Ngo *see* BABUNGO
Ngobu *see* GOBU
N'goi *see* NGOI
NGOÏ (Côte d'Ivoire)
variants N'goi
note Mande language; subcategory
of Guro
AAT: nl
LCSH: nl
JPB
see also Guro
Ngola *see* MBUNDU
Ngoli *see* NGUL

NGOLO (Cameroun)
variants Ngoro
note Bantu language
AAT: nl
LCSH: nl
BES, CK, DDMM, ELZ, ETHN, GPM
1959, GPM 1975, HAB, HB, HBDW, KK
1960, KK 1965, WOH

NGOM (Cameroun, Congo Republic, Gabon)
variants Bangomo
note Bantu language
AAT: Ngom
LCSH: nl
DDMM, ETHN, GPM 1959, GPM 1975,
WRB

NGOMA (Kenya)
note Southern Nilotic language; one
of the groups included in the
collective term Sapaut
AAT: nl
LCSH: nl
DDMM
see also Sapaut

Ngoma *see* GOMA

NGOMBE (Zaire)
variants Gombe
subcategories Doko, Ngonje,
Mowea
note Bantu language
AAT: Ngombe
LCSH: Ngombe
DDMM, DPB 1985, DPB 1987, ELZ,
ETHN, FN 1994, GAH 1950, GPM 1959,
GPM 1975, HAB, HB, HBDW, IAI, JK,
JLS, JMOB, KK 1965, MGU 1967, MLB,
MUD 1991, OB 1973, OBZ, RSW, SMI,
TP, UIH, WBF 1964, WEW 1973, WH,
WM, WOH, WRB, WRB 1959, WRNN
AWW*, HBU*

NGONDE (Malawi, Tanzania)
variants Konde, Nkonde
note Bantu language; a division of
Nyakyusa
AAT: nl
LCSH: Ngonde
ASH, DDMM, ECB, ETHN, GPM 1959,
GPM 1975, HB, HBDW, IAI, JD, JLS, KK
1990, MFMK, RGL, RJ 1960, RSW, SMI,
UIH, WVB

MHW*, TEW*
see also Nyakyusa

NGONDI (Central African Republic,
Congo Republic)
variants Ngundi
note Bantu language
AAT: nl
LCSH: nl
DDMM, ETHN, GPM 1959, HB, MGU
1967, WH

Ngondje *see* NGONJE

Ngong *see* NGONGO

NGONGO (Zaire)
variants Bangongo, Bangwoong,
Ngong
note Bantu language; subcategory of
Kuba
AAT: Ngongo
LCSH: Ngongo
DDMM, DPB 1985, DPB 1987, EBHK,
ELZ, ETHN, GAH 1950, GPM 1959, GPM
1975, HAB, HB, IAI, JC 1971, JLS, JV
1966, JV 1984, NIB, OB 1973, OBZ, RSW,
SMI, SV 1988, TERV, WRB
JC 1982*, JV 1978*
see also Kuba

NGONI (Malawi, Mozambique,
Tanzania)
variants Angoni, Wangoni
note Bantu language. The name is
derived from Nguni in South
Africa who migrated northwards
under the name Ngoni.
AAT: Ngoni
LCSH: Ngoni
BS, CDR 1985, DDMM, ECB, ELZ,
ETHN, GPM 1959, GPM 1975, HAB, HB,
HBDW, IAI, JD, JK, JLS, JM, JV 1966,
KFS, KK 1990, LJPG, MFMK, MGU 1967,
RGL, RJ 1960, RJ 1961, ROMC, RSW,
SD, SMI, UIH, WDH, WG 1980, WH,
WOH, WVB
ECMG*, MBL*

NGONJE (Zaire)
variants Gonji, Ngondje
note Bantu language; subcategory of Ngombe
AAT: nl
LCSH: nl
AWW, HB, HBU
see also Ngombe

NGOOMBE (Congo Republic, Zaire)
variants Bangweemy, Bangoombe
note Bantu language; subcategory of Kuba
AAT: nl
LCSH: nl
HB
JC 1982, JV 1978
see also Kuba

Ngoro *see* NGOLO

Ngoroine *see* NGURIMI

Ngoumba *see* NGUMBA

Ngounie River *see* Toponyms Index

NGOVE (Gabon)
note Bantu language
AAT: nl
LCSH: nl
CK, HB, LP 1985

Ngoyo *see* WOYO

Ngudi *see* NGUL

NGUL (Zaire)
variants Ngoli, Ngudi, Nguli, Ngwi
note Bantu language. Some authorities distinguish between Ngul and Ngoli.
AAT: nl
LCSH: nl
DDMM, DPB 1985, ETHN, GPM 1959, HB, JV 1966, NIB

Ngula *see* NGULU (Tanzania)

Nguli *see* NGUL

NGULU (Malawi, Mozambique)
variants Nguru, Nguu, Western Makua
note Bantu language; not to be confused with the Ngulu of Tanzania
AAT: nl (uses Lomwe)
LCSH: nl
DDMM, GPM 1959, GPM 1975, KK 1990, MGU 1967, TP, UIH, WG 1980, WS
TOB 1967*

NGULU (Tanzania)
variants Ngula, Nguu, Wanguru
note Bantu language; not to be confused with the Ngulu of Malawi and Mozambique, who speak a dialect of Makua
AAT: nl
LCSH: Ngulu
DDMM, ECB, ETHN, GPM 1959, GPM 1975, HB, IAI, KK 1990, MFMK, RJ 1960, UIH, WH
EG*, HC*

NGUMBA (Cameroun, Equatorial Guinea)
variants Mvumbo, Ngoumba
note Bantu language; an ethnic group in the region before the Fang immigration; a Fang style/culture division. see LP*
AAT: Ngumba
LCSH: nl
CDR 1985, DDMM, ETHN, GPM 1959, GPM 1975, HAB, HB, IAI, IEZ, JAF, JK, JV 1984, KK 1965, LP 1979, LP 1985, MGU 1967, MLB, SG, TP, WH, WMR, WOH, WRB, WS
LP 1990*
see also Fang

Ngumbi *see* HUMBE

NGUNDA (Central African Republic)
note Central Ubangian language
AAT: nl
LCSH: nl
DB 1978, DDMM, HB, HBU

Ngundi *see* NGONDI

NGUNGULU (Congo Republic)
variants Angungwel, Ngungwel
note Bantu language; subcategory of
Teke
AAT: nl
LCSH: nl
DDMM, DPB 1985, ETHN, HB, JV 1966,
UIH
JV 1973*
see also Teke

Ngungwel *see* NGUNGULU

NGUNI (Botswana, Lesotho,
Namibia, South Africa, Swaziland)
subcategories Bhaka, Tembu
note Bantu language; may be
designated by the region in which
they live, e.g. Cape Nguni, Natal
Nguni
AAT: nl
LCSH: Nguni
ARW, BS, DDMM, EBR, ETHN, FW,
GPM 1959, GPM 1975, HAB, HB, HMC,
HRZ, IAI, JLS, JM, JV 1966, KFS, MHN,
MLB, PG 1990, PMPO, ROMC, SG, SMI,
SV, TP, WDH, WG 1980, WG 1984, WH,
WOH, WS, WVB
ECMG*, EMS*

Ngunu *see* NGWO

NGURIMI (Tanzania)
variants Ngoroine, Nguruimi,
Ngurumi
note Bantu language
AAT: nl
LCSH: nl
DDMM, ECB, ETHN, GPM 1959, MFMK,
UIH

Nguru *see* NGULU (Malawi,
Mozambique)

Nguru *see* LOMWE

Nguruimi *see* NGURIMI

Ngurumi *see* NGURIMI

NGUTU (Gabon)
note Bantu language; subcategory of
Mbaama
AAT: nl
LCSH: nl
LP 1985
see also Mbaama

Nguu *see* NGULU (Malawi,
Mozambique)

Nguu *see* NGULU (Tanzania)

NGWA (Nigeria)
note Kwa language; subcategory of
Igbo sometimes listed with the
Ohuhu as Ohuhu-Ngwa
AAT: nl
LCSH: Ngwa
DDMM, ETHN, GIJ, HMC, NOI, RWL,
VCU 1965, WS
CFGJ*
see also Igbo

Ngwa *see* BANGWA

Ngwanu *see* WAN

NGWATO (Botswana, South Africa)
variants Mangwato, Ngwatu
note Bantu language; a 19th century
configuration of the Tswana
AAT: nl
LCSH: Ngwato
DDMM, ETHN, GPM 1959, GPM 1975,
HAB, HB, HBDW, IAI, JM, MGU 1967,
MK, RS 1980, RSW, SMI, UIH , WDH,
WH
PBMI*
see also Tswana

Ngwatu *see* NGWATO

Ngwi *see* NGUL

NGWO (Cameroun)
variants Ngunu
note Bantoid language; subcategory
of Widekum; one of the groups
included in the collective term
Bamenda
AAT: nl
LCSH: Ngwo
DDMM, DWMB, ETHN, GPM 1959, GPM
1975, IEZ, LP 1993, NOI
PMK*
see also Bamenda, Widekum

NGWYES (Gabon)
note Bantu language
AAT: nl
LCSH: nl
JK, SV

Nhaneca *see* NYANEKA

Nharo San *see* NARON

Nharon *see* NARON
Niabua *see* NYABWA
Niabwa *see* NYABWA
NiamNiam *see* ZANDE
Niamwezi *see* NYAMWEZI
NIANANGON (Côte d'Ivoire)
 note Mande language; subcategory
 of Guro
 AAT: nl
 LCSH: nl
 JPB*
 see also Guro
Nianga *see* NYANGA
NIAPU (Congo Republic, Zaire)
 note Central Sudanic language
 AAT: nl
 LCSH: nl
 GPM 1959, HB, JC 1971, JMOB, WH
NIARHAFOLO (Burkina Faso, Côte
 d'Ivoire)
 variants Nyarhafolo
 note Gur language; subcategory of
 Senufo
 AAT: nl
 LCSH: nl
 DDMM, DWMB, JPB, RJ 1958
 see also Senufo
Niari River *see* Toponyms Index
Niaturu *see* NYATURU
NIEMBO (Zaire)
 variants Bena Niembo
 note Bantu language; subcategory of
 Luba-Hemba
 AAT: nl
 LCSH: nl
 CDR 1985, HJK, JAF, WS
 JC 1978*
Niger River *see* Toponyms Index
Nika *see* NYIKA
Nile River *see* Toponyms Index
NILO-HAMITIC people (Ethiopia,
 Kenya, Sudan, Tanzania, Uganda,
 Zaire)
 note This collective term (following
 GWH*, GWH 1969* and PGPG*) was
 used to refer to peoples now

differentiated as speakers of
Eastern Nilotic and Southern
Nilotic languages, and includes
the following groups: 1.
Northern Nilo-Hamites: Bari,
Kakwa, Kuku, Lango (in Sudan),
Ligo, Lokoya, Lotuko, Luluba,
Marshia, Mandari, Nyangbaa,
Nyepu, Pöjulu; 2. Central Nilo-
Hamites: Dodoth, Donyiro, Jie,
Jiye, Karimojong, Kumam, Teso,
Topotha, Turkana, and other
groups in the area including the
Ik, Labwor, Napore, Nyakwai,
Nyangeya, and Tepes; 3.
Southern Nilo-Hamites:
Barabaig, Dorobo, Endo, Keyyo,
Kipsikis, Kony, Maasai,
Marakwet, Nandi, Pok, Samburu,
Sapaut, Sebei, Suk, Tatog, Terik,
Tuken, and other unclassified
groups including the Hadzapi,
Iraqw, and Sandawe.
 AAT: use Eastern Hamitic
 LCSH: Nilo-Hamitic Peoples
 DDMM, IAI, RJ 1960, WEW 1973, WOH,
 WRB 1959
 GWH*, GWH 1969*, PGPG*
Nilotes *see* NILOTIC people
Nilotic Kavirondo *see* LWOO

205

NILOTIC people (Ethiopia, Sudan, Uganda, Zaire)
variants Nilotes
note This collective term is now restricted to speakers of Western Nilotic languages, living on the borders of Ethiopia, Sudan, Uganda and Zaire, and includes the following groups: Acoli, Alur, Anuak, Atuot, Bor, Burun, Dho Luo, Dinka, Jo Paluo, Jo Padhola, Jur, Koma, Kunama, Labwor, Lango (in Uganda), Lwoo, Maban, Nuer, Nyakwai, Pari, Shilluk, Teso, and Thuri.
AAT: nl (uses Eastern Hamitic)
LCSH: Nilotic people
AJB, ATMB, ATMB 1956, BS, EBR, ELZ, EWA, GPM 1959, GPM 1975, HBDW, HRZ, IAI, JG 1963, JJM 1972, JM, MTKW, PG 1990, PMPO, RGL, RJ 1958, ROMC, SMI, WEW 1973, WG 1980, WG 1984, WH, WRB 1959
AJB*, CSBS*, DDMM*

NINGAWA (Nigeria)
variants Ningi
note Benue-Congo language
AAT: nl
LCSH: nl
BS, DDMM, ETHN, GPM 1959, RWL, SD

Ningi *see* NINGAWA

NINGO (Ghana)
note Kwa language
AAT: nl
LCSH: nl
GPM 1959, MM 1950

NINZAM (Nigeria)
note Benue-Congo language
AAT: nl
LCSH: nl
DDMM, ETHN, GPM 1959, HB, JG 1963, RWL

Niominka *see* SERER
Nioniosi *see* NYONYOSI
Nioniosse *see* NYONYOSI
Nioniossi *see* NYONYOSI
Nitsogo *see* TSOGO
Njaal *see* NZADI

NJABI (Congo Republic, Gabon)
variants Bandjabi, Bandzabi, Banjabi, Benzabi, Ndjabi, Ndzabi, Njawi, Nzabi, Nzebi
note Bantu language
AAT: nl (uses Nzebi)
LCSH: nl (uses Nzabi)
BES, BS, CFL, DDMM, DPB 1987, ETHN, GPM 1959, GPM 1975, HAB, HB, HBDW, IAI, JK, LP 1979, LP 1985, MGU 1967, MH, MLJD, OGPS, RSAR, SG, UIH, WH, WOH, WRB, WS

Njamus *see* NJEMPS
Njari *see* NZADI
Njawi *see* NJABI
Njei *see* NZANGI
Njeign *see* NZANGI
Njem *see* NYEM

NJEMBE (Zaire)
note Bantu language; subcategory of Wongo
AAT: nl
LCSH: nl
DPB 1985, SV
JC 1978*
see also Wongo

NJEMPS (Kenya)
variants Il Chamus, Njamus, Tiamus
note Eastern Nilotic language
AAT: nl
LCSH: Njemps
ATMB 1956, DDMM, ECB, ETHN, GPM 1959, JLS, RS 1980, WH
GWH 1969*

NJIMOM (Cameroun)
note Grasslands chiefdom in Bamum
AAT: nl
LCSH: nl
LP 1993, PH
see also Bamum

Njinga *see* MBAMBA

NJINIKOM (Cameroun)
AAT: nl
LCSH: nl
PH, TN 1973
LP 1993*

Nkaan *see* YANZ

NKAMBE (Cameroun)
note one of the groups included in
the collective term Bamenda
AAT: nl
LCSH: nl
EBHK, ETHN, JL, PH
LP 1993*
see also Bamenda
NKANGALA (Angola)
note Bantu language
AAT: nl
LCSH: nl
DDMM, ETHN, MGU 1967
N'kanu *see* NKANU
NKANU (Angola, Zaire)
variants Bakanu, Bankanu, Kano,
Kanu, N'kanu
note Bantu language; Kongo related
group who are Kongo and Yaka
influenced
AAT: nl
LCSH: nl
ALM, BES, CDR 1985, DDMM, DPB
1985, DPB 1986, DPB 1987, ELZ, ETHN,
GPM 1975, HH, JC 1971, JC 1978, JD, JK,
KK 1965, MLB, MLB 1994, MLF, MLJD,
OB 1973, OBZ, PG 1990, RSW, TERV,
TP, WG 1984, WS
FHCP*
see also Kongo
NKAPA (Cameroun)
note one of the chiefdoms included
in the collective term Bamileke
AAT: nl
LCSH: nl
LP 1993, PH
see also Bamileke
Nkem *see* NKIM
Nkhumbi *see* KHUMBI
NKIM (Nigeria)
variants Nkem, Nkum
note Bantoid language; subcategory
of Ejagham; one of the groups
included in the Ekoid language
cluster
AAT: nl
LCSH: nl
DDMM, ETHN, GIJ, GPM 1959, HB,
MGU 1967, RWL

see also Ejagham
Nkimi *see* BANKIM
Nko *see* NSAW
NKOLE (Rwanda, Uganda)
variants Ankole, Banyankole,
Nkore, Nyankole, Nyankore
note Bantu language. The term
Nyankore was a British 19th-
century creation out of four
kingdoms, the Nkore (dominant),
Buhweju, Buzimba, and Igara.
AAT: Nkole
LCSH: use Nyankole
BS, DDMM, ECB, ETHN, GAH 1950,
GPM 1959, GPM 1975, HAB, HB, HBDW,
HRZ, IAI, JJM 1972, JLS, JM, LJPG, MGU
1967, MLJD, MTKW, PG 1990, RGL, RJ
1960, RS 1980, RSW, SD, SMI, UIH, WH
BKT*
Nkom *see* KOM
NKOMI (Gabon)
note Bantu language; one of the
groups included in the collective
term Myene
AAT: nl
LCSH: Nkomi
CK, DDMM, ETHN, GPM 1959, HB, JD,
LP 1979, LP 1985
see also Myene
Nkonde *see* NGONDE
Nkope *see* Toponyms Index
Nkore *see* NKOLE
NKOSI (Cameroun, Nigeria)
variants Bakosi, Bakossi, Kossi
note Bantu language
AAT: use Kossi
LCSH: use Kossi
DDMM, ETHN, GPM 1959, GPM 1975,
HAB, HB, HBDW, JLS, MUD 1991, RFT
1974, RGL, RJ 1958, RWL, SMI, TN 1984,
UIH, WH
SNEK*
Nkot *see* YEMBA

NKPORO (Nigeria)
 note Kwa language; subcategory of
 Eastern Igbo
 AAT: nl
 LCSH: nl
 CFGJ, GIJ, JLS
 see also Igbo
NKU (Zaire)
 note Bantu language
 AAT: nl
 LCSH: nl
 DPB 1985
 GDP*
Nkuchu *see* NKUTSHU
Nkucu *see* NKUTSHU
Nkum *see* NKIM
Nkumbi *see* KHUMBI
NKUNDO (Zaire)
 variants Kundu, Nkundu
 note Bantu language; subcategory of
 Mongo
 AAT: nl
 LCSH: use Nkundu
 BS, DBP 1985, DDMM, ELZ, ETHN, FN
 1994, GAH 1950, GPM 1959, GPM 1975,
 HAB, HB, IAI, JC 1978, JD, JMOB, LJPG,
 MGU 1967, MLJD, OBZ, RSW, SMI, UIH,
 WH, WRB
 see also Mongo
Nkundu *see* NKUNDO
NKUTSHU (Zaire)
 variants Ankutshu, Bankutshu,
 Nkuchu, Nkucu, Nkutu,
 Wankutshu
 note Bantu language. The term is
 used as a collective term to
 designate Mongo-related groups,
 such as Tetela, Hamba, Jonga, and
 Kusu, that consider themselves to
 be descended from a primordial
 ancestor Ankutshu a Membele.
 AAT: Nkutshu
 LCSH: nl
 CK, DDMM, DPB 1985, DPB 1987, ELZ,
 ETHN, GPM 1959, GPM 1975, IAI,
 JMOB, KMT 1971, OBZ, RSW, WRB
 JOJ*
Nkutu *see* NKUTSHU

Nkwem *see* BAFRENG
Nkwen *see* BAFRENG
NNAM (Nigeria)
 variants Ndem
 note Bantoid language
 AAT: nl
 LCSH: nl
 DDMM, ETHN, GIJ, RWL
No, Lake *see* Toponyms Index
Noho *see* NOO
NOHULU (Côte d'Ivoire)
 note Gur language; subcategory of
 Senufo
 AAT: nl
 LCSH: nl
 DDMM, JPB
 see also Senufo
NOK (Nigeria)
 note village and nearby site of
 ancient culture, circa 500 BCE-
 500 CE, known for its terracotta
 sculpture
 AAT: Nok
 LCSH: Noke site; Terra-cotta sculpture,
 Nok
 ARW, BDG 1980, DFHC, DOA, DP, EBR,
 EEWF, EL, ELZ, EVA, EWA, FW, GAC,
 GBJM, GBJS, HB, HRZ, JJM 1972, JK, JL,
 JLS, JM, JV 1984, KK 1965, KMT 1970,
 LJPG, LM, LSD, MCA, MLB, NOI, PG
 1990, PMPO, PR, RGL, ROMC, RSRW,
 RSW, SMI, SV, TB, TP, WG 1980, WG
 1984, WH, WRB, WRB 1959, WS
 BEF 1977*, EE*, JFJ*
NOMOLI (Sierra Leone)
 note used to refer to stone
 sculptures from ancient sites in
 Sierra Leone
 AAT: Nomoli (figurines)
 LCSH: nl
 DP, SMI, TLPM, WG 1980, WG 1984
NONDA (Zaire)
 note Bantu language; subcategory of
 Bangubangu
 AAT: nl
 LCSH: nl
 AEM, DPB 1986
 see also Bangubangu
Nono *see* NOO

NOO (Cameroun)
variants Banoo, Noho, Nono
note Bantu language; one of the
 groups included in the Bo-
 Mbongo cluster
AAT: nl
LCSH: nl (uses Tanga)
DDMM, GPM 1959, GPM 1975, HB , RJ
1958, WH
MAB*
see also Bo-Mbongo

NOSSI-BÉ (Madagascar)
variants Nosy Be
note Malagasi language
 (Austronesian)
AAT: nl
LCSH: use Nosy-Be
KK 1990
CKJR*, JMA*

Nosy Be *see* NOSSI-BÉ
Nourouma *see* NUNA
Nri *see* NRI-AWKA

NRI-AWKA (Nigeria)
variants Nri
note Kwa language; one of the
 divisions of Igbo; referred to as
 Northern or Onitsha Igbo
AAT: nl
LCSH: nl
DFHC, GIJ, IAI, JLS, MK, NOI, RJ 1958,
SMI, VCU 1965
CFGJ*
see also Igbo

Nsapa-Nzapo *see* NSAPO

NSAPO (Zaire)
variants Bansapo, Bena Nsapo,
 Nsapa-Nzapo, Nsapo Nsapo,
 Nsaponsapo, Zapozap
note Bantu language; originating
 from an admixture of Songye and
 Luluwa
AAT: nl (uses Nsapo-Nsapo)
LCSH: nl
CDR 1985, CMK, DPB 1987, FN 1994, JK,
JMOB, MLB, OB 1961, RS 1980, RSAR,
WG 1980, WRNN, WS

Nsapo Nsapo *see* NSAPO
Nsaponsapo *see* NSAPO

NSAW (Cameroun)
variants Banso, Bansso, Nso, Nko
note Bantoid language; subcategory
 of Tikar; used as a collective term
 to include Mbiami and others; one
 of the groups included in the
 collective term Bamenda
AAT: nl
LCSH: use Nso
CK, DDMM, DFHC, DWMB, EBHK, GPM
1959, GPM 1975, HAB, HB, HBDW, IAI,
IEZ, KFS, KK 1960, KK 1965, PH, RJ
1958, TN 1984, TN 1986, UIH, WS
LP 1993*, MMML*, PMK*
see also Bamenda, Tikar

Nsei *see* BAMESSING

NSELLE (Nigeria)
note Bantoid language; subcategory
 of Ofutop
AAT: nl
LCSH: nl
DDMM, GIJ, RWL, WG 1984, WS
see also Ofutop

NSENGA (Malawi; Zambia,
Zimbabwe)
variants Asenga, Senga
note Bantu language; one of the
 groups included in the collective
 term Maravi; not to be confused
 with the Senga who are also in
 Zambia.
AAT: nl
LCSH: Nsenga language use Senga
 language
ARW, BS, DDMM, EBR, ETHN, GPM
1959, GPM 1975, HB, HBDW, IAI, JV
1966, KFS, MGU 1967, RJ 1961, UIH, WH
TEW*, WVB*
see also Maravi

NSIT (Nigeria)
note Benue-Congo language; one of
 the divisions of Ibibio
AAT: nl
LCSH: nl
ETHN, RWL, WS
see also Ibibio

Nso *see* NSAW
Nsong *see* TSONG

Nsongo *see* TSONG

NSUKKA (Nigeria)

note Kwa language; one of the divisions of Igbo

AAT: nl
LCSH: nl
DDMM, HMC, JLS, RWL
CFGJ*

see also Igbo

Nsundi *see* SUNDI

NSUNGLI (Cameroun)

variants Limbum

note Bantoid language; a collective term used to refer to the Tang, War, Wiya; subcategory of Tikar; one of the groups included in the collective term Bamenda

AAT: nl
LCSH: use Limbum
DDMM, ETHN, GPM 1959, IEZ, PH, RJ 1958, WEW 1973
MMML*, PMK*

see also Bamenda, Tikar

NTA (Nigeria)

note Bantoid language; subcategory of Ejagham; one of the groups included in the Ekoid language cluster

AAT: nl
LCSH: nl
DDMM, ETHN, HB, JC 1971, KFS, MGU 1967

see also Ejagham

NTANDU (Zaire)

variants Bantandu

note Bantu language; subcategory of Kongo

AAT: nl
LCSH: Ntandu dialect use Ntaandu dialect
DDMM, DPB 1985, MGU 1967, OB 1973, OBZ, UIH, WM

see also Kongo

Ntem *see* NTUMU

NTEM (Cameroun)

variants Kaka-Ntem, Tem

note Bantoid language; an independent chiefdom of Tikar;

used collectively to include the Mfumte, Mbaw and Mbem; one of the groups included in the collective term Bamenda

AAT: nl
LCSH: nl
DDMM, ETHN, GPM 1975, HBDW, IEZ, PH
MMML*, PMK*

see also Tikar

NTOMBA (Zaire)

variants Ntumba, Tumba

note Bantu language; one of the groups included in the collective term Mongo

AAT: Ntomba
LCSH: Ntomba
BS, DPB 1985, DPB 1987, ETHN, GAH 1950, GPM 1959, GPM 1975, HB, IAI, JMOB, JV 1966, MGU 1967, OBZ, RS 1980, SMI, TERV, UIH, WH, WRB

see also Mongo

Ntoumou *see* NTUMU

Ntribu *see* DELO

NTSAYE (Congo Republic, Gabon)

variants Teke-Tsaaye, Tsaaye, Tsaayi, Tsai, Tsaya, Tsaye, Tsayi

note Bantu language; subcategory of Teke

AAT: nl (uses Tsaya)
LCSH: nl
BS, DDMM, DPB 1985, ETHN, GBJS, GPM 1959, GPM 1975, JC 1978, JK, JLS, JV 1973, JV 1984, LM, LP 1979, MGU 1967, MPF 1992, RLD 1974, SV, UIH, WRNN, WS

see also Teke

Ntum *see* NTUMU

Ntumba *see* NTOMBA

NTUMU (Cameroun, Equatorial
Guinea, Gabon, Guinea)
variants Ntum, Ntem, Ntoumou,
Woleu-Ntem
note Bantu language; subcategory of
Fang; Fang style/culture divisions
of Mabea and Ngumba. see LP
1990*.
AAT: nl
LCSH: nl
AW, CDR 1985, CK, DDMM, ELZ,
ETHN, GAC, GPM 1959, GPM 1975,
HAB, HB, HBDW, IAI, IEZ, JAF, JK, JLS,
JV 1984, LP 1979, LP 1985, MLB, SG,
SMI, TP, UIH, WH, WS
LP 1990*
see also Fang

NUBA (Sudan)
note linguistically diverse, speaking
Kordofanian and Eastern Sudanic
languages; collective term for
peoples of the Nuba Mountains in
the Kordofan region of the Sudan;
divided into four main groups: 1.
Heiban and Toro; 2. Moro and
Tira; 3. Korongo; 4. Dilling,
Koalib, Mesakin, Nyima, Tullishi,
and Tumtum.
AAT: Nuba
LCSH: Nuba
ATMB 1956, BS, DDMM, DOA, ETHN,
EBR, ELZ, GB, GPM 1959, GPM 1975,
HAB, HB, IAI, ICWJ, JLS, JV 1984, LJPG,
MLJD, RJ 1959, ROMC, RS 1980, RSW,
SMI, TP, WFJP, WG 1984, WH
CSBS*, JMF*, SFN*

Nuba Hills *see* Toponyms Index
Nubia *see* Toponyms Index
NUBIANS (Egypt, Sudan)
note Eastern Sudanic language;
collective term for peoples of the
Kordofan region--Anag, Barabra,
Birked, Dilling, Midobi, Nyima.
Nubia was an ancient Nile Valley
kingdom with capitals at Napata
and then Meroe.
AAT: Nubian
LCSH: Nubians

ARW, ATMB, ATMB 1956, CSBS, DFHC,
ETHN, FW, GPM 1959, HAB, HB,
HBDW, HRZ, IAI, ICWJ, JG 1963, JL, JM,
KMT 1971, LJPG, LPR 1995, MCA 1986,
PMPO, RJ 1959, ROMC, SFN, SMI, TP,
WH
BGFL*, MW*, SH*

NUER (Ethiopia, Sudan)
variants Naath
subcategories Bul, Dok, Dor,
Gaweir, Jagei, Jikany, Lak, Lek,
Nuong, Thiang
note West Nilotic language; one of
the groups included in the
collective term Nilotic people
AAT: nl
LCSH: Nuer
AF, ATMB, ATMB 1956, BS, CFL, CSBS,
DDMM, DFHC, EBR, ELZ, ETHN, GB,
GPM 1959, GPM 1975, HB, IAI, ICWJ, JG
1963, JJM 1972, JLS, JM, LJPG, MCA
1986, PMPO, RGL, RJ 1959, RS 1980,
RSW, SD, SMI, UIH, WEW 1973, WH,
WOH, WRB 1959
AJB*, BHM*, EEP 1940*
see also Nilotic people

Numidia *see* Toponyms Index
NUMU (Burkina Faso, Côte d'Ivoire,
Ghana)
note Mande language
AAT: nl
LCSH: nl
DDMM, DWMB, ETHN, GPM 1959, HB,
JG 1963, JPB, KFS, PRM, RAB, TFG, WH
see also Mande

NUNA (Burkina Faso)
variants Nourouma, Nuni, Nunuma,
Nuruma
note Gur language; one of the
peoples included in the collective
term Grunshi
AAT: use Nunuma
LCSH: Nuna dialect use Nunuma dialect
CDR 1987, CFL, DDMM, DWMB, ELZ,
ETHN, GPM 1959, GPM 1975, HAB, HB,
IAI, JG 1963, JK, JLS, JP 1953, JPB, MUD
1991, SD, SV, TP, UIH, WH, WRB, WS
KEB*
see also Grunshi

NUNGU (Nigeria)
variants Rinderi, Rindri, Wamba
note Benue-Congo language
AAT: nl (uses Rinderi)
LCSH: nl
DDMM, GPM 1959, GPM 1975, HB, JG
1963, KK 1965, RJ 1958, RWL, UIH, WH,
WS

Nuni *see* NUNA

NUNU (Zaire)
note Bantu language
AAT: nl
LCSH: Nunu
BS, DPB 1985, DPB 1987, GPM 1959,
GPM 1975, HB, JV 1966, JV 1973, OBZ,
SMI
RWH*

Nunuma *see* NUNA

NUONG (Sudan)
variants Nyuong
note Westen Nilotic language;
subcategory of Nuer
AAT: nl
LCSH: nl
ATMB 1956, DDMM, ETHN
CSBS*
see also Nuer

NUPE (Nigeria)
variants Takpa
subcategories Bassa-Nge, Kupa
note Kwa language; an early
kingdom founded by the
legendary 16th-century figure
Tsoede
AAT: Nupe
LCSH: Nupe
AF, BS, CDR 1985, CK, CMK, DDMM,
DFHC, DFM, DOA, DWMB, EBR, ELZ,
FW, GB, GPM 1959, GPM 1975, HAB,
HB, HH, HJD, HMC, HRZ, IAI, JD, JG
1963, JJM 1972, JK, JL, JLS, JM, JV 1984,
KFS, KK 1960, KK 1965, KMT 1971,
LJPG, LPR 1986, LSD, MHN, MLJD, NIB,
NOI, PG 1990, PMPO, PRM, PSG, RAB,
RGL, RJ 1958, ROJF, ROMC, RS 1980,
RSW, RWL, SD, SMI, SV, TB , TP, UIH,
WBF 1964, WEW 1973, WFJP, WG 1980,
WG 1984, WH, WOH, WRB, WRB 1959
CFPB*, HJD*, SFN 1942*

Nuruma *see* NUNA

Nwa *see* WAN

Nwe *see* BANGWA

NWENSHI (Zaire)
note Bantu language
AAT: nl
LCSH: nl
DDMM, DPB 1987, HB, OB 1961

NYABO (Liberia)
note Kwa language
AAT: nl
LCSH: nl
DDMM, ETHN, KK 1965

Nyabungu *see* SHI

NYABWA (Côte d'Ivoire)
variants Niabua, Niabwa
note Kwa language
AAT: nl
LCSH: Nyabwa language
DDMM, GPM 1959, HB, UIH, WS
JPB*

Nyakusa *see* NYAKYUSA

NYAKWAI (Uganda)
note West Nilotic language; one of
the groups included in the
collective term Nilotic people
AAT: nl
LCSH: nl
DDMM, ETHN
PGPG*
see also Nilotic people, Nilo-
Hamitic people

NYAKYUSA (Malawi, Tanzania)
variants Banyakyusa, Nyakusa
note Bantu language; includes the
Kukwe, Luguru, Ngonde, Selya,
Saku, and other assimilated
groups
AAT: Nyakyusa
LCSH: Nyakyusa
BS, DDMM, EBR, ECB, ETHN, GPM
1959, GPM 1975, HB, IAI, JLS, LJPG,
MFMK, RGL, RJ 1960, ROMC, SD, SMI,
UIH, WH, WOH, WVB
ECMG*, MHW*, TEW*

NYALA (Kenya, Uganda)
note Bantu language
AAT: nl
LCSH: nl
DDMM, ECB, ETHN, HB, UIH

Nyali *see* NYARI
Nyamang *see* NYIMA
Nyambara *see* NYANGBAA
Nyambo *see* KARAGWE
Nyamuezi *see* NYAMWEZI
NYAMWANGA (Tanzania, Zambia)
variants Mwanga
note Bantu language
AAT: Nyamwanga
LCSH: nl
DDMM, ETHN, GPM 1959, HB, HC,
RGW, RJ 1960, MFMK, UIH
Nyamwese *see* NYAMWEZI
Nyamwesi *see* NYAMWEZI
NYAMWEZI (Tanzania)
variants Banyamwezi, Niamwezi,
Nyamuezi, Nyamwese, Nyamwesi,
Wanjamwezi, Wanyamwezi
note Bantu language. The term
Greater Unyamwezi encompasses
the Nyamwezi properly speaking
(with the important chiefdom of
Unyanyembe), the Sukuma,
Sumbwa, Kimbu and Konongo.
AAT: Nyamwezi
LCSH: Nyamwezi
ARW, BS, CDR 1985, CK, DDMM,
DOWF, ECB, ELZ, ESCK, ETHN, GBJS,
GPM 1959, GPM 1975, HAB, HB, HBDW,
HRZ, IAI, JD, JJM 1972, JK, JLS, JM, JV
1966, KFS, KK 1990, LJPG, MFMK, MGU
1967, MLB, MPF 1992, NIB, PG 1990,
RGL, RJ 1960, ROMC, RS 1980, RSW,
SD, SMI, TP, UIH, WBF 1964, WDH, WG
1980, WG 1984, WOH, WRB, WRNN,
WS, WVB
BEBG*, HC*, PEB*, RGA*
NYANEKA (Angola)
variants Nhaneca
note Bantu language; one of the
groups included in the collective
term Mbangala
AAT: nl
LCSH: Nyaneka language
DDMM, ETHN, GPM 1959, GPM 1975,
HB, IAI, MGU 1967, UIH
see also Mbangala
Nyang *see* ANYANG

NYANGA (Zaire)
variants Banyanga, Nianga
note Bantu language
AAT: nl
LCSH: Nyanga
BES, DDMM, DPB 1985, DPB 1987, ENS,
ETHN, FN 1994, GAH 1950, GPM 1959,
GPM 1975, HB, HRZ, IAI, JC 1978, JLS,
MGU 1967, OBZ, PR, RGL, SMI, UIH,
WEW 1973
DPB 1986*, DPB 1978*, DBKM*
Nyangara *see* NYANGBAA
Nyangatom *see* DONYIRO
NYANGBAA (Sudan, Uganda,
Zaire)
variants Nyambara, Nyangara,
Nyangbara
note Eastern Nilotic language; one
of the groups included in the
collective term Nilo-Hamitic
people
AAT: nl
LCSH: nl
ATMB 1956, CSBS, DDMM, DPB 1987,
ETHN, GPM 1959, HB, RJ 1959, WEW
1973, WH
GWH*
see also Nilo-Hamitic people
Nyangbara *see* NYANGBAA
NYANGEYA (Uganda)
variants Nyangiya
note People known under this name
appear to be affiliated with either
Eastern Nilotic or Eastern
Sudanic languages. The Nyangeya
are one of the groups included in
the collective term Nilo-Hamitic
people
AAT: nl
LCSH: nl
ATMB 1956, DDMM, ETHN, GPM 1959,
HB, JG 1963, UIH, WH
PGPG*
see also Nilo-Hamitic people
Nyangi *see* ANYANG
Nyangiya *see* NYANGEYA
Nyanika *see* NYIKA

213

NYANJA (Malawi, Mozambique, Tanzania, Zambia)
variants Anyanja
note Bantu language. Nyanja is used as a cover term to include the Nyasa, Manganja and Nyanja proper. It is one of the groups included in the collective term Maravi.
AAT: Nyanja
LCSH: Nyanja
DDMM, ETHN, GPM 1959, GPM 1975, HAB, HB, HBDW, IAI, KK 1990, MGU 1967, RJ 1961, ROMC, SMI, UIH, WEW 1973, WH, WVB
TEW*
see also Maravi

Nyankole *see* NKOLE
Nyankore *see* NKOLE
Nyarhafolo *see* NIARHAFOLO
NYARI (Uganda, Zaire)
variants Nyali
note Bantu language
AAT: nl
LCSH: nl
DDMM, DPB 1987, ETHN, GPM 1959, GPM 1975, HAB, HB, HBDW, IAI, MGU 1967, OBZ, UIH

NYASA (Malawi, Tanzania, Zambia)
variants Wanyassa
note Bantu language; one of the groups included in the collective term Nyanja
AAT: nl
LCSH: nl
DDMM, ETHN, GPM 1959, GPM 1975, HB, KK 1990, SD, WH
TEW*
see also Nyanja

Nyasa, Lake *see* Toponyms Index
NYATURU (Tanzania)
variants Arimi, Limi, Niaturu, Remi, Turu, Walimi, Waniaturu
note Bantu language
AAT: use Turu
LCSH: Nyaturu
BS, DDMM, ECB, ETHN, GPM 1959, GPM 1975, HAB, HB, HC, IAI, MFMK,

MGU 1967, NOI, PMPO, RGL, RJ 1960, RS 1980, UIH, WH, WOH

NYEDE (Côte d'Ivoire)
variants Nyedebwa
note Kwa language
AAT: nl
LCSH: nl
DDMM, JPB

Nyedebwa *see* NYEDE
Nyefu *see* NYEPU
NYEM (Cameroun)
variants Djem, Dzem, Ndzem, Njem
note Bantu language
AAT: nl
LCSH: nl
DDMM, ETHN, GPM 1959, GPM 1975, HB, HBDW, IAI, KK 1965, LP 1979, MGU 1967, RJ 1958, WH, WS, WOH

NYEMBA (Angola, Namibia, Zambia)
note Bantu language; one of the groups included in the collective term Ngangela
AAT: nl
LCSH: use Ngangela
DDMM, DPB 1987, ETHN, GPM 1959, HB
see also Ngangela

NYENE (Côte d'Ivoire)
variants Nyini
note Gur language; subcategory of Senufo
AAT: nl
LCSH: nl
DWMB, JPB, SV
see also Senufo

NYENGO (Angola, Zambia)
note Bantu language
AAT: nl
LCSH: nl
DDMM, GPM 1959, MGU 1967, UIH

NYEPU (Sudan, Zaire)

variants Nyefu

note Eastern Nilotic language; one of the groups included in the collective term Nilo-Hamitic people

AAT: nl

LCSH: nl

ATMB 1956, DDMM, DPB 1987, ETHN, GPM 1959, HB, UIH

GWH*

see also Nilo-Hamitic people

NYIHA (Tanzania, Zambia)

note Bantu language; not to be confused with the Nyika of Kenya and Tanzania

AAT: nl

LCSH: nl

DDMM, ECB, ETHN, GPM 1959, HB, MFMK, RJ 1960, UIH

AHP*, RGW*

NYIKA (Kenya, Tanzania)

variants Mijikenda, Nika, Nyanika, Wanyika

note Bantu language; a Swahili term for an ethnic cluster of various groups living in the bush (nyika): Chonyi, Digo, Duruma, Dzihana, Giryama, Kambe, Kauma, Rabai and Ribe; not to be confused with the Nyiha of Tanzania and Zambia

AAT: use Mijikenda

LCSH: use Nika

BS, DDMM, ECB, ELZ, ETHN, EWA, GC, GPM 1959, GPM 1975, HB, HBDW, IAI, JK, JLS, JV 1984, KK 1990, MGU 1967, RGL, RJ 1960, ROMC, RSRW, RSW, SD, SMI, UIH, WH, WS, WVB

AHP 1952*, AL*

Nyilamba *see* IRAMBA

NYIMA (Sudan)

variants Nyamang, Nyimang

note Eastern Sudanic language; one of the peoples included in the collective terms Nuba and Nubians

AAT: nl

LCSH: nl

ATMB, DDMM, ETHN, GPM 1959, GPM 1975, HB, HBDW, HRZ, JG 1963, RJ 1959, WH

SFN*

see also Nuba, Nubians

Nyimang *see* NYIMA

NYINDU (Zaire)

variants Banyindu

note Bantu language

AAT: nl

LCSH: nl

CDR 1985, DPB 1986, DPB 1987, ETHN, HB, JC 1978

Nyini *see* NYENE

Nyirambi *see* IRAMBI

Nyisanzu *see* ISANZU

NYOLE (Uganda)

variants Nyore, Nyuli

note Bantu language

AAT: nl

LCSH: Nyole language use Nyore language

DDMM, ECB, ETHN, GPM 1959, GPM 1975, HB, KK 1965, MTKW, UIH

NYONGA (Cameroun)

variants Bali-Nyonga

note Bantoid language; subcategory of Bali

AAT: nl

LCSH: use Bali

ETHN, HB, JLS, PH, LP 1993

PMK*

see also Bali

Nyonyose *see* NYONYOSI

NYONYOSI (Burkina Faso)

variants Nioniosi, Nioniosse, Nioniossi, Nyonyose

note Gur language. The term Nyonyosi may be used for Mossi-influenced Kurumba.

AAT: nl (uses Nioniosse)

LCSH: use Kurumba

ETHN, GPM 1959, HB, JD, JK, JLS, MLB, RJ 1958, TP, WG 1984

ASH 1973*, CDR 1987*

see also Kurumba

Nyore *see* NYOLE

NYORO (Uganda)
variants Banyoro, Bunyoro
note Bantu language; the name of a
 people and of one of the
 interlacustrine kingdoms known
 as Bunyoro, ruled over for many
 centuries by a succession of
 Batembuzi, Bachwezi and Babito
 dynasties
AAT: Nyoro
LCSH: Nyoro
AIR 1959, BD, BS, DDMM, DPB 1986,
ECB, ELZ, GAH 1950, GPM 1959, GPM
1975, HB, HBDW, HRZ, IAI, JD, JJM
1972, JLS, JM, JMOB, KMT 1971, MCA
1986, MGU 1967, MLJD, MTKW, NIB,
PMPO, RGL, RJ 1960, ROMC, RS 1980,
RSW, SD, SMI, UIH, WDH, WH
BKT*, JOB*, JOB 1960*, JOR*, MCF*
see also Kitara

NYOS (Cameroun)
note Bantoid language; subcategory
 of Kom
AAT: nl
LCSH: nl
EBHK, KK 1965, PH
MMML*
see also Kom

Nyuli *see* NYOLE

NYUNGWE (Mozambique)
variants Teta, Tete
note Bantu language
AAT: nl
LCSH: Nyungwe language use Tete
 language
DDMM, ETHN, GPM 1959, HB, IAI,
MGU 1967, RS 1980, UIH, WH

Nyuong *see* NUONG

Nzabi *see* NJABI

NZADI (Zaire)
variants Ndjaal, Njaal, Njari, Nzari
note Bantu language
AAT: nl
LCSH: nl
DDMM, DPB 1985, ETHN, GPM 1959, JV
1966, OB 1973, UIH

NZAKARA (Central African
 Republic, Zaire)
variants Sakara, Zakara

note Southern Ubangian language
AAT: nl
LCSH: Nzakara
ATMB, ATMB 1956, BS, DB 1978,
DDMM, DPB 1987, ETHN, FE 1933, GAH
1950, GPM 1959, GPM 1975, HB, HBDW,
HBU, IAI, JD, JG 1963, JMOB, MLJD,
OBZ, SG, UIH, WH, WS
ARL*

NZAM (Nigeria)
note Kwa language; one of the
 divisions of Igbo
AAT: nl
LCSH: nl
RWL, VCU 1965
see also Igbo

Nzama *see* NZAMAN

NZAMAN (Cameroun, Gabon)
variants Nzama, Nzamane
note Bantu language; Fang
 style/culture division. see LP 1979*
AAT: nl
LCSH: nl
JK, LM , LP 1990, MUD 1986, SG, WS
LP 1979*
see also Fang

Nzamane *see* NZAMAN

NZANGI (Cameroun, Nigeria)
variants Njei, Njeign, Paka
note Chadic language; one of the
 groups included in the collective
 term Kirdi
AAT: nl
LCSH: nl
BEL, DDMM, DPB 1985, ETHN, GPM
1959, GPM 1975, HB, HBDW, JG 1963,
NOI, RWL
see also Kirdi

Nzari *see* NZADI

Nzebi *see* NJABI

Nzema *see* NZIMA

Nzeman *see* NZIMA

NZIKPRI (Côte d'Ivoire)
note Kwa language; subcategory of
 Baule
AAT: nl
LCSH: nl
JPB
see also Baule

NZIMA (Côte d'Ivoire, Ghana)
variants Assoko, Nzema, Nzeman, Zema
note Kwa language; one of the neighboring groups included in the collective term Lagoon people; one of the groups included in the collective term Akan
AAT: nl
LCSH: Nzima
BS, DDMM, DWMB, ENS, ETHN, GPM 1959, HB, HCDR, IAI, JLS, LM, MM 1950, RJ 1958, RSW, SMI, TFG, UIH, WEW 1973, WH, WS
JPB*, VIG*
see also Akan, Lagoon people

NZIMU (Cameroun)
variants Ndzimu
AAT: nl
LCSH: nl
GPM 1959, GPM 1975, HB, WH, WOH, WS

Nzombo *see* ZOMBO

Oba *see* OGBA

Obamba *see* MBAAMA

OBANG (Nigeria)
note Bantoid language; subcategory of Ejagham
AAT: nl
LCSH: nl
CK, DDMM, ELZ, ETHN, GIJ, GPM 1959, GPM 1975, HB, NOI, RWL, WH
see also Ejagham

Obolo *see* ANDONI

OBORO (Nigeria)
note one of the divisions of Igbo; live near Uamahia in the Cross River region
AAT: nl
LCSH: nl
GIJ, WS
see also Igbo

ODODOP (Cameroun, Nigeria)
subcategories Korop, Okoyong
note Benue-Congo language; one of the groups included in the collective term Cross River people
AAT: nl
LCSH: nl
DDMM, ETHN, GPM 1959, GPM 1975, HB, HBDW, JG 1963, NOI, RWL, WH
see also Cross River people

OFUTOP (Nigeria)
variants Efutop
subcategories Nselle
note Bantoid language; share a common language with the Atam
AAT: nl
LCSH: nl
DDMM, ETHN, GIJ, RWL
see also Atam

Ogaadeen *see* OGADEN

OGADEN (Ethiopia, Somalia)
variants Ogaadeen
note Eastern Cushitic language; subcategory of Somali
AAT: nl
LCSH: Ogaden
ETHN, GPM 1959, HB, HBDW, IML 1969, JM, KFS, PMPO, ROMC
see also Somali, Toponyms Index

OGBA (Nigeria)
variants Oba
note Kwa language; formerly considered a subcategory of Igbo
AAT: nl
LCSH: nl
DDMM, GIJ, RWL

OGONI (Nigeria)

note Benue-Congo language; a collective term used for the linguistically related groups Eleme, Gokana, Kana

AAT: Ogoni
LCSH: Ogoni language use Kana language
BS, CMK, DDMM, DWMB, EEWF, ELZ, ETHN, FW, GBJS, GIJ, HBDW, IAI, JD, JG 1963, JK, JLS, KMT 1970, MKW 1978, MLB, NOI, RFT 1974, RGL, RJ 1958, ROMC, RSAR, RWL, WG 1980, WRB, WRB 1959, WRNN, WS
EE*, HW*, JHH*

see also Cross River people

OGORI (Nigeria)

note Benue-Congo language

AAT: nl
LCSH: nl
DDMM, ETHN

Ogowe River *see* Toponyms Index

Ogu Oku *see* OGU UKU

OGU UKU (Nigeria)

variants Ogu Oku

note Kwa language; subcategory of Igbo; one of the groups referred to as Northeastern Igbo

AAT: nl
LCSH: nl
DWMB, RWL
CFGJ*

see also Igbo

Ogua *see* AGUA

Ohaffia *see* ABAM

Ohafya *see* ABAM

OHENDO (Zaire)

note Bantu language; one of the groups included in the collective term Mongo

AAT: nl
LCSH: Ohendo
JC 1978

see also Mongo

Ohori *see* AHORI

OHUHU (Nigeria)

variants Ohuhu-Ngwa

note Kwa language; one of the divisions of Igbo sometimes listed as Ohuhu-Ngwa; one of the groups referred to as Southern or Owerri Igbo

AAT: nl
LCSH: nl
DDMM, DWMB, ETHN, GIJ, IAI, RWL
CFGJ*

see also Igbo

Ohuhu-Ngwa *see* OHUHU

OKAK (Cameroun, Equatorial Guinea, Gabon)

note Bantu language; division of Fang; a Fang style/culture division. see LP 1979.

AAT: nl
LCSH: nl
ETHN, GAC, GPM 1975, HB, JK, JV 1984, LM, MUD 1986, SG, WS
LP 1979*, LP 1985*, LP 1990*

see also Fang

Okanda *see* OKANDE

OKANDE (Gabon)

variants Kande, Okanda

note Bantu language

AAT: use Kande
LCSH: nl
CK, DDMM, DP, ETHN, GPM 1959, HB, KK 1965, MGU 1967, OGPS, WH, WOH, WRB, WS
LP 1979*, LP 1985*, LP 1990*

OKANO (Cameroun, Equatorial Guinea, Gabon)

note a Fang style/culture division. see LP 1990.

AAT: nl
LCSH: nl
LP 1990, LP 1985

see also Fang

Okavango River *see* Toponyms Index

Okebo *see* NDO

Oke'bu *see* NDO

Okebu *see* NDO

Okene *see* IGBIRA

Okiek *see* DOROBO

Okoba *see* OKOBO

OKOBO (Nigeria)
variants Okoba
note Benue-Congo language;
sometimes further divided as
Okobo Eta and Odu Okobo
AAT: nl
LCSH: nl
CMK, DDMM, ETHN, HB, RWL, WS

OKOLLO (Uganda)
note Central Sudanic language;
subcategory of Madi; sometimes
referred to as Southern Madi
AAT: nl
LCSH: nl
DDMM, ETHN
see also Madi

OKOYONG (Nigeria)
variants Akoiyang
note Benue-Congo language;
scission of the Ododop; one of the
groups included in the collective
term Cross River people
AAT: nl
LCSH: nl
DDMM, ETHN, IAI, JG 1963, JLS, RWL
see also Ododop, Cross River
people

Okpela *see* OKPELLA

OKPELLA (Nigeria)
variants Okpela
note Kwa language; one of the
groups included in the collective
term Kukuruku
AAT: Okpella
LCSH: nl
DDMM, ETHN, JLS, KFS, RWL
see also Kukuruku

OKPOTO (Nigeria)
variants Kwotto
note This name and its variant
Kwotto have been used to refer to
the Idoma, part of the Igala, the
Igbira and Orri. see RWL.
AAT: nl
LCSH: use Ebira
DDMM, ETHN, GPM 1959, GPM 1975,
HB, JG 1963, NIB, RJ 1958, RWL

OKU (Cameroun)
variants Bamuku
note Bantoid language; one of the
groups included in the collective
term Bamenda
AAT: nl
LCSH: nl
DDMM, EBHK, ETHN, GDR, HAB, LM,
PH, RFT 1974, TN 1984, TN 1986, TP,
WS
LP 1993*, MKW*, MMML*, PMK*
see also Bamenda

OKUNG (Angola)
note Khoisan language; one of the
groups included in the collective
term Bushmen
AAT: nl
LCSH: nl
ATMB 1956, DDMM, GPM 1959, HB, JG
1963, WH
see also Bushmen

Old Calabar *see* Toponyms Index
Old Oyo *see* Toponyms Index
Olduvai Gorge *see* Toponyms Index
OLI (Zaire)
variants Booli, Ooli
note Bantu language
AAT: nl
LCSH: nl
DDMM, DPB 1985, DPB 1987, GAH
1950, GPM 1959, GPM 1975, HB, IAI,
JMOB, MGU 1967, OB 1973, OBZ, UIH,
WH, WS

OLI (Cameroun)
variants Ewodi, Uli, Wori, Wouri,
Wuri
note Bantu language; one of the
groups included in the collective
term Duala-Limba
AAT: nl
LCSH: nl
CK, DDMM, DP, ELZ, ETHN, GPM 1959,
GPM 1975, HB, IEZ, MGU 1967, PH, UIH,
WH, WOH
see also Duala-Limba

Olifantspoort *see* Toponyms Index
Olombo *see* LOMBO
Ombaamba *see* MBAAMA

OMBO (Zaire)
variants Baombo, Hombo
note Bantu language; one of two
 linguistic communities among the
 Songola
 AAT: nl
 LCSH: Ombo language
 DDMM, DPB 1981, DPB 1986, DPB 1987,
 ETHN, GPM 1959, GPM 1975, IAI, JAF,
 MGU 1967, OBZ, SMI, WMR
 AEM 1952*
see also Songola

OMETO (Ethiopia)
note Cushitic language; subcategory
 of Sidamo
 AAT: Ometo
 LCSH: nl
 ATMB, ATMB 1956, GPM 1959, HB, IAI,
 RJ 1959, UIH, WH
 ERC*
see also Sidamo

Omo River *see* Toponyms Index

ONDO (Nigeria)
note Kwa language; subcategory of
 Yoruba
 AAT: nl
 LCSH: nl
 BS, DDMM, DWMB, ETHN, GPM 1959,
 HB, HBDW, KFS, NOI, RWL, SMI, SV,
 UIH
 HJD*
see also Yoruba

Ondoumbo *see* NDUMBO
Ondumbo *see* NDUMBO
Onga *see* JONGA
ONITSHA (Nigeria)
note Kwa language; both a town
 and a division of Igbo; one of the
 groups referred to as Northern
 Igbo
 AAT: nl
 LCSH: nl
 DDMM, DWMB, EBR, ETHN, FW, GPM
 1959, GPM 1975, HB, HMC, JLS, JM,
 KFS, LM, NOI, RWL, SMI, SV, UIH, WG
 1980
 CFGJ*
see also Igbo

Ooli *see* OLI (Zaire)

OPOBO (Nigeria)
note Benue-Congo language; one of
 the divisions of Ibibio and a
 regional division in Nigeria
 AAT: nl
 LCSH: nl
 ELZ, NOI, RWL
see also Ibibio

Orange River *see* Toponyms Index

ORATTA (Nigeria)
note Kwa language; subcategory of
 Igbo
 AAT: nl
 LCSH: nl
 CFGJ, GIJ, RWL, SV, VCU 1965
see also Igbo

ORATTA-IKWERRI (Nigeria)
note Kwa language; subcategory of
 Igbo; one of the groups referred to
 as Southern Igbo
 AAT: nl
 LCSH: Oratta-Ikwerri language use Ikwere
 language
 CFGJ*, RWL*
see also Igbo

ORLU (Nigeria)
note Kwa language; subcategory of
 Igbo
 AAT: nl
 LCSH: nl
 DDMM, ETHN, RWL, VCU 1965
see also Igbo

Orma *see* OROMO

OROMO (Ethiopia, Kenya, Somalia)
variants Gala, Galla, Gallinyas,
Ilma Orma, Orma, Oromota
subcategories Arusi, Gabbra, Guji,
Itu, Macha, Tulama, Wallaga,
Wollo
note Cushitic language; may be
divided into Eastern or Baraytuma
and Western or Borana
AAT: nl (uses Arusi)
LCSH: Oromo
AF, ARW, ATMB, ATMB 1956, BES, BS,
DBNV, DDMM, EBR, ECB, ELZ, ETHN,
GB, GPM 1959, GPM 1975, GWH 1955,
HAB, HB, HBDW, HRZ, IAI, JD, JG 1963,
JK, JLS, JM, JP 1953, JV 1966, KFS, KK
1990, LJPG, LPR 1995, MFMK, MLJD,
PG 1990, RGL, RJ 1959, ROMC, RS 1980,
RSW, SD, SMI, TP, UIH, WH, WOH
EKH*, GWH 1955*, IML 1969*, MOH*

Oromota *see* OROMO

ORON (Nigeria)
note Benue-Congo language;
sometimes considered a
subcategory of Ibibio
AAT: Oron
LCSH: Oron
BDG 1980, CMK, DDMM, DP, EBR, ELZ,
ETHN, GBJS, GIJ, HB, HBDW, JD, JK,
JLS, KFS 1989, LJPG, MKW 1978, NOI,
RJ 1958, ROMC, RSAR, RSW, RWL, SMI,
SV, TB, TP, WG 1980, WG 1984, WRB,
WRNN, WS
EE*, KN*
see also Ibibio

Orri *see* UTONKON
Orungu *see* RONGO
Oscheba *see* MAKE
Oseyba *see* MAKE
Oshiba *see* MAKE
Ossyeba *see* MAKE
OSU (Ghana)
note Kwa language
AAT: nl
LCSH: nl
IAI, MM 1950, SMI
Osudoku *see* OSUDUKU

OSUDUKU (Ghana)
variants Osudoku
note Kwa language
AAT: nl
LCSH: nl
GPM 1959, MM 1950
Osyeba *see* MAKE
Otank *see* UTANGA
Otoro *see* TORO (Sudan)
OTURKPO (Nigeria)
note Kwa language; subcategory of
Idoma
AAT: nl
LCSH: use Idoma
DDMM, ETHN, GPM 1959, JLS, RWL
see also Idoma
Ouadaï *see* WADAI (Toponyms
Index)
OUARZATA (Morocco)
note Berber language
AAT: Ouarzata
LCSH: nl
Oubi *see* UBI
Ouellé *see* UELE (Toponyms Index)
OULAD DELIM (Mauritania)
note Semitic language; one of the
groups included in the collective
term Bedouin
AAT: nl
LCSH: nl
GPM 1959, WH
see also Bedouin
Oule *see* LOWIILI
Ouobe *see* WOBE
Ouobi *see* WOBE
Ouolof *see* WOLOF
Ovambo *see* AMBO

OVIMBUNDU (Angola)
variants Kimbanda, Mbundo,
 Mbundu, Quimbundo, Umbundu,
 Vakuanano, Vanano, Vimbundo
note Bantu language; includes the
 Bié (Viye), Wambu, Bailundu,
 Tshiaka (Ciaka), Huambo,
 Kakonda, Ndulu, Ngalangi, and
 other smaller incorporated groups;
 one of the groups included in the
 Lunda-Lovale peoples. The prefix
 Ovi- is maintained to avoid
 confusion with the Mbundu who
 are also in Angola north of the
 Ovimbundu.
AAT: use Mbundu
LCSH: use Benguella
ACN, AW, BS, CFL, CK, DDMM, DPB
1987, EB, EBHK, EBR, ELZ, ETHN, GPM
1959, GPM 1975, HAB, HB, HJK, HRZ,
IAI, JC 1978, JK, JL, JLS, JM, JV 1966,
LJPG, MGU 1967, MLJD, NIB, PR,
ROMC , RSAR, RSW, SMI, SV, TERV,
UIH, WEW 1973, WG 1980, WG 1984,
WH, WRB, WRNN, WS, WVB
CWMN*, GMC*, MEM*, MLB 1994*
see also Lunda-Lovale

OWE (Nigeria)
note Kwa language; subcategory of
 Yoruba
AAT: nl
LCSH: nl
DDMM, DWMB, ETHN, GPM 1959, KFS,
RWL, SMI
see also Yoruba

OWERRI (Nigeria)
note Kwa language; one of the
 divisions of Igbo; one of the
 groups referred to as Southern
 Igbo
AAT: nl
LCSH: use Itsekiri
DDMM, DWMB, EBR, ETHN, FW, GPM
1959, GPM 1975, HMC, KFS, SMI, WH
CFGJ*, HMC 1982*,
see also Igbo

OWO (Nigeria)
note Kwa language; subcategory of
 Yoruba
AAT: Owo
LCSH: nl
BDG 1980, DDMM, DFHC, DFM,
DWMB, EL, ELZ, FW, GPM 1959, HJD,
IAI, JK, JLS, JM, JV 1984, KFS 1989, KK
1965, LJPG, LM, MK, MLB, NOI, PH,
RGL, SV, WG 1980, WG 1984, WRB,
WRNN
EE*, HJD*, KE 1992*, WBF 1982*
see also Yoruba

OYO (Nigeria)
note Kwa language; subcategory of
 Yoruba. The Oyo empire was an
 ancient West African empire,
 circa 1050-1900 CE, whose
 capital was known as Old Oyo or
 Katunga.
AAT: Oyo
LCSH: Oyo & Oyo Empire
BDG 1980, CDR 1985, DDMM, DFHC,
DFM, DWMB, EBR, ELZ, ETHN, FW,
GPM 1959, GPM 1975, HB, HBDW,
HMC, HRZ, IAI, JLS, JM, JV 1984, KFS,
LJPG, NOI, RJ 1958, ROMC, SMI, SV,
UIH, WG 1984, WH, WLA, WRB
BD*, CFPK*, HJD*, SOB*
see also Old Oyo, Yoruba

OZU-ITEM (Nigeria)
note Kwa language; subcategory of
 Igbo
AAT: nl
LCSH: nl
CFGJ, GIJ, WS

PABIR (Nigeria)
variants Babur
note Chadic language
AAT: nl
LCSH: nl
DDMM, ELZ, ETHN, GPM 1959, GPM 1975, HB, JG 1963, RWL, UIH, WS

Padhola *see* JO PADHOLA

Padogo *see* PODOKO

Padorho *see* GBADOGO

Paduko *see* PODOKO

PAGABETE (Zaire)
variants Pagabeti
note Bantu language
AAT: nl
LCSH: nl
DPB 1987, ETHN, HB, IAI

Pagabeti *see* PAGABETE

Pahouin *see* FANG

Pajade *see* BADYARANKE

Pajadinca *see* BADYARANKE

Pajulu *see* PÖJULU

Paka *see* NZANGI

Pakala *see* KULANGO

Pakombe *see* PERE

Pakot *see* SUK

PALARA (Côte d'Ivoire)
variants Kpalagha, Pallaka
note Gur language; subcategory of Senufo
AAT: nl
LCSH: nl
AJG, DDMM, DWMB, ETHN, HB, JPB, UIH, WEW 1973
see also Senufo

Pallaka *see* PALARA

PAMBEN (Cameroun)
note one of the groups included in the collective term Bamileke
AAT: nl
LCSH: nl
LP 1993
see also Bamileke

PAMBIA (Central African Republic, Sudan, Zaire)
variants Apambia
note Southern Ubangian language
AAT: nl
LCSH: nl
ATMB, ATMB 1956, DB 1978, DDMM, ETHN, FE 1933, GPM 1959, GPM 1975, HB, HBDW, JG 1963, UIH

Pamue *see* FANG

PANDE (Central African Republic)
note Bantu language
AAT: nl
LCSH: nl
DDMM, ETHN, GPM 1959, HB, MGU 1967, UIH, WH

Panga *see* IPANGA

PANGWA (Tanzania)
variants Wapangwa
note Bantu language
AAT: Pangwa
LCSH: Pangwa
ECB, ETHN, GPM 1959, GPM 1975, HB, MFMK, MK, RJ 1960, UIH, WG 1980, WH

Pangwe *see* FANG

Panon *see* PAPE

PAPE (Cameroun, Nigeria)
variants Panon
note Adamawa language
AAT: nl
LCSH: nl
BEL, DDMM, ETHN, GPM 1959, GPM 1975, HB, JG 1963, RJ 1958, UIH
EPHE 9*

PAPEI (Guinea, Guinea-Bissau)
variants Papel, Pepel
note West Atlantic language
AAT: nl
LCSH: nl
DDMM, ETHN, GPM 1959, HB, IAI, KK 1965, RJ 1958, SD, UIH, WH

Papel *see* PAPEI

Papiakum *see* BABA

PARE (Tanzania)
variants Asu
note Bantu language; a collective
term for the peoples of Mount
Pare, the result of recent merging
of the Gweno and Asu
AAT: Pare
LCSH: use Asu
BS, CDR 1985, DDMM, ECB, ETHN,
EWA, GPM 1959, GPM 1975, HAB,
HBDW, IAI, JJM 1972, JLS, KK 1990,
MFMK, MGU 1967, NIB, RJ 1960, SMI,
UIH, WG 1980, WH, WOH
HC*, SMPP*
see also Gweno

PĂRI (Ethiopia, Sudan)
variants Feri, Lokoro
note West Nilotic language; one of
the groups included in the
collective term Nilotic people
AAT: nl
LCSH: Pari language
ATMB 1956, DDMM, ETHN, GPM 1959,
GPM 1975, HAB, HB, IAI, RJ 1959, UIH,
WH
AJB*
see also Nilotic people

PATE (Kenya)
note Bantu language; a linguistic
division of Swahili
AAT: nl
LCSH: nl
DDMM, ETHN, HB, KFS
see also Swahili, Toponyms Index

PATI (Cameroun)
note Bantu language
AAT: nl
LCSH: nl
EBHK, ETHN, JLS

PATORO (Burkina Faso, Côte
d'Ivoire, Mali)
note Gur language; subcategory of
Senufo
AAT: nl
LCSH: nl
JPB, SV
AJG*
see also Senufo

PATRI (Central African Republic)
variants Kpatili
note Southern Ubangian language
AAT: nl
LCSH: nl
DB 1978, DDMM, ETHN, HB

PATU (Zaire)
variants Phatu
note Bantu language
AAT: nl
LCSH: nl
DDMM, DPB 1985

PEDI (South Africa)
variants Bapedi
note Bantu language; subcategory of
Sotho; sometimes referred to as
Northen Sotho or Transvaal Sotho
AAT: Pedi
LCSH: Pedi
ACN, BES, DDMM, EBR, ETHN, GPM
1959, GPM 1975, HAB, HB, HBDW, IAI,
JLS, JM, JRE, JTSV, KFS, MCA 1986,
MGU 1967, MHN, ROMC, SMI, UIH,
WDH, WFJP, WH, WRB
see also Sotho

PELENDE (Zaire)
note Bantu language
AAT: nl
LCSH: nl
DDMM, DPB 1985, DPB 1987, ETHN, JK,
OBZ, OB 1973, SMI

PEMBA (Tanzania)
variants Phemba
note Bantu language; subcategory of
Swahili
AAT: Pemba
LCSH: nl
DDMM, DPB 1985, ETHN, GPM 1959,
GPM 1975, HB, HRZ, JAF, JK, JM,
MFMK, MGU 1967, OB 1973, PMPO,
ROMC, SMI, WG 1984, WH
see also Swahili, Toponyms Index

PENDE (Zaire)
variants Bapende, Kasai Pende, Phende, Pindi, Pinji
note Bantu language. Some sources distinguish between Eastern (or Kasai) Pende and Western Pende.
AAT: Pende
LCSH: Pende
AF, ALM, ASH, AW, BES, BS, CDR 1985, CK, CMK, DDMM, DFHC, DOWF, DP, DPB 1985, DPB 1987, EB, EBR, EEWF, ELZ, ETHN, FHCP, FN 1994, FW, GAH 1950, GBJM, GBJS, GPM 1959, GPM 1975, HAB, HB, HBDW, HH, HJK, HMC, IAI, JAF, JC 1971, JC 1978, JD, JK, JLS, JM, JMOB, JV 1966, JV 1984, KFS, KK 1960, KK 1965, KMT 1970, LJPG, LP 1985, MCA, MGU 1967, MH, MHN, MK, MLB, MLJD, MWM, OB 1973, OBZ, RFT 1974, RS 1980, RSAR, RSRW, RSW, SD, SMI, SV, SV 1988, SVFN, TB, TERV, TP, UIH, WBF 1964, WG 1980, WG 1984, WH, WMR, WOH, WRB, WRB 1959, WRNN, WS
LDS*

Pepehiri *see* AHIZI
Pepel *see* PAPEI
PERE (Zaire)
variants Bapere, Bapili, Bapiri, Bili, Pakombe, Peri, Piri
note Bantu language
AAT: Pere
LCSH: nl
ALM, DDMM, DPB 1987, DWMB, ELZ, ETHN, GAH 1950, GPM 1959, GPM 1975, HB, JC 1978, JD, JK, JMOB, MGU 1967, MLB, MLJD, OBZ, TP, UIH, WG 1980, WH, WRNN
DPB 1986*, HVGB*

Peri *see* PERE
Pessi *see* KPELLE
PETA (Malawi, Tanzania)
variants Chipeta
note Bantu language
AAT: nl
LCSH: nl
DDMM, ETHN, GPM 1959, GPM 1975, JLS, MGU 1967, WVB

Peuhl *see* FULANI
Peul *see* FULANI
Pfokomo *see* POKOMO

Phatu *see* PATU
Phemba *see* PEMBA
Phende *see* PENDE
PHOKA (Malawi)
note Bantu language
AAT: nl
LCSH: Phoka
DDMM, ETHN, GPM 1959, HB, JLS

Pianga *see* PYAANG
Piapun *see* PYAPUN
Pigmies *see* PYGMIES
Pilapila *see* YOWA
PIMBWE (Tanzania)
note Bantu language
AAT: nl
LCSH: nl
ECB, ETHN, GPM 1959, GPM 1975, HB, IAI, MGU 1967, MFMK, RJ 1960, UIH, WH, WVB
RGW*

Pindi *see* PENDE
PINDI (Zaire)
variants Bapindi, Bapindji, Mpiin, Pindji
note Bantu language
AAT: nl
LCSH: nl
DDMM, DP, DPB 1987, ETHN, GPM 1959, GPM 1975, HAB, HB, HBDW, JV 1966, KFS, MGU 1967, OB 1973, OBZ, RSW, SMI, TERV, TP, WH
DPB 1985*

Pindji *see* PINDI
Pinji *see* PENDE
Piri *see* PERE
PODOKO (Cameroun)
variants Padogo, Paduko
note Chadic language
AAT: nl
LCSH: use Paduko
DDMM, ETHN, GPM 1959, HB

PODZO (Mozambique)
note Bantu language
AAT: nl
LCSH: nl
DDMM, ETHN, GPM 1959, GPM 1975, HB, KFS, MGU 1967, UIH
TEW*

Pogolo *see* POGORO

POGORO (Tanzania)
variants Pogolo, Wapogoro
note Bantu language
AAT: Pogoro
LCSH: Pogoro
DDMM, ECB, ETHN, GPM 1959, GPM
1975, HB, MFMK, RJ 1960, UIH, WH,
WOH

PÖJULU (Sudan, Uganda, Zaire)
variants Fadjelu, Fajulu, Pajulu
note Eastern Nilotic language; one
of the groups included in the
collective term Nilo-Hamitic
people
AAT: nl
LCSH: nl
ATMB 1956, CSBS, DDMM, DPB 1987,
ETHN, GAH 1950, GPM 1959, GPM
1975, HAB, HB, JG 1963, JMOB, OBZ,
UIH, WH
GWH*
see also Nilo-Hamitic people

POK (Kenya)
variants Lako
note Southern Nilotic language; one
of the groups included in the
collective terms Nilo-Hamitic
people and Sapaut
AAT: nl
LCSH: nl
DDMM, ETHN, GPM 1959, GPM 1975,
UIH
GWH 1969*
see also Nilo-Hamitic people,
Sapaut

Poke *see* TOPOKE

POKOMO (Tanzania, Kenya)
variants Pfokomo, Wafokomo,
Wapokomo
note Bantu language
AAT: nl
LCSH: Pokomo
AHP 1952, DDMM, ECB, ETHN, GPM
1959, GPM 1975, HAB, HB, HBDW, IAI,
JLS, MCA 1986, MGU 1967, RGL, RJ
1960, SMI, UIH, WH, WS
AHP 1952*

Pokot *see* SUK

POMO (Cameroun, Central African
Republic)
note Bantu language
AAT: nl
LCSH: nl
DDMM, GPM 1959, GPM 1975, HB, WH

Ponda *see* LUCHAZI

Pondo *see* MPONDO

PONDO (Central African Republic)
note Adamawa language
AAT: nl
LCSH: nl
DDMM, ETHN

PONGO (Cameroun)
variants Bongo
note Bantu language
AAT: nl
LCSH: nl
DDMM, DP, EDA, ETHN, GPM 1959, HB,
WH
see also Duala-Limba

Pongwe *see* MPONGWE

Popo *see* GUN

POPOI (Zaire)
variants Bapopoie
note Central Sudanic language; one
of the groups included in the
collective term Mangbetu
AAT: nl
LCSH: nl
ATMB 1956, DDMM, DPB 1987, ESCK,
ETHN, GAH 1950, GPM 1959, HAB, HB,
IAI, JG 1963, JMOB, OBZ, SV, UIH, WH
JEL*
see also Mangbetu

PORO (Côte d'Ivoire, Guinea,
Liberia, Sierra Leone)
note a society or association
widespread in West Africa
AAT: nl
LCSH: nl
DFHC, DP, EBR, ELZ, FW, GAC, GWS,
JLS, JM, LJPG, LM, LPR 1986, NIB,
PMPO, RAB, SAB, SMI, SV, TB, WG
1980

Porto Novo *see* Toponyms Index

Portuguese East Africa *see*
Toponyms Index

Portuguese West Africa *see*
Toponyms Index
POTO (Zaire)
note Bantu language; one of the
groups referred to as Gens d'Eau
or Ngala; one of the groups
included in the collective term
Losengo
AAT: nl
LCSH: nl
BES, DDMM, DPB 1987, ETHN, GPM
1959, GPM 1975, HBU, HBDW, IAI,
MGU 1967, OBZ, RS 1980, RSW, SD, SV
1988, WH
see also Losengo, Ngala, Ngiri
Potopo *see* KOTOPO
POTOPOTO (Kenya)
note Bantu language
AAT: nl
LCSH: nl
DDMM, JLS
Pounou *see* PUNU
Pouvi *see* BUBI
Povi *see* BUBI
PRAMPRAM (Ghana)
variants Prampran
note Kwa language
AAT: nl
LCSH: nl
GPM 1959, MM 1950, RS 1980
Prampran *see* PRAMPRAM
PRE-BEMBE (Zaire)
note Bantu language. Many groups
living among the Bembe and Boyo
are sometimes referred to as Pre-
Bembe, including the Bwari,
Goma, Kasingo, Sanze and others.
AAT: nl
LCSH: nl
DPB 1987, WS
DPB 1981*
Psikye *see* KAPSIKI
Pubi *see* BUBI
Pullo *see* FULANI
Pulo *see* FULANI
Pungu *see* CIPUNGU
Puno *see* PUNU

Punt *see* Toponyms Index
PUNU (Congo Republic, Gabon)
variants Apono, Bapunu, Pounou,
Puno
note Bantu language
AAT: Punu
LCSH: Punu language
AW, BES, BS, CDR 1988, CFL, CMK,
DDMM, ETHN, FW, GBJS, GPM 1959,
GPM 1975, HB, HMC, IAI, JAF, JD, JK,
JTSV, KFS 1989, LM, LP 1979, LP 1985,
MGU 1967, MLB, MLJD, MUD 1991,
RSRW, SG, SV, SV 1988, TP, UIH, WH,
WOH, WRB, WRNN, WS
Puvi *see* BUBI
PYAANG (Congo Republic, Zaire)
variants Bapyaang, Pianga
note Bantu language; subcategory of
Kuba
AAT: nl
LCSH: nl
CDR 1985, DFHC, EBHK, HH, JC 1971,
JC 1978, JC 1982, JK, JP 1953, JV 1966,
JV 1978, OB 1973, SV, WRB
see also Kuba
PYAPUN (Nigeria)
variants Piapun
note Chadic language
AAT: nl
LCSH: nl
DDMM, ETHN, HB, RWL, WS
PYEM (Nigeria)
variants Fyam
note Benue-Congo language
AAT: nl
LCSH: nl
DDMM, DWMB, ETHN, GPM 1959, GPM
1975, HB, JG 1963, JLS, RWL

PYGMIES (Burundi, Cameroun, Central African Republic, Congo Republic, Equatorial Guinea, Gabon, Rwanda, Zaire)
variants Bakola, Pigmies
note The languages spoken by Pygmies tend to be those of the Bantu, Sudanic, or Ubangian language speakers with whom they are in contact. Distinctive groups of Pygmies include the Abongo, Aka, Akua, Babinga, Bagyele, Basua, Cwa, Efe, Gesera, Mbuti, Twa, Zigaba.
AAT: Pygmy
LCSH: Pygmies
ARW, ATMB, ATMB 1956, DFHC, DPB 1981, DPB 1985, DPB 1986, DPB 1987, EBR, ELZ, ESCK, FW, GBJM, GPM 1959, GPM 1975, HB, HRZ, IAI, JK, JL, JLS, JM, JPB, LJPG, LP 1985 , PMPO, PR, RJ 1960, ROMC, RS 1980, RSW, SD, SMI, WG 1980, WH, WRB 1959, WS, WVB CMT*, PAS*, RPT*, RRG*, SB*, SB 1985*

Qasim *see* KASENA
Qemant *see* KEMANT
Qimr *see* GIMR
Qottu *see* ITTU
QUA (Nigeria)
variants Kwa
note Bantoid language; subcategory of Ejagham; one of the groups included in the Ekoid language cluster
AAT: nl
LCSH: nl
DDMM, GIJ, HB, IAI, KK 1960, RWL
see also Ejagham
Quiaca *see* CIAKA
Quilenge *see* CILENGE
Quimbares *see* MBALI
Quimbundo *see* OVIMBUNDU

Quioco *see* CHOKWE
Quipungo *see* CIPUNGU
Quissama *see* KISAMA

RABAI (Kenya)
note Bantu language; one of the groups included in the collective term Nyika
AAT: Rabai
LCSH: nl
AHP 1952, ECB, ETHN, GPM 1959, GPM 1975, HB, UIH
see also Nyika
Rabat *see* Toponyms Index
Ragoli *see* LOGOOLI
Rahanwein *see* RAHANWIIN
Rahanweyn *see* RAHANWIIN
RAHANWIIN (Somalia)
variants Rahanwein, Rahanweyn
note Cushitic language; clan-family of the Somali; one of the groups included in the collective term Sab
AAT: nl
LCSH: nl (uses Rahanweyn)
ATMB 1956, ETHN, GPM 1959, HB, UIH IML*, IML 1969*
see also Sab, Somali
RANGI (Tanzania)
variants Irangi, Langi, Rongo, Warangi, Warongo
note Bantu language
AAT: nl
LCSH: Rangi
ECB, ETHN, GPM 1959, GPM 1975, HB, MFMK, RJ 1960, UIH, WH, WOH

RASHAD (Sudan)
 variants Rashaida, Rashaidaa
 note Kordofanian language
 AAT: nl
 LCSH: nl (uses Rashayida)
 AF, DDMM, ETHN, GPM 1959, HB, JG
 1963, JLS
Rashaida *see* RASHAD
Rashaidaa *see* RASHAD
Rega *see* LEGA
REGEIBAT (Mauritania)
 variants Reguibat
 note Semitic language; one of the
 groups included in the collective
 term Bedouin
 AAT: nl
 LCSH: nl
 GPM 1959, LPR 1995, RJ 1958, WH
 see also Bedouin
Reguibat *see* REGEIBAT
REHAMNA (Morocco)
 AAT: Rehamna
 LCSH: nl
 GPM 1959
Remi *see* NYATURU
RENDILE (Kenya)
 variants Rendille
 subcategories Ariaal
 note Cushitic language
 AAT: Rendile
 LCSH: Rendile
 ATMB 1956, DDMM, ECB, ETHN, GPM
 1959, GPM 1975, HB, HBDW, IAI, JLS,
 KFS 1989, LPR 1995, RJ 1960, RS 1980,
 SMI, UIH, WH
Rendille *see* RENDILE
RESHIAT (Ethiopia, Kenya)
 note Eastern Cushitic language
 AAT: nl
 LCSH: nl
 ATMB 1956, DDMM, ETHN, GPM 1959,
 GPM 1975, JG 1963, WH
 ERC*
Rgwe *see* IRIGWE

RIBE (Kenya, Tanzania)
 variants Rihe
 note Bantu language; one of the
 groups included in the collective
 term Nyika
 AAT: Ribe
 LCSH: Ribe
 AHP 1952, DDMM, ECB, ETHN, GPM
 1959, HB, JG 1963, RJ 1960, UIH, WS
 see also Nyika
RIF (Algeria, Morocco)
 variants Riff
 note Berber language; one of the
 groups included in the collective
 term Berber
 AAT: nl
 LCSH: Rif language
 ETHN, GPM 1959, GPM 1975, HBDW,
 HRZ, JM, LJPG, ROMC, SMI, WH
 ANB*
 see also Berber, Toponyms Index
Riff *see* RIF
Rift Valley *see* Toponyms Index
Rifum *see* BANKIM
Rigwe *see* IRIGWE
Rihe *see* RIBE
Rinderi *see* NUNGU
Rindri *see* NUNGU
Rio Muñi *see* Toponyms Index
Riverain Ibibio *see* EFIK
RIVERAIN IGBO (Nigeria)
 note Kwa language; a subcategory
 of Igbo; one of the groups
 included in the term Western Igbo
 AAT: nl
 LCSH: nl
 RWL
 CFGJ*
 see also Igbo

RIVERAIN people (Zaire)
 note Under this label are often
 grouped small specialized
 populations living in the Zaire-
 Ubangi river basin including the
 so-called Ngiri groups and others,
 such as the Eleku, Bobangi,
 Iboko, Kango, Ngele, Babale, and
 Mabembe.
 AAT: nl
 LCSH: nl
 DPB 1987, HBU
 see also Ngiri
RIYAH (Libya)
 note Semitic language; subcategory
 of Bedouin
 AAT: nl
 LCSH: nl
 GPM 1959
 see also Bedouin
Rizeigat *see* RIZEYGAT
RIZEYGAT (Chad, Sudan)
 variants Rizeigat
 subcategories Mahria
 note Semitic language; a tribal
 federation in northern Darfur;
 subcategory of Baggara
 AAT: nl
 LCSH: nl
 GPM 1959, IGC, LPR 1995
 see also Baggara, Sudan Arabs
ROLONG (Botswana, Namibia,
 South Africa)
 note Bantu language; subcategory of
 Tswana
 AAT: nl
 LCSH: Rolong
 ARW, ETHN, GPM 1959, GPM 1975, HB,
 MGU 1967, UIH, WDH, WH
 JNC*
 see also Tswana
Rombi *see* RUMBI
RON (Nigeria)
 variants Bokkos
 note Chadic language
 AAT: nl
 LCSH: Ron language

DDMM, ETHN, GPM 1959, GPM 1975,
 JG 1963, JLS, RWL, SD
Ronga *see* TSONGA
Ronge *see* TEMEIN
Rongo *see* RANGI
RONGO (Gabon)
 variants Orungu, Marongo
 note Bantu language; one of the
 groups included in the collective
 term Myene
 AAT: nl
 LCSH: use Orungu
 CK, DDMM, DP, EBHK, ETHN, GPM
 1959, HB, LP 1985, UIH, WH
 see also Myene
ROTSE (Zambia, Zimbabwe)
 variants Barotse
 note Bantu language; also the name
 of their ancient kingdom
 AAT: use Lozi
 LCSH: use Lozi
 BES, CK, DDMM, DFHC, EB, EEWF,
 ETHN, ELZ, FW, GB, GPM 1959, GPM
 1975, HAB, HB, HBDW, HH, IAI, JD, JJM
 1972, JK, JV 1966, KMT 1971, MLB,
 MLJD, MUD 1991, PMPO, RGL, RJ 1961,
 ROMC, RSW, SMI, TP, UIH, WFJP, WG
 1980, WH, WMR, WRNN, WS, WVB,
 WRB
 BAR*, ECMG*, MUM*
 see also Lozi
Rozvi *see* ROZWI
ROZWI (South Africa, Zimbabwe)
 variants Barozwi, Rozvi
 note Bantu language; one of the
 divisions of Shona; also the name
 of a 17th- and 18th-century
 empire in Zimbabwe
 AAT: Rozwi
 LCSH: nl
 BD, CDR 1985, DDMM, FW, GPM 1959,
 GPM 1975, HB, PG 1973, PG 1990, WDH,
 WG 1984, WH, WRB 1959
 BAR*
 see also Great Zimbabwe, Shona
Ruanda *see* RWANDA
Rue *see* BARWE

RUFIJI (Tanzania)
variants Ruihi
note Bantu language
AAT: nl uses Rufijic
LCSH: Rufiji River
DDMM, ECB, ETHN, GPM 1959, GPM
1975, HB, HC, KK 1990, MFMK, WOH,
UIH

Ruihi *see* RUFIJI

RUKUBA (Nigeria)
note Benue-Congo language
AAT: Rukuba
LCSH: Rukuba
DDMM, ETHN, GPM 1959, GPM 1975,
HB, JAF, JG 1963, JLS, RWL

RUMBI (Zaire)
variants Barumbi, Lombi, Rombi,
Walumbi
note Central Sudanic language; one
of the groups included in the
collective term Mangbetu
AAT: nl
LCSH: nl
ATMB 1956, DDMM, DPB 1986, DPB
1987, ESCK, ETHN, FHCP, GPM 1959,
GPM 1975, HAB, HB, IAI, JG 1963,
JMOB, OBZ, UIH, WH, HB
HVGB*, JEL*
see also Mangbetu

RUNDI (Burundi, Tanzania)
variants Barundi, Warundi
note Bantu language
AAT: nl
LCSH: Rundi
BS, DDMM, DPB 1981, DPB 1987, ECB,
ELZ, ETHN, GAH 1950, GPM 1959, GPM
1975, HAB, HB, IAI, JMOB, LJPG, MGU
1967, MTKW, OBZ, RJ 1960, SMI, UIH,
WH, WOH
AIM*, MDAT*

RUNGA (Central African Republic,
Chad)
note Nilo-Saharan language
AAT: nl
LCSH: Runga language
ATMB 1956, DDMM, ETHN, FE 1933,
GPM 1959, GPM 1975, HB, JG 1963,
ROMC, WH

RUNGWA (Tanzania)
note Bantu language

AAT: nl
LCSH: nl
ETHN, GPM 1959, HB, MGU 1967,
MFMK, UIH

Ruund *see* LUNDA

Ruvuma River *see* Toponyms Index

Ruwenzori Mountains *see*
Toponyms Index

Ruzizi River *see* Toponyms Index

RWANDA (Rwanda)
variants Banyarwanda, Ruanda
note Bantu language. Rwanda is
the name of a country and of a
kingdom. Banyarwanda is the full
name of the people living in
Rwanda. There are three
constituent groups: Tutsi, Hutu
and Twa.
AAT: use Ruanda
LCSH: nl
AF, BES, BS, DDMM, DPB 1987, EB,
ETHN, GAH 1950, GBJM, GPM 1959,
GPM 1975, HAB, HB, HRZ, IAI, JJM
1972, JLS, JMOB, JV 1984, KK 1990,
KMT 1971, LJPG, MCA 1986, MGU 1967,
MPF 1992, MTKW, OBZ, PG 1990, PR, RJ
1960, ROMC, RS 1980, RSW, SMI, UIH,
WFJP, WG 1980, WG 1984, WH, WRB
1959, WH
FLVN*, JJM 1961*, MCVG*, MDAT*

Saafue *see* SAAFWE

SAAFWE (Côte d'Ivoire)

variants Saafue

note Kwa language; subcategory of
Baule
AAT: nl
LCSH: nl
JPB

see also Baule

Saamia *see* SAMIA

SAB (Somalia)

note Cushitic language; a collective
term among the Somali which
includes the Bimal, Digil,
Rahanwiin and Tunni
AAT: nl
LCSH: nl
ATMB 1956, GPM 1959, GPM 1975, HB,
UIH
IML*, IML 1969*

see also Somali

SABAEANS (Ethiopia, Somalia)

note migrated to Ethiopian plateau
from Arabian peninsula circa 6th
century BCE
AAT: Sabaean
LCSH: Sabeans
GPM 1975, PG 1990, PR

Sabaot *see* SAPAUT

SAHARAN & SAHELIAN people

note These peoples are represented
by 1. sedentary populations of the
Kanembu and Kamadja types; 2.
semi-sedentary populations of the
Maba, Zaghawa, Daza, Teda, Tou
types; 3. nomadic populations of
the Saeda and Central Chad types;
and 4. semi-nomadic populations
of the Kreda and Annakaza types.
Historically a series of sultanates
developed in the Sahel region
including, Sennar, Darfur, Wadai,
Baguirmi, Kanem, Bornu, and
others.
AAT: nl
LCSH: nl
HBDW, HRZ, SMI, WH

ALR*, EPHE 10*

Sahel *see* Toponyms Index

SAHO (Eritrea, Ethiopia, Somalia)

variants Sao

note Cushitic language; often
grouped with the Saho and
referred to as the Saho-Afar
AAT: nl
LCSH: Saho
ATMB, ATMB 1956, DDMM, ETHN,
GPM 1959, GPM 1975, HB, HBDW, JG
1963, RJ 1959, SMI, UIH, WEW 1973,
WH, WMR
IML 1969*

see also Afar

SAKA (Zaire)

variants Bosaka

note Bantu language; subcategory of
Mongo
AAT: nl
LCSH: nl
DDMM, DPB 1987, ETHN, GAH 1950,
GPM 1959, GPM 1975, HAB, HB, JMOB,
OBZ, WH

see also Mongo

SAKALAVA (Madagascar)

note Malagasi language
(Austronesian)
AAT: Sakalava
LCSH: Sakalava
BES, BS, DDMM, ETHN, GPM 1959,
GPM 1975, HB, IAI, JK, JLS, JP 1953,
JPJM, JV 1984, KFS, KK 1990, MPF 1992,
ROMC, RSRW, SMI, SVFN, TP, WG
1984, WH, WMR, WRNN
CKJR*, JMA*

Sakara *see* NZAKARA

SAKATA (Zaire)

variants Basakata, Lesa

note Bantu language
AAT: nl
LCSH: Sakata
BS, DDMM, DPB 1985, DPB 1987,
ETHN, GAH 1950, GPM 1959, GPM
1975, HB, HBDW, JC 1971, JMOB, JPJM,
JV 1966, KFS, MGU 1967, OB 1973, OBZ,
SMI, UIH, WH
ERB*, LIC*

SAKU (Tanzania)

note Bantu language; a division of Nyakyusa

AAT: nl
LCSH: nl
DDMM, ETHN, HB
MHW*, TEW*

see also Nyakyusa

Salaga *see* Toponyms Index

SALAMPASU (Zaire)

variants Asalampasu, Basalampasu, Mpasu

note Bantu language; one of the groups referred to as Akaawand

AAT: Salampasu
LCSH: Salampasu
ACN, CDR 1985, CMK, DDMM, DPB 1987, ELZ, ETHN, FHCP, GAH 1950, GBJS, HB, HMC, IAI, JAF, JC 1971, JC 1978, JK, JLS, JMOB, JPJM, JV 1966, KFS, KFS 1989, LM, MH, MHN, MLB, MLF, MLJD, OB 1961, OB 1973, OBZ, RSW, SMI, TERV, TP, UIH, WBF 1964, WG 1980, WH, WOH, WRB, WRNN
ELC*

see also Akaawand

SALIA (Zaire)

note Bantu language; one of the groups included in the collective term Ngelima

AAT: nl
LCSH: nl
SV

see also Ngelima

Samba *see* TSAAM

Samba Daka *see* DAKA

Samba Leko *see* LEKO

Sambaa *see* SHAMBAA

Sambala *see* SHAMBAA

Sambara *see* SHAMBAA

SAMBURU (Kenya)

variants Il Loikop, Loikop, Loikpo, Sampur

note Eastern Nilotic language; one of the groups included in the collective term Nilo-Hamitic people; close in culture to the Maasai and sometimes considered to be a branch of the Maasai

AAT: Samburu
LCSH: Samburu
AF, ATMB 1956, BS, DDMM, EBR, ECB, ETHN, GPM 1959, GPM 1975, GWH 1969, HAB, IAI, JLS, LSD, MCA 1986, PG 1990, PMPO, RJ 1960, RS 1980, SMI, TP, UIH, WH
NP*, PLS*, TM*

see also Nilo-Hamitic people

SAMIA (Kenya, Uganda)

variants Saamia, Samya

note Bantu language; one of the groups included in the collective term Luyia

AAT: nl
LCSH: nl
DDMM, ECB, ETHN, GPM 1959, GPM 1975, HB, MGU 1967, MTKW, UIH, WH

see also Luyia

SAMO (Burkina Faso, Mali)

variants Samogo, Samorho, Samorrho, Semou

note Mande language

AAT: nl
LCSH: Samo
BS, CDR 1987, CK, DDMM, DWMB, ETHN, GPM 1959, GPM 1975, HB, HBDW, IAI, JG 1963, JPB, MH, MLJD, RJ 1958, SD, UIH, VP, WH

see also Mande

Samogo *see* SAMO

Samorho *see* SAMO

Samorrho *see* SAMO

Sampur *see* SAMBURU

Samun Dukiya *see* Toponyms Index

Samya *see* SAMIA

San *see* HEIKUM

SAN (Botswana, Namibia, South Africa)

variants Sanno

note Khoisan language; often used as a general term for Bushmen
AAT: San
LCSH: San
BS, DDMM, DOA, EBR, ETHN, GPM 1959, HBDW, HRZ, JG 1963, JLS, JM, JV 1984, KFS, MCA 1986, NIB, PMPO, PR, PRM, ROMC, SMI, TP, UIH, WDH, WG 1984, WH, WOH, WRNN
ALB*, CVN*, JLW 1981*

see also Bushmen

SANAGA (Cameroun)

note Bantu language
AAT: nl
LCSH: nl
ETHN, HB, JAF, KK 1965, LP 1993, MGU 1967

Sanaga River *see* Toponyms Index

Sanaki *see* Zanaki

SANDAWE (Tanzania)

variants Sandawi

note Khoisan language; one of the groups included in the collective term Nilo-Hamitic people
AAT: Sandawe
LCSH: Sandwe
ARW, ATMB 1956, BS, DDMM, ECB, ETHN, GPM 1959, GPM 1975, GWH 1969, HB, HBDW, IAI, JG 1963, JLS, JM, KK 1990, LJPG, MFMK, PMPO, RJ 1960, ROMC, SMI, UIH, WEW 1973, WH, WOH, WRB

see also Nilo-Hamitic people

Sandawi *see* SANDAWE

SANGA (Zaire)

note Bantu language; not to be confused with the Basanga who are a subcategory of Songye, also in Zaire. The ethnic term has also been used as a collective term to include the Sanga proper, the Lebi, Yanga, Yongolo, and Tembuji.
AAT: nl
LCSH: Sanga

BES, DDMM, DPB 1987, ETHN, FN 1994, GPM 1959, HAB, HB, HJK, IAI, JLS, JV 1966, MGU 1967, OB 1961, OBZ, UIH, WG 1984, WVB
FGR*, MUK*

Sanga *see* Toponyms Index

Sangala, Northern *see* KAGURU

Sangha River *see* Toponyms Index

Sangho *see* SANGO

Sango *see* SANGU (Tanzania)

SANGO (Central African Republic, Chad, Zaire)

variants Basango, Sangho

note Western Ubangian language; a lingua franca based on a group of Ngbandi dialects. With the Gbanziri and Monjombo, they are Riverains of Ubangi river.
AAT: Sango
LCSH: Sango language
ATMB 1956, BES, BS, CFL, DDMM, DPB 1981, DPB 1986, ETHN, GAH 1950, GBJS, GPM 1959, GPM 1975, HAB, HB, HBDW, HBU, IAI, JD, JG 1963, JMOB, LM, LP 1979, MCA, MHN, MLJD, MPF 1992, MUD 1986, MUD 1991, OBZ, SG, SMI, SV, WH, WRB, WRNN, WS

see also Ngbandi

SANGU (Gabon)

variants Ashango, Machango, Masango, Mashango, Massango, Shango

note Bantu language; not to be confused with the Sangu of Tanzania
AAT: Sangu
LCSH: nl
CK, CMK, DDMM, DP, ELZ, ETHN, EWA, GPM 1959, HB, HMC, JAF, JK, KMT 1970, LP 1985, MLB, OGPS, TB, WH, WOH, WRB

SANGU (Tanzania)

variants Sango

note Bantu language; not to be confused with the Sangu of Gabon
AAT: nl
LCSH: nl
BS, DDMM, ETHN, ECB, GPM 1959, GPM 1975, HAB, IAI, KK 1990, MGU 1967, MFMK, RJ 1960, UIH, WH

Sankura *see* ZARA

Sankuru River *see* Toponyms Index

Sanno *see* SAN

SANUSI (Libya)

variants Sanussi

note Semitic language; fraternity among the Cyrenaican Bedouin; one of the groups included in the collective term Bedouin
AAT: nl
LCSH: nl
GPM 1959 , GPM 1975, JM
EEP 1949*

see also Bedouin

Sanussi *see* SANUSI

SANWI (Côte d'Ivoire)

note Kwa language; subcategory of Anyi
AAT: nl
LCSH: Sanwi dialect use Sanvi dialect
CDR 1985, ENS, GPM 1959, JK, SV, WRB
JPB*

Sanya *see* SANYE

SANYE (Kenya)

variants Ariangulu, Langulu, Sanya, Walangulu, Wasanye

note Cushitic language
AAT: nl
LCSH: Sanye language use Boni language
ATMB 1956, DDMM, ECB, ETHN, GPM 1959, GPM 1975, HB, JG 1963, RJ 1960, UIH, WH

SANZE (Zaire)

variants Basanze

note Bantu language; one of the groups included in the collective term Pre-Bembe
AAT: nl
LCSH: nl

DPB 1986, DPB 1987
DPB 1981*

see also Pre-Bembe

Sao *see* SAHO

SAO (Cameroun, Chad, Nigeria)

variants So

note Chadic language; an ancient empire; also a group of peoples who lived east, south and west of Lake Chad; sometimes referred to as Kotoko
AAT: Sao & Sao Empire
LCSH: Sao
AML, ATMB 1956, BDG 1980, DDMM, DP, DWMB, EBR, EEWF, ELZ, ETHN, EWA, GBJM, GPM 1959, HB, IAI, IEZ, JJM 1972, JK, JL, JLS, JM, JPAL, JPB, KFS 1989, LJPG, LM, MG, MLB, NIB, PH, PR, RGL, RJ 1958, ROMC, RWL, SMI, SVFN, TP, UIH, WBF 1964, WG 1980, WG 1984, WH, WMR, WRB, WRNN, WVB
GJJG*

see also Kotoko

Sapan *see* SAPO

SAPAUT (Uganda)

variants Elgon Maasai, Sabaot, Sabaut

note Southern Nilotic language; collective term for the Kony, Ngoma, Pok, and Sapiny; one of the groups included in the collective term Nilo-Hamitic people
AAT: nl
LCSH: nl (uses Sapiny)
DDMM, ETHN , GPM 1959, WH
GWH 1969*

see also Nilo-Hamitic people

Sape *see* SAPI-PORTUGUESE

Sapei *see* SEBEI

Sapi *see* SAPI-PORTUGUESE

Sapiny *see* SEBEI

SAPI-PORTUGUESE (Sierra
Leone)
variants Sape, Sapi, Sherbro-
Portuguese
note early colonial style; one of the
distinctive art forms and styles
that are the product of
acculturative movements in West
Africa, sometimes referred to
collectively as Afro-Portuguese;
also referred to as Bulom
AAT: Sapi-Portuguese
LCSH: nl
BS, GB, HAB, JK, JLS, JPB, JV 1984, SV,
TP, UIH, WRNN, WS
EBWF*, JYL*
see also Bulom

SAPO (Liberia)
variants Sabo, Sapan
note Kwa language
AAT: Sapo
LCSH: nl
DDMM, ETHN, GPM 1959, GPM 1975,
HB, JLS, UIH, WH, WRB
GSDS*, GSGH*

SARA (Central African Republic,
Chad)
note Central Sudanic language
AAT: Sara
LCSH: Sara
AF, AML, ATMB, ATMB 1956, BS,
DDMM, ELZ, ETHN, FE 1933, GPM
1975, HB, HBDW, HMC, HRZ, IAI, JG
1963, JLS, JM, JP 1953, MH, MLJD, MPF
1992, ROMC, RSW, SMI, UIH, WH, WS
JPM*

Saraka *see* THARAKA
Sarakole *see* SONINKE
Saramo *see* ZARAMO
Sarurab *see* Toponyms Index
SATIKRAN (Côte d'Ivoire)
note Kwa language; subcategory of
Baule
AAT: nl
LCSH: nl
JPB
see also Baule
Save *see* SHABE

Save kingdom *see* SHABE
Saye *see* SAYI
SAYI (Zaire)
variants Saye
note Bantu language; subcategory of
Hemba
AAT: nl
LCSH: nl
FN 1994, SV
see also Hemba
Schilele *see* LEELE
Schilluk *see* SHILLUK
SEBA (Zaire, Zambia)
variants Shishi
note Bantu language
AAT: nl
LCSH: nl
DDMM, ETHN, GPM 1959, HB, MGU
1967, OB 1961, WVB
Sebei *see* KONY
SEBEI (Kenya, Uganda)
variants Sabei, Sapei, Sapiny
note Southern Nilotic language;
group of independent but closely
related "tribes" on the northern
and northwestern slopes of Mount
Elgon; one of the groups included
in the collective term Nilo-
Hamitic people
AAT: nl
LCSH: use Sapiny
ATMB, ATMB 1956, BS, DDMM, ECB,
ETHN, GPM 1959, GPM 1975, HB, IAI,
MTKW, SD, UIH, WEW 1973, WH, WRB
1959
GWH 1969*, WRG*, WRG 1976*
see also Nilo-Hamitic people
SEFWI (Côte d'Ivoire)
note Kwa language; subcategory of
Anyi
AAT: nl
LCSH: nl
DDMM, ETHN, GPM 1959, HB, HCDR,
RJ 1958, RSAR, UIH
see also Anyi

SEGEJU (Kenya, Tanzania)
variants Daiso, Daisu
note Bantu language; subcategory of
Swahili
AAT: nl
LCSH: nl
DDMM, ECB, ETHN, GPM 1959, GPM
1975, HB, IAI, JLS, MFMK, MGU 1967,
RJ 1960, UIH
see also Swahili
Segu *see* Toponyms Index
Seguha *see* ZIGULA
Seke *see* SHAKE
Sekiani *see* SHAKE
Sekiyani *see* SHAKE
SELYA (Tanzania)
note Bantu language; a division of
Nyakyusa
AAT: nl
LCSH: nl
DDMM, ETHN, GPM 1959, GPM 1975,
HB
ECMG*, MHW*, TEW*
see also Nyakyusa
SEMBLA (Burkina Faso)
note Mande language
AAT: nl
LCSH: Sembla language
DDMM, ETHN, HB, RFT 1974, WS
Semou *see* SAMO
SENA (Malawi, Mozambique)
variants Asena
note Bantu language; one of the
groups included in the collective
term Maravi
AAT: nl
LCSH: Sena language
DDMM, ETHN, GPM 1959, GPM 1975,
HB, MGU 1967, WH, WVB
TEW*
see also Maravi
SENAMBELE (Burkina Faso, Côte
d'Ivoire, Mali)
note Gur language; subcategory of
Senufo; a collective term used for
ethnic groups of Senufo farmers
AAT: nl
LCSH: nl

JPB, SV, WS
AJG*, DR*
see also Senufo
SENARI (Côte d'Ivoire, Mali)
note Gur language; subcategory of
Senufo
AAT: nl
LCSH: Senari language
DDMM, ETHN, WEW 1973
JPB*
see also Senufo
Senegal River *see* Toponyms Index
Senegambia *see* Toponyms Index
Senga *see* NSENGA
SENGA (Zambia)
variants Asenga
note Bantu language; not to be
confused with the Nsenga, also in
Zambia. see TEW and WWJS*.
AAT: nl
LCSH: nl
DDMM, GPM 1959, GPM 1975, TEW,
UIH, WH
WVB*, WWJS*
SENGELE (Zaire)
variants Basengele, Sengere
note Bantu language
AAT: Sengele
LCSH: nl
DPB 1985, DPB 1986, DPB 1987, ETHN,
GAH 1950, GPM 1959, GPM 1975, HB,
IAI, JMOB, JPJM, JV 1966, KFS, MGU
1967, OBZ, RSW, WH, WRB
Sengere *see* SENGELE
Sengo *see* LOSENGO
SENHAJA (Morocco)
note Berber language; one of the
groups included in the collective
term Berber
AAT: nl
LCSH: nl
DDMM, GPM 1959
see also Berber
Sennar *see* Toponyms Index
Senoufo *see* SENUFO

SENUFO (Burkina Faso, Côte d'Ivoire, Mali)
variants Senoufo, Siena, Sienna
subcategories Fijembele, Fodonon, Fono, Foro, Gbato, Gbonzoro, Jamala, Jimini, Kafire, Kadle, Komono, Kpeene, Kufolo, Nafana, Niarhafolo, Nyene, Nohulu, Palara, Patoro, Senambele, Senari, Tagba, Tagwana, Tangara, Tenere, Tyebara, Tyefo, Tyeli
note Gur language; frequently referred to by their geographic regions or administrative districts or "cercles" such as Koutiala, San, Sikasso, Bobo Dioulasso, Korhogo, Kong, etc.
AAT: Senufo
LCSH: Senufo
ACN, AF, ASH, AW, BS, CDR 1987, CMK, DDMM, DF, DFHC, DFM, DOA, DOWF, DP, DWMB, EB, EBR, EEWF, EFLH, ELZ, ETHN, EVA, EWA, FW, GAC, GBJM, GBJS, GPM 1959, GPM 1975, GWS, HAB, HB, HBDW, HH, HMC, IAI, JAF, JD, JEEL, JK, JL, JLS, JM, JP 1953, JPJM, JTSV, JV 1984, KE, KFS, KFS 1989, KK 1960, KK 1965, KMT 1970, LJPG, LM, LPR 1986, MH, MHN, MLB, MLJD, MUD 1991, NIB, PRM, PSG, RAB, RFT 1974, RGL, RS 1980, RSAR, RSRW, RSW, SMI, SV, SV 1988, SVFN, TB, TLPM, TP, UIH, WBF 1964, WEW 1973, WG 1980, WG 1984, WH, WMR, WOH, WRB, WRNN, WS
AJG*, BH 1966*, DR*, JE*, JPB*

SERE (Central African Republic, Sudan, Zaire)
note Western Ubangian language
AAT: nl
LCSH: nl
ATMB, ATMB 1956, DB 1978, DDMM, DPB 1987, ESCK, ETHN, GPM 1959, GPM 1975, HAB, HB, IAI, JG 1963, OBZ, RJ 1959, SMI, UIH, WH
PBAB*

SERER (Gambia, Senegal)
variants Niominka, Serere
note West Atlantic language. Distinction is made between the Serer-Sin and Serer-Non groups, the latter possibly not being Serer. see DDMM.
AAT: Serer
LCSH: Serer
BS, DDMM, DWMB, EBR, ELZ, ETHN, EWA, GB, GPM 1959, GPM 1975, HAB, HB, HBDW, IAI, JG 1963, JL, JLS, JM, JP 1953, KFS, MPF 1992, RGL, ROMC, RS 1980, RSW, SMI, TFG, UIH, WEW 1973, WH
DPG*

Serere *see* SERER

Serongo *see* SOLONGO

Serruchen *see* AIT SEGHROUCHEN

SESE (Uganda)
variants Sesse
note Bantu language
AAT: nl
LCSH: nl
ECB, ETHN, IAI, RJ 1960

SESE (Congo Republic)
note Bantu language; a division of Teke
AAT: nl
LCSH: nl
DDMM, DPB 1985, JV 1973
see also Teke

Sesse *see* SESE

SEWA (Zambia)
note Bantu language
AAT: nl
LCSH: nl
GPM 1959, HB
WWJS*

SEWA MENDE (Sierra Leone)
note Mande language; subcategory of Mende
AAT: nl
LCSH: nl
GPM 1959, MEM 1950
see also Mende

Sha *see* SHABE

SHABE (Nigeria)
variants Sabe, Save, Sha, Tshabe
note Kwa language; subcategory of
Yoruba; also an ancient kingdom
of the Yoruba usually referred to
as Save or Sawe
AAT: nl
LCSH: nl
DDMM, ELZ, GPM 1959, HJD, MG,
RWL, WS
CDF*
see also Yoruba

SHAI (Ghana)
note Kwa language
AAT: Shai
LCSH: nl
BS, GPM 1959, HB, HCDR, IAI, JLS, MM
1950, RGL, RJ 1958

SHAKE (Cameroun, Congo
Republic, Gabon)
variants Baseke, Seke, Sekiani,
Sekiyani
note Bantu language
AAT: Shake
LCSH: use Kota
DDMM, ETHN, GPM 1959, GPM 1975,
HB, JAF, LP 1979, LP 1985, MUD 1986,
WRB, WS
LP 1990*

SHAKO (Ethiopia)
note Cushitic language
AAT: nl
LCSH: nl
ATMB 1956, DDMM, ETHN, GPM 1959,
GPM 1975, JG 1963
ERC*

SHAMAYE (Congo Republic,
Gabon)
variants Bushamaye, Bushmaye
note Bantu language; subcategory of
Kota
AAT: nl
LCSH: nl
AW, CDR 1985, JAF, JK, LP 1985, MUD
1986, WG 1980, WS
LP 1979*
see also Kota

Shamba *see* SHAMBAA

SHAMBAA (Kenya, Tanzania)
variants Sambaa, Sambala,
Sambara, Shamba, Shambala,
Wachambala, Waschambaa,
Washambala
note Bantu language; literally
people of the Usambara
mountains. The transcription
Shambaa seems currently
preferred over the more
conventional Shambala.
AAT: nl (uses Shambala)
LCSH: use Shambala
CK, DDMM, ECB, ELZ, ETHN, GPM
1959, GPM 1975, HAB, HB, HBDW, JD,
JLS, KK 1990, MGU 1967, MLB, RJ 1960,
SMI, UIH, WBF 1964, WG 1980, WH,
WOH, WRB, WS
HC*, STF*

Shambala *see* SHAMBAA

SHANGA (Mozambique, Zimbabwe)
note Bantu language; subcategory of
Ndau
AAT: Shanga
LCSH: nl
DDMM, ETHN, GPM 1959, GPM 1975
see also Ndau

SHANGA (Nigeria)
note Mande language. There are
several small groups of peoples in
Nigeria under this name. see
RWL*.
AAT: nl
LCSH: nl
DDMM, ETHN, GPM 1959, GPM 1975,
RJ 1958

SHANGAAN (Mozambique, South
Africa)
variants Shangan, Shangana
note Bantu language; subcategory of
Tsonga
AAT: nl
LCSH: use Tsonga
CK, DDMM, ETHN, JLS, HB, SG, TP,
WDH
see also Tsonga

Shangan *see* SHANGAAN

Shangana *see* SHANGAAN

Shango *see* SANGU

Shankadi *see* LUBA-SHANKADI

SHASHI (Tanzania)
 note Bantu language
 AAT: nl
 LCSH: nl
 ECB, ETHN, GPM 1959, GPM 1975, HB,
 MFMK, RJ 1960, WH

SHAWIA (Algeria)
 variants Chaouia
 note Berber language; one of the
 groups included in the collective
 term Berber
 AAT: nl
 LCSH: use Chaouia
 ANB, DDMM, ETHN, GPM 1959, GPM
 1975, HBDW, LJPG, ROMC, WH
 see also Berber

SHERBRO (Sierra Leone)
 note West Atlantic language. The
 Bulom, Sherbro and Krim are
 often confused with one another.
 AAT: Sherbro
 LCSH: Sherbro
 AW, DDMM, DFHC, DWMB, EB, EBR,
 ETHN, FW, GPM 1959, GPM 1975, HB,
 HBDW, IAI, JD, JLS, JPJM, JV 1984, KFS,
 KFS 1989, KK 1965, LJPG, MLB, MLJD,
 MWM, PMPO, RFT 1974, RGL, RJ 1958,
 ROMC, RS 1980, RSRW, SAB, SG, SMI,
 SV, SVFN , TB, TP, UIH, WBF 1964, WG
 1980, WG 1984, WH, WMR, WOH, WRB,
 WRNN, WS
 HUH*, MEM 1950*

Sherbro-Portuguese *see* SAPI-
PORTUGUESE

SHI (Congo Republic, Zaire)
 variants Amashi, Banyabungu,
 Bashi, Nyabungu
 note Bantu language; organized in
 several chiefdoms, e.g. Bahaya,
 Baloho, Bishugi, Barhongorhongo
 and Banyiramba; not to be
 confused with the Mashi of
 Angola and Zambia
 AAT: nl
 LCSH: Shi language

BS, DDMM, DPB 1981, DPB 1986, DPB
1987, ETHN, GAH 1950, GPM 1959,
GPM 1975, HB, IAI, JMOB, MGU 1967,
MLF, OBZ, SMI, TP, UIH, WH, WRB
1959
CUY*, RMP*

Shien *see* TIEN

SHILA (Zaire, Zambia)
 note Bantu language; collective
 term given to the fishermen of
 Lake Moero and the Lower
 Luapula river
 AAT: nl
 LCSH: nl '
 DDMM, DPB 1987, ETHN, GPM 1959,
 GPM 1975, HAB, HB, HBDW, IAI, JV
 1966, OBZ, RJ 1961, UIH, WH, WVB
 WWJS*

Shilange *see* LULUWA

Shilele *see* LEELE

SHILLUK (Sudan)
 variants Colo, Golo, Schilluk,
 Shulla
 note West Nilotic language; one of
 the groups included in the
 collective term Nilotic people
 AAT: Shilluk
 LCSH: Shilluk
 AF, ATMB, ATMB 1956, BS, CSBS,
 DDMM, DP, DPB 1987, EBR, ELZ,
 ETHN, GAH 1950, GPM 1959, GPM
 1975, HAB, HB, HRZ, IAI, JD, JG 1963,
 JK, JLS, JM, KK 1990, LJPG, MLJD,
 PMPO, RJ 1959, RS 1980, RSW, SD, SMI,
 TP, UIH, WG 1980, WH, WLH, WRB,
 WRNN, WS
 AJB*
 see also Nilotic people

Shimba *see* HIMBA

Shinje *see* SHINJI

SHINJI (Angola, Zaire, Zambia)
 variants Shinje, Xinji, Yungo
 note Bantu language
 AAT: nl
 LCSH: nl
 DDMM, DPB 1985, DPB 1987, GPM
 1959, GPM 1975, HB, HBDW, JV 1966,
 MGU 1967, MLB 1994, OB 1973, UIH

Shioko *see* CHOKWE

Shir *see* MANDARI

SHIRA (Gabon)

variants Achira, Ashira, Eshira, Gisira, Sira

note Bantu language
AAT: Shira
LCSH: Shira
BES, CDR 1985, CK, DDMM, DP, EBR, ELZ, ETHN, EWA, GPM 1959, GPM 1975, HAB, HB, IAI, JD, JK, KMT 1970, LP 1979, LP 1985, MGU 1967, OGPS, RS 1980, SG, SV, TB, UIH, WG 1980, WH, WOH, WRB, WRNN, WS
AMVM*

SHIRAZI (Kenya, Tanzania)

note Bantu language; subcategory of Swahili
AAT: nl
LCSH: nl
ELZ, GPM 1975, HB, IAI, JLS, KFS, PG 1990, RJ 1960, WG 1984
AHP*

see also Swahili

Shishi *see* SEBA

Shiwa *see* SHUWA

SHLUH (Mauritania, Morocco)

variants Chleuh

note Berber language; one of the groups included in the collective term Berber
AAT: nl
LCSH: nl
GPM 1959, GPM 1975, JPJM, ROMC

see also Berber

Shoa *see* SHUWA

Shobwa *see* SHOOWA

Shogo *see* TSOGO

Sholio *see* MORWA

SHONA (Mozambique, Zambia, Zimbabwe)

variants Mashona

note Bantu language; a congeries of "tribes" including the Hera, Kalanga, Karanga, Korekore, Manyika, Mbire, Ndau, Rozwi, Tawara, and Zezuru
AAT: Shona
LCSH: Shona

ACN, BS, CDR 1985, CMK, DDMM, DOA, EBR, EEWF, ETHN, FW, GBJS, GPM 1959, GPM 1975, HAB, HB, HRZ, IAI, JD, JJM 1972, JK, JLS, JM, KFS, MGU 1967, MLJD, MUD 1991, NIB, PG 1990, PMPO, PR, RFT 1974, RGL, RJ 1961, ROMC, RS 1980, RSW, SD, SG, SMI, TP, UIH, WDH, WEW 1973, WG 1980, WG 1984, WMR, WOH, WRB, WRB 1959, WRNN, WS, WVB
ECMG*, HKVV*, MIB*

SHOOWA (Zaire)

variants Bashobwa, Bashoobo, Shobwa

note Bantu language; subcategory of Kuba
AAT: nl (use Shobwa)
LCSH: Shoowa
BS, CDR 1985, ELZ, ETHN, HB, JC 1978, JC 1982, JK, JLS, JV 1966, JV 1978, KFS, MK, OB 1961, OB 1973, SMI, SV 1988, WRB
GSM*

see also Kuba

SHU (Uganda, Zaire)

variants Bashu

note Bantu language; subcategory of Konjo
AAT: nl
LCSH: nl
DPB 1986, DPB 1987, ETHN, HB, JMOB, UIH
RMP*

see also Konjo

Shubi *see* SINJA

Shuge *see* SHUWA

SHUKRIA (Sudan)

variants Shukriyya

note Semitic language; subcategory of Abbala; nomadic Arabs of the Sudan region and one of the groups included in the collective term Sudan Arabs
AAT: nl
LCSH: nl
DDMM, GPM 1959, GPM 1975, HB, HRZ, IAI, RJ 1959, WH

see also Abbala, Sudan Arabs

Shukriyya *see* SHUKRIA

Shulla *see* SHILLUK

SHUWA (Cameroun, Chad, Niger, Nigeria)
variants Choa, Shiwa, Shoa, Shuge
note Semitic language
AAT: nl
LCSH: nl
AML, BS, DDMM, ETHN, GPM 1959,
GPM 1975, HB, RJ 1958, RS 1980, RWL,
SD, UIH
see also Aramka

SIA (Burkina Faso, Mali)
variants Sya, Zia
note Mande language
AAT: nl
LCSH: nl
DDMM, DWMB, ETHN, GPM 1959, GPM
1975, HB, HBDW, JG 1963, JP 1953, WH
see also Mande

Siamu *see* SYEMU

SIDAMO (Ethiopia)
subcategories Bako, Gibe, Gimira,
Janjero, Kafa, Maji, Ometo,
Wollamo
note Cushitic language
AAT: nl
LCSH: Sidamo
ATMB, ATMB 1956, BS, DDMM, ETHN,
GPM 1959, GPM 1975, HAB, HB, HBDW,
IAI, JG 1963, JLS, KFS, RJ 1959, SD, SMI,
UIH, WH, WIS
ERC*, JNB*

Siena *see* SENUFO

Sienna *see* SENUFO

SIHANAKA (Madagascar)
note Malagasi language
(Austronesian)
AAT: nl
LCSH: nl
BS, DDMM, ETHN, GPM 1959, GPM
1975, HB, JK, JP 1953, WH
CKJR*, JMA*

Sijilmasa *see* Toponyms Index

Sikasingo *see* KASINGO

SIKOMSE (Burkina Faso)
note Gur language; term may be
used for Mossi-influenced
Kurumba
AAT: nl
LCSH: nl

ASH 1980, WOH

Simba *see* HIMBA

SIMBA (Gabon)
note Bantu language
AAT: nl
LCSH: nl
CK, ETHN, GPM 1959, GPM 1975, HB

SIMBITI (Kenya, Tanzania)
note Bantu language; subcategory of
Kuria
AAT: nl
LCSH: nl
DDMM, ETHN, GPM 1959, GPM 1975,
HB, MFMK
see also Kuria

Simpi *see* ESIMBI

Sindja *see* SINJA

Sindya *see* SINJA

SINJA (Tanzania)
variants Shubi, Sindja, Sindya, Subi
note Bantu language
AAT: nl
LCSH: nl (uses Zinza)
DDMM, ECB, ETHN, GPM 1959, GPM
1975, HB, KK 1965, KMT 1971, MFMK,
UIH

Sira *see* SHIRA

SIRIKWA (Kenya)
note ancient pre-Kalenjin culture in
western Kenya
AAT: nl
LCSH: nl
ECB, RJ 1960, ROJF
see also Kalenjin

SISALA (Burkina Faso, Ghana)
variants Isala, Sissala
note Gur language; one of the
groups included in the collective
term Grunshi
AAT: Sisala
LCSH: Sisala
CDR 1987, DDMM, DWMB, ETHN, GPM
1959, GPM 1975, HAB, HB, HBDW,
HCDR, IAI, JG 1963, JP 1953, MM 1952,
RAB, RGL, RJ 1958, ROMC, SMI, UIH
EDT*
see also Grunshi

Sissala *see* SISALA

SIWA (Egypt)
 note Berber language; one of the
 groups included in the collective
 term Berber
 AAT: nl
 LCSH: Siwa language
 ETHN, GPM 1959, IAI, LJPG, SMI, WH,
 WOH
 see also Berber
Snan *see* YOHURE
So *see* SAO
So *see* TEPES
SO (Cameroun)
 note Bantu language
 AAT: nl
 LCSH: nl
 DDMM, ETHN, HB
SO (Zaire)
 variants Basoko, Eso, Esoko, Soko
 note Bantu language
 AAT: nl
 LCSH: nl
 BES, DDMM, DPB 1987, ETHN, GAH
 1950, GB, GPM 1959, GPM 1975, HAB,
 HBDW, HRZ, IAI, JMOB, JV 1984, LM,
 MGU 1967, NIB, NOI, OBZ, PMPO, RJ
 1958, RS 1980, UIH, WH, WRB
SOBO (Nigeria)
 note Kwa language. The collective
 term "Sobo," thought to be
 pejorative by some sources, has
 been used to refer to both the
 Isoko and Urhobo peoples.
 AAT: use Urhobo
 LCSH: Sobo
 CK, DDMM, DWMB, ELZ, ETHN, HB,
 HBDW, IAI, JG 1963, KMT 1970, NOI, RJ
 1958, SMI, RWL, WRB
 see also Isoko, Urhobo
Soddo *see* Toponyms Index
Sodi *see* SOLI
Sofala *see* Toponyms Index
Sofala *see* NDAU
SOGA (Uganda)
 note Bantu language
 AAT: Soga
 LCSH: Soga
 BES, EBR, ECB, ETHN, GPM 1959, GPM
 1975, HAB, HB, HBDW, IAI, JM, MGU

1967, MTKW, RGL, RJ 1960, SD, UIH,
WH
MCF*
Sogo *see* TSOGO
Soko *see* SO
SOKORO (Chad)
 note Chadic language
 AAT: nl
 LCSH: nl
 AML, DDMM, ETHN, GPM 1959, GPM
 1975, HB, JG 1963, WH
Sokoto *see* Toponyms Index
SOLI (Zambia)
 variants Sodi
 note Bantu language
 AAT: nl
 LCSH: Soli
 ETHN, GPM 1959, HB, MGU 1967, RJ
 1961, UIH, WVB
 PCM*
SOLONGO (Angola, Zaire)
 variants Asolongo, Assolongo,
 Basolongo, Muserongo, Serongo,
 Sorongo
 note Bantu language; subcategory of
 Kongo
 AAT: use Sorongo
 LCSH: Solongo
 ASH, CDR 1985, CK, DDMM, DPB 1985,
 DPB 1987, ELZ, GAH 1950, GPM 1975,
 HAB, HB, HBDW, IAI, JC 1971, JC 1978,
 JMOB, JV 1966, MGU 1967, MLB, MLB
 1994, OB 1973, OBZ, TP, UIH, WG 1980,
 WG 1984, WH, WM
 see also Kongo

SOMALI (Djibouti, Ethiopia, Kenya, Somalia)
subcategories Daarood, Digil, Dir, Hawiye, Isaaq, Issa, Ogaden, Rahanwiin, Sab
note Cushitic language
AAT: Somali
LCSH: Somali language
AF, ARW, ATMB, ATMB 1956, BS, DDMM, DOA, EBR, ECB, ELZ, ETHN, GB, GPM 1959, GPM 1975, HAB, HB, HBDW, HRZ, IAI, JD, JG 1963, JLS, JM, JV 1984, KK 1990, LPR 1995, MCA 1986, MLJD, PMPO, RJ 1959, ROMC, RS 1980, SD, SMI, TP, UIH, WEW 1973, WFJP, WG 1984, WIS, WOH, WRNN
IML*

Somba *see* BATAMMALIBA

SOMONO (Burkina Faso, Mali)
note Mande language; a division Bamana
AAT: nl
LCSH: nl
DWMB, ETHN, GPM 1959, HB, JLS, MLJD, RJ 1958, UIH
see also Bamana

Sonde *see* SOONDE

Songa *see* TSONGA

Songai *see* SONGHAI

Songe *see* SONGYE

SONGHAI (Algeria, Benin, Burkina Faso, Mali, Niger, Nigeria)
variants Hombori, Songai, Songhay, Sonrai, Sonray, Sonrhay
note Nilo-Saharan language (creole Tuareg). Distinctions are made between the northern nomadic branch and the southern sedentary branch in cities such as Djenne and Timbuctu. The term also encompasses a variety of sections of groups (Sorko, Bozo, Do, Gaw, Zarma) that are differentially assimilated to the Songhay. Some are masters of the land, others of the water, still others of the bush. The term is also the name for an ancient empire whose capital was Gao. The founders were of Soninke origin. At its peak in the 16th century, the empire extended from the boundaries of Mauritania, Algeria, and Mali to Senegal, Niger, and Guinea.
AAT: Songhai
LCSH: Songhai
AF, BD, BS, CDR 1987, DDMM, DWMB, EBR, ELZ, ET, ETHN, GB, GBJM, GPM 1959, GPM 1975, HAB, HB, HBDW, HRZ, IAI, JAF, JD, JG 1963, JJM 1972, JK, JL, JLS, JP 1953, JPJM, JV 1984, KE, KFS, KMT 1970, LJPG, LM, LPR 1986, LSD, MPF 1992, PG 1990, PMPO, PR, PRM, RAB, RGL, RJ 1958, ROMC, RSW, RWL, SD, SMI, TFG, TP, UIH, WG 1980, WG 1984, WH, WRB, WRB 1959, WRNN, WS
JR*, PST*, TAH*
see also Zarma

Songhay *see* SONGHAI

Songo *see* TSONG

SONGO (Angola)
variants Basongo, Sungu
note Bantu language
AAT: Songo
LCSH: nl
ARW, AW, CDR 1985, DDMM, DPB 1985, DPB 1987, ELZ, ESCK, ETHN, FN 1994, GPM 1959, GPM 1975, HAB, HB, HBDW, HJK, IAI, JC 1978, JJM 1972, JLS, JMOB, JV 1966, JV 1984, KFS, KK 1965, MGU 1967, MHN, MLB, MLB 1994, RGL, RSRW, SMI, UIH, WG 1980, WG 1984, WH, WRB, WRNN, WS, WVB

SONGOLA (Zaire)

variants Basongola, Songorra,
Wasongola, Wasongora

note Bantu language; known in
recent literature as the Northern
Binja; includes the Ombo and
Binja linguistic communities

AAT: nl

LCSH: Songola

DDMM, DPB 1981, DPB 1986, DPB 1987,
ETHN, FHCP, GAH 1950, GPM 1959,
GPM 1975, HAB, HBDW, IAI, JLS,
JMOB, JV 1966, MLF, OBZ, UIH, WH
AEM 1952*

see also Binja, Ombo

SONGOMENO (Zaire)

variants Basongo Meno,
Basongomeno

note Bantu language

AAT: nl

LCSH: nl

BS, CK, DDMM, DPB 1985, DPB 1987,
ETHN, GAH 1950, GPM 1959, GPM
1975, HBDW, JMOB, JV 1966, NIB, OB
1973, RSW, TB, WH, WRB

Songorra *see* SONGOLA

SONGYE (Zaire)

variants Basonge, Basongye,
Bayembe, Songe

note Bantu language. Songye
divisions include: 1. southern:
Benekiiye, Bamilembwe,
Bampanza, Bamaziba; 2. central-
northern: Bekaleebwe, Basanga,
Balaa, Batempa, Bakwanzala,
Bangongo, Bamala, Benampassa,
Yembe. The Builanda are related
to the Songye but also to the Luba
of Shaba.

AAT: Songye

LCSH: use Songe

ACN, AF, ALM, APM, ASH, AW, BES,
BS, CDR 1985, CFL, CK, CMK, DDMM,
DOA, DOWF, DP, DPB 1981, DPB 1986,
DPB 1987, EB, EBHK, EBR, EEWF, ELZ,
ETHN, FN 1994, FW, GAH 1950, GBJS,
GPM 1959, GPM 1975, HAB, HB, HH,
HJK, HMC, IAI, JC 1971, JC 1978, JD,
JJM 1972, JLS, JMOB, JPJM, JTSV, JV

1966, JV 1984, KFS, KFS 1989, KK 1960,
KK 1965, KMT 1970, LJPG, LM, LP 1993,
MGU 1967, MHN, MLB, MLF, MLJD,
MUD 1991, OB 1961, OB 1973, OBZ,
RGL, RSAR, RSRW, RSW, SMI, SV, SV
1988, TB, TERV, TP, UIH, WBF 1964,
WG 1980, WG 1984, WH, WMR, WOH,
WRB, WRB 1959, WRNN, WS
DH*, FHCP*, LES*

see also Beelande

Soninka *see* MANDING

SONINKE (Burkina Faso, Côte
d'Ivoire, Gambia, Guinea-Bissau,
Mali, Mauritania, Niger, Senegal)

variants Marka Soninke, Sarakole

note Mande language

AAT: Soninke

LCSH: Soninke

BS, CDR 1987, DDMM, DWMB, EBR,
ELZ, ETHN, GB, GBJS, GPM 1959, GPM
1975, HAB, HB, HBDW, HRZ, IAI, JD, JG
1963, JJM 1972, JK, JLS, JM, JP 1953,
JPJM, JTSV, KFS, LJPG, LM, LPR 1986,
LPR 1995, MLB, MPF 1992, PMPO, PG
1990, PRM, RAB, RGL, RJ 1958, ROMC,
RSW, SMI, TFG, TP, UIH, VP, WG 1984,
WH, WRB, WRNN, WS

see also Mande, Wagadu

SONJO (Tanzania)

variants Sonyo

note Bantu language

AAT: nl

LCSH: Sonjo

DDMM, ECB, ETHN, GPM 1959, GPM
1975, HB, MFMK, MGU 1967, RJ 1960,
WH, WRB

Sonrai *see* SONGHAI

Sonray *see* SONGHAI

Sonrhay *see* SONGHAI

Sonyo *see* SONJO

SOONDE (Zaire)

variants Basonde, Sonde

note Bantu language

AAT: nl

LCSH: nl

DPB 1985, ETHN, GPM 1959, GPM 1975,
HB, JC 1978, JV 1966, OB 1973, OBZ

Sorko *see* BOZO

Sorogo *see* BOZO

Sorongo *see* SOLONGO

Soso *see* TSOTSO (Angola)
Soso *see* SUSU (Guinea)
Sosso *see* TSOTSO
SOTHO (Botswana, Lesotho, South Africa)
 variants Basuto, Suto, Suthu
 subcategories Lovedu, Pedi
 note Bantu language. Some sources distinguish between the Northern Sotho (the Pedi and Lovedu) and the Southern Sotho. Some sources use the term Western Sotho for the Tswana.
 AAT: Sotho
 LCSH: Sotho
 AW, BES, BS, DDMM, EBR, ELZ, ETHN, FW, GB, GPM 1959, GPM 1975, HAB, HB, HBDW, HRZ, IAI, JD, JK, JLS, JM, JRE, JTSV, JV 1966, KFS, LJPG, MCA 1986, MGU 1967, MHN, MLJD, MPF 1992, NIB, PR, RGL, ROMC, RS 1980, RSW, SD, SMI, TP, UIH, WDH, WG 1980, WG 1984, WH, WRB, WRB 1959, WS, WVB
 HA*
 see also Tswana, Toponyms Index
SOUS (Morocco)
 note Berber language; one of the groups included in the collective term Berber
 AAT: nl
 LCSH: Sous region
 ETHN, EWA
 see also Berber
Soussou *see* SUSU
Spanish Sahara *see* Toponyms Index
Stanley Falls *see* Toponyms Index
Stanley Pool *see* Toponyms Index
Su *see* ISUWU
Sua *see* BASUA
Suaheli *see* SWAHILI
Suaili *see* SWAHILI
SUBA (Kenya)
 variants Suna
 note Bantu language
 AAT: nl
 LCSH: Suba
 ECB, ETHN, GPM 1959, HB, MFMK

Subi *see* SINJA
Subia *see* SUBIYA
SUBIYA (Botswana, Namibia)
 variants Masubiya, Masupia, Subia
 note Bantu language
 AAT: nl
 LCSH: Subiya language
 CK, DDMM, ELZ, ETHN, GPM 1959, GPM 1975, HAB, HB, IAI, JLS, JV 1966, MGU 1967, MHN, RSW, UIH, WH, WVB, WH
Sudaani *see* SUDAN ARABS
Sudan *see* Toponyms Index
SUDAN ARABS (Sudan)
 variants Sudaani, Sudani
 note A collective term used to refer to both nomadic (Abbala) and semi-nomadic (Baggara) peoples of the Sudan, living in the Bagirmi, Wadai, Kanem, and Kordofan regions. These include the Abbala, nomadic groups of the Hamar, Kababish, and Shukria; and the Baggara, semi-nomadic groups of the Hawazma, Humr, Messeria, and Rizeygat.
 AAT: nl
 LCSH: nl
 DDMM, EWA, IAI, JPB, RJ 1959, SMI, WH
 AML*
 see also Abbala, Baggara
Sudani *see* SUDAN ARABS

SUK (Kenya, Uganda)

variants Pakot, Pokot

note Southern Nilotic language; one of the groups included in the collective term Nilo-Hamitic people

AAT: use Pokot
LCSH: Suk
AF, ATMB, ATMB 1956, BS, CSBS, DDMM, EBR, ECB, ETHN, GB, GPM 1959, GPM 1975, GWH, HAB, HB, IAI, JG 1963, JLS, LSD, MCA 1986, MTKW, PMPO, RJ 1960, RS 1980, RSW, SMI, UIH, WFJP, WH, WRB 1959, WS
GWH 1969*, KDP*

see also Nilo-Hamitic people

SUKU (Zaire)

variants Basuku

note Bantu language

AAT: Suku
LCSH: Suku
ALM, AW, BS, CDR 1985, CFL, CMK, DDMM, DFHC, DOWF, DPB 1985, DPB 1987, EB, EBHK, EBR, EEWF, ELZ, ETHN, FHCP, FW, GAH 1950, GBJS, GPM 1959, GPM 1975, HB, HH, HJK, HMC, IAI, JC 1971, JC 1978, JD, JK, JLS, JMOB, JTSV, JV 1966, JV 1984, KFS 1989, MHN, MLB, MLB 1994, MLJD, MUD 1991, NOI, OB 1973, OBZ, PMPO, RGL, RS 1980, RSAR , RSRW, RSW, SD, SG, SMI, SV 1988, TB, TERV, TLPM, TP, UIH, WBF 1964, WG 1980, WG 1984, WH, WMR, WRB, WRNN, WS
APB*, HH 1993*

SUKUMA (Tanzania)

variants Basukuma, Wasukuma

note Bantu language; one of the groups included in the collective term Greater Unyamwezi

AAT: Sukuma
LCSH: Sukuma
BS, CK, DDMM, ECB, ETHN, GPM 1959, GPM 1975, HAB, HB, HC, JD, JLS, JM, KK 1990, MFMK, MGU 1967, MLJD, RGL, RJ 1960, ROMC, RSW, SD, SMI, UIH, WH, WOH, WRNN, WS, WVB
BEBG*, BTM*, PEB*, RGA*, RGA 1967*

see also Unyamwezi

SUMA (Central African Republic)

note Western Ubangian language

AAT: nl
LCSH: nl
DB 1978, DDMM, ETHN, HB

SUMBWA (Tanzania)

note Bantu language; one of the groups included in the collective term Greater Unyamwezi

AAT: Sumbwa
LCSH: nl
DDMM, ECB, ETHN, GPM 1959, GPM 1975, HAB, HB, HC, IAI, JJM 1972, JV 1966, MFMK, MGU 1967, RJ 1960, UIH, WH, WOH
BEBG*, RGA*, RGA 1967*

see also Unyamwezi

Suna *see* SUBA

SUNDI (Zaire)

variants Basundi, Nsundi

subcategories Gangala

note Bantu language; subcategory of Kongo

AAT: Sundi
LCSH: Sundi
ASH, BES, CDR 1985, CK, DDMM, DPB 1985, DPB 1987, EBHK, ELZ, ETHN, GPM 1959, GPM 1975, HAB, HB, HJK, IAI, JC 1971, JD, JK, JMOB, KFS 1989, KK 1965, KMT 1971, LM, MLB, OB 1973, OBZ, RGL, RLD 1974, RS 1980, RSW, SG, SV, TB, UIH, WG 1980, WG 1984, WH, WMR, WRB
AR*, KL*

see also Kongo

Sungu *see* SONGO

SUPPIRE (Burkina Faso, Mali)

note Gur language

AAT: nl
LCSH: Suppire language
DDMM, WEW 1973

SURA (Nigeria)

variants Mavul, Mwaghavul

note Chadic language

AAT: nl
LCSH: use Mwaghavul
DDMM, DWMB, ETHN, GPM 1975, HB, IAI, JG 1963, JLS, NOI, RWL, SMI

SURMA (Ethiopia)
note Eastern Sudanic language.
The Mekan are sometimes called
Surma by the Gimira. see ATMB
1956 and ERC*.
AAT: nl
LCSH: use Mekan
ATMB 1956, ETHN, GPM 1959, GPM
1975, HB, IAI, JG 1963, RJ 1959, TP, UIH
ERC*
see also Mekan
SUSU (Guinea, Guinea-Bissau,
Sierra Leone)
variants Soso, Soussou
note Mande language
AAT: nl
LCSH: Susu
ASH, BES, BS, DDMM, DWMB, ETHN,
GPM 1959, GPM 1975, HB, HRZ, IAI, JD,
JG 1963, JJM 1972, JK, JM, KFS, MLJD,
PRM, RJ 1958, ROMC, RSAR, RSW, SD,
SMI, UIH, WEW 1973, WH
MEM 1950*
see also Mande
Suthu *see* SOTHO
Suto *see* SOTHO
SWAGA (Uganda, Zaire)
variants Baswaga
note Bantu language; subcategory of
Konjo
AAT: nl
LCSH: nl
DPB 1986, ETHN, HB, UIH
RMP*
see also Konjo
SWAHILI (Comoros, Kenya,
Mozambique, Somalia, Tanzania,
Zaire)
variants Suaheli, Suaili, Wasuaheli
subcategories Bajun, Hadimu,
Komoro, Mrima, Pemba, Shirazi,
Segeju, Tumbatu, Unguja
note Bantu language. Swahili is a
contextual term applied to people
of mixed African, Arab and
Persian origins, living on the East
Coast of Africa and adjoining

islands, such as Zanzibar, Lamu,
Pemba, etc. In Zaire the term
Swahili (pl. Baswahili) is applied
also to segments of local
populations and to individuals
who adhere to Islam. Swahili-
speakers of the East African
Coast, i.e. Somalia, Kenya,
Tanzania and the islands
(Zanzibar, Pemba, Pate, Lamu,
Kilwa, Bajun, Mafia, and Manda)
include Arabs of the East African
Coast, Shirazi, and Swahili
'properly speaking.' The Arabs of
the East African Coast have been
grouped into four types: 1.
Shihiri or non-Swahilized Arabs;
2. Wamanga or those of the 18th
century Omani dominion; 3.
Waungwana or the descendants of
early colonists from Arabia; and
4. Waarabu who claim Arab
descent. see AHP* and AHP 1961*.
AAT: Swahili
LCSH: uses Swahili speaking peoples
AF, ATMB, ATMB 1956, BS, CDR 1985,
DDMM, EBR, ECB, ELZ, ESCK, ETHN,
GPM 1959, GPM 1975, HB, HBU, HBDW,
HRZ, IAI, JC 1978, JJM 1972, JK, JLS,
JM, JMA, JMOB, JPJM, JV 1966, JV 1984,
KK 1990, KMT 1971, LJPG, MFMK, MGU
1967, MLB, MLJD, MPF 1992, PG 1990,
PMPO, PR, RJ 1960, ROMC, RSW, SD,
SMI, SV, TP, UIH, WEW 1973, WG 1984,
WH, WOH, WRNN, WVB
AHP*, JOM 1992*, MJS*
SWAKA (Zaire, Zambia)
note Bantu language
AAT: nl
LCSH: nl
DDMM, EBR, ETHN, GPM 1959, HB, IAI,
JV 1966, MGU 1967, RJ 1961, UIH, WVB
WWJS*
Swati *see* SWAZI

SWAZI (Mozambique,South Africa, Swaziland)
variants Amaswazi, Swati
note Bantu language; predominantly of Nguni culture and referred to as Ebantfu bakangwane or 'People of the Ngwane'
AAT: Swazi
LCSH: Swazi
ACN, BES, DDMM, ETHN, GPM 1959, GPM 1975, HB, HBDW, HRZ, IAI, IS, JLS, JRE, MCA 1986, MGU 1967, MHN, PMPO, RGL, ROMC, RS 1980, RSW, SD, SG, SMI, SV, TP, UIH, WDH, WG 1980, WG 1984, WH, WRB, WRB 1959, WVB
HIK*

Swaziland *see* Toponyms Index
Sya *see* SIA
SYEMU (Burkina Faso)
variants Siamu
note Gur language
AAT: nl
LCSH: nl
CDR 1987, HB, JPB, WS

Taabwa *see* TABWA
Tabi *see* INGASSANA
TABI (Zaire)
AAT: nl
LCSH: nl
JAF, JK

TABWA (Zaire, Zambia)
variants Batabwa, Taabwa
note Bantu language
AAT: Tabwa
LCSH: Tabwa
BES, BS, CDR 1985, CK, DDMM, DOA, DPB 1987, DWMB, EB, EBHK, ELZ, ETHN, FHCP, GAH 1950, GBJS, GPM 1959, GPM 1975, HAB, HB, HBDW, HMC, IAI, IS, JC 1971, JK, JLS, JMOB, JPB, JRE, JV 1966, MCA 1986, MGU 1967, MHN, MK, MLB, OB 1961, OBZ, RJ 1961, RS 1980, RSW, SG, SMI, TERV, TP, UIH, WG 1980, WG 1984, WH, WRB 1959, WRNN, WS, WVB

AREM*
Tada *see* Toponyms Index
TADJONI (Kenya)
note Bantu language; subcategory of Luyia
AAT: nl
LCSH: nl
DDMM, ECB, ETHN, GPM 1959, GW
see also Luyia
TADKON (Cameroun)
note enclave in Tikar
AAT: nl
LCSH: nl
LP 1993, PH
PAG*
see also Tikar
TADMEKKET (Mali)
note Berber language; division of the Tuareg
AAT: nl
LCSH: nl
EBJN, EDB
see also Tuareg
TAGBA (Burkina Faso, Côte d'Ivoire)
note Gur language. Some sources consider the Tagba a subcategory of Senufo.
AAT: nl
LCSH: Tagba language use Tagbana language
BH 1966, DDMM, DWMB, ESCK, ETHN, GPM 1959, HB, HBDW, JG 1963, JPB, UIH
JMF*
see also Senufo
Tagbana *see* TAGWANA
Tagbanga *see* TAGWANA
TAGWANA (Côte d'Ivoire)
variants Tagbana, Tagbanga, Tangabele
note Gur language; subcategory of Senufo
AAT: nl
LCSH: use Tagbana
DDMM, DR, DWMB, ETHN, JG 1963, RJ 1958, SV, UIH
AJG*, JPB*
see also Senufo

Taifasy *see* ANTAIFASY
Taimoro *see* ANTAIMORO
Taisaka *see* ANTAISAKA
Taita *see* TEITA
Takamanda *see* ANYANG
Takat *see* ATAKA
Takpa *see* NUPE
TAKUM (Nigeria)
 note Benue-Congo language; has
 been considered a subcategory of
 both Kpan and Jukun
 AAT: nl
 LCSH: nl
 DDMM, ETHN, PH, RWL, WS
 see also Jukun, Kpan
TAL (Nigeria)
 note Chadic language
 AAT: nl
 LCSH: nl
 DDMM, ETHN, GPM 1959, HB, JG 1963,
 RWL, WS
TALA (Nigeria)
 note Chadic language
 AAT: nl
 LCSH: nl
 DDMM, ETHN, GPM 1959, LP 1993,
 RWL
TALAI (Kenya)
 note Southern Nilotic language;
 sometimes referred to by the cover
 term Marakwet
 AAT: nl
 LCSH: nl
 ETHN, GWH 1969
 see also Marakwet
TALE (Central African Republic,
Zaire)
 note Adamawa language
 AAT: nl
 LCSH: nl
 DDMM, ETHN, HB
TALINGA (Uganda, Zaire)
 note Bantu language; close cultural
 relationship between Bwizi and
 Talinga
 AAT: nl
 LCSH: nl
 DPB 1987, ETHN, IAI, OBZ

 see also Bwizi
TALLENSI (Burkina Faso, Ghana)
 note Gur language; divided into
 Namoo and Talis clans; one of the
 groups included in the collective
 term Frafra
 AAT: Tallensi
 LCSH: Tallensi
 BS, DF, DWMB, ETHN, FTS, GPM 1959,
 GPM 1975, HB, HCDR, IAI, IEZ, JG 1963,
 JLS, LPR 1986, MM 1952, PMPO, RGL,
 RJ 1958, ROMC, RS 1980, RSW, SD, SMI,
 WH, WRB 1959
 MF, MF 1987*
 see also Frafra
TALODI (Sudan)
 note Kordofanian language
 AAT: nl
 LCSH: nl
 ATMB, ATMB 1956, ETHN, GPM 1959,
 GPM 1975, HAB, HB, HBDW, JG 1963,
 ROMC, WH
Tama *see* MAJANGIR
Tamari *see* BATAMMALIBA
TAMAZIGHT (Algeria, Morocco)
 note Berber language; one of the
 groups included in the collective
 term Berber
 AAT: nl
 LCSH: Tamazight language
 DDMM, ETHN, HBDW, WEW 1973, WH
 ANB*
 see also Berber
TAMBA (Benin)
 variants Taneka
 note Gur language
 AAT: nl
 LCSH: nl
 DDMM, GPM 1959, GPM 1975, HB, IAI,
 RJ 1958, UIH
Tambahoaka *see*
 ANTAMBAHOAKA
Tamberma *see* BATAMMALIBA
TAMBO (Zambia)
 note Bantu language
 AAT: nl
 LCSH: nl
 DDMM, ETHN, GPM 1959, GPM 1975,
 HB, RGW, WVB

Tambwe *see* MATAMBWE
TANALA (Madagascar)
 note Malagasi language
 (Austronesian)
 AAT: nl
 LCSH: Tanala
 DDMM, ETHN, GPM 1959, GPM 1975,
 HAB, HB, IAI, JPJM, KFS, LJPG, MPF
 1992, ROMC, SMI, WH, WOH
 CKJR*, HDSV*, JMA*, RL*
TANDA (Zaire)
 note Bantu language
 AAT: nl
 LCSH: nl
 DDMM, DPB 1987, ETHN, GAH 1950,
 HBU, JLS
Tandroy *see* ANTANDROY
Taneka *see* TAMBA
TANG (Cameroun)
 note Bantoid language; subcategory
 of Tikar; one of the groups
 included in the collective terms
 Bamenda and Nsungli
 AAT: nl
 LCSH: nl
 DDMM, ETHN, GPM 1959, GPM 1975,
 HB
 MMML*, PMK*
 see also Bamenda, Nsungli, Tikar
TANGA (Cameroun)
 variants Batanga
 note Bantu language; one of the
 groups included in the collective
 term Bo-Mbongo cluster
 AAT: nl
 LCSH: Tanga
 DDMM, ETHN, GPM 1959, GPM 1975,
 HB, IEZ, LP 1990, MFMK, MGU 1967,
 UIH, WH, WOH
 EDA*, MAB*
 see also Bo-Mbongo
Tangabele *see* TAGWANA
TANGALE (Nigeria)
 note Chadic language
 AAT: nl
 LCSH: nl
 DDMM, ETHN, GPM 1959, HB, JG 1963,
 RWL, SD, UIH, WH

Tanganyika, Lake *see* Toponyms
 Index
TANGARA (Côte d'Ivoire)
 note Gur language; subcategory of
 Senufo
 AAT: nl
 LCSH: nl
 DDMM, SV
 AJG*
 see also Senufo
TANGI (Uganda, Zaire)
 variants Batangi
 note Bantu language; subcategory of
 Konjo
 AAT: nl
 LCSH: nl
 DPB 1986, ETHN, HB
 see also Konjo
Tankarana *see* ANTANKARANA
Tanosy *see* ANTANOSY
Taoudenni *see* Toponyms Index
TAROK (Nigeria)
 variants Torod, Yergam, Yergum
 note Benue-Congo language
 AAT: nl
 LCSH: use Yergum
 CK, DDMM, ETHN, GPM 1959, GPM
 1975, HB, JG 1963, JLS, RJ 1958, RWL,
 UIH, WH, WS
Taruga *see* Toponyms Index
Tassili-n-Ajjer *see* Toponyms Index
Tatela *see* TETELA

TATOG (Tanzania)
variants Datoga, Mangati, Tatoga, Taturu
note Southern Nilotic language; includes several groups, the largest of whom are the Barabaig; one of the groups included in the collective term Nilo-Hamitic people
AAT: nl
LCSH: nl (uses Mangati)
ATMB 1956, DDMM, ECB, ETHN, GPM 1959, GPM 1975, HB, HBDW, IAI, JG 1963, MFMK, RJ 1960, SD, UIH, WH GWH 1969*
see also Nilo-Hamitic people

Tatoga *see* TATOG

Tatonga *see* BARABAIG

Taturu *see* TATOG

TAUNG (Lesotho, South Africa)
note Bantu language
AAT: nl
LCSH: nl
ARW, DDMM, ETHN, HB, PR, SD, WDH

Taurawa *see* TAWARA

Tavara *see* TAWARA

TAVETA (Kenya)
note Bantu language
AAT: nl
LCSH: Taveta
DDMM, ECB, ETHN, GPM 1959, HB, RJ 1960, UIH

Tawana *see* TSWANA

TAWARA (Mozambique, Zimbabwe)
variants Taurawa, Tavara
note Bantu language; subcategory of Shona
AAT: nl
LCSH: Tawara
DDMM, GPM 1959, HB, WH
see also Shona

Tchaman *see* IGBIRA

Tchamba *see* CHAMBA (Cameroun)

Tchien *see* TIEN

Tchipungu *see* CIPUNGU

Tchokossi *see* ANUFO

Tchokwe *see* CHOKWE

Tchumbuli *see* CHAMBULI

TEDA (Chad, Libya, Niger)
variants Tibbu, Toda, Todaga
note Nilo-Saharan language. Tubu is a name given by the Kanuri to the Teda and Daza. The Aza are a separate people living among the Teda.
AAT: nl
LCSH: use Tibbu
AML, ARW, ATMB, ATMB 1956, BS, DDMM, ETHN, GPM 1959, GPM 1975, HAB, HB, HBDW, IAI, JEC 1958, JG 1963, JLS, JP 1953, JPAL, LCB, LJPG, LPR 1995, MLJD, MPF 1992, NOI, PMPO, SD, SMI, TP, UIH, WH ANK*
see also Aza, Tubu

TEGALI (Sudan)
note Kordofanian language
AAT: nl
LCSH: nl
ATMB, ATMB 1956, DDMM, ETHN, JG 1963

Tegdaoust *see* Toponyms Index

Tege *see* TEKE

Tege *see* TEGESSIE

TEGESSIE (Côte d'Ivoire)
variants Tege, Teguesse, Teguessie, Tenbo, Tuuni
note Gur language; subcategory of Lorhon
AAT: nl
LCSH: nl
DDMM, DP, ETHN, GPM 1959, GPM 1975, JPB, WH
see also Lorhon

TEGUE (Congo Republic, Zaire)
note Bantu language; subcategory of Teke
AAT: nl
LCSH: nl
DDMM, GPM 1959, RLD 1974
see also Teke

Teguesse *see* TEGESSIE

Teguessie *see* TEGESSIE

TEITA (Kenya)
variants Adavida, Dabida, Dawida, Taita
note Bantu language
AAT: Teita
LCSH: use Taita
DDMM, ECB, ETHN, GPM 1959, GPM 1975, HAB, HB, HBDW, IAI, JLS, MGU 1967, RGL, RJ 1960, SMI, UIH, WH, WOH
AHP 1952*, GGH*

TEKE (Congo Republic, Gabon, Zaire)
variants Anzika, Bakono, Bateke, Tege, Teo, Tere, Tsio
note Bantu language; subdivided into a number of geographically determined groups including the Boo, Jinju, Kukuya, Kwei, Mbe, Mfunu, Ngenge, Ngungulu, Ntsaye, Sese, Tegue, Tio, and Wu. see JV 1973 for many more subcategories.
AAT: Teke
LCSH: Teke
AF, ALM, ASH, AW, BES, BS, CDR 1985, CFL, CK, CMK, DDMM, DOA, DOWF, DP, DPB 1985, DPB 1987, EB, EBHK, EBR, EEWF, ELZ, ETHN, EWA, FW, GAH 1950, GB, GBJM, GBJS, GPM 1959, GPM 1975, HAB, HB, HBDW, HH, HMC, IAI, JC 1971, JC 1978, JD, JJM, JK, JL, JLS, JM, JMOB, JP 1953, JTSV, JV 1966, KFS, KFS 1989, KK 1965, KMT 1970, KMT 1971, LM, LP 1979, LP 1985, LP 1993, MGU 1967, MH, MHN, MLB, MLJD, MPF 1992, NIB, OB 1973, OBZ, RFT 1974, RGL, RLD 1974, RS 1980, RSAR, RSW, SG, SMI, SV, SVFN, TB, TERV, TLPM, TP, UIH, WBF 1964, WG 1980, WG 1984, WH, WM, WMR, WOH, WRB, WRB 1959, WRNN, WS
HE*, JV 1973*
see also Tio

Teke-Tsaaye *see* NTSAYE

TEKNA (Morocco)
note Berber language; one of the groups included in the collective term Berber
AAT: nl
LCSH: Tekna
GPM 1959, GPM 1975, WH
LPR 1995*
see also Berber

Tekrour *see* TEKRUR

TEKRUR (Mauritania, Senegal)
variants Tekrour
note ancient West African kingdom
AAT: nl
LCSH: nl
HB, LPR 1995, WH
BBH*

TELLEM (Mali)
note Along with the Toloy, an ancient culture preceding the Dogon, circa 11th-16th century CE. The Kurumba are also known as Tellem.
AAT: Tellem
LCSH: use Kurumba
ASH, BS, CDR 1985, EBR, ETHN, FW, GWS, HB, HH, JAF, JK, JL, JLS, JM, JPJM, JV 1984, KFS, LJPG, LM, MHN, MLB, PR, SG, SMI, SV, TP, WG 1980, WG 1984, WS
HLP*
see also Dogon, Kurumba, Toloy

Tem *see* NTEM

TEM (Benin,Togo)
variants Temba
note Gur language
AAT: Tem
LCSH: Tem
DDMM, DWMB, ETHN, GPM 1959, GPM 1975, HB, HBDW, IAI, JG 1963, RJ 1958, SMI, UIH, WH
JCF*, MFAA*

Temba *see* TEM

TEMBO (Zaire)
variants Batembo, Motembo, Watembo
note Bantu language
AAT: nl
LCSH: Tembo language
DDMM, DPB 1986, DPB 1987, ETHN, FN 1994, GAH 1950, GPM 1959, HAB, HB, HBDW, JMOB, MGU 1967, OB 1973, OBZ, UIH, WH

TEMBU (South Africa)
variants Thembu
note Bantu language; subcategory of
Nguni
AAT: Tembu
LCSH: Tembu
DDMM, GPM 1959, GPM 1975, HB, SD,
TP, UIH, WDH, WH, WRNN
JBR*
see also Nguni

TEMEIN (Sudan)
variants Ronge
note Eastern Sudanic language
AAT: nl
LCSH: nl
ATMB, ATMB 1956, DDMM, ETHN,
GPM 1959, GPM 1975, HB, JG 1963

TEMNE (Sierra Leone)
variants Atemne, Timne
note West Atlantic language;
sometimes distinguished as Sanda
Temne and Yuni (Yoni) Temne
AAT: Temne
LCSH: Temne
AW, BS, CK, CMK, DDMM, DP, DWMB,
ETHN, FW, GB, GPM 1959, GPM 1975,
GSGH, HAB, HB, HBDW, IAI, JD, JG
1963, JK, JLS, JM, JTSV, KFS, KLT, LM,
LPR 1995, MLB, MLJD, RAB, RGL, RJ
1958, ROMC, RSW, SD, SG, SMI, SV, TB,
TP, UIH, WBF 1964, WEW 1973, WG
1980, WH, WOH, WRB, WRB 1959,
WRNN, WS
MEM 1950*
see also Baga

Tenbo *see* TEGESSIE

TENDA (Guinea-Bissau, Senegal)
subcategories Tenda Mayo
note West Atlantic language.
Tenda is a collective term that
includes the Badyaranke, Bassari,
Bedik, Boin, Konyagi, Tenda
Mayo and many others.
AAT: nl
LCSH: Tenda
BS, DDMM, DWMB, ETHN, GPM 1959,
HB, HBDW, IAI, JP 1953, LJPG, MPF
1992, RJ 1958, SMI, UIH, WH
MDL*

Tenda Boeni *see* BOIN

TENDA MAYO (Guinea, Senegal)
note West Atlantic language;
subcategory of Tenda
AAT: nl
LCSH: nl
MDL, UIH
see also Tenda

Tende *see* TIENE

TENERE (Côte d'Ivoire)
variants Teneure
note Gur language; subcategory of
Senufo
AAT: nl
LCSH: nl
DDMM, ETHN, JPB
see also Senufo

Teneure *see* TENERE

Teo *see* TEKE

TEPES (Uganda)
variants So, Tepeth
note Eastern Sudanic language; one
of the groups included in the
collective term Nilotic people
AAT: nl
LCSH: Tepeth
ATMB, DDMM, ETHN, GPM 1959, GPM
1975, HB, PGPG, UIH
CDL*
see also Nilo-Hamitic people

Tepeth *see* TEPES

TERA (Nigeria)
note Chadic language
AAT: nl
LCSH: Tera language
DDMM, DWMB, ETHN, GPM 1959, GPM
1975, HB, HBDW, IAI, JG 1963, JLS,
MBBH, NOI, RWL, UIH, WEW 1973, WH

Tere *see* TEKE

TERIK (Kenya)
note Southern Nilotic language; one
 of the groups included in the
 collective term Nilo-Hamitic
 people
 AAT: nl
 LCSH: nl
 DDMM, ECB, ETHM, GPM 1959, GPM
 1975, HB, UIH
 GWH 1969*
see also Nilo-Hamitic people
TESHI (Ghana)
variants Teshie
note Kwa language
 AAT: nl
 LCSH: nl
 IAI, MM 1950
Teshie *see* TESHI
Tesio *see* TESO
TESO (Kenya, Uganda)
variants Ateso, Iteso, Tesio, Tesyo,
 Wamia
note Eastern Nilotic language; one
 of the groups included in the
 collective term Nilo-Hamitic
 people
 AAT: Teso
 LCSH: Teso
 ARW, ATMB, ATMB 1956, BS, DDMM,
 ECB, ETHN, EWA, GPM 1959, GPM
 1975, HAB, HB, HBDW, IAI, JG 1963,
 JLS, JM, LJPG, MTKW, PMPO, RJ 1960,
 ROMC, SD, SMI, UIH, WEW 1973, WH,
 WRB 1959
 PGPG*
see also Nilo-Hamitic people
Tesyo *see* TESO
Teta *see* NYUNGWE
Tete *see* NYUNGWE
TETELA (Zaire)
variants Atetela, Batetela, Tatela
note Bantu language; called Kusu
 east of the Lomami River.
 Together with the Hamba, Jonga
 and Kusu, the Tetela make up a
 cluster of peoples known as
 Nkutshu.

AAT: Tetela
LCSH: Tetela
AW, BES, BS, CDR 1985, CK, DDMM,
DPB 1981, DPB 1986, DPB 1987, EEWF,
ELZ, ETHN, FN 1994, GAH 1950, GPM
1959, GPM 1975, HAB, HB, HBDW, HJK,
HMC, IAI, JC 1971, JC 1978, JJM 1972,
JLS, JMOB, JPJM, JV 1966, KK 1965,
KMT 1971, LJPG, MGU 1967, OB 1961,
OB 1973, OBZ, RFT 1974, ROMC, RS
1980, RSW, SMI, SV 1988, UIH, WBF
1964, WG 1980, WG 1984, WH, WRB,
WRNN, WS
JOJ*, LD*, LDH*
see also Kusu, Nkutshu
Teuso *see* IK
Tew *see* TOW
THARAKA (Kenya)
variants Saraka
note Bantu language
 AAT: nl
 LCSH: Tharaka
 DDMM, ECB, ETHN, GPM 1959, HB,
 JLS, MGU 1967, RJ 1960, UIH, WH
 JMGK*
Thembu *see* TEMBU
THIANG (Sudan)
note Western Nilotic language;
 subcategory of Nuer
 AAT: nl
 LCSH: nl
 ATMB 1956, CSBS, DDMM, ETHN, UIH,
 WH
see also Nuer
Thiro *see* TIRA
Thonga *see* TSONGA
Thonga *see* TONGA (Mozambique)
THURI (Sudan)
note Western Nilotic language; one
 of the groups included in the
 collective term Nilotic people
 AAT: nl
 LCSH: nl
 DDMM, ETHN, GPM 1959, HB, WH
 AJB*
see also Nilotic people
Tiamus *see* NJEMPS
Tibbu *see* TEDA
Tibesti *see* Toponyms Index
Tiefo *see* TYEFO

TIEN (Liberia)
variants Shien, Tchien
note Kwa language
AAT: Tien
LCSH: nl
CK, DDMM, ELZ, GSDS, GSGH, HB,
JPB, WEW 1973, WRB

TIENE (Zaire)
variants Tende, Tiini
note Bantu language
AAT: nl
LCSH: nl
DDMM, DPB 1985, ECB, ETHN, GPM
1959, HB, HBDW, MGU 1967, OB 1973,
OBZ

TIGANIA (Kenya)
note Bantu language
AAT: nl
LCSH: nl
DDMM, ECB, ETHN, HB, JLS

TIGONG (Cameroun, Nigeria)
note Benue-Congo languages;
collective term for the Ashuku,
Abong, Batu, Magu, Mbembe,
Nama and Yukutare
AAT: Tigong
LCSH: nl
DDMM, ETHN, GPM 1975, HB, JG 1963,
RWL, UIH, WEW 1973, WH, WRB,
WRNN

TIGRE (Eritrea, Ethiopia, Sudan)
subcategories Habab
note Semitic language; one of the
groups included in the collective
term Beja. The Bogos are
sometimes erroneously referred to
as Tigre.
AAT: nl
LCSH: Tigre language
ATMB, ATMB 1956, DDMM, ETHN,
GPM 1959, GPM 1975, HAB, HB, HBDW,
HRZ, IAI, JG 1963, JM, PMPO, RJ 1959,
ROMC, SD, SMI, UIH, WEW 1973, WG
1984, WH
OUEE*, RMLP*, WIS*
see also Beja

TIGRINYA (Eritrea, Ethiopia)
note Semitic language
AAT: nl
LCSH: Tigrinya

ATMB, ATMB 1956, DDMM, ETHN,
GPM 1959, GPM 1975, HBDW, IAI, JG
1963, RJ 1959, ROMC, WEW 1973, WH
WIS*

Tiini *see* TIENE

TIKAR (Cameroun)
note Bantoid language; one of the
five component migrant groups in
both Bamenda and Bamileke;
independent chiefdoms including
Bafut, Bum, Fungom, Kom,
Magba, Mbaw, Mbem, Ndop,
Ngambe, Nsaw, Nsungli, Ntem,
Tadkon, Tang, War, and Wiya
AAT: Tikar
LCSH: Tikar
AF, BEL, BES, BS, CK, CMK, DDMM,
DFHC, DWMB, EBHK, EBR, ELZ, ETHN,
GB, GPM 1959, GPM 1975, HAB, HB,
HBDW, HMC, IAI, IEZ, JAF, JD, JJM
1972, JK, JP 1953, KFS, KK 1960, LJPG,
LM, MK, MLJD, MPF 1992, PH, RFT
1974, RGL, RJ 1958, RSAR, RSW, SD,
SMI, SV, TN 1984, UIH, WG 1980, WH,
WOH, WRB, WS
LP 1993*, MKW*, MMML*, PAG*, PMK*
see also Bamenda, Bamileke,
Grasslands

Timbouctou *see* TIMBUKTU
Timbuktu *see* Toponyms Index
Timne *see* TEMNE
Tindega *see* HADZAPI
Tindiga *see* HADZAPI
TINTO (Cameroun)
AAT: nl
LCSH: nl
KK 1965, PH, TN 1984

TIO (Congo Republic, Zaire)

variants Atyo, Makoko, Tyo

note division of Teke; also a 17th-
century Teke kingdom (Makoko),
and a term synonymous with the
Teke as a whole.

AAT: nl

LCSH: use Teke

BS, DDMM, DPB 1985, EBHK, ETHN,
GPM 1959, HB, IAI, JC 1971, JK, JLS, JV
1966, JV 1984, MGU 1967, OB 1973, RLD
1974, UIH

JV 1973*

see also Teke

TIRA (Sudan)

variants Thiro

note Kordofanian language; a
division of the Nuba

AAT: nl

LCSH: nl

ATMB, ATMB 1956, DDMM, ETHN,
GPM 1959, GPM 1975, HB, JG 1963, SD
SFN*

see also Nuba

TIRIKI (Kenya)

note Bantu language; one of the
groups included in the collective
term Luyia

AAT: nl

LCSH: Tiriki

DDMM, ECB, ETHN, GPM 1959, GPM
1975, HB, SMI

see also Luyia

TITU (Zaire)

note Bantu language

AAT: nl

LCSH: nl

DDMM, DPB 1985, DPB 1987, ETHN,
KFS, OBZ, WH

TIV (Cameroun, Nigeria)

variants Mbitse, Mitshi, Munchi,
Munshi, Tivi, Tiwi

subcategories Utanga

note Bantoid or "sub-Bantu "
language

AAT: Tiv

LCSH: Tiv

AF, CFL, CK, CMK, DDMM, DFHC,
DWMB, EBR, ETHN, FW, GIJ, GPM

1959, GPM 1975, HAB, HB, HBDW,
HMC, IAI, JD, JG 1963, JK, JLS, JM,
JTSV, KFS, KK 1965, KMT 1971, LJPG,
LM, MCA, MCA 1986, MGU 1967, MKW
1978, MLB, MLJD, NIB, NOI, PH, PMPO,
RGL, RJ 1958, ROMC, RS 1980, RSAR,
RSW, SD, SMI, SV, SV 1988, TP, UIH,
WBF 1964, WEW 1973, WFJP, WG 1980,
WG 1984, WH, WRB, WRNN, WS
LBPB*, RMD*, RWL*

Tivi *see* TIV

Tiwi *see* TIV

Tlemcen *see* Toponyms Index

TLHAPING (Botswana)

note Bantu language; subcategory of
Tswana

AAT: nl

LCSH: Tlhaping

DDMM, ETHN, GPM 1959, GPM 1975,
HB, HMC, UIH, WDH, WH

see also Tswana

To *see* ENDO

TOBOTE (Ghana, Togo)

note Gur language; often linked
with the Bassar

AAT: nl

LCSH: use Bassari

DDMM, ETHN, GPM 1959, JG 1963, WH

see also Bassar

Tobur *see* LABWOR

Toda *see* TEDA

Todaga *see* TEDA

TOFINU (Benin)

note Kwa language

AAT: Tofinu

LCSH: nl (uses Tofinnu)

DDMM, GPM 1959, UIH

Tofoke *see* TOPOKE

TOGBO (Central African Republic,
Zaire)

note Ubangian language

AAT: Togbo

LCSH: nl

ATMB, ATMB 1956, CDR 1985, DDMM,
DPB 1986, DPB 1987, EB, ETHN, GAH
1950, GPM 1959, HAB, HB, HBU,
HBDW, JC 1978, JG 1963, JMOB, OBZ,
RS 1980, UIH, WH, WRB

Togere *see* Toponyms Index

Toka *see* TONGA (Mozambique)

TOLOY (Mali)

note a pre-Tellem people who date circa 3rd-2nd century BCE
AAT: nl
LCSH: nl
JLS

see also Tellem

TOMA (Guinea)

note Mande language; known as Loma in Liberia and as Toma in Guinea
AAT: use Loma
LCSH: Toma
ASH, BS, CDR 1985, CK, CMK, DDMM, DP, DWMB, ELZ, ETHN, EWA, GPM 1959, GPM 1975, GSGH, HAB, HB, HBDW, HH, HMC, HRZ, IAI, JD, JK, JL, JLS, JP 1953, JPB, KFS, KFS 1989, LJPG, LPR 1986, MH, MLB, MLJD, RFT 1974, RGL, RJ 1958, RS 1980, RSAR, RSRW, RSW, SD, SMI, TP, UIH, WG 1980, WG 1984, WH, WMR, WRB, WRNN, WS

see also Loma

Tombo *see* DOGON

Tondidarou *see* Toponyms Index

Tonga *see* TSONGA

TONGA (Cameroun)

note Bantoid language; one of the groups included in the collective term Bamileke
AAT: nl
LCSH: nl
DDMM, ETHN, LP 1993

see also Bamileke

TONGA (Malawi)

note Bantu language; related to the Tumbuka; sometimes referred to as lakeshore Tonga; not to be confused with the Tonga of Mozambique, and the Tsonga who are also known as Thonga
AAT: nl
LCSH: use Tumbuka
DDMM, ETHN, GPM 1959, GPM 1975, IAI, UIH, WDH, WRB 1959
TEW*

see also Tumbuka

TONGA (Malawi, Mozambique, Zambia, Zimbabwe)

variants Thonga, Toka, Tonka

note Bantu language; not to be confused with the Tumbuka Tonga of Malawi and the Tsonga who are also known as Thonga. The name has been applied to a number of people sharing a common culture and language, spread over a vast area along the Zambesi River and throughout parts of Zambia, Zimbabwe, Malawi, Mozambique and South Africa. They are sometimes grouped as 1. Northern (or Zambezi) Tonga, 2. Western (or Nyasa) Tonga and 3. Shona Tonga. The Northern Tonga are divided into the Plateau Tonga, the Southern Tonga (or Toka), and the Valley Tonga (or We). They are sometimes grouped with the Ila and referred to as Ila-Tonga.
AAT: Tonga
LCSH: Tonga
ACN, BES, BS, DDMM, ETHN, GPM 1959, GPM 1975, HAB, HB, HBDW, HMC, IAI, JD, JLS, JV 1966, MGU 1967, MLJD, NIB, RGL, RJ 1961, RS 1980, RSW, SMI, UIH, WDH, WG 1980, WH, WOH, WRB 1959, WS, WVB
BAR 1968*, EC*, ECMG*, MAJ*, TEW*

see also Ila

TONGWE (Tanzania)

variants Utongwe

note Bantu language
AAT: nl
LCSH: nl
DDMM, ECB, ETHN, GPM 1959, GPM 1975, HB, KK 1990, MFMK, MGU 1967, TP, UIH

Tonka *see* TONGA (Mozambique)

Tooro *see* TORO

TOOROBBE (Nigeria)
subcategories Fulani
note a Fulani ethnic subcategory
AAT: nl
LCSH: nl
RWL
BBH*
see also Fulani

TOPOKE (Zaire)
variants Poke, Tofoke
note Bantu language
AAT: nl
LCSH: Topoke
BES, DDMM, DPB 1987, ETHN, GAH 1950, GPM 1959, GPM 1975, HAB, HB, HBDW, IAI, JMOB, MGU 1967, OBZ, UIH

Toposa *see* TOPOTHA

TOPOTHA (Ethiopia, Sudan)
variants Dabosa, Toposa
note Eastern Nilotic language; one of the groups included in the collective term Nilo-Hamitic people
AAT: Topotha
LCSH: nl (uses Nyangatom)
AF, ATMB 1956, CSBS, DDMM, ETHN, GPM 1959, GPM 1975, HB, JG 1963, JLS, RJ 1959, UIH, WH
PGPG*
see also Nilo-Hamitic people

TORO (Sudan)
variants Otoro
note Kordofanian language; one of the divisions of the Nuba
AAT: nl
LCSH: nl
ATMB, DDMM, ETHN, GPM 1959, GPM 1975, HB, ICWJ, JG 1963
SFN*
see also Nuba

TORO (Uganda)
variants Tooro
note Bantu language
AAT: nl
LCSH: use Tooro
DDMM, DPB 1986, ECB, ETHN, GPM 1959, GPM 1975, HAB, HB, HBDW, IAI, JM, MGU 1967, MTKW, PG 1990, RJ 1960, SMI, UIH, WH

Torod *see* TAROK

TOTELA (Botswana, Zambia)
note Bantu language
AAT: nl
LCSH: nl
DDMM, ETHN, GPM 1959, HB, MGU 1967, UIH, WH, WVB

Tou *see* TOW

Touareg *see* TUAREG

Toubou *see* TUBU

Toucouleur *see* TUKULOR

Toupouri *see* TUPURI

Toura *see* TURA

Tourka *see* TURKA

Toussian *see* TUSYAN

TOW (Zaire)
variants Tew, Tou, Tuku
note Bantu language
AAT: nl
LCSH: nl
DPB 1985, HB, JV 1966, UIH

TRARZA (Mauritania)
note Semitic language; one of the groups included in the collective term Bedouin
AAT: nl
LCSH: nl
GPM 1959, GPM 1975, LPR 1995, WH
see also Bedouin

TSAAM (Zaire)
variants Samba, Tsaamba, Tsamba
note Bantu language
AAT: nl
LCSH: nl
CDR 1985, DDMM, DPB 1985, DPB 1987, ETHN, FN 1994, GAH 1950, GPM 1959, HAB, HB, HBDW, IAI, JV 1966, OB 1973, OBZ, UIH, WH

Tsaamba *see* TSAAM

Tsaaye *see* NTSAYE

Tsaayi *see* NTSAYE

Tsai *see* NTSAYE

Tsamba *see* TSAAM

TSANGI (Congo Republic, Gabon)
variants Batsangi, Batsangui,
Tsangui
note Bantu language
AAT: nl
LCSH: nl
DDMM, ETHN, HB, JD, JK, LP 1979, LP
1985, WS

Tsangui *see* TSANGI

Tsaya *see* NTSAYE

Tsaye *see* NTSAYE

Tsayi *see* NTSAYE

TSCHITUNDA (Angola)
note Bantu language; one of the
groups included in the collective
term Ngangela
AAT: nl
LCSH: nl
KK 1960
see also Ngangela

Tschokwe *see* CHOKWE

Tschopi *see* CHOPI

Tshabe *see* SHABE

Tshaman *see* EBRIE

Tsheenya *see* ENYA

Tshiaka *see* CIAKA

Tshilenge *see* CILENGE

Tshioko *see* CHOKWE

Tshipungu *see* CIPUNGU

Tshokwe *see* CHOKWE

Tshuapa River *see* Toponyms Index

Tshwa *see* CWA

TSIMIHETY (Madagascar)
note Malagasi language
(Austronesian)
AAT: nl
LCSH: Tsimihety
BS, DDMM, ELZ, ETHN, GPM 1959,
GPM 1975, HB, IAI, ROMC, WH
CKJR*, JMA*

Tsio *see* TEKE

Tsogho *see* TSOGO

TSOGO (Gabon)
variants Apindji, Ashogo,
Mitshogho, Mitsogo, Mitsogho,
Nitsogo, Shogo, Sogo, Tsogho

note Bantu language. According to
several sources, the Apindji are a
closely related group. see DDMM
and ETHN.
AAT: Tsogo
LCSH: Tsogo language
BES, BS, CDR 1985, CFL, CK, DDMM,
ETHN, GPM 1959, GPM 1975, HB, IAI,
JD, JK, JLS, JV 1984, KFS, KFS 1989, LM,
LP 1979, LP 1985, LP 1990, MGU 1967,
MHN, MLB, MLJD, MUD 1986, MUD
1991, RFT 1974, RSAR, SG, SV, TP, UIH,
WG 1980, WMR, WRB, WRNN, WS
OGPS*

TSONG (Zaire)
variants Nsong, Nsongo, Songo
note Bantu language
AAT: nl
LCSH: nl
DDMM, DPB 1985, DPB 1987, ETHN,
GAH 1950, GPM 1959, HB, JMOB, JV
1966, JV 1984, OB 1973, SMI, UIH

TSONGA (Mozambique, Swaziland,
South Africa)
variants Baronga, Bathonga,
Ronga, Songa, Thonga, Tonga
subcategories Shangaan
note Bantu language; not to be
confused with the Tonga of
Malawi and the Tonga of
Mozambique who are also known
as Thonga
AAT: use Thonga
LCSH: Tsonga
BES, BS, CK, DDMM, ETHN, GPM 1959,
GPM 1975, HAB, HB, HBDW, IAI, JLS,
MGU 1967, RJ 1961, SG, TP, UIH, WDH,
WH, WRB
HAJ*

TSOTSO (Angola)
variants Soso, Sosso
note Bantu language; sometimes
considered as Kongo related and
strongly influenced by the Yaka
and Suku
AAT: nl
LCSH: nl
DDMM, DPB 1985, EBHK, GPM 1975,
HB, JL, WRNN, WS
FHCP*
see also Kongo

TSWA (Zaire)
note Bantu language; one of the
groups included in the collective
term Mongo
AAT: nl
LCSH: nl
DDMM, DPB 1987, WRNN
see also Mongo

TSWA (Mozambique, South Africa,
Zimbabwe)
note Bantu language
AAT: nl
LCSH: Tswa language
ETHN, HB, IAI, UIH, WDH, WEW 1973,
WS

TSWANA (Botswana, Namibia,
South Africa, Zimbabwe)
variants Bechuana, Chwana,
Tawana
subcategories Hurutshe, Khatla,
Kwena, Ngwato, Rolong,
Tlhaping
note Bantu language; sometimes
referred to as Western Sotho. The
Tswana are sometimes divided
into a Western group and an
Eastern group.
AAT: Tswana
LCSH: Tswana
ACN, BS, CK, DDMM, EB, EBR, ELZ,
ETHN, GPM 1959, GPM 1975, HB, HRZ,
IAI, JD, JLS, JM, JV 1966, JV 1984, MGU
1967, MLJD, MUD 1991, NIB, PG 1990,
PMPO, PR, ROMC, RS 1980, RSW, SD,
SMI, TP, UIH, WDH, WEW 1973, WOH,
WVB
IS 1953*

see also Sotho

TUAREG (Algeria, Burkina Faso,
Libya, Mali, Niger)
variants Touareg
note Berber language; one of the
groups included in the collective
term Berber; divisions include the
Ajjer, Ahaggar, Adrar, Air
(including the Ferwan), Geres,
Illabakan, Iwllemmeden
(including the Dinnik and
Ataram), and the Tadmekket.
AAT: Tuareg
LCSH: Tuareg(s)
AF, AML, ARW, BS, DOA, EBR, ELZ,
ETHN, EWA, GPM 1959, GPM 1975,
HAB, HB, HBDW, HRZ, IAI, JEG 1958,
JG 1963, JJM 1972, JL, JLS, JM, JP 1953,
JPJM, KE, KFS, LCB, LJPG, LPR 1986,
LPR 1995, MCA, MG, MLB, MLJD, MPF
1992, PG 1990, PMPO, RJ 1958, ROMC,
RS 1980, RSW, SD, SMI, TFG, TP, UIH,
WG 1984, WH, WOH
AG*, ANB*, EDB*, EDB 1984*, EBJN*,
HLH*, JDMZ*, JEG 1971*, MVO*
see also Berber

TUBU (Chad, Libya, Niger, Sudan)
variants Toubou
note a collective name given by the
Kanuri to the Daza and Teda
AAT: nl
LCSH: Tubu language use Daza language
AML, ATMB, ATMB 1956, BS, DDMM,
ETHN, GPM 1959, GPM 1975, HB,
HBDW, JEC 1958, JLS, JP 1953, LPR
1995, MG, MLJD, MPF 1992, NOI, SD,
SMI, UIH, WH
JEC 1958*, JEC 1982*
see also Daza, Teda

Tuchokwe *see* CHOKWE
Tuculeur *see* TUKULOR
Tugen *see* TUKEN

TUKEN (Kenya)
variants Kamasia, Kamasya, Tugen
note Southern Nilotic language; one
of the groups included in the
collective term Nilo-Hamitic
people
AAT: nl
LCSH: use Tugan
DDMM, ECB, ETHN, GPM 1959, GPM
1975, GWH, HB, JLS, UIH, WH
GWH 1969*
see also Nilo-Hamitic people

TUKONGO (Angola, Zaire)
variants Tukungo, Kongo do Kasai
note Bantu language; subcategory of
Kongo. Some sources use
Tukongo to refer to the Wongo or
Dinga.
AAT: nl
LCSH: nl
DDMM, ETHN, FHCP, HB, JAF, JMOB,
MGU 1967, MLB 1994
see also Dinga, Wongo

Tuku *see* TOW

Tukuleur *see* TUKULOR

TUKULOR (Mauritania, Senegal)
variants Toucouleur, Tuculeur,
Tukuleur
note West Atlantic language; term
used for sedentary Fulani groups
in Mauritania and Senegal
AAT: nl
LCSH: use Toucouleur
BS, DDMM, DWMB, ETHN, EWA, GPM
1959, GPM 1975, HAB, HB, HBDW, IAI,
JD, JLS, JP 1953, JPJM, KFS, LM, NOI,
RAB, RJ 1958, ROMC, RSW, RWL, SMI,
TFG, UIH, WH, WRB
YW*
see also Fulani

Tukungo *see* TUKONGO

TULA (Nigeria)
variants Ture
note Adamawa language
AAT: nl
LCSH: nl
DDMM, ETHN, GPM 1959, GPM 1975,
HB, JG 1963, LJPG, NIB, RJ 1958, RWL

TULAMA (Ethiopia)
note Eastern Cushitic language;
subcategory of Oromo
AAT: nl
LCSH: nl
DDMM, ETHN, GPM 1959, GPM 1975,
HB, UIH, WH
GWH 1955*, MOH*
see also Oromo

TULEAR (Madagascar)
note Malagasi language
(Austronesian)
AAT: nl
LCSH: nl
JMA, KK 1990

Tulishi *see* TULLISHI

TULLISHI (Sudan)
variants Tulishi
note Kordofanian language; one of
the divisions of the Nuba
AAT: nl
LCSH: nl
ATMB, ATMB 1956, DDMM GPM 1959,
HB, RJ 1959, SD
SFN*
see also Nuba

Tumba *see* NTOMBA

TUMBATU (Kenya)
note Bantu language; subcategory of
Swahili
AAT: nl
LCSH: nl
DDMM, ECB, GPM 1959, HB, IAI, MGU
1967, WH
see also Swahili

Tumbi *see* MATUMBI

TUMBUKA (Malawi, Tanzania, Zambia)

note Bantu language. The term is sometimes used collectively to include the Tumbuka, Kamanga, Henga, Tonga and others. see TEW; one of the groups included in the collective term Maravi.

AAT: nl
LCSH: Tumbuka
DDMM, ETHN, GPM 1959, GPM 1975, HAB, HB, IAI, JV 1966, KK 1990, MGU 1967, RJ 1961, ROMC, SMI, UIH, WH, WVB
SMF*, TEW*

see also Maravi

TUMBWE (Zaire)

variants Batumbwe

note Bantu language; one of the groups included in the collective term Holoholo

AAT: nl
LCSH: use Holoholo
CDR 1985, DDMM, DPB 1981, DPB 1987, GAH 1950, GPM 1959, GPM 1975, HAB, HB, JC 1971, JC 1978, JV 1966, OB 1961, OBZ, SV, UIH, WH

see also Holoholo

TUMTUM (Sudan)

note Kordofanian language; one of the divisions of the Nuba

AAT: nl
LCSH: nl
ATMB, ATMB 1956, CSBS, DDMM, ETHN, GPM 1959, GPM 1975, HB, JG 1963, ROMC, WEW 1973

see also Nuba

TUNDJUR (Chad)

variants Tungur

note Chadic language

AAT: nl
LCSH: nl
ETHN, GPM 1959, MPF 1992, WH

Tungaw *see* TUNGO

TUNGO (Cameroun)

variants Babanki-Tungaw, Babanki-Tungo, Tungaw

note subcategory of Babanki; one of the groups included in the collective term Bamenda

AAT: nl
LCSH: nl
DF, EBHK, HH, KK 1965, LP 1993, PH, TN 1973, TN 1984, TN 1986, WG 1980
GDR*, PAG*, MMML*

see also Babanki, Bamenda

Tungur *see* TUNDJUR

TUNNI (Somalia)

note Cushitic language; one of the groups included in the collective term Sab

AAT: nl
LCSH: nl
ATMB 1956, ETHN, GPM 1959
IML 1969*

see also Sab

TUPURI (Cameroun, Central African Republic)

variants Toupouri

note Adamawa language; one of the groups included in the collective term Kirdi

AAT: nl
LCSH: Tupuri language use Tuburi language
BEL, BS, DDMM, DWMB, ETHN, GPM 1959, HB, IAI, IEZ, JP 1953, MPF 1992, RJ 1958

see also Kirdi

TURA (Côte d'Ivoire)

variants Toura, Wen

note Mande language

AAT: Tura
LCSH: Tura
DDMM, DWMB, EFLH, ETHN, GPM 1959, GPM 1975, GSGH, HAB, HB, IAI, JEEL, JK, JPB, LJPG, RGL, RJ 1958, RSW, SMI, WRB, WS
BH 1962*, EFHH*

Ture *see* TULA

TURKA (Burkina Faso)
variants Tourka, Turuka
note Gur language
AAT: nl
LCSH: nl
CDR 1987, CK, DDMM, ETHN, GPM
1959, GPM 1975, HB, JG 1963, JK, MK,
RJ 1958, UIH, WS

TURKANA (Kenya, Sudan)
note Eastern Nilotic language; one
of the groups included in the
collective term Nilo-Hamitic
people
AAT: Turkana
LCSH: Turkana
AF, ARW, ATMB, ATMB 1956, BS,
CSBS, DDMM, ECB, ELZ, ETHN, GB,
GPM 1959, GPM 1975, HAB, HB, IAI, JG
1963, JLS, LSD, MCA 1986, PMPO, PR,
RJ 1960, RS 1980, RSW, SMI, TLPM,
UIH, WH, WRB 1959, WRNN, WS
AWF*, GUB*, GWH*, PGPG*

see also Nilo-Hamitic people
Turkana, Lake *see* Toponyms Index
Turu *see* NYATURU
Turuka *see* TURKA
Turumbu *see* LOMBO
Tusi *see* TUTSI
Tusia *see* TUSYAN
Tusian *see* TUSYAN
Tussi *see* TUTSI
TUSYAN (Burkina Faso)
variants Toussian, Tusia, Tusian,
Win
note Gur language
AAT: nl
LCSH: nl
AF, ARW, CDR 1987, DDMM, DWMB,
ETHN, GPM 1959, HB, IAI, JLS, JPB,
MK, RJ 1958, UIH, WH, WRNN, WS

TUTSI (Burundi, Rwanda)
variants Batutsi, Tusi, Tussi,
Watusi, Watussi, Watutsi
note Bantu language
AAT: Tutsi
LCSH: Tutsi
AF, BS, EBR, ELZ, ETHN, GB, GPM
1975, HB, HRZ, IAI, JD, JJM 1972, JM,
JMOB, KMT 1971, LSD, MCA 1986, MH,

MHN, MLB, MLJD, MTKW, NIB, OBZ,
PG 1990, PMPO, RJ 1960, RS 1980, RSW,
SD, SMI, TP, UIH, WH, WOH, WRB 1959
JJM 1961*, MDAT*

Tuuni *see* TEGESSIE

TWA (Burundi, Rwanda, Zaire)
variants Batoa, Batwa
note Bantu language; one of the
groups included in the collective
term Pygmies; term used for some
Pygmy groups. Some sources
consider the Twa and Cwa to be
the same people.
AAT: Twa
LCSH: use Batwa
BS, DDMM, DPB 1986, DPB 1987, ELZ,
ETHN, GB, GPM 1959, GPM 1975, HAB,
HB, HBDW, HRZ, IAI, JG 1963, JK, JLS,
JM, JMOB, JV 1966, KK 1965, KMT 1971,
NIB, OB 1973, OBZ, PMPO, RJ 1960,
ROMC, RSW, SB, SD, SMI, UIH, WFJP,
WG 1980, WG 1984, WH, WOH, WRB
1959, WVB
JJM 1961*, MDAT*, PE*, SB*, SFS*

see also Pygmies

TWAGI (Zaire)
note Bantu language; one of the
groups included in the collective
term Holoholo
AAT: nl
LCSH: nl
DDMM, DPB 1981, DPB 1987
AC*

see also Holoholo

TWI (Côte d'Ivoire, Ghana)
note Kwa language; one of the
groups included in the collective
term Akan
AAT: nl
LCSH: Twi
DDMM, DWMB, ENS, ETHN, GPM 1975,
HB, HBDW, HCDR, IAI, JG 1963, JOB,
JPB, LPR 1986, RJ 1958, ROMC, SMI,
WEW 1973, WRB 1959

see also Akan

TWIFO (Ghana)
 note 14th-century Akan kingdom
 AAT: nl
 LCSH: nl
 BDG 1980, TFG, WG 1984
 see also Akan
Twyfelfontein *see* Toponyms Index
Tyama *see* EBRIE
TYEBARA (Côte d'Ivoire)
 variants Kembara, Kiembara
 note Gur language; subcategory of
 Senufo
 AAT: nl
 LCSH: nl
 DDMM, DR, JD, JPB, RSW, SG, SV
 AJG*
 see also Senufo
TYEFO (Burkina Faso)
 variants Tiefo
 note Gur language; subcategory of
 Senufo
 AAT: nl
 LCSH: nl
 DDMM, DWMB, ETHN, GPM 1959, HB,
 IAI, UIH, WS
 see also Senufo
TYELI (Côte d'Ivoire)
 variants Tyelibele
 note Gur language; subcategory of
 Senufo
 AAT: nl
 LCSH: nl
 ETHN, WS
 AJG*
 see also Senufo
Tyelibele *see* TYELI
Tyo *see* TIO
Tyokosi *see* ANUFO

Ubangi River *see* Toponyms Index
Ubena *see* BENA
UBI (Côte d'Ivoire, Liberia)
 variants Oubi

 note Kwa language; one of the
 groups included in the collective
 term Kran
 AAT: nl
 LCSH: nl
 DDMM, ETHN, GPM 1959, HB, JK, JPB,
 WH, WRB
 GSDS*
 see also Kran
UDI (Nigeria)
 note Kwa language; one of the
 divisions of Igbo
 AAT: Udi
 LCSH: nl
 JK, WRB
 see also Igbo
UDUK (Ethiopia, Sudan)
 note Nilo-Saharan language
 AAT: nl
 LCSH: Uduk
 ATMB, ATMB 1956, CSBS, DDMM,
 ETHN, GPM 1959, HB, ICWJ, JG 1963,
 UIH
 ERC*
Uele River *see* Toponyms Index
Uge *see* GAYI
Ujiji *see* JIJI
UKELE (Nigeria)
 variants Ukelle
 note Benue-Congo language
 AAT: nl
 LCSH: nl
 AW, DDMM, ETHN, GIJ, GPM 1959,
 GPM 1975, HB, HCCA, JG 1963, NOI,
 RWL, SV, UIH, WEW 1973
Ukelle *see* UKELE
Ukwu *see* IGBO-UKWU
ULAD 'ALI (Libya)
 note Semitic language; one of the
 groups included in the collective
 term Bedouin
 AAT: nl
 LCSH: nl
 HB, LPR 1995
 see also Bedouin

ULE (Côte d'Ivoire)
 note Kwa language
 AAT: nl
 LCSH: nl
 DDMM, HB, JD
ULED NAIL (Algeria)
 note Semitic language; one of the
 groups included in the collective
 term Bedouin
 AAT: nl
 LCSH: nl
 GB, GPM 1959, WH
 see also Bedouin
ULED SAID
 note Semitic language; one of the
 groups included in the collective
 term Bedouin
 AAT: nl
 LCSH: nl
 GPM 1959
 see also Bedouin
Uli *see* OLI (Cameroun)
Uliminden Tuareg *see*
 IWLLEMMEDEN
Ulindi River *see* Toponyms Index
Umbundu *see* OVIMBUNDU
UMUNRI (Nigeria)
 note Kwa language; one of the
 divisions of Igbo
 AAT: nl
 LCSH: nl
 NOI, RJ 1958, VCU 1965
 CFGJ*
 see also Igbo
UNGA (Zaire, Zambia)
 variants Baunga
 note Bantu language
 AAT: nl
 LCSH: Unga
 CDR 1985, DDMM, DPB 1987, ETHN, FN
 1994, GPM 1959, GPM 1975, HAB, HB,
 IAI, JV 1966, RJ 1961, UIH, WH, WS,
 WVB
 WWJS*
UNGUJA (Kenya, Tanzania)
 note Bantu language; subcategory of
 Swahili; also a site of the Unguja

kuu civilisation in Zanzibar, circa
9th century and later
 AAT: nl
 LCSH: nl
 DDMM, ETHN, MGU 1967, PG 1990, RJ
 1960, UIH
 see also Swahili
UNYAMWEZI (Tanzania)
 note The term Greater Unyamwezi
 encompasses the Nyamwezi
 properly speaking (with the
 important chiefdom of
 Unyanyembe), the Sukuma,
 Sumbwa, Kimbu and Konongo.
 AAT: nl
 LCSH: nl
 BEBG
 RGA*, RGA 1967*
Upemba *see* Toponyms Index
UREWE (Burundi, Rwanda)
 note ancient Iron Age culture in
 Rwanda and Burundi; site of
 ceramic production
 AAT: nl
 LCSH: nl
 JLS, PR
URHOBO (Nigeria)
 note Kwa language. The term
 "Sobo" is a collective term that
 has been used to refer to both the
 Isoko and Urhobo peoples.
 AAT: Urhobo
 LCSH: use Sobo
 BS, CFL, DDMM, DFM, DWMB, EBR,
 ETHN, FW, GBJS, GPM 1959, GPM 1975,
 HB, HMC, IAI, JK, JLS, JTSV, KFS, KK
 1965, MKW 1978, MLB, NOI, PMPO,
 RGL, RJ 1958, RWL, SMI, SV, TP, UIH,
 WBF 1964, WEW 1973, WG 1980, WG
 1984, WRB, WRNN, WS
 see also Sobo
Urua *see* Toponyms Index
URUAN (Nigeria)
 note Benue-Congo language; one of
 the major divisions of Ibibio
 AAT: nl
 LCSH: nl
 RWL, WS
 see also Ibibio

Usambara *see* Toponyms Index
Ushi *see* AUSHI
UTANGA (Nigeria)
 variants Otank, Utange
 note Bantoid language; subcategory
 of Tiv
 AAT: nl
 LCSH: nl
 DDMM, ETHN, GIJ, GPM 1959, RWL
 see also Tiv
Utange *see* UTANGA
Utongwe *see* TONGWE
UTONKON (Nigeria)
 variants Orri
 note Benue-Congo language
 AAT: nl
 LCSH: nl
 DDMM, ETHN, GIJ, GPM 1959, NOI,
 RWL, WH
UTUGWANG (Nigeria)
 note Benue-Congo language;
 subcategory of Mbube; sometimes
 referred to as Eastern Mbube
 AAT: nl
 LCSH: nl
 DDMM, ETHN, RWL
 see also Mbube
UZEKWE (Nigeria)
 variants Ezekwe
 note Benue-Congo language
 AAT: nl
 LCSH: nl
 DDMM, ETHN, JAF, RWL

VAGALA (Ghana)
 variants Vagalla, Vagla
 note Gur language
 AAT: nl
 LCSH: Vagala language
 DDMM, ETHN, GPM 1959, GPM 1975,
 HB, HCDR, HMC, WH
Vagalla *see* VAGALA
Vagla *see* VAGALA

VAI (Liberia, Sierra Leone)
 variants Gallinas, Vei
 note Mande language
 AAT: Vai
 LCSH: Vai
 BS, CK, DDMM, DWMB, ELZ, ETHN,
 GPM 1959, GPM 1975, GSGH, HAB, HB,
 HBDW, HH, IAI, JD, JG 1963, JJM 1972,
 JK, JLS, JM, JP 1953, JPB, KFS, KFS
 1989, KK 1965, MLB, PMPO, PRM, PSG,
 RGL, RJ 1958, ROMC, RSRW, SAB, SG,
 SMI, TB, UIH, WG 1980, WG 1984, WH,
 WRB, WRNN, WS
 MEM 1950*, SEH 1967*
 see also Mande
Vakuanano *see* OVIMBUNDU
Vanano *see* OVIMBUNDU
Vandau *see* NDAU
Vanuma *see* BVANUMA
VAZIMBA (Madagascar)
 note Malagasi language
 (Austronesian)
 AAT: nl
 LCSH: nl
 GPM 1975, HB, WH
 JMA*
Vei *see* VAI
VENDA (South Africa, Zimbabwe)
 variants Bavenda, Bawenda
 note Bantu language
 AAT: Venda
 LCSH: Venda
 ACN, ARW, BES, BS, DDMM, EBR,
 ETHN, GPM 1959, GPM 1975, HAB, HB,
 HBDW, IAI, JD, JLS, JM, JRE, JTSV, KFS,
 LJPG, MCA 1986, MGU 1967, MLJD,
 NIB, PMPO, RGL, ROMC, RSW, SD, SMI,
 TP, UIH, WDH, WG 1984, WH, WRB,
 WRB 1959, WS
VERE (Cameroun, Nigeria)
 variants Werre
 note Adamawa language
 AAT: nl
 LCSH: Vere
 BEL, DDMM, DWMB, ETHN, GPM 1959,
 GPM 1975, HB, HBDW, JG 1963, NOI,
 RWL, WG 1984, WH
Vetre *see* METYIBO

VEZO (Madagascar)
 note Malagasi language
 (Austronesian)
 AAT: nl
 LCSH: Vezo
 DDMM, ETHN, GPM 1975, HB, JK, TP
 JMA*

Victoria, Lake *see* Toponyms Index

VIDUNDA (Tanzania)
 variants Ndunda
 note Bantu language
 AAT: nl
 LCSH: nl
 DDMM, ETHN, ECB, GPM 1959, HB, IAI,
 MFMK
 TOB*

VILI (Congo Republic, Gabon, Zaire)
 variants Bavili, Ivili
 note Bantu language; subcategory of
 Kongo; sometimes referred to as
 Cabinda or Fiote (but see separate
 entries)
 AAT: Vili
 LCSH: Vili
 ASH, BES, CDR 1985, CFL, CK, DDMM,
 DP, DPB 1985, DPB 1987, EBHK, ELZ,
 ETHN, EWA, FHCP, FW, GAH 1950, GB,
 GBJS, GPM 1959, GPM 1975, HAB, HB,
 HBDW, HJK, IAI, JC 1978, JD, JK, JL,
 JLS, JTSV, JV 1966, JV 1984, KFS 1989,
 KK 1960, KK 1965, KMT 1970, LJPG,
 LM, LP 1979, LP 1985, MGU 1967, MHN,
 MK, MLB, MLB 1994, MLJD, MPF 1992,
 MUD 1986, MUD 1991, OB 1973, OBZ,
 RGL, ROMC, SG, SMI, TB, TERV, UIH,
 WG 1980, WG 1984, WH, WMR, WOH,
 WRB, WRNN, WS
 see also Cabinda, Fiote, Kongo

Vimbundo *see* OVIMBUNDU

VINZA (Tanzania)
 note Bantu language
 AAT: Vinza
 LCSH: nl
 DDMM, ECB, ETHN, GPM 1959, GPM
 1975, HB, HC, MFMK, MGU 1967, UIH

VIRA (Zaire)
 variants Bavira, Wavira
 note Bantu language
 AAT: nl
 LCSH: nl

DPB 1981, DPB 1986, DPB 1987, ETHN,
GAH 1950, GPM 1959, HB, OBZ, RGL,
WH

Viri *see* BVIRI

Virunga Mountains *see* Toponyms
Index

VIYE (Angola)
 variants Bié
 note Bantu language; one of the
 groups included among the
 Ovimbundu
 AAT: nl
 LCSH: nl
 GPM 1959, GMC, HB, MEM, WS
 see also Ovimbundu

Voko *see* WOKO

Volta, Lake *see* Toponyms Index

Volta River *see* Toponyms Index

VORA (Central African Republic)
 note Central Ubangian language
 AAT: nl
 LCSH: nl
 DB 1978, DDMM, ETHN, UIH

Voute *see* WUTE

Vouvi *see* BUBI

Vugusu *see* BUKUSU

VUMA (Uganda)
 variants Bavuma
 AAT: nl
 LCSH: nl (uses Bavuma)
 ECB, HB, IAI

VUMBA (Kenya)
 variants Wavumba
 note Bantu language
 AAT: nl
 LCSH: nl
 DDMM, ECB, HB, MFMK, RJ 1960

VUNGUNYA (Zaire)
 note Bantu language
 AAT: nl
 LCSH: nl
 DDMM, DPB 1987, ETHN

Vute *see* WUTE

Vuvi *see* BUBI

WAAN (Zaire)
variants Bahuana, Bahungana,
 Huana, Hungaan, Hungana,
 Hunganna, Wana
note Bantu language
 AAT: nl
 LCSH: nl (uses Huana)
 AF, ALM, AW, BES, CDR 1985, CK,
 DDMM, DPB 1985, DPB 1987, EB,
 EBHK, EEWF, ELZ, GAH 1950, GBJS,
 GPM 1959, GPM 1975, HB, HJK, JC 1971,
 JC 1978, JD, JJM 1972, JK, JMOB, JV
 1966, KK 1965, MGU 1967, MLB, OB
 1973, OBZ, RSW, SMI, SV 1988, TERV,
 TP, UIH, WBF 1964, WG 1980, WG 1984,
 WH, WMR, WRB, WRNN
Wabemba *see* BEMBA
Wabembe *see* BEMBE (Zaire)
Wabena *see* BENA
Wabende *see* BENDE (Kenya)
Wabira *see* BIRA
Wabondei *see* BONDEI
Wabuye *see* BOYO
Wachagga *see* CHAGGA
Wachambala *see* SHAMBAA
WADAI (Chad)
variants Ouadai
note ancient kingdom with various
 small freeholdings
 AAT: nl
 LCSH: nl
 AML, ETHN, GPM 1975, HB, JL
Wadai region *see* Toponyms Index
Wadigo *see* DIGO
Wadoe *see* DOE
Wadumbo *see* DUMBO (Uganda)
Waembu *see* EMBU
Wafokomo *see* POKOMO
WAGADU (Mali)
note empire of the Soninke and site
 of Jenne culture
 AAT: nl
 LCSH: nl
 CDR 1985, JV 1984, TFG, WG 1984
see also Soninke
Wagadugu *see* Toponyms Index
Waganga *see* MANGANJA

Wageia *see* LWOO
Wagenia *see* ENYA
Wagga *see* WAJA
Wagindo *see* NGINDO
Wagiryama *see* GIRYAMA
Wahehe *see* HEHE
Waholoholo *see* HOLOHOLO
WAJA (Nigeria)
variants Wagga
note Adamawa language
 AAT: Waja
 LCSH: Waja language
 DDMM, DWMB, ETHN, GPM 1959, GPM
 1975, IAI, JG 1963, JK, KFS, MBBH,
 MLB, NIB, NOI, RJ 1958, RWL, UIH,
 WFJP, WG 1980, WG 1984, WRB
Wakamba *see* KAMBA (Kenya)
Wakerewe *see* KEREWE
Wakikuyu *see* GIKUYU
Wakissi *see* KISI
Wakwere *see* KWERE
WALA (Ghana)
variants Wali
note Gur language; a collective
 term including the Dagomba,
 Lobi, LoDagaba, and Mamprussi
 AAT: nl
 LCSH: Wala
 DDMM, DWMB, ETHN, GPM 1959, GPM
 1975, HB, HBDW, HCDR, IAI, JG 1963,
 LPR 1969, LPR 1986, RAB, RGL, RJ
 1958, SMI, UIH, WH
 MM 1951*, MM 1952*
Walangulu *see* SANYE
Walega *see* LEGA
Walese *see* LESE
Wali *see* WALA
Walimi *see* NYATURU
WALLAGA (Ethiopia)
note Eastern Cushitic language;
 subcategory of Oromo
 AAT: nl
 LCSH: nl
 ETHN, GPM 1959
 GWH 1955*, MOH*
see also Oromo
Walumbi *see* RUMBI

Wamakonde *see* MAKONDE

Wamakua *see* MAKUA

Wamatumbi *see* MATUMBI

Wamawia *see* MAWIA

Wamba *see* NUNGU

Wambu *see* HUAMBO

Wambundu *see* WUUM

Wamia *see* TESO

Wamuera *see* MWERA

Wamwera *see* MWERA

WAN (Côte d'Ivoire)
 variants Ngwanu, Nwa
 note Mande language
 AAT: nl
 LCSH: nl
 CDR 1985, DDMM, ETHN, HB, JG 1963,
 JK, JLS, UIH, WS
 JPB*
 see also Mande

Wana *see* WAAN

Wanande *see* KONJO

WANDA (Tanzania)
 variants Wandya
 note Bantu language
 AAT: nl
 LCSH: nl
 DDMM, ETHN, GPM 1959, GPM 1975,
 HB, MFMK, SD, WVB

Wandala *see* MANDARA

Wandamba *see* NDAMBA

Wandendehule *see* NDENDEULI

Wanderobo *see* DOROBO

Wandonde *see* NDONDE

Wanduruma *see* DURUMA

Wandya *see* WANDA

WANGA (Kenya)
 variants Hanga, Wawanga
 note Bantu language; one of the
 groups included in the collective
 term Luyia
 AAT: nl
 LCSH: Wanga
 DDMM, ECB, ETHN, GPM 1959, GPM
 1975, HB, RJ 1960
 see also Luyia

Wangara *see* MALINKE

Wangata *see* NGATA

Wangindo *see* NGINDO

Wangoni *see* NGONI

Wanguru *see* NGULU (Tanzania)

Waniaturu *see* NYATURU

Wanjamwezi *see* NYAMWEZI

WANJI (Tanzania)
 note Bantu language
 AAT: nl
 LCSH: nl
 DDMM, ETHN, GPM 1959, GPM 1975,
 HB, LP 1993, MFMK, SD, UIH

Wankutshu *see* NKUTSHU

Wanyamwezi *see* NYAMWEZI

Wanyassa *see* NYASA

Wanyika *see* NYIKA

Wapangwa *see* PANGWA

Wapogoro *see* POGORO

Wapokomo *see* POKOMO

WAR (Cameroun)
 note independent chiefdom of
 Tikar; one of the groups included
 in the collective terms Bamenda
 and Nsungli
 AAT: nl
 LCSH: nl
 GPM 1959, GPM 1975, HB, IEZ, PH
 MMML*, PMK*
 see also Bamenda, Nsungli, Tikar

WARA (Burkina Faso)
 note Gur language
 AAT: nl
 LCSH: nl
 DDMM, ETHN, GPM 1959, GPM 1975,
 JG 1963, UIH, WH

Warangi *see* RANGI

WAREBO (Côte d'Ivoire)
 note Kwa language; subcategory of
 Baule
 AAT: nl
 LCSH: nl
 JPB*
 see also Baule

Warega *see* LEGA

Warongo *see* RANGI

Warri *see* ITSEKIRI

Warua *see* LUBA

Warundi *see* RUNDI

WASA (Ghana)
 variants Wasaw
 note Kwa language; one of the
 groups included in the collective
 term Akan
 AAT: nl
 LCSH: nl
 DDMM, ETHN, GPM 1959, GPM 1975,
 HB, HCDR, RJ 1958
 see also Akan

Wasanye *see* SANYE

Wasaramo *see* ZARAMO

Wasaw *see* WASA

Waschamba *see* CHAMBA
 (Cameroun)

Waschambaa *see* SHAMBAA

Washambala *see* SHAMBAA

Wasiba *see* HAYA

Wasongola *see* SONGOLA

Wasongora *see* SONGOLA

Wasuaheli *see* SWAHILI

Wasukuma *see* SUKUMA

Wasulunka *see* MALINKE

Watembo *see* TEMBO

Watende *see* KURIA

Watindega *see* HADZAPI

Watschiwokwe *see* CHOKWE

Watusi *see* TUTSI

Watussi *see* TUTSI

Watutsi *see* TUTSI

Wavira *see* VIRA

Wavumba *see* VUMBA

Wawanga *see* WANGA

Waxaramo *see* ZARAMO

Wayao *see* YAO

Wazaramo *see* ZARAMO

Wazigua *see* ZIGULA

Wazimba *see* ZIMBA

Wazula *see* ZULA

We *see* NGERE

WE (Zambia)
 note Bantu language; subcategory of
 Valley Tonga
 AAT: nl
 LCSH: nl
 DDMM, ETHN, GPM 1975, HB, IAI, UIH,
 WVB
 see also Tonga

Webe *see* WOBE

Wee *see* NGERE

Wemba *see* BEMBA

Wen *see* TURA

Werre *see* VERE

Whydah *see* Toponyms Index

Whydah *see* AIZO

WIDEKUM (Cameroun)
 variants Mbudikem
 subcategories Meta, Mogamaw,
 Ngemba, Ngie, Ngwo
 note an independent chiefdom and
 one of the five component migrant
 groups in both Bamenda and
 Bamileke
 AAT: nl
 LCSH: nl
 CMK, DDMM, DWMB, ETHN, GIJ, GPM
 1959, GPM 1975, HMC, IEZ, JAF, JLS,
 KK 1960, KK 1965, PH, RFT 1974, SG,
 TN 1984, TN 1986, WG 1984, WH,
 WRNN, WS
 GDR*, LP 1993*, PAG*, PMK*
 see also Bamenda, Bamileke

Wiili *see* LOWIILI

WIKO (Zambia)
 note Bantu language; cluster of
 small Luba-derived groups in
 Barotse kingdom
 AAT: nl
 LCSH: nl
 DDMM, IAI
 ECMG*

Wile *see* LOWIILI

Win *see* TUSYAN

WINIAMA (Burkina Faso)
variants Ko, Winye, Winyema
note Gur language; one of the
peoples included in the collective
term Grunshi
AAT: nl
LCSH: nl (uses Ko)
CDR 1985, CDR 1987, DDMM, GPM
1959, HB, JK, JLS, PH, WRNN, WS
see also Grunshi
Winye *see* WINIAMA
Winyema *see* WINIAMA
Wisa *see* BISA (Zaire)
WIYA (Cameroun)
note independent chiefdom of
Tikar; one of the groups included
in the collective terms Bamenda
and Nsungli
AAT: nl
LCSH: nl
DDMM, GPM 1959, GPM 1975, HB, IAI,
IEZ
MMML*, PMK*
see also Bamenda, Nsungli, Tikar
WOABA (Benin)
variants Yoabu
note Gur language
AAT: nl
LCSH: nl
DDMM, DWMB, GPM 1959, HB, IAI, RJ
1958
WOBE (Côte d'Ivoire)
variants Ouobe, Ouobi, Webe
subcategories Gbeon
note Kwa language
AAT: use Wee
LCSH: Wobe
BS, DDMM, DWMB, EBR, EFLH, ELZ,
ETHN, EWA, FW, GPM 1959, GPM 1975,
GSGH, HAB, HB, HBDW, HH, IAI, JD,
JEEL, JPB, LM, MLB, MLJD, RGL, RJ
1958, RSW, SMI, TB, UIH, WG 1980,
WH, WRB, WS
JNG*

WODAABE (Cameroun, Mali,
Mauritania, Niger, Nigeria,
Senegal)
note West Atlantic language. There
are numerous subcategories of
Wodaabe who are a Fulani related
peoples. see RWL pp 105-107.
AAT: Wodaabe
LCSH: use Bororo
AF, BS, DDMM, GPM 1975, IAI , JLS,
MPF 1992, SG
MD*, RWL*
see also Fulani
WOKO (Cameroun)
variants Boko, Voko
note Adamawa language
AAT: nl
LCSH: nl
BEL, DDMM, DWMB, ETHN, GPM 1959,
GPM 1975, HB, JG 1963, RJ 1958, WH
Wolamo *see* WOLLAMO
Woleu-Ntem *see* NTUMU
WOLLAMO (Ethiopia)
variants Wolamo
note Cushitic language; subcategory
of Sidamo
AAT: nl
LCSH: nl
CK, ETHN, GPM 1959, ERC, HB, JG
1963, RJ 1959
see also Sidamo
WOLLO (Ethiopia)
note Eastern Cushitic language;
subcategory of Oromo
AAT: nl
LCSH: nl
DDMM, ETHN, GPM 1959, GPM 1975,
HB, WH
GWH 1955*, MOH*
see also Oromo

WOLOF (Gambia, Mauritania, Senegal)
variants Jolof, Ouolof
note West Atlantic language. In the early 19th-century, the Wolof organized into states including Walo, Kayor, Baol, Sin, Barra, Jolof, Salum, and Baadibu.
AAT: Wolof
LCSH: Wolof
AF, BS, DDMM, DWMB, EBR, ETHN, EWA, GB, GPM 1959, GPM 1975, HAB, HB, HBDW, HRZ, IAI, JD, JG 1963, JLS, JM, JP 1953, JPB, KFS, LJPG, LM, MLJD, MPF 1992, MWM, PMPO, PRM, RAB, RGL, RJ 1958, ROMC, RSW, SMI, TFG, TP, UIH, WEW 1973, WH, WRB, WRB 1959, WRNN, WS
CFPK*, DPG*

WONGO (Zaire)
variants Bawongo
subcategories Njembe
note Bantu language
AAT: Wongo
LCSH: nl
BS, CK, DDMM, DPB 1985, DPB 1987, ELZ, ETHN, FHCP, GAH 1950, GPM 1959, GPM 1975, HAB, HB, HJK, JC 1978, JK, JMOB, JV 1966, MGU 1967, MLB, OB 1973, OBZ, SV, TB, TERV, TP, UIH, WG 1980, WH, WRB, WRNN, WS

Wori *see* OLI (Cameroun)
Worodougou *see* WORODUGU
WORODUGU (Côte d'Ivoire)
variants Worodougou
note Mande language
AAT: nl
LCSH: nl
DDMM, JPB
MUS*

Woumbou *see* WUUM
Wouri *see* OLI
WOVEA (Cameroun)
note Bantu language; one of the groups included in the collective term Kpe-Mboko
AAT: nl
LCSH: nl
DDMM, ETHN, GPM 1959
EDA*

see also Kpe-Mboko
WOYO (Angola, Zaire)
variants Bahoyo, Bawoyo, Ngoyo
note Bantu language; subcategory of Kongo; sometimes referred to as Fiote
AAT: Woyo
LCSH: nl
ALM, BES, CMK, DDMM, DPB 1985, ELZ, FHCP, FW, HB, JC 1971, JC 1978, JD, JK, JLS, JV 1966, KK 1965, LM, MGU 1967, MK, MLB, MLB 1994, MLF, MLJD, NIB, OB 1973, OBZ, RSAR, SG, TERV, UIH, WG 1980, WG 1984, WRB, WRNN, WS

see also Fiote, Kongo
WU (Congo Republic)
note Bantu language; one of the divisions of Teke
AAT: nl
LCSH: nl
DDMM, DPB 1985, JV 1963
JV 1973*

see also Teke
WUKARI (Nigeria)
note Benue-Congo language; a subcategory of Jukun but also used to designate a regional division of Nigeria. see RWL.
AAT: nl
LCSH: nl
ETHN, HB, KK 1960, KK 1965, JPJM, PH, RWL

see also Jukun
WUM (Cameroun)
note Bantoid language; one of the groups included in the collective term Bamenda; sometimes used synonymously with Aghem
AAT: Wum
LCSH: nl
DDMM, DF, DWMB, EBHK, ETHN, GPM 1959, GPM 1975, HAB, HMC, JK, JLS, KK 1960, KK 1965, LP 1993, PH, RFT 1974, RS 1980, TN 1984, TN 1986, UIH, WG 1980, WOH, WRNN
GDR*, MKW*, PMK*

see also Aghem, Bamenda
Wumboko *see* MBOKO (Cameroun)

273

Wumbu *see* WUUM

Wumu *see* WUUM

WUMVU (Congo Republic, Gabon)
variants Bawumbu
note Bantu language; subcategory of
Kota
AAT: nl
LCSH: nl
CDR 1985, DDMM, DP, ETHN, SV
see also Kota

WURBO (Nigeria)
variants Wurbu
note Benue-Congo language;
subcategory of Jukun
AAT: nl
LCSH: nl
JK, HB, RWL, WG 1984
see also Jukun

Wurbu *see* WURBO

Wuri *see* OLI (Cameroun)

WURKUM (Nigeria)
variants Wurkun
note Chadic language
AAT: nl (uses Wurkun)
LCSH: nl
DDMM, ETHN, GPM 1959, GPM 1975,
HB, JK, JLS, MKW 1978, RWL, WG 1984,
WH, WRNN, WS

Wurkun *see* WURKUM

Wushi *see* BABESSI

WUTE (Cameroun, Nigeria)
variants Baboute, Babute, Bute,
Mbute, Voute, Vute
note Bantoid language; congeries of
small kingdoms
AAT: nl
LCSH: nl
BEL, BS, DDMM, DWMB, ETHN, GB,
GPM 1959, GPM 1975, HAB, HB, IAI,
IEZ, JG 1963, JLS, JP 1953, KFS, KK
1965, LJPG, RGL, RJ 1958, RWL, SMI,
TN 1984, UIH, WH, WOH
CT 1981*

WUUM (Congo Republic, Gabon,
Zaire)
variants Bahumbu, Bawumbu,
Hum, Humbu, Huum, Wambundu,

Woumbou, Wumbu, Wumu,
Wuumu
note Bantu language
AAT: nl
LCSH: nl
BES, CFL, DDMM, DP, DPB 1985, DPB
1987, ELZ, ETHN, GPM 1959, GPM 1975,
HB, IAI, JK, JMOB, JV 1984, KK 1965, LP
1979, LP 1985, MGU 1967, MUD 1986,
OB 1973, OBZ, RSW, SV, UIH, WH, WM,
WRB, WS

Wuumu *see* WUUM

XAM (South Africa)
note Khoisan language; one of the
groups included in the collective
term Bushmen
AAT: nl
LCSH: nl
BS, ETHN, GPM 1959, GPM 1975, HB,
JG 1963, TP, WH
see also Bushmen

Xasonke *see* KASONKE

XHOSA (South Africa)
variants Amaxosa, Caffre, Kaffirs,
Khosa, Xosa
note Bantu language. Kaffirs is
considered a derogatory term.
AAT: Xhosa
LCSH: Xhosa
ACN, AF, BES, BS, DDMM, EBR, ETHN,
GPM 1959, GPM 1975, HB, HRZ, IAI,
JLS, JM, JRE, JTSV, JV 1984, KFS, MCA
1986, MGU 1967, PMPO, ROMC, RS
1980, RSW, SD, SMI, TP, UIH, WDH,
WEW 1973, WH
DC*, JHS*

Xinji *see* SHINJI

Xosa *see* XHOSA

Xunkhwe *see* HUKWE

Yaa *see* YAKA (Congo Republic)

Yaad Tenga *see* YATENGA

YABASSI (Cameroun)

note Bantu language
AAT: nl
LCSH: nl
DDMM, ELZ

Yache *see* YACHI

YACHI (Nigeria)

variants Yache

note Kwa language
AAT: nl
LCSH: nl
DDMM, GIJ, GPM 1959, GPM 1975, NOI,
RJ 1958, RWL, UIH

Yacouba *see* DAN

Yacuba *see* DAN

YAELIMA (Zaire)

variants Eyajima, Yajima

note Bantu language
AAT: Yaelima
LCSH: nl
CK, DDMM, DPB 1987, ELZ, ETHN,
GAH 1950, GPM 1959, GPM 1975, HAB,
HBDW, HH, HJK, JC 1971, JD, JMOB,
MLJD, RSW, TB, WG 1980, WH

YAGBA (Nigeria)

note Kwa language; subcategory of
Yoruba
AAT: nl
LCSH: nl
DDMM, ETHN, HB, KK 1965, NOI, UIH,
RWL
HJD*

see also Yoruba

Yajima *see* YAELIMA

YAKA (Angola, Zaire)

variants Bayaka

note Bantu language
AAT: Yaka
LCSH: Yaka
ALM, ASH, AW, BES, BS, CDR 1985,
CFL, CK, CMK, DDMM, DFHC, DOA,
DOWF, DP, DPB 1985, DPB 1987, EB,
EBHK, EBR, EEWF, ELZ, ETHN, FW,
GAH 1950, GBJM, GBJS, GPM 1959,
GPM 1975, GWS, HAB, HB, HBDW, HH,
HJK, IAI, JC 1971, JC 1978, JD, JK, JL,
JLS, JMOB, JTSV, JV 1966, KFS, KFS
1989, KK 1965, KMT 1970, LJPG, LM,
LSD, MCA, MGU 1967, MHN, MLB,
MLB 1994, MLJD, MWM, OB 1973, OBZ,
RGL, RS 1980, RSAR, SMI, SV 1988,
TLPM, TP, UIH, WBF 1964, WG 1980,
WG 1984, WH, WMR, WOH, WRB, WRB
1959, WRNN, WS
APB*, FHCP*, HH 1993*, TERV*

YAKA (Central African Republic)

note Western Ubangian language
AAT: nl
LCSH: nl
DB 1978, DDMM, ETHN, GPM 1959, HB,
UIH

YAKA (Congo Republic)

variants Yaa, Yakka

note Bantu language
AAT: nl
LCSH: nl
DDMM, DPB 1985, ETHN, GPM 1959,
KK 1960, LP 1979, MGU 1967, UIH, WH

Yakka *see* YAKA (Congo Republic)

YAKÖ (Nigeria)

variants Lokö, Yakurr

note Benue-Congo language; one of
the groups included in the
collective term Cross River people
AAT: nl
LCSH: Yako language
DDMM, DWMB, ETHN, GIJ, GPM 1959,
GPM 1975, HB, HBDW, IAI, JG 1963,
JLS, NOI, RGL, RJ 1958, RWL, SMI, UIH,
WRB 1959
CDF 1964*

see also Cross River people

YAKOKO (Nigeria)

note Adamawa language; one of the
groups included in the collective
terms Mumuye and Cross River
people
AAT: nl
LCSH: nl
CK, DDMM, ETHN, NOI, RWL

see also Mumuye, Cross River
people

YAKOMA (Central African
Republic, Zaire)
note Western Ubangian language
AAT: nl
LCSH: Yakoma language
BES, BS, DDMM, DPB 1987, ETHN,
GPM 1959, GPM 1975, HAB, HBU,
HBDW, IAI, JG 1963, JMOB, UIH, WH

YAKORO (Nigeria)
note Benue-Congo language
AAT: nl
LCSH: Yakoro language use Bekwarra
language
DDMM, DWMB, ETHN, GPM 1959, JG
1963, LJPG, NOI, RJ 1958
see also Cross River people

Yakuba *see* DAN

Yakurr *see* YAKÖ

Yala *see* IYALA

Yalonka *see* YALUNKA

YALUNKA (Guinea, Sierra Leone)
variants Yalonka
note Mande language. The term
Yalunka is an anglicized version
for a detached branch of the
Dyalonke in Sierra Leone. see
GPM 1959.
AAT: nl
LCSH: Yalunka
DDMM, ETHN, GPM 1959, GPM 1975,
HB, IAI, JLS, LJPG, PRM, RJ 1958, SD,
SMI, WH
CMF*, MEM 1950
see also Dyalonke

Yamba *see* YEMBA

YAMBASA (Cameroun)
variants Jambassa, Yambassa
note Bantu language; subcategory of
Banen
AAT: nl
LCSH: nl
CK, DDMM, ETHN, HB, IAI, IEZ, KK
1965, MGU 1967, RJ 1958, TN 1984, UIH
MMML*
see also Banen

Yambassa *see* YAMBASA

YAMBULA (Zaire)
note Bantu language; one of the
divisions of the Hemba
AAT: nl
LCSH: nl
JAF
see also Hemba

YANGERE (Central African
Republic, Zaire)
variants Yanguere
note Central Ubangian language
AAT: Yangere
LCSH: nl
ATMB 1956, DB 1978, DDMM, DPB
1987, ELZ, ETHN, GPM 1959, GPM 1975,
HAB, HBU, HBDW, JK, JL, MG, RSW,
SVFN, TP, WBF 1964, WH, WRB, WRNN

Yanguere *see* YANGERE

Yans *see* YANZ

Yansi *see* YANZ

YANZ (Zaire)
variants Batende, Bayansi, Bayanzi,
Mbiem, Nkaan, Yans, Yansi,
Yanzi
note Bantu language
AAT: nl (uses Yanzi)
LCSH: nl (uses Yanzi)
BES, CK, DDMM, DPB 1985, DPB 1987,
ELZ, ETHN, FW, GAH 1950, GPM 1959,
GPM 1975, HB, HBDW, JC 1971, JC
1978, JK, JMOB, JPJM, JV 1966, KFS,
LJPG, MGU 1967, MLB, MLJD, OB 1973,
OBZ, RS 1980, RSW, SMI, UIH, WBF
1964, WEW 1973, WG 1980, WH, WRB
GDP*, RDB*

Yanzi *see* YANZ

YAO (Malawi, Mozambique, Tanzania)
variants Wayao
note Bantu language; heterogeneous composition, comprising, apart from the Yao proper, Lomwe, Nyanja, and Ngoni
AAT: Yao
LCSH: Yao
BS, CDR 1985, DDMM, EBR, ECB, ELZ, ETHN, GPM 1959, GPM 1975, HAB, HB, HBDW, HRZ, IAI, JJM 1972, JLS, JM, JPAL, KK 1990, LJPG, MCA 1986, MFMK, MGU 1967, PMPO, RJ 1961, ROMC, SMI, TP, UIH, WG 1980, WH, WOH, WRB 1959, WS, WVB
ECMG*, JCM*, TEW*

Yaounde *see* EWONDO

Yaoure *see* YOHURE

YARSE (Burkina Faso)
note Gur language
AAT: nl
LCSH: nl
CDR 1987, DWMB, ENS, GPM 1959, GPM 1975, HB, HBDW, IAI, JP 1953, KFS, MPF 1992, RAB, RJ 1958

YASA (Cameroun, Equatorial Guinea)
variants Yassa
note Bantu language
AAT: nl
LCSH: Yasa
DDMM, ETHN, GPM 1959, HB, IEZ, MGU 1967, MPF 1992

Yassa *see* YASA

YATENGA (Burkina Faso)
variants Yaad Tenga
note name of a region and of a kingdom inhabited by Dogon and Mossi conquerors
AAT: nl
LCSH: Yatenga region & Yatenga Kingdom
BS, CDR 1985, HB, JL, JLS, MLB, WRB 1959
EPHE 10*

Yaunde *see* EWONDO

Yaure *see* YOHURE

Yedina *see* BUDUMA

YEEI (Botswana, Namibia)
variants Bayei, Koba, Yeye, Yei
note Bantu language
AAT: nl
LCSH: use Yeye
DDMM, ETHN, GPM 1959, GPM 1975, IAI, JLS, MGU 1967, UIH, WH, WVB

Yei *see* YEEI

YEKE (Tanzania, Zaire, Zambia)
variants Bayeke
note Bantu language; conquering group from Unyamwezi under chief Mushidi (Msiri)
AAT: nl
LCSH: nl
DDMM, DPB 1987, ELZ, GAH 1950, GPM 1959, GPM 1975, HB, HBDW, HJK, IAI, JC 1971, JK, JLS, JMOB, JV 1966, OB 1961, OBZ, ROMC, RSW, UIH, WH, WVB
RGA*, RGA 1967*
see also Unyamwezi

YELA (Zaire)
variants Boyela
note Bantu language
AAT: Yela
LCSH: Yela language use Yele language
DDMM, DPB 1987, ETHN, GAH 1950, GPM 1959, HB, IAI, JC 1978, JK, JMOB, JPJM, KFS, OBZ, WG 1980, WH

YEMBA (Cameroun)
variants Nkot, Yamba
note Bantoid language
AAT: nl
LCSH: nl
DDMM, ETHN, PH

YEMBE (Zaire)
note Bantu language; one of the divisions of Songye
AAT: nl
LCSH: Yembe language use Songe language
DDMM, DP, ETHN, HB, JC 1971, MGU 1967, MLJD, OBZ, WS
see also Songye

Yemma *see* JANJERO

Yergam *see* TAROK

Yergum *see* TAROK

YEW (Zaire)
variants Bayew
note Bantu language; a Bwa-related
group in Zaire
AAT: nl
LCSH: nl
OBZ
see also Bwa

Yeye *see* YEEI

Yidena *see* BUDUMA

YIKUBEN (Nigeria)
variants Yukuben
note Benue-Congo language
AAT: nl
LCSH: nl
DDMM, RWL, WS

Yira *see* KIRA

Yoabu *see* WOABA

YOHURE (Côte d'Ivoire)
variants Snan, Yaoure, Yaure
note Mande language; a group
which preceded the Baule;
divided into three groups by
Alain-Michel Boyer as 1. the
Yohure-Baule or Northern
Yohure, 2. the Asanfwe, and 3.
the Namanle or Nanpanle. see
JPB*.
AAT: nl (uses Yaure)
LCSH: nl
DDMM, ELZ, GBJS, JK, JLS, MLB, MPF
1992, TFG, WRNN, WS
JPB*

Yola *see* BIAFADA

YOMBE (Angola, Congo Republic,
Zaire)
variants Bayombe, Majombe,
Mayombe, Mayumba, Mayumbe,
Yumbe
note Bantu language; subcategory of
Kongo
AAT: Yombe
LCSH: Yombe
ALM, ASH, AW, BES, BS, CDR 1985,
CFL, CK, DDMM, DP, DPB 1985, DPB
1987, EBHK, ETHN, FHCP, GAH 1950,
GBJS, GPM 1959, GPM 1975, HAB, HB,
HBDW, HJK, IAI, JAF, JC 1971, JC 1978,
JK, JL, JLS, JMOB, JTSV, JV 1966, KFS
1989, KK 1965, KMT 1970, KMT 1971,
LJPG, LM, MGU 1967, MHN, MK, MLB,
MLB 1994, MLJD, MPF 1992, MUD 1986,
MUD 1991, NIB, OB 1973, RGL, RS 1980,
RSAR, RSW, SG, SMI, SV, TERV, UIH,
WEW 1973, WG 1980, WH, WM, WRB,
WRNN, WS, WVB
FHS*, JC 1978*, MMN*
see also Kongo

Yorba *see* YORUBA

Yorouba *see* YORUBA

YORUBA (Benin, Nigeria, Togo)
variants Yorba, Yorouba
subcategories Ahori, Akoko,
Anago, Atakpame, Awori, Bunu,
Dassa, Egba, Egbado, Egun, Ekiti,
Ibarapa, Idanre, Ife, Igbolo,
Igbomina, Ijebu, Ilesha, Ikale,
Isha, Kabba, Ketu, Mahin,
Manigri, Nago, Ondo, Owe, Owo,
Oyo, Shabe, Yagba
note Kwa language. The Yoruba
kingdoms date from circa 1000
CE to the present.
AAT: Yoruba
LCSH: Yoruba
ACN, AF, ASH, AW, BD, BS, CDR 1985,
CFL, CK, CMK, DDMM, DF, DFHC,
DFM, DOA, DOWF, DP, DWMB, EB,
EBR, EEWF, EL, ELZ, ETHN, EVA,
EWA, FW, GAC, GB, GBJM, GBJS, GPM
1959, GPM 1975, GWS, HB, HBDW, HH,
HMC, HRZ, IAI, JAF, JD, JG 1963, JJM
1972, JK, JL, JLS, JM, JP 1953, JPJM,
JTSV, JV 1984, KFS, KFS 1989, KK 1960,
KK 1965, KMT 1970, KMT 1971, LJPG,
LM, LP 1993, LSD, MCA, MG, MH,
MHN, MK, MLB, MLJD, MPF 1992,
MWM, NIB, NOI, PG 1990, PH, PMPO,
PRM, RAB, RFT 1974, RGL, ROMC, RS
1980, RSAR, RSRW, RSW, RWL, SD,
SMI, SV, SVFN, TB, TLPM, TP, UIH,
WBF 1964, WEW 1973, WFJP, WG 1980,
WG 1984, WH, WLA, WMR, WOH, WRB,
WRB 1959, WRNN, WS
CDF*, RAHD*, RAHD 1991*, RFT*,
RWL*, WBF 1980*
see also Ife kingdom, Oyo

YOWA (Benin)

variants Pilapila

note Gur language
AAT: nl
LCSH: nl
DDMM, DWMB, GPM 1959, HB, IAI, RJ
1958, UIH

Yukuben *see* YIKUBEN

YUKUTARE (Cameroun, Nigeria)

variants Bitare

note Benue-Congo language; one of
the groups included in the
collective term Tigong
AAT: nl
LCSH: nl
DDMM, DWMB, ETHN, GPM 1959, GPM
1975, HB, JG 1963, RWL, WH

see also Tigong

Yumbe *see* YOMBE

Yungo *see* SHINJI

YUNGUR (Nigeria)

variants Binna, Gbinna, Yunguri

subcategories Mboi

note Adamawa language
AAT: nl
LCSH: nl
DDMM, DWMB, ETHN, GPM 1959, GPM
1975, HAB, HB, JG 1963, JLS, MBBH,
NOI, RWL, WH

Yunguri *see* YUNGUR

ZAFIMANIRY (Madagascar)

note Malagasi language
(Austronesian)
AAT: nl
LCSH: Zafimaniry
IAI
CKJR*, HDSV*, JMA*

ZAFISORO (Madagascar)

note Malagasi language
(Austronesian)
AAT: nl
LCSH: nl
CKJR*, HDSV*

ZAGHAWA (Chad, Libya, Niger,
Sudan)

note Nilo-Saharan language; one of
the groups included in the
collective term Beri. Some are
semi-nomadic pastoralists; some
are organized in the sultanates of
Kapka and Kobe; others in the
"chefferies" of Guruf, Dirong, and
Kige.
AAT: nl
LCSH: Zaghawa
AML, ATMB, ATMB 1956, BS, DDMM,
ETHN, GPM 1959, GPM 1975, HAB, HB,
HBDW, HRZ, IAI, JG 1963, JLS, MPF
1992, NIB, RJ 1959, ROMC, SMI, UIH,
WH
MTJT*

see also Beri

ZAIANE (Morocco)

variants Zayan

note Berber language; peoples of
the Middle Atlas region
AAT: Zaiane
LCSH: nl
GPM 1959, JPJM

Zakara *see* NZAKARA

Zambezi River *see* Toponyms Index

ZANAKI (Tanzania)

variants Sanaki

note Bantu language
AAT: nl
LCSH: Zanaki
DDMM, ECB, ETHN, GPM 1959, GPM
1975, HB, MFMK, UIH

ZANDE (Central African Republic, Sudan, Zaire)
variants Azande, NiamNiam
subcategories Mani, Mittu
note Southern Ubangian language. The Zande form a homogeneous culture, but are the product of the amalgamation of numerous "tribes" that were absorbed by the dominant Mbomu culture in the last two centuries. In the west they are ruled by the Abandia dynasty, in the East by the Avungara dynasty. The Dio people were incorporated among the Zande.
AAT: Zande
LCSH: Zande
AF, ALM, ATMB, ATMB 1956, BEL, BES, BS, CDR 1985, CFL, CK, CMK, CSBS, DB 1978, DDMM, DOA, DOWF, DPB 1985, DPB 1986, DPB 1987, EB, EBHK, EBR, EEWF, ELZ, ESCK, ETHN, FE 1933, FHCP, FW, GAH 1950, GBJM, GBJS, GPM 1959, GPM 1975, HAB, HB, HBDW, HBU, HJK, HRZ, IAI, IEZ, JC 1971, JC 1978, JD, JG 1963, JK, JLS, JM, JMOB, JV 1984, KFS, KK 1965, LJPG, LM, MHN, MLB, MLJD, MPF 1992, NIB, OBZ, PMPO, RGL, RJ 1959, ROMC, RS 1980, RSAR, RSRW, RSW, SD, SG, SMI, SV 1988, SVFN, TB, TERV, TP, UIH, WFJP, WG 1980, WH, WMR, WOH, WRB, WRB 1959, WRNN, WS
EDD*, EEP*, HBU 1962*, PBAB*
see also Abandia, Dio, Avungara

Zanj *see* Toponyms Index

ZANSI (South Africa, Zimbabwe)
note Bantu language; subcategory of Ndebele
AAT: nl
LCSH: nl
HKVV*
see also Ndebele

Zanzibar *see* Toponyms Index

Zapozap *see* NSAPO

ZARA (Burkina Faso)
variants Sankura
note Gur language; subcategory of Bwa
AAT: nl
LCSH: use Bobo Dioula
DDMM, DWMB, ETHN, GPM 1959, HB, KK 1965, MPF 1992, UIH
see also Bwa

ZARAMO (Tanzania)
variants Dzalamo, Saramo, Wasaramo, Waxaramo, Wazaramo, Zaramu
note Bantu language
AAT: Zaramo
LCSH: Zaramo
ASH, BS, CDR 1985, CK, DDMM, ECB, ELZ, ETHN, GPM 1959, GPM 1975, HB, HBDW, HC, IAI, JD, JK, JLS, KK 1990, MFMK, MGU 1967, MK, MLJD, RJ 1960, RS 1980, RSW, TP, UIH, WBF 1964 , WG 1980, WG 1984, WH, WMR, WOH, WRB, WRNN, WS
DIP*, LWS*, MLS*, MLS 1995*, TOB 1967*

Zaramu *see* ZARAMO

Zaria *see* Toponyms Index

ZARMA (Benin, Burkina Faso, Niger, Nigeria)
variants Djerma, Jerma, Zerma
note Nilo-Saharan language
AAT: nl
LCSH: Zarma
BS, CK, DDMM, DWMB, ETHN, GPM 1959, GPM 1975, HAB, HB, HBDW, IAI, JD, JG 1963, JL, JLS, JM, JP 1953, JPJM, KFS, MLJD, MPF 1992, RJ 1958, ROMC, RWL, SMI, UIH, WH, WOH
UIH

Zayan *see* ZAIANE

Zegura *see* ZIGULA

ZELA (Zaire)
variants Bazela
note Bantu language. The Zela,
who are people of the interior, are
often contrasted with the Shila,
who are people of the rivers.
AAT: nl
LCSH: Zela
DDMM, DPB 1987, FN 1994, GAH 1950,
HB, IAI, JC 1971, JC 1978, JK, JV 1966,
KFS 1989, MPF 1992, OB 1961, OBZ,
RWL, SG, TP, UIH, WRNN
ABU*
see also Shila

Zema *see* NZIMA

ZENAGA (Mauritania)
note Berber language; one of the
groups included in the collective
tern Bedouin
AAT: nl
LCSH: Zenaga language
DDMM, ETHN, EWA, GPM 1959, GPM
1975, HBDW, IAI, JP 1953, RJ 1958, WH
see also Bedouin

Zerma *see* ZARMA

ZEZURU (Mozambique, Zimbabwe)
subcategories Hera
note Bantu language
AAT: nl
LCSH: Zezuru
DDMM, ETHN, GPM 1959, GPM 1975,
HAB, HB, IAI, MGU 1967, RJ 1961,
ROMC, UIH, WH
see also Hera

Zia *see* SIA

Ziba *see* HAYA

ZIGABA (Rwanda)
note one of the groups included in
the collective term Pygmies
AAT: nl
LCSH: nl
GPM 1959
see also Pygmies

Zigua *see* ZIGULA

ZIGULA (Mozambique,Tanzania)
variants Seguha, Wazigua, Zegura,
Zigua
note Bantu language
AAT: Zigula
LCSH: Zigula
BS, DDMM, ECB, ETHN, GPM 1959,
GPM 1975, HAB, HB, IAI, JLS, KK 1990,
MFMK, MGU 1967, RJ 1960, UIH, WH,
WVB
HC*, TOB 1967*

ZIMBA (Zaire)
variants Bazimba, Wazimba
note Bantu language; divided into
Wazimba wa Mulu and Wazimba
wa Maringa. The Zimba and the
Bangubangu are known in recent
literature as the Southern Binja in
contrast to the Songola or
Northern Binja.
AAT: nl
LCSH: nl
BS, CK, DDMM, DPB 1981, DPB 1986,
DPB 1987, DWMB, ETHN, FN 1994,
GAH 1950, GPM 1959, GPM 1975, HB,
HBDW, HRZ, IAI, JMOB, JP 1953, JV
1966, MGU 1967, OBZ, PG 1990, RJ
1961, SV, UIH, WH, WS, WVB
see also Binja

Zimbabwe *see* Toponyms Index

Zimbabwe, Great *see* GREAT
ZIMBABWE

Zinka *see* ZINZA

ZINZA (Tanzania)
variants Dzindza, Jinja, Zinka
note Bantu language
AAT: nl
LCSH: Zinza
DDMM, ECB, ETHN, GPM 1959, GPM
1975, HB, IAI, KK 1990, MFMK, MGU
1967, RJ 1960, SMI, UIH, WH
BKT*, SVB*

Ziraha *see* SAGARA

ZOMBO (Angola, Zaire)

variants Bazombo, Nzombo, Zoombo

note Bantu language; subcategory of Kongo

AAT: nl

LCSH: Zombo dialect use Zoombo dialect

BES, CDR 1985, DDMM, DPB 1985, DPB 1987, EBHK, ELZ, FHCP, GAH 1950, GPM 1959, GPM 1975, HAB, HB, HBDW, JK, JMOB, JV 1966, MGU 1967, MLB 1994, OB 1973, TERV, UIH, WH, WS

see also Kongo

Zoombo *see* ZOMBO

ZULA (Zaire)

variants Wazula

note Bantu language; subcategory of Bangubangu

AAT: nl

LCSH: nl

FN 1994, GBJS, JMOB, SG, WRNN, WS AEM*

see also Bangubangu

ZULU (Lesotho, Malawi, South Africa, Swaziland)

variants Amazulu

note Bantu language

AAT: Zulu

LCSH: Zulu

ACN, AF, ARW, BES, BS, CK, DDMM, DOA, ETHN, EBR, FW, GBJM, GBJS, GPM 1959, GPM 1975, HAB, HB, HMC, HRZ, IAI, IS, JD, JJM 1972, JK, JLS, JM, JMOB, JRE, JTSV, JV 1966, JV 1984, KMT 1971, LM, LSD, MCA 1986, MGU 1967, MLJD, MUD 1991, NIB, PG 1990, PMPO, RFT 1974, RGL, ROMC, RS 1980, RSAR, RSW, SD, SMI, SV, SV 1988, SVFN, TP, UIH, WDH, WEW 1973, WFJP, WG 1980, WG 1984, WH, WMR, WOH, WRB, WRB 1959, WRNN, WS, WVB CLK*, JMA 1981*, MCDP*

Zumper *see* KUTEP

LANGUAGE NOTES

THE TRANSCRIPTION OF ETHNIC NAMES

The following information on some common problems and confusions associated with the transcription of African ethnonyms should help the user of the index to detect possible name variants.

I. Prefixes used as classifiers in African languages

In the hundreds of Bantu languages that are spoken in Africa, and in some other languages as well, prefixes are used as classifiers and placed in front of the radicals of ethnic names. These prefixes have singular and plural forms in order to refer to a single male or female member of an ethnic unit or to a collectivity of members (from two persons to the entire group). Thus, Mu-Nyoro applies to one member of the Nyoro group and Ba-Nyoro to several or all members of the Nyoro ethnic unit. There are other classes of prefixes that refer to the language, the country or the political unit, the collectivity, the state of being, etc.

It is now common practice in anthropological, historical, linguistic, art historical and other writings on Africa to drop these prefixes and to retain only the root word. The classifiers are of immense significance in the structure of the African languages, but outside their grammatical and syntactical contexts they have no real function. The suffixation of these special classifiers has caused a lot of problems in the past and continues to pose questions in the present. Most of the early authors, and even some recent ones, still use these prefixes, sometimes written in different ways such as Munyoro/Banyoro, Mu-Nyoro/Ba-Nyoro, muNyoro/baNyoro.

Following are examples of frequently used prefixes.

I. a. Prefixes indicating group affiliation e.g.

A	A-Ngoni
ABA-	Aba-Tutsi
AMA-	Ama-Zulu
BA-	Ba-Bembe
BAA-	Baa-Milembwe
BAKWA-	Bakwa-Mputu
BANYA-	Banya-Rwanda
BASI-	Basi-Kasingo
BEE-	Bee-Kalebwe
BENA-	Bena-Kanyok
BENE-	Bene-Mukuni
BO-	Bo-Bai
MA-	Ma-Binza
WA-	Wa-Swahili

In some instances authors may erroneously have used singular forms, such as Mu-, Mukwa-, Munya-, Musi-, Mwina-, Mo-, and Li- instead of the plural forms indicated above, to refer to the total membership of the ethnic group; thus Mu-Kongo instead of Ba-Kongo, Mukwa-Mputu instead of Bakwa-Mputu. These cases apply in particular to the Bantu languages.

There are other languages as well in which prefixal elements occur, such as:

In Tuareg languages:	Kel-	Kel Ajjer
In Berber languages:	Beni-	Beni Amer
	Uled-/Oulad-	Uled Nail/Oulad Delim
	Ait-/Ayt-	Ait Jussi/Ayt Atta
In Malagasy languages:	Ante-/Anta-	Antemoro/Antaimoro

It would be an error to think that all A-, Ba-, Be- Bo- or Ma- morphemes with which ethnic terms begin are prefixes and can therefore be dropped. Many are simply part of the root. This is particularly evident in some languages, such as the so-called Bantoid ones of Cameroun and Nigeria. Even for Bantu languages, the greatest caution is needed in this matter, particularly when adequate linguistic and cultural information is lacking. When there is doubt, the term should be kept intact.

There are also some cases where the maintenance of Ba- or a similar element may be preferable in order to avoid possible confusion with a similar term or to discard further complications by modifying a well-established tradition for a major art-producing group such as changing Bamum (or Bamun) into Mum (or even Mom and Mam as some linguists do).

I. b. Prefixes used as classifiers to designate the language of an ethnic group

These prefixes to construct glossonyms should obviously not be used. Following are some of the major prefixes in Bantu languages:

AMA-	Ama-Shi (the language of the Shi people)
BU-	Bu-Shoong (the language of the Bushong people)
CE-	Ce-Enya (the language of the Enya people)
CI-	Ci-Luba (the language of the Luba people)
E-	E-Budu (the language of the Budu people)
GE-	Ge-Kuyu (the language of the Kuyu people)
I-	I-Nyanga (the language of the Nyanga people)
IKI-	Iki-Rundi (the language of the Rundi people)
KE-	Ke-Sengele the language of the Sengele people)
KI-	Ki-Lega (the language of the Lega people)
KINYA-	Kinya-Rwanda (the language of the Rwanda)
KENYA-	Kenya-Mitoko (the language of the Mitoko)
KW-	Kw-Amba (the language of the Amba people)
LE-	Le-Angba (the language of the Angba people)

LI-	Li-Ngala (the language of the Ngala people)
LO-	Lo-Mbole (the language of the Mbole people
O-	O-Tetela (the language of the Tetela people)
OLU-	Olu-Ganda (the language of the Ganda people)
ORU-	Oru-Nyankore (the language of the Nyankore)
SE-	Se-Suto (the language of the Sotho people)
URU-	Uru-Ciga (the language of the Ciga people)

Cautions similar in scope to those outlined in I. a. must be made in these cases. In some linguistic areas of Africa, the name of the language may drastically differ from that of the ethnic group. It should be kept in mind that we are dealing with ethnic names and not with languages.

I. c. Other Bantu prefixes

There are also prefixes in Bantu languages that denote the country, the territory, or the political unit occupied by a particular ethnic group. Thus, BU-Nyoro (the country and the kindom of the Nyoro people); U-Nyamwezi (the country of the Nyamwezi); BU-Lega (the territory occupied by the Lega people).

II. Letters or groups of letters often used interchangeably

These variations may occur in the beginning, at the end, or anywhere in the middle of the term. Note that many of the so-called variants are the result of erroneous or incomplete transcriptions of sounds, or the product of misunderstandings and misinterpretations by foreign observers. Some of these different spellings may flow from the inherent difficulties in transcribing complicated sound patterns, from dialect variations, or from the manner in which an ethnic name is pronounced by the group concerned or by its neighbors.

Following are some recurring examples of these problems:

B-	instead of	GB-	Banziri instead of Gbanziri
B-	instead of	MB-	Budza instead of Mbuja
BW-	instead of	NGB-	Bwaka instead of Ngbaka
CH-	instead of	C-	Chokwe instead of Cokwe
CH-	instead of	S-	Mbochi instead of Mbosi
CU-	instead of	CW-	Cua instead of Cwa
D-	instead of	ND-	Dengese instead of Ndengese
DJ-	instead of	CH-	Djagga instead of Chaga
DJ-	instead of	DY-	Bidjogo instead of Bidyogo
DJ-	instead of	J-	Adja instead of Aja
DZ-	instead of	J-	Kidzem instead of Kijem
E-	instead of	I-	Ntsaye instead of Tsaayi
EI-	instead of	AI-	Mangbei instead of Mangbai

285

F-	instead of	P-	Fajulu instead of Pajulu
G-	instead of	NG-	Guere instead of Ngere
GB-	instead of	NGB-	Gbandi instead of Ngbandi
GG-	instead of	QQ-	Baggara instead of Baqqara
GN-	instead of	NY-	Agni instead of Anyi
GU-	instead of	G-	Guisiga instead of Gisiga
GY-	instead of	DY-	Gye instead of Dye
I-	instead of	Y-	Musgoi instead of Musgoy
JI-	instead of	DY-	Jie instead of Dye
K-	instead of	G-	Kikuyu instead of Gikuyu
LU-	instead of	LW-	Luena instead of Lwena
MV-	instead of	MB-	Mvuba instead of Mbuba
N-	instead of	M-	Bamun instead of Bamum
NJ-	instead of	NZ-	Mbanja instead of Mbanza
NI-	instead of	NY-	Nianga instead of Nyanga
NY-	instead of	NJ-	Nyem instead of Njem
O-	instead of	U-	Soso instead of Susu
OU-	instead of	U-	Senoufo instead of Senufo
OU-	instead of	W-	Ouolof instead of Wolof
QUI-	instead of	CI-	Quipungu instead of Cipungu
R-	instead of	L-	Rega instead of Lega
SH-	instead of	S-	Ashanti instead of Asante
TSW-	instead of	CW-	Tshwa instead of Cwa
U-	instead of	O-	Mituku instead of Mitoko
U-	instead of	W-	Luena instead of Lwena
V-	instead of	F-	Eve instead of Efe
Z-	instead of	J-	Nzem instead of Nje

III. Other recurring features that lead to different transcriptions

Accents (mainly acute) placed on a vowel, particularly striking in the transcriptions of French speakers: Sénoufo for Senufo

Doubled consonants or vowels: Abbe for Abe, Beembe for Bembe

Consonants inserted between vowels: Kawonde for Kaonde, Mahu for Mau

Plural elements derived from a European language: les Dogons for Dogon, die Eweer for Ewe, the Yorubas for Yoruba

Final vowels or diphthongs added in a language where such final vowels do not occur: Bushongo for Bushoong

LINGUISTIC CLASSIFICATION

In listing the various ethnic names, we have indicated the language group to which a particular people or a cluster of related peoples belong. In so doing, we have taken a simple approach, avoiding the use of the enormously complex linguistic classifications that have been proposed by the major schools of linguists, classifications which are still changing and often tend to be tentative. In many instances linguistic classifications are based on esoteric terminologies and unusual transcriptions of terms, which make the situation even more difficult for the non-expert. We also have omitted the use of such technical terms as linguistic family, subfamily, branch, zone, group or language set, as applied in some of the great linguistic classifications, and some of the newer less familiar terms, to name the language subdivisions. When for a particular ethnic group the notation "Gur" language is made, it means that this group speaks a language belonging to the Gur branch. Some of the major works on linguistic classification are included in the bibliography and in the apparatus of sources.

Among the principal classifications that were consulted are *Ethnologue: Languages of the World*, Barbara Grimes, ed., (12th edition, 1992); *The Languages of Africa*, Joseph Greenberg (1963); *Comparative Bantu: An Introduction to the Comparative Linguistics and Prehistory of the Bantu Languages*, Malcolm Guthrie (1967); *A Thesaurus of African Languages: A Classified and Annotated Inventory of the Spoken Languages of Africa*, Michael Mann and David Dalby (1987); *The Non-Bantu Languages of North-Eastern Africa: With a Supplement on the Non-Bantu Languages of Southern Africa*, Archibald Tucker and Margaret Bryan (1956); *African Language Structures*, William Welmers (1973).

The terminology used is as follows:

Afroasiatic family
 Berber language
 Chadic language
 Cushitic language
 Semitic language

Niger-Congo-Kordofanian family
 West Atlantic language
 Mande language
 Gur language
 Kwa language
 Adamawa language
 Ubangian language:
 Central Ubangian language
 Southern Ubangian language
 Western Ubangian language
 Southeastern Ubangian language

Bantu language
Bantoid (or Bantu-like) language
Benue-Congo language (for non-Bantu/Bantoid languages)
Kordofanian language

Nilo-Saharan family
 Nilotic language:
 Eastern Nilotic language
 Southern Nilotic language
 Western Nilotic language
 Eastern Sudanic language
 Central Sudanic language
 Nilo-Saharan language (to include the remaining languages)

Austronesian family
 Malagasy language

Khoisan family
 Khoisan language

Abeokuta. Nigeria, town founded by EgbaYoruba.

Abka. Sudan, rock art site; site of pottery and Neolithic tool industry.

Abomey. Benin, site and capital of the Fon kingdom of Dahomey, 17th-19th century.

Abyssinia. name used for ancient Ethiopia.

Acacus. Libya, rock art site.

Accra. Ghana, capital city and pre-colonial trading center.

Adamawa. Camerouns, Nigeria, a high plateau extending from the Bight of Benin to Lake Chad; variants: Adamaoua.

Adrar. Mauritania, mountainous regions in the Sahara inhabited by both Berber and Arabic peoples; rock art sites.

Adrar Bous. Niger, rock art site.

Adrar des Iforas. Mali, Algeria, region in the central Sahara; rock art site.

Adulis. Ethiopia, ancient city and seaport of Aksum Empire.

Afrique Equatoriale Française. *see* **French Equatorial Africa**.

Afrique Occidentale Française. *see* **French West Africa**.

Agadez. Niger, early town; Iron Age site.

Ahaggar. mountainous region in central Sahara and southern Algeria; rock art site; variants: Hoggar.

Akites. Kenya, rock painting site.

Akjoujt. Mauritania, site of copper mines; variants: Akjoutt.

Akure. Nigeria, pre-colonial town; site of Yoruba palace.

Albert, Lake. *see* **Mobutu Sese Seko, Lake**.

Algeria. country; capital is Algiers; variants: Democratic and Popular Republic of Algeria, Algerie, al-Jumhuriya al Jazairiya ad-Dimuqratiya ash-Shabiya.

Alima River. Congo Republic, tributary of the Zaire River.

Allada. Benin, pre-colonial town in the Dahomey Kingdom; variants: Great Ardra.

Ambriz. Angola, seaport and precolonial trading center.

Amekni. Algeria, Neolithic site; early pottery.

Anglo-Egyptian Sudan. former name of the Republic of Sudan.

Angola. country; capital is Luanda; formerly Portuguese West Africa; variants: Peoples Republic of Angola, Republica Popular de Angola.

Aruwimi River. northeastern Zaire.

Assinie. Côte d'Ivoire, archeological site; pre-colonial seaport.

Atlas Mountains. several chains of mountains in North Africa, including the Haut Atlas, Moyen Atlas, Anti-Atlas, Atlas Saharien, in Morocco and Algeria.

Aures Mountains. mountains in eastern Algeria populated by Berber peoples.

Awadaghust. Mauritania, ancient town of Ghana Empire; variants: Audoghast, Awdaghost.

Azania. ancient name for the coastal towns of Kenya and Tanzania. *see also* **Zanj**.

Bafing River. western Mali and Guinea, the upper course of the Senegal River.

Bahr-al-Ghazal. river and region in southwestern Sudan, part of the Nile valley.

Bamako. Mali, early trading town within the Mali Empire.

Bambuto Mountains. Cameroun.

Bandama River. Côte d'Ivoire.

Bandiagara Cliffs. Mali, plateau region and site of Tellem and Dogon art.

Banfora. Burkina Faso, rock art site.

Bangweulu, Lake. northern Zambia; variants: Lake Bangweolo.

Bankoni. Mali, archeological site of terra cotta sculpture.

Bardaï. Chad, rock art site; town.

Basutoland. *see* **Lesotho**.

Bauchi. Nigeria, region identifed with the Hausa; town located near rock art sites.

Begho. Ghana, 14th-century trading center and market for local artisans; center of small Mossi kingdom.

Benguela. Angola, archeological site; early seaport; variants: Benguella.

Benin. country; capital is Porto Novo; formerly Dahomey and part of French West Africa; variants: Republic of Benin, Réublic du Benin.

Benin River. southern Nigeria.

Benue River. Cameroun and Nigeria, tributary of the Niger River.

Bida. Nigeria, city and site of early Bronze work.

Bigo. Uganda, earthwork and Iron Age site west of Lake Victoria.

Bobo-Dioulasso. Burkina Faso, French colonial administrative district; variants: Bobo-Djulasso.

Bomu River. Central African Republic and Zaire, unites with the Uele River to form the Ubangi river; variants: Mbomu River.

Bondoukou. Côte d'Ivoire, early trading center.

Bono-Mansu. Ghana, ancient Akan capital variants: Bono Manso.

Boskop. Republic of South Africa, locality in the Transvaal; archeological site.

Botswana. country; formerly Bechuanaland; capital is Gaborone; variants: Republic of Botswana.

Brandberg. Namibia, rock art site.

British Camerouns. British Trust Territory, divided between Cameroun and Nigeria in 1961.

British East Africa. name applied to former British dependencies consisting of Uganda, Kenya, Zanzibar, and Tanzania.

British Somaliland. former British protectorate, a part of Somalia since 1960.

Bulawayo. Zimbabwe, capital of Matabele Empire; rock art site.

Burkina Faso. country; formerly Upper Volta and part of French West Africa; capital is Ouagadougou; variants: Haute Volta.

Burundi. country; formerly part of Ruanda-Urundi; capital is Bujumbura; variants: Republic of Burundi, Republica y'Uburundi.

Cameroun. country; formerly French Cameroun and British Cameroons; capital is Yaoundé; variants: Cameroon, Republic of Cameroon.

Cape Province. Republic of South Africa, province and locus of many rock art sites; variants: Cape of Good Hope.

Cape Verde. country; formerly Cape Verde Islands; capital is Praia; variants: Republic of Cape Verde, Republica de Cabo Verde, Ilhas do Cabo Verde.

Carthage. Tunisia, ancient trading city on the Mediterranean Sea.

Casamance River. river in Senegal; also a region in Senegal between the Gambia and the Guinea-Bissau border; variants: Kasamance.

Central African Republic. country; formerly Oubangi-Chari and part of French Equatorial Africa; capital is Bangui; variants: République Centrafricaine, Central African Empire, Ubangi-Shari.

Chad. country; formerly part of French Equatorial Africa; capital is N'Djamena (Fort Lamy); variants: Republic of Chad, République du Tchad, Tchad.

Chad, Lake. Chad, Niger, Nigeria, and the northernmost part of Cameroun.

Chari River. Central African Republic and Chad; variants: Shari River.

Chondwe. Zambia, Iron Age site.

Comoros. country; capital is Moroni; variants: Federal Islamic Republic of the Comoros, Comoro Islands, Îles Comores, Jumhuriyat-al-Qumur al-Itthadiya al-Islamiyah.

Congo Republic. country; formerly Middle Congo, part of Congo Brazzaville and French Equatorial Africa; capital is Brazzaville; variants: People's Republic of the Congo, République Populaire du Congo.

Côte d'Ivoire. country; formerly part of French West Africa; capital is Abidjan; variants: Ivory Coast, Elfenbeinküste.

Cross River. river in Nigeria and Cameroun; site of monoliths and region noted for its artistic tradition.

Cunene River. southwest Angola; variants: Kunene River.

Cyrenaica. easternmost part of Libya inhabited by the Cyrenaicans.

Daboya. Ghana, early town within the Gonja Kingdom.

Daima. Nigeria, Iron Age site, early town.

Dakabori. Mali, archeological site of Djenne civilization.

Dambwa. Zimbabwe, Iron Age site.

Daura. Nigeria, Hausa city-state.

Dhlo Dhlo. Zimbabwe, stone ruin and Iron Age site.

Djado Plateau. Niger, rock art site.

Djibouti. country; formerly part of French Somaliland and Territory of the Afar and Issas; capital is Djibouti; variants: Republic of Djibouti, Jumhouriyya Djibouti.

Drakensberg. South Africa, mountain range extending through Cape Province, the province of Natal, the Republic of South Africa, and Lesotho; region containing many rock art sites.

Edward, Lake. one of the Great Lakes of East Africa, between Zaire and Uganda; variants: Albert Edward Nyanza.

Efon Alaye. Nigeria, site of Yoruba art and architecture; variants: Effon-Alaiye.

Egypt. country; formerly United Arab Republic, capital is Cairo; variants: Arab Republic of Egypt, Misr, Jumhuriya Misr al-Arabiya.

Elgon, Mount. mountain on the boundary between Kenya and Uganda.

Elila River. eastern Zaire, with the Ulindi River known as the Lwindi River.

Engaruka. Tanzania, Iron Age site noted for its stone terraced ruins.

Ennedi. Chad, Iron Age site; rock art site.

Equatorial Guinea. country; formerly Spanish Guinea; capital is Malabo; composed of Rio Muñi (mainland) and Bioko (Fernando Po); variants: Republic of Equatorial Guinea, Republica de Guinea Ecuatorial, Territorios Españoles del Golfo de Guinea.

Eritrea. country; formerly part of Ethiopia; capital is Asmara.

Esie. Nigeria, early settlement.

Ethiopia. country; capital is Addis Ababa; variants: People's Democratic Republic of Ethiopia, Ye Etiyop'iya Hezbawi Dimokrasiyawi Republik, Abyssinia.

Fayum. Egyptian province; site of depression formed by a dry lake bed in Upper Egypt; variants: Faiyum.

Fezzan. desert region and province in southwestern Libya; rock art site.

Fouta Djallon. Guinea, mountainous district and archeological site; variants: Futa Jallon.

Fouta Toro. Senegal, region inhabited by the Fulani; rock art site; archeological site.

French Cameroun. a French trust territory which became part of the United Republic of Cameroun.

French Equatorial Africa. French territory from c.1910-1958 which included Chad, Congo Republic, Gabon, and the Central African Republic (Ubangi-Chari); variants: Afrique Equatoriale Française, French Congo.

French Somaliland. formerly French Territory of the Afars and the Issas, now Djibouti (Jibuti).

French West Africa. French territory from c.1885-1958 which included Benin, Burkina Faso, Côte d'Ivoire, Guinea, Mali, Mauritania, Sudan, Cameroun, Niger, and Senegal; variants: Afrique Occidentale Française.

Fumban. Cameroun, capital of the Bamum kingdom.

Funj. Sudan, ancient capital of Senna Kingdom.

Gabon. country; formerly part of French Equatorial Africa; capital is Libreville; variants: Gabonese Republic, République Gabonaise, Gabun.

Gambia. country; formerly part of British West Africa; capital is Banjul; variants: Republic of the Gambia, The Gambia.

Gambia River. Guinea, Senegal, and the Gambia.

Gao. Mali, Iron Age site; early town in the Mali Empire and later capital of the Songhay Empire.

Gedi. Kenya, pre-colonial Islamic trading post.

German East Africa. German territory from 1891-1914 which included Rwanda, Burundi, and Tanzania.

German Southwest Africa. now Namibia.

Ghana. country; formerly Gold Coast and part of British West Africa; capital is Accra; variants: Republic of Ghana, British Togoland, Côte d'Or.

Gobir. Nigeria, Hausa city-states; variants: Gober.

Gokomere. Zimbabwe, Iron Age site.

Great Lakes. a succession of lakes in the Great Rift Valley of East Africa.

Guinea. country; formerly part of French West Africa; capital is Conakry; variants: Republic of Guinea, République du Guinée, French Guinea, Guinée française, Guinée.

Guinea-Bissau. country, formerly Portuguese Guinea; capital is Bissau; variants: Republic of Guinea-Bissau, Republica da Guiné-Bissau.

Guinea, Gulf of. West African gulf which includes the Bights of Biafra and Benin.

Ilorin. Nigeria, ancient city of the Oyo Empire.

Ingombe Ilede. Zambia, Zimbabwe, site of pottery tradition and 14th-century metalwork industry.

Inyanga. Zimbabwe, Ziwa pottery site, rock art site.

Ishango. Zaire, site of late Stone Age microlithic industry.

Ituri River. eastern Zaire.

Jebba. Nigeria, early town and site of shrine where Tsoede bronzes were found.

Jebel Barkal. Sudan, originally Egyptian religious center, later a site of the Kush Kingdom.

Jebel Uwinat. Sudan, rock art site; variants: Jebel Owenat.

Jenne-Jeno. Mali, oldest known city south of the Sahara, circa 200 BCE-1300 CE, on an island in the River Niger.

Jos Plateau. region in central Nigeria.

Juba. city on the White Nile in lower Sudan.

Juba River. Ethiopia and Somalia.

Kabylie. mountainous area in northern Algeria; known as Great Kabylie, Little Kabylie.

Kafue River. Zambia, flows to the Zambezi River.

Kagera. Burundi, Tanzania, Uganda, river and region of iron smelting; also a region in Rwanda.

Kalambo Falls. south end of Lake Tanganyika on the Tanzania-Zambia border, archeological site.

Kalundu. Zambia, Iron Age site.

Kaniana. Mali, archeological site thought to be of the Djenne civilization.

Kankan. Guinea, precolonial town within the Mali Empire.

Kano. Nigeria, Hausa city states.

Kapwirimbwe. Zambia, Iron Age site; early settlement.

Kariba, Lake. Zambia and Zimbabwe.

Kasai River. Zaire, Angola.

Katsina. Nigeria, Hausa city-states; variants: Katsena.

Kenya. country; formerly East Africa Protectorate and part of British East Africa; capital is Nairobi; variants: Republic of Kenya, Jamhuri ya Kenya.

Kenya, Mount. central Kenya.

Khami. Zimbabwe, stone ruin and Iron Age site; variants: Kami.

Kiantapo. Zaire, cave and rock art site.

Kilimanjaro, Mount. Tanzania.

Kinshasa. Zaire, early trading center; formerly Léopoldville.

Kita. Mali, pre-colonial town; rock art site.

Kivu Lake. lake bordering on Zaire and Rwanda.

Kondoa. Tanzania, archeological site; rock art site.

Kong. Côte d'Ivoire, pre-colonial town.

Kordofan. Sudan, plateau and province in central Sudan.

Korhogo. Côte de'Ivoire, archeological site; early town.

Kubai. Mali, archeological site of Djenne civilization.

Kumasi. Ghana, pre-colonial town and capital of Asante Confederacy.

Kumbi Saleh. ancient site and Islamic trade center on the border of Mali and Mauritania; thought to be the capital of the Ghana Kingdom.

Kwa River. western Zaire.

Kwale. Kenya, Iron Age site.

Kwando River. central Angola, Botswana and Zambia; variants: Cuando River.

Kwango River. Angola, Zaire, flows into Kasai River.

Kwanza River. Angola; variants: Cuanza.

Kwilu River. western Zaire and northern Angola.

Lamu. island off the coast of Kenya; archeological site.

Lelesu. Tanzania, Iron Age site.

Lesotho. country; formerly Basutoland; capital is Maseru; independent kingdom lying within the Republic of South Africa; region of numerous rock art sites. *see also* **Drakensberg**.

Liberia. country; capital is Monrovia; variant: Republic of Liberia.

Libya. country; former colonies of Cyrenaica, Tripolitania, and Fezzan; capital is Tripoli; variants: Socialist People's Libyan Arab Jamahiriya, al-Jamahiriya al-Arabiya al-Libya al-Shabiya al-Ishtirakiya.

Likouala River. Congo Republic.

Limpopo River. Mozambique and South Africa.

Liptako. Burkina Faso, region identified with the Fulani.

Loange River. Angola, Zaire, flows into the Kasai River.

Lomami River. central Zaire.

Lualaba River. Zambia and southeastern Zaire; name for the upper Zaire River.

Luapula River. Zaire and Zambia.

Lukenye River. Zaire, flows into the Kasai River; variants: Lukenie River.

Madagascar. country; capital is Antananarivo; variants: Democratic Republic of Madagascar, Malagasy Republic, Repoblika Demokratika Malagasy, République Malgache.

Mafia. island in the Indian Ocean off the coast of Tanzania; archeological site; formerly part of the Zanzibar Sultanate.

Maghrib. Arabic name for northwest Africa, used to include Morocco, Algeria, Tunisia, Libya.

Mai Ndombe, Lake. Zaire; variants: Lake Leopold.

Malawi. country; formerly Nyasaland; capital is Lilongwe; variants: Republic of Malawi, British Central Africa Protectorate.

Malawi, Lake. Tanzania, Malawi, and Mozambique; variants: Lake Nyasa.

Mali. country; formerly French Sudan; capital is Bamako; variants: Republic of Mali, République du Mali, Soudan français.

Maniema. Zaire, place name sometimes used to identify the art of the region; variants: Manyema.

Manyikeni. Mozambique, Iron Age site; variants: Manekweni.

Mapungubwe. Zimbabwe, Iron Age site; stone ruin.

Masina. Mali, early town, center of Islamic power and region often identified with the Fulani; variants: Massina, Macina.

Matabeleland. former province in Rhodesia, now divided into two provinces in Zimbabwe.

Mauritania. country; capital is Nouakchott; variants: Islamic Republic of Mauritania, Mauritanie.

Mauritius. country; formerly Île de France; capital is Port Louis.

Mayotte. French territory; one of the Comoro Islands but did not declare independence with them in 1975.

Mbafu Cave. Zaire, rock art site.

Mbanza Kongo. Angola, capital of the Kongo Kingdom.

Meru, Mount. Tanzania.

Mobutu Sese Seko, Lake. Uganda, Zaire; variants: Lake Albert, Albert Nyanza.

Morocco. country; capital is Rabat; variants: Al-Mamlakah al-Maghribiya, Maroc, Marruecos.

Mozambique. country; formerly Portuguese East Africa; capital is Maputo (Lourenço Marques); variants: Republic of Mozambique, Moçambique.

Mweru, Lake. Zaire, Zambia; variants: Moero Lake.

Naletale. Zimbabwe, stone ruin and Iron Age site; variant Naletali.

Namibia. country; formerly South West Africa; capital is Windhoek; variants: Republic of Namibia, Suidwes Afrika.

Nantaka. Mali, archeological site of Djenne civilization.

Naqa. Sudan, Kushitic ruins.

Natal. Republic of South Africa, northeastern coastal province that contains the foothills of the Drakensberg Mountains and many rock art sites.

Ngami, Lake. Botswana.

Ngounie River. Gabon, flows to the Ogowe River.

Niari River. Zaire and Congo Republic.

Niger. country; formerly part of French West Africa; capital is Niamey; variants: Republic of Niger, République du Niger.

Niger River. Benin, Burkina Faso, Guinea, Mali, Nigeria.

Nigeria. country; formerly part of British West Africa; capital is Lagos; variant: Federal Republic of Nigeria.

Nile River. longest river in Africa; many divisions and regional variants: White Nile, Blue Nile.

Nkope. Malawi, Iron Age site.

No Lake. south central Sudan; lake formed at the confluence of the Bahr-al-Jebel and Bahr-al-Ghazal becoming the White Nile.

Nuba Hills. Sudan, group of hills in the Kordofan region of the Sudan.

Nubia. region in the Nile valley from Aswan to Khartoum including southern Egypt and northern Sudan; site of an ancient empire.

Numidia. ancient country in north Africa, approximately co-extensive with modern Algeria; Roman province.

Nyasa, Lake. *see* **Malawi, Lake**.

Ogaden. region in southeast Ethiopia.

Ogowe River. Congo Republic, Gabon; variants: Ogooué River.

Okavango River. river in southwest Africa, rises in Angola where it is known as the Cubango River, flows through Angola ending in Botswana in the Okavango basin.

Old Calabar. Nigeria, 19th-century collective of trading towns in the Niger Delta region.

Old Oyo. Nigeria, capital of Oyo Kingdom; variants: Katunga.

Olduvai Gorge. Tanzania, ravine and archeological site.

Olifantspoort. South Africa, Transvaal province, rock art site.

Omo River. southwestern Ethiopia; flows into Lake Turkana.

Orange River. South Africa, Lesotho, and Namibia.

Pate. Kenya, early island town on the coast of Kenya.

Pemba. island in the Indian Ocean off the coast of Tanzania, archeological site; formerly part of the Zanzibar Sultanate.

Porto Novo. Benin, early seaport; capital of Benin.

Portuguese East Africa. Mozambique.

Portuguese West Africa. Angola.

Punt. Ethiopia, Somalia, ancient Egyptian name for the eastern coast of Africa known as the "horn" of Africa.

Rabat. Morocco, capital and early Islamic town on the northern coast.

Rif. Morocco, hilly coastal region in northern Morocco inhabited by the Berber; variants: Er Rif

Rift Valley. East Africa, great depression extending from the Red Sea to Mozambique; variants: Great Rift Valley.

Rio Muñi. Equatorial Guinea, river and province.

Ruvuma River. Tanzania and Mozambique; variants: Rovuma River.

Ruwenzori Mountains. Zaire and Uganda.

Ruzizi River. Zaire, Rwanda, and Burundi.

Rwanda. country; formerly part of Ruanda-Urundi; capital is Kigali; variant: Ruanda.

Sabrata. Libya, ancient coastal city of Roman origin; variants: Sabratha.

Sahel. narrow belt of semi-desert between the Sudan savana and the Sahara.

Salaga. Ghana, early town and trading center.

Samun Dukiya. Nigeria, Nok village.

Sanaga River. Cameroun.

Sanga. Zaire, Iron Age site.

Sangha River. Congo, flows into the Zaire River.

Sankuru River. Zaire, flows into the Kasai River.

São Tomé and Príncipe. country; an island in the Gulf of Guinea; formerly a Portuguese province; capital is São Tomé; variant: Democratic Republic of São Tomé and Príncipe.

Sarurab. Sudan, Neolithic pottery site.

Segu. Mali, early town within the Mali Empire; variants: Segou.

Senegal. country; formerly part of French West Africa; capital is Dakar; variants: Republic of Senegal, République du Sénégal.

Senegal River. rises in the Fouta Djallon highlands of Guinea near the Sierra Leone border, flowing northwest through Mali.

Senegambla. region around the Senegal and Gambia rivers; a confederation of the Gambia and Senegal since 1982.

Sennar. Sudan, Nile Valley site and early town within the Kush Kingdom.

Seychelles. country; group of islands in the Indian Ocean; capital is Victoria; variant: Republic of Seychessles.

Sierra Leone. country; formerly part of British West Africa; capital is Freetown; variant: Republic of Sierra Leone.

Sijilmasa. Morocco, early Islamic town; variants: Sijilmassa.

Soddo. Ethiopia, monolith site; variants: Sodo.

Sofala. Mozambique, early coastal trading post.

Sokoto. Nigeria, river; early town and sultanate within the Fulah Empire.

Somalia. country; formerly British and Italian Somaliland; capital is Mogadishu; variants: Somali Democratic Republic, Jamhuriyadda Dimugradiga Somaliya.

Sotho. Lesotho, Republic of South Africa, region of rock art sites.

Soudan Français. Mali, French territory from 1946-1958 which became the Sudanese Republic from 1958-1960.

South Africa. country; capitals are Pretoria and Capetown; variants: Republic of South Africa, Republiek van Suid-Afrika, Union of South Africa.

Spanish Sahara. former Spanish territory, now part of Morocco; variants: Western Sahara, Saharan Arab Democratic Republic.

Stanley Falls. Congo, Zaire, cataracts of the Lualaba River; variants: Boyoma Falls.

Stanley Pool. a widening of the Zaire River in southwestern Zaire and Congo Republic; variants: Malebo Pool.

Sudan. country; formerly Anglo-Egyptian Sudan; capital is Khartoum; variants: Republic of the Sudan, Jumhuriyat as-Sudan. Also used for the region in north-central Africa south of the Sahara desert and extending across the African continent; variants: Soudan, Bilad-es-Sudan.

Swaziland. country; independent Kingdom bordering on Mozambique and the Republic of South Africa; capital is Mbabane; locus of many rock art sites.

Tada. Nigeria, early town on the Niger River and site of shrine where Tsoede bronzes were found.

Tanganyika, Lake. Burundi, Tanzania, Zaire.

Tanzania. country; formerly German East Africa including Tanganyika and Zanzibar; capital is Dar-es-Salaam; variants: United Republic of Tanzania, Jamhuri ya Mwungana wa Tanzania.

Taoudenni. Mali, early town; rock art site.

Taruga. Nigeria, Iron Age site; Nok village.

Tassili-n-Ajjer. Algeria, mountain range in the central Sahara; region of numerous rock art sites.

Tegdaoust. Mauritania, early Islamic trading center.

Tibesti. Chad, mountainous region in the Sahara.

Timbuktu. Mali, early Islamic trading center; variants: Timbouctou, Tombouctou.

Tlemcen. Algeria, early Islamic town.

Togere. Mali, archeological site of Djenne civilization.

Togo. country; formerly French Togo; capital is Lomé; variants: Republic of Togo, République Togolaise, Togoland.

Tondidarou. Mali, archeological site; standing stones.

Transvaal. Republic of South Africa, province; region of rock art sites.

Tshuapa River. west central Zaire; variants: Chuapa River.

Tunisia. country; capital is Tunis; variants: Republic of Tunisia, al-Jumhuriyah at-Tunisiya, Tunisie.

Turkana, Lake. one of the Great Lakes on the border of Ethiopia, Sudan and Kenya; variants: Lake Rudolf.

Twyfelfontein. Namibia, rock art site.

Ubangi River. Central African Republic, Congo and Zaire; variants Oubangui River.

Uele River. Zaire, unites with the Bomu River to form the Ubangi River; variants: Ouelle.

Uganda. country; capital is Kampala; variants: Republic of Uganda.

Ulindi River. Zaire; flows into the Lualaba River.

Upemba. region and lake in southern Zaire.

Urua. Zaire district identified with Luba sculpture.

Usambara. mountainous region in Tanzania and south-east Kenya.

Victoria, Lake. Tanzania, Uganda; variants: Victoria Nyanza.

Virunga Mountains. Zaire, Rwanda, Uganda; variants: Mfumbiro.

Volta, Lake. Ghana.

Volta River. Burkina Faso, Ghana; some sections further named as the Red Volta, Black Volta and White Volta rivers.

Wadal. Chad, region; former sultanae; variants: Ouadaï.

Wagadugu. Burkina Faso, pre-colonial trading center and capital of Mossi Kingdom in the 15th century; variants: Ouagadougou.

Whydah. Benin, coastal city of the Dahomey Kingdom; variants: Wydah, Ouidah.

Zaire. country; formerly Belgian Congo; capital is Kinshasa; variants: Republic of Zaire, République du Zaïre, Congo Belge, Republic of the Congo, Congo Leopoldville, Congo-Kinshasa, Congo Free State.

Zambezi River. south-central and southeast Africa.

Zambia. country; formerly Northern Rhodesia; capital is Lusaka; variant: Republic of Zambia

Zanj. Arabized term for Azania. *see also* **Azania**.

Zanzibar. East Africa, early Islamic seacoast town and archeological site; former Sultanate comprising the islands of Zanzibar, Pemba, Mafia, and the coasts of Somalia, Kenya, and Tanzania.

Zaria. Nigeria, one of the Hausa city-states.

Zimbabwe. country; formerly Rhodesia and Southern Rhodesia; capital is Harare; variants: Republic of Zimbabwe.

COUNTRY INDEX

ALGERIA

AGADEZ	BENI MENASSER	HAMYAN	TAMAZIGHT
AHAGGAR	BENI MZAB	KABYLE	TUAREG
AJJER	BENI YENNI	MAURES	ULED NAIL
ANTESSAR	BERABISH	RIF	
BEDOUIN	BERBER	SHAWIA	
BELLA	GARAMANTES	SONGHAI	

ANGOLA

AMBO	KAKONDA	MBAKA	NGANDA
AMBOIM	KHUMBI	MBALI	NGANDYERA
BAILUNDO	KISAMA	MBAMBA	NGANGELA
BALA	KONGO	MBANGALA	NKANGALA
BEMBA	KOROCA	MBOKA	NKANU
BOLO	KUNG	MBONDO	NYANEKA
BUSHMEN	KWAMBI	MBUKUSHU	NYEMBA
CHAAMBA	KWANDU	MBUNDA	NYENGO
CHOKWE	KWANYAMA	MBUNDU	OKUNG
CIAKA	LIBOLO	MBWELA	OVIMBUNDU
CILENGE	LUANDA	MINUNGU	SHINJI
CIPUNGU	LUCHAZI	MUKUBAL	SOLONGO
CUANDO	LUNDA	MULONDO	SONGO
HANYA	LUNDA-LOVALE	MWILA	TSCHITUNDA
HERERO	LUVALE	MWIMBE	TSOTSO
HIMBA	LUYANA	NDEMBU	TUKONGO
HOLO	LWENA	NDIMBA	VIYE
HUAMBO	LWIMBI	NDOMBE	WOYO
HUKWE	MASHI	NDONGA	YAKA
HUMBE	MATAMBA	NDULU	YOMBE
JAGA	MATAPA	NGALANGI	ZOMBO

BENIN

AGOTIME	CHAMBULI	GUN	SONGHAI
AIZO	DOMPAGO	GURMA	TAMBA
AJA	DYE	HAUSA	TEM
ANUFO	EDO	KABRE	TOFINU
AWORI	EGUN	KOTOKOLI	WOABA
BARGU	FON	KROBO	YORUBA
BATAMMALIBA	FULANI	LAMBA	YOWA
BINI	GE	LIGBA	ZARMA
BUSA	GONJA	NAGO	

BOTSWANA

AUEN	HUKWE	MBUKUSHU	SOTHO
BUSHMEN	HURUTSHE	NARON	SUBIYA
HERERO	KALANGA	NGUNI	TLHAPING
HIECHWARE	KGALAGADI	NGWATO	TOTELA
HIMBA	KHATLA	ROLONG	TSWANA
HOA	KWENA	SAN	YEEI

BURKINA FASO

ANTESSAR
BAMANA
BIRIFOR
BISA
BOBO
BOBO-FING
BOLON
BUILSA
BWA
DAFING
DAGARA
DIELI
DOGON
DOROSIE
DYAN
DYULA
FALAFALA
FIJEMBELE
FRAFRA

FULANI
GAN
GBADOGO
GOUIN
GRUNSHI
GURENSI
GURMA
KARABORO
KASENA
KOMONO
KPEENE
KUNTA
KURUMBA
KUSASI
LOBI
LODAGAA
LODAGABA
LOWIILI
LURUM

LYELE
MAMPRUSI
MANDE
MARKA
MOBA
MOSSI
NAKOMSE
NATIORO
NIARHAFOLO
NUMU
NUNA
NYONYOSI
PATORO
SAMO
SEMBLA
SENAMBELE
SENUFO
SIA
SIKOMSE

SISALA
SOMONO
SONGHAI
SONINKE
SUPPIRE
SYEMU
TAGBA
TALLENSI
TUAREG
TURKA
TUSYAN
TYEFO
WARA
WINIAMA
YARSE
ZARA
ZARMA

BURUNDI

GESERA
HA
HIMA

HUTU
JIJI

PYGMIES
RUNDI

TUTSI
TWA

CAMEROUN

ABO
ABONG
ADAMAWA
AGHEM
ANYANG
AWING
BABA
BABADJU
BABANKI
BABESSI
BABETE
BABINGA
BABOANTU
BABUNGO
BACHAMA
BAFANDJI
BAFANG
BAFIA
BAFO
BAFOCHU
BAFOU-FONDONG
BAFRENG
BAFU
BAFUM
BAFUNDA
BATUFAM
BAYANGAM

BAFUSSAM
BAFUT
BAGAM
BAGYELE
BAHUAN
BAKA
BAKASSA
BAKEMBAT
BALANG
BALENG
BALESSING
BALI
BALIKUMBAT
BALOM
BALONG
BALUM
BAMALE
BAMANYAN
BAMBALANG
BAMBUI
BAMBULUE
BAMEKA
BAMENA
BAMENDA
BAMENDJINDA
BAZU
BEBA BEFANG

BAMENDJING
BAMENDJO
BAMENDU
BAMENKOMBO
BAMENOM
BAMENYAM
BAMESSING
BAMESSO
BAMETO
BAMILEKE
BAMUGONG
BAMUGUM
BAMUM
BAMUMKUMBIT
BAMUNKA
BANA
BANDA
BANDENG
BANDENKOP
BANDREFAM
BANE
BANEN
BANGAM
BANGANG
BANGANGTE
BELO
BENGA

BANGANTU
BANGU
BANGULAP
BANGWA
BANJA
BANJUN
BANKA
BANKIM
BANSOA
BANWAM
BANYO
BAPA
BAPE
BAPI
BASA
BATA
BATABI
BATAM
BATCHAM
BATCHINGU
BATI
BATIBO
BATIE
BATIKALE
BATU
BENUE
BETI

298

COUNTRY INDEX

BITEKU
BO-MBONGO
BOGOTO
BONGO
BONGOR
BONKENG
BUDUMA
BULAHAY
BULU
BUM
CHAMBA
CROSS RIVER
DABA
DASO
DEK
DIAMARE
DIBUM
DITAM
DJIBETE
DOYAYO
DSCHANG
DUALA-LIMBA
DUMBO
DURU
DWALA
EJAGHAM
ELELEM
ESIMBI
ESU
ETON
EWONDO
FALI
FANG
FEGWA
FOMOPEA
FONCANDA
FONDONERA
FONGO
FONJOMEKWET
FONJUMETOR
FONTCHATULA
FONTEM
FOREKE
FOREKE CHACHA
FOSSONG
FOSSUNGO
FOTABONG
FOTETSA
FOTO
FOTO DUNGATET
FOTOMENA
FOTUNI
FOZIMOGNDI

FOZIMOMBIN
FULANI
FUMBAN
FUNGOM
GALIM
GANGSIN
GASO
GAYI
GBAYA
GISEI
GISIGA
GORORI
GUDUR
GUIDAR
GUMMAI
HAUSA
HIDE
HINA
ISU
ISUWU
JAKONG
KADA
KAPSIKI
KARA
KARE
KEAKA
KEKEM
KERA
KIJEM
KIRDI
KOM
KOMA
KOTOKO
KOTOPO
KPE-MBOKO
KPERE
KUK
KUNDU
KUTIN
KWELE
KWIRI
LAABUM
LAIKOM
LAKA
LEKO
LIMBA
LOGONE
LONDO
MABEA
MAGBA
MAKAA
MAKE
MAMBILA

MANDAGE
MANDARA
MANGBEI
MANKON
MARGI
MASSA
MATAKAM
MBAW
MBEM
MBEMBE
MBIAMI
MBILI
MBIMU
MBO
MBOKO
MBOT
MBUM
META
MFUMTE
MISAJE
MME
MOFU
MOGAMAW
MOUKTELE
MULWI
MUMUYE
MUNDANG
MUNGO
MUNJUK
MUSGOY
MUSGUN
MUSSEY
MUTI
MUTURUA
MVAE
MVELE
NAMA
NDIKI
NDOBO
NDOP
NDORO
NDU
NGAMBE
NGEMBA
NGIE
NGOLO
NGOM
NGUMBA
NGWO
NJIMOM
NJINIKOM
NKAMBE
NKAPA

NKOSI
NOO
NSAW
NSUNGLI
NTEM
NTUMU
NYEM
NYONGA
NYOS
NZAMAN
NZANGI
NZIMU
ODODOP
OKAK
OKANO
OKU
OLI
PAMBEN
PAPE
PATI
PODOKO
POMO
PONGO
PYGMIES
SANAGA
SAO
SHAKE
SHUWA
SO
TADKON
TANG
TANGA
TIGONG
TIKAR
TINTO
TIV
TONGA
TUNGO
TUPURI
VERE
WAR
WIDEKUM
WIYA
WODAABE
WOKO
WOVEA
WUM
WUTE
YABASSI
YAMBASA
YASA
YEMBA
YUKUTARE

CAPE VERDE

LEBU

CENTRAL AFRICAN REPUBLIC

AKA	GOBU	MBATI	POMO
ALI	GUBU	MBIMU	PONDO
BABINGA	GUNDI	MBOMOTABA	PYGMIES
BAGIRMI	KARA (West)	MBUGU	RUNGA
BANDA	KARA (East)	MBUM	SANGO
BANU	KARE (Northwest)	NDOGO	SARA
BOGONGO	KARE (Southeast)	NGAMA	SERE
BUDIGRI	KPALA	NGANDO	SUMA
BURAKA	KREISH	NGBAKA	TALE
DAÏ	LAKKA	NGBAKA MABO	TOGBO
DAKPA	LANGBA	NGBANDI	TUPURI
FULANI	LANGBWASE	NGONDI	VORA
GANZI	MANGBEI	NGUNDA	YAKA
GBANZIRI	MANI	NZAKARA	YAKOMA
GBAYA (East)	MANZA	PAMBIA	YANGERE
GBAYA (South)	MBAI	PANDE	ZANDE
GBOFI	MBANJA	PATR	

CHAD

ARAMKA	FUR	LAKA	MUNDANG
AZA	GIMR	LOGONE	MUNJUK
BAGGARA	GUIDAR	MABA	MUSGUN
BAGIRMI	HADJERAI	MANDAGE	MUSSEY
BAI	HAUSA	MANGBEI	NGAMA
BERI	HAWAZMA	MANZA	NGAMBAI
BIDEYAT	KADA	MARBA	RIZEYGAT
BONGOR	KANEMBU	MASSA	RUNGA
BORORO	KANURI	MBAI	SANGO
BUDUMA	KARANGA	MBARA	SAO
BUGUDUM	KARE	MBUM	SARA
DAÏ	KENGA	MESSERIA	SHUWA
DAJU	KERA	MIDA'A	SOKORO
DANGALEAT	KINGA	MIMI	TEDA
DAZA	KIRDI	MOKULU	TUBU
DJIMI	KOTOKO	MUBI	TUNDJUR
FULANI	KWANG	MULWI	ZAGHAWA

THE COMOROS

KOMORO SWAHILI

CONGO REPUBLIC

AKA	BONGILI	GANGALA	KUBA
AKWA	BOO	GBAYA	KUKUYA
BABINGA	DIKIDIKI	JINJU	KUNYI
BANGI	DJIKINI	KARA	KUYU
BEMBE	DONDO	KONGO	KWALA
BOMBOLI	FIOTE	KOTA	KWEI

300

KWELE	MBEENGY	NGOM	SHI
LAADI	MBETE	NGONDI	TEGUE
LIKUBA	MBOKO	NGOOMBE	TEKE
LOBALA	MBOMOTABA	NGUNGULU	TIO
LOLO	MBOSHI	NIAPU	TSANGI
LUMBO	MBUNJO	NJABI	VILI
MAHONGWE	MFUNU	NTSAYE	WU
MALUK	MONJOMBO	PUNU	WUMVU
MANGBETU	NDASA	PYAANG	WUUM
MBAAMA	NDUMBO	PYGMIES	YAKA
MBANGWE	NGARE	SESE	YOMBE
MBATI	NGEENDE	SHAKE	
MBE	NGENGE	SHAMAYE	

CÔTE D'IVOIRE

ABE	DIELI	JIMINI	NGBAN
ABIDJI	DIOMANDE	KADLE	NGERE
ABRI	DOO	KAFIRE	NGOÏ
ABRON	DRANU	KASEMBELE	NIANANGON
ABURE	DYALONKE	KOMONO	NIARHAFOLO
ADIZI	DYULA	KPEENE	NOHULU
ADJUKRU	EBRIE	KRAN	NUMU
AGBA	EGA	KROBU	NYABWA
AGUA	ESUMA	KRU	NYEDE
AHIZI	FAAFUE	KUFOLO	NYENE
AITU	FALAFALA	KULANGO	NZIKPRI
AJA	FAMOSI	KULEBELE	NZIMA
AKAN	FIJEMBELE	KULIME	PALARA
AKWE	FODONON	KUYA	PATORO
AKYE	FONO	KUZIE	SAAFWE
ALADYAN	FORO	KWADYA	SANWI
ALANGWA	FULANI	LAGOON people	SATIKRAN
ANYI	GADI	LIGBI	SEFWI
ASANFWE	GAGNOA	LOBI	SENAMBELE
ASEBU	GAGU	LODAGAA	SENARI
ASSINI	GAN	LOMAPO	SENUFO
AVIKAM	GARBO	LORHON	SONINKE
AYAHU	GBADI	LOWIILI	TAGBA
BAKWE	GBARZON	LYELE	TAGWANA
BASSAM	GBATO	MAGWE	TANGARA
BAULE	GBEON	MALINKE	TEGESSIE
BETE	GBONZORO	MANDE	TENERE
BETTYE	GBU	MANGORO	TURA
BINYE	GODE	MANINKA	TWI
DAGARA	GODIE	MAU	TYEBARA
DAHO	GOUIN	METYIBO	TYELI
DALOA	GREBO	MORONU	UBI
DAN	GUIBEROUA	MWAN	ULE
DAN-NGERE	GULOME	NAFANA	WAN
DEGHA	GURO	NAMANLE	WAREBO
DENKYIRA	GWA	NANAFUE	WOBE
DIABE	HWELA	NDENYE	WORODUGU
DIDA	JAMALA	NEYO	YOHURE

DJIBOUTI

ADOIMARA	GADABURSI	SOMALI
AFAR	ISSA	

EGYPT

BAHARIYA	BERBER	KENUZI	SIWA
BEDOUIN	COPTS	MAHAS	
BEJA	FELLAHIN	NUBIANS	

EQUATORIAL GUINEA

BABINGA	BUBI	NGUMBA	OKANO
BAGYELE	FANG	NTUMU	PYGMIES
BENGA	MAKE	OKAK	YASA

ERITREA

ADOIMARA	AMARAR	BILEN	SAHO
AFAR	BAREA	HABAB	TIGRE
AGAW	BEJA	KUNAMA	TIGRINYA

ETHIOPIA

ADOIMARA	COPTS	ITU	OGADEN
AFAR	DAAROOD	JANJERO	OMETO
AGAW	DASENECH	KAFA	OROMO
AMHARA	DIR	KEMANT	PĂRI
ANUAK	DONYIRO	KOMA	RESHIAT
ARBORE	DORZE	KONSO	SABAEANS
ARGOBBA	FALASHA	KUNAMA	SAHO
ARUSI	GABBRA	LONGARIM	SHAKO
ASAIMARA	GADABURSI	LWOO	SIDAMO
BAKO	GAFAT	MABAN	SOMALI
BARAYTUMA	GATO	MACHA	SURMA
BAREA	GIBE	MAJANGIR	TIGRE
BEJA	GIMIRA	MAJI	TIGRINYA
BENI AMER	GUJI	MAO	TOPOTHA
BENI SHANGUL	GURAGE	MEKAN	TULAMA
BERTA	HADENDOWA	MURLE	UDUK
BILEN	HADIYA	MURSI	WALLAGA
BISHARIN	HAMAR	NILO-HAMITIC	WOLLAMO
BORAN	HARARI	people	WOLLO
BURUN	INGASSANA	NILOTIC people	
BUSSA	ISSA	NUER	

GABON

ABONGO	BONGOMO	KELE	MBANGWE
ADJUMBA	BULU	KOTA	MBETE
AKUA	DJIKINI	KWELE	MBISSISIOU
BABINGA	DUMA	LUMBO	MEKENY
BAKA	ENENGA	MAHONGWE	MPONGWE
BARAMA	FANG	MAKE	MVAE
BENGA	GALWA	MBAAMA	MYENE

NDAMBOMO	NJABI	PUNU	TEKE
NDASA	NKOMI	PYGMIES	TSANGI
NDUMBO	NTSAYE	RONGO	TSOGO
NGENGE	NTUMU	SANGU	VILI
NGOM	NZAMAN	SHAKE	WUMVU
NGOVE	OKAK	SHAMAYE	WUUM
NGUTU	OKANDE	SHIRA	
NGWYES	OKANO	SIMBA	

THE GAMBIA

BAMANA	KASONKE	MANDING	SIN
FULANI	LUSO-AFRICANS	MANKANYA	SONINKE
JOOLA	MANDE	SERER	WOLOF

GHANA

ABRON	BASSAR	GA-ADANGME	MANDE
ADA	BETTYE	GONJA	MOBA
ADANGME	BIM	GRUNSHI	NAFANA
ADANSE	BIMOBA	GURENSI	NAMNAM
ADELI	BIRIFOR	HAUSA	NANUMBA
AFEMA	BISA	HWELA	NINGO
AGOTIME	BUILSA	KABRE	NUMU
AHAFO	CANGBORONG	KASENA	NZIMA
AHANTA	CHAMBA	KOMA	OSU
AKAN	CHEREPONG	KONKOMBA	OSUDUKU
AKWAMU	DAGARA	KPONE	PRAMPRAM
AKWAPIM	DAGARTI	KPOSSO	SHAI
AKYEM	DAGOMBA	KRACHI	SISALA
ANLO	DEGHA	KRINJABO	TALLENSI
ANO	DELO	KROBO	TESHI
ANUFO	DYE	KUSASI	TOBOTE
ANYI	EFUTU	KWAHU	TWI
AOWIN	EWE	LARTEH	TWIFO
ASAFO	FANTI	LIGBI	VAGALA
ASANTE	FON	LODAGAA	WALA
ASSINI	FRAFRA	LODAGABA	WASA
ATWODE	FULANI	LOWIILI	
AWUTU	GA	MAMPRUSI	

GUINEA

BADYARANKE	FELUP	KURANKO	MOSSI
BAGA	FULANI	LANDUMA	NTUMU
BAMANA	GBUNDI	MALINKE	PAPEI
BANYUN	JOOLA	MANDE	SUSU
BASSARI	KISSI	MANDYAK	TENDA MAYO
BULOM	KONYAGI	MANINKA	TOMA
DAN	KONYANKE	MANO	YALUNKA
DYALONKE	KPELLE	MBULUNGISH	

GUINEA-BISSAU

BADYARANKE	FULANI	MANDING	SUSU
BEDIK	KASANGA	MANDYAK	TENDA
BIAFADA	KOBIANA	NALU	
BIDYOGO	LANDUMA	PAPEI	
FELUP	MANDE	SONINKE	

KENYA

ARIAAL	GUSII	LUYIA	SAMIA
ARUSHA	HAWIYE	LWOO	SANYE
ARUSI	IGEMBE	MAASAI	SEBEI
BAJUN	IGOJI	MANDARI	SEGEJU
BARABAIG	IK	MARAKWET	SHAMBAA
BARAYTUMA	IMENTI	MBERE	SHIRAZI
BENDE	IRAMBA	MERU	SIMBITI
BONI	ISSA	MIUTINI	SIRIKWA
BORAN	ISUKHA	MUTHAMBI	SOMALI
BUKUSU	JIYE	MWIMBI	SUBA
CHAGGA	JO PADHOLA	NANDI	SUK
CHONYI	KADAM	NGOMA	SWAHILI
CHUKA	KALENJIN	NILO-HAMITIC	TADJONI
DAAROOD	KAMBA	people	TALAI
DASENECH	KAMBE	NJEMPS	TAVETA
DHO LUO	KARIMOJONG	NYALA	TEITA
DIGO	KAUMA	NYIKA	TERIK
DOROBO	KAVIRONDO	OROMO	TESO
DURUMA	KEYYO	PATE	THARAKA
DZIHANA	KINANGOP	POK	TIGANIA
ELMOLO	KIPSIKIS	POKOMO	TIRIKI
EMBU	KIROBA	POTOPOTO	TUKEN
ENDO	KONY	RABAI	TUMBATU
GABBRA	KURIA	RENDILE	TURKANA
GIKUYU	LAIKIPIAK	RESHIAT	UNGUJA
GIRYAMA	LANGO	RIBE	VUMBA
GISU	LOGOOLI	SAMBURU	WANGA

LESOTHO

NGUNI	SOTHO	TAUNG	ZULU

LIBERIA

BASSA	GBI	KPELLE	MENDE
BOLO	GBU	KRAN	NGERE
DAN	GBUNDI	KRU	NYABO
DE	GOLA	KULIME	SAPO
GARBO	GREBO	LOMA	TIEN
GBANDI	JABO	MANDE	UBI
GBARZON	KISSI	MANO	VAI

LIBYA

AJJER	BERBER	RIYAH	ULAD 'ALI
ALAWITI	CYRENAICANS	SANUSI	ZAGHAWA
ANTESSAR	GARAMANTES	TEDA	
AZA	GHADAMES	TUAREG	
BEDOUIN	NEFUSA	TUBU	

MADAGASCAR

ANTAIFASY	BARA	MAHAFALY	TULEAR
ANTAIMORO	BETANIMENA	MERINA	VAZIMBA
ANTAISAKA	BETSILEO	NOSSI-BÉ	VEZO
ANTAMBAHOAKA	BETSIMISARAKA	SAKALAVA	ZAFIMANIRY
ANTANDROY	BEZANOZANO	SIHANAKA	ZAFISORO
ANTANKARANA	FESIRA	TANALA	
ANTANOSY	KOMORO	TSIMIHETY	

MALAWI

BARWE	MANGANJA	NYAKYUSA	TONGA (West)
CEWA	MARAVI	NYANJA	TUMBUKA
KAMANGA	MWAMBA	NYASA	YAO
KUKWE	NGONDE	PETA	ZULU
LAMBYA	NGONI	PHOKA	
LOMWE	NGULU	SENA	
MAKUA	NSENGA	TONGA (East)	

MALI

ANTESSAR	DIELI	KUNTA	SENAMBELE
BAMANA	DOGON	KURUMBA	SENARI
BEDOUIN	DYALONKE	MALINKE	SENUFO
BELEDUGU	DYULA	MANDE	SIA
BELLA	FIJEMBELE	MANINKA	SOMONO
BOBO	FULANI	MARKA	SONGHAI
BOBO-FING	ISAWAGHEN	MAURES	SONINKE
BOLON	IWLLEMMEDEN	MINIANKA	SUPPIRE
BORORO	KAGORO	NEMADI	TELLEM
BOZO	KASONKE	PATORO	TOLOY
BWA	KPEENE	SAMO	TUAREG
DAFING	KULEBELE	SARAKOLE	WODAABE

MAURITANIA

BEDOUIN	KABYLE	SARAKOLE	WODAABE
BERBER	KUNTA	SHLUH	WOLOF
BRAKNA	MAURES	SONINKE	ZENAGA
FULANI	NEMADI	TEKRUR	
GARAMANTES	OULAD DELIM	TRARZA	
IMRAGUEN	REGEIBAT	TUKULOR	

MOROCCO

AIT ATTA	AYT HADIDDU	IDA-OU-NADIF	SENHAJA
AIT BA AMRAN	BEDOUIN	JEBALA	SHLUH
AIT OUGERSIF	BENI M'TIR	MAURES	SOUS
AIT SEGHROUCHEN	BERBER	OUARZATA	TAMAZIGHT
	CHIADMA	REHAMNA	TEKNA
AIT YOUSSI	CHICHAOUA	RIF	ZAIANE

MOZAMBIQUE

BARWE	MAKONDE	NYUNGWE	TONGA
CEWA	MAKUA	PODZO	TSONGA
CHEMBA	MANYIKA	SENA	TSWA
CHOPI	MARAVI	SHANGA	YAO
CUABO	MAWIA	SHANGAAN	ZEZURU
DUMA	NDAU	SHONA	ZIGULA
KARANGA	NGONI	SWAHILI	
KUNDA	NGULU	SWAZI	
LOMWE	NYANJA	TAWARA	

NAMIBIA

AMBO	HERERO	MBUKUSHU	ROLONG
AUEN	HIMBA	NAMA	SAN
AUNI	KHOIKHOI	NAMIB	SUBIYA
BERGDAMA	KUNG	NDONGA	TSWANA
BUSHMEN	KWAMBI	NGUNI	YEEI
HEIKUM	KWANYAMA	NYEMBA	

NIGER

ADARAWA	BUDUMA	KADARA	TEDA
AGADEZ	DAZA	KANEMBU	TUAREG
AIR	FULANI	KANURI	TUBU
AJJER	GURMA	KUNTA	WODAABE
ANTESSAR	HAUSA	MAURES	ZAGHAWA
AZA	HOMBORI	MAWRI	ZARMA
BEDOUIN	ILLABAKAN	SHUWA	
BELLA	ISAWAGHEN	SONGHAI	
BORORO	IWLLEMMEDEN	SONINKE	

NIGERIA

ABAJA	AFIKPO	ANAGUTA	ATAM
ABAKWARIGA	AFO	ANAM	AWKA
ABAM	AGALA	ANANG	AWORI
ABANLIKU	AGATU	ANDONI	BACHAMA
ABIRIBA	AGWAGWUNE	ANGAS	BAHUMONO
ABOH	AHORI	ANKWE	BALEB
ABONG	AJA	APOI	BARAWA
ABUA	AKAJU	ARAGO	BARGU
ACHALLA	AKOKO	ARO	BASA
ACHI	AKWEYA	ASA	BASSA KADUNA
ADA	ALAYI	ASHUKU	BASSA KOMO
ADAMAWA	ANAGO	ATAKA	BASSA NGE

BATA	GAMERGU	KAJE	MONTOL
BATU	GANAWURI	KALABARI	MORWA
BAUSHI	GAYI	KAMBARI	MUMUYE
BEKWARRA	GBARI	KANA	NAMA
BENDE	GOKANA	KANAKURU	NDE
BENDE-BETE	GUDE	KANAM	NDONI
BENIN	GUN	KANEMBU	NDORO
BENUE	GURE	KANURI	NEMBE
BETE	GWA	KAPSIKI	NGENGE
BINI	GWANDARA	KARA	NGIZIM
BIROM	GWORAM	KARIM	NGWA
BOKI	HAUSA	KATAB	NINGAWA
BOLEWA	HIDE	KEAKA	NINZAM
BUDUMA	HINA	KEBBI	NKIM
BUNU	HONA	KETU	NKOSI
BURA	IBARAPA	KIRDI	NKPORO
BUSA	IBEKU	KOENOEM	NNAM
CHAM	IBENO	KOFYAR	NRI-AWKA
CHAMBA	IBIBIO	KOMA	NSELLE
CHIP	IDANRE	KONA	NSIT
CROSS RIVER	IDOMA	KORO	NSUKKA
people	IFE	KOROP	NTA
DAKA	IGALA	KOROROFA	NUNGU
DAKAKARI	IGBERE	KOTOKO	NUPE
DASSA	IGBIRA	KOTOPO	NZAM
DEGEMA	IGBO	KPAN	NZANGI
DEK	IGBOLO	KUKURUKU	OBANG
DIMMUCK	IGBOMINA	KULERE	OBORO
DJIBETE	IJEBU	KUMBA	ODODOP
DONG	IJO	KUPA	OFUTOP
DUKAWA	IKA	KURAMA	OGBA
EDO	IKALE	KUTEP	OGONI
EFIK	IKULU	KUTIN	OGORI
EFUT	IKWERRE	KWALE	OGU UKU
EGBA	IKWO	LAFIA	OHUHU
EGBADO	ILE-IFE	LAKKA	OKOBO
EGBEMA	ILORIN	LARDANG	OKOYONG
EGEDE	INEME	LEKO	OKPELLA
EGUN	IRIGWE	LOGONE	OKPOTO
EJAGHAM	ISHA	LONGUDA	ONDO
EKET	ISHAN	MABO-BARKUL	ONITSHA
EKITI	ISOKO	MADA	OPOBO
EKPEYE	ISU-AMA	MAGU	ORATTA
EKWE	ISU-ITEM	MAHIN	ORATTA-IKWERRI
ELEGU	ITAKETE	MAKA	ORLU
ELEME	ITSEKIRI	MAMA	ORON
ENGENNI	IVBIOSAKON	MAMBILA	OTURKPO
ENYONG	IYALA	MANDARA	OWE
ETCHE	IZI	MANIGRI	OWERRI
ETSAKO	JABA	MARGI	OWO
ETULO	JARAWA	MATAKAM	OYO
ETUNG	JEN	MBAISE	OZU-ITEM
EZIAMA	JIBU	MBE	PABIR
EZZA	JORTO	MBEMBE	PAPE
FALI	JUKUN	MBOI	PYAPUN
FON	KABBA	MBUBE	PYEM
FULANI	KABILA	MBULA	QUA
GAANDA	KADARA	MIGILI	RIVERAIN IGBO
GADE	KAGORO	MIRIAM	RON

COUNTRY INDEX

NIGERIA SOUTH AFRICA

RUKUBA	TANGALE	URUAN	WUTE
SAO	TAROK	UTANGA	YACHI
SHABE	TERA	UTONKON	YAGBA
SHANGA	TIGONG	UTUGWANG	YAKÖ
SHUWA	TIV	UZEKWE	YAKOKO
SOBO	TOOROBBE	VERE	YAKORO
SONGHAI	TULA	WAJA	YIKUBEN
SURA	UDI	WODAABE	YORUBA
TAKUM	UKELE	WUKARI	YUKUTARE
TAL	UMUNRI	WURBO	YUNGUR
TALA	URHOBO	WURKUM	ZARMA

RWANDA

GESERA	KIGA	RWANDA	ZIGABA
HIMA	NKOLE	TUTSI	
HUTU	PYGMIES	TWA	

SENEGAL

BADYARANKE	FELUP	LUSO-AFRICANS	SONINKE
BALANTE	FULANI	MALINKE	TEKRUR
BAMANA	JOOLA	MANDE	TENDA
BANYUN	KARON	MANDING	TENDA MAYO
BASSARI	KASANGA	MANDYAK	TUKULOR
BAYOT	KASONKE	MANINKA	WODAABE
BEDIK	KOBIANA	MANKANYA	WOLOF
BOIN	KONYAGI	MAURES	
BORORO	KONYANKE	SERER	
DYALONKE	LEBU	SIN	

SIERRA LEONE

BAGA	KISSI	KURANKO	SEWA MENDE
BULOM	KO MENDE	LANDUMA	SHERBRO
DYALONKE	KONO	LIMBA	SUSU
FULANI	KPA MENDE	LOKO	TEMNE
GBANDI	KRIM	MANDE	VAI
GOLA	KRIO	MENDE	YALUNKA

SOMALIA

ADOIMARA	BONI	ISAAQ	SAHO
AFAR	BORAN	ISSA	SOMALI
AGAW	DAAROOD	OGADEN	SWAHILI
ARUSI	DIGIL	OROMO	TUNNI
BAJUN	DIR	RAHANWIIN	
BARAYTUMA	GADABURSI	SAB	
BIMAL	HAWIYE	SABAEANS	

SOUTH AFRICA

BERGDAMA	ENHLA	KORANA	MPONDO
BHAKA	HANANWA	LEMBA	NAMA
BOMVANA	HOLI	LOVEDU	NDEBELE
BUSHMEN	KHOIKHOI	MFENGU	NDZUNDZA

NGUNI	SAN	TEMBU	XAM
NGWATO	SHANGAAN	TSONGA	XHOSA
PEDI	SOTHO	TSWA	ZANSI
ROLONG	SWAZI	TSWANA	ZULU
ROZWI	TAUNG	VENDA	

SUDAN

ABABDAH	DOK	LABWOR	NUBA
ABBALA	DONGOTONO	LAFOFA	NUBIANS
ACOLI	DONYIRO	LAK	NUER
ANAG	DOR	LANGO	NUONG
ANUAK	FELLAHIN	LARO	NYANGBAA
ATUOT	FULANI	LEK	NYEPU
BAGGARA	FUNJ-HAMAJ	LIGO	NYIMA
BAGIRMI	FUR	LOGIR	PAMBIA
BAI	GAWEIR	LOGIRI	PÄRI
BAKA	GBAYA	LOGO	PÖJULU
BANDA	GIMR	LOKOYA	RASHAD
BARABRA	GOLO	LONGARIM	RIZEYGAT
BARI	HAMAR	LOTUKO	SERE
BEJA	HAUSA	LULUBA	SHILLUK
BELANDA	HAWAZMA	LWOO	SHUKRIA
BENI AMER	HEIBAN	MABAN	SUDAN ARABS
BERI	INGASSANA	MADI	TALODI
BERTA	JA'ALIYYIN	MAHAS	TEGALI
BERTI	JAGEI	MAHRIA	TEMEIN
BIDEYAT	JIKANY	MANDARI	THIANG
BINGA	JIYE	MANI	THURI
BIRKED	JUR	MARSHIA	TIGRE
BISHARIN	KABABISH	MESAKIN	TIRA
BONGO	KAKWA	MESSERIA	TOPOTHA
BOR	KALIKO	MIDOBI	TORO
BORORO	KANURI	MITTU	TUBU
BUL	KARA	MORO	TULLISHI
BURUN	KARE	MORU	TUMTUM
BVIRI	KATLA	MUNDU	TURKANA
DAJU	KOALIB	MURLE	UDUK
DIDINGA	KOMA	NDOGO	ZAGHAWA
DILLING	KORONGO	NILO-HAMITIC	ZANDE
DINKA	KREISH	people	
DIO	KUKU	NILOTIC people	

SWAZILAND

NGUNI	SWAZI	TSONGA	ZULU

TANZANIA

ALAWA	BUNGU	DOROBO	GOROWA
ARUSHA	BURUNGI	DURUMA	GUHA
BARABAIG	CHAGGA	FIPA	
BENA	CILE	GAYA	
BENDE	DIGO	GIRYAMA	
BONDEI	DOE	GOGO	

GWE	KURIA	NDALI	SAGARA
GWENO	KUTU	NDAMBA	SAKU
HA	KWAFI	NDENDEULI	SANDAWE
HADIMU	KWERE	NDENGEREKO	SANGU
HADZAPI	LAMBYA	NDONDE	SEGEJU
HANGAZA	LIMA	NGINDO	SELYA
HAYA	LUGURU	NGONDE	SHAMBAA
HEHE	LUNGU	NGONI	SHASHI
HOLOHOLO	LWOO	NGULU	SHIRAZI
HUTU	MAASAI	NGURIMI	SIMBITI
IKIZU	MAFIA	NILO-HAMITIC	SINJA
IKOMA	MAKONDE	people	SONJO
IRAMBA	MAKUA	NYAKYUSA	SUKUMA
IRAMBI	MALILA	NYAMWANGA	SUMBWA
IRAQW	MAMBA	NYAMWEZI	SWAHILI
ISANZU	MAMBWE	NYANJA	TATOG
JIJI	MANDA	NYASA	TONGWE
JITA	MARAVI	NYATURU	TUMBUKA
KAGURU	MASASI	NYIHA	UNGUJA
KAHE	MATAMBWE	NYIKA	UNYAMWEZI
KALANGA	MATENGO	PANGWA	VIDUNDA
KAMI	MATUMBI	PARE	VINZA
KARA	MAWIA	PEMBA	WANDA
KARAGWE	MBUGU	PETA	WANJI
KAVIRONDO	MBUGWE	PIMBWE	YAO
KAWENDE	MBUNGA	POGORO	YEKE
KEREWE	MERU	POKOMO	ZANAKI
KIMBU	MPORORO	RANGI	ZARAMO
KINGA	MPOTO	RIBE	ZIGULA
KIROBA	MRIMA	RUFIJI	ZINZA
KISI	MWAMBA	RUNDI	
KONONGO	MWERA	RUNGWA	
KUKWE	NATA	SAFWA	

TOGO

ADANGME	BATAMMALIBA	GONJA	LIGBA
ADELI	BETTYE	GURMA	MAMPRUSI
AGOTIME	BIMOBA	HAUSA	MOBA
AJA	CHAMBA	KABRE	MOSSI
AKAN	CHAMBULI	KASELE	MWABA-GURMA
ANLO	DELO	KEBU	NAUDEM
ANO	DIFALE	KONKOMBA	TEM
ANUFO	DOMPAGO	KOTOKOLI	TOBOTE
ANYI	DYE	KPOSSO	YORUBA
ATAKPAME	EWE	KROBO	
ATWODE	FULANI	KUSASI	
BASSAR	GE	LAMBA	

TUNISIA

ARAD	BERBER	JEBALA	JERID
BEDOUIN	HAMAMA	JERBA	

UGANDA

ACOLI
ALUR
AMBA
BUGANDA
BUHWEJU
BVIRI
DODOTH
DUMBO
GANDA
GISU
GWERE
HERA
HIMA
HUKU
IK
IRU
ISUKHA
JIYE
JO PADHOLA

JO PALUO
KADAM
KAKWA
KALENJIN
KARIMOJONG
KAVIRONDO
KENYI
KIGA
KIRA
KONJO
KONY
KUKU
KUMAM
LABWOR
LANGO
LENDU
LESE
LOTUKO
LUGBARA

LULUBA
LUYIA
LWOO
MADI
MALELE
MANGBETU
MATE
MORU
NAPORE
NDO
NILO-HAMITIC
 people
NILOTIC people
NKOLE
NYAKWAI
NYALA
NYANGBAA
NYANGEYA
NYARI

NYOLE
NYORO
OKOLLO
PÖJULU
SAMIA
SAPAUT
SEBEI
SESE
SHU
SOGA
SUK
SWAGA
TALINGA
TANGI
TEPES
TESO
TORO
VUMA

ZAIRE

AGBARAMBO
AKA
AKAAWAND
ALUR
AMBA
AMBO
ANGBA
AUSHI
AVOKAYA
BABEMO
BAI
BAKA
BAKWA KATAWA
BAKWANZALA
BALE
BALI
BAMALA
BAMWE
BANDA
BANGBA
BANGI
BANGONGO
BANGUBANGU
BANKAAN
BARI
BASANGA
BASHILEP
BASUA
BATEMPA
BATI
BEELANDE
BEMBA
BEMBE (West)
BEMBE (East)

BEO
BEYRU
BINJA
BINJI
BINZA
BIOMBO
BIRA
BISA
BIYEENG
BOKO
BOKONGO
BOKOTE
BOLEMBA
BOLENDO
BOLIA
BOMBOLI
BOMBWANJA
BOONDE
BOYO
BUDIA
BUDU
BUJWE
BUKIL
BULAANG
BUMA
BURAKA
BURU
BUSHOONG
BVANUMA
BVIRI
BWA
BWARI
BWENDE
BWILE

BWIZI
CHOKWE
COOFA
CWA
DIA
DINGA
DIO
DOKO
DONGO
DZING
EFE
EKIIYE
EKOLOMBE
EKONDA
ELEKU
ENYA
FOMA
FURIIRU
FURU
GBANZIRI
GBAYA
GOBU
GOLO
GOMA
GUHA
HAMBA
HAVU
HEMBA
HERA
HIMA
HOLO
HOLOHOLO
HONGO
HUKU

HUNDE
IBEKE
IDIING
IMOMA
IPANGA
IYEMBE
JAGA
JAMBA
JANDO
JONGA
KAAM
KAHELA
KAKWA
KALA
KALANGA
KALEBWE
KALIKO
KALUNDWE
KAMBA
KANGO
KANYOK
KAONDE
KARE
KASENGA
KASINGO
KAYUWEENG
KAZIBATI
KEL
KELA
KELE
KET
KIRA
KOMO
KONGO

311

KONJO
KOTA
KOTO
KPALA
KUBA
KUKU
KUKUYA
KUNDA
KUNYI
KUSU
KUTU
KWAME
KWESE
LALA
LALIA
LAMBA
LANGA
LANGBA
LANGBWASE
LEELE
LEGA
LEKA
LEMBWE
LEMFU
LENDU
LENGOLA
LENJE
LESE
LIBINZA
LIFUMBA
LIKA
LINGA
LOANGO
LOBALA
LOBO
LOGO
LOI
LOKI
LOMBO
LOMOTWA
LORI
LOSENGO
LUBA
LUBA-BAMBO
LUBA-BAMEMA
LUBA-HEMBA
LUBA-KASAI
LUBA-LOLO
LUBA-
 LUBENGULE
LUBA-SHANKADI
LUCHAZI
LUGBARA
LULA
LULUWA
LUMBU
LUNDA
LUNDA-LOVALE
LUNTU

LUVALE
LUWA
LWALU
LWENA
LWIMBI
MA
MABENDI
MABISANGA
MABITI
MADI
MADJUU
MAKERE
MAKUTU
MALELE
MALUK
MAMBA
MAMPOKO
MAMVU
MANGBETU
MANGBUTU
MANI
MANYANGA
MANZA
MATE
MAYOGO
MAZIBA
MBA
MBAGANI
MBAL
MBALA
MBANJA
MBATA
MBEENGY
MBEKO
MBELO
MBESA
MBILIANKAMBA
MBINSA
MBOKA
MBOLE (East)
MBOLE (Southwest)
MBOMA
MBOMOTABA
MBONDO
MBUBA
MBUGU
MBUJA
MBULI
MBUTI
MBUUN
MEEGYE
METOKO
MFINU
MIANGBA
MILEMBWE
MINUNGU
MONGO
MONGOBA
MONJOMBO

MONO
MONYA
MORU
MOWEA
MPAMA
MPANGU
MPANZA
MPASSA
MPE
MPEMBA
MPESA
MPUT
MPUUN
MUKULU
MUNDU
NDAKA
NDEMBU
NDENGESE
NDIBU
NDO
NDOLO
NDUNGA
NGALA
NGANDU
NGATA
NGBAKA
NGBANDI
NGBEE
NGBELE
NGBUNDU
NGEENDE
NGELIMA
NGENGELE
NGIRI
NGOMBE
NGONGO
NGONJE
NGOOMBE
NGUL
NIAPU
NIEMBO
NILO-HAMITIC
 people
NILOTIC people
NJEMBE
NKANU
NKU
NKUNDO
NKUTSHU
NONDA
NSAPO
NTANDU
NTOMBA
NUNU
NWENSHI
NYANGA
NYANGBAA
NYARI
NYEPU

NYINDU
NZADI
NZAKARA
OHENDO
OLI
OMBO
PAGABETE
PAMBIA
PATU
PELENDE
PENDE
PERE
PINDI
PÖJULU
POPOI
POTO
PRE-BEMBE
PYAANG
PYGMIES
RIVERAIN people
RUMBI
SAKA
SAKATA
SALAMPASU
SALIA
SANGA
SANGO
SANZE
SAYI
SEBA
SENGELE
SERE
SHI
SHILA
SHINJI
SHOOWA
SHU
SO
SOLONGO
SONGOLA
SONGOMENO
SONGYE
SOONDE
SUKU
SUNDI
SWAGA
SWAHILI
SWAKA
TABI
TABWA
TALE
TALINGA
TANDA
TANGI
TEGUE
TEKE
TEMBO

TETELA	TUKONGO	WOYO	YEMBE
TIENE	TUMBWE	WUUM	YEW
TIO	TWA	YAELIMA	YOMBE
TITU	TWAGI	YAKA	ZANDE
TOGBO	UNGA	YAKOMA	ZELA
TOPOKE	VILI	YAMBULA	ZIMBA
TOW	VIRA	YANGERE	ZOMBO
TSAAM	VUNGUNYA	YANZ	ZULA
TSONG	WAAN	YEKE	
TSWA	WONGO	YELA	

ZAMBIA

AMBO	KWANDU	LWIMBI	SENGA
AUSHI	KWANGWA	MAMBWE	SEWA
BEMBA	LALA	MARAVI	SHILA
BENA	LAMBA	MASHI	SHINJI
BENA KAZEMBE	LENJE	MBUNDA	SHONA
BISA	LEYA	MBWELA	SOLI
BWILE	LIMA	MINUNGU	SWAKA
CEWA	LOMOTWA	MUKULU	TABWA
CHOKWE	LOZI	NDEMBU	TAMBO
FIPA	LUANO	NGANGELA	TONGA
HENGA	LUBA	NSENGA	TOTELA
ILA	LUCHAZI	NYAMWANGA	TUMBUKA
IWA	LUNDA	NYANJA	UNGA
KAONDE	LUNDA-LOVALE	NYASA	WE
KAWENDE	LUNDWE	NYEMBA	WIKO
KOLOLO	LUNGU	NYENGO	YEKE
KOREKORE	LUVALE	NYIHA	
KUNDA	LUYANA	ROTSE	
KWANDI	LWENA	SEBA	

ZIMBABWE

BARWE	KARANGA	MATABELE	TAWARA
CEWA	KOLOLO	NDAU	TONGA
DUMA	KOREKORE	NDEBELE	TSWA
ENHLA	KUNDA	NSENGA	TSWANA
HERA	LEMBA	ROTSE	VENDA
HIECHWARE	LOZI	ROZWI	ZANSI
HOLI	MANYIKA	SHANGA	ZEZURU
KALANGA	MARAVI	SHONA	

313

LIST OF ABBREVIATIONS
‡ = extensively indexed art sources

AA 1982	Adler, Alfred. 1982.
AAAI	Ibrahim, Abd Allah Ali. 1994.
AAG	Gerbrands, Adrian A. 1957.
AAG 1967	Gerbrands, Adrian A. 1967.
AB 1978	Badawy, Alexander. 1978.
ABJ	Bjorkelo, Anders J. 1976.
ABM	Maesen, Albert. 1959.
ABU	Boulanger, André. 1985.
AC	Coupez, A. 1955.
ACFC	Chaffin, Alain, and Françoise Chaffin. 1979.
ACL	Cauneille, A. 1968.
ACN	Nettleton, Anitra C.E. 1986.
ACPG	Gamitto, Antonio C.P. 1960.
AD	Duchâteau, Armand. 1990.
ADC	Claerhout, Adriaan. 1971.
ADG	Grüb, Andreas. 1992.
ADM	Mille, Adrien. 1970.
ADS	Sote, Adetoun. 1990.
AEM	Meeussen, A.E. 1954.
AEM 1952	Meeussen, A.E. 1952.
AF	Fisher, Angela. 1984.
AFD	Droogers, A.F. 1980.
AG	Gendreau, André, and Marie Dufour. 1992.
AGAG	Guenneguez, Andre, and Afo Guenneguez. 1992.
AGL	Lima, Augusto Guilherme. 1971.
AGMI	Ishumi, Abel G.M. 1980.
AH	Hauenstein, Alfred. 1967.
AHB	Hampâté Bâ, Amadou. 1994.
AHF	Fakhry, Ahmed. 1942.
AHP	Prins, A.H.J. 1961.
AHP 1952	Prins, A.H.J. 1952.
AIM	Misago, Alois. 1994.
AIR	Richards, Audrey. 1956.
AIR 1959	Richards, Audrey. 1959.
AJB	Butt, Audrey. 1964.
AJG	Glaze, Anita J. 1981.
AJGW	Wyse, Akintola J.G. 1980.
AJM	Makumbi, A.J. 1963.
AJW	Wills, A.J. 1967.
AK	Kagwa, Apolo. 1934.
AKI	East, Rupert, and Akiga. 1965.
AL	Lang, Alphonse. 1937.
ALB	Barnard, Alan. 1992.
ALG	Goemaere, Alphonse. 1988.
ALH	Harwood, Alan. 1970.
‡ ALM	Mignot, Alain. 1985.
ALR	Le Rouvreur, Albert. 1962.
ALV	Lavondès, Anne. 1961.
AM	Merlet, Annie. 1991.
AMB	Burssens, Amaat. 1954.
AMC	Champion, Arthur M. 1967.
AMD	Duperray, Anne-Marie. 1984.
AMDM	de Meireles, Artur Martins. 1960.
AML	Lebeuf, Annie M.D. 1959.
AMM	Martin del Molina, A. 1989.
AMP	Podlewski, Andre Michel. 1966.
AMV	Vergiat, Antonin M. 1937.
AMVM	Mawiri, Ambroisine, Victor Mbumba, and Vincent de Paul Nyonda. 1986.

ANB	Basset, André. 1952.
ANDH	Nettleton, Anitra, and D. Hammond-Tooke, eds. 1989.
ANG	Gnonsoa, Angèle. 1985.
ANH	Hjort, Anders, and Gudrun Dahl. 1991.
ANK	Kronenberg, Andreas. 1958.
ANK 1972	Kronenberg, Andreas. 1972.
APB	Bourgeois, Arthur P. 1984.
APB 1985	Bourgeois, Arthur P. 1985.
APLP	Ponter, Anthony, and Laura Ponter. 1993.
APM	Merriam, Alan P. 1982.
AR	Reikat, Andrea. 1990.
ARCF	Radcliffe-Brown, A.R., and C. Daryll Forde, eds. 1950.
AREM	Roberts, Allen F., and Evan M. Maurer, eds. 1985.
ARL	Retel-Laurentin, Anne. 1969.
ARU	Rubin, Arnold. 1976.
ARU 1969	Rubin, Arnold. 1969.
‡ ARW	Willcox, A.R. 1984.
AS	Shorter, Aylward. 1979.
‡ ASH	Schweeger-Hefel, Annemarie. 1969.
ASH 1973	Schweeger-Hefel, Annemarie, and Wilhelm Staude. 1973.
ASH 1980	Schweeger-Hefel, Annemarie. 1980.
AT	Tagliaferri, Aldo. 1974.
AT 1989	Tagliaferri, Aldo. 1989.
ATC	Culwick, Arthur T., and G.M. Culwick. 1935.
ATMB	Tucker, A.N., and M.A. Bryan. 1966.
ATMB 1956	Tucker, A.N., and M.A. Bryan. 1956.
AVV	de Veciana Vilaldach, Antonio. 1956.
AW	Wardwell, Allen. 1986.
AWF	Fedders, Andrew. 1977.
AWS	Southall, Aidan William. 1956.
AWW	Wolfe, Alvin W. 1961.
AYL	Lugira, Aloysius Muzzanganda. 1970.
BA	Akinsele, Bayo, and the Benin Museum. 1981.
BAF	Frank, Barbara. 1981.
BAL	Lewis, Bazett A. 1972.
BAR	Reynolds, Barrie. 1963.
BAR 1968	Reynolds, Barrie. 1968.
BBH	Hama, Boubou. 1968.
BC	Courteau, Bernard. 1974.
BCR	Ray, Benjamin C. 1991.
BD	Davidson, Basil. 1966.
BD 1959	Davidson, Basil. 1959.
BDG	de Grunne, Bernard. 1982.
‡ BDG 1980	de Grunne, Bernard, et al. 1980.
BEBG	Engelbrecht, Beate, and Bernhard Gardi, eds. 1989.
BEF 1977	Fagg, Bernard. 1977.
BEG	Gardi, Bernhard. 1986.
BEG 1985	Gardi, Bernhard. 1985.
BEG 1988	Gardi, Bernhard. 1988.
BEL	Lembezat, Bertrand. 1961.
BES	Söderberg, Bertil. 1956.
BF	Freyer, Bryna. 1987.
BG	Gottschalk, Burkhard. 1988.
BGD	Dennis, Benjamin G. 1972.
BGFL	Gratien, B., and F. le Saout. 1996.
BH	Holas, Bohumil. 1969. *Sculpture sénoufo.*
BH 1952	Holas, Bohumil. 1952.
BH 1962	Holas, Bohumil. 1962.
BH 1966	Holas, Bohumil. 1966.
BH 1969	Holas, Bohumil. 1969. *Arts traditionnels de la Côte d'Ivoire.*

BH 1975	Holas, Bohumil. 1975.
BHM	MacDermot, Brian Hugh. 1972.
BJC	Costermans, B.J. 1953.
BKT	Taylor, Brian K. 1962.
BL	Lala, Bevarrah. 1992.
BLB	Bellman, Beryl L. 1984.
BM	Menzel, Brigitte. 1968.
BM 1972	Menzel, Brigitte. 1972-73.
BMB	Barkindo, Bawuro M. 1989.
BMS	Brooklyn Museum Staff, eds. 1978.
BRL	Lokomba, Baruti. 1972.
BRS	Stefaniszyn, Bronislaw. 1964.
BS	Centre national de la recherche scientifique. *Bulletin Signalétique.*
BTM	Millroth, Berta. 1965.
BUG	Gutmann, Bruno. 1932-1938.
BWB	Blackmun, Barbara Winston. 1987.
CAE	Einstein, Carl. 1920.
CAK	Kratz, Corinne A. 1994.
CB	Bonnet, Charles, ed. 1990.
CDF	Forde, C. Daryll. 1969.
CDF 1954	Forde, C. Daryll, ed. 1954.
CDF 1964	Forde, C. Daryll. 1964.
CDL	Laughlin, Charles D., and Elizabeth A. Allgeier. 1979.
‡ CDR 1985	Roy, Christopher D. 1985.
‡ CDR 1987	Roy, Christopher D. 1987.
CE	Ehret, Christopher. 1974.
CEH	Hopen, C. Edward. 1958.
CEMP	Ehret, Christopher, and Merrick Posnansky. 1982.
CFGJ	Forde, C. Daryll, and G.I. Jones. 1952.
CFL	Falgayrettes-Leveau, Christiane, and Lucien Stéphan. 1993.
CFN	Fäik-Nzuji, Clémentine. 1992.
CFPB	Forde, C. Daryll, Paula Brown, and Robert C. Armstrong. 1970.
CFPK	Forde, C. Daryll, and P.M. Kaberry, eds. 1967.
CGW	Widstrand, Carl Gosta. 1958.
CH	Hayes, Charles. 1977.
CHB	Buhan, Christine, and Etienne Kange Essiben. 1979.
CHR	Ratton, Charles. 1931.
‡ CK	Kjersmeier, Carl. 1967.
CKJR	Kottak, Conrad Phillip, et al., eds. 1986.
CKM	Meek, Charles K. 1931.
CLH	Harries, C.L. 1929.
CLK	Kennedy, Carolee. 1978.
CLS	Semple, Clara. 1992.
CM	McPherson, Charlotte. 1978.
CMD	Doke, Clement Martyn. 1931.
CMF	Fyle, C. Magbaily. 1986.
CMG	Geary, Christraud M. 1988.
CMG 1983	Geary, Christraud M. 1983.
CMG 1994	Geary, Christraud M. 1994.
‡ CMK	Kreamer, Christine Mullen. 1986.
CMS	Sekintu, C.M., and K.P. Wachsmann. 1956.
CMT	Turnbull, Colin M. 1972.
CMT 1961	Turnbull, Colin M. 1961.
CO	Oppong, Christine. 1973.
COA	Adepegba, Cornelius Oyeleke. 1986.
CP	Petridis, Constantijn. 1992.
CRC	Cowen, Chester R. 1974.
CRG	Gaba, Christian R., ed. 1973.
CRH	Hallpike, Christopher R. 1972.
CSBS	Seligman, C.G., and Brenda Z. Seligman. 1932.

CSE	Estermann, Carlos. 1975-81.
CT 1960	Tardits, Claude. 1960.
CT 1980	Tardits, Claude. 1980.
CT 1981	Tardits, Claude. 1981.
CTH	Hodge, Carleton T., ed. 1971.
CUY	Cuypers, J. B. 1970.
CVN	Valiente Noailles, Carlos. 1993.
CWI	Ichegbo, Clement Waleru. 1992.
CWMN	White, Charles Matthew Newton. 1948.
DAB	Binkley, David. A. 1988.
DAT	Tait, David. 1961.
DB	Barreteau, Daniel. 1987.
DB 1978	Barreteau, Daniel, ed. 1978.
DBKM	Biebuyck, Daniel P., and Kahombo Mateene. 1969.
DBNV	Biebuyck, Daniel P., and Nelly Van den Abbeele. 1984.
DC	Costello, Dawn. 1990.
DCBF	Conrad, David C., and Barbara E. Frank, eds. 1995.
DCW	Western, Dominique Coulet. 1975.
DD	Darbois, Dominique. 1967.
DDMM	Mann, Michael, and David Dalby. 1987.
DED	Duerden, Dennis. 1971.
DF	Fraser, Douglas, ed. 1972.
DFHC	Fraser, Douglas, and Herbert M. Cole, eds. 1972.
DFM	McCall, Daniel F., and Edna G. Bay, eds. 1975.
DGD	Duquette, Danielle Gallois. 1983.
DH	Hersak, Dunja. 1986.
DHB	Herbst, D. 1985.
DHR	Ross, Doran H. 1979.
DHR 1983	Ross, Doran H., ed. 1983.
DHR 1992	Ross, Doran H. 1992.
DIP	Pelrine, Diane M. 1991.
DJM	Jacques-Meunié, D. 1961.
DJP	Parkin, David J. 1991.
DJS	Stenning, Derrick J. 1959.
DMCM	Mato, Daniel, and Charles Miller III. 1990.
DMW	Warren, Dennis M. 1975.
‡ DOA	Turner, Jane, ed. *Dictionary of Art*. 1996.
DOWF	Olderogge, Dmitry, and Werner Forman. 1969.
‡ DP	Paulme, Denise. 1962. *African Sculpture*.
DP 1940	Paulme, Denise. 1940.
DP 1954	Paulme, Denise. 1954.
DP 1962	Paulme, Denise. 1962. *Une société de Côte d'Ivoire.*
DP 1963	Paulme, Denise, ed. 1963.
DPB 1969	Biebuyck, Daniel P., ed. 1969.
DPB 1973	Biebuyck, Daniel P. 1973.
DPB 1978	Biebuyck, Daniel P. 1978.
DPB 1981	Biebuyck, Daniel P. 1981.
‡ DPB 1985	Biebuyck, Daniel P. 1985.
‡ DPB 1986	Biebuyck, Daniel P. 1986.
‡ DPB 1987	Biebuyck, Daniel P. 1987.
DPB 1994	Biebuyck, Daniel P. 1994.
DPG	Gamble, David P. 1957.
DPJB	Paulme, Denise, and Jacques Brosse. 1956.
DPMZ	Plaschke, Dietrich, and Manfred A. Zirngibl. 1992.
DR	Richter, Dolores. 1980.
DSN	Newbury, David S. 1979.
DST	Sigge-Taupe, Dietlinde. 1975.
DTN	Niane, Djibril Tamsir. 1989.
DV	Vangroenweghe, Daniel. 1988.
DV 1977	Vangroenweghe, Daniel. 1977.

DVB	Brokensha, David, ed. 1972.
DVZ	Zeitlyn, David. 1994.
DWMB	Westermann, Dietrich, and M.A. Bryan. 1952.
DWR	Robinson, David Wallace. 1975.
DZ	Zahan, Dominique. 1979.
DZ 1960	Zahan, Dominique. 1960.
DZ 1974	Zahan, Dominique. 1974.
DZ 1980	Zahan, Dominique. 1980.
EA	Andersson, Efraim. 1953.
EA 1987	Andersson, Efraim. 1987.
‡ **EB**	Bassani, Ezio. 1977.
EB 1986	Bassani, Ezio, et al. 1986.
EB 1989	Bassani, Ezio. 1989.
‡ **EBHK**	Beumers, Erna, and Hans-Joachim Koloss, eds. 1992.
EBJN	Bernus, Edmund, and Johannes Nicolaisen. 1982.
EBR	Encyclopaedia Britannica. 1980.
EBWF	Bassani, Ezio, and William Fagg. 1988.
EC	Colson, Elizabeth. 1949.
‡ **ECB**	Burt, Eugene C. 1980.
ECB 1983	Burt, Eugene C. 1983.
ECMG	Colson, Elizabeth, and Max Gluckman, eds. 1959.
EDA	Ardener, Edwin. 1956.
EDA 1962	Ardener, Edwin. 1962.
EDB	Bernus, Edmond. 1981.
EDB 1974	Bernus, Edmond. 1974.
EDB 1984	Bernus, Edmond. 1984.
EDD	de Dampierre, Eric. 1967.
EDE	Earthy, Emily Dora. 1933.
EDH	Hecht, Elisabeth-Dorothea. 1993.
EDT	Tengan, Edward. 1991.
EE	Eyo, Ekpo. 1977.
EEFW	Eyo, Ekpo, and Frank Willett. 1980.
EEP	Evans-Pritchard, E.E. 1976.
EEP 1940	Evans-Pritchard, E.E. 1940.
EEP 1949	Evans-Pritchard, E.E. 1949.
EEP 1951	Evans-Pritchard, E.E. 1951.
‡ **EEWF**	Elisofon, Eliot, and William Fagg. 1958.
EFHH	Fischer, Eberhard, and Hans Himmelheber. 1984.
EFLH	Fischer, Eberhard, and Lorenz Homberger. 1985.
EFLH 1986	Fischer, Eberhard, and Lorenz Homberger. 1986.
EG	Grohs, Elisabeth. 1980.
EH	Herold, Erich. 1967.
EHA	Adjakly, Edoh. 1985.
EHW	Winter, Edward H. 1956.
EJK	Krige, Eileen J., and Jacob Daniel Krige 1943.
EKH	Haberland, Eike. 1963.
EL	Lifschitz, Edward, ed. 1987.
ELBT	Turner, Edith L.B. 1992.
ELC	Cameron, Elisabeth. 1992.
ELP	Peters, Emrys L. 1990.
‡ **ELZ**	Leuzinger, Elsy. 1967.
ELZ 1950	Leuzinger, Elsy. 1950.
EMS	Shaw, Ella Margaret, and Nicholas van Warmelo. 1972-1988.
EMT	Thomas, Elizabeth Marshall. 1965.
EN	Nowack, Ernst. 1954.
‡ **ENS**	Schildkrout, Enid, ed. 1987.
EOA	Ayisi, Eric O. 1979.
EP	Pearson, Emil. 1977.
EPHE 4	École pratique des hautes études. 1979.
EPHE 5	École pratique des hautes études. 1981.

LIST OF ABBREVIATIONS

EPHE 8	École pratique des hautes études and Albert de Surgy, ed. 1987.
EPHE 9	École pratique des hautes études and Danouta Liberski, ed. 1986.
EPHE 10	École pratique des hautes études and Luc de Heusch, ed.. 1987.
EPHE 12	École pratique des hautes études and Albert de Surgy, ed. 1993.
EPS	Skinner, Elliott Percival. 1989.
ERB	Bylin, Eric. 1966.
ERC	Cerulli, Ernesta. 1956.
ERV	Vatter, Ernest. 1926.
‡ **ESCK**	Schildkrout, Enid, and Curtis A. Keim. 1990. *African Reflections.*
ESCK 1990	Schildkrout, Enid; and Curtis A. Keim. 1990. *Mangbetu Ivories.*
ESG	Goody, Esther N. 1973.
ET	Terray, Emmanuel. 1969.
ETHN	Grimes, Barbara F., ed. *Ethnologue Index.* 12th ed.
ETTJ	Torday, Emil, Thomas A. Joyce, and Norman H. Hardy. 1910.
EV	Verhulpen, Edmond. 1936.
EVA	Asihene, E.V. 1972.
EVS 1930	von Sydow, Eckart. 1930.
EVS 1954	von Sydow, Eckart. 1954.
EVT	Tobisson, Eva. 1986.
EVW	Winans, Edgar V. 1962.
EW	Wolfe, Ernie. 1986.
EWA	*Encyclopedia of World Art.* vol. 1. 1959.
EWM	Muller, Ernst W. 1957.
EWS	Smith, Edwin William. 1926.
FB	Bebey, Francis. 1975.
FCG	Gamst, Frederick C. 1969.
FE 1933	Éboué, Felix. 1933.
FEM	Makila, F.E. 1978.
FEO	Otchere, Freda E. 1992.
FG	Gistelinck, Frans, and M. Sabbe, eds. 1991.
FGR	Grévisse, F. 1956.
‡ **FHCP**	Herreman, Frank, and Constijn Petridis, eds. 1993.
FHE	Herreman, Frank, et al. 1991.
FHF	Herrman, Ferdinand. n.d.
FHF 1969	Herrman, Ferdinand. 1969.
FHM	Melland, Frank Hulme. 1923.
FHS	Hagenbucher-Sacripanti, Frank. 1973.
FK	Korsching, Friederike. 1980.
FL	Lafargue, Fernand. 1976.
FLVN	Van Noten, Francis L. 1983.
FMD	Deng, Francis M. 1972.
FMO	Olbrechts, Frans M. 1946.
FN	Neyt, François. 1985.
FN 1977	Neyt, François. 1977.
FN 1979	Neyt, François. 1979.
FN 1982	Neyt, François. 1982.
FN 1985	Neyt, François. 1985
FN 1994	Neyt, François. 1994.
FRF	Ferretti, Fred. 1975.
FRG	Gollbach, Friedrich. 1992.
FRK	Kroger, Franz. 1978.
FRV	Vivelo, Frank Robert. 1977.
FSM	Stoullig-Marin, Françoise. 1993.
FTS	Smith, Fred T. 1978.
FVGD	Van Riel, F., and G. De Plaen. 1967.
‡ **FW**	Willett, Frank. 1971.
FW 1967	Willett, Frank. 1967.
GA	Atkins, Guy, ed. 1972.
GAAC	Chernova, Galina A. 1967.
GAB	Boyer, Gaston. 1953.

GAC	Corbin, George A. 1988.
GAH	Hulstaert, Gustaaf. 1961.
GAH 1938	Hulstaert, Gustaaf. 1938.
GAH 1950	Hulstaert, Gustaaf. 1950.
GB	Buschan, Georg. 1922.
GBJM	Balandier, Georges, and Jacques Maquet. 1974.
‡ GBJS	Berjonneau, Gérald, Jean-Louis Sonnery, and Bernard de Grunne. 1987.
GC	Connah, Graham. 1987.
GCG 1968	Calame-Griaule, Geneviève. 1968.
GD 1972	Dieterlen, Germaine, and Youssouf Cissé. 1972.
GD 1988	Dieterlen, Germaine. 1988.
GDH	Hartwig, Gerald W. 1979.
GDP	de Plaen, Guy. 1974.
GDR	Gallery DeRoche. 1993.
GE	Eberhard, Giselle. 1983.
GED	Dupré, Georges. 1985.
GES	Schweinfurth, Georg. 1875.
GFS	Scanzi, Giovanni Franco. 1993.
GG	Gerster, Georg. 1970.
GGH	Harris, Grace G. 1978.
GGT	Geis-Tronich, Gudrun. 1991.
GH	Harley, George Way. 1950.
GHDV	Hulstaert, Gustaaf, D. Vangroenweghe, and H. Vinck. 1984.
GHZ	Heurtebize, Georges. 1986.
‡ GIJ	Jones, G.I. 1984.
GIT	Turle, Gillies. 1992.
GJJG	Jansen, Gerard, and J.G. Gauthier. 1973.
GJK	Klima, George J. 1970.
GK	Kay, George. 1964.
GKMM	Kubik, Gerhard, and M.A. Malamusi. 1987.
GL	Lindblom, Gerhard. 1918.
GLM	Le Moal, Guy. 1980.
GM	Manessy, Gabriel. 1979.
GMC	Childs, Gladwyn Murray. 1949.
GNB	Niangoran-Bouah, Georges. 1984-87.
GOL	Lienhardt, Godfrey. 1961.
GOW	Wilson, Godfrey. 1939.
GPM 1959	Murdock, George Peter. 1959.
GPM 1975	Murdock, George Peter. 1975.
GPN	Preston, George Nelson. 1985.
GR	Rouget, Gilbert. 1985.
GRC	Cardona, Giorgio R. 1989.
GRK	Kubik, Gerhard. 1987.
GS	Savonnet, Georges. 1976.
GSDS	Schröder, Günter, and Dieter Seibel. 1974.
GSGH	Schwab, George, and George W. Harley. 1947.
GSM	Meurant, Georges. 1986.
GT	Tessmann, Gunter. 1913.
GT 1934	Tessmann, Gunter. 1934.
GUB	Best, Gunter. 1993.
GUD	Dahl, Gudrun. 1979.
GW	Wagner, Gunter. 1970.
GWH	Huntingford, G.W.B. 1968.
GWH 1953	Huntingford, G.W.B. 1953.
GWH 1955	Huntingford, G.W.B. 1955.
GWH 1969	Huntingford, G.W.B. 1969.
GWS	Sannes, G.W. 1970.
HA	Ashton, E.H. 1952.
HAB	Bernatzik, Hugo A. 1954.
HAEF	Felgas, Helio A. Esteves. 1963.

HAJ	Junod, Henri Alexandre. 1897.
HAL	Lavachery, Henri. 1954.
HAS	Sani, Habibu A. 1993.
HB	Baumann, Hermann. 1975-1979.
HB 1935	Baumann, Hermann. 1935.
HBAG	Burssens, Herman, and Alain Guisson. 1992.
HBDW	Baumann, Hermann, and Dietrich Westermann. 1967.
HBR	Brandt, Henry. 1956.
HBU	Burssens, Herman. 1958.
HBU 1962	Burssens, Herman. 1962.
HC	Cory, Hans. 1956.
HCCA	Cole, Herbert M., and Chike C. Aniakor. 1984.
‡ HCDR	Cole, Herbert M., and Doran H. Ross. 1977.
HCF	Camps-Fabrer, Henriette. 1970.
HDG	Gunn, Harold D. 1953.
HDG 1956	Gunn, Harold D. 1956.
HDSV	Deschamps, Hubert, and Suzanne Vianes. 1959.
HE	Ebiatsa-Hopiel. 1990.
HEA	Aschwanden, Herbert. 1982.
HEH	Hochegger, Hermann. 1975.
HEL	Labouret, Henri. 1931.
HG	Gabreyesus, Hailemariam. 1991.
HGFC	Gunn, Harold D., and F.P. Conant. 1960.
HGH	Huber, Hugo. 1963.
HH	Himmelheber, Hans. 1960.
HH 1967	Himmelheber, Hans. 1967.
HH 1993	Himmelheber, Hans. 1993.
HIK	Kuper, Hilda. 1952.
HJD	Drewal, Henry John, John Pemberton III, and Rowland Abiodun. 1989.
HJD 1990	Drewal, Henry John, and Margaret Thompson Drewal. 1990.
HJK	Koloss, Hans-Joachim. 1990.
HJK 1977	Koloss, Hans-Joachim. 1977.
HJK 1987	Koloss, Hans-Joachim. 1987.
HK	Knöpfli, Hans. 1975.
HKG	Kammerer-Grothaus, Helke. 1991.
HKS	Schneider, Harold K. 1981.
HKS 1970	Schneider, Harold K. 1970.
HKTF	Koloss, Hans-Joachim, and Till Förster. 1990.
HKVV	Kuper, Hilda, J. Van Velsen, and A.J.B. Hughes. 1954.
HL	Loth, Heinrich. 1987.
HLH	Lhôte, Henri. 1955.
HLL	Ellert, H. 1984.
HLP	Leloup, Hélène et al. 1994.
HMC	Cole, Herbert M. 1970.
HMC 1982	Cole, Herbert M. 1982.
HMC 1989	Cole, Herbert M. 1989.
HMD	Dubois, Henri M. 1938.
HNB	Bantje, Han. 1978.
HOM	Monnig, Hermann O. 1978.
HPH	Hahn, Hans Peter. 1991.
HRZ	*Horizon History of Africa.* 1971.
HUD	Deschamps, Hubert. 1970.
HUD 1936	Deschamps, Hubert. 1936.
HUH	Hall, Henry Usher. 1938.
HUT	Tracey, Hugh. 1948.
HUZ	Zemp, Hugo. 1971.
HVG 1960	van Geluwe, Huguette. 1960.
HVGA	van Geluwe, Huguette. 1957. *Les Bira et les peuplades limitrophes.*
HVGB	van Geluwe, Huguette. 1957. *Mamvu-Mangutu et Balese-Mvuba.*
HVV	Vallois, Henri V., and Paulette Marquer 1976.

HVW	von Wissmann, Hermann, et al. 1988.
HW	Witte, Hans. 1988.
IAI	International African Institute Library. 1973.
IAS	International African Seminar, Jan Vansina, R. Mauny, and L.V. Thomas, eds. 1964.
ICWJ	Cunnison, Ian, and Wendy James, eds. 1972.
ID	Dugast, Idelette. 1955-60.
IDG	de Garine, Igor. 1964.
IE	Ebeling, Ingelore. 1987.
IEZ	INADES and Ernest Zocli. 1973.
IGC	Cunnison, Ian. 1966.
IGC 1959	Cunnison, Ian. 1959.
IKK	Katoke, Israel K. 1975.
IL	Leverenz, Irene. 1994.
IML	Lewis, I.M. 1961.
IML 1969	Lewis, I.M. 1969 (1955).
IMP	Pokornowski, Ila M., et al. 1985.
INK	Kimambo, Isaria N. 1969.
IS	Schapera, Isaac. 1930.
IS 1953	Schapera, Isaac. 1953.
ISAA	University of Iowa. 1986-1994. *Iowa Studies in African Art.*
IVS	Strecker, Ivo A. 1988.
IW	Wilks, Ivor. 1989.
JA	Ayliff, John, and Rev. Joseph Whiteside. 1962.
JAB	Berque, Jacques. 1954.
JAE	Engelbrecht, Jan Anthonie. 1936.
JAEN	Nenquin, Jacques A.E. 1963.
JAEN 1967	Nenquin, Jacques A.E. 1967.
‡ JAF	Fry, Jacqueline, ed. 1978.
JAG 1962	Goody, Jack. 1962.
JAG 1967	Goody, Jack. 1967.
JAG 1972	Goody, Jack. 1972.
JAG 1987	Goody, Jack. 1987.
JAS	Sweeney, James. 1970.
JB	Borgatti, Jean. 1979.
JB 1983	Borgatti, Jean. 1983.
JBA	Eicher, Joanne B. 1969.
JBJG	Braimah, J.A., and Jack Goody. 1967.
JBO	Boachie-Ansah, J. 1985.
JBR	Broster, Joan A. 1976.
JBRH	Bendor-Samuel, John, and Rhonda L. Hartell, eds. 1989.
JBX	Buxton, Jean. 1973.
‡ JC 1971	Cornet, Joseph. 1971.
‡ JC 1978	Cornet, Joseph. 1978.
JC 1982	Cornet, Joseph. 1982.
JCA	Anafulu, Joseph C. 1981.
JCF	Froelich, Jean-Claude, Pierre Alexandre, and Robert Cornevin. 1963.
JCF 1954	Froelich, Jean-Claude. 1954.
JCH	Haumant, Jean-Camille. 1929.
JCM	Mitchell, J. Clyde. 1956.
JCRT	Cornet, Joseph, and Robert Farris Thompson. 1981.
JCY	Yoder, John Charles. 1992.
‡ JD	Delange, Jacqueline. 1974.
JDC	Clark, J. Desmond. 1970.
JDF	Fage, J.D. 1978.
JDI	Dias, Jorge, et al. 1968.
JDMZ	Drouin, Jeannine, and Mohamed Aghali Zakara. 1979.
JDYP	Peel, John D.Y. 1983.
JE	Eid, Jakline, and Till Förster. 1988.
JEC 1958	Chapelle, Jean. 1958.
JEC 1982	Chapelle, Jean. 1982.

JEEL	Etienne-Nugue, Jocelyn, and Elisabeth Laget. 1985.
JEG 1958	Gabus, Jean. 1958.
JEG 1967	Gabus, Jean. 1967.
JEG 1971	Gabus, Jean. 1971.
JEL	Larochette, J. 1958.
JEMS	Etienne-Nugue, Jocelyn, and M. Saley. 1987.
JER	Redinha, Jose. 1965.
JF	Freedman, Jim. 1984.
JFJ	Jemkur, J.F. 1992.
JFLB	Les Bras, Jean François. 1971.
JFT	Thiel, Josef Franz. 1972.
JFV	Vincent, Jeanne Françoise. 1975.
JG 1963	Greenberg, Joseph H. 1963.
JGG	Gauthier, J.G. 1979.
JGK	Kennedy, John G., ed. 1978.
JGMN	Gluck, Julius, and Margot Noske. 1956.
JH	Hilberth, John. 1973.
JHD	Driberg, J.H.A. 1923.
JHH	Hill, J.H. 1967.
JHS	Soga, John Henderson. 1932.
JJ	Johnson, John William, and Fa-Digi Sisòkò. 1986.
JJM 1961	Maquet, Jacques J. 1961.
JJM 1972	Maquet, Jacques J. 1972.
JJP	Pawlik, Jacek Jan. 1990.
‡ JK	Kerchache, Jacques, Jean-Louis Paudrat, and Lucien Stéphan. 1993.
JKS	Spieth, Jakob. 1906.
‡ JL	Laude, Jean. 1971.
JL 1973	Laude, Jean. 1973.
JLG	Gibbs, James L., ed. 1965.
‡ JLS	Stanley, Janet L. 1986-1995.
JLTD	Lewis-Williams, J.David, and T.A. Dowson. 1989.
‡ JLW	Lewis-Williams, J. David. 1983.
JLW 1981	Lewis-Williams, J. David. 1981.
JLW 1990	Lewis-Williams, J. David. 1990.
JLW 1994	Lewis-Williams, J. David, and T.A. Dowson, eds. 1994.
JM	Murray, Jocelyn. 1981.
JMA	Mack, John. 1986.
JMA 1981	Mack, John. 1981.
JMA 1994	Mack, John, ed. 1994.
JMC	Chernoff, John Miller. 1979.
JMEW	Wognou, Jean Marcel Eugene. 1985.
JMF	Faris, James C. 1972
JMG	Gautier, Jean-Marie. 1950.
JMGK	Middleton, John, and Greet Kershaw. 1953.
JMHL	Maes, Joseph, and Henri Lavachery. 1930.
JMJS	Marquart, J., J.D. Schmeltz, and J.P.B. de Josselin De Jong. 1904-1916.
JMK	Keletigui, Jean Marie. 1978.
JML	Malan, J.S. 1974.
JMOB	Maes, Joseph, and Olga Boone. 1935.
JMR	Robert, J.M. 1949.
JMTD	Middleton, John, and David Tait, eds. 1958.
JNB	Brogger, Jan. 1986.
JNBO	Osogo, John N.B. 1965.
JNC	Comaroff, Jean. 1985.
JNG	Girard, Jean. 1967.
JNL	Lydall, Jean, and Ivo Strecker. 1979.
JOB	Beattie, John. 1971.
JOB 1960	Beattie, John. 1960.
JODO	de Oliveira, Jose Osorio. 1954.
JOJ	Jacobs, John. 1962.

JOK	Kenyatta, Jomo. 1938.
JOM	Middleton, John, ed. 1970.
JOM 1960	Middleton, John. 1960.
JOM 1992	Middleton, John. 1992.
JOP	Perrott, John. 1992.
JOR	Roscoe, John. 1928.
JOR 1923	Roscoe, John. 1923.
JOR 1924	Roscoe, John. 1924.
JOSA	Ayomike, J.O.S. 1990.
JOV	Vogel, Joseph O. 1994.
JP 1953	Leroi-Gourhan, André, and Jean Poirier. 1953.
JPAL	Lebeuf, Jean-Paul, and Annie Lebeuf. 1977.
‡ JPB	Barbier, Jean-Paul, et al. 1993.
JPB 1990	Barbier, Jean-Paul, ed. 1990.
JPE	Eschlimann, Jean-Paul. 1985.
‡ JPJM	Mack, John, and John Picton. 1989.
JPK	Kirby, Jon P. 1986.
JPL	Lebeuf, Jean-Paul. 1961.
JPL 1978	Lebeuf, Jean-Paul, et al. 1978.
JPL 1989	Lebeuf, Jeal-Paul, and Johannes Hermann Immo Kirsch. 1989.
JPM	Magnant, Jean-Pierre. 1986.
JPN	Notué, Jean-Paul. 1993.
JPO	Ombolo, Jean-Pierre. 1986.
JPOS	Olivier de Sardan, Jean-Pierre. 1984.
JQL	Lombard, Jacques. 1965.
JR	Rouch, Jean. 1954.
JRE	Roumeguère-Eberhardt, Jacqueline. 1963.
JS	Stauder, Jack. 1971.
JSB	Boston, J.S. 1977.
JSL	LaFontaine, J.S. 1959.
JSM	Mbiti, John S. 1990.
JSRA	Szwed, John F., and Roger D. Abrahams. 1978.
JTSV	Thompson, Jerry L., and Susan Vogel. 1990.
JV 1954	Vansina, Jan. 1954.
JV 1966	Vansina, Jan. 1966.
JV 1973	Vansina, Jan. 1973.
JV 1978	Vansina, Jan. 1978.
‡ JV 1984	Vansina, Jan. 1984.
JV 1990	Vansina, Jan. 1990.
JVW	Van Wing, J. 1959.
JW	Woodburn, James. 1970.
JWB	Burton, John W. 1987.
JWF	Fernandez, J.W. 1982.
JWN	Nunley, John Wallace. 1987.
JYA	Adamson, Joy. 1967.
JYL	Levenson, Jay A., ed. 1991.
JYM	Martin, Jean-Yves. 1970.
KDP	Patterson, Karl David. 1969.
KE	Ezra, Kate. 1988.
KE 1992	Ezra, Kate. 1992.
KEB	Banaon, Kouame Emmanuel. 1990.
KEG	Effah Gyamfi, Kwaku. 1985.
KFS	Schädler, Karl Ferdinand. 1987.
KFS 1989	Schädler, Karl Ferdinand. 1989.
KH	Heymer, Kay, ed. 1993.
KHE	Ebert, Karen Heide. 1975.
‡ KK 1960	Krieger, Kurt, and Gerdt Kutscher. 1960.
‡ KK 1965	Krieger, Kurt. 1965.
‡ KK 1990	Krieger, Kurt. 1990.
KL	Laman, Karl. 1953-1968.

KLT	Little, Kenneth. 1967.
KMT 1970	Trowell, Margaret. 1970 (1964).
KMT 1971	Trowell, Margaret. 1971.
KN	Nicklin, Keith. 1983.
KNG	Knoedler Gallery. 1991.
KNM	Mufuka, K. Nyamayaro. 1983.
KPW	Wachsmann, Klaus P., ed. 1971.
KSL	Loughran, Katheryne S., ed. 1986.
KZ	Zetterstrom, Kjell. 1976.
LAH	Holy, Ladislav. 1967.
LAH 1991	Holy, Ladislav. 1991.
LBPB	Bohannan, Laura, and Paul Bohannan. 1953.
LCB	Briggs, Lloyd Cabot. 1960.
LD	Djomo Lola. 1988.
LDB	de Beir, L. 1975.
LDH	de Heusch, Luc. 1955.
LDH 1995	de Heusch, Luc, ed. 1995.
LDS	de Sousberghe, Léon. 1959.
LEJ	Jefferson, Louise E. 1973.
LES	Stappers, Leo. 1953.
LEX	CICIBA. 1989.
LF	Frobenius, Leo. 1898.
LF 1933	Frobenius, Leo. 1933.
LH	Harries, Lyndon. 1944.
LIB	M. Lionel Bender, ed. 1983.
LIC	Colldén, Lisa. 1971.
LJPG	Gaskin, L.J.P. 1965.
LKL	Kohl-Larsen, Ludwig. 1958.
LLCS	Cavalli-Sforza, Luigi Luca, ed. 1986.
LM	Meyer, Laure. 1992.
LML	Lavazza, Luigia Maria. 1993.
LOH	Homberger, Lorenz, ed. 1991.
‡ **LP 1979**	Perrois, Louis. 1979.
‡ **LP 1985**	Perrois, Louis. 1985.
‡ **LP 1990**	Perrois, Louis, and Marta Sierra Delage. 1990.
‡ **LP 1993**	Perrois, Louis, ed. 1993.
LPM	Mair, Lucy Philip. 1974.
LPR 1969	Prussin, Labelle. 1969.
LPR 1986	Prussin, Labelle. 1986.
‡ **LPR 1995**	Prussin, Labelle, et al. 1995.
LS	Siroto, Leon. 1969.
LS 1995	Siroto, Leon. 1995.
LSD	Dubin, Lois Sherr. 1987.
LSG	Schomerus-Gernbock, Lotte. 1981.
LUM	Lumbwe Mudindaambi. 1976.
LVT	Thomas, L.V. 1959.
LWS	Swantz, Lloyd W. 1966.
MAB	Bekombo Priso, Manga, ed. 1993. *Défis et prodiges.*
MAB 1993	Bekombo Priso, Manga. 1993. *Ser hombre, ser alguien.*
MACK	Arnoldi, Mary Jo, and Christine Mullen Kreamer. 1995.
MAF	Fabunmi, M.A. 1969.
MAH	Hiltunen, Maija. 1986.
MAJ	Jaspan, M.A. 1953.
MAP	Père, Madeleine. 1988.
MAZ	Zirngibl, Manfred A. 1983.
MB	Bloch, Maurice. 1971.
MBBH	Berns, Marla C., and Barbara Rubin Hudson. 1986.
MBK	Kalanda, Mabika. 1992.
MBL	Lukhero, Matshakaza B. 1992.
MCA	Carey, Margret. 1991.

MCA 1986	Carey, Margret. 1986.
MCC	Courtney-Clark, Margaret. 1986.
MCD 1984	Dupré, Marie-Claude. 1984.
MCDP	Conner, Michael W., and Diane M. Pelrine. 1983
MCF	Fallers, Margaret Chave. 1960.
MCJ	Jedrej, M. Charles. 1995.
MCVG	van Grunderbeek, Marie-Claude. 1983.
MD	Dupire, Marguerite. 1962.
MDAT	Trouwborst, A.A., M. d'Hertefelt, and J.H. Scherer. 1962.
MDCB	Musée du Congo belge. 1932-50.
MDL	de Lestrange, Monique. 1955.
MDM	McLeod, M.D. 1981.
MEJM	Musée d'ethnographie and Jean-Claude Muller. 1994.
MEM	McCulloch, Merran. 1952.
MEM 1950	McCulloch, Merran. 1950.
MEM 1951	McCulloch, Merran. 1951.
MF	Fortes, Meyer. 1967.
MF 1987	Fortes, Meyer. 1987.
MFAA	Mamah Fousseni, Abby-Alphah Ouro-Djobo. 1984.
MFEP	Fortes, Meyer, and E.E. Evans-Pritchard, eds. 1940.
MFGD	Fortes, Meyer, and Germaine Dieterlen, eds. 1965.
‡ MFMK	Jahn, Jens, ed. (M. Felix et al.) 1996.
MG	Griaule, Marcel. 1947.
MG 1963	Griaule, Marcel. 1963.
MG 1965	Griaule, Marcel. 1965.
MGM	Marwick, M.G. 1965.
MGS	Smith, M.G. 1978.
MGU 1967	Guthrie, Malcolm. 1967.
‡ MH	Huet, Michel. 1978.
MHN	Nooter, Mary H., et al. 1993.
MHP	Piault, Marc Henri. 1970.
MHW	Wilson, Monica Hunter. 1951.
MI	Izard, Michel. 1970.
MIB	Bourdillon, M.F.C. 1976.
MIG	Gelfand, Michael. 1966.
MIP	Pennie, Michael. 1991.
MJ	Jackson, Michael. 1977.
MJA	Arnoldi, Mary Jo. 1995.
MJF	Field, Margaret Joyce. 1940.
MJH	Herskovits, Melville J. 1962.
MJH 1938	Herskovits, Melville J. 1938.
MJH 1967	Herskovits, Melville J. 1967.
MJHL	Melville J. Herskovits Library. 1972.
MJS	Swartz, Marc J. 1991.
‡ MK	Kecskési, Maria. 1987.
MKK	Kamara, Mamadou Koble. 1992.
MKW	Wittmer, Marcilene Keeling. 1976.
MKW 1978	Wittmer, Marcilene Keeling, and William Arnett. 1978.
MKW 1991	Wittmer, Marcilene Keeling. 1991.
‡ MLB	Bastin, Marie Louise. 1984.
MLB 1961	Bastin, Marie Louise. 1961.
MLB 1978	Bastin, Marie Louise. 1978.
MLB 1982	Bastin, Marie Louise. 1982.
‡ MLB 1994	Bastin, Marie Louise. 1994.
MLDA	de Areia, M.L. Rodrigues. 1985.
MLF	Felix, Marc Leo. 1987.
MLF 1989	Felix, Marc Leo. 1989.
‡ MLJD	Leiris, Michel, and Jacqueline Delange. 1968.
MLS	Swantz, Marja-Liisa. 1986.
MLS 1995	Swantz, Marja-Liisa. 1995.

LIST OF ABBREVIATIONS

MLV	Museum voor Land en Volkenkunde. 1957.
MM 1950	Manoukian, Madeline. 1950.
MM 1951	Manoukian, Madeline. 1951.
MM 1952	Manoukian, Madeline. 1952.
MME	Edel, May M. 1952.
MMG	Gilombe, Mudiji Malamba. 1989.
MMML	McCulloch, Merran, Margaret Littlewood, and I. Dugast. 1954.
MMN	Mantuba-Ngoma, Mabiala. 1989.
MMT	Maenhaut, M. 1939.
MOG	Gessain, Monique, and Marie-Therese Lestrange, eds. 1980.
MOG 1967	Gessain, Monique. 1967.
MOG 1976	Gessain, Monique. 1976.
MOH	Hassen, Mohammed. 1992.
MOM	Mekkawi, Mod. 1979.
MPA	Museum of Primitive Art. 1960.
MPF 1992	Ferry, Marie-Paule, and Ch. de Lespinay. 1992.
MPF 1991	Ferry, Marie-Paul. 1991.
MR	Rivière, Marceau. 1975.
MRAC 1960	Musée royal de l'Afrique centrale. 1960.
MRAC 1961	Musée royal de l'Afrique centrale. 1961.
MRAC 1962	Musée royal de l'Afrique centrale. 1962-81.
MRAC 1982	Musée royal de l'Afrique centrale. 1982-84.
MRAR	Roberts, Mary Nooter, and Allen F. Roberts, eds. 1996.
MRCB 1952	Musée du Congo belge. 1952-59.
MRF	Fontinha, Mario, and Acacio Videira. 1963.
MS	Soret, Marcel. 1959.
MSD	Delage, Marta Sierra. 1980.
MTD	Drewal, Margaret Thompson. 1992.
MTJT	Tubiana, Joseph, and Marie-José Tubiana. 1977.
MTKW	Trowell, Margaret, and K.P. Wachsmann. 1953.
MTL	Langley, Myrtle. 1979.
MTM	Mnyampala, Mathias E. 1995.
MTZ	Tahiri-Zagret, Michel. 1987.
MUD	Musée Dapper. 1988. *Art et mythologie; Figures tshokwe.*
MUD 1986	Musée Dapper. 1986.
MUD 1988	Musée Dapper. 1988. *Au royaume du signe.*
MUD 1991	Musée Dapper. 1991.
MUD 1994	Musée Dapper. 1994.
MUD 1995	Musée Dapper. 1995.
MUG	Gangambi, Muyaga. 1974.
MUK	Kabengele, Munaga. 1986.
MUM	Mainga, Mutumba. 1973.
MUS	Sanogo, Mustapha. 1985.
MVO	Van Offelen, Marion. 1983.
MVR	Raso, Manuel Villar. 1987.
MW	Wenzel, Marian. 1972.
MWM	Mount, Marshall Ward. 1973.
MWSV	Weber, Michael J., et al. 1987.
MYH	Heldman, Marilyn, et al. 1994.
NB	Ballif, Noel. 1992.
NBS	Schwartz, Nancy Beth. 1972.
NDB	Biya, Ndebi. 1987.
NGK	Kibango, Ngolo. 1976.
NHHG	Graburn, Nelson H.H., ed. 1967.
‡ NIB	Barley, Nigel. 1994.
NIB 1983	Barley, Nigel. 1983.
NIB 1988	Barley, Nigel. 1988.
NK	Kante, Nambala, and Pierre Erny. 1993.
NL	Levtzion, Nehemia. 1973.
NMAA	National Museum of African Art. 1992. *West African Strip-Woven Cloth.*

NOI	Ita, Nduntuei O. 1971.
NP	Pavitt, Nigel. 1991.
NVE	Van Everbroeck, Nestor. 1974.
OB 1961	Boone, Olga. 1961.
OB 1973	Boone, Olga. 1973.
OBZ	Boone, Olga. 1954.
OD	Dempwolff, Otto. 1916.
OGI	Iwo, O.G. 1991.
OGPS	Gollnhofer, Otto, et al. 1975.
OHDD	Danfulani, Umar Habila Dadem. 1995.
OI	Ikime, Obaro. 1972.
ON	Nduka, Otonti, ed. 1993.
OOE	Eneweke, Ossie Onuora. 1981.
OSN	Nuoffer, Oskar. 1925.
OUEE	Oxford University Expedition to Ethiopia. 1975.
PAG	Gebauer, Paul. 1979.
PAJB	Alexandre, P., and J. Binet. 1958.
PANB	Adler, Peter, and Nicholas Barnard. 1992. *African Majesty.*
PANB 1992	Adler, Peter, and Nicholas Barnard. 1992. *Asafo! African Flags of the Fante.*
PAS	Schebesta, Paul. 1933.
PB 1968	Bardon, Pierre. 1968.
PBA	Ben-Amos, Paula. 1980.
PBAB	Baxter, P.T.W., and Audrey Butt. 1953.
PBAR	Ben-Amos, Paula, and Arnold Rubin, eds. 1983.
PBEC	Bonté, Pierre, et al. 1991.
PBMI	Bonté, Pierre, and Michel Izard, eds. 1991.
PBPC	Bohannan, Paul, and Philip Curtin. 1988.
PC	Crociani, Paola. 1994.
PCM	Manchishi, P.C., and E.T. Musona. 1984-91.
PE	Elshout, Pierre. 1963.
PEB	Brandstrom, Per. 1986.
PEG	Geschiere, Peter. 1995.
PFB	Berliner, Paul F. 1978.
PG 1973	Garlake, Peter S. 1973.
‡ PG 1990	Garlake, Peter S. 1990.
PG 1995	Garlake, Peter S. 1995.
PGGA	Guillaume, Paul, and Guillaume Apollinaire. 1917.
PGPG	Gulliver, Pamela, and P.H. Gulliver. 1968.
‡ PH	Harter, Pierre. 1986.
PHG	Gulliver, P.H. 1963.
PHG 1971	Gulliver, P.H. 1971.
PIB	Bonnafe, Pierre. 1979.
PIM	Meauzé, Pierre. 1967.
PJD	Dark, Philip J.C. 1982.
PJH	Hountondji, Paulin J. 1983.
PJI	Imperato, Pascal J. 1983.
PJLV	Vandenhoute, P.J.L. 1948.
PJLV 1947	Vandenhoute, P.J.L. 1947.
PL	Lassalle, Phillippe, and Jean-Bernard Sugier. 1992.
PLM	Mercier, Paul. 1952.
PLM 1968	Mercier, Paul. 1968.
PLR	Ravenhill, Philip L. 1994.
PLR 1980	Ravenhill, Philip L. 1980.
PLS	Spencer, Paul. 1965.
PLT	Laburthe-Tolra, Philippe. 1985.
PMK	Kaberry, Phyllis Mary. 1952.
PMPO	Martin, Phyllis M., and Patrick O'Meara. 1986.
POD	Dada, Paul O. 1985.
PP	Pickford, Peter, Beverly Pickford, and Margaret Jacobsohn. 1990.
‡ PR	Robertshaw, Peter, ed. 1990.

LIST OF ABBREVIATIONS

PRM	McNaughton, Patrick R. 1988.
PRM 1975	McNaughton, Patrick R. 1975.
PRM 1979	McNaughton, Patrick R. 1979.
PS	Stevens, Phillips. 1978.
PSG	Gilfoy, Peggy Stoltz. 1987.
PST	Stoller, Paul. 1987.
PSW	Wingert, Paul S. 1950.
PTM	Meyer, Piet, Isabelle Wettstein, and Brigitte Kauf. 1981.
PVC	Cotte, Paul Vincent. 1947.
PVD	van Dongen, Paul, Matthi Forrer, and Willem R. van Gulik. 1987.
PW	Westerdijk, Peter. 1988. *The African Throwing Knife.*
PW 1988	Westerdijk, Peter. 1988. *Symbols of Wealth.*
RAB	Bravmann, René A. 1973.
RAHD	Abiodun, Rowland, Henry John Drewal, and John Pemberton III, eds. 1994.
RAHD 1991	Abiodun, Rowland, Henry John Drewal, and John Pemberton III. 1991.
RAL	LeCoq, Raymond. 1953.
RBB	Boeder, Robert B. 1984.
RBJ	Jaulin, Robert. 1985.
RBL	Lee, Richard B. 1979.
RBP	Phillips, Ruth B. 1995.
RC	Cohen, Ronald. 1967.
RCS	Stevenson, R.C. 1984.
RDB	de Beaucorps, Remi. 1933.
REB	Bradbury, R.E., and P.C. Lloyd. 1957.
RF	Fardon, Richard. 1990.
RFG	Gray, Robert F. 1963.
RFT	Thompson, Robert Farris. 1971.
‡ RFT 1974	Thompson, Robert Farris. 1974.
RFT 1983	Thompson, Robert Farris. 1983. *Flash of the Spirit.*
RFTH	Thompson, Robert Farris. 1983. *Painting From a Single Heart.*
RG	Gaffé, René. 1945.
RGA	Abrahams, R.G. 1967. *The Peoples of Greater Unyamwezi.*
RGA 1967	Abrahams, R.G. 1967. *The Political Organization of Unyamwezi.*
RGL	Robert Goldwater Library. 1982.
RGS	Summers, Roger. 1958.
RGW	Willis, Roy G. 1966.
RH	Horton, Robin. 1965.
RHF	Finnegan, Ruth H. 1965.
RIH	Huntington, Richard. 1988.
RJ 1958	Jones, Ruth. 1958.
RJ 1959	Jones, Ruth. 1959.
RJ 1960	Jones, Ruth. 1960.
RJ 1961	Jones, Ruth. 1961.
RJG	Goldwater, Robert John. 1960.
RJG 1986	Goldwater, Robert John. 1986.
RL	Linton, Ralph. 1933.
‡ RLD 1974	Lehuard, Raoul. 1974.
RLD 1977	Lehuard, Raoul. 1977.
RLD 1980	Lehuard, Raoul. 1980.
RLD 1989	Lehuard, Raoul. 1989.
RMD	Downes, Rupert Major. 1971.
RME	Effa, Rene-Marie, and J.B. Fotso Guifo. 1984.
RMLP	Plant, Ruth M.L. 1985.
RMP	Packard, Randall M. 1981.
RMS	Stone, Ruth M. 1982.
ROB	Brain, Robert, and Adam Pollock. 1971.
ROB 1980	Brain, Robert. 1980.
ROF	Fouquer, Roger. 1971.
ROJF	Oliver, Roland, and J.D. Fage, eds. 1982.
ROL	Levinsohn, Rhoda. 1984.

ROMC	Oliver, Roland, and Michael Crowder, eds. 1981.
ROP	Poynor, Robin. 1995.
ROS	Schmitz, Robert. 1912.
RP	Peterli, Rita. 1971.
RPT	Trilles, R.P. 1932.
RR	Redfield, Robert, Melville Herskovits Jr., and Gordon F. Ekholm. 1959.
RRG	Grinker, Roy R. 1994.
RRPR	Ritzenthaler, Robert E. and Pat Ritzenthaler. 1962.
RS	Sieber, Roy, Douglas Newton, and Michael D. Coe. 1986.
‡ **RS 1972**	Sieber, Roy. 1972.
‡ **RS 1980**	Sieber, Roy. 1980.
‡ **RSAR**	Sieber, Roy, and Arnold Rubin. 1968.
RSR	Rattray, Robert Sutherland. 1923.
RSR 1927	Rattray, Robert Sutherland. 1927.
RSR 1932	Rattray, Robert Sutherland. 1932.
RSRW	Sieber, Roy, and Roslyn Adele Walker. 1987.
RSW	Wassing, René S. 1968.
RT	Tonnoir, René. 1970.
RT 1966	Tonnoir, René. 1966.
RTJ	Johnson, R. Townley. 1979.
RW	Widman, Ragnar. 1967.
RWH	Harms, Robert W. 1987.
RWL	Wente-Lukas, Renate. 1985.
RWL 1977	Wente-Lukas, Renate. 1977.
SA 1992	Ardener, Shirley, ed. 1992.
SAB	Boone, Sylvia Ardyn. 1986.
SACW	Waane, S.A.C. 1976.
SAM	Marks, Stuart A. 1976.
SB	Bahuchet, Serge, ed. 1979.
SB 1985	Bahuchet, Serge. 1985.
SBJB	Blair, Sheila, and Jonathan Bloom. 1994.
SBO	Bocola, Sandro, ed. 1995.
SBS	Brett-Smith, Sarah C. 1994.
SC	Curtil, Sophie. 1992.
SCA	Abega, Severin Cecile. 1987.
SD	Denyer, Susan. 1978.
SDB	Drucker-Brown, Susan. 1975.
SE	Eneyo, Silas. 1991.
SEH	Holsoe, Svend E. 1979.
SEH 1967	Holsoe, Svend E. 1967.
SFN	Nadel, S.F. 1947.
SFN 1942	Nadel, S.F. 1942.
SFS	Seitz, Stefan. 1970.
SG	Greub, Suzanne, ed. 1988.
SGAL	de Ganay, Solange, et al. 1987.
SH	Hale, Sondra. 1973.
SHD	Deane, Shirley. 1985.
SIA	Arom, Simha. 1974.
SK	Koudolo, Svetlana. 1991.
SKM	McIntosh, Susan K., ed. 1995.
SMF	Friedson, Steven M. 1996.
SMI	Smithsonian Institution. 1991.
SMPP	Moore, Sally Falk, and Paul Puritt. 1977.
SN	Na'ibi, Shuaibu, and Aphaji Hassam. 1969.
SNEK	Ejedepang-Koge, Samuel Ngome. 1971.
SO	Ottenberg, Simon. 1975.
SO 1989	Ottenberg, Simon. 1989.
SOB	Babayemi, S.O. 1991.
SOPO	Ottenberg, Simon, and Phoebe Ottenberg, eds. 1963.
SPB	Blier, Suzanne Preston. 1982.

LIST OF ABBREVIATIONS

SPB 1987	Blier, Suzanne Preston. 1987.
SPB 1995	Blier, Suzanne Preston. 1995.
SS	Saberwal, Satish. 1972.
STF	Feierman, Steven. 1974.
STS	Santandrea, Stefano. 1966.
SUL	Lagercrantz, Sture. 1950.
SV	Vogel, Susan Mullin, ed. 1981.
SV 1986	Vogel, Susan Mullin. 1986.
‡ **SV 1988**	Vogel, Susan Mullin, et al. 1988.
SVB	Bjerke, Svein. 1981.
‡ **SVFN**	Vogel, Susan Mullin, and Francine N'Diaye. 1985.
SVPR	Vogel, Susan Mullin, and Philip L. Ravenhill. 1980.
SYN	Ntara, Samuel Yosia. 1973.
SZ	Zangabadt, Sen Luka Gwom. 1992.
TAD	Dowson, T.A. 1992
TAH	Hale, Thomas A. 1990.
TB	Bodrogi, Tibor. 1968.
TC	Celenko, Theodore. 1983.
TDCT	Delachaux, Théodore, and Charles Emile Thiébaud. 1933.
‡ **TERV**	Verswijver, Gustaaf, et al., eds. 1995.
TEW	Tew, Mary Douglas. 1950.
TEW 1963	Tew, Mary Douglas. 1963.
TF 1988	Förster, Till. 1988.
‡ **TFG**	Garrard, Timothy F. 1989.
TFP	Pacere, Titinga Frédéric. 1991.
TLPM	Lundbaek, Torben, and Poul Mørk. 1968.
TM	Magor, Thomasin. 1994.
TN 1973	Northern, Tamara. 1973.
TN 1975	Northern, Tamara. 1975.
TN 1984	Northern, Tamara. 1984.
TN 1986	Northern, Tamara. 1986.
TO	CICIBA and Theophile Obenga. 1989.
TO 1976	Obenga, Theophile. 1976.
TOB	Beidelman, T.O. 1971.
TOB 1967	Beidelman, T.O. 1967.
TOS	Saitoti, Tepilit Ole. 1980.
TOZ	Tozzer Library. 1981.
‡ **TP**	Phillips, Tom, ed. 1995.
TS	Shaw, Thurstan. 1977.
TS 1993	Shaw, Thurstan, et al., eds. 1993.
TSA	Atabe, Thomas Sube. 1979.
TWCS	Sumaili, Tobias W.C. 1986.
UGH	UNESCO *General History of Africa*. 1981.
UIH	UNESCO *African Ethnonyms and Toponyms*. 1984.
UR	Röschenthaler, Ute. 1993.
VCU 1965	Uchendu, Victor C. 1965.
VGJS	Sheddick, Vernon George John. 1953.
VIG	Grottanelli, Vinigi. 1977-78.
VIL	Lanternari, Vittorio. 1976.
VL	Lamb, Venice. 1975.
VP	Pâques, Viviana. 1954.
VP 1964	Pâques, Viviana. 1964.
VP 1977	Pâques, Viviana. 1977.
VWT	Turner, Victor Witter. 1967.
VWT 1953	Turner, Victor Witter. 1953. *The Lozi Peoples of North-Western Rhodesia.*
VWT 1986	Turner, Victor Witter. 1986.
VWTU	Turner, Victor Witter. 1953. *Luanda Rites and Ceremonies.*
WAMS	d'Azevedo, Warren L., and Marvin D. Solomon. 1962.
‡ **WBF 1964**	Fagg, William Buller. 1964.
WBF 1968	Fagg, William Buller. 1968.

WBF 1980	Fagg, William Buller. 1980.
WBF 1982	Fagg, William, John Pemberton III, and Bryce Holcombe, eds. 1982.
WDH	Hammond-Tooke, W.D., ed. 1974.
WDH 1962	Hammond-Tooke, W.D. 1962.
WDM	de Mahieu, Wauthier. 1980.
WDM 1985	de Mahieu, Wauthier. 1985.
WEVB	van Beek, W.E.A. 1987.
WEW 1973	Welmers, William E. 1973.
WFB	Burton, W.F. 1961.
WFJP	Fagg, William, and John Picton. 1978.
WG 1980	Gillon, Werner. 1980.
‡ **WG 1984**	Gillon, Werner. 1984.
WH	Hirschberg, Walter. 1965.
WHGH	Haacke, Wilfrid H.G. 1982.
WIR	Rubin, William, ed. 1984.
WIS	Shack, William A. 1974.
WIS 1966	Shack, William A. 1966.
WJ	James, Wendy. 1988.
WJL	Lange, Werner J. 1975.
WKAK	Kronenberg, Waltraud, and A. Kronenberg. 1981.
WLA	d'Azevedo, Warren L., ed. 1973.
WLA 1965	d'Azevedo, Warren L. 1965.
WLA 1972	d'Azevedo, Warren L. 1972.
WLH	Hofmayr, Wilhelm. 1925.
WLL	Leslau, Wolf. 1969.
WLL 1957	Leslau, Wolf. 1957.
WM	MacGaffey, Wyatt. 1970.
WM 1986	MacGaffey, Wyatt. 1986.
WM 1991	MacGaffey, Wyatt. 1991.
WM 1993	MacGaffey, Wyatt, and Michael D. Harris. 1993.
WMB	van Binsbergen, Wim. 1992.
WMR	Robbins, Warren M. 1966.
WOB	Bleek, Wolf. 1975.
WOH	Heise, Wolfram, Antje Spliethoff-Laiser, and Sybille Wolkenhauer. 1993.
‡ **WRB**	Bascom, William Russell. 1973.
WRB 1959	Bascom, William Russell, and Melville J. Herskovits, eds. 1959.
WRB 1969	Bascom, William Russell. 1969. *Ifa Divination.*
WRBB	Bascom, William Russell. 1969. *The Yoruba of Southwestern Nigeria.*
WRG	Goldschmidt, Walter. 1967.
WRG 1976	Goldschmidt, Walter. 1976.
‡ **WRNN**	Robbins, Warren M., and Nancy Ingram Nooter. 1989.
WRO	Ochieng, William Robert. 1974.
‡ **WS**	Schmalenbach, Werner, ed. 1988.
WSS	Simmons, William Scranton. 1971.
WVB	Brelsford, William Vernon. 1965.
WVD	Davies, W.V., ed. 1991.
WW	Watson, William. 1958.
WWJS	Whiteley, Wilfred H., and J. Slaski. 1950.
YHH	Habi, Ya'akub H. 1987.
YR	Regnier, Yves. 1938.
YW	Wane, Yaya. 1969.
ZL	Ligers, Ziedonis. 1964.

BIBLIOGRAPHY

Abega, Severin Cecile. 1987. *L'esana chez les Beti*. Yaounde: Éditions CLE.

Abiodun, Rowland, Henry John Drewal, and John Pemberton III. 1991. *Yoruba: Art and Aesthetics*. Zurich: Museum Rietburg.

_____, eds. 1994. *The Yoruba Artist: New Theoretical Perspectives on African Arts*. Washington: Smithsonian Institution Press.

Abrahams, R.G. 1967. *The Peoples of Greater Unyamwezi, Tanzania (Nyamwezi, Sukuma, Sumbwa, Kimbu, Konongo)*. London: International African Institute.

_____. 1967. *The Political Organization of Unyamwezi*. Cambridge: Cambridge University Press.

Adamson, Joy. 1967. *The Peoples of Kenya*. New York: Harcourt, Brace and World.

Adepegba, Cornelius Oyeleke. 1986. *Decorative Arts of the Fulani Nomads*. Ibadan: Ibadan University Press.

Adjakly, Edoh. 1985. *Pratique de la tradition religieuse et reproduction sociale chez les Guen/Mina du sud-est du Togo*. Geneva: Institut universitaire d'études du développement.

Adler, Alfred. 1982. *La mort et le masque du roi: Royauté sacrée des Moundang du Tchad*. Paris: Payot.

Adler, Peter, and Nicholas Barnard. 1992. *African Majesty: The Textile Art of the Ashanti and Ewe*. London: Thames and Hudson.

_____. 1992. *Asafo! African Flags of the Fante*. London: Thames and Hudson.

African-American Institute. 1978. *African Grass and Fiber Arts*. New York: The African-American Institute.

Akinsele, Bayo, and the Benin Museum. 1981. *The Treasures of Chief Nanna of Itsekiri: An Exhibition Organized by the Benin National Museum*. Benin City: National Commission for Museums and Monuments.

Alexandre, P., and J. Binet. 1958. *Le groupe dit Pahouin (Fang-Boulou-Beti)*. Paris: Presses universitaires de France.

Anafulu, Joseph C. 1981. *The Ibo-Speaking Peoples of Southern Nigeria: A Selected Annotated List of Writings 1627-1970*. Munich: Kraus International.

Andersson, Efraim. 1953. *Les Kuta*. Uppsala: Studia ethnographica upsaliensia.

_____. 1987. *Ethnologie religieuse des Kuta: Mythologie et folklore*. 3 vols. Uppsala: Forutvarande institutionen for allman och jamforande etnografi vid Uppsala Universitet.

Ardener, Edwin. 1956. *The Coastal Bantu of the Cameroons*. London: International African Institute.

_____. 1962. *Divorce and Fertility: An African Study*. London: Oxford University Press.

Ardener, Shirley, ed. 1992. *Persons and Powers of Women in Diverse Cultures: Essays in Commemoration of Audrey I. Richards, Phyllis Kaberry, and Barbara E. Ward*. New York: Berg.

Arnoldi, Mary Jo. 1995. *Playing with Time: Art and Performance in Central Mali*. Bloomington: Indiana University Press.

Arnoldi, Mary Jo, and Christine Mullen Kreamer. 1995. *Crowning Achievements: African Arts of Dressing the Head*. Los Angeles: Fowler Museum of Cultural History, UCLA.

Arom, Simha. 1974. *Les Mimbo, génies du piègeage, et le monde surnaturel des Ngbaka-Mabo, République Centrafricaine*. Paris: SELAF.

Art and Architecture Thesaurus. 1996. The Getty Art History Information Program. AAT: ART, Version 2.1. New York: Oxford University Press for the J. Paul Getty Trust.

Aschwanden, Herbert. 1982. *Symbols of Life: An Analysis of the Consciousness of the Karanga*. Gweru, Zimbabwe: Mambo Press.

BIBLIOGRAPHY

Ashton, E.H. 1952. *The Basuto*. London: Oxford University Press for the International African Institute.

Asihene, E.V. 1972. *Introduction to Traditional Art of Western Africa*. London: Constable.

Atabe, Thomas Sube. 1979. *Religion in Bakossi Traditional Society: A Literary Enquiry*. Yaounde: Atabe.

Atkins, Guy, ed. 1972. *Manding Art and Civilization*. London: Studio International.

Ayisi, Eric O. 1979. *An Introduction to the Study of African Culture*. 2d ed. London: Heinemann Educational.

Ayliff, John, and Rev. Joseph Whiteside. 1962. *A History of the Abambo*. Cape Town: C. Struik.

Ayomike, J.O.S. 1990. *The Itsekiri at a Glance*. Benin City: Mayomi.

Babayemi, S.O. 1991. *Topics on Oyo History*. Lagos: Lichfield Nigeria.

Badawy, Alexander. 1978. *Coptic Art and Archaeology: The Arts of the Christian Egyptians from the Late Antique to the Middle Ages*. Cambridge: MIT Press.

Bahuchet, Serge. 1985. *Les Pygmées aka et la fôret centraficaine: Ethnologie écologique*. Paris: SELAF.

_____, ed. 1979. *Pygmées du Centrafrique: Études ethnologiques, historiques et linguistiques sur les Pygmées "Ba Mbenga" (Aka/Baka) du nord-ouest du bassin congolais*. Paris: SELAF.

Balandier, Georges, and Jacques Maquet. 1974. *Dictionary of Black African Civilization*. New York: Leon Amiel.

Ballif, Noel. 1992. *Les Pygmées de la grande forêt (Aka, Baka, Sangha, Lobaye)*. Paris: Harmattan.

Banaon, Kouame Emmanuel. 1990. *Poterie et société chez le Nuna de Tierkou*. Stuttgart: Franz Steiner.

Bantje, Han. 1978. *Kaonde Song and Ritual*. Tervuren: Musée royal de l'Afrique centrale.

Barbier, Jean Paul, ed. 1990. *Art pictural des Pygmées*. Geneva: Barbier-Mueller Museum.

Barbier, Jean Paul, et al. 1993. *Art of Côte d'Ivoire: From the Collections of the Barbier-Mueller Museum*. 2 vols. Geneva: Barbier-Mueller Museum.

Bardon, Pierre. 1968. *Collection des masques d'or Baoulé de l'IFAN*. Dakar: IFAN.

Barkindo, Bawuro M. 1989. *The Sultanate of Mandara to 1902: A History of the Evolution, Development and Collapse of a Central Sudanese Kingdom*. Stuttgart: Franz Steiner.

Barley, Nigel. 1983. *Symbolic Structures: An Exploration of the Culture of the Dowayos*. Cambridge: Cambridge University Press.

_____. 1988. *Foreheads of the Dead: An Anthropological View of Kalabari Ancestral Screens*. Washington: Smithsonian Institution Press for the National Museum of African Art.

_____. 1994. *Smashing Pots: Feats of Clay from Africa*. London: British Museum Press.

Barnard, Alan. 1992. *Hunters and Herders of Southern Africa: A Comparative Ethnography of the Khoisan Peoples*. Cambridge: Cambridge University Press.

Barreteau, Daniel. 1987. *Langues et cultures dans le bassin du lac Tchad: Journées d'études les 4 et 5 septembre 1984, ORSTOM (Paris)*. Paris: Éditions de l'ORSTOM.

_____, ed. 1978. *Inventaire des études linguistiques sur les pays d'Afrique noire d'expression française et sur Madagascar*. Paris: Conseil international de la langue française.

Bascom, William Russell. 1969. *Ifa Divination: Communication between Gods and Men in West Africa*. Bloomington: Indiana University Press.

_____. 1969. *The Yoruba of Southwestern Nigeria*. New York: Holt, Rinehart and Winston.

_____. 1973. *African Art in Cultural Perspective: An Introduction.* New York: W.W. Norton.

Bascom, William Russell, and Melville J. Herskovits, eds. 1959. *Continuity and Change in African Cultures.* Chicago: University of Chicago Press, Phoenix Books.

Bassani, Ezio. 1977. *Scultura africana nei musei italiani.* Bologna: Edizioni Calderini.

_____. 1989. *La grande scultura dell'Africa nera.* Florence: Artificio.

Bassani, Ezio, and William Fagg. 1988. *Africa and the Renaissance: Art in Ivory.* New York: Center for African Art/Prestel-Verlag.

Bassani, Ezio, et al. 1986. *Arte in Africa: Realtà e prospettive nello studio della storia delle arti africane (*Art in Africa: Reality and Perspectives in a Study of the History of African Arts). Modena: Edizioni Panini.

Basset, André. 1952. *La langue berbère.* London: Oxford University Press for the International African Institute.

Bastin, Marie Louise. 1961. *Art décoratif Tshokwe.* 2 vols. Lisbon: Museo do Dundo.

_____. 1978. *Statuettes Tshokwe du héros-civilisateur "Tshibinda Ilunga."* Arnouville: Arts d'Afrique noire.

_____. 1982. *La sculpture Tshokwe.* Meudon: Alain et Françoise Chaffin.

_____. 1984. *Introduction aux arts d'Afrique noire.* Arnouville: Arts d'Afrique noire.

_____. 1994. *Sculpture angolaise, mémorial des cultures.* Lisbon: Electa.

Baumann, Hermann. 1935. *Lunda. Bei Bauern und Jägern in Inner-Angola: Ergebnisse der Angola-Expedition des Museums für Völkerkunde, Berlin.* Berlin: Wurfel Verlag.

_____. 1975-1979. *Die Völker Afrikas und ihre traditionellen Kulturen.* Vols. 1-2. Wiesbaden: Franz Steiner.

Baumann, Hermann, and Diedrich Westermann. 1967. *Les peuples et les civilisations de l'Afrique suivi de: Les langues et l'éducation.* Paris: Payot.

Baxter, P.T.W., and Audrey Butt. 1953. *The Azande and Related Peoples of the Anglo-Egyptian Sudan and Belgian Congo.* London: International African Institute.

Beattie, John. 1960. *Bunyoro: An African Kingdom.* New York: Holt.

_____. 1971. *The Nyoro State.* Oxford: Clarendon Press.

Bebey, Francis. 1975. *African Music: A People's Art.* New York: Lawrence Hill.

Beidelman, T.O. 1967. *The Matrilineal Peoples of Eastern Tanzania (Zaramo, Luguru, Kaguru, Ngulu, etc.).* London: International African Institute.

_____. 1971. *The Kaguru: A Matrilineal People of East Africa.* New York: Holt, Rinehart and Winston.

Bekombo Priso, Manga. 1993. *Ser hombre, ser alguien: Ritos e iniciaciones en el sur del Camerun.* Bellaterra: Servei de Publicacions de la Universitat Autonoma de Barcelona.

_____, ed. 1993. *Défis et prodiges: La fantastique histoire de Djèki-la-Njambe.* Paris: Association des classiques africains.

Bellman, Beryl L. 1984. *The Language of Secrecy: Symbols and Metaphors in Poro Ritual.* New Brunswick, N.J.: Rutgers University Press.

Ben-Amos, Paula. 1980. *Art of Benin.* New York: Thames and Hudson.

Ben-Amos, Paula, and Arnold Rubin, eds. 1983. *The Art of Power, the Power of Art: Studies in Benin Iconography.* Los Angeles: Museum of Cultural History, UCLA.

Bender, M. Lionel, ed. 1983. *Nilo-Saharan Language Studies.* East Lansing: African Studies Center, Michigan State University.

Bendor-Samuel, John, and Rhonda L. Hartell, eds. 1989. *The Niger-Congo Languages: A Classification and Description of Africa's Largest Language Family.* Lanham: University Press of America.

Berjonneau, Gérald, Jean-Louis Sonnery, and Bernard de Grunne. 1987. *Chefs-d'oeuvre inédits de l'Afrique noire (*Rediscovered Masterpieces of African Art). Paris: Bordas.

BIBLIOGRAPHY

Berliner, Paul F. 1978. *The Soul of Mbira: Music and Traditions of the Shona People of Zimbabwe.* Berkeley and Los Angeles: University of California Press.

Bernatzik, Hugo A. 1954. *Die Neue Grosse Völkerkunde: Völker und Kulturen der Erde in Wort und Bild.* Frankfurt am Main: Herkul.

Berns, Marla C., and Barbara Rubin Hudson. 1986. *The Essential Gourd: Art and History in Northeastern Nigeria.* Los Angeles: Museum of Cultural History, UCLA.

Bernus, Edmond. 1974. *Les Illabakan (Niger): Une tribu touarègue sahélienne et son aire de nomadisation.* Paris: ORSTOM.

_____. 1981. *Touaregs nigériens: Unité culturelle et diversité régionale d'un peuple pasteur.* Paris: Éditions de l'ORSTOM.

_____. 1984. *Touaregs.* Paris: Berger-Levrault.

Bernus, Edmund, and Johannes Nicolaisen. 1982. *Études sur les Touaregs.* Niamey: Institut de recherches en sciences humaines.

Berque, Jacques. 1954. *Les Seksawa. Recherches sur les structures sociales du Haut-Atlas occidental.* Paris: Presses universitaires de France.

Best, Gunter. 1993. *Marakwet and Turkana: New Perspectives on the Material Culture of East African Societies.* Frankfurt am Main: Museum für Völkerkunde.

Beumers, Erna, and Hans-Joachim Koloss, eds. 1992. *Kings of Africa: Art and Authority in Central Africa. Collection Museum für Völkerkunde, Berlin.* Maastricht: Foundation Kings of Africa.

Biebuyck, Daniel P. 1973. *Lega Culture: Art, Initiation, and Moral Philosophy among a Central African People.* Berkeley and Los Angeles: University of California Press.

_____. 1978. *Hero and Chief: Epic Literature from the Banyanga (Zaire Republic).* Berkeley and Los Angeles: University of California Press.

_____. 1981. *Statuary from the Pre-Bembe Hunters: Issues in the Interpretation of Ancestral Figurines Ascribed to the Basikasingo-Bembe-Boyo.* Tervuren: Musée royal de l'Afrique centrale.

_____. 1985. *Arts of Zaire: Volume I, Southwestern Zaire.* Berkeley and Los Angeles: University of California Press.

_____. 1986. *Arts of Zaire: Volume II, Eastern Zaire.* Berkeley and Los Angeles: University of California Press.

_____. 1987. *The Arts of Central Africa: An Annotated Bibliography.* Boston: G.K. Hall.

_____. 1994. *La sculpture des Lega* (Lega Sculpture). Paris: Leloup.

_____, ed. 1969. *Tradition and Creativity in Tribal Art.* Berkeley and Los Angeles: University of California Press.

Biebuyck, Daniel P., and Kahombo Mateene. 1969. *The Mwindo Epic from the Banyanga (Congo Republic).* Berkeley and Los Angeles: University of California Press.

Biebuyck, Daniel P., and Nelly Van den Abbeele. 1984. *The Power of Headdresses: A Cross-Cultural Study of Forms and Functions.* Brussels: Tendi S.A.

Binkley, David A. 1988. *A View From the Forest: The Power of Southern Kuba Initiation Masks.* Ann Arbor: University Microfilms International.

Biya, Ndebi. 1987. *Être, pouvoir et génération: Le système mbok chez les Basa du Sud-Cameroun.* Paris: Harmattan.

Bjerke, Svein. 1981. *Religion and Misfortune: The Bacwezi Complex and the other Spirit Cults of the Zinza of Northwestern Tanzania.* Oslo: Universitetsforlaget; New York: Columbia University Press.

Bjorkelo, Anders J. 1976. *State and Society in Three Central Sudanic Kingdoms, Kanem Bornu, Bagirmi, and Wadai.* Bergen: Universitetet i Bergen.

BIBLIOGRAPHY

Blackmun, Barbara Winston. 1987. *Royal and Nonroyal Benin Distinctions in Igbesanmwan Ivory Carving*. Iowa City: University of Iowa.

Blair, Sheila, and Jonathan Bloom. 1994. *The Art and Architecture of Islam, 1250-1800*. New Haven: Yale University Press.

Bleek, Wolf. 1975. *Marriage, Inheritance, and Witchcraft: A Case Study of a Rural Ghanaian Family*. Leiden: Afrika-Studiencentrum.

Blier, Suzanne Preston. 1982. *Gestures in African Art*. New York: L. Kahan Gallery/African Arts.

_____. 1987. *The Anatomy of Architecture: Ontology and Metaphor in Batammaliba Architectural Expression*. Cambridge: Cambridge University Press.

_____. 1995. *African Vodun: Art, Psychology, and Power*. Chicago: University of Chicago Press.

Bloch, Maurice. 1971. *Placing the Dead: Tombs, Ancestral Villages and Kinship Organization in Madagascar*. London: Seminar Press.

Boachie-Ansah, J. 1985. *An Archaeological Contribution to the History of Wenchi*. Calgary: Department of Archaeology, University of Calgary.

Bocola, Sandro, ed. 1995. *Afrikanische Sitze* (African Seats). Munich: Prestel.

Bodrogi, Tibor. 1968. *Afrika müvészete* (Art in Africa). New York: McGraw Hill.

Boeder, Robert B. 1984. *Silent Majority: A History of the Lomwe in Malawi*. Pretoria: African Institute of South Africa.

Bohannan, Laura, and Paul Bohannan. 1953. *The Tiv of Central Nigeria*. London: International African Institute.

Bohannan, Paul, and Philip Curtin. 1988. *Africa and Africans*. 3d ed. Prospect Heights, Ill.: Waveland Press.

Bonnafe, Pierre. 1979. *Nzo lipfu, le lignage de la mort: La sorcellerie, idéologie de la lutte sociale sur le plateau Kukuya*. Nanterre: Service de publication, Laboratoire d'ethnologie et de sociologie comparative, Université de Paris X.

Bonnet, Charles, ed. 1990. *Kerma, Royaume de Nubie: L'antiquité africaine au temps des pharaons*. Geneva: Mission archéologique de l'Université de Geneve au Soudan/Musée d'art et d'histoire.

Bonté, Pierre, et al. 1991. *Al-Ansâb: La quête des origines. Anthropologie historique de la société tribale arabe*. Paris: Éditions de la maison des sciences de l'homme et Cambridge University Press.

Bonté, Pierre, and Michel Izard, eds. 1991. *Dictionnaire de l'ethnologie et de l'anthropologie*. Paris: Presses universitaires de France.

Boone, Olga. 1954. "Carte ethnique du Congo belge et du Ruanda-Urundi." *Zaire* 8: 451-465.

_____. 1961. *Carte ethnique du Congo: Quart sud-est*. Tervuren: Musée royal de l'Afrique centrale.

_____. 1973. *Carte ethnique de la République du Zaire: Quart sud-ouest*. Tervuren: Musée royal de l'Afrique centrale.

Boone, Sylvia Ardyn. 1986. *Radiance from the Waters: Ideals of Feminine Beauty in Mende Art*. New Haven: Yale University Press.

Borgatti, Jean. 1979. *From the Hands of Lawrence Ajanaku*. Los Angeles: UCLA Publication Services Department.

_____. 1983. *Cloth as Metaphor: Nigerian Textiles from the Museum of Cultural History*. Los Angeles: Museum of Cultural History, UCLA.

Boston, J.S. 1977. *Ikenga Figures among the Northwest Igbo and the Igala*. London: Ethnographica.

BIBLIOGRAPHY

Boulanger, André. 1985. *Société et religion des Zela (République du Zaire)*. Bandundu: CEEBA.

Bourdillon, M.F.C. 1976. *The Shona Peoples: An Ethnography of the Contemporary Shona with Special References to their Religion*. Gwelo, Rhodesia: Mambo Press.

Bourgeois, Arthur P. 1984. *Art of the Yaka and Suku*. Meudon: Chaffin.

_____. 1985. *The Yaka and Suku*. Leiden: E.J. Brill.

Boyer, Gaston. 1953. *Un peuple de l'ouest soudanais, les Diawara*. Dakar: IFAN.

Bradbury, R.E., and P.C. Lloyd. 1957. *The Benin Kingdom and the Edo-Speaking Peoples of South-Western Nigeria, with a section on the Itsekiri by P.C. Lloyd*. London: International African Institute.

Braimah, J. A., and Jack Goody. 1967. *Salaga: The Struggle for Power*. London: Longmans, Green and Company.

Brain, Robert. 1980. *Art and Society in Africa*. London: Longman Group.

Brain, Robert, and Adam Pollock. 1971. *Bangwa Funerary Sculpture*. Toronto: University of Toronto Press.

Brandstrom, Per. 1986. *Who is a Sukuma and Who is a Nyamwezi: Ethnic Identity in West-Central Tanzania*. Uppsala: Department of Cultural Anthropology, University of Uppsala.

Brandt, Henry. 1956. *Nomades du soleil*. Lausanne: Guilde du livre.

Bravmann, René A. 1973. *Islam and Tribal Art in West Africa*. Cambridge: Cambridge University Press.

Brelsford, William Vernon. 1965. *The Tribes of Zambia*. 2d ed. Lusaka: Government Printer.

Brett-Smith, Sarah C. 1994. *The Making of Bamana Sculpture: Creativity and Gender*. Cambridge: Cambridge University Press.

Briggs, Lloyd Cabot. 1960. *Tribes of the Sahara*. Cambridge: Harvard University Press.

Brogger, Jan. 1986. *Belief and Experience among the Sidamo: A Case Study Towards an Anthropology of Knowledge*. Oslo: Norwegian University Press.

Brokensha, David, ed. 1972. *Akwapim Handbook*. Tema: Ghana Publishing.

Brooklyn Museum Staff, eds. 1978. *Africa in Antiquity: The Arts of Ancient Nubia and the Sudan*. 2 vols. Brooklyn: Brooklyn Museum.

Broster, Joan A. 1976. *The Tembu: Their Beadwork, Songs, and Dances*. Capetown: Purnell.

Buhan, Christine, and Etienne Kange Essiben. 1979. *La mystique du corps: Jalons pour une anthropologie du corps, les Yabyan et les Yepeke, Bakoko, Elog-Mpoo ou Yamban-Ngée, de Dibombari au Sud-Cameroun*. Paris: Harmattan.

Burssens, Amaat. 1954. *Introduction à l'étude des langues bantoues du Congo belge*. Antwerp: De Sikkel.

Burssens, Herman. 1958. *Les peuplades de l'entre Congo-Ubangi*. London: International African Institute.

_____. 1962. *Yanda-beelden en Mani-sekte bij de Azande*. 2 vols. Tervuren: Musée royal de l'Afrique centrale.

Burssens, Herman, and Alain Guisson. 1992. *Mangbetu: Art de cour africain de collections privées belges*. Brussels: Kredietbank.

Burt, Eugene C. 1980. *An Annotated Bibliography of the Visual Arts of East Africa*. Bloomington: Indiana University Press.

_____. 1983. "Bibliography of the Visual Arts in East Africa. Supplement." *Africana Journal* 14: 205-252.

Burton, John W. 1987. *A Nilotic World: The Atuot-Speaking Peoples of the Southern Sudan*. New York: Greenwood Press.

BIBLIOGRAPHY

Burton, W.F. 1961. *Luba Religion and Magic in Custom and Belief.* Tervuren: Musée royal de l'Afrique centrale.

Buschan, Georg. 1922. *Illustrierte Völkerkunde.* 2 vols. Stuttgart: Strecker und Schröder.

Butt, Audrey. 1964. *The Nilotes of the Sudan and Uganda.* London: International African Institute.

Buxton, Jean. 1973. *Religion and Healing in Mandari.* Oxford: Clarendon Press.

Bylin, Eric. 1966. *Basakata: Le peuple du pays de l'entre-fleuves Lukenie-Kasai.* Uppsala: Studia etnografica uppsaliensa.

Calame-Griaule, Geneviève. 1968. *Dictionnaire dogon, dialecte toro: Langue et civilisation.* Paris: Librairie C. Klincksieck.

Cameron, Elisabeth. 1992. *Reclusive Rebels: An Approach to the Sala Mpasu and their Masks.* Mesa: Mesa College Art Gallery.

Camps-Fabrer, Henriette. 1970. *Les bijoux de Grande Kabylie: Collections du Musée du Bardo et du Centre de recherches anthropologiques, préhistoriques et ethnographiques, Alger.* Paris: Arts et métiers graphiques.

Cardona, Giorgio R. 1989. "Noms de peuples et noms de langues." In *Graines de paroles: Puissance du verbe et traditions orales,* ed. Geneviève Calame-Griaule. Paris: Éditions du CNRS.

Carey, Margret. 1986. *Beads and Beadwork of East and South Africa.* Princes Risborough: Shire.

_____. 1991. *Beads and Beadwork of West and Central Africa.* Princes Risborough: Shire.

Cauneille, A. 1968. *Le Chaamba (leur nomadisme), évolution de la tribu durant l'administration française.* Paris: Éditions du CNRS.

Cavalli-Sforza, Luigi Luca, ed. 1986. *African Pygmies.* Orlando: Academic Press.

Celenko, Theodore. 1983. *A Treasury of African Art from the Harrison Eiteljorg Collection.* Bloomington: Indiana University Press.

Centre national de la recherche scientifique. 1970-1985. *Bulletin Signalétique 521: Sociologie-Ethnologie.* Vols. 24-39. Paris: Centre national de la recherche scientifique.

_____. 1986-1992. *Bulletin Signalétique 529: Ethnologie.* Vols. 40-46. Paris: Centre national de la recherche scientifique.

Cerulli, Ernesta. 1956. *Peoples of South-West Ethiopia and its Borderland.* London: International African Institute.

Chaffin, Alain, and Françoise Chaffin. 1979. *L'art Kota: Les figures de reliquaire.* Meudon: Chaffin.

Champion, Arthur M. 1967. *The Agiryama of Kenya.* London: Royal Anthropological Institute.

Chapelle, Jean. 1958. *Nomades noirs du Sahara.* Paris: Librairie Plon.

_____. 1982. *Nomades noirs du Sahara: Les Toubous.* Paris: Harmattan.

Chernoff, John Miller. 1979. *African Rhythm and African Sensibility: Aesthetics and African Musical Idioms.* Chicago: University of Chicago Press.

Chernova, Galina A. 1967. *The Art of Tropical Africa in the Collections of the Soviet Union* (in Russian). Moscow: Moscow Soviet Artists.

Childs, Gladwyn Murray. 1949. *Umbundu: Kinship and Character: Being a Description of the Social Structure and Individual Development of the Ovimbundu of Angola.* London: Oxford University Press for the International African Institute.

CICIBA. 1989. *Lexique ethnique de l'Afrique centrale, orientale, et australe.* Gabon: Le centre d'information bantu.

BIBLIOGRAPHY

CICIBA and Theophile Obenga. 1989. *Les peuples bantu: Migrations, expansion et identité culturelle. Actes du colloque international, Libreville 1-6 avril 1985*. Libreville: CICIBA.

Claerhout, Adriaan. 1971. *Afrikaanse Kunst: Nederlands en Belgisch bezit uit openbare verzamelingen* (African Art: Dutch and Belgian Collections). Amsterdam: Nederlandse stichting openbaar kunstbezit.

Clark, J. Desmond. 1970. *The Prehistory of Africa*. New York: Praeger.

Cohen, Ronald. 1967. *The Kanuri of Bornou*. New York: Holt, Rinehart and Winston. Reprint, Prospect Heights, Ill.: Waveland Press, 1987.

Cole, Herbert M. 1970. *African Arts of Transformation*. Santa Barbara: University of California.

_____. 1982. *Mbari: Art and Life Among the Owerri Igbo*. Bloomington: Indiana University Press.

_____. 1989. *Icons, Ideals, and Power: The Art of Africa*. Washington: Smithsonian Institution Press for the National Museum of African Art.

Cole, Herbert M., and Chike C. Aniakor. 1984. *Igbo Arts: Community and Cosmos*. Los Angeles: Museum of Cultural History, UCLA.

Cole, Herbert M., and Doran H. Ross. 1977. *The Arts of Ghana*. Los Angeles: Museum of Cultural History.

Colldén, Lisa. 1971. *The Traditional Religion of the Sakata*. Uppsala: Institutet for allman och jamforande etnografi.

Colson, Elizabeth. 1949. *Life Among the Cattle-Owning Plateau Tonga: The Material Culture of a Northern Rhodesia Native Tribe*. Livingstone: Rhodes-Livingstone Institute.

Colson, Elizabeth, and Max Gluckman, eds. 1959. *Seven Tribes of British Central Africa*. Manchester: Manchester University Press for the Rhodes-Livingston Institute.

Comaroff, Jean. 1985. *Body of Power, Spirit of Resistance: The Culture and History of a South African People*. Chicago: University of Chicago Press.

Connah, Graham. 1987. *African Civilization: Precolonial Cities and States in Tropical Africa: An Archeological Perspective*. Cambridge: Cambridge University Press.

Conner, Michael W., and Diane M. Pelrine. 1983. *The Geometric Vision: Arts of the Zulu*. West Lafayette, In.: Purdue University Galleries, Department of Creative Arts; [Bloomington]: African Studies Program, Indiana University.

Conrad, David C., and Barbara E. Frank, eds. 1995. *Status and Identity in West Africa: Nyamakakaw of Mande*. Bloomington: Indiana University Press.

Corbin, George A. 1988. *Native Arts of North America, Africa, and the South Pacific: An Introduction*. New York: Harper and Row.

Cornet, Joseph. 1971. *Art of Africa: Treasures from the Congo*. London: Phaidon Press.

_____. 1978. *A Survey of Zairian Art: The Bronson Collection*. Raleigh: North Carolina Museum of Art.

_____. 1982. *Art royal Kuba*. Milano: Edizioni Sipiel Milano.

Cornet, Joseph, and Robert Farris Thompson. 1981. *The Four Moments of the Sun: Kongo Art in Two Worlds*. Washington: National Gallery of Art.

Cory, Hans. 1956. *African Figurines: Their Ceremonial Use in Puberty Rites in Tanganyika*. New York: Grove Press.

Costello, Dawn. 1990. *Not Only for its Beauty: Beadwork and its Cultural Significance among the Xhosa-Speaking Peoples*. Pretoria: University of South Africa.

Costermans, B. J. 1953. *Mosaïque bangba: Notes pour servir à l'étude des peuplades de l'Uele*. Brussels: Institut royal colonial belge.

Cotte, Paul Vincent. 1947. *Regardons vivre une tribu malgache: Les Betsimisaraka*. Paris: La nouvelle édition.

BIBLIOGRAPHY

Coupez, A. 1955. *Esquisse de la langue holoholo.* Tervuren: Musée royal du Congo belge.

Courteau, Bernard. 1974. *Quand les dieux dansent les dieux créent.* Montreal: Lemeac.

Courtney-Clark, Margaret. 1986. *Ndebele: The Art of an African Tribe.* New York: Rizzoli.

Cowen, Chester R. 1974. "The Monumental Architecture and Sculpture of the Konso of Southern Ethiopia." Master's thesis, University of Oklahoma.

Crociani, Paola. 1994. *Bedouin of the Sinai.* Reading: Garnet Publications.

Culwick, Arthur T., and G.M. Culwick. 1935. *Ubena of the Rivers.* London: Allen and Unwin.

Cunnison, Ian. 1959. *The Luapula Peoples of Northern Rhodesia: Custom and History in Tribal Politics.* Manchester: Manchester University Press for the Rhodes-Livingstone Institute.

_____. 1966. *Baggara Arabs: Power and Lineage in a Sudanese Nomad Tribe.* Oxford: Clarendon Press.

Cunnison, Ian, and Wendy James, eds. 1972. *Essays in Sudan Ethnography Presented to Sir Edward Evans-Pritchard.* New York: Humanities Press.

Curtil, Sophie. 1992. *Masques vouvi; masques boa.* Paris: N.p.

Cuypers, J. B. 1970. *L'alimentation chez les Shi.* Tervuren: Musée royal du Congo belge.

Dada, Paul O. 1985. *A Brief History of Igbomina (Igboona), or The People Called Igbomina/Igboona.* Ilorin: Matanmi Press.

Dahl, Gudrun. 1979. *Suffering Grass: Subsistence and Society of Waso Borana.* Stockholm: Department of Social Anthropology, University of Stockholm.

Danfulani, Umar Habila Dadem. 1995. *Pebbles and Deities: Pa Divination among the Ngas, Mupun and Mwaghavul in Nigeria.* New York: P. Lang.

Darbois, Dominique. 1967. *Masks and Figures from Eastern and Southern Africa.* London: Hamlyn.

Dark, Philip J.C. 1982. *An Illustrated Catalogue of Benin Art.* Boston: G.K. Hall.

Davidson, Basil. 1959. *The Lost Cities of Africa.* Boston: Little, Brown and Company.

_____. 1966. *African Kingdoms.* New York: Time.

Davies, W.V., ed. 1991. *Egypt and Africa: Nubia from Prehistory to Islam.* London: British Museum Press in Association with the Egyptian Exploration Society.

d'Azevedo, Warren L. 1965. *The Artist Archetype in Gola Culture.* N.p.: Desert Ranch Institute, University of Nevada.

_____. 1972. *Gola of Liberia.* 2 vols. New Haven: Human Relations Area Files.

_____, ed. 1973. *The Traditional Artist in African Societies.* Bloomington: Indiana University Press.

d'Azevedo, Warren L., and Marvin D. Solomon. 1962. *A General Bibliography of the Republic of Liberia.* Evanston, Ill.: Northwestern University.

Deane, Shirley. 1985. *Talking Drums: From a Village in Cameroon.* London: J. Murray.

de Areia, M.L. Rodrigues. 1985. *Les symboles divinatoires: Analyse socio-culturelle d'une technique de divination des Cokwe de l'Angola.* Coimbra, Portugal: Instituto de Anthropologia, Universidad de Coimbra.

de Beaucorps, Remi. 1933. *Les Bayansi du Bas-Kwilu.* Louvain: Éditions de l'Aucam.

de Beir, L. 1975. *Religion et magie des Bayaka.* St. Augustin: Anthropos-Institut St. Augustin.

de Dampierre, Eric. 1967. *Un ancien royaume bandia du Haut-Oubangui.* Paris: Librairie Plon.

de Ganay, Solange, et al. 1987. *Ethnologiques: Hommages à Marcel Griaule.* Paris: Hermann.

BIBLIOGRAPHY

de Garine, Igor. 1964. *Les Massa du Cameroun: Vie économique et sociale.* Paris: Presses universitaires de France.

de Grunne, Bernard. 1982. *The Terracotta Statuary of the Inland Delta of the Niger in Mali.* Munich: Galerie Biedermann/F. Jahn.

de Grunne, Bernard, et al. 1980. *Terres cuites anciennes de l'ouest africain* (Ancient Terracottas from West Africa). Louvain: Institut supérieur d'archéologie et d'histoire de l'art, Collège Érasme.

de Heusch, Luc. 1955. *Vie quotidienne des Mongo du Kasai.* Brussels: Exploration du monde.

_____, ed. 1995. *Objets-signes d'Afrique.* Gent: Snoeck-Ducaju; Tervuren: Musée royal de l'Afrique centrale.

Delachaux, Théodore, and Charles Emile Thiébaud. 1933. *Land und Völker von Angola.* Neuenburg: Verlagsanstalt Viktor Attinger.

Delage, Marta Sierra. 1980. *Tallas y máscaras africanas en el Museo nacional de etnología.* Madrid: Ministerio de cultura, Dirección general del patrimonia artístico, Archivos y Museos, Patronato nacional de museos.

Delange, Jacqueline. 1974. *The Art and Peoples of Black Africa.* New York: Dutton.

de Lestrange, Monique. 1955. *Les Coniagui et les Bassari (Guinée française).* Paris: Presses universitaires de France.

de Mahieu, Wauthier. 1980. *Structures et symboles: Les structures sociales du groupe komo du Zaire dans leur élaboration symbolique.* London: International African Institute.

_____. 1985. *Qui a obstrué la cascade? Analyse sémantique du rituel de la circoncision chez le Komo du Zaire.* Cambridge: Cambridge University Press.

de Meireles, Artur Martins. 1960. *Mutilacões etnicas dos Manjacos.* Bissau: Centro de Estudos da Guine Portuguesa.

Dempwolff, Otto. 1916. *Die Sandawe: Linguistisches und ethnographisches Material aus Deutsch-Ostafrika.* Hamburg: Friederichsen.

Deng, Francis M. 1972. *The Dinka of the Sudan.* New York: Holt, Rinehart and Winston.

Dennis, Benjamin G. 1972. *The Gbandes: A People of the Liberian Hinterland.* Chicago: Nelson Hall.

Denyer, Susan. 1978. *African Traditional Architecture: An Historical and Geographical Perspective.* New York: Africana Publishing Company.

de Oliveira, Jose Osorio. 1954. *Uma accao cultural em Africa.* Lisbon: N.p.

de Plaen, Guy. 1974. *Les structures d'autorité des Bayanzi.* Paris: Éditions universitaires.

Deschamps, Hubert. 1936. *Les Antaisaka: Géographie humaine, coutumes et histoire d'une population malgache.* Tananarive: Imprimerie moderne de l'Emyrne, Pitot de la Beaujardière.

_____. 1970. *Histoire générale de l'Afrique noire, de Madagascar, et des Archipels.* 2 vols. Paris: Presses universitaires de France.

Deschamps, Hubert, and Suzanne Vianès. 1959. *Les Malgaches du sud-est: Antemoro, Antesaka, Antambahoaka, peuples de Farafangana (Antefasi, Zafiasoro, Sahavoai, Sahafatra).* Paris: Presses universitaires de France.

de Sousberghe, Léon. 1959. *L'art pende.* Brussels: Académie royale de Belgique.

de Veciana Vilaldach, Antonio. 1956. *Los Bujeba (Bisio) de la Guinea Española; Contribucion al estudio del negro africano.* Madrid: Consejo superior de investigaciones.

Dias, Jorge, et al. 1968. *Escultura africana no Museu de Etnologia do Ultramar* (African Sculpture in the Overseas Ethnological Museum). Lisbon: Junta de Investigações do Ultramar.

BIBLIOGRAPHY

Dieterlen, Germaine. 1988. *Essai sur la religion bambara*. 2d ed. Brussels: Éditions de l'Université de Bruxelles.

Dieterlen, Germaine, and Youssouf Cissé. 1972. *Les fondements de la société d'initiation du Komo*. Paris: Mouton.

Djomo Lola. 1988. *La dynamique de la personne dans la religion et la culture tetela*. Kinshasa: Faculté de théologie catholique.

Doke, Clement Martyn. 1931. *The Lambas of Northern Rhodesia: A Study of Their Customs and Beliefs*. London: George G. Harrap.

Downes, Rupert Major. 1971. *Tiv Religion*. Ibadan: Ibadan University Press.

Dowson, T.A. 1992. *Rock Engravings of Southern Africa*. Johannesburg: Witwatersrand University Press.

Drewal, Henry John, and Margaret Thompson Drewal. 1990. *Gelede: Art and Female Power among the Yoruba*. Bloomington: Indiana University Press.

Drewal, Henry John, John Pemberton III, and Rowland Abiodun. 1989. *Yoruba: Nine Centuries of African Art and Thought*. New York: The Center for African Art/Harry N. Abrams.

Drewal, Margaret Thompson. 1992. *Yoruba Ritual: Performers, Play, Agency*. Bloomington: Indiana University Press.

Driberg, J.H.A. 1923. *The Lango: A Nilotic Tribe of Uganda*. London: T.F. Unwin.

Droogers, A.F. 1980. *The Dangerous Journey: Symbolic Aspects of Boys' Initiation among the Wagenia of Kisangani, Zaire*. New York: Mouton.

Drouin, Jeannine, and Mohamed Aghali Zakara. 1979. *Traditions touarègues nigériennes: Amerolquis héros, civilisateur pré-islamique, et Aligurran, archétype social*. Paris: Harmattan.

Drucker-Brown, Susan. 1975. *Ritual Aspects of the Mamprusi Kingship*. Leiden: Afrika-Studiecentrum.

Dubin, Lois Sherr. 1987. *The History of Beads: From 30,000 B.C. to the Present*. New York: Harry N. Abrams.

Dubois, Henri M. 1938. *Monographie des Betsileo (Madagascar)*. Paris: Institut d'ethnologie.

Duchâteau, Armand. 1990. *Benin trésor royal: Collection du Museum für Völkerkunde, Vienne*. Paris: Éditions Dapper.

Duerden, Dennis. 1971. *African Art*. London: Hamlyn.

Dugast, Idelette. 1955-60. *Monographie de la tribu des Ndiki (Banen du Cameroun)*. Paris: Institut d'ethnologie.

Duperray, Anne-Marie. 1984. *Les Gourounsi de Haute-Volta: Conquête et colonisation, 1896-1933*. Stuttgart: Franz Steiner.

Dupire, Marguerite. 1962. *Peuls nomades: Étude descriptive des Wodaabe du Sahel nigérien*. Paris: Institut d'ethnologie.

Dupré, Georges. 1985. *Les naissances d'une société: Espace et historicité chez le Beembe du Congo*. Paris: Éditions de l'ORSTOM.

Dupré, Marie-Claude. 1984. *Naissance et renaissances du masque kidumu: Art, politique et histoire chez le Téké-Tsaayi*. 3 vols. Paris: Éditions du CNRS.

Duquette, Danielle Gallois. 1983. *Dynamique de l'art bidjogo (Guinée-Bissau): Contribution à une anthropologie de l'art des sociétés africaines*. Lisbon: Instituto de investigaçao cientifica tropical.

Earthy, Emily Dora. 1933. *Valenge Women: The Social and Economic Life of the Valenge Women of Portuguese East Africa: An Ethnographic Study*. Reprint, London: Cass, 1968.

BIBLIOGRAPHY

East, Rupert, and Akiga. 1965. *Akiga's Story: The Tiv Tribe as Seen by One of its Members.* London: Oxford University Press for the International African Institute.

Ebeling, Ingelore. 1987. *Masken und Maskierung: Kult, Kunst, und Kosmetic: Von den Naturvölkern bis zur Gegenwart.* Cologne: DuMont.

Eberhard, Giselle. 1983. *Art ancien de Mali: L'Afrique révèle un nouveau chapitre de son histoire.* Geneva: Barbier-Muller Museum.

Ebert, Karen Heide. 1975. *Sprache und Tradition der Kera (Tschad).* Berlin: Reimer.

Ebiatsa-Hopiel. 1990. *Les Teke: Peuples et nation.* Montpellier: Ebiatsa-Hopiel.

Éboué, Felix. 1933. *Les peuples de l'Oubangi-Chari: Essai d'ethnographie, de linguistique et d'économie sociale.* Reprint, New York: AMS Press, 1977.

École pratique des hautes études. 1979. *Le Sacrifice III. Systèmes de pensée en Afrique noire, cahier 4, 1979.* Paris: École pratique des hautes études (Section des sciences religieuses).

————. 1981. *Le Sacrifice IV: Systèmes de pensée en Afrique noire, cahier 5, 1981.* Paris: École pratique des hautes études (Section des sciences religieuses).

École pratique des hautes études and Luc de Heusch, ed. 1987. *Chefs et rois sacrés. Systèmes de pensée en Afrique noire, cahier 10, 1987.* Paris: École pratique des hautes études (Section des sciences religieuses).

École pratique des hautes études and Albert de Surgy, ed. 1987. *Fétiche: Objets-enchantés, mots réalisés. Systèmes de pensée en Afrique noire, cahier 8, 1985.* Paris: École pratique des hautes études (Section des sciences religieuses).

————. 1993. *Fétiches II: Puissance des objets, charme des mots. Systèmes de pensée en Afrique noire, cahier 12, 1993.* Paris: École pratique des hautes études (Section des sciences religieuses).

École pratique des hautes études and Danouta Liberski, ed. 1986. *Le deuil et ses rites. Systèmes de pensée en Afrique noire, cahier 9, 1986.* Paris: École pratique des hautes études (Section des sciences religieuses).

Edel, May M. 1952. *The Chiga of Uganda.* 2d rev. ed., New Brunswick, N.J.: Transaction, 1996.

Effa, René-Marie, and J. B. Fotso Guifo. 1984. *Si Bandjoun m'était conté.* Yaounde: Edicam.

Effah Gyamfi, Kwaku. 1985. *Bono Manso: An Archaeological Investigation into Early Akan Urbanism.* Calgary: Department of Archaeology, University of Calgary Press.

Ehret, Christopher. 1974. *Ethiopians and East Africans: The Problem of Contacts.* Nairobi: East African Publishing House.

Ehret, Christopher, and Merrick Posnansky. 1982. *The Archaeological and Linguistic Reconstruction of African History.* Berkeley and Los Angeles: University of California Press.

Eicher, Joanne B. 1969. *African Dress: A Select and Annotated Bibliography of Subsaharan Countries.* East Lansing: African Studies Center, Michigan State University.

Eid, Jakline, and Till Förster. 1988. *Paroles de devin: La fonte à la cire-perdue chez les Senoufo de Côte d'Ivoire.* Paris: ADEIAO/Musée national des arts africains et océaniens.

Einstein, Carl. 1920. *Negerplastik.* Munich: Kurt Wolff.

Ejedepang-Koge, Samuel Ngome. 1971. *The Tradition of a People, Bakossi: A Historico-Socio-Anthropological Study of One of Cameroon's Bantu Peoples.* Rev. ed. Washington: S.N. Ejedepang-Koge, 1986.

Elisofon, Eliot, and William Fagg. 1958. *Sculpture of Africa.* London: Thames and Hudson. Reissue, New York: Hacker Art Books, 1978.

Ellert, H. 1984. *The Material Culture of Zimbabwe.* Harare: Sam Gozo/Longmans.

Elshout, Pierre. 1963. *Les Batwa des Ekonda.* Tervuren: Musée royal de l'Afrique centrale.

BIBLIOGRAPHY

Encyclopaedia Britannica. 1980. "African Peoples, Arts of." p. 232-278 in *New Encyclopaedia Britannica Macropaedia*. Vol. 1. Chicago: Encyclopaedia Britannica.

Encyclopedia of World Art. 1959. Vol. 1. New York: McGraw Hill.

Eneweke, Ossie Onuora. 1987. *Igbo Masks: The Openness of Ritual and Theater*. Lagos: Department of Culture, Federal Ministry of Information and Culture.

Eneyo, Silas. 1991. *The Andoni Monarchy: An Introduction to the History of the Kingship Institution of the Andoni People*. Port Harcourt: Riverside Communications.

Engelbrecht, Beate, and Bernhard Gardi, eds. 1989. *Man Does Not Go Naked. Textilien und Handwerk aus Afrikanischen und Anderen Ländern*. Basel: Ethnologisches Seminar der Universität und Museum für Völkerkunde in Kommission bei Wepf.

Engelbrecht, Jan Anthonie. 1936. *The Korana: An Account of their Customs and History*. Capetown: M. Miller.

Eschlimann, Jean-Paul. 1985. *Les Agni devant la mort: Côte d'Ivoire*. Paris: Karthala.

Estermann, Carlos. 1975-81. *Etnografia do sudoeste de Angola* (The Ethnography of Southwestern Angola). 3 vols. New York: Africana Publishing.

Etienne-Nugue, Jocelyn, and Elisabeth Laget. 1985. *Artisanats traditionnels: Côte d'Ivoire*. Paris: Harmattan.

Etienne-Nugue, Jocelyn, and M. Saley. 1987. *Artisannats traditionnels Niger*. Dakar: Institut culturel africain.

Evans-Pritchard, E.E. 1949. *The Sanusi of Cyrenaica*. Oxford: Clarendon Press.

_____. 1951. *Kinship and Marriage Among the Nuer*. Oxford: Clarendon Press.

_____. 1940. *The Nuer, a Description of the Modes of Livelihood and Political Institutions of a Nilotic People*. New York: Oxford University Press, 1969.

_____. 1976. *Witchcraft, Oracles and Magic among the Azande*. Oxford: Clarendon Press.

Eyo, Ekpo. 1977. *Two Thousand Years: Nigerian Art*. Lagos: Federal Department of Antiquities.

Eyo, Ekpo, and Frank Willett. 1980. *Treasures of Ancient Nigeria*. New York: Knopf in association with the Detroit Institute of Arts.

Ezra, Kate. 1988. *Art of the Dogon: Selections from the Lester Wunderman Collection*. New York: Metropolitan Museum of Art.

_____. 1992. *Royal Art of Benin: The Perls Collection in the Metropolitan Museum of Art*. New York: Metropolitan Museum of Art.

Fabunmi, M.A. 1969. *Ife Shrines*. Ife: University of Ife Press.

Fage, J.D. 1978. *An Atlas of African History*. New York: Africana Publishing Company.

Fagg, Bernard. 1977. *Nok Terracottas*. Lagos: Ethnographica for the National Museum.

Fagg, William Buller. 1964. *Afrique: Cent tribus—cent chefs-d'oeuvre*. Berlin: Congrès pour la liberté de la culture.

_____. 1968. *African Tribal Images: The Katherine White Reswick Collection*. Cleveland: Cleveland Museum of Art.

_____. 1980. *Yoruba Beadwork: Art of Nigeria*. New York: Rizzoli.

Fagg, William, John Pemberton III, and Bryce Holcombe, eds. 1982. *Yoruba: Sculpture of West Africa*. New York: Alfred A. Knopf.

Fagg, William, and John Picton. 1978. *The Potter's Art in Africa*. London: British Museum Publications.

Fäik-Nzuji, Clémentine. 1992. *Symboles graphiques en Afrique noire*. Paris: Éditions Karthala.

Fakhry, Ahmed. 1942. *Bahria Oasis*. Cairo: Government Press, Bulaq.

Falgayrettes-Leveau, Christiane, and Lucien Stéphan. 1993. *Formes et couleurs: Sculptures de l'Afrique noire*. Paris: Éditions Dapper.

347

BIBLIOGRAPHY

Fallers, Margaret Chave. 1960. *The Eastern Lacustrine Bantu (Ganda and Soga).* London: International African Institute.

Fardon, Richard. 1990. *Between God, the Dead, and the Wild: Chamba Interpretations of Religion and Ritual.* Washington: Smithsonian Institution Press.

Faris, James C. 1972. *Nuba Personal Art.* London: Duckworth.

Fedders, Andrew. 1977. *Turkana Pastoral Craftsmen.* Nairobi: Transafrica Book Distributors.

Feierman, Steven. 1974. *The Shambaa Kingdom: A History.* Madison: University of Wisconsin Press.

Felgas, Helio A. Esteves. 1963. *As populações nativas do norte de Angola.* Lisbon: N.p.

Felix, Marc Leo. 1987. *100 Peoples of Zäire and their Sculpture: The Handbook.* Brussels: Zäire Basin Art History Research Foundation.

_____. 1989. *Maniema: An Essay on the Distribution of the Symbols and Myths as Depicted in the Masks of Greater Maniema.* Munich: Jahn.

Fernandez, J.W. 1982. *Bwiti: An Ethnography of the Religious Imagination in Africa.* Princeton: Princeton University Press.

Ferretti, Fred. 1975. *Afo-A-Kom: Sacred Art of Cameroon.* New York: Third Press.

Ferry, Marie-Paul. 1991. *Thesaurus tenda: Dictionnaire ethnolinguistique des langues sénégalo-guinéennes.* 3 vols. Paris: Peeters. Reissue, Paris: Selaf, 1992.

Ferry, Marie-Paule, and Ch. de Lespinay. 1992. *Répertoire du comité français des études africaines.* Paris: Centre de recherches africaines/Copédith.

Field, Margaret Joyce. 1940. *Social Organization of the Ga People.* London: The Crown Agents for the Colonies.

Finnegan, Ruth H. 1965. *Survey of the Limba Peopleof Northern Sierra Leone.* London: Her Majesty's Stationery Office.

Fischer, Eberhard, and Lorenz Homberger. 1985. *Die Kunst der Guro, Elfenbeinküste.* Zurich: Museum Rietberg.

_____. 1986. *Maskengestalten der Guro, Elfenbeinküste* (Masks in Guro Culture, Ivory Coast). Zurich: Museum Rietberg.

Fischer, Eberhard, and Hans Himmelheber. 1984. *The Arts of the Dan in West Africa.* Zurich: Museum Rietberg.

Fischer, Werner, and Manfred A. Zirngibl. 1978. *African Weapons: Knives, Daggers, Swords, Axes, Throwing Knives.* Passau: Prinz.

Fisher, Angela. 1984. *Africa Adorned.* New York: Harry N. Abrams.

Fontinha, Mario, and Acacio Videira. 1963. *Cabacas gravades da Lunda.* Lisbon: Companhia de diamantes de Angola, Servicos culturais.

Forde, C. Daryll. 1964. *Yakö Studies.* London: Oxford University Press for the International African Institute.

_____. 1969. *The Yoruba-Speaking Peoples of South-Western Nigeria.* London: International African Institute.

_____, ed. 1954. *African Worlds: Studies in the Cosmological Ideas and Social Values of African Peoples.* London: Oxford University Press.

Forde, C. Daryll, and G.I. Jones. 1952. *The Ibo and Ibibio-Speaking Peoples of South-Eastern Nigeria.* London: International African Institute.

Forde, C. Daryll, and P. M. Kaberry, eds. 1967. *West African Kingdoms in the Nineteenth Century.* London: Oxford University Press for the International African Institute.

Forde, C. Daryll, Paula Brown, and Robert G. Armstrong. 1970. *Peoples of the Niger-Benue Confluence. The Nupe, the Igbira, and the Igala.* London: International African Institute.

Förster, Till. 1988. *Die Kunst der Senufo.* Zurich: Museum Rietberg.

Fortes, Meyer. 1967. *The Web of Kinship among the Tallensi: The Second Part of an Analysis of the Social Structure of a Trans-Volta Tribe*. London: Oxford University Press.

_____. 1987. *Religion, Morality and the Person: Essays on Tallensi Religion*. Cambridge: Cambridge University Press.

Fortes, Meyer, and Germaine Dieterlen, eds. 1965. *African Systems of Thought: Studies Presented and Discussed at the Third International African Seminar in Salisbury, December 1960*. London: Oxford University Press for the International African Institute.

Fortes, Meyer, and E.E. Evans-Pritchard, eds. 1940. *African Political Systems*. London: Oxford University Press for the International African Institute.

Fouquer, Roger. 1971. *La sculpture moderne des Makonde*. Paris: Nouvelles éditions latines.

Frank, Barbara. 1981. *Die Kulere: Bauern in Mittelnigeria*. Wiesbaden: Steiner.

Fraser, Douglas, ed. 1972. *African Art as Philosophy*. New York: Interbook.

Fraser, Douglas, and Herbert M. Cole, eds. 1972. *African Art and Leadership*. Madison: University of Wisconsin Press.

Freedman, Jim. 1984. *Nyabingi: The Social History of an African Divinity*. Tervuren: Musée royal de l'Afrique centrale.

Freyer, Bryna. 1987. *Royal Benin Art in the Collection of the National Museum of African Art*. Washington: Smithsonian Institution Press for the National Museum of African Art.

Friedson, Steven M. 1996. *Dancing Prophets: Musical Experience in Tumbuka Healing*. Chicago: University of Chicago Press.

Frobenius, Leo. 1898. *Die Masken und Geheimbünde Afrikas*. Halle: Abhandlungen der Kaiserlichen Leopoldinish-Carolinischen Deutschen Akademie der Naturforscher.

_____. 1933. *Kulturgeschichte Afrikas*. Zurich: Phaidon-Verlag.

Froelich, Jean-Claude. 1954. *La tribu konkomba du nord-Togo*. Dakar: IFAN.

Froelich, Jean-Claude, Pierre Alexandre, and Robert Cornevin. 1963. *Les populations du Nord-Togo*. Paris: Presses universitaires de France.

Fry, Jacqueline, ed. 1978. *Vingt-cinq sculptures africaines* (Twenty-Five African Sculptures). Ottawa: The National Gallery of Canada for the Corporation of the National Museums of Canada.

Fyle, C. Magbaily. 1986. *Tradition, Song, and Chant of the Yalunka*. Freetown: People's Educational Association of Sierra Leone.

Gaba, Christian R., ed. 1973. *Scriptures of an African People: Ritual Utterances of the Anlo*. New York: NOK.

Gabreyesus, Hailemariam. 1991. *The Gurague and their Culture*. New York: Vantage Press.

Gabus, Jean. 1958. *Au Sahara: Arts et symboles*. Neuchâtel: Éditions de la Baconnière.

_____. 1967. *Art nègre: Recherche de ses fonctions et dimensions*. Neuchâtel: Éditions de la Baconnière.

_____. 1971. *Les Touaregs*. Neuchâtel: Musée d'ethnographie.

Gaffé, René. 1945. *La sculpture au Congo belge*. Paris: Éditions du cercle d'art.

Gallery DeRoche. 1993. *Art of Cameroon: The Gebauer Family Collection as Exhibited at Gallery DeRoche*. San Francisco: Gallery DeRoche.

Gamble, David P. 1957. *The Wolof of Senegambia, together with Notes on the Lebu and the Serer*. London: International African Institute.

Gamitto, Antonio C.P. 1960. *King Kazembe and the Marave, Cheva, Bisa, Bemba, Lunda and other Peoples of Southern Africa, being the Diary of the Portuguese Expedition to that Potentate in the Years 1831 and 1832*. 2 vols. Lisbon: N.p.

Gamst, Frederick C. 1969. *The Qemant: A Pagan-Hebraic Peasantry of Ethiopia.* New York: Holt, Rinehart and Winston.

Gangambi, Muyaga. 1974. *Les masques pende de Gatundo.* Bandundu: CEEBA.

Gardi, Bernhard. 1985. *Ein Markt wie Mopti: Handwerkerkasten und traditionelle Techniken in Mali.* Basel: Ethnologisches Seminar der Universität und Museum für Völkerkunde.

————. 1986. *Zaire. Masken und Figuren.* Basel: Museum für Völkerkunde.

————. 1988. *Mali: Land im Sahel. Begleitschrift zur Ausstellung: Führer durch das Museum für Völkerkunde und Schweizerische Museum für Völkskunde Basel.* Basel: Das Museum.

Garlake, Peter S. 1973. *Great Zimbabwe.* New York: Stein and Day.

————. 1990. *The Kingdoms of Africa.* New York: Peter Bedrick Books.

————. 1995. *The Hunter's Vision: The Prehistoric Rock Art of Zimbabwe.* Seattle: University of Washington Press.

Garrard, Timothy F. 1989. *Gold of Africa: Jewellery and Ornaments from Ghana, Côte d'Ivoire, Mali, and Senegal in the Collection of the Barbier-Mueller Museum.* Geneva: Barbier-Mueller Museum.

Gaskin, L.J.P. 1965. *A Bibliography of African Art.* London: International African Institute.

Gauthier, J.G. 1979. *Archéologie du pays Fali, nord Cameroun.* Paris: Éditions du centre national de la recherche scientifique.

Gautier, Jean-Marie. 1950. *Étude historique sur les Mpongues et tribus avoisinantes.* Montpellier: Imprimerie Laffitte-Lauriol.

Geary, Christraud M. 1983. *Things of the Palace: A Catalogue of the Bamum Palace Museum in Foumban (Cameroon).* Wiesbaden: Franz Steiner.

————. 1988. *Images from Bamum: German Colonial Photography at the Court of King Njoya, Cameroon, West Africa, 1902-1915.* Washington: Smithsonian Institution Press for the National Museum of African Art.

————. 1994. *The Voyage of King Njoya's Gift: A Beaded Sculpture from the Bamum Kingdom, Cameroon.* Washington: Smithsonian Institution Press for the National Museum of African Art.

Gebauer, Paul. 1979. *Art of Cameroon.* Portland, Ore.: Portland Museum of Art.

Geis-Tronich, Gudrun. 1991. *Materielle Kultur der Gulmance in Burkina Faso.* Stuttgart: Franz Steiner.

Gelfand, Michael. 1966. *An African's Religion: The Spirit of Nyajena, Case History of a Karanga People.* Cape Town: Juta.

Gendreau, André, and Marie Dufour. 1992. *Nomades.* Saint-Laurent, Quebec: Fides.

Gerbrands, Adrian A. 1957. *Art as an Element of Culture, especially in Negro-Africa.* Leiden: E.J. Brill.

————. 1967. *Afrika: Kunst aus dem schwarzen Erdteil.* Leiden: Aurel Bongers Recklinghausen.

Gerster, Georg. 1970. *Churches in Rock: Early Christian Art in Ethiopia.* London: Phaidon.

Geschiere Peter. 1995. *Sorcellerie et politique en Afrique: La viande des autres.* Paris: Karthala.

Gessain, Monique. 1967. *Les migrations des Coniagui et Bassari.* Paris: Société des africanistes, Museé de l'homme.

————. 1976. *Collections Bassari du Museé de l'homme, du département d'anthropologie de l'Université de Montreal, Canada, du Musée de l'I.F.A.N. à Dakar et du C.R.D.S. à Saint-Louis, Sénégal.* Paris: Musée national d'histoire naturelle.

BIBLIOGRAPHY

Gessain, Monique, and Marie-Therese Lestrange, eds. 1980. *Tenda 1980: Badyaranke, Bassari, Bedik, Boin, Coniagui*. Paris: Société des africanistes.

Gibbs, James L., ed. 1965. *Peoples of Africa*. New York: Holt, Rinehart and Winston.

Gilfoy, Peggy Stoltz. 1987. *Patterns of Life: West African Strip-Weaving Tradition*. Washington: Smithsonian Institution Press.

Gillon, Werner. 1980. *Collecting African Art*. New York: Rizzoli.

———. 1984. *A Short History of African Art*. New York: Facts on File.

Gilombe, Mudiji Malamba. 1989. *Le langage des masques africains: Étude des formes et fonctions symboliques des "Mbuya" des Phende*. Kinshasa: Facultés catholiques de Kinshasa.

Girard, Jean. 1967. *Dynamique de la société ouobé: Loi des masques et coutumes*. Dakar: IFAN.

Gistelinck, Frans, and M. Sabbe, eds. 1991. *Kronkronbali: Figuratieve Terracotta uit West-Afrika*. Leuven: Bibliotheek van de faculteit der godgeleerdheid.

Glaze, Anita J. 1981. *Art and Death in a Senufo Village*. Bloomington: Indiana University Press.

Gluck, Julius, and Margot Noske. 1956. *Afrikanische Masken: Achtundvierzig Aufnahmen*. Baden-Baden: Woldemar Klein.

Gnonsoa, Angèle. 1985. *Le ministère des affaires culturelles présente Masques de l'Ouest ivoirien*. Abidjan: MAC/CEDA.

Goemaere, Alphonse. 1988. *Notes sur l'histoire, la religion, les institutions sociales et la jurisprudence chez les Ndengese et les Ohendo (République du Zaire)*. Bandundu: CEEBA.

Goldschmidt, Walter. 1967. *Sebei Law*. Berkeley and Los Angeles: University of California Press.

———. 1976. *The Culture and Behavior of the Sebei: A Study in Continuity and Adaption*. Berkeley and Los Angeles: University of California Press.

Goldwater, Robert John. 1960. *Bambara Sculpture from the Western Sudan*. New York: University Publishers.

———. 1986. *Primitivism in Modern Art*. Cambridge: Harvard University Press, Belknap Press.

Gollbach, Friedrich. 1992. *Leben und Tod bei den Tswana: Das Traditionelle Lebens und Todesverständnis der Tswana im Südlichen Afrika*. Berlin: D. Reimer.

Gollnhofer, Otto, et al. 1975. *Art et artisanat tsogho*. Paris: ORSTOM.

Goody, Esther N. 1973. *Contexts of Kinship: An Essay in the Family Sociology of the Gonja of Northern Ghana*. Cambridge: Cambridge University Press.

Goody, Jack. 1962. *Death, Property, and the Ancestors: A Study of the Mortuary Customs of the LoDagaa of West Africa*. Stanford: Stanford University Press.

———. 1967. *The Social Organization of the LoWiili*. London: Oxford University Press for the International African Institute.

———. 1972. *The Myth of the Bagre*. Oxford: Clarendon Press.

———. 1987. *Religion, Morality and the Person: Essays on Tallensi Religion*. Cambridge: Cambridge University Press.

Gottschalk, Burkhard. 1988. *Madebele: Buschgeister im Land der Senufo*. Meerbusch: B. Gottschalk.

Graburn, Nelson H.H., ed. 1967. *Ethnic and Tourist Arts: Cultural Expressions from the Fourth World*. Berkeley and Los Angeles: University of California Press.

Gratien, B., and F. le Saout. 1996. *Nubie: Les cultures antiques du Soudan, à travers les explorations et les fouilles françaises et franco-soudanaises*. Lille: Université Charles de Gaulle.

BIBLIOGRAPHY

Gray, Robert F. 1963. *The Sonjo of Tanganyika: An Anthropological Study of an Irrigation-Based Society*. London: Oxford University Press for the International African Institute.

Greenberg, Joseph H. 1963. *The Languages of Africa*. Bloomington: Indiana University.

Greub, Suzanne, ed. 1988. *Expressions of Belief: Masterpieces of African, Oceanic, and Indonesian Art from the Museum voor Volkenkunde, Rotterdam*. New York: Rizzoli.

Grévisse, F. 1956. *Notes ethnographiques relatives à quelques populations autochtones du Haut-Katanga industriel*. Elizabethville: Bullétin CEPSI.

Griaule, Marcel. 1947. *Arts de l'Afrique noire*. Paris: Éditions du Chêne.

_____. 1963. *Masques dogons*. 2d ed. Paris: Institut d'ethnologie.

_____. 1965. *Conversations with Ogotommeli: An Introduction to Dogon Religious Ideas*. London: Oxford University Press for the International African Institute.

Grimes, Barbara F., ed. 1992. *Ethnologue Index*. 12th ed. Dallas: Summer Institute of Linguistics. Available at www.sil.org.

Grinker, Roy R. 1994. *Houses in the Rain Forest: Ethnicity and Inequality among Farmers and Foragers in Central Africa*. Berkeley and Los Angeles: University of California Press.

Grohs, Elisabeth. 1980. *Kisazi: Reiferiten der Mädchen bei den Zigua und Ngulu Ost-Tanzanias*. Berlin: Reimer.

Grottanelli, Vinigi. 1977-78. *Una società guineana—gli Nzima*. 2 vols. Torino: Boringhieri.

Grüb, Andreas. 1992. *The Lotuho of the Southern Sudan: An Ethnological Monograph*. Stuttgart: Franz Steiner.

Guenneguez, Andre, and Afo Guenneguez. 1992. *Art de la Côte d'Ivoire et de ses voisins: Catalogue des objets extraits de la collection Guenneguez*. Paris: Harmattan.

Guillaume, Paul, and Guillaume Apollinaire. 1917. *Sculptures nègres*. Reprint, New York: Hacker Art Books, 1972.

Gulliver, P.H. 1963. *Social Control in an African Society: A Study of the Arusha Agricultural Masai of Northern Tanganyika*. Boston: Boston University Press.

_____. 1971. *Neighbors and Networks: The Idiom of Kinship in Social Action among the Ndendeuli of Tanzania*. Berkeley and Los Angeles: University of California Press.

Gulliver, Pamela, and P.H. Gulliver. 1968. *The Central Nilo-Hamites*. London: International African Institute.

Gunn, Harold D. 1953. *Peoples of the Plateau Area of Northern Nigeria*. London: International African Institute.

_____. 1956. *Pagan Peoples of the Central Area of Northern Nigeria*. London: International African Institute.

Gunn, Harold D., and F.P. Conant. 1960. *Peoples of the Middle Niger Region of Northern Nigeria*. London: International African Institute.

Guthrie, Malcolm. 1967. *Comparative Bantu: An Introduction to the Comparative Linguistics and Prehistory of the Bantu Languages*. 4 vols. Farnborough: Gregg.

Gutmann, Bruno. 1932-1938. *Die Stammeslehren der Dschaga*. 3 vols. Munich: Beck.

Haacke, Wilfrid H.G. 1982. *Traditional Hut-Building Technique of the Nama: With some Related Terminology*. Windhoek: State Museum.

Haberland, Eike. 1963. *Galla Süd-Aethiopiens* (The Galla of Southern Ethiopia). Stuttgart: W. Kohlhammer.

Habi, Ya'akub H. 1987. *The People Called Bassa-Nge*. Zaria: Ahmadu Bello University.

Hagenbucher-Sacripanti, Frank. 1973. *Les fondements spirituels du pouvoir du royaume de Loango, République populaire du Congo*. Paris: ORSTOM.

Hahn, Hans Peter. 1991. *Die Materielle Kultur der Bassar (Nord-Togo)*. Stuttgart: Franz Steiner.

BIBLIOGRAPHY

Hale, Sondra. 1973. *Nubians: A Study in Ethnic Identity*. Khartoum: Institute of African and Asian Studies, University of Khartoum.

Hale, Thomas A. 1990. *Scribe, Griot, and Novelist: Narrative Interpreters of the Songhay Empire*. Gainesville: University of Florida Press.

Hall, Henry Usher. 1938. *The Sherbro of Sierra Leone: A Preliminary Report on the Work of the University Museum's Expedition to West Africa, 1937*. Philadelphia: University Press, University of Pennsylvania.

Hallpike, Christopher R. 1972. *The Konso of Ethiopia: A Study of the Values of a Cushitic People*. Oxford: Clarendon Press.

Hama, Boubou. 1968. *Contribution à la connaissance de l'histoire des Peul*. Paris: Présence africaine.

Hampâté Bâ, Amadou. 1994. *Oui, mon commandant! Mémoires (II)*. Arles: Actes du Sud.

Hammond-Tooke, W.D. 1962. *Bhaca Society, a People of the Transkeian Uplands, South Africa*. Oxford: Oxford University Press.

_____, ed. 1974. *The Bantu-Speaking Peoples of Southern Africa*. 2d ed. London: Routledge and Kegan Paul.

Harley, George Way. 1950. *Masks as Agents of Social Control in Northern Liberia*. Cambridge, Mass.: Peabody Museum of Art.

Harms, Robert W. 1987. *Games Against Nature: An Eco-Cultural History of the Nunu of Equatorial Africa*. Cambridge: Cambridge University Press.

Harries, C.L. 1929. *The Laws and Customs of the Bapedi and Cognate Tribes of the Transvaal*. Johannesburg: Hortors.

Harries, Lyndon. 1944. *The Initiation Rites of the Makonde Tribe*. Livingston: The Rhodes-Livingston Institute.

Harris, Grace G. 1978. *Casting Out Anger: Religion among the Taita of Kenya*. Cambridge: Cambridge University Press.

Harter, Pierre. 1986. *Arts anciens du Cameroun*. Arnouville: Arts d'Afrique noire.

Hartwig, Gerald W. 1979. *Oral Evidence and its Potential: The Example of the Tanzanian Kerebe*. Khartoum: Institute of Africa and Asian Studies, University of Khartoum.

Harwood, Alan. 1970. *Witchcraft, Sorcery and Social Categories among the Safwa*. London: Oxford University Press for the International African Institute.

Hassen, Mohammed. 1992. *The Oromo of Ethiopia: A History 1570-1860*. Cambridge: Cambridge University Press.

Hauenstein, Alfred. 1967. *Les Hanya: Description d'un groupe ethnique bantou de l'Angola*. Wiesbaden: Steiner.

Haumant, Jean-Camille. 1929. "Les Lobi et leur coutume." Paris: Thèse, Université de Paris.

Hayes, Charles. 1977. *Contemporary Makonde Sculpture: The Madan Sapra Collection, Nairobi, Kenya, East Africa*. Beverly Hills, Calif.: David Love.

Hecht, Elisabeth-Dorothea. 1993. *Die traditionellen Frauenvereine der Harari in Harar und in Addis Ababa*. Berlin: Dietrich Reimer.

Heise, Wolfram, Antje Spliethoff-Laiser, and Sybille Wolkenauer. 1993. *Verzeichnis der Völkerkundlichen Sammlung des Instituts für Völkerkunde der Georg-August-Universität zu Göttingen. Teil IV: Afrika*. Göttingen: Das Institut.

Heldman, Marilyn, et al. 1994. *African Zion: The Sacred Art of Ethiopia*. New Haven: Yale University Press.

Herbst, D. 1985. *Tegniese skeppinge van die Swazi in KaNgwane*. Pretoria: Raad vir geesteswetenskaplike navorsing.

Herold, Erich. 1967. *The Art of Africa: Tribal Masks from the Náprstek Museum, Prague*. London: Paul Hamlyn.

BIBLIOGRAPHY

Herreman, Frank, and Constijn Petridis, eds. 1993. *Face of the Spirits: Masks from the Zaire Basin*. Antwerp: Snoeck-Ducaju and Zoon.

Herreman, Frank, et al. 1991. *Etnografisch Museum Antwerpen*. Brussels: Gemeentekrediet.

Herrman, Ferdinand. 1969. *Afrikanische Kunst aus dem Völkerkundemuseum der Portheim-Stiftung*. Berlin: Springer-Verlag.

_____. n.d. *Afrikanische Plastik*. Baden-Baden: Waldemar Klein.

Hersak, Dunja. 1986. *Songye Masks and Figure Sculpture*. London: Ethnographica.

Herskovits, Melville J. 1938. *Dahomey: An Ancient West African Kingdom*. 2 vols. Reprint, Evanston, Ill.: Northwestern University Press, 1967.

_____. 1962. *The Human Factor in Changing Africa*. New York: Knopf.

_____. 1967. *The Backgrounds of African Art*. New York: Biblo and Tannen.

Heurtebize, Georges. 1986. *Quelques aspects de la vie dans l'Androy (extrême-sud de Madagascar)*. Tananarive: Musée d'art et d'archéologie de l'Université de Madagascar.

Heymer, Kay, ed. 1993. *Tanzende Bilder: Fahnen der Fante Asafo in Ghana*. Bonn: Kunst und Austellungshalle der Bundesrepublik Deutschland.

Hilberth, John. 1973. *The Gbaya*. Uppsala: Institutionen for allman och jamforande etnografi.

Hill, J.H. 1967. *Ogboni Sculpture: A Critical Apppraisal of Its Creative Attributes*. Oxford: Oxford University Press.

Hiltunen, Maija. 1986. *Witchcraft and Sorcery in Ovambo*. Helsinki: Finnish Anthropological Society.

Himmelheber, Hans. 1960. *Negerkunst und Negerkünstler*. Braunschweig: Klinkhardt und Biermann.

_____. 1967. *Plastik der Afrikaner*. Frankfurt am Main: Städtisches Museum für Völkerkunde.

_____. 1993. *Zaire 1938/39: Photographic Documents on the Arts of the Yaka, Pende, Tshokwe, and Kuba*. Zurich: Museum Rietberg.

Hirschberg, Walter. 1965. *Völkerkunde Afrikas*. Mannheim: Bibliographisches Institut.

Hjort, Anders, and Gudrun Dahl. 1991. *Responsible Man: The Atmaan Beja of North-Eastern Sudan*. Stockholm: Stockholm Studies in Social Anthropology in cooperation with Nordiska Afrikainstitutet, Uppsala.

Hochegger, Hermann. 1975. *Normes et pratiques sociales chez les Buma (République du Zaire)*. Bandundu: CEEBA.

Hodge, Carleton T., ed. 1971. *Papers on the Manding*. The Hague: Mouton for Indiana University.

Hofmayr, Wilhelm. 1925. *Die Schilluk: Geschichte, Religion und Leben eines Niloten-Stammes*. St. Gabriel: Modling bei Wien Administration des Anthropos.

Holas, Bohumil. 1952. *Les masques Kono (Haute-Guinée française): Leur rôle dan la vie religieuse et politique*. Paris: Librairie orientaliste Paul Geuthner.

_____. 1962. *Les Toura: Esquisse d'une civilisation montagnarde de Côte d'Ivoire*. Paris: Presses universitaires de France.

_____. 1966. *Les Sénoufo (y compris les Minianka)*. Paris: Presses universitaires de France.

_____. 1969. *Arts traditionnels de la Côte d'Ivoire*. 2d ed. Abidjan: CEDA.

_____. 1969. *Sculpture sénoufo*. 2d ed. Abidjan: Centre des sciences humaines.

_____. 1975. *Le Gagou: Son portrait culturel*. Paris: Presses universitaires de France.

Holsoe, Svend E. 1967. "The Cassava-leaf People: An Ethnohistorical Study of the Vai People with Particular Emphasis on the Tewo Chiefdom." Ph.D. diss., Boston University.

_____. 1979. *A Standardization of Liberian Ethnic Nomenclature*. Philadelphia: Institute for Liberian Studies.

Holy, Ladislav. 1967. *The Art of Africa: Masks and Figures from Eastern and Southern Africa*. London: Paul Hamlyn.

_____. 1991. *Religion and Custom in a Muslim Society: The Berti of Sudan*. Cambridge: Cambridge University Press.

Homberger, Lorenz, ed. 1991. *Die Löffel in der Kunst Afrikas*. Zurich: Museum Rietberg.

Hopen, C. Edward. 1958. *The Pastoral Fulbe Family in Gwandu*. London: Oxford University Press for the International African Institute.

Horizon History of Africa. 1971. New York: American Heritage Publishing.

Horton, Robin. 1965. *Kalabari Sculpture*. Lagos: Department of Antiquities.

Hountondji, Paulin J. 1983. *African Philosophy: Myth and Reality*. Bloomington: Indiana University Press.

Huber, Hugo. 1963. *The Krobo: Traditional Social and Religious Life of a West African People*. St. Augustin: Anthropos Institute.

Huet, Michel. 1978. *The Dance, Art and Ritual of Africa*. New York: Pantheon.

Hulstaert, Gustaaf. 1938. *Le mariage des Nkundo* (Marriage of the Nkundo). Brussels: G. van Campenhout.

_____. 1950. *Carte linguistique du Congo belge*. Brussels: Institut royal colonial belge.

_____. 1961. *Les Mongo: Aperçu général*. Tervuren: Musée royal de l'Afrique centrale.

Hulstaert, Gustaaf, D. Vangroenweghe, and H. Vinck. 1984. *De Mongo Cultuur*. N.p.: Gemeentekrediet.

Huntingford, G.W.B. 1953. *The Nandi of Kenya: Tribal Control in a Pastoral Society*. London: Routledge and Paul.

_____. 1955. *The Galla of Ethiopia: The Kingdoms of Kafa and Janjero*. London: International African Institute. Reprint, 1969.

_____. 1968. *The Northern Nilo-Hamites*. London: International African Institute.

_____. 1969. *The Southern Nilo-Hamites*. London: International African Institute.

Huntington, Richard. 1988. *Gender and Social Structure in Madagascar*. Bloomington: Indiana University Press.

Ibrahim, Abd Allah Ali. 1994. *Assaulting with Words: Popular Discourse and the Bridle of Shari'ah*. Evanston, Ill.: Northwestern University Press.

Ichegbo, Clement Waleru. 1992. *The Evo Man*. Port Harcourt: Pam Unique Publishers.

Ikime, Obaro. 1972. *The Isoko People: A Historical Survey*. Ibadan: Ibadan University Press.

Imperato, Pascal J. 1983. *Buffoons, Queens, and Wooden Horsemen: The Dyo and Gouan Societies of the Bambara of Mali*. New York: Kilima House.

INADES and Ernest Zocli. 1973. *Bibliografia delle etnie del Cameroun*. Rome: Comitato di coordinamento delle organizzazioni per il servizio volontario.

International African Institute. 1927. *Practical Orthography of African Languages*. London: International African Institute.

International African Institute Library. 1973. *Cumulative Bibliography of African Studies*. 5 vols. London: International African Institute; Boston: G.K. Hall.

International African Seminar, Jan Vansina, R. Mauny, and L.V. Thomas, eds. 1964. *The Historian in Tropical Africa: Studies Presented and Discussed at the Fourth International African Seminar, 1961*. London: Oxford University Press for the International African Institute.

BIBLIOGRAPHY

Ishumi, Abel G.M. 1980. *Kiziba: The Cultural Heritage of an Old African Kingdom.* Syracuse: Maxwell School of Citizenship and Public Affairs, Syracuse University.

Ita, Nduntuei O. 1971. *Bibliography of Nigeria: A Survey of Anthropological and Linguistic Writings from the Earliest Times to 1966.* London: Frank Cass.

Iwo, O.G. 1991. *A Social History of Degema.* Port Harcourt: Don Sun Communications.

Izard, Michel. 1970. *Introduction à l'histoire des royaumes mossi.* 2 vols. Paris: Collège de France, Laboratoire d'anthropologie sociale.

Jackson, Michael. 1977. *The Kuranko: Dimensions of Social Reality in a West African Society.* New York: St. Martin's Press.

Jacobs, John. 1962. *Tetela-Grammatica.* Vol.1. Tervuren: Musée royal du Congo belge.

Jacques-Meunié, D. 1961. *Cités anciennes de Mauritanie, provinces de Tagannt et du Hodh.* Paris: Librairie C. Klincksieck.

Jahn, Jens, ed. 1996. *Tanzania: Meisterwerke Afrikanischer Skulptur.* Munich: Kunstbau Lenbachhaus.

James, Wendy. 1988. *The Listening Ebony: Moral Knowledge, Religion and Power among the Uduk of Sudan.* Oxford: Clarendon Press.

Jansen, Gerard, and J.G. Gauthier. 1973. *Ancient Art of the Northern Cameroons: Sao and Fali.* Oosterhout: Anthropological Publications.

Jaulin, Robert. 1985. *La muerte en los Sara.* Barcelona: Editorial Mitre.

Jaspan, M.A. 1953. *The Ila-Tonga Peoples of North-Western Rhodesia.* London: International African Institute.

Jedrej, M. Charles. 1995. *Ingessana: The Religious Institutions of a People of the Sudan-Ethiopia Borderland.* New York: E.J. Brill.

Jefferson, Louise E. 1973. *The Decorative Arts of Africa.* New York: Viking Press.

Jemkur, J.F. 1992. *Aspects of the Nok Culture.* Zaria: Ahmadu Bello University Press.

Johnson, John William, and Fa-Digi Sisòkò. 1986. *The Epic of Son-Jara: A West African Tradition.* Bloomington: Indiana University Press.

Johnson, R. Townley. 1979. *Major Rock Paintings of Southern Africa.* Bloomington: Indiana University Press.

Jones, G.I. 1984. *Art of Eastern Nigeria.* Cambridge: Cambridge University Press.

Jones, Ruth. 1958. *Africa Bibliography Series: Ethnography, Sociology, Linguistics, and Related Subjects. West Africa. General, Ethnography/Sociology, Linguistics.* London: International African Institute.

_____. 1959. *Africa Bibliography Series: Ethnography, Sociology, Linguistics, and Related Subjects. North-East Africa. General, Ethnography/Sociology, Linguistics.* London: International African Institute.

_____. 1960. *Africa Bibliography Series: Ethnography, Sociology, Linguistics, and Related Subjects. East Africa. General, Ethnography/Sociology, Linguistics.* London: International African Institute.

_____. 1961. *Africa Bibliography Series: Ethnography, Sociology, Linguistics, and Related Subjects. South-East Central Africa and Madagascar. General, Ethnography/Sociology, Linguistics.* London: International African Institute.

Junod, Henri Alexandre. 1897. *Les chants et les contes des Ba-ronga de la baie de Delagoa.* Reprint, Nendeln: Kraus Reprint, 1970.

Kabengele, Munaga. 1986. *Os Basanga de Shaba: Um grupo etnico do Zaire: Ensaio de antropologia geral.* Sao Paulo: FFLCH--USP.

Kaberry, Phyllis Mary. 1952. *Women of the Grassfields: A Study of the Economic Position of Women in Bamenda, British Cameroons.* London: Her Majesty's Stationery Office.

Kagwa, Apolo. 1934. *The Customs of the Baganda.* New York: Columbia University Press.

BIBLIOGRAPHY

Kalanda, Mabika. 1992. *La révélation du Tiakani*. Kinshasa: Lask.

Kamara, Mamadou Koble. 1992. *Les fonctions des masques dans la société Dan de Sipilou*. Zurich: Museum Rietberg.

Kammerer-Grothaus, Helke. 1991. *Skulpturen aus Ebenholz: Kunst der Makonde*. Heilegkreuztal: Verlag Aktuelle Texte.

Kante, Nambala, and Pierre Erny. 1993. *Forgerons d'Afrique noire: Transmission des savoirs traditionnels en pays malinke*. Paris: Harmattan.

Katoke, Israel K. 1975. *The Karagwe Kingdom: A History of the Abanyambo of Northwestern Tanzania, 1400-1915*. Nairobi: East African Publishing House.

Kay, George. 1964. *Chief Kalaba's Village*. Manchester: Manchester University Press.

Kecskési, Maria. 1987. *African Masterpieces and Selected Works from Munich: The Staatliches Museum für Völkerkunde*. New York: Center for African Art.

Keletigui, Jean Marie. 1978. *Les Sénoufo face au cosmos*. Abidjan: Nouvelles éditions africaines.

Kennedy, Carolee. 1978. *The Art and Material Culture of the Zulu-Speaking Peoples*. Los Angeles: UCLA Museum of Cultural History.

Kennedy, John G., ed. 1978. *Nubian Ceremonial Life: Studies in Islamic Syncretism and Cultural Change*. Berkeley and Los Angeles: University of California Press.

Kenyatta, Jomo. 1938. *Facing Mount Kenya: The Tribal Life of the Gikuyu*. Reprint, New York: AMS Press, 1978.

Kerchache, Jacques, Jean-Louis Paudrat, and Lucien Stéphan. 1993. *Art of Africa*. New York: Harry N. Abrams.

Kibango, Ngolo. 1976. *Minganji, danseurs de masques pende*. Bandundu: CEEBA.

Kimambo, Isaria N. 1969. *A Political History of the Pare of Tanzania, c. 1500-1900*. Nairobi: East African Publishing House.

Kirby, Jon P. 1986. *Gods, Shrines, and Problem-Solving among the Anufo of Northern Ghana*. Berlin: D. Reimer.

Kjersmeier, Carl. 1967. *Centres de style de la sculpture nègre africaine*. New York: Hacker Art Books.

Klima, George J. 1970. *The Barabaig: East African Cattle Herders*. New York: Holt, Rinehart and Winston.

Knoedler Gallery. 1991. *Tribal Shields from South-Western Abyssinia*. London: Knoedler Gallery.

Knöpfli, Hans. 1975. *Volkskunst in Kamerun: Das Zentrum für Einheimisches Kunsthandwerk in Bali/Kamerun*. Basel: Kooperations avang. Kirchen und Missionen in der deutschsprachigen Schweiz.

Kohl-Larsen, Ludwig. 1958. *Wildbeuter in Ostafrika: Die Tindiga, ein Jäger und Sammlervölk*. Berlin: D. Reimer.

Koloss, Hans-Joachim. 1977. *Kamerun: Könige, Masken, Feste: Ethnologische Forschungen im Grasland der Nordwest-Provinz von Kamerun. Veröffenlicht anlässlich der Ausstellung Kamerun, Könige, Masken, Feste*. Stuttgart: Institut für Auslandsbeziehungen.

_____. 1987. *Zaïre, Meisterwerke afrikanischer Kunst*. Berlin: Mann.

_____. 1990. *The Art of Central Africa: Masterpieces from the Berlin Museum für Völkerkunde*. New York: Metropolitan Museum of Art.

Koloss, Hans Joachim, and Till Förster. 1990. *Die Kunst der Senufo, Elfenbeinküste*. Berlin: Museum für Völkerkunde.

Korsching, Friederike. 1980. *Beduinen im Negev: Eine Ausstellung der Sammlung Sonia Gidal/Staatliches Museum für Völkerkunde, München*. Mainz am Rhein: P.V. Zabern.

BIBLIOGRAPHY

Kottak, Conrad Phillip et al., eds. 1986. *Madagascar: Society and History*. Durham: Carolina Academic Press.

Koudolo, Svetlana. 1991. *La participation des institutions d'Afa et du Vodu dans les processus de la socialisation des enfants (en milieu Ewe)*. Lome: DI.FO.P.

Kratz, Corinne A. 1994. *Affecting Performance: Meaning, Movement, and Experience in Okiek Women's Initiation*. Washington: Smithsonian Institution Press.

Kreamer, Christine Mullen. 1986. *Art of Sub-Saharan Africa: The Fred and Rita Richman Collection*. Atlanta: High Museum of Art.

Krieger, Kurt. 1965. *Westafrikanische Plastik*. 3 vols. Berlin: Museum für Völkerkunde.

_____. 1990. *Ostafrikanische Plastik*. Berlin: Museum für Völkerkunde.

Krieger, Kurt, and Gerdt Kutscher. 1960. *Westafrikanische Masken*. Berlin: Museum für Völkerkunde.

Krige, Eileen J., and Jacob Daniel Krige. 1943. *The Realm of a Rain-Queen: A Study of the Pattern of Lovedu Society*. Reprint, New York: AMS Press, 1978.

Kroger, Franz. 1978. *Übergangsriten im Wandel: Kindheit, Reife und Heirat bei den Bulsa in Nord-Ghana*. Hohenschaftlarn bei München: Kommissionsverlag K. Renner.

Kronenberg, Andreas. 1958. *Die Teda von Tibesti*. Horn: F. Berger.

_____. 1972. *Logik und Leben: Kulturelle Relevanz der Didinga und Longarim, Sudan*. Wiesbaden: Steiner.

Kronenberg, Waltraud, and A. Kronenberg. 1981. *Die Bongo Bauern und Jäger im Südsudan*. Wiesbaden: Steiner.

Kubik, Gerhard. 1987. *Tusona-Luchazi Ideographs: A Graphic Tradition Practised by a People of West Central Africa*. Vienna: Fohrenau.

Kubik, Gerhard, and Moya A. Malamusi. 1987. *Nyau: Maskenbünde im Südlichen Malawi*. Vienna: Verlag der Osterreichischen Akademie der Wissenschaften.

Kuper, Hilda. 1952. *The Swazi*. London: International African Institute.

Kuper, Hilda, J. Van Velsen, and A.J.B. Hughes. 1954. *The Shona and Ndebele of Southern Rhodesia: The Shona by Hilda Kuper. The Ndebele by A.J.B. Hughes and J. van Velsen*. London: International African Institute.

Labouret, Henri. 1931. *Les tribus du rameau Lobi*. Paris: Institut d'ethnologie.

Laburthe-Tolra, Philippe. 1985. *Initiations et sociétés secrètes au Cameroun: Les mystères de la nuit*. Paris: Karthala.

Lafargue, Fernand. 1976. *Religion, magie, sorcellerie des Abidji en Côte d'Ivoire*. Paris: Nouvelles éditions latines.

LaFontaine, J.S. 1959. *The Gisu of Uganda*. London: International African Institute.

Lagercrantz, Sture. 1950. *Contribution to the Ethnography of Africa*. Reprint, Westport, Conn.: Greenwood Press, 1979.

Lala, Bevarrah. 1992. *Éducation traditionelle ou les rites de passage*. Bangui: B. Lala.

Laman, Karl. 1953-1968. *The Kongo*. 4 vols. Uppsala: Studia ethnographica upsaliensia.

Lamb, Venice. 1975. *West African Weaving*. London: Duckworth.

Lang, Alphonse. 1937. *La tribu des Va-nyaneka*. Corbeil: Imprimerie Crete.

Lange, Werner J. 1975. *Gimira: Remnants of a Vanishing Culture*. Bemberg: Difo-Druck.

Langley, Myrtle. 1979. *The Nandi of Kenya: Life Crisis Rituals in a Period of Change*. London: C. Hurst.

Lanternari, Vittorio. 1976. *Incontro con una cultura africana*. Napoli: Liguori.

Larochette, J. 1958. *Grammaire des dialectes Mangbetu et Medje suivie d'un manuel de conversation et d'un lexique*. Tervuren: Musée royal de l'Afrique centrale.

Lassalle, Philippe, and Jean-Bernard Sugier. 1992. *Rituels et développement, ou, Le jardin du Soufi*. Paris: Harmattan.

BIBLIOGRAPHY

Laude, Jean. 1971. *The Arts of Black Africa*. Berkeley and Los Angeles: University of California Press.

_____. 1973. *African Art of the Dogon: The Myths of the Cliff Dwellers*. New York: Brooklyn Museum/Viking Press.

Laughlin, Charles D., and Elizabeth A. Allgeier. 1979. *An Ethnography of the So of Northeastern Uganda*. New Haven: Human Relations Area Files.

Lavachery, Henri. 1954. *Statuaire de l'Afrique noire*. Brussels: Office de publicité.

Lavazza, Luigia Maria. 1993. *Kitumba*. Monte Fiascone: Galleria di Arte e Cultura.

Lavondès, Anne. 1961. *Art traditionnel malgache: Introduction à une exposition*. Tananarive: Institut de recherche scientifique de Madagascar.

Lebeuf, Annie M.D. 1959. *Les populations du Tchad (Nord du 10ᵉ parallèle)*. Paris: Presses universitaires de France.

Lebeuf, Jean-Paul. 1961. *L'habitation des Fali, montagnards du Cameroun septentrional: Technologie, sociologie, mythologie, symbolisme*. Paris: Hachette.

Lebeuf, Jean-Paul, et al. 1978. *Systèmes de signes*. Paris: Hermann.

Lebeuf, Jean-Paul, and Annie Lebeuf. 1977. *Les arts des Sao: Cameroun, Tchad, Nigeria*. Paris: Chêne.

Lebeuf, Jean-Paul, and Johannes Hermann Immo Kirsch. 1989. *Ouara, ville perdue, Tchad*. Paris: Éditions recherche sur les civilisations.

LeCoq, Raymond. 1953. *Les Bamileké*. Paris: Éditions africaines.

Lee, Richard B. 1979. *The !Kung San: Men, Women, and Work in a Foraging Society*. Cambridge: Cambridge University Press.

Lehuard, Raoul. 1974. *Statuaire du Stanley-Pool: Contribution à l'étude des arts et techniques des peuples teke, lari, bembe, sundi et bwende de la République populaire du Congo*. Villiers-le-Bel: Arts d'Afrique noire.

_____. 1977. *Les Phemba du Mayombe*. Arnouville: Arts d'Afrique noire.

_____. 1980. *Fétiches à clous du Bas-Zaire*. Arnouville: Arts d'Afrique noire.

_____. 1989. *Art Bakongo: Les centres de style*. 3 vols. Arnouville: Arts d'Afrique noire.

Leiris, Michel, and Jacqueline Delange. 1968. *African Art*. New York: Golden Press.

Leloup, Hélène et al. 1994. *Dogon Statuary*. Strasbourg: Éditions Amez.

Lembezat, Bertrand. 1961. *Les populations païennes du Nord-Cameroun et de l'Adamaoua*. Paris: Presses universitaires de France.

Le Moal, Guy. 1980. *Les Bobo: Nature et fonction des masques*. Paris: ORSTOM.

Leroi-Gourhan, André, and Jean Poirier. 1953. *Ethnologie de l'Union Française (territoires extérieurs). Asie, Océanie, Amérique*. Vol. 2. Paris: Presses universitaires de France.

Le Rouvreur, Albert. 1962. *Sahéliens et Sahariens du Tchad*. Paris: Berger-Levrault. Reprint, Paris: Harmattan, 1989.

Les Bras, Jean François. 1971. *Les transformations de l'architecture funéraire en Imerina (Madagascar)*. Tananarive: Musée d'art et d'archéologie de l'Université Madagascar.

Leslau, Wolf. 1957. *Coutumes et croyances des Falachas (Juifs d'Abyssinie)*. Paris: Institut d'ethnologie.

_____. 1969. *Falasha Anthology: The Black Jews of Ethiopia*. New York: Schocken.

Leuzinger, Elsy. 1950. *Wesen und Form des Schmuckes Afrikanischer Völker*. Zurich: Lang.

_____. 1967. *Africa: The Art of the Negro Peoples*. New York: Crown Publishers.

Levenson, Jay A., ed. 1991. *Circa 1492: Art in the Age of Exploration*. New Haven: Yale University Press; Washington: National Gallery of Art.

Leverenz, Irene. 1994. *Der Kuhstall Gottes: Ein Ritual der Agar-Dinka*. Munich: Trickster.

Levinsohn, Rhoda. 1984. *Art and Craft of Southern Africa: Treasures in Transition.* Craighall: Delta Books.

Levtzion, Nehemia. 1973. *Ancient Ghana and Mali.* London: Methuen.

Lewis, Bazett A. 1972. *The Murle: Red Chiefs and Black Commoners.* Oxford: Clarendon Press.

Lewis, I.M. 1955. *Peoples of the Horn of Africa: Somali, Afar, and Saho.* London: International African Institute. Reprint, 1969.

_____. 1961. *A Pastoral Democracy: A Study of Pastoralism and Politics Among the Northern Somali of the Horn of Africa.* London: Oxford University Press for the International African Institute.

Lewis-Williams, J. David. 1981. *Believing and Seeing: Symbolic Meanings in Southern San Rock Paintings.* London: Academic Press.

_____. 1983. *The Rock Art of Southern Africa.* Cambridge: Cambridge University Press.

_____. 1990. *Discovering Southern African Rock Art.* Cape Town: David Philip.

Lewis-Williams, J.D., and T.A. Dowson. 1989. *Images of Power: Understanding Bushman Rock Art.* Johannesburg: Southern Book Publishers.

_____, eds. 1994. *Contested Images: Diversity in Southern African Rock Art.* Johannesburg: Witwatersrand University Press.

Lhôte, Henri. 1955. *Les Touaregs du Hoggar (Ahaggar).* 2d ed. Paris: Payot.

Library of Congress Subject Headings. 1996. Library of Congress, Cataloging Policy and Support Office. Washington, DC: Library of Congress, Cataloging Distribution Service. Available at Telnet: locis.loc.gov

Lienhardt, Godfrey. 1961. *Divinity and Experience: The Religion of the Dinka.* Oxford: Clarendon Press.

Lifschitz, Edward, ed. 1987. *The Art of West African Kingdoms.* Washington: Smithsonian Institution Press for the National Museum of African Art.

Ligers, Ziedonis. 1964. *Les Sorko, mâitres du Niger: Étude ethnographique.* Paris: Librairie des cinq continents.

Lima, Augusto Guilherme. 1971. *Fonctions sociologiques des figurines de culte hamba dans la société et dans la culture tshokwe.* Luanda: Instituto de investigaçao cientifica de Angola.

Lindblom, Gerhard. 1918. *The Akamba in British East Africa: An Ethnological Monograph.* Uppsala: K.W. Appelbergs.

Linton, Ralph. 1933. *The Tanala: A Hill Tribe of Madagascar.* Chicago: Field Museum of Natural History.

Little, Kenneth. 1967. *The Mende of Sierra Leone: A West African People in Transition.* London: Routledge and Kegan Paul.

Lokomba, Baruti. 1972. *Structure et fonctionnement des institutions politiques traditionnelles chez les Lokelé, Haut-Zaire.* Brussels: CEDAF.

Lombard, Jacques. 1965. *Structures de type "féodal" en Afrique noire: Études des dynamismes internes et des relations sociales chez les Bariba du Dahomée.* Paris: Mouton.

Loth, Heinrich. 1987. *Woman in Ancient Africa.* Westport, Conn.: Lawrence Hill.

Loughran, Katheryne S., ed. 1986. *Somalia in Word and Image.* Washington: Foundation for Cross-Cultural Understanding; Bloomington: Indiana University Press.

Lugira, Aloysius Muzzanganda. 1970. *Ganda Art: A Study of the Ganda Mentality with Respect to Possibilities of Acculturation in Christian Art.* Kampala: Osasa Publications.

Lukhero, Matshakaza B. 1992. *Ngoni nc'wala Ceremony.* Zambia: National Educational Company of Zambia.

BIBLIOGRAPHY

Lumbwe Mudindaambi. 1976. *Objets et techniques de la vie quotidienne mbala*. Bandundu: CEEBA.

Lundbaek, Torben, and Poul Mørk. 1968. *Afrikansk kunst: Kjersmeiers samling*. Copenhagen: Nationalmuseet.

Lydall, Jean, and Ivo Strecker. 1979. *The Hamar of Southern Ethiopia*. Hohenschaftlarn: Renner.

MacDermot, Brian Hugh. 1972. *Cult of the Sacred Spear: The Story of the Nuer Tribe in Ethiopia*. London: R. Hale.

MacGaffey, Wyatt. 1970. *Custom and Government in the Lower Congo*. Berkeley and Los Angeles: University of California Press.

_____. 1986. *Religion and Society in Central Africa: The Bakongo of Lower Zaire*. Chicago: University of Chicago Press.

_____. 1991. *Art and Healing of the Bakongo Commented by Themselves: Minkisi from the Laman Collection*. Stockholm: Folkens museum-etnografiska.

MacGaffey, Wyatt, and Michael D. Harris. 1993. *Astonishment and Power. The Eyes of Understanding: Kongo Minkisi; Resonance, Transformation, and Rhyme: The Art of Renée Stout*. Washington: Smithsonian Institution Press for the National Museum of African Art.

Mack, John. 1981. *Zulus*. Morristown, N.J.: Silver Burdett.

_____. 1986. *Madagascar: Island of the Ancestors*. London: British Museum Publications.

_____, ed. 1994. *Masks: The Art of Expression*. London: British Museum Press.

Mack, John, and John Picton. 1989. *African Textiles*. New York: Harper and Row.

Maenhaut, M. 1939. *Les Walendu*. Elisabethville: Éditions de la revue juridique du Congo belge.

Maes, Joseph, and Olga Boone. 1935. *Les peuplades du Congo belge: Nom et situation géographique*. Brussels: Musée du Congo belge.

Maes, Joseph, and Henri Lavachery. 1930. *L'Art nègre à l'exposition du Palais des Beaux Arts*. Brussels: Librairie nationale d'art et d'histoire.

Maesen, Albert. 1959. *Arte del Congo*. Rome: De Luca.

Magnant, Jean-Pierre. 1986. *La terre sara, terre tchadienne*. Paris: Harmattan.

Magor, Thomasin. 1994. *African Warriors: The Samburu*. New York: Harry N. Abrams.

Mainga, Mutumba. 1973. *Bulozi under the Luyana Kings: Political Evolution and State Formation in Pre-Colonial Zambia*. London: Longmans.

Mair, Lucy Philip. 1974. *African Societies*. London: Cambridge University Press.

Makila, F.E. 1978. *An Outline History of the Babukusu of Western Kenya*. Nairobi: Kenya Literature Bureau.

Makumbi, A.J. 1963. *Maliro ndi Myambo y Achewa*. London: Longmans.

Malan, J.S. 1974. *The Herero-Speaking Peoples of Kaokoland*. Windhoek: State Museum.

Mamah Fousseni, Abby-Alphah Ouro-Djobo. 1984. *La culture traditionelle et la littérature orale de Tem*. Stuttgart: Steiner.

Manchishi, P.C., and E.T. Musona. 1984-91. *The People of Zambia: A Short History of the Soli from 1500-1900*. Lusaka: Multimedia Publications.

Manessy, Gabriel. 1979. "Contribution à la classification généalogique des langues voltaïques." In *Langues et civilisations à tradition orale* 37. Paris: Société d'études linguistiques de France.

Mann, Michael, and David Dalby. 1987. *A Thesaurus of African Languages: A Classified and Annotated Inventory of the Spoken Languages of Africa. With an Appendix on Their Written Representation*. London: Hans Zell Publishers for the International African Institute.

BIBLIOGRAPHY

Manoukian, Madeline. 1950. *Akan and Ga-Adangme Peoples*. London: International African Institute.

————. 1951. *Tribes of the Northern Territories of the Gold Coast*. London: International African Institute.

————. 1952. *The Ewe-Speaking People of Togoland and the Gold Coast*. London: International African Institute.

Mantuba-Ngoma, Mabiala. 1989. *Frauen, Kunsthandwerk und Kultur bei den Yombe in Zaire*. Göttingen: Éditions Re.

Maquet, Jacques J. 1961. *The Premise of Inequality in Ruanda: A Study of Political Relations in a Central African Kingdom*. London: Oxford University Press for the International African Institute.

————. 1972. *Civilizations of Black Africa*. New York: Oxford University Press.

Marks, Stuart A. 1976. *Large Mammals and a Brave People: Subsistence Hunters in Zambia*. Seattle: University of Washington Press.

Marquart, J., J.D. Schmeltz, and J.P.B. de Josselin De Jong. 1904-1916. *Ethnographisch album van het stroomgebied van den Congo* (Ethnographic Album of the Congo Basin). The Hague: M. Nijhoff.

Martin, Jean-Yves. 1970. *Les Matakam du Cameroun: Essai sur la dynamique d'une société pré-industrielle*. Paris: ORSTOM.

Martin, Phyllis M., and Patrick O'Meara. 1986. *Africa*. 2d ed. Bloomington: Indiana University Press.

Martin del Molina, A. 1989. *Los Bubis: Ritos y creencias*. Madrid: Centro cultural hispano-guineano.

Marwick, M.G. 1965. *Sorcery in its Social Setting: A Study of the Northern Rhodesia Cewa*. Manchester: Manchester University Press.

Mato, Daniel, and Charles Miller III. 1990. *Sande: Masks and Statues from Liberia and Sierra Leone*. Amsterdam: Galerie Balolu.

Mawiri, Ambroisine, Victor Mbumba, and Vincent de Paul Nyonda. 1986. *Épopée mulombi*. Gabon: N.p.

Mbiti, John S. 1990. *African Religions and Philosophy*. 2d rev. ed. Oxford: Heinemann.

McCall, Daniel F., and Edna G. Bay, eds. 1975. *African Images: Essays in African Iconology*. New York: Africana Publishing Company for the African Studies Center, Boston University.

McCulloch, Merran. 1950. *The Peoples of Sierra Leone Protectorate*. London: International African Institute. Reissue, 1964.

————. 1951. *The Southern Lunda and Related Peoples (Northern Rhodesia, Belgian Congo, Angola)*. London: International African Institute.

————. 1952. *The Ovimbundu of Angola*. London: International African Institute.

McCulloch, Merran, Margaret Littlewood, and I. Dugast. 1954. *Peoples of the Central Cameroons: Tikar; Bamum and Bamileke; Banen, Bafia, and Balom*. London: International African Institute.

McIntosh, Susan K., ed. 1995. *Excavations at Jenne-Jeno, Hambarketolo and Kaniana (Inland Niger Delta, Mali), the 1981 Season*. Berkeley and Los Angeles: University of California Press.

McLeod, M. D. 1981. *The Asante*. London: British Museum Publications.

McNaughton, Patrick R. 1975. *Iron: Art of the Blacksmith in the Western Sudan*. Lafayette, Ind.: Haywood Printing.

————. 1979. *Secret Sculptures of Komo: Art and Power in Bamana (Bambara) Initiation Associations*. Philadelphia: Institute for the Study of Human Issues.

BIBLIOGRAPHY

_____. 1988. *The Mande Blacksmiths: Knowledge, Power, and Art in West Africa.* Bloomington: Indiana University Press.

McPherson, Charlotte. 1978. *African Grass and Fiber Arts.* New York: The African-American Institute.

Meauzé, Pierre. 1967. *L'Art nègre: Sculpture* (African Art: Sculpture). Paris: Hachette.

Meek, Charles K. 1931. *A Sudanese Kingdom: An Ethnographical Study of the Jukun-Speaking Peoples of Nigeria.* London: Kegan Paul, Trench, and Trubner.

Meeussen, A.E. 1952. *Esquisse de la lange ombo (Maniema-Congo belge).* Tervuren: Musée royal du Congo belge.

_____. 1954. *Linguistische schets van het Bangubangu.* Tervuren: Musée royale de l'Afrique centrale.

Mekkawi, Mod. 1979. *Bibliography on Traditional Architecture in Africa.* Washington, DC: Mekkawi.

Melland, Frank Hulme. 1923. *In Witch-Bound Africa: An Account of the Primitive Kaonde Tribe and their Beliefs.* Reprint, London: F. Cass, 1967.

Melville J. Herskovits Library. 1972. *Catalog of the Melville J. Herskovits Library of African Studies, Northwestern University Library.* 8 vols. Boston: G.K. Hall.

Menzel, Brigitte. 1968. *Goldgewichte aus Ghana.* Berlin: Museum für Völkerkunde.

_____. 1972-73. *Textilien aus Westafrika.* 3 vols. Berlin: Museum für Völkerkunde.

Mercier, Paul. 1952. *Les Ase du Musée d'Abomey.* Dakar: IFAN.

_____. 1968. *Tradition, changement, histoire: Les "Somba" du Dahomey septentrional.* Paris: Éditions Anthropos.

Merlet, Annie. 1991. *Autour du Loango, XIV^e - XIX^e siècle: Histoire des peuples du sud-ouest du Gabon au temps du royaume de Loango et du "Congo français."* Libreville: Centre culturel français Saint-Exupéry-Sepia.

Merriam, Alan P. 1982. *African Music in Perspective.* New York: Garland.

Meurant, Georges. 1986. *Shoowa Design: African Textiles from the Kingdom of Kuba.* London: Thames and Hudson.

Meyer, Laure. 1992. *Black Africa: Masks, Sculpture, Jewelry.* Paris: Éditions Pierre Terrail.

Meyer, Piet, Isabelle Wettstein, and Brigitte Kauf. 1981. *Kunst und Religion der Lobi.* Zurich: Museum Rietberg.

Middleton, John. 1960. *Lugbara Religion: Ritual and Authority among an East African People.* London: Oxford University Press for the International African Institute.

_____. 1992. *The World of Swahili: An African Mercantile Civilization.* New Haven: Yale University Press.

_____. ed. 1970. *Black Africa: Its Peoples and Their Cultures Today.* New York: MacMillan.

Middleton, John, and Greet Kershaw. 1953. *The Central Tribes of the North-Eastern Bantu: The Kikuyu, including Embu, Meru, Mbere, Chuka, Mwimbi, Tharaka, and the Kamba of Kenya.* London: International African Institute. Reprint, 1965.

Middleton, John, and David Tait, eds. 1958. *Tribes without Rulers: Studies in African Segmentary Systems.* London: Routledge and Kegan Paul.

Mignot, Alain. 1985. *La terre et le pouvoir chez les Guin du sud-est du Togo.* Paris: Publications de la Sorbonne.

Mille, Adrien. 1970. *Contribution à l'étude des villages fortifiés de l'Imerina ancien (Madagascar).* Tananarive: Musée d'art et d'archéologie de l'Université de Madagascar.

Millroth, Berta. 1965. *Lyuba: Traditional Religion of the Sukuma.* Uppsala: Almquist and Wiksells.

BIBLIOGRAPHY

Misago, Alois. 1994. *Konzeptuelle Metapher und soziale Organisation bei den Rundi in Ostafrika*. Berlin: Koster.

Mitchell, J. Clyde. 1956. *The Yao Village: A Study in the Social Structure of a Nyasaland Tribe*. Manchester: Manchester University Press for the Rhodes-Livingston Institute. Reprint, 1966.

Mnyampala, Mathias E. 1995. *The Gogo: History, Customs and Traditions*. Armonk, N.Y.: M.E. Sharpe.

Monnig, Hermann O. 1978. *The Pedi*. Pretoria: Van Schaik.

Moore, Sally Falk, and Paul Puritt. 1977. *The Chagga and Meru of Tanzania*. London: International African Institute.

Mount, Marshall Ward. 1973. *African Art: The Years Since 1920*. Bloomington: Indiana University Press.

Mufuka, K. Nyamayaro. 1983. *Dzimbahwe: Life and Politics in the Golden Age, 1100-1500 A.D.* Harare: Harare Publishing House.

Muller, Ernst W. 1957. "Le rôle social du nkumu chez les Ekonda." *Problèmes d'Afrique centrale* 38: 281-289.

Murdock, George Peter. 1959. *Africa: Its Peoples and Their Culture History*. New York: McGraw Hill.

_____. 1975. *Outline of World Cultures*. 5th ed. New Haven, Conn.: Human Relations Area Files.

Murray, Jocelyn. 1981. *Cultural Atlas of Africa*. New York: Facts-on-File.

Musée Dapper. 1986. *La voie des ancêtres: En hommage à Claude Lévi-Strauss*. Paris: Éditions Dapper.

_____. 1988. *Art et mythologie: Figures tshokwe*. Paris: Éditions Dapper.

_____. 1988. *Au royaume du signe: Appliqués sur toile des Kuba, Zaïre*. Paris: Éditions Dapper/Éditions Adam Biro.

_____. 1991. *Cuillers sculptures*. Paris: Éditions Dapper.

_____. 1994. *Dogon*. Paris: Éditions Dapper.

_____. 1995. *Masques*. Paris: Éditions Dapper.

Musée d'ethnographie and Jean-Claude Muller. 1994. *Le quotidien des Rukuba: Collections du Nigeria*. Neuchâtel: Musée d'ethnographie.

Musée du Congo belge. 1932-50. *Bibliographie ethnographique du Congo belge et des régions avoisinantes*. 14 vols. Tervuren: Musée du Congo belge.

_____. 1952-59. *Bibliographie ethnographique du Congo belge et des régions avoisinantes*. 10 vols. Tervuren: Musée royal du Congo belge.

Musée royal de l'Afrique centrale. 1960. *Bibliographie ethnographique du Congo belge et des régions avoisinantes*. Tervuren: Musée royal de l'Afrique centrale.

_____. 1961. *Bibliographie ethnographique du Congo et des régions avoisinantes*. Tervuren: Musée royal de l'Afrique centrale.

_____ 1962-81. *Bibliographie ethnographique du Congo belge et des régions avoisinantes*. 18 vols. Tervuren: Musée royal de l'Afrique centrale.

_____. 1982-84. *Bibliographie de l'Afrique sud-saharienne: Sciences humaines et sociales*. 3 vols. Tervuren: Musée royal de l'Afrique centrale.

Museum of Primitive Art. 1960. *Bambara Sculpture from the Western Sudan*. New York: Museum of Primitive Art.

Museum voor Land en Volkenkunde. 1957. *Une collection ethnographique des Ababdes et des Bicharin, dans le Museum voor Land en Volkenkunde*. Rotterdam: Museum voor Land en Volkenkunde.

Nadel, S.F. 1942. *A Black Byzantium: The Kingdom of Nupe in Nigeria*. London: Oxford University Press for the International African Institute of African Languages and Cultures.

BIBLIOGRAPHY

_____. 1947. *The Nuba: An Anthropological Study of the Hill Tribes in Kordofan.* Reprint, New York: AMS Press, 1978.

Na'ibi, Shuaibu, and Alhaji Hassan. 1969. *The Gwari, Gade and Koro Tribes.* Ibadan: Ibadan University Press.

National Museum of African Art. 1992. *History, Design and Craft in West African Strip-Woven Cloth.* Washington: Smithsonian Institution Press.

Nduka, Otonti, ed. 1993. *Studies in Ikwerre History and Culture.* Ibadan: Kraft Books.

Nenquin, Jacques A.E. 1963. *Excavations at Sanga, 1957: The Protohistoric Necropolis.* Tervuren: Musée royal de l'Afrique centrale.

_____. 1967. *Contributions to the Study of the Prehistoric Cultures of Rwanda and Burundi.* Tervuren: Musée royal de l'Afrique centrale.

Nettleton, Anitra C.E. 1986. *Catalogue, Standard Bank Foundation Collection of African Art (1797-1986), University Art Galleries' Collection of African Art and Selected Works from the University Ethnological Museum Collection.* Johannesburg: University of the Witwatersrand.

Nettleton, Anitra, and D. Hammond-Tooke, eds. 1989. *African Art in Southern Africa: From Tradition to Township.* Johannesburg: Ad. Donker.

Newbury, David S. 1979. *Kamo and Lubambo: Dual Genesis Traditions on Ijwi Island (Zaire).* Brussels: Cahiers du CEDAF.

Neyt, François. 1977. *La grande statuaire hemba du Zaïre.* Louvain: Institut supérieur d'archéologie et d'histoire de l'art.

_____. 1979. *L'Art Eket: Collection Azar.* Paris: Abeille international.

_____. 1982. *The Art of the Holo.* Munich: Fred Jahn.

_____. 1985. *The Arts of the Benue, to the Roots of Tradition, Nigeria.* N.p.: Éditions Hawaiian Agronomics.

_____. 1994. *Luba: To the Sources of the Zaire.* Paris: Éditions Dapper.

Niane, Djibril Tamsir. 1989. *Histoires des Mandingues de l'ouest: Le royaume du Gabou.* Paris: Karthala and Association ARSAN.

Niangoran-Bouah, Georges. 1984-87. *The Akan World of Gold Weights.* 3 vols. Abidjan: Nouvelles éditions africaines.

Nicklin, Keith. 1983. *Ekpu: The Oron Ancestor Figures.* London: Ethnographica.

Nketia, J.H. Kwabena. 1974. *The Music of Africa.* New York: Norton.

Nooter, Mary H., et al. 1993. *Secrecy: African Art that Conceals and Reveals.* New York: Museum for African Art.

Northern, Tamara. 1973. *Royal Art of Cameroon: The Art of the Bamenda-Tikar.* Hanover, N.H.: Hopkins Center Art Galleries, Dartmouth College.

_____. 1975. *The Sign of the Leopard: Beaded Art of Cameroon. A Loan Exhibition from the Cameroon Collections of the Linden-Museum Stuttgart.* Storrs, Conn.: The William Benton Museum of Art/University of Connecticut.

_____. 1984. *The Art of Cameroon.* Washington: Smithsonian Institution Traveling Exhibition Service.

_____. 1986. *Expressions of Cameroon Art: The Franklin Collection.* Beverly Hills, Calif.: Rembrandt Press.

Notué, Jean-Paul. 1993. *Batcham: Sculptures du Cameroun. Nouvelles perspectives anthropologiques.* Marseille: Musées de Marseille, Réunion des musées nationaux.

Nowack, Ernst. 1954. *Land und Volk der Konso, Süd-Äthiopien.* Bonn: Im Selbstverlag des Geographischen Instituts der Universität.

Ntara, Samuel Yosia. 1973. *The History of the Chewa (Mbiri ya Achewa.)* Wiesbaden: Franz Steiner.

Nunley, John Wallace. 1987. *Moving with the Face of the Devil: Art and Politics in Urban West Africa.* Urbana: University of Illinois Press.

Nuoffer, Oskar. 1925. *Afrikanische Plastik in der Gestaltung von Mutter und Kind.* Dresden: Carl Reissner.

Obenga, Theophile. 1976. *La cuvette congolaise: Les hommes et les structures; Contributions à l'histoire traditionnelle de l'Afrique centrale.* Paris: Présence africaine.

Ochieng, William Robert. 1974. *A Pre-Colonial History of the Gusii of Western Kenya from c. 1500 to 1914 A.D.* Kampala: East African Literature Bureau.

Olbrechts, Frans M. 1946. *Plastiek van Congo.* Antwerp: De Standaard. translated as *Congolese Sculpture.* Reprint, New Haven, Conn.: Human Relations Area Files, 1982.

Olderogge, Dmitry, and Werner Forman. 1969. *The Art of Africa: Negro Art from the Institute of Ethnography, Leningrad.* London: Paul Hamlyn.

Oliver, Roland, and Michael Crowder, eds. 1981. *Cambridge Encylopedia of Africa.* New York: Cambridge University Press.

Oliver, Roland, and J.D. Fage, eds. 1982. *The Cambridge History of Africa.* 8 vols. Cambridge: Cambridge University Press.

Olivier de Sardan, Jean-Pierre. 1984. *Les sociétés Songhay-Zarma, Niger-Mali: Chefs, guerriers, esclaves, paysans.* Paris: Karthala.

Ombolo, Jean-Pierre. 1986. *Essai sur l'histoire: Les clans et les regroupements claniques des Eton du Cameroun.* Yaounde: N.p.

Oppong, Christine. 1973. *Growing Up in Dagbon.* Tema: Ghana Publishing Corporation.

Osogo, John N.B. 1965. *Life in Kenya in the Olden Days: The Baluyia.* London: Oxford University Press.

Otchere, Freda E. 1992. *African Studies Thesaurus: Subject Headings for Library Users.* Westport, Conn.: Greenwood Press.

Ottenberg, Simon. 1975. *Masked Rituals of Afikpo: The Context of an African Art.* Seattle: University of Washington Press for the Henry Art Gallery.

_____. 1989. *Boyhood Rituals in an African Society: An Interpretation.* Seattle: University of Washington Press.

Ottenberg, Simon, and Phoebe Ottenberg, eds. 1963. *Cultures and Societies of Africa.* New York: Random House.

Oxford University Expedition to Ethiopia. 1975. *Rock-Hewn Churches of Eastern Tigray: An Account of the Oxford University Expedition to Ethiopia, 1974.* Oxford: Oxford University Exploration Club.

Pacere, Titinga Frédéric. 1991. *Le langage des tam-tams et des masques en Afrique (bendrologie): Une littérature méconnue.* Paris: Harmattan.

Packard, Randall M. 1981. *Chiefship and Cosmology: An Historical Study of Political Competition.* Bloomington: Indiana University Press.

Pâques, Viviana. 1954. *Les Bambara.* Paris: Presses universitaires de France for the International African Institute.

_____. 1964. *L'arbre cosmique dans la pensée populaire et dans la vie quotidienne du Nord-Ouest africain.* Paris: Institut d'ethnologie.

_____. 1977. *Le roi pêcheur et le roi chasseur.* Strasbourg: Institut d'anthropologie.

Parkin, David J. 1991. *Sacred Void: Spatial Images of Work and Ritual among the Giriama of Kenya.* Cambridge: Cambridge University Press.

Patterson, Karl David. 1969. *The Pokot of Western Kenya, 1910-1963: The Response of a Conservative People to Colonial Rule.* Syracuse: Syracuse University.

Paulme, Denise. 1940. *Organisation sociale des Dogon. Soudan français.* Paris: Domat-Monchrestien.

_____. 1954. *Les gens du riz, Kissi de Haute-Guinée française.* Paris: Plon.

_____. 1962. *African Sculpture*. London: Elek Books.

_____. 1962. *Une société de Côte d'Ivoire, hier et aujourd'hui: Les Bété*. Paris: Mouton.

_____, ed. 1963. *Women of Tropical Africa*. Berkeley and Los Angeles: University of California Press.

Paulme, Denise, and Jacques Brosse. 1956. *Parures africaines*. Paris: Hachette.

Pavitt, Nigel. 1991. *Samburu*. London: Kyle Cathie.

Pawlik, Jacek Jan. 1990. *Expérience sociale de la mort: Étude des rites funéraires des Bassar du Nord-Togo*. Fribourg: Éditions universitaires Fribourg Suisse.

Pearson, Emil. 1977. *People of the Aurora*. San Diego: Beta Books.

Peel, John D.Y. 1983. *Ijeshas and Nigerians: The Incorporation of a Yoruba Kingdom 1890s-1970s*. Cambridge: Cambridge University Press.

Pelrine, Diane M. 1991. "Zaramo Arts: A Study of Forms, Contexts, and History." Ph.D. diss., Indiana University.

Pennie, Michael. 1991. *African Assortment: African Art in Museums in England and Scotland*. Bath: Bath College of Higher Education Press.

Père, Madeleine. 1988. *Les Lobi: Tradition et changement*. 2 vols. Laval: Siloé.

Perrois, Louis. 1979. *Art du Gabon: Les arts plastiques du Bassin de l'Ogooué*. Arnouville: Arts d'Afrique noire.

_____. 1985. *Ancestral Art of Gabon: From the Collections of the Barbier-Mueller Museum*. Geneva: Barbier-Mueller Museum.

_____, ed. 1993. *Les rois sculpteurs: Art et pouvoir dan le Grassland Camerounais. Legs Pierre Harter*. Paris: Éditions de la réunion des musées nationaux.

Perrois, Louis, and Marta Sierra Delage. 1990. *The Art of Equatorial Guinea: The Fang Tribes*. New York: Rizzoli.

Perrott, John. 1992. *Bush for the Bushman: Need "The Gods Must Be Crazy" Kalahari People Die?* Greenville, Pa.: Beaver Pond Publishing.

Peterli, Rita. 1971. *Die Kultur eines Bariba-Dorfes im Norden von Dahome*. Basel: Pharos-Verlag.

Peters, Emrys L. 1990. *The Bedouin of Cyrenaica*. Cambridge: Cambridge University Press.

Petridis, Constantijn. 1992. *Wooden Masks of the Kasai Pende*. Ghent: University of Ghent, Department of Ethnic Art.

Phillips, Ruth B. 1995. *Representing Women: Sande Masquerades of the Mende of Sierra Leone*. Los Angeles: UCLA Fowler Museum of Cultural History.

Phillips, Tom, ed. 1995. *Africa: The Art of a Continent*. London: Royal Academy of Arts.

Piault, Marc Henri. 1970. *Histoire mawri: Introduction à l'étude des processus constitutifs d'un État*. Paris: Éditions du centre national de la recherche scientifique.

Pickford, Peter, Beverly Pickford, and Margaret Jacobsohn. 1990. *Himba: Nomads of Namibia*. London: New Holland.

Plant, Ruth M.L. 1985. *Architecture of the Tigre, Ethiopia*. Worcester: Ravens Educational and Development Services.

Plaschke, Dietrich, and Manfred A. Zirngibl. 1992. *African Shields: Graphic Arts of the Black Continent*. Munich: Panterra.

Podlewski, Andre Michel. 1966. *Les forgerons Mafa*. Paris: ORSTOM.

Pokornowski, Ila M., et al. 1985. *African Dress II: A Select and Annotated Bibliography*. East Lansing: African Studies Center, Michigan State University.

Ponter, Anthony, and Laura Ponter. 1993. *Spirits in Stone: The New Face of African Art*. Sebastopol, Calif.: Ukama Press.

BIBLIOGRAPHY

Poynor, Robin. 1995. *African Art from the Harn Museum: Spirit Eyes, Human Hands.* Gainesville: University of Florida.

Preston, George Nelson. 1985. *Sets, Series and Ensembles in African Art.* New York: Abrams.

Prins, A.H.J. 1952. *The Coastal Tribes of the North-Eastern Bantu (Pokomo, Nyika, Teita).* London: International African Institute.

———. 1961. *The Swahili-Speaking Peoples of Zanzibar and the East African Coast (Arabs, Shirazi and Swahili).* London: International African Institute.

Prussin, Labelle. 1969. *Architecture in Northern Ghana: A Study of Forms and Functions.* Berkeley and Los Angeles: University of California Press.

———. 1986. *Hatumere: Islamic Design in West Africa.* Berkeley and Los Angeles: University of California Press.

Prussin, Labelle, et al. 1995. *African Nomadic Architecture: Space, Place, and Gender.* Washington: Smithsonian Institution Press/National Museum of African Art.

Radcliffe-Brown, A. R., and C. Daryll Forde, eds. 1950. *African Systems of Kinship and Marriage.* London: Oxford University Press for the International African Institute.

Raso, Manuel Villar. 1987. *Andalucia en la curva del Niger.* Granada: Universidad de Granada, Diputación provinicial de Granada..

Ratton, Charles. 1931. *Masques africains.* Paris: Librairie des arts décoratifs.

Rattray, Robert Sutherland. 1923. *Ashanti.* Reprint, New York: Negro Universities Press/Greenwood Publishing, 1969.

———. 1927. *Religion and Art in Ashanti.* Reprint, Oxford: Clarendon Press, 1969.

———. 1932. *The Tribes of the Ashanti Hinterland.* Oxford: Clarendon.

Ravenhill, Philip L. 1980. *Baule Statuary: Meaning and Modernization.* Philadelphia: Institute for the Study of Human Issues.

———. 1994. *The Self and the Other: Personhood and Images among the Baule, Côte d'Ivoire.* Los Angeles: Fowler Museum of Cultural History.

Ray, Benjamin C. 1991. *Myth, Ritual and Kingship in Buganda.* New York: Oxford University Press.

Redfield, Robert, Melville Herskovits Jr., and Gordon F. Ekholm. 1959. *Aspects of Primitive Art.* New York: Museum of Primitive Art.

Redhina, Jose. 1965. *Distribuicão etnica da provincia de Angola.* 2d ed. Luanda: Centro de informacão e turismo de Angola.

Regnier, Yves. 1938. *Les Chaamba sous le régime français, leur transformation.* Paris: Domat-Montchrestien.

Reikat, Andrea. 1990. *Niombo: Begräbnisrituale in Zentralafrica: Katalog zu einer Ausstellung des Rautenstrauch-Joest-Museums.* Cologne: Rautenstrauch-Joest-Museum.

Retel-Laurentin, Anne. 1969. *Oracles et ordalies chez les Nzakara.* Paris: Mouton.

Reynolds, Barrie. 1963. *Magic, Divination and Witchcraft among the Barotse of Northern Rhodesia.* Berkeley and Los Angeles: University of California Press.

———. 1968. *The Material Culture of the Peoples of the Gwembe Valley.* New York: Praeger.

Richards, Audrey. 1956. *Chisungu: A Girls Initiation Ceremony Among the Bemba of Northern Rhodesia.* London: Faber and Faber.

———. 1959. *East African Chiefs: A Study of Political Development in Some Uganda and Tanganyika Tribes.* New York: Praeger.

Richter, Dolores. 1980. *Art, Economics and Change: The Kulebele of Northern Ivory Coast.* La Jolla, Calif.: Psych/Graphic Publishers.

Ritzenthaler, Robert E., and Pat Ritzenthaler. 1962. *Cameroons Village: An Ethnography of the Bafut.* Milwaukee: Milwaukee Public Museum.

368

BIBLIOGRAPHY

Rivière, Marceau. 1975. *Les chefs-d'oeuvre africains des collections privées françaises* (African Masterpieces from Private French Collections*)*. Paris: Éditions Philbi.

Robbins, Warren M. 1966. *African Art in American Collections.* New York: Praeger.

Robbins, Warren M., and Nancy Ingram Nooter. 1989. *African Art in American Collections, 1989.* Washington: Smithsonian Institution Press.

Robert Goldwater Library. 1982. *Catalog of the Robert Goldwater Library, The Metropolitan Museum of Art.* 4 vols. Boston: G.K. Hall.

Robert, J.M. 1949. *Croyances et coutumes magico-religieuses des Wafipa paiens.* Tabora: Tanganyika Mission Press.

Roberts, Allen F., and Evan M. Maurer, eds. 1985. *Tabwa. The Rising of a New Moon: A Century of Tabwa Art.* Ann Arbor: University of Michigan Museum of Art.

Roberts, Mary Nooter, and Allen F. Roberts, eds. 1996. *Memory: Luba Art and the Making of History.* New York: Prestel.

Robertshaw, Peter, ed. 1990. *A History of African Archaeology.* London: J. Currey.

Robinson, David Wallace. 1975. *Chiefs and Clerics: Abdul Bokar Kan and Futa Toro, 1853-1891.* Oxford: Clarendon Press.

Röschenthaler, Ute. 1993. *Die Kunst der Frauen: Zur Komplementarität von Nacktheit und Maskierung bei den Ejagham im Südwesten Kameruns.* Berlin: Verlag für Wissenschaft und Bildung.

Roscoe, John. 1923. *The Banyankole: The Second Part of the Report of the Mackie Ethnological Expedition to Central Africa.* Cambridge: Cambridge University Press.

_____. 1924. *The Bagesu and other Tribes of the Uganda Protectorate: The Third Part of the Report of the Mackie Ethnological Expedition to Central Africa.* Cambridge: Cambridge University Press.

_____. 1928. *The Bakitara or Banyoro: The First Part of the Report of the Mackie Ethnological Expedition to Central Africa.* Cambridge: Cambridge University Press.

Ross, Doran H. 1979. *Fighting with Art: Appliquéd Flags of the Fante Asafo.* Los Angeles: Regents of the University of California.

_____. 1992. *Elephant: The Animal and Its Ivory in African Culture.* Los Angeles: Fowler Musem of Cultural History, UCLA.

_____, ed. 1983. *Akan Transformations: Problems in Ghanaian Art History.* Los Angeles: Museum of Cultural History, UCLA.

Rouch, Jean. 1954. *Les Songhay.* Paris: Presses universitaires de France.

Rouget, Gilbert. 1985. *Music and Trance: A Theory of the Relations between Music and Possession.* Chicago: University of Chicago Press.

Roumeguère-Eberhardt, Jacqueline. 1963. *Pensée et société africaines: Essais sur une dialectique de complémentarité antagoniste chez les Bantu du sud-est.* Paris: Mouton. 2d ed., Paris: Publisud, 1986.

Roy, Christopher D. 1992. *Art and Life in Africa: Selections from the Stanley Collection, Exhibitions of 1985 and 1992.* Iowa City: University of Iowa Art Museum.

_____. 1987. *Art of the Upper Volta Rivers.* Meudon: Chaffin.

Rubin, Arnold. 1969. "The Arts of the Jukun-speaking Peoples of Northern Nigeria." Ph.D. diss., Indiana University.

_____. 1976. *Figurative Sculptures of the Niger River Delta.* Los Angeles: Gallery K/Barry A. Kitnik.

Rubin, William, ed. 1984. *Primitivism in Twentieth Century Art: Affinity of the Tribal and the Modern.* 2 vols. Boston: Little, Brown and Company for the Museum of Modern Art, New York.

Saberwal, Satish. 1972. *The Embu of Kenya.* New Haven: Human Relations Area Files.

Saitoti, Tepilit Ole. 1980. *Maasai.* New York: Harry N. Abrams.

BIBLIOGRAPHY

Sani, Habibu A. 1993. *Sociology of the Ebira Tao People of Nigeria.* Ilorin: University of Ilorin Press.

Sannes, G.W. 1970. *African "Primitives": Function and Form in African Masks and Figures.* London: Faber and Faber.

Sanogo, Mustapha. 1985. "Contribution à l'étude du Koma: Une société initiatique masculine chez les Worodougou de Côte d'Ivoire." Doctoral thesis, 3d cycle. Paris: École pratique des hautes études.

Santandrea, Stefano. 1966. *Aggiornamenti sull gruppo Ndogo del Bahr el Ghazal (Sudan) Tribu: Ndogo, Sere, Bai, Bviri e Golo.* Bologne: Editrice Nigrizia.

Savonnet, Georges. 1976. *Les Birifor de Diepla et sa région, insulaires du rameau lobi: Haute-Volta.* Paris: ORSTOM.

Scanzi, Giovanni Franco. 1993. *L'art traditionnel Lobi* (Lobi Traditional Art). Bergamo: Ed. Milanos.

Schädler, Karl Ferdinand. 1987. *Weaving in Africa South of the Sahara.* Munich: Panterra.

————. 1989. *Afrika Maske und Skulptur.* Olten: Historisches Museum Olten.

Schaeffner, André. 1936. *Origine des instruments de musique: Introduction ethnologique à l'histoire de la musique instrumentale.* Reprint, La Haye: Mouton, 1968.

Schapera, Isaac. 1930. *The Khoisan Peoples of South Africa: Bushmen and Hottentots.* Reprint, London: Routledge and Kegan Paul, 1965.

————. 1953. *The Tswana.* London: International African Institute.

Schebesta, Paul. 1933. *Among Congo Pigmies.* Reprint, New York: AMS Press, 1977.

Schildkrout, Enid, ed. 1987. *The Golden Stool: Studies of the Asante Center and Periphery.* New York: American Museum of Natural History.

Schildkrout, Enid, and Curtis A. Keim. 1990. *African Reflections: Art from Northeastern Zaire.* Seattle: University of Washington Press for the American Museum of Natural History.

————. 1990. *Mangbetu Ivories: Innovations between 1910 and 1914.* Boston: African Studies Center, Boston University.

Schmalenbach, Werner, ed. 1988. *African Art from the Barbier-Mueller Collection, Geneva.* Munich: Prestel.

Schmitz, Robert. 1912. *Les Baholoholo (Congo belge).* Brussels: A. DeWit.

Schneider, Harold K. 1970. *The Wahi Wanyaturu: Economics in an African Society.* Chicago: Aldine Publishing.

————. 1981. *The Africans: An Ethnological Account.* Englewood Cliffs, N.J.: Prentice-Hall.

Schomerus-Gernbock, Lotte. 1981. *Die Mahafaly: Eine ethnische Gruppe im Sud-Westen Madagaskars.* Berlin: D. Reimer.

Schröder, Günter, and Dieter Seibel. 1974. *Ethnographic Survey of Southeastern Liberia: The Liberian Kran and the Sapo.* Newark, Del.: Liberian Studies Association in America for the Tubman Center of African Culture.

Schwab, George, and George W. Harley. 1947. *Tribes of the Liberian Hinterland.* Cambridge, Mass.: Peabody Museum.

Schwartz, Nancy Beth. 1972. *Mambilla: Art and Material Culture.* Milwaukee: Milwaukee Public Museum.

Schweeger-Hefel, Annemarie. 1969. *Plastik aus Afrika.* Vienna: Museum für Völkerkunde.

————. 1980. *Masken und Mythen: Sozialstrukturen der Nyonyosi und Sikomse in Obervolta.* Vienna: A. Schendl.

Schweeger-Hefel, Annemarie, and Wilhelm Staude. 1973. *Die Kurumba von Lurum.* Vienna: A. Schendl.

BIBLIOGRAPHY

Schweinfurth, Georg. 1875. *Artes Africanae: Illustrations and Descriptions of Productions of the Industrial Arts of Central African Tribes.* Leipzig: N.p.

Seitz, Stefan. 1970. "Die Töpfer-Twa in Ruanda." Ph.D. diss., Freiburg im Breisgau.

Sekintu, C.M, and K.P. Wachsmann. 1956. *Wall Patterns in Hima Huts.* Kampala: Uganda Museum.

Seligman, C.G., and Brenda Z. Seligman. 1932. *Pagan Tribes of the Nilotic Sudan.* Reprint, London: Routledge and Kegan Paul, 1965.

Semple, Clara. 1992. *Traditional Jewellery and Ornament of Sudan.* London: N.p.

Shack, William A. 1966. *The Gurage: A People of the Ensete Culture.* London: Oxford University Press for the International African Institute.

_____. 1974. *The Central Ethiopians: Amhara, Tigrinya and Related Peoples.* London: International African Institute.

Shaw, Ella Margaret, and Nicholas J. van Warmelo. 1972-88. *The Material Culture of the Cape Nguni.* 4 vols. Cape Town: South African Museum.

Shaw, Thurstan. 1977. *Unearthing Igbo-Ukwu: Archaelogical Discoveries in Eastern Nigeria.* Ibadan: Oxford University Press.

Shaw, Thurstan, et al, eds. 1993. *The Archaeology of Africa: Foods, Metals, and Towns.* London: Routledge.

Sheddick, Vernon George John. 1953. *The Southern Sotho.* London: International African Institute.

Shorter, Aylward. 1979. *Priest in the Village: Experiences of African Community.* London: G. Chapman.

Sieber, Roy. 1972. *African Textiles and Decorative Arts.* New York: Museum of Modern Art.

_____. 1980. *African Furniture and Household Objects.* Bloomington: Indiana University Press.

Sieber, Roy, and Arnold Rubin. 1968. *Sculpture of Black Africa: The Paul Tishman Collection.* Los Angeles: Los Angeles County Museum of Art.

Sieber, Roy, and Roslyn Adele Walker. 1987. *African Art in the Cycle of Life.* Washington: Smithsonian Institution Press for the National Museum of African Art.

Sieber, Roy, Douglas Newton, and Michael D. Coe. 1986. *African, Pacific, and Pre-Columbian Art in the Indiana University Art Museum.* Bloomington: Indiana University Art Museum/Indiana University Press.

Sigge-Taupe, Dietlinde. 1975. *Die Glaubensvorstellungen der Timne und Bullom 1562-1800: Ein Beitrag zur Ethnohistorie Sierra Leones.* Vienna: Institut für Völkerkunde der Universität Wien.

Simmons, William Scranton. 1971. *Eyes of the Night: Witchcraft among a Senegalese People.* Boston: Little, Brown and Company.

Siroto, Leon. 1969. "Masks and Social Organization among the Bakwele People of Western Equatorial Africa." Ph.D. diss., Columbia University.

_____. 1995. *East of the Atlantic, West of the Congo: Art of Equatorial Africa.* San Francisco: The Fine Arts Musuems of San Francisco.

Skinner, Elliott Percival. 1989. *The Mossi of Burkina Faso: Chiefs, Politicians and Soldiers.* Prospect Heights, Ill.: Waveland Press.

Smith, Edwin William. 1926. *The Golden Stool: Some Aspects of the Conflict of Cultures in Modern Africa.* Reprint, Chicago: Afro-Am Press, 1969.

Smith, Fred T. "Gurensi Wall Painting." *African Arts* 11 (July 1978): 36-41+.

Smith, M.G. 1978. *The Affairs of Daura.* Berkeley and Los Angeles: University of California Press.

BIBLIOGRAPHY

Smithsonian Institution. 1991. *Catalog of the Library of the National Museum of African Art Branch of the Smithsonian Institution Libraries. Smithsonian Institution Libraries Research Guide # 7.* 2 vols. Boston: G.K. Hall.

Söderberg, Bertil. 1956. *Les instruments de musique au Bas-Congo et dans les régions avoisinantes: Étude ethnographique.* Stockholm: The Ethnographical Museum of Sweden.

Soga, John Henderson. 1932. *The Ama-Xosa: Life and Customs.* Lovedale: Lovedale Press.

Sote, Adetoun. 1990. *The Egba-Ake Community of Abeokuta.* Ibadan: Book Builders.

Soret, Marcel. 1959. *Les Kongo nord-occidentaux, avec la collaborations d'André Jacquot pour les questions de linguistique.* Paris: Presses universitaires de France.

Southall, Aidan William. 1956. *Alur Society: A Study in Processes and Types of Domination.* Cambridge: W. Heffer.

Spencer, Paul. 1965. *The Samburu: A Study of Gerontocracy in a Nomadic Tribe.* Berkeley and Los Angeles: University of California Press.

Spieth, Jakob. 1906. *Die Ewe-Völkes: Material zur Kunde des Ewe-Völkes in Deutsch-Togo.* Berlin: D. Reimer.

Stanley, Janet L. 1986-1995. *The Arts of Africa: An Annotated Bibliography.* 4 vols. Atlanta: African Studies Association Press.

Stappers, Leo. 1953. *Zuid-Kisongye bloemlezing: Milembwe-Teksten.* Tervuren: Musée royal du Congo belge.

Stauder, Jack. 1971. *The Majangir: Ecology and Society of a Southwest Ethiopian People.* Cambridge: Cambridge University Press.

Stefaniszyn, Bronislaw. 1964. *Social and Ritual Life of the Ambo of Northern Rhodesia.* London: Oxford University Press for the International African Institute.

Stenning, Derrick J. 1959. *Savannah Nomads: A Study of the Wodaabe Pastoral Fulani of Western Bornu Province, Northern Region, Nigeria.* London: Oxford University Press for the International African Institute.

Stevens, Phillips. 1978. *The Stone Images of Esie, Nigeria.* Ibadan: Ibadan University Press.

Stevenson, R.C. 1984. *The Nuba People of Kordofan Province: An Ethnographic Survey.* Khartoum: Graduate College, University of Khartoum.

Stoller, Paul. 1987. *In Sorcery's Shadow: A Memoir of Apprenticeship among the Songhay of Niger.* Chicago: University of Chicago Press.

Stone, Ruth M. 1982. *Let the Inside Be Sweet: The Interpretation of Music Event among the Kpelle of Liberia.* Bloomington: Indiana University Press.

Stoullig-Marin, Françoise. 1993. "The Principal Ethnic Groups of African Art." In *Art of Africa,* ed. Jacques Kerchache, Jean-Louis Paudrat, and Lucien Stéphan. New York: Harry N. Abrams.

Strecker, Ivo A. 1988. *The Social Practice of Symbolization: An Anthropological Analysis.* London: Athlone Press.

Sumaili, Tobias W.C. 1986. *Shimunenga and the Traditional Culture of the Baila.* Lusaka: Institute for African Studies.

Summers, Roger. 1958. *Inyanga: Prehistoric Settlements in Southern Rhodesia.* Cambridge: Cambridge University Press for Inyanga Research Fund.

Swantz, Lloyd W. 1966. *The Zaramo of Tanzania.* Dar es Salaam: N.p.

Swantz, Marja-Liisa. 1986. *Ritual and Symbol in Transitional Zaramo Society, with Special Reference to Women.* 2d ed. Uppsala: Scandinavian Institute of African Studies.

————. 1995. *Blood, Milk and Death: Body Symbols and the Power of Regeneration among the Zaramo of Tanzania.* Westport, Conn.: Bergin and Garvey.

BIBLIOGRAPHY

Swartz, Marc J. 1991. *The Way the World Is: Cultural Processes and Social Relations among the Mombasa Swahili*. Berkeley and Los Angeles: University of California Press.

Sweeney, James. 1970. *African Sculpture*. 3d ed. Princeton: Princeton University Press.

Szwed, John F., and Roger D. Abrahams. 1978. *Afro-American Folk Culture: An Annotated Bibliography of Materials from North, Central, and South America and the West Indies*. 2 vols. Philadelphia: Institute for the Study of Human Issues.

Tagliaferri, Aldo. 1974. *Fabulous Ancestors: Stone Carvings from Sierra Leone and Guinea*. New York: Africana Publishing.

_____. 1989. *Stili del potere: Antiche sculture in pietra dalla Sierra Leone e dalla Guinea*. Milan: Electa.

Tahiri-Zagret, Michel. 1987. *Le crépuscule de la dynastie des Ware*. Abidjan: N.p.

Tait, David. 1961. *The Konkomba of Northern Ghana*. Cambridge: Cambridge University Press.

Tardits, Claude. 1960. *Bamileké de l'ouest Cameroun: Contribution à l'étude des populations*. Paris: Berger-Levrault.

_____. 1980. *Le royaume Bamoum*. Paris: Armand Colin.

_____. 1981. *Contribution de la recherche ethnologique à l'histoire des civilisations du Cameroun* (The Contribution of Ethnological Research to the History of Cameroon Cultures). 2 vols. Paris: Éditions du Centre national de la recherche scientifique.

Taylor, Brian K. 1962. *The Western Lacustrine Bantu (Nyoro, Toro, Nyankore, Kiga, Haya, and Zinza, with Sections on the Amba and Konjo)*. London: International African Institute.

Tengan, Edward. 1991. *The Land as Being and Cosmos: The Institution of the Earth Cult among the Sisala of Northwestern Ghana*. New York: P. Lang.

Terray, Emmanuel. 1969. *L'organization sociale des Dida de Côte d'Ivoire: Essai sur un village dida de la région de Lakora*. Abidjan: Université d'Abidjan.

Tessmann, Gunter. 1913. *Die Pangwe. Völkerkundliche Monographie eines Westafrikanischen Negerstammes. Ergebnisse der Lübecker Pangwe-Expedition 1907-1909 und früherer Forschungen 1904-1907*. 2 vols. Berlin: Ernst Wasmuth.

_____. 1934. *Die Bafia und die Kultur der Mittelkamerun-Bantu*. Stuttgart: Strecker und Schröder.

Tew, Mary Douglas. 1950. *Peoples of the Lake Nyasa Region*. London: Oxford University Press for the International African Institute.

_____. 1963. *The Lele of the Kasai*. London: Oxford University Press for the International African Institute.

Thiel, Josef Franz. 1972. *La situation religieuse des Mbiem*. Bandundu: Centre d'études ethnologiques.

Thomas, Elizabeth Marshall. 1965. *Warrior Herdsmen*. New York: Alfred A. Knopf.

Thomas, L.V. 1959. *Les Diola: Essai d'analyse fonctionnelle sur une population de Basse-Casamance*. Dakar: IFAN.

Thompson, Jerry L., and Susan Vogel. 1990. *Closeup: Lessons in the Art of Seeing. African Sculpture from an American Collection and the Horstmann Collection*. New York: Center for African Art.

Thompson, Robert Farris. 1971. *Black Gods and Kings: Yoruba Art at UCLA*. Los Angeles: UCLA Museum and Laboratories of Ethnic Arts and Technology.

_____. 1974. *African Art in Motion: Icon and Act*. Berkeley and Los Angeles: University of California Press.

_____. 1983. *Flash of the Spirit: African and Afro-American Art and Philosophy*. New York: Random House.

373

BIBLIOGRAPHY

_____. 1983. *Painting From a Single Heart: Preliminary Remarks on Bark-Cloth Designs of the Mbute Women of Haut-Zaire*. Munich: Fred und Jens Jahn.

Tobisson, Eva. 1986. *Family Dynamics among the Kuria: Agro-Pastorialists in Northern Tanzania*. Goteborg: Acta Universitatis Gothoburgensis.

Tonnoir, René. 1966. "Le bondjo, trompe rituelle et instrument privilégié des chefs chez les Ekonda." *Africa-Tervuren* 12: 48-53.

_____. 1970. *Giribuma: Contribution à l'histoire et à la petite histoire du Congo équatorial*. Tervuren: Musée royal de l'Afrique centrale.

Torday, Emil, Thomas A. Joyce, and Norman H. Hardy. 1910. *Notes ethnographiques sur les peuples communément appelés Bakuba, ainsi que sur les peuplades apparentées: Les Bushongo*. Brussels: Ministère des colonies.

Tozzer Library. 1981. *Tozzer Library Index to Anthropological Subject Headings, Harvard University*. 2d rev. ed. Boston: G.K. Hall.

Tracey, Hugh. 1948. *Chopi Musicians: Their Music, Poetry, and Instruments*. London: Oxford University Press.

Trilles, R. P. 1932. *Les Pygmées de la forêt équatoriale*. Paris: Bloud and Gay.

Trouwborst, A.A., M. d'Hertefelt, and J.H. Scherer. 1962. *Les anciens royaumes de la zone inter-lacustre méridionale; Rwanda, Burundi, Buha*. London: International African Institute.

Trowell, Margaret. 1964. *Classical African Sculpture*. 2d ed. New York: Praeger.

_____. 1971. *African Design*. 3d ed. New York: Praeger.

Trowell, Margaret, and K.P. Wachsmann. 1953. *Tribal Crafts of Uganda*. London: Oxford University Press.

Tubiana, Joseph, and Marie-José Tubiana. 1977. *The Zaghawa from an Ecological Perspective: Foodgathering, the Pastoral System, Tradition and Development of the Zaghawa of the Sudan and the Chad*. Rotterdam: A.A. Balkema.

Tucker, A. N., and M.A. Bryan. 1956. *The Non-Bantu Languages of North-Eastern Africa: With a Supplement on the Non-Bantu Languages of Southern Africa by E.O.J. Westphall*. London: Oxford University Press for the International African Institute.

_____. 1966. *Linguistic Analyses: The Non-Bantu Languages of North-Eastern Africa: With a Supplement on the Ethiopic Languages by Wolf Leslau*. London: Oxford University Press for the International African Institute.

Turle, Gillies. 1992. *The Art of the Maasai: 300 Newly Discovered Objects and Works of Art*. New York: Alfred A. Knopf.

Turnbull, Colin M. 1961. *The Forest People*. New York: Simon and Schuster.

_____. 1972. *The Mountain People*. New York: Simon and Schuster.

Turner, Edith L.B. 1992. *Experiencing Ritual: A New Interpretation of African Healing*. Philadelphia: University of Pennsylvania Press.

Turner, Jane, ed. 1996. *The Dictionary of Art*. New York: Grove's Dictionaries.

Turner, Victor Witter. 1953. *The Lozi Peoples of North-Western Rhodesia*. London: International African Institute.

_____. 1953. *Luanda Rites and Ceremonies*. Livingstone: Rhodes-Livingstone Museum.

_____. 1967. *The Forest of Symbols: Aspects of Ndembu Ritual*. Ithaca: Cornell University Press.

_____. 1986. *The Anthropology of Performance*. New York: PAS Publications.

Uchendu, Victor C. 1965. *The Igbo of Southeast Nigeria*. New York: Holt, Rinehart and Winston.

BIBLIOGRAPHY

UNESCO International Scientific Committee for the Drafting of a General History of Africa. 1981. *General History of Africa.* 8 vols. London: Heinemann Educational Books; Berkeley and Los Angeles: University of California Press.

UNESCO. 1984. *African Ethnonyms and Toponyms: Report and Papers of the Meeting of Experts Organized by UNESCO in Paris, 3-7 July, 1978.* Paris: UNESCO.

University of Iowa. 1986-1994. *Iowa Studies in African Art: The Stanley Conferences at the University of Iowa.* 3 vols. Iowa City: University of Iowa.

Valiente Noailles, Carlos. 1993. *The Kua: Life and Soul of the Central Kalahari Bushmen.* Brookfield, Vt.: Balkema.

Vallois, Henri V., and Paulette Marquer. 1976. *Les Pygmées Baka du Cameroun: Anthropologie et ethnographie avec une annexe démographique.* Paris: Éditions du Museum.

van Beek, W.E.A. 1987. *The Kapsiki of the Mandara Hills.* Prospect Heights, Ill.: Waveland Press.

van Binsbergen, Wim. 1992. *Tears of Rain: Ethnicity and History in Central Western Zambia.* London: Kegan Paul International.

Vandenhoute, P.J.L. 1947. *Afrikaanse kunst in Nederland.* Leiden: Rijksmuseum voor volkenkunde.

————. 1948. *Classification stylistique du masque Dan et Guéré de la Côte d'Ivoire occidentale.* Mededelingen van het Rijksmuseum voor volkenkunde 4. Leiden: Brill.

van Dongen, Paul, Matthi Forrer, and Willem R. van Gulik. 1987. *Topstukken uit het Rijksmuseum voor volkenkunde* (Masterpieces from the National Museum of Ethnology). Leiden: Rijksmuseum voor Volkenkunde.

Van Everbroeck, Nestor. 1974. *Ekond'e Mputela: Histoire, croyances, organisation clanique, politique, sociale et familiale des Ekonda et de leurs Batoa.* Tervuren: Musée royal de l'Afrique centrale.

van Geluwe, Huguette. 1957. *Les Bira et les peuplades limitrophes.* London: International African Institute.

————. 1957. *Mamvu-Mangutu et Balese-Mvuba.* London: International African Institute.

————. 1960. *Les Bali et les peuplades apparentées (Ndaka, Mbo, Beke, Lika, Budu, Nyari).* Tervuren: Musée royal du Congo belge.

Vangroenweghe, Daniel. 1977. "Oorsprong en verspreiding van Bobongo en Iyaya bij de Ekonda." *Africa-Tervuren* 23: 106-128.

————. 1988. *Bobongo: La grande fête des Ekonda (Zaire).* Berlin: D. Reimer.

van Grunderbeek, Marie-Claude. 1983. *Le premier âge du fer au Rwanda et au Burundi: Archéologie et environnement.* Butare: Institut national de recherche scientifique.

Van Noten, Francis L. 1983. *Histoire archéologique du Rwanda.* Tervuren: Musée royal de l'Afrique central.

Van Offelen, Marion. 1983. *Nomads of Niger.* New York: Harry N. Abrams.

Van Riel, F., and G. De Plaen. 1967. *Données sur les Binja des environs de Kasongo recueilles par F. Van Riel.* Tervuren: Musée royal de l'Afrique centrale.

Vansina, Jan. 1954. *Les tribus Ba-Kuba et les peuplades apparentées.* London: International African Institute.

————. 1966. *Kingdoms of the Savanna.* Madison: University of Wisconsin Press.

————. 1973. *The Tio Kingdom of the Middle Congo, 1880-1892.* London: Oxford University Press for the International African Institute.

————. 1978. *The Children of Woot: A History of the Kuba Peoples.* Madison: University of Wisconsin Press.

BIBLIOGRAPHY

_____. 1984. *Art History in Africa: An Introduction to Method*. London: Longman Group.

_____. 1990. *Paths in the Rainforest: Toward a History of Political Tradition in Equatorial Africa*. Madison: University of Wisconsin Press.

Van Wing, J. 1959. *Études Bakongo: Sociologie, religion et magie*. 2d ed. Bruges: Desclée de Brouwer.

Vatter, Ernest. 1926. *Religiöse Plastik der Naturvölker*. Frankfurt am Main: Frankfurter Verlags-Anstalt.

Vergiat, Antonin M. 1937. *Moeurs et coutumes de Manjas*. Paris: Payot.

Verhulpen, Edmond. 1936. *Baluba et Balubaisés du Katanga*. Antwerp: L'avenir belge.

Verswijver, Gustaaf, et al. 1995. *Treasures from the Africa-Museum, Tervuren*. Tervuren: Royal Museum for Central Africa.

Vincent, Jeanne Françoise. 1975. *Le pouvoir et le sacré chez les Hadjeray du Tchad*. Paris: Éditions Anthropos.

Vivelo, Frank Robert. 1977. *The Herero of Western Botswana: Aspects of Change in a Group of Bantu-Speaking Cattle Herders*. St. Paul: West Publishing.

Vogel, Joseph O. 1994. *Great Zimbabwe: The Iron Age in South Central Africa*. New York: Garland.

Vogel, Susan Mullin. 1986. *African Aesthetics: The Carlo Monzino Collection*. New York: Center for African Art.

_____, ed. 1981. *For Spirits and Kings: African Art from the Paul and Ruth Tishman Collection*. New York: Museum of Modern Art.

Vogel, Susan Mullin, et al. 1989. *Art/Artifact: African Art in Anthropology Collections*. 2d ed. New York: Center for African Art.

Vogel, Susan Mullin, and Francine N'Diaye. 1985. *African Masterpieces from the Musée de l'Homme*. New York: Center for African Art/Harry N. Abrams.

Vogel, Susan Mullin, and Phillip L. Ravenhill. 1980. *Beauty in the Eyes of the Baule: Aesthetics and Cultural Values*. Philadelphia: Institute for the Study of Human Issues.

von Sydow, Eckart. 1930. *Handbuch der Westafrikanischen Plastik*. Berlin: Dietrich Reimer.

_____. 1954. *Afrikanische Plastik: Aus dem Nachlass herausgegeben von Gerdt Kutscher*. New York: Wittenborn.

von Wissmann, Hermann, et al. 1988. *Im Innern Afrikas: Die Erforschung des Kassai Während der Jahre 1883-1885*. Leipzig: F.A. Brockhaus.

Waane, S.A.C. 1976. *Pottery Making Traditions of the Ikombe Kisi of Kyela District: An Anthropological Paper*. Dar es Salaam: National Museum of Tanzania.

Wachsmann, Klaus P., ed. 1971. *Essays on Music and History in Africa*. Evanston, Ill.: Northwestern University Press.

Wagner, Gunter. 1970. *The Bantu of Western Kenya: With Special Reference to the Vugusu and the Logoli*. London: Oxford University Press for the International African Institute.

Wane, Yaya. 1969. *Les Toucouleur du Fouta Tooro (Sénégal): Stratification sociale et structure familiale*. Dakar: Institut fondamental d'Afrique noire.

Wardwell, Allen. 1986. *African Sculpture from the University Museum, University of Pennsylvania*. Philadelphia: Philadelphia Museum of Art.

Warren, Dennis M. 1975. *The Techiman-Bono of Ghana: An Ethnography of an Akan Society*. Dubuque, Iowa: Kendall/Hunt Publishing Company.

Wassing, René S. 1968. *African Art: Its Background and Traditions*. London: Alpine Fine Arts Collection.

BIBLIOGRAPHY

Watson, William. 1958. *Tribal Cohesion in a Money Economy: A Study of the Mambwe People of Northern Rhodesia.* Manchester: Manchester University Press for the Rhodes-Livingstone Institute.

Weber, Michael J., et al. 1987. *Perspectives: Angles on African Art.* New York: Center for African Art/Harry N. Abrams.

Welmers, William E. 1973. *African Language Structures.* Berkeley and Los Angeles: University of California Press.

Wente-Lukas, Renate. 1977. *Die materielle Kultur der nicht-islamischen Ethnien von Nord-Cameroun und Nordostnigeria.* Wiesbaden: Steiner.

_____. 1985. *Handbook of Ethnic Units in Nigeria.* Studien zur Kulturkunde, vol. 74. Stuttgart: Franz Steiner Verlag Weisbaden.

Wenzel, Marian. 1972. *House Decoration in Nubia.* Toronto: University of Toronto Press.

Westerdijk, Peter. 1988. *The African Throwing Knife: A Style Analysis.* Utrecht: P. Westerdijk.

_____. 1988. *Symbols of Wealth: Abstractions in African Metalwork.* New York: Michael Ward.

Westermann, Dietrich, and M.A. Bryan. 1952. *The Languages of West Africa.* London: Oxford University Press for the International African Institute.

Western, Dominique Coulet. 1975. *A Bibliography of the Arts of Africa.* Waltham, Mass.: African Studies Association, Brandeis University.

White, Charles Matthew Newton. 1948. *The Material Culture of the Lunda-Lovale Peoples.* Livingstone: Rhodes-Livingstone Museum.

Whiteley, Wilfred H., and J. Slaski. 1950. *The Bemba and Related Peoples of Northern Rhodesia/Peoples of the Luapula Valley.* London: International African Institute.

Widman, Ragnar. 1967. *The Niombo Cult among the Babwende.* Stockholm: Etnografiska museet.

Widstrand, Carl Gosta. 1958. *African Axes.* Uppsala: Almqvist and Wiksell.

Wilks, Ivor. 1989. *Wa and the Wala: Islam and Polity in Northwestern Ghana.* Cambridge: Cambridge University Press.

Willcox, A.R. 1984. *The Rock Art of Africa.* New York: Holmes and Meier.

Willett, Frank. 1967. *Ife in the History of West African Sculpture.* New York: McGraw-Hill.

_____. 1971. *African Art: An Introduction.* New York: Praeger. Reprint, London: Thames and Hudson, 1985.

Willis, Roy G. 1966. *The Fipa and Related Peoples of South-West Tanzania and North-East Zambia.* London: International African Institute.

Wills, A.J. 1967. *An Introduction to the History of Central Africa.* London: Oxford University Press.

Wilson, Godfrey. 1939. *The Constitution of Ngonde.* Livingstone: Rhodes-Livingstone Institute.

Wilson, Monica Hunter. 1951. *Good Company: A Study of Nyakyusa Age-Villages.* London: Oxford University Press for the International African Institute.

Winans, Edgar V. 1962. *Shambala: The Constitution of a Traditional State.* Berkeley and Los Angeles: University of California Press.

Wingert, Paul S. 1950. *The Sculpture of Negro Africa.* New York: Columbia University Press.

Winter, Edward H. 1956. *Bwamba: A Structural-Functional Analysis of a Patrilineal Society.* Cambridge: W. Heffer and Sons.

Witte, Hans. 1988. *Earth and the Ancestors: Ogboni Iconography.* Amsterdam: Gallery Balolu.

BIBLIOGRAPHY

Wittmer, Marcilene Keeling. 1976. "Bamum Village Masks." Ph.D. diss., Indiana University.

_____. 1991. *Visual Diplomacy: The Art of the Cameroon Grassfields*. Cambridge, Mass.: Hurst Gallery.

Wittmer, Marcilene Keeling, and William Arnett. 1978. *Three Rivers of Nigeria: Art of the Lower Niger, Cross, and Benue from the Collection of William and Robert Arnett*. Atlanta: High Museum of Art.

Wognou, Jean Marcel Eugene. 1985. *Les Basaa du Cameroun: Monographie historique d'après la tradition orale*. Niamey: Organisation de l'unité africaine, Centre d'études linguistiques et historiques par tradition orale.

Wolfe, Alvin W. 1961. *In the Ngombe Tradition*. Evanston, Ill.: Northwestern University Press.

Wolfe, Ernie. 1986. *Vivango: The Commemorative Sculpture of the Mijikenda of Kenya*. Williamstown, Mass.: Williams College Museum of Art.

Woodburn, James. 1970. *Hunters and Gatherers: The Material Culture of the Nomadic Hadza*. London: British Museum.

Wyse, Akintola J.G. 1980. *Search Light on the Krio of Sierra Leone: An Ethnographical Study of a West African People*. Freetown: Institute of African Studies, University of Sierra Leone.

Yoder, John Charles. 1992. *The Kanyok of Zaire: An Institutional and Ideological History to 1895*. Cambridge: Cambridge University Press.

Zahan, Dominique. 1960. *Sociétés d'initiation Bambara*. Paris: Mouton.

_____. 1974. *The Bambara*. Leiden: E.J. Brill.

_____. 1979. *The Religion, Spirituality, and Thought of Traditional Africa*. Chicago: University of Chicago Press.

_____. 1980. *Antilopes du soleil: Arts et rites agraires d'Afrique noire*. Vienna: Édition A. Schendl.

Zangabadt, Sen Luka Gwom. 1992. *The Berom Tribe of Plateau State of Nigeria*. Jos Nigeria: Fab Education Books.

Zeitlyn, David. 1994. *Sua in Somie: Aspects of Mambila Traditional Religion*. St. Augustin: Academia Verlag.

Zemp, Hugo. 1971. *Musique Dan. La musique dans la pensée et la vie sociale d'une société africaine*. Paris: Mouton.

Zetterstrom, Kjell. 1976. *The Yamein Mano of Northern Liberia*. Uppsala: University of Uppsala.

Zirngibl, Manfred A. 1983. *Seltene afrikanische Kurzwaffen*. Grafenau: Morsak.